Impressions of Light

Impressions of Light

THE FRENCH LANDSCAPE FROM COROT TO MONET

George T. M. Shackelford and Fronia E. Wissman

contributions by David P. Becker, Karen E. Haas, Anne E. Havinga, Joanna Karlgaard, Nicole R. Myers, Sue Welsh Reed, Rebecca Senf, and Barbara Stern Shapiro

MFA PUBLICATIONS

a division of the Museum of Fine Arts, Boston

MFA PUBLICATIONS
a division of the Museum of Fine Arts, Boston
465 Huntington Avenue
Boston, Massachusetts 02115
Tel. 617 369 3438 Fax 617 369 3459
www.mfa-publications.org

This book was published to accompany the exhibition *Impressions of Light: The French Landscape from Corot to Monet*, organized by the Museum of Fine Arts, Boston, December 15, 2002–April 13, 2003.

© 2002 by Museum of Fine Arts, Boston
ISBN 0-87846-646-0 hardcover
ISBN 0-87846-647-9 softcover
Library of Congress Control Number: 2002104335

Front cover: Pierre-Auguste Renoir, *The Seine at Chatou,* 1881 (cat. no. 102)

Back cover: Jean-Baptiste-Camille Corot, *Mother and Child in a Wooded Landscape,* 1856 (cat. no. 17)

Frontispiece: Claude Monet, *View of the Sea at Sunset,* about 1862 (cat. no. 83)

All photographs of works in the Museum of Fine Arts, Boston's collection are by the Department of Photographic Services, Museum of Fine Arts, Boston.

Designed and produced by Cynthia Rockwell Randall

Edited by Sarah E. McGaughey and Emiko K. Usui
Documentation edited by Denise Bergman

Printed and bound at Arnoldo Mondadori Editore, Verona, Italy

Trade distribution:
Distributed Art Publishers/D.A.P.
155 Sixth Avenue, 2nd floor
New York, New York 10013
Tel. 212 627 1999 Fax 212 627 9484

FIRST EDITION
Printed in Italy

Contents

Foreword

Jean-Baptiste-Camille Corot wrote to a friend in 1827, at the beginning of his career, "I have only one aim in life, which I wish to pursue steadfastly: it is to make landscapes." Emerging from the revival of landscape art at the end of the eighteenth century, Corot and his colleagues were to revolutionize the depiction of light and nature in their time, giving new vitality to a tradition that would culminate in the late Impressionism of Claude Monet after 1900. *Impressions of Light: The French Landscape from Corot to Monet* explores that great tradition through more than 150 great works from the collections of the Museum of Fine Arts, Boston.

For the first time, this book and the exhibition it accompanies reunite Boston's impressive holdings of landscape paintings with equally distinguished examples of works on paper: pastels, watercolors, drawings, prints, and a superb selection of photographs. Thanks are due to the team of curators and authors, led by Sue Welsh Reed, George T. M. Shackelford, and Fronia E. Wissman, who have written this thoughtful book and, with the help of many members of the Museum's staff, produced an equally handsome exhibition.

Among the treasures showcased here are a painting by Corot and three drawings by Jean-François Millet given to the Museum in 1876, the year of its opening. In addition to magnificent gifts and bequests from Boston collectors of the nineteenth and twentieth centuries, we find here purchases made possible by the generosity of many donors to the institution—including, for instance, a noteworthy photograph by Alphonse Jeanrenaud acquired only in 2001. I would like to acknowledge, on behalf of the Museum and the public it serves, our unending gratitude to the men and women who have made this great collection one of the richest of its kind in the world.

In 1926, the year of his death, Claude Monet wrote that "the only merit I have is to have painted directly from nature with the aim of conveying my impressions in front of the most fugitive effects." We hope that our readers and visitors will take this extraordinary opportunity to study a century of such impressions, to see through the artist's eyes the splendor of light.

MALCOLM ROGERS
Ann and Graham Gund Director

Acknowledgments

Impressions of Light grew out of an earlier project, an exhibition entitled *Monet, Renoir, and the Impressionist Landscape*, organized by the Museum of Fine Arts, Boston, on the occasion of the opening of the Nagoya/Boston Museum of Fine Arts in 1999. We are grateful to our colleagues in Nagoya, particularly Saeko Yamawaki and Makiko Yamada, for their cooperation. That exhibition, slightly altered, was subsequently presented in 2000 and in 2002 in North America and in Ireland. We would like to thank our associates at the following institutions for their support of the project: at the National Gallery of Canada: Pierre Théberge, Colin B. Bailey, Serge Thériault, Usher Caplan; at the Virginia Museum of Fine Arts: Katharine Lee Reid, Richard Woodward, Malcolm Cormack; at the Museum of Fine Arts, Houston: Peter Marzio, Edgar Peters Bowron, Mary Morton; and at the National Gallery of Ireland: Raymond Keaveney, Fionnuala Croke.

The authors and contributors are grateful to the following individuals who have given advice during the preparation of the catalogue: Sylvie Aubenas, Katia Busch, Denis Canguilhem, David Park Curry, Malcolm Daniel, Louise Désy, Douglas Druick, Robert Hershkowitz, Erica E. Hirshler, Charles Isaacs, Ken Jacobson, Elaine Kilmurray, Robert Klein, Mack Lee, Alexandra R. Murphy, Marc Simpson, Abigail G. Smith, MaryAnne Stevens, Paul Hayes Tucker, and Bradford Washburn.

We would like to thank members of the Museum of Fine Arts, Boston, staff—both past and present—who played a role in the production of this book and in the creation of the exhibition that it accompanies: Clifford S. Ackley, Gregory J. Albers, Jim Armbruster, Ronni Baer, Natalia Bard, Jennifer Bose, Raymond Burke, Gary Bustin, Deborah Carton, Keith Crippen, Leane DelGaizo, Kathleen Drea, Gail B. English, Rae Francoeur, Julia Fuld, David Geldart, Katherine Getchell, Phil Getchell, Larry Gibbons, Kelly Gifford, Dawn Griffin, Deanna M. Griffin, Sarah Gurney, Andrew Haines, Melinda Hallisey, Mazie Harris, Patricia B. Jacoby, Jennifer Jandebeur, Irene Konefal, Thomas Lang, Emily Lasner, Margaret Laster, Alexandra Ames Lawrence, Mary Lister, Susan Longhenry, Rhona MacBeth, Annette Manick, Barbara Martin, William McAvoy, Terry McAweeney, Sarah E. McGaughey, Jennifer McIntosh, Max McNeil, Elizabeth Meyers, Martha Rush Mueller, Patrick Murphy, Saravuth Neou, Kimberly Nichols, Janet O'Donoghue, Roy Perkinson, Mark Polizzotti, Cynthia R. Randall, Thomas E. Rassieur, Ann and Graham Gund Director Malcolm Rogers, Gary Ruuska, Gilian Shallcross, John S. Stanley, Stephanie Stepanek, Erika Swanson, Emiko K. Usui, Lydia Vagts, Julia Valiela, Gen Watanabe, Jennifer Weissman, Jean Woodward, John D. Woolf, and Jim Wright.

THE AUTHORS

Impressions of Light:
The French Landscape from Corot to Monet

George T. M. Shackelford

Impressions of Light presents a selection of more than eighty paintings and seventy works of graphic art by artists from Jean-Baptiste-Camille Corot to Claude Monet, as well as by figures of the generations before and after them who shared their inspiration. It begins with the roots of the Impressionist landscape in the art of Corot and the Barbizon School and extends as far as the Post-Impressionist compositions of Paul Gauguin, Vincent van Gogh, and the late work of Monet himself. Drawn entirely from the great collection of paintings and graphic arts at the Museum of Fine Arts, Boston, this book showcases some of Boston's most famous works by these well-known artists and others such as Jean-François Millet, Pierre-Auguste Renoir, and Edgar Degas. But the project also features astonishing paintings, newly brought to light from the Museum's collection, by artists such as Paul Huet, Karl Bodmer, and Antoine Chintreuil, whose fame in the early twenty-first century has been overshadowed by that of the Impressionist generation.

Even those who know nineteenth-century French landscape well may be surprised to find here paintings that they have never seen before. Recent generations of collectors and scholars have widened our view of the genre, bringing a new understanding of how these vanguard artists fit into a more complicated pattern of artistic development. Above all, modern audiences will be astonished by the richness and variety of the works of graphic art assembled here and reproduced in this book, many for the first time. For example, while Degas's paintings of the racecourse may be familiar to most admirers of Impressionism, few readers of this book may know that many if not most of Degas's greatest landscape images were created on paper, mostly in the experimental medium of monotype. Degas revived the monotype in the late 1870s and returned to it between 1890 and 1892 to make some of the most radical landscape images of the nineteenth century. Five of these rare and beautiful works are included here (cat. nos. 94–95, 121–23).

In fact, the Museum's collection of works on paper—pastels, watercolors, drawings, and prints—is particularly rich in the production of artists who were primarily known as painters but who were equally adept in graphic media. Millet is thus seen in paintings, charcoal and black chalk drawings, etchings, watercolors, and a magnificent series of pastels. Gauguin is represented not only in paintings such as the *Landscape with Two Breton Women* of 1889 but also by a daring zincograph, printed on bright yellow paper and colored by hand in the same year (see cat. nos. 124–25). The book also includes works by such artists as Rodolphe Bresdin, who worked almost exclusively in graphic media, producing some of the century's most curious and beautiful prints and drawings (cat. nos. 40–42). Corot is represented by paintings, drawings, prints, and the hybrid medium of *cliché-verre*, a newly invented process in his day in which a photographic negative was

made by painting or scraping a light-blocking medium on a glass plate, the plate in turn used to print the image on photo-sensitive paper.

In our time, as in 1859 when photography was first given a place beside the arts of painting and drawing at the Salon (the juried exhibitions sponsored by the Académie des Beaux-Arts), photographs by Eugène Cuvelier or Gustave Le Gray reveal that the nineteenth century's newest artistic tool could be richly exploited for the creation of landscape images (see cat. nos. 24–26, 30). The subjects treated by painters and photographers are often remarkably similar—indeed many of these artists were acquainted with one another—yet they have rarely been discussed on equal terms, in part because of the hegemony of painting in the public imagination. When placed alongside the paintings, these photographs, prints, and drawings tell much more completely the story of French art in the nineteenth century.

Charting the Journey

The development of the French nineteenth-century landscape forms a complex tale, yet too often the narrative has been reduced to a simple and direct trajectory: from the plein-air cloud studies of the British painter John Constable, whose work exerted a profound influence across the English Channel, to the freely painted compositions of the Barbizon School; and on from there to Monet's *Impression: Sunrise* and the sunstruck landscapes of Van Gogh at Arles, Saint-Rémy, and Auvers. This story recognizes the fact that the Impressionists, encouraged by the example of their forebears at Barbizon, rejected the fussy, overly finished effects of paintings intended for exhibition at the official Salons. They opted instead to paint sketchlike compositions in the open air and to exhibit these "impressions" as finished works, thus forging a modern landscape style, much to the consternation of the critics as well as the public. Their advances, in turn, were the background against which the artists at the end of the century elaborated their own vision of what landscape art should be.

This version is undoubtedly true, but it describes only one of the many ways in which the art of landscape emerged across the century from the achievements of the Men of 1830, as Corot and his contemporaries were called; French landscape's development in the 1860s, 1870s, and 1880s was not a simple linear progression away from the preoccupations of an official style and toward a modernist idiom. The present book attempts to trace some of the major paths of that development. Beginning with the French artists who brought landscape into a new light at the end of the eighteenth century—artists such as Pierre-Henri de Valenciennes and Jean-Joseph-Xavier Bidauld (see cat. nos. 1–2)—it then

focuses on the painting and graphic arts of the Barbizon masters: Corot, above all, but also Théodore Rousseau, Charles-François Daubigny, Narcisse-Virgile Diaz de la Peña, and Constant Troyon, as well as the Barbizon artist most closely identified with the Museum, Millet. Boston's phenomenal holdings of Impressionist landscape painting and graphic arts—most significantly, the work of Monet, but also the achievements of his contemporaries—are treated in turn. But by including here, for instance, not only the works of the indisputably Impressionist landscape painters—Monet and Renoir, with Paul Cézanne, Degas, Camille Pissarro, and Alfred Sisley—but also works by some of their more traditionalist contemporaries—François-Louis Français, Jean Charles Cazin, and Henri-Joseph Harpignies, for example—this project seeks to enrich the story of the French nineteenth-century landscape, pointing out interesting byways that intersect or branch off from those paths.

Points of Departure

Camille Corot, whose achievement in landscape dominates the first half of the nineteenth century, began his own artistic journey by going to terrain that was considered, in his day, the source of the great landscape traditions of art history: Italy. Corot was attracted to Italy by its fabled light, the qualities of which were supposed to be especially favorable for painting, and by the antiquity and nobility of the motifs that he would find there. He followed in the footsteps of a generation of painters who arrived in Rome in the last decades of the eighteenth century, among them Valenciennes and Bidauld, who were active in Italy in the 1780s. The great contribution that these painters made to the practice of landscape painting in their time was in the stress that they placed on the experience of nature *en plein air*, advocating the use of the painted oil sketch made in the landscape.

Their landscape sketches did not necessarily serve directly for the elaboration of "composed" landscape paintings worthy of the Salon, such as Valenciennes's *Italian Landscape with Bathers* (cat. no. 1). In the treatise that Valenciennes published in 1800 for the practical use of artists, the *Eléments de perspective* (Elements of perspective), he distinguished such compositions from studies made for the singular purpose of perfecting the artist's sensibility.[1] Valenciennes (known as the "David of landscape," a reference to his contemporary Jacques-Louis David, the painter of ancient history) also argued for the worthiness of the historical landscape in the Academic hierarchy. *Eléments de perspective* codified the practice of artists of his own generation—Bidauld, for example—and gave practical advice to the generation that was to follow—painters like Théodore Caruelle d'Aligny, Huet, and, of course, Corot—so that by the 1820s, sketching was a firmly

Fig. 1. Paul Huet, *The Forest of Compiègne*, about 1830, Museum of Fine Arts, Boston.

established part of the landscape painter's practice. Huet, for example, is known to have employed a single canvas to execute five small-scale views in the forest near the château of Compiègne (fig. 1). He later expanded some of those miniature impressions in larger canvases, but the rest remained studies made for their own sake.

Corot was similarly imbued with Valenciennes's lessons through his teachers, Jean-Victor Bertin and Achille Michallon, and went to Rome in December 1825 to paint the expected views of the Colosseum and the Forum, motifs along the Tiber, and panoramic stretches of the Roman Campagna. In sketch after sketch, he judiciously captured the particular qualities of light as it fell onto manmade structures or distant grassy plains.[2] Even when he turned his attention to the human figure, he was intent upon understanding the action of light; in one of his earliest figure paintings, *Old Man Seated on a Trunk* (fig. 2), dated to February 1826, he placed the figure before a high, light-filled opening so that he could intensify the effect of bright highlight and deep shadow through the sketch's subtle monochromy.

Corot made sketches not only in Italy but also in his native France. One drawn in the wild regions around Fontainebleau in the early 1830s served as the inspiration for the *Forest*

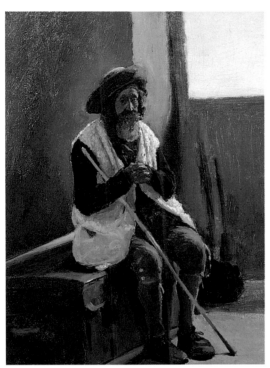

Fig. 2. Jean-Baptiste-Camille Corot, *Old Man Seated on a Trunk*, 1826, Museum of Fine Arts, Boston.

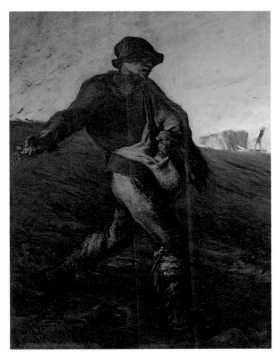

Fig. 3. Jean-François Millet, *The Sower*, 1850, Museum of Fine Arts, Boston.

of Fontainebleau (cat. no. 12), the only picture of four he submitted to the Salon of 1846 that was accepted by the jury. The Salon exhibitions, usually held each year in Paris, were the prime venue for the public display of the new work of painters and sculptors. At the Salon, reputations were made, maintained, or lost. There, collectors, dealers, and the interested public could encounter the works of newly emerging talents whose pictures had been selected for exhibition by the jury, and see the latest output of established figures who, by virtue of their previous success, were allowed to bypass the jury and exhibit the work of their own choosing. A staggering number and variety of paintings were placed on view. While figural compositions—history paintings, portraits, or scenes from daily life— were in the majority in the early years of the century, landscape came increasingly to dominate Salon exhibitions by the middle decades of the 1800s. Corot's *Forest of Fontainebleau*, which a recent critic has called "the greatest pure landscape of his middle years," was accepted for exhibition but was not well received.[3] Corot's contemporaries found it awkward and raw, one caustically remarking that "M. Corot, the famous landscape artist, paints everything with the dirt that falls from his boots as they're being cleaned."[4]

The canvas shows one of the clearings bordered by great trees that characterized the semiwilderness of the forest, a centuries-old gaming preserve featuring massive outcroppings of rock and great old oaks that attracted tourists from Paris. The village of Barbizon, at the edge of the forest, became in the 1840s the center of a new artistic community that celebrated the kind of landscape that could be depicted with the dirt of the painter's boots—the so-called Barbizon School. The most important painters of the landscape vanguard thus practiced their craft in this region: not only Corot, but also Rousseau, Troyon, Diaz, Millet, and Gustave Courbet. In the years before and after the Revolution of 1848, Courbet and Millet struggled to establish a new movement in art, Realism, which would react against the prevailing tendencies of both the Neoclassical and Romantic schools. Rejecting the ancient past revered by Jean-Auguste-Dominique Ingres and the fanciful exoticism of Eugène Delacroix, they gave precedence to scenes drawn from the experience of the meek and lowly and sent to the Salon paintings of peasants, stonebreakers, and winnowers of grain. Exhibited at the Salon of 1850–51, Millet's *Sower* (fig. 3) and Courbet's *Stone Breakers* and *A Burial at Ornans* announced the Realists' new direction.[5] Millet's grave image of rural labor is set at the fall of night, with the dynamic counterpoise of a monumental sculpture by Michelangelo. "Not since the appearance of . . . the reapers on the portals of the great cathedrals of France," a modern critic has written, "had the peasant taken his place so prominently among the powers of the nation."[6]

The rise of Realism in French painting gave forth not only Courbet's and Millet's heroic figural compositions but also a new notion of how landscape should be interpreted.

Fig. 4. Jean-Baptiste-Camille Corot, *A Morning, Dance of the Nymphs*, 1850, Musée d'Orsay, Paris.

Painters such as Corot and Rousseau sought to depict commonplace settings—ordinary meadows, fields, or woodlands—and to invest these simple landscapes with a sense both of poetry and of the quiet dignity of the earth itself. The mood of Corot's paintings could indeed be humble, painted with the earth, as in his early *Farm at Recouvrières, Nièvre* (cat. no. 11). But by the later 1840s he was also capable of painting works of profoundly lyrical sensitivity, as he demonstrated in the elegiac *Twilight* (cat. no. 13). Throughout the 1840s and 1850s, he was generally regarded as the chief landscape painter in France—"the greatest landscape painter of our time," wrote the critic Philippe de Chennevières in 1851.[7]

It was at the Salon of 1850–51 that Corot presented *A Morning, Dance of the Nymphs* (fig. 4), the painting that introduced to the public the characteristics of the style he was to elaborate for the next quarter century. How very different from Millet's *Sower*—exhibited at the same Salon—is this vision of Bacchic revels bathed in morning light. *Morning* revealed Corot's mastery of a delicate brushstroke, softly modeled foliage, and a sophisticated compositional structure in which marked contrasts of light and shade were sensitively balanced. Far from the bare-bones realism of the *Forest of Fontainebleau*, Corot's *Morning* signaled a turning point in his career, toward subjects of "intimate charm and mellowness of sentiment."[8]

Outside the Salon, the artists of Barbizon were often preoccupied with graphic media. For each of them, drawing was an essential component in the elaboration of a painted composition, but independent drawings in a variety of techniques also were created outside the process of making paintings. Millet's *End of the Day*, for example, or Corot's charming

brush and wash studies of landscape elements were conceived respectively as finished works of art and as tours de force of graphic bravura (see cat. nos. 51, 67–69). Such independent works could find a market with a public that might not be willing or able to purchase a major Salon composition. Like Millet, the landscapists Corot, Rousseau, and Daubigny proved their skill with the etching needle—sometimes issuing prints in portfolios for collectors of graphic arts (see cat. nos. 22, 71–72). And all three experimented with the newly developed technique of cliché-verre (cat. nos. 16–18, 23, 73).

The cliché-verre evolved as one response to the developments that painters witnessed in the new field of photography, introduced in France and England at the end of the 1830s and widely popularized in the 1840s and 1850s, in tandem with the rise of Barbizon landscape painting. The new medium was suspect to some critics, who saw the camera as a machine and the steps of developing and printing a photographic image as mechanical processes not subject to the artist's intellect or aesthetic choice. Nonetheless, the worlds of painting and photography were often interlinked in the early days of the medium. Many photographers—Edouard-Denis Baldus or Cuvelier, for example—had begun their careers as painters. Baldus described himself for much of his career as a *"peintre-photographe"* (painter-photographer); Cuvelier, whose father was also a passionate photographer and a friend of Corot, was himself acquainted with Rousseau and Millet.

Along with Gustave Le Gray, Cuvelier photographed in the Forest of Fontainebleau, attracted to the same motifs that fascinated painters. Thus Cuvelier's photograph *At "La Reine Blanche," Forest of Fontainebleau* (cat. no. 25) records the soaring branches of a famous tree with the same sense of awe and grandeur that suffuses Bodmer's painting *Oaks and Wild Boars* (cat. no. 47). Similarly, the photograph attributed to Paul Gaillard, *Farmyard* (cat. no. 50), treats a subject that would later be taken up by Millet in the pastel *Farmyard by Moonlight* (cat. no. 63), although Millet chose to depict a spectral moonlight that could not be captured by the camera in the 1850s. According to the Bostonian Edward Wheelwright, who visited Millet in Barbizon in the mid-1850s, the painter was himself interested in making photographs, though he did not yet comprehend the coming status of the photograph as a work of art in itself, believing that "no mechanism [could] be a substitute for genius."[9]

Millet did not understand the complex manipulation of processes that could profoundly affect the appearance of the photograph. Far from being products of a mechanism, the greatest photographs resulted from a complex weighing of intuition and experience, just as did the greatest paintings, drawings, or prints. Two views of the Mediterranean coast near Mount Agde taken from the same vantage point by Le Gray (who was known to Millet's contemporary Courbet) reveal the variety of effects that the

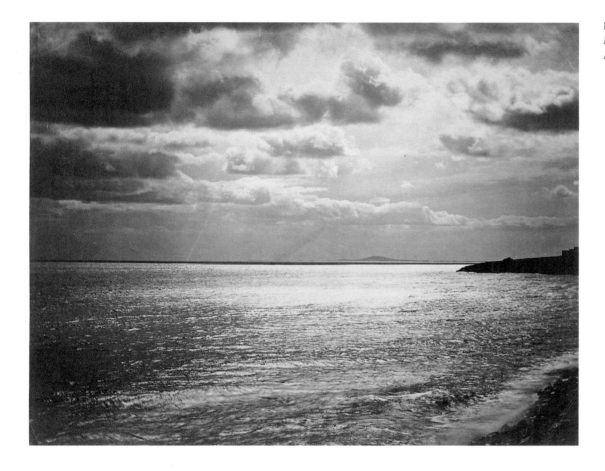

Fig. 5. Gustave Le Gray, *Seascape—Mediterranean with Mount Agde*, albumen print, 1856–59, Museum of Fine Arts, Boston.

photographer could achieve (fig. 5, cat. no. 30). Varying the exposure of the negative that captured the surface of the water to highlight or to suppress the reflective quality, the artist then printed that negative along with another that recorded cloud formations. He thereby created works of fiction based on nature, subtly manipulated and shaped by his intellect. By varying the exposure of his negatives and their combinations, the artist could alter the emotional content of the image, yielding results that could be either scintillating or subtly ominous. Although such an artist as Millet regarded photographs as tools, rather than as works of art in themselves, he may well have learned to admire the rich tonal effects that artists such as Cuvelier could achieve. Millet's crayon and pastel drawing *Twilight* (fig. 6), for instance, explores the effect of atmosphere on light in parallel with his friend Cuvelier's *Lane in Fog, Arras* (cat. no. 24) which is roughly contemporaneous in date.

More than his other colleagues at Barbizon, Millet sought to integrate the graphic arts into the practice of his painting. His *Priory at Vauville, Normandy* (cat. no. 58), for example, was the transcription in oil of one of his charming pen and watercolor drawings.

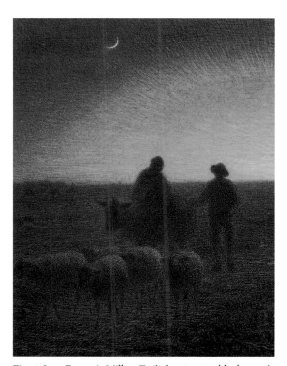

Fig. 6. Jean-François Millet, *Twilight*, 1859–63, black conté crayon and pastel, Museum of Fine Arts, Boston.

But more important still is the fusion of the practices of drawing and painting in his pastels, which rank among his greatest achievements (see cat. nos. 59–63). Although Millet had experimented with pastel at the beginning of his career, in the 1840s, it was not until the years around 1860 that he turned to the medium with genuine interest. By then, he had mastered the use of black conté crayon to create drawings of great sophistication of design and richness of tone, works such as *Twilight, End of the Day*, and *Faggot Gatherers Returning from the Forest* (fig. 6, cat. nos. 51–52). Millet gradually added hints of colored chalks to crayon drawings, evolving a highly personal method of mingling black outlines and hatchings with glimmering strokes of color, creating some of the most poetically beautiful images in his oeuvre. By the middle of the decade, Millet's pastels had become highly prized, and in 1865 the collector Emile Gavet approached the artist with an offer to pay him more than his pastels commonly brought in the marketplace in exchange for the entirety of his production in the medium. (Eventually Millet agreed to supply an initial twenty pastels to Gavet.)[10] Ten years later, shortly after Millet's death, the young Vincent van Gogh wrote to his brother from Paris about the sale of Gavet's collection, the greatest group of Millet pastels assembled in the nineteenth century: "When I entered the hall . . . where they were exhibited, I felt like saying, 'Take off your shoes, for the place where you are standing is Holy Ground.'"[11] The Museum of Fine Arts, Boston, now owns twenty-two of the Gavet pastels, plus nine others, making its holdings the most important collection of Millet's known pastel compositions.

New Directions

By the 1860s, the pioneers of the Barbizon School were artists in their fifties (or in Corot's case, sixties), and a younger generation of artists was beginning to make its mark on the art of French landscape. A group of them—Monet, Renoir, Pissarro, Cézanne, Sisley, and Degas, all born since 1830—would later be known as the Impressionists. Although each of them played an important role in the story of the Impressionist landscape, that story is especially linked to the career of Monet, its most famous, most steadfast, and arguably most innovative practitioner.

Monet's career began at the moment that Barbizon painting had achieved its great success in France, but it had its start not in the Ile-de-France but in Normandy, where Monet was raised. In 1857, when he was sixteen, Monet met in Le Havre the marine painter Eugène Boudin (see cat. nos. 75–76, 78), who took an interest in the young man and invited him along to paint in the open air. Later, Monet said that the experience was revelatory for him: "Boudin, with untiring kindness, undertook my education. My eyes

were finally opened and I really understood nature; I learned at the same time to love it."[12] Boudin became Monet's unofficial teacher for several years, and his gift for painting skies was matched by the talents of the younger artist.

In May 1859, Monet went to Paris to see the Salon exhibition and to try his hand at learning more about painting landscape. During that year, writing to Boudin from the capital, the younger man singled out for praise the landscapes he saw at the Salon by the Barbizon masters Daubigny, Troyon, Rousseau, and Corot. Troyon's paintings were particularly attractive to Monet, who greatly admired the older artist's ability to capture the fleeting effects of clouds, sunlight, and atmosphere. "A magnificent sky," he wrote, "a stormy sky. There is a lot of movement, of wind in these clouds."[13] Earlier, Monet had visited Troyon in his studio, and he immediately recognized Troyon's skill. "I could not begin to describe all the lovely things I saw there," he wrote to Boudin. Looking at Monet's canvases, Troyon advised the young man to learn how to draw by studying the human figure, at that time the foundation of every artist's education. "Don't neglect painting," he nevertheless told Monet, "go to the country from time to time and make studies, and above all develop them."[14] Monet might have seen in Troyon's studio sketches made in the open air, like *Field outside Paris* (cat. no. 34), which Troyon would develop and refine into paintings for the Paris art market and which also lay behind large-scale pictures like *Hound Pointing* (cat. no. 38) and those he painted for the official Salon exhibitions.

In the Salon, still controlled by the Académie, as well as in the more informal market of picture dealers, landscape had taken the place of history painting in the public imagination and in the minds and hearts of critics. Monet, recognizing the ascendancy of landscape painting, was determined to follow the path on which he had set out under Boudin. Still, taking Troyon's advice, he embarked in 1860 on a course of study to learn to draw the human figure, entering an informal art school, the Académie Suisse. In 1862 he entered the studio of Charles Gleyre, a history painter, where he met Renoir, the American James McNeill Whistler, and Frédéric Bazille, each of whom practiced not only figure painting but also landscape, and Sisley, who was to devote himself to pure landscape. In addition to his study from the model, Monet continued to paint during excursions to the countryside near Paris, notably at the village of Chailly, near Barbizon.

Aware of the historical associations of the Fontainebleau landscape, Monet spent much of the spring of 1863 in Chailly. He returned in the following year, when he probably painted *Woodgatherers at the Edge of the Forest* (fig. 7), the subject of which was derived from those of artists of the Realist generation such as Rousseau and Millet (see cat. nos. 20, 52). At this period in his development, most of Monet's subjects and compositions reflected his awareness of the art of these masters, as well as the continuing importance

of Boudin and of Johan Barthold Jongkind (see cat. no. 77), a Dutch marine painter whom Monet had met on the Normandy coast in 1862.

Boudin's influence on Monet, however strong, was by no means exclusive, even in the early 1860s. Although his masterly views of Normandy's ports and beaches (see cat. nos. 76, 78) depicted light in the fractured manner that Monet was to perfect later in his career, the inland landscape of *Woodgatherers at the Edge of the Forest* is greatly simplified, its effects flattened and almost schematic. Monet used choppy, broad strokes of color and juxtaposed warm browns and greens against the blue of the sky, thus recalling the boldly painted landscapes of Courbet, whose *Stream in the Forest* (cat. no. 46) was painted at about the same time. Courbet's earthy palette and his preference for dense, boldly painted volumes may have inspired Monet again when, about 1864, he took his easel into the streets of Honfleur, near Le Havre, to paint on site a view of the rue de la Bavolle (cat. no. 79).[15] Perhaps following Troyon's advice to "develop" his studies, Monet used this plein-air canvas as the basis for a later version (fig. 42, p. 141), in which the effects he studied before the motif were further refined.[16]

Traveling Companions

Monet's experience had its parallels in that of his future Impressionist colleagues Renoir, Pissarro, and Sisley, each of whom felt the strong pull of Barbizon style in the mid-1860s. Renoir painted both sober portraits inspired by Realist genre scenes, such as *The Cabaret of Mother Anthony*, and large-scale nudes, such as *Diana the Huntress*; both echoed Courbet's style and his subject matter—his bathers as well as his scenes of daily life. At the Salons of 1864, 1865, and 1866, Pissarro exhibited riverbank landscapes in the tradition of Daubigny,

who made a specialty of such themes. Also in 1866, Sisley exhibited *A Street at Marlotte: Environs of Fontainebleau*, a painting that recalls Corot in its massing of farm buildings and both Daubigny and Courbet in its sober palette. Degas, not yet allied with the landscape painters, exhibited at the same Salon a large-scale scene, *Steeplechase*. An amalgam of Realist landscape and figure painting, Degas's ambitious composition nodded to Courbet's dramatic scenes of the hunt, as well as to the images of figures in the landscape painted by his mentor Edouard Manet.[17]

By the end of the 1860s, however, the young artists of the nascent Impressionist movement were advancing in uncharted directions, beyond the idiom of Barbizon painting. In 1869, working side by side at the fashionable boating place of La Grenouillère, Monet and Renoir began to paint works in which the optical experience of sunlight falling on rippling water was recorded on canvas with a new vocabulary of brushstrokes. They were inspired by Courbet and Manet, but their aim was the invention of an altogether new pictorial language.

These paintings marked a turning point in the history of the French landscape, but they flow from the experiments that Monet had conducted in the middle years of the decade. His careful, deliberate technique, particularly evident in the handling of the alternating lights and shadows in his views of the river (see fig. 8), recalls the thick brushstrokes he used to paint the *Rue de la Bavolle, Honfleur*. It seems, moreover, that Monet again intended to use these riverside paintings—which were executed at the scale of canvases intended for the marketplace, if not for the Salon—to develop other compositions in the studio. In late September 1869 he wrote to Bazille from a village near the Seine: "I do have a dream, of a picture, the bathing place at La Grenouillère, for which I have made a few bad sketches, but it's only a dream. Renoir, who has just passed two months here, would also like to paint this picture."[18]

A conventionally ambitious, larger-scale Salon composition that derived from these studies never materialized—like Valenciennes before him, Monet found the making of the sketch its own reward. It seems likely, however, that Monet sent a more developed version of one of the *pochades*, as he called them, to the Salon of 1870, along with an interior. The jury rejected both works.[19] Renoir shrewdly ignored his new landscapes and exhibited at the same Salon two magnificent but less innovative figure paintings: a Courbet-like *Bather with a Griffon*, nearly life-size, and a *Woman of Algiers*, manifestly inspired by Eugène Delacroix's Orientalist subjects. In the wake of Monet's exclusion from the Salon, both Daubigny (long a defender of the young painter) and Corot resigned from the jury in protest. But despite his absence in the exhibition, much was made of Monet's being at the

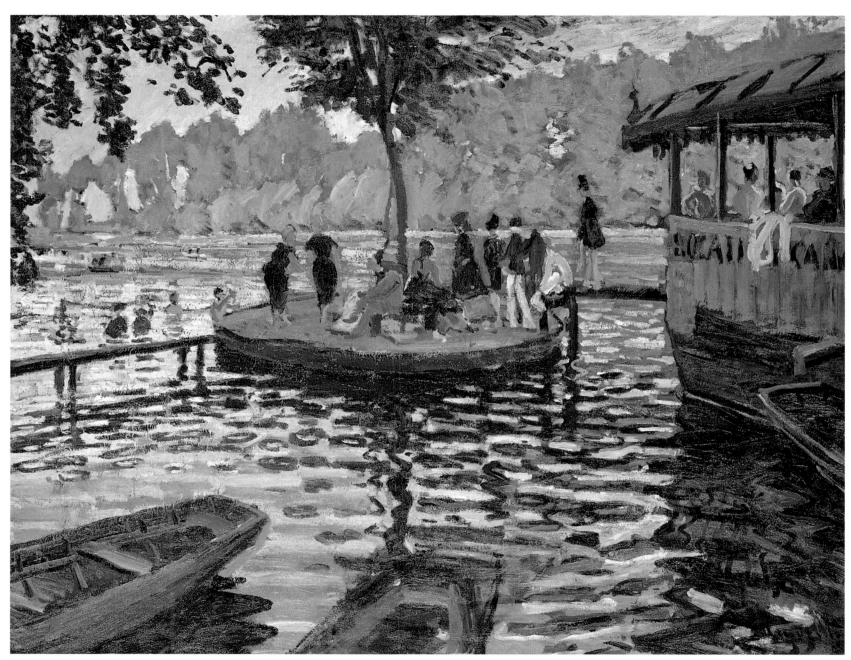

Fig. 8. Claude Monet, *La Grenouillère*, 1869,
The Metropolitan Museum of Art, New York.

vanguard of painting. The critic Arsène Houssaye wrote: "The two real masters of this school which, instead of saying art for art's sake, says nature for nature's sake, are MM. Monet (not to be confused with Manet) and Renoir, two real masters, like Courbet of Ornans, through the brutal frankness of their brush."[20]

Although his first attempt at exhibiting one of his "bad sketches" of La Grenouillère was rebuffed, Monet was to exhibit another work of this type in the second Impressionist exhibition, in 1876. By that time, he had already presented to the public the now-famous *Impression: Sunrise*, the sketchy, lightly worked view of the port at Le Havre that gave the Impressionist movement its name. That picture was initially shown at the first exhibition of the newly founded Société anonyme des Artistes Peintres, Sculpteurs, Graveurs, held in the former studio of the photographer Félix Nadar on a busy commercial street in Paris. It opened on April 15, 1874. Writing ten days later, the satirist Louis Leroy presented the comments of two fictional visitors to the Salon:

> — . . . What does that painting represent? Look in the catalogue.
> —Impression, Sunrise.
> —Impression, I was sure of it. I said to myself, too, because I am impressed, there must be some impression in it. . . . And what freedom, what ease in the execution! An embryonic wallpaper is still more finished than that seascape there![21]

Leroy's humorous exchange aside (and despite popular mythology), the critics' response to the newly named Impressionists was generally favorable, and on the whole they praised the Impressionists' desire to exhibit free from the strictures of the Salon system—to institutionalize, as it were, the notion of a "Salon des Refusés," an exhibition of artists working outside Academic taste and tradition.[22] Recognizing that the group assembled artists from a wide variety of backgrounds, critics such as Armand Silvestre made an attempt to understand the painters' common motivations and to help their readers distinguish one participant from another:

> At their head are three artists whom I have spoken of several times and who have, at least, the merit of being immutable in their goals. This immutability even touches on an aspect common to all three, which gives priority above all to the processes of their painting. At first glance, one is hard pressed to distinguish what differentiates the paintings of M. Monet from those of M. Sisley and the manner of the latter from that of M. Pissarro. A bit of study will soon teach you that M. Monet is the most able and the most daring, M. Sisley is the most harmonious and timid, M. Pissarro is, in the end, the inventor of this painting, the most real and the most naive. . . . What is sure is that the vision of things that these three landscape painters affect does not resemble in the least that of any earlier master; that it has its plausible side; and that it affirms itself with a character of conviction that does not admit the possibility of disdain.[23]

Each in His Own Way

By the mid-1870s, in spite of the critics' recognition of close affinities between them, each artist had evolved a mature vision of how landscape might be painted. Both Renoir and Monet had formulated a wholly individual manner of painting in the open air. Renoir's *Woman with a Parasol and Small Child on a Sunlit Hillside* (cat. no. 93), painted about 1874–76, shows his distinctive feathered brushstroke, with which he suggests both the sheer white fabric of the reclining woman's dress and the soft tufts of grass on which she lies; sharp contrasts between the foreground shadows of deep emerald green and the background highlights of bright yellow and white convey the sense of brilliant sunshine. Monet's 1875 depiction of his wife Camille sewing in a garden while a child is playing at her feet (cat. no. 92) employs a characteristic flickering pattern of small daubed or curved brushstrokes. Here, dark greens and reds are juxtaposed with brighter, lighter versions of the same hues. This has the result of conveying the action of the light on the bed of dahlias and the grassy verge that make up the background of the picture, while the figures are set off from the vegetation by their blue and white clothing.

The overall effect of these treatments of the figure set in a landscape is a sense of freedom and improvisation, contrasting sharply with the more classically refined surfaces of such works as Degas's *Racehorses at Longchamp* (cat. no. 82), probably begun about 1871 and reworked in the mid-1870s. Degas, who in the 1850s had painted pure landscapes in Italy and had used landscape backgrounds in his early history paintings, in the 1860s specialized in painting people in everyday scenes, mostly indoors—at home, in a café, or at the opera. He rarely turned to landscape at this period except as background for his racing pictures. Although he is known to have painted pastels in the open air (see cat. no. 85), he did not take his easel and canvas into the countryside. Unlike Monet and Renoir, he painted such landscapes entirely in the studio, reproducing or adapting from memory scenes he had witnessed in the suburbs of Paris. The seemingly careless arrangement of horses in the open air is misleading, for Degas rearranged the elements of the picture more than once before settling on a final pattern of jockeys and mounts.

A middle ground between the sense of improvisation that Monet and Renoir cherished and the calculated strategies of Degas can be found in the paintings of Pissarro and Cézanne. Working together in the environs of Pontoise and nearby Auvers in the 1870s, these friends evolved a more geometrically structured response to the landscape. Pissarro, who in these years turned to themes taken from the lives of the agricultural workers in his district, often chose to order his paintings by introducing straight lines or geometrical shapes, as in *Sunlight on the Road, Pontoise*, of 1874 (cat. no. 90), or *The Côte des Boeufs at*

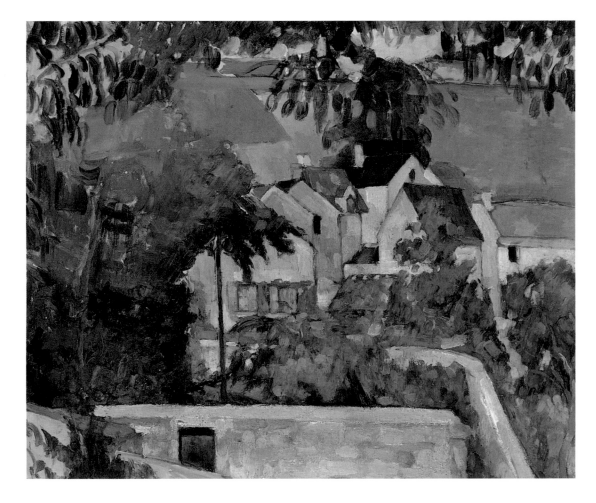

Fig. 9. Paul Cézanne, *Quartier Four, Auvers-sur-Oise (Landscape, Auvers)*, about 1873, Philadelphia Museum of Art.

L'Hermitage, of 1877 (fig. 56, p. 219). Likewise, Cézanne, in *Quartier Four, Auvers-sur-Oise* (fig. 9), painted in about 1873, employed the rhythmic architectural forms of walls and houses both to animate and to anchor his composition. In the middle years of the decade, both artists, along with Sisley, adopted a lightened palette in which the deeper shades of green and brown were softened by the admixture of whites and grays. And all three artists, particularly Cézanne, employed opaque, layered paint structures that together with their carefully shaped compositions confirm the studied processes by which these ordinary views were elaborated.

Pissarro is distinct from Sisley and Cézanne in his affinity for printmaking. Like Degas and Mary Cassatt, Pissarro was fascinated by the techniques of etching and mono-type and produced some of his most ambitious and revolutionary work in these media. As the progress of his etching *Wooded Landscape at the Hermitage, Pontoise* (cat. nos. 97–99), reveals, his visual acuity was matched by a restless intelligence that pursued his subject through a complex development—each step along the way offering a new solution to the problem of rendering on paper, in black and white, the intricate spatial relationships of the *sous-bois* motif that he had treated in paint a few years earlier.

As the loosely affiliated artists explored different manners of depicting the landscape, each member of the group chose his sites and themes according to his particular tempera-ment. On the whole, however, they shared a preference for subject matter that veered

away from the conspicuously picturesque, avoiding the hackneyed compositional formats that they scorned in the work of Salon painters. Thus, Monet painted an uneventful section of the road outside Vétheuil (cat. no. 89), Pissarro painted an equally uninspiring street in Pontoise on a dingy, snowy day (cat. no. 87), and Sisley, who might have chosen to paint a fountain in the park at Versailles, preferred to paint the pumping station at the Marly reservoir (cat. no. 91). By choosing subjects and points of view that seemed to contemporary audiences not only unimportant but somehow undignified, the Impressionists emphasized the distinction between their landscapes and those of the Barbizon School and its latter-day adherents at the Salon.

In line with their avoidance of conventional motifs, the Impressionists' compositions typically are free of apparent sentiment or evident meaning, especially when compared with the landscape paintings being shown at the Salon in the 1870s. For example, Chintreuil's *Last Rays of the Sun on a Field of Sainfoin* (cat. no. 64) makes use of pyrotechnic cloud effects above the bowed heads of the harvesters praying while haymaking. This painting, exhibited at the Salon of 1870, romanticizes and glorifies France's fertile landscape and traditional agrarian economy. The Impressionists tended to avoid such easily recognized interpretations: although Pissarro often returned to similar themes of rural labor, which Millet had made famous a generation earlier, his scenes of peasants or villagers in the fields are, in contrast to Chintreuil's dramatic vision, notably matter-of-fact (see cat. no. 116).

Faraway Horizons

During the 1870s, the Impressionists concentrated on depicting places close to Paris, along the Seine or its tributaries downstream from the capital, in such towns as Argenteuil, Bougival, and Pontoise. In the next decade, Monet abandoned the villages along the Seine frequented by Parisians in favor of sites—some equally touristic, others more remote in character—on the coasts of France. Monet typically avoided the views that Boudin had painted at the height of the Second Empire in such works as *Fashionable Figures on the Beach* (cat. no. 78), which exploited the relationship between sea and sky; instead he turned to painting the sea in juxtaposition with the land.

Monet's works of the early 1880s attest to his love for the rough Normandy coasts, where Delacroix, Courbet, and Millet had painted in the previous generation. There, at Pourville, Fécamp, and Etretat, Monet explored motifs that he had first treated in the late 1860s and early 1870s. His 1881 *Seacoast at Trouville* (cat. no. 104) seems to equate the windswept form of a tree beside the sea with a watchful human presence, just as Millet

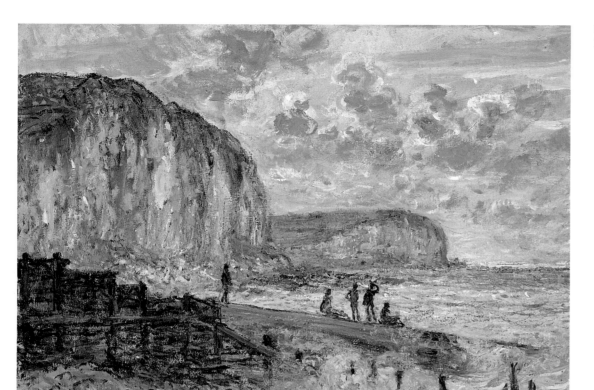

had done in his 1866 *End of the Hamlet of Gruchy* (cat. no. 57), a depiction of his native village. Monet's *Fisherman's Cottage on the Cliffs at Varengeville*, from 1882 (cat. no. 105), resembles not only that village view but also another by Millet showing a group of stone buildings perched on the sea, the 1872–74 *Priory at Vauville, Normandy* (cat. no. 58). Monet, like Millet, felt a profound connection to the Normandy landscape: "The countryside is very beautiful and I am very sorry I did not come here earlier," he wrote to his companion Alice Hoschedé from Pourville in February 1882. "One could not be any closer to the sea than I am, on the shingle itself, and the waves beat at the foot of the house."[24]

A group of these Normandy landscapes by Monet were presented at the Impressionist exhibition of 1882, where just under a third of Monet's paintings showed such cliffside views, sometimes stormy, sometimes sunny—among them the *Seacoast at Trouville* and probably the *Cliffs of the Petites Dalles* (fig. 10).[25] Although both Monet and Renoir remained largely unconcerned with its organization, the 1882 exhibition was heralded by critics as a great moment for the Impressionist landscape painters, who one by one had dropped out of the most recent group shows. Monet had "defected" in 1880 to exhibit at the Salon; and in 1881 Degas's band of figural artists had dominated the planning of the exhibition, causing Renoir and Sisley to withdraw as well. But in 1882, the landscape painters had returned to the fold—and the figure painters had decamped.[26] However, not all the landscape Impressionists shared Monet's passion for coastal scenery. At the same exhibition, Sisley presented *Overcast Day at Saint-Mammès* (fig. 11), a view of the village on the Seine near Moret-sur-Loing, the town in which he had settled in 1880. Unlike Monet, he rarely trav-

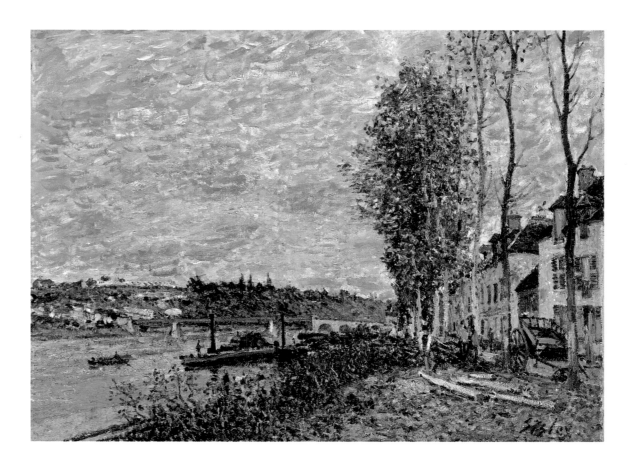

Fig. 11. Alfred Sisley, *Overcast Day at Saint-Mammès,* about 1880, Museum of Fine Arts, Boston.

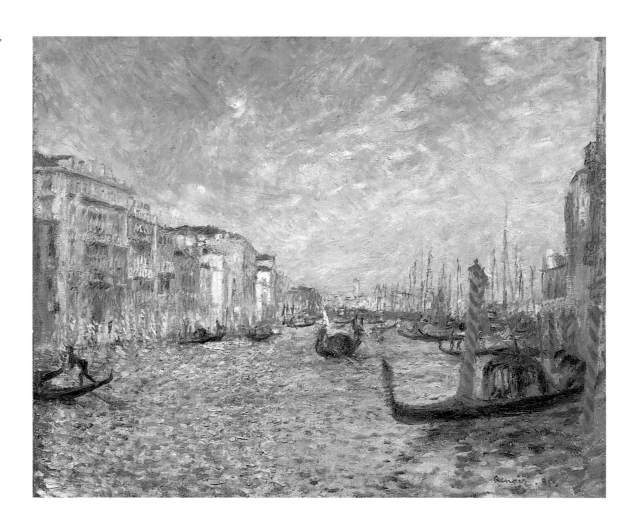

Fig. 12. Pierre-Auguste Renoir, *Grand Canal, Venice,* 1881, Museum of Fine Arts, Boston.

eled outside the Ile-de-France; he was to make this humble landscape the subject of much of his painting for the rest of his life. Renoir was represented in 1882 by a group of paintings lent by his dealer, Paul Durand-Ruel. These included not only a large group of figure paintings but also views taken along the Seine, among them *The Seine at Chatou* (cat. no. 102) and his new views of Venice (see fig. 12), which he had painted during a trip to Italy in the autumn of 1881.

Many of Monet's recent views of Normandy were featured in the first of his solo exhibitions at the Galerie Durand-Ruel (including, perhaps, the *Road at La Cavée, Pourville,* cat. no. 103), held in the spring of 1883. In the autumn of that year, Durand-Ruel dispatched to the New World—to the *American Exhibition of Foreign Products, Arts, & Manufactures* held at the Mechanics' Building in Boston—a group of paintings by artists he represented: the Impressionists, but also more conservative painters. "A shipment has been made of some of our paintings for the exhibition in Boston," Pissarro wrote to Monet in June. "The information from Americans that I know, is that it is a mediocre exhibition which will have no influence. I have spoken of this to Durand-Ruel, he replied to me that this is a test, that he will profit from the occasion by showing us."[27] The exhibition was, indeed, a trial run for the larger exhibition of Impressionists that Durand-Ruel would send to New York three years later. Along with paintings by Manet, Pissarro, Renoir, and Sisley, there were three paintings by Monet in the Boston show: an early view of *The Artist's House at Argenteuil* and two Normandy views, *The Customs House at Dieppe* and *Low Tide at Varengeville.*[28]

Judging from the response of the press alone, the expedition to Boston was not an unqualified success. "The French exhibit is an odd and incongruous affair, very extensively seasoned with the eccentric products of the *Salon de Refusés,*" wrote one critic. He went on to say:

> Here we have Edouard Manet, lately deceased with two works; Claude Monet; a queer
> genius named Pissarro; and a marvelous realist-impressionist called Renoir. . . . Altogether,
> Paris would laugh to see this assortment of perverse and burlesque canvases; and we, on
> the other hand, can not but regret their predominance in a collection shown here as pur-
> porting to represent the contemporary art of France. . . . Mr. Monet is scarcely worth seri-
> ous attention. . . . We mention his works because the presence of these so-called "impres-
> sionists" (who do not seem to have any impressions worth recording) now for the first time
> allows us to perceive how just is the estimate in which they are held at home.[29]

At home, contrary to the opinion of the critic, Monet's works only increased in popularity—in part because the painter continued to pursue new avenues of exploration. In

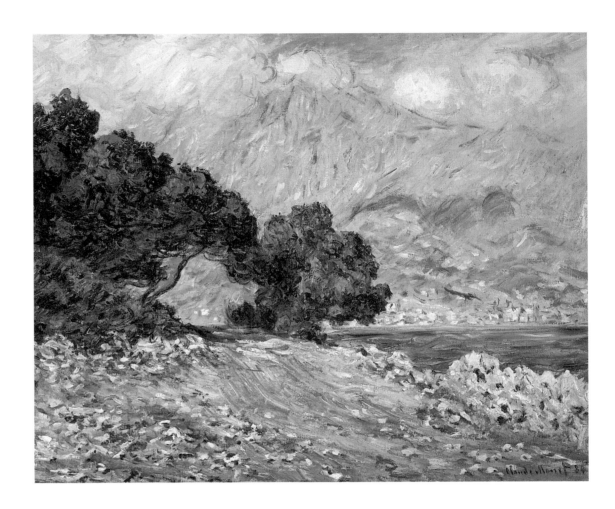

the 1880s, for example, Monet's contact with the Mediterranean world—a contact established through his friend Renoir—was to have lasting consequences for his art as well as for the history of Impressionist landscape painting. In Italy and the South of France, Monet found the warm golden light that had attracted artists there for centuries, a light that had clearly marked the work of a previous generation, from Valenciennes and Bidauld to Corot and Huet (see cat. nos. 1–2, fig. 2, cat. no. 6). Inspired by Renoir's enthusiasm for the Mediterranean, Monet forsook the Atlantic coast in 1883 and journeyed with Renoir to Italy; on that trip, Renoir painted his *Landscape on the Coast, near Menton* (cat. no. 107). Monet went back to the Riviera alone early in the following year and painted both in Bordighera, on the Italian coast, and on the Côte d'Azur, producing his own view of the Menton coastline (fig. 13), a riot of color and brushstroke that prefigures the most audacious southern landscapes of Van Gogh (see. cat. no. 129).

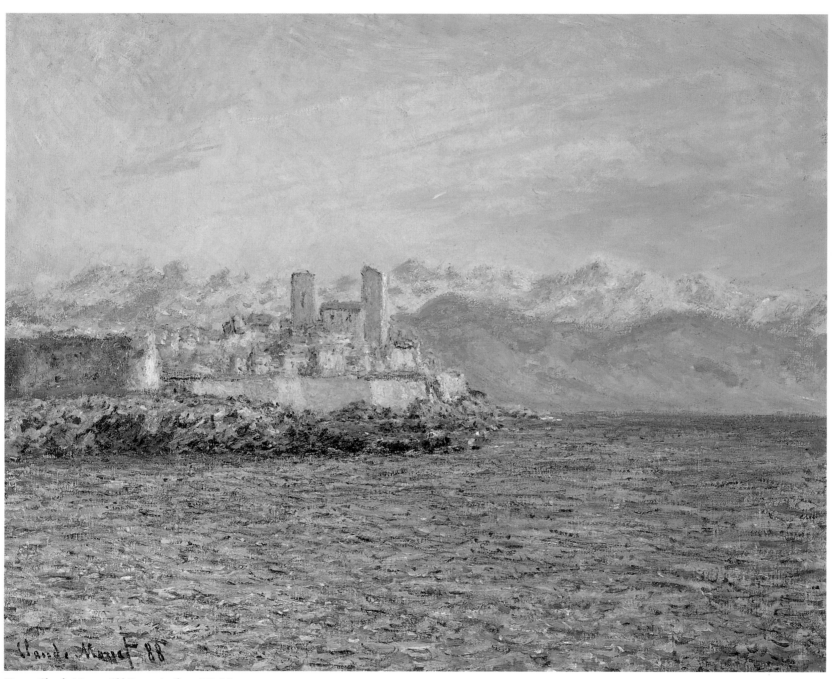

Fig. 14. Claude Monet, *Old Fort at Antibes*, 1888, Museum of Fine Arts, Boston.

After several years, Monet again returned to the South, this time to Antibes, where in the spring of 1888 he painted yet another group of canvases.[30] "I can see what I want to do quite clearly but I'm not there yet," he wrote to Alice Hoschedé on February 1. "I've fourteen canvases under way, so you see how preoccupied I've become." Among the motifs that most fascinated him was the view across the bay to the city, dominated by the tower of the old fort (fig. 14). Three weeks later, the painter told Hoschedé about his frustrations: "Everything's against me, it's unbearable and I'm so feverish and bad-tempered I feel quite ill . . . it's a miracle that I can work at all with all these worries, but I'm beginning to earn a reputation here as a ferocious and terrible person."[31] *Cap d'Antibes, Mistral* (cat. no. 119), which shows the snowcapped Alps beyond the Bay of Antibes, reveals the energetic and even ferocious brushwork that Monet adopted during this trip to paint the agitated motifs that he discovered on the Mediterranean coast.

It was in Antibes, too, that Monet was to refine his practice of painting a fixed motif under changing conditions of light at different times of day, a practice that he was to develop almost into a system over the next decade. Monet had often painted multiple views of a particularly interesting motif, and he had already presented to the public groups of paintings of related subjects. In 1876 he had painted twelve views in and around the Gare Saint-Lazare, six of which he exhibited at the third Impressionist exhibition, in 1877.[32] In 1882 closely related views of the Normandy coast had constituted a kind of series within the group of paintings that Durand-Ruel selected to represent Monet at the Impressionist exhibition. As the decade drew to a close, in the early spring of 1889, Monet painted a group of landscapes in the valley of the river Creuse in a remote region of central France. Setting up his easel high above the spot where two small rivers converged, he painted the valley in vivid sunlight (cat. no. 120) and in the gloom of twilight (fig. 28). These, following the paintings of Antibes, were steps in the process toward Monet's fully developed serial method, which he would explore more deeply in the 1890s with such series as his 1890–91 Grainstacks (see cat. nos. 142–43) and 1897 Mornings on the Seine (see cat. no. 144), and in the first decade of the twentieth century with his triumphant series of Water Lilies of 1903–8, exhibited as a group in 1909 (see cat. nos. 153–54).

On Shifting Ground

The paintings of the Creuse River valley were shown as a group at the Galerie Georges Petit at an exhibition timed to coincide with the 1889 Exposition Universelle. The venue was perhaps the most luxurious in Paris. Monet's works—more than 140 paintings—were paired with sculpture by his friend Auguste Rodin. The exhibition was a resounding criti-

cal success. "Nature has never been revealed with more intensity and truth," wrote the critic Octave Maus.[33] At the same moment, however, a challenge was being mounted to Impressionism, and perhaps most specifically to Monet's vision of nature. At a café near the site of the exposition, Gauguin and some of his friends had mounted a display of some of their recent work in a new style that sought to unite color and form with deeply charged emotion and to leave behind the Impressionists' slavish imitation of optical reality. They dubbed their new style "Synthetist"—though they were not above capitalizing on the public recognition of the Impressionists by calling themselves the *Groupe Impressioniste et Synthétiste*. To accompany the exhibition, Gauguin published a series of zincographs in a highly stylized, antinatural idiom, including *Women Washing Clothes* (cat. no. 125).

In the last half of the 1880s, Gauguin, Odilon Redon, Georges Seurat, and Paul Signac (see cat. nos. 124, 150, 133–34)—all of whom had exhibited with the Impressionists in 1886—and Van Gogh (see cat. nos. 129–30)—whose brother Theo had sold Monet's works—rejected the Impressionists' methods as overly dependent on optical effects and searched for some new stylistic means. Gauguin gradually abandoned the broken brushstrokes that he had used in the early 1880s (see cat. no. 115) in favor of stylized forms and large masses of color. Redon, who had always been at odds with the prevailing landscape tendencies of the movement, continued to pursue his unique vision of a fantastic dream universe, thereby making an important contribution to the development of Symbolism (see cat. no. 145) across Europe. Seurat and Signac, likewise, left the feathered brushstroke of Impressionism behind to evolve a method of painting with small dots of color, a technique that they thought more scientific and rational than the subjective optics of Monet and Renoir. A critic would later label their work with the term "Neo-Impressionism."[34] Gauguin, Redon, and Signac, as well as Seurat, pursued the graphic media in drawings, watercolors, and lithographs in addition to painting through the 1880s and 1890s (see cat. nos. 125, 145, 136–38), and Van Gogh ended up rejecting the Impressionists' delicately nuanced palette in favor of an emphatically drawn, boldly colored painting style, which he believed expressed his deepest emotions.

Partly because of these challenges, Monet, Renoir, and Pissarro themselves altered their landscape styles in the final decade of the century. Monet evolved his series as a way of expressing his continuing belief in the power of visual sensation and in the validity of representing these sensations as a means of artistic expression (see cat. nos. 142–44). Renoir, who in the late 1880s had expressed his dissatisfaction with the modes of traditional Impressionism, in the 1890s approached a manner that associated his art with the great traditions of French painting, deliberately referencing such painters of the eighteenth cen-

tury as Jean-Antoine Watteau and Jean-Honoré Fragonard. Thus, many of his late land-scapes peopled by beautiful young women (cat. no. 140) seem like fictions, as he reduced "the setting to little more than a freely brushed colored backdrop, with only the merest hints of natural features."[35] Pissarro, who in the mid-1880s had briefly adopted the Neo-Impressionist style advocated by Seurat and his disciple Signac, returned to his structured compositions of the 1870s in such paintings as *Morning Sunlight on the Snow, Eragny-sur-Epte* (cat. no. 141). At the end of the decade he embarked on a series of Parisian street scenes that seemed to bring his art back to the views of urban life that Monet, Renoir, and even Gustave Caillebotte had pioneered in the late 1860s and early 1870s. And, most remarkably, the figure painter Degas—who had once commented, "If I were the government I would have a special brigade of gendarmes to keep an eye on artists who paint landscapes from nature"—took up landscape once again in the 1890s, even holding a solo exhibition of his imaginative landscape pastels in 1892 (see cat. nos. 122–23).[36]

By the first years of the twentieth century, the artists of the Impressionist vanguard were internationally renowned. Their paintings were shown in exhibitions and collected enthusiastically throughout Europe and North America, and a growing appreciation of their achievements was felt in Japan. In the 1890s, Monet's series exhibitions had regularly shaped public understanding of the evolution of his style, and in the early twentieth cen-tury, the exhibitions of his London views, his Water Lilies, and his views of Venice had garnered him lavish praise. The work of Cézanne, by contrast, had received little public recognition during the artist's lifetime, except perhaps from a handful of critics and from other painters: it is interesting to note that Cézanne's *Pond* (cat. no. 108) was owned by Caillebotte, while his *Turn in the Road* (cat. no. 114) passed from the collection of the critic Théodore Duret to the painter Paul-César Helleu and eventually to Cézanne's friend Monet. After the turn of the century, however, a young generation of painters—in which were counted Henri Matisse, Pierre Bonnard, Pablo Picasso, and Georges Braque—found in the works of Cézanne, as well as in the works of Gauguin and Van Gogh, the inspira-tion for their vivid experiments with color and the radical distortion of form.

A View from the Other Side

At the turn of the twentieth century, Boston was a leading center for the collecting of modern paintings and graphic arts—and above all for the appreciation of French artists. In the autumn of 1902, the Boston photographer Thomas E. Marr came to the Museum of Fine Arts, then in its Italian Gothic building on Copley Square, to document the Museum's galleries. He set up his camera in the "fifth picture gallery" on the second floor of the building, where the visitor could appreciate the strength of Boston's collection of modern pictures.

American paintings were displayed on the west side of the gallery, whereas European paintings were hanging opposite them on the east. One view that Marr took toward the north wall (fig. 15) allowed him to look beyond the door in the center of that wall into the "fourth picture gallery." Both rooms were devoted to modern painters, and in them works by Millet, Diaz, Corot, Jean-Léon Gérôme, J. M. W. Turner, and other modern European artists could be seen side by side with works by their American counterparts—George Inness and Whistler, as well as the Boston masters William Morris Hunt, Joseph Foxcroft Cole, and the young Edmund Tarbell. A great variety of paintings were thus hung, frame to frame, in dizzying numbers; as a result, the juxtapositions

Fig. 15. Thomas E. Marr, American, 1849–1910, Picture gallery, Museum of Fine Arts, view to the northeast, 1902, Museum of Fine Arts, Boston.

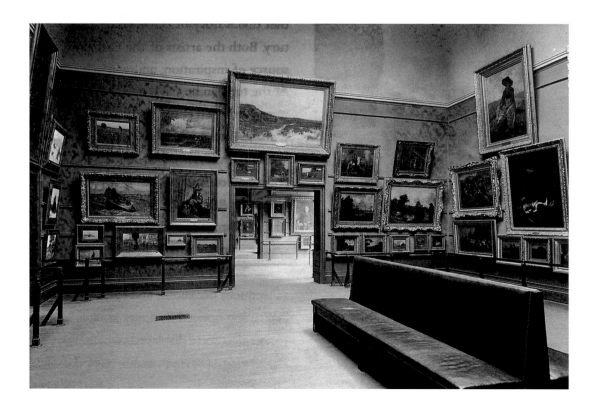

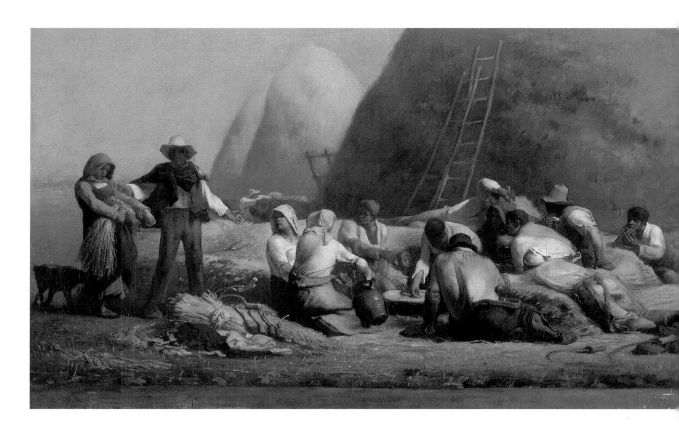

Fig. 16. Jean-François Millet, *Harvesters Resting (Ruth and Boaz)*, 1850–53, Museum of Fine Arts, Boston.

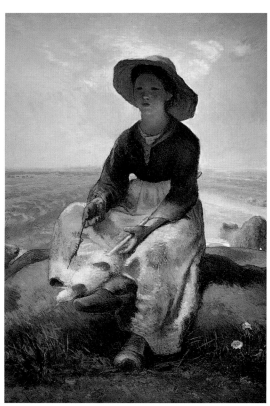

Fig. 17. Jean-François Millet, *Young Shepherdess*, about 1870–73, Museum of Fine Arts, Boston.

could seem jarring. On either side of the door, for instance, two contemporary masterpieces by the Boston native Winslow Homer, his *Fog Warning* (1885) and *The Lookout— "All's Well"* (1896)—both recent museum purchases—balanced two large landscapes of the 1820s by or attributed to the English master Constable, generally regarded as one of the "grandfathers" of Impressionism.[37]

The Constable landscapes, on the other hand, were the first elements in a sequence that told a story of the development of modern European painting in the nineteenth century. Both the artists of the Barbizon School and the Romantics looked to Constable as a source of inspiration, and works by these artists hung on the eastern wall of the gallery. At the top can be seen the *Young Shepherdess* (fig. 17), painted by Millet between 1870 and 1873, purchased at the posthumous sale of the artist's studio in 1875 by the Parisian dealer Durand-Ruel and sold to Boston collector Samuel Dennis Warren, who presented it to the Museum in 1877.[38] At the lower rank of the wall were four paintings by Millet from the collection of Mrs. Martin Brimmer, whose late husband had purchased the first of them, *Harvesters Resting* (fig. 16), shortly after the Salon of 1853, where it had gained the artist his first widespread recognition as the leader of the Barbizon School of Realists. The painting was among the first Millets seen in Boston and among the most familiar: it was exhibited at the Boston Athenaeum just one year after its first appearance in Paris and on several subsequent occasions, and had been on display at the Museum of Fine Arts since the institution opened its doors in 1876.[39] Between the row of four Millets and the *Young Shepherdess* were displayed two contrasting works by the Romantic master Delacroix, the stirring *Lion Hunt*, acquired in 1895, and the somber *Entombment of Christ* (1848), given in 1896.

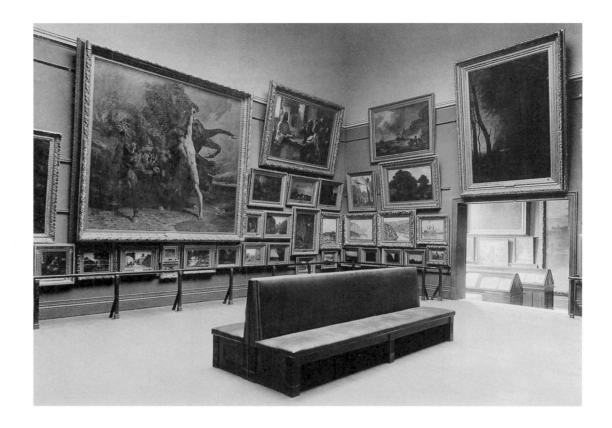

Fig. 18. Thomas E. Marr, American, 1849–1910, Picture gallery, Museum of Fine Arts, view to the southeast, 1902, Museum of Fine Arts, Boston.

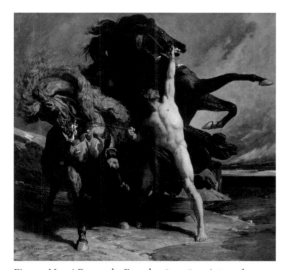

Fig. 19. Henri Regnault, French, 1843–1871, *Automedon with the Horses of Achilles,* 1868, Museum of Fine Arts, Boston.

The story of Romantic painting continued along the wall. Another view of the gallery (fig. 18) reveals Henri Regnault's *Automedon with the Horses of Achilles,* the young artist's submission to the Salon of 1868, which the Museum purchased in 1890 (fig. 19). Regnault's epic treatment of a scene from Homer's *Iliad* seemed to Boston audiences alternately inspirational or dangerous, thrilling or insidiously grandiose. The quiet dignity of its neighbor to the right, *The Friend of the Humble,* a contemporary history painting by Léon Lhermitte, may have appealed to the Puritan tastes of those who feared the pernicious influence of Regnault's *Automedon.* Both works were regarded as key examples of the modern French school; Lhermitte's had lately returned from the 1900 Paris World's Fair. Beside and below them are three ranks of smaller landscape paintings, including works by or attributed to Millet, Corot, Georges Michel, Français (compare cat. no. 74), and Cazin (compare cat. nos. 109, 132).[40]

Over the doorway to the long southern gallery is another large-scale exhibition picture, Corot's depiction of *Dante and Virgil* in a gloomy forest of the Underworld, which the collector Quincy Adams Shaw had given to the Museum even before it opened its doors—the first work by the artist to enter the collection. Two other Corots hang on the second tier—an early mature work by the master, the *Forest of Fontainebleau* from the Salon of 1846 (cat. no. 12), and a composition from the last years of his life, *Bathers in a Clearing* (cat. no. 66)—concluding the progression of landscape and figure painting that had begun with the canvases by Constable on the opposite wall.

Three paintings, paler in tone than the pictures that surround them, hang beneath these works by Corot and seem to announce a new direction for the narrative. They are by the artist who had taken the banner of French landscape painting from Corot's hands,

who was already being widely acknowledged as the greatest living painter of landscape, and who would go on, in the first quarter of the twentieth century, to reinvent the painting of landscape once more. This was Claude Monet, and the paintings are three from the collection of Denman Waldo Ross: at right, *Ships in a Harbor* (about 1873; cat. no. 86); at left, *Cliffs of the Petites Dalles* (1880; fig. 10); and at center, *Valley of the Creuse (Gray Day)* (1889; fig. 28). On loan to the Museum of Fine Arts from Ross in 1902, four years later they would be the first works by the artist to be given to any American museum.

A century ago, then, Corot and Monet—the artists whose paintings stand at either end of this book—were juxtaposed, frame to frame, on the Museum's walls. On one side of a gallery in the building on Copley Square the visitor could point out the major tendencies in the history of French landscape in the nineteenth century. Its rise to prominence in the first half could be documented in such daring works as Corot's *Forest of Fontainebleau*, which the critic Jules Champfleury had considered "more a serious *study*, a rigorous and well-considered sketch, than a painting."[41] Works by artists from Millet to Français illustrated the wide variety of approaches to landscape in the 1860s and 1870s. And at the end of the room, three pictures by Monet hinted at the transformation of landscape in the work of the Impressionist vanguard in the past quarter century. The rapid impression recorded in *Ships in a Harbor* gave witness to the movement's origins; the *Cliffs of the Petites Dalles* reflected the hegemony of landscape in the early 1880s; and the attentive record of dim light on the *Valley of the Creuse*, one of the paintings that Monet had exhibited as a unified group in 1889, foreshadowed his transformation of landscape in the series pictures of the 1890s.[42]

The complexity of the story of French landscape was yet to be reflected in the Museum's collection in 1902, however, for some of its most important works—Neo-classical, Romantic, Realist, Impressionist, or Post-Impressionist—were acquired only decades later. And, in fact, some of the collection's greatest masterpieces had not yet been created. Still, the development of nineteenth-century landscape out of the Barbizon School and into Impressionism was apparent, and to the knowledgeable visitor, the role played by Boston's artists and patrons in shaping the Museum's growing collection would have been clear. The paintings on display in this room and in adjacent galleries in 1902 were either made by artists who played a pivotal role in the development of the Museum's collection or had been lent or given by benefactors who were to profoundly shape the history of the institution. For example, ties of friendship and aesthetics bound the painters Homer and Hunt, the latter a friend of both Martin Brimmer and Quincy Adams Shaw, supporters of the Museum. Both Homer and Hunt were friends of Cole, who studied at

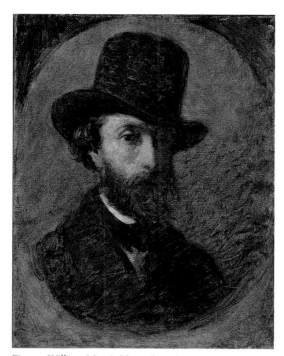

Fig. 20. William Morris Hunt, American, 1824–1879, *Self-Portrait*, 1849, Museum of Fine Arts, Boston.

Barbizon with the painter Charles Jacque; Cole married and lived for many years in Paris, exhibited at the Salon, and eventually became a trusted adviser to collectors of both Barbizon and Impressionist paintings, selecting on behalf of a Boston collector some of the first Monets to come to the city (see figs. 14, 26, 27).[43]

The growth of Boston's collection of landscape pastels, watercolors, drawings, prints, and photographs can also be predicted from the study of period catalogues of the Museum's presentations. Some of the ones brought together in this book could have been seen by the visitor to Copley Square at the turn of the last century in the room devoted to works on paper, immediately beside the fifth picture gallery.[44] There the visitor would have encountered a wide variety of modern watercolors, drawings, and prints. French works were intermingled with works of American and English origin: Millet's haunting drawing *Faggot Gatherers Returning from the Forest* (cat. no. 51) and his delicate watercolor study of a farmhouse near Vichy (cat. no. 55) were installed there, and alongside watercolors by Homer, charcoal drawings by Hunt, nature studies by Cole and John Ruskin, and watercolors by Turner were the two astonishing monotype landscapes by Degas (cat. nos. 122–23), beautifully enhanced with pastel, which Denman Ross had placed on loan along with his paintings by Monet. Many of the prints and drawings by Barbizon artists discussed in this book came to the Museum in the same way that the artists' canvases did, through the gift of patrons like Brimmer or Shaw, or as the gift of such artists as William Perkins Babcock—in short, from donors who formed their collections during the lifetime of the artists, or very shortly thereafter. But the majority of the watercolors, drawings, and prints illustrated here do not have as direct and personal a history; instead, they came into Boston collections long after the deaths of the artists who had created them. Many of these graphic works, indeed, virtually all of the photographs, came to Boston as Museum purchases, chosen by curators so that an already exceptional collection could recount, as completely as possible, the story of French art in the nineteenth century.

From Barbizon to Boston

Boston's collection of French landscapes has its origins at the Salon of 1850–51, where both Corot's *Morning, Dance of the Nymphs* and Millet's *Sower* were exhibited (see figs. 4, 3). At the end of the Salon, *Morning* was purchased by the state. Millet's *Sower*, however, was purchased by the young Hunt, not yet thirty years old, who had first seen the painting at the Salon and arranged to be introduced to Millet by Babcock, another Boston artist who lived at Barbizon. Hunt's *Self-Portrait* of 1849 (fig. 20) records the image of the scion of an affluent and cultured family, who had left Harvard before his 1844 graduation to pur-

sue a career in art and who, like his brother, the architect Richard Morris Hunt, had gravitated toward Paris, entering the studio of Thomas Couture in 1847. Through the first half of the 1850s, following his introduction to Millet, he was often in Barbizon, working with Millet and painting works more or less imitative of the master in facture and subject, with a strong admixture of Couture's distinctive chiaroscuro—works such as *The Belated Kid* (fig. 21), a mild-mannered homage to Millet's *Sower*. Their friendship became a strong one—Hunt and Babcock served as witnesses to Millet's marriage in 1853—and Hunt's advocacy of Millet led him to purchase yet more paintings by the artist and to encourage his friends to do so. It is significant, perhaps, that the first Boston collectors of Millet made their purchases in France and not in the United States—they were not, therefore, prey to the advice and opinions of their fellow countrymen, who were often suspicious of foreign ideas and influences. Hunt and his college friend Brimmer bought three Millets presented at the Salon of 1853 (among them *Harvesters Resting,* fig. 16), and Brimmer purchased another genre painting at this time.[45] (Although Shaw—from the Harvard class of 1849—was in Paris between 1851 and 1858, it is not certain that he yet shared his compatriots' enthusiasm for Millet, though he was to become the greatest of all collectors of the painter.)[46]

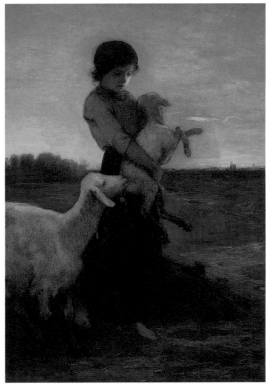

Fig. 21. William Morris Hunt, *The Belated Kid,* 1854–57, Museum of Fine Arts, Boston.

Hunt returned to the United States in 1855 and did not visit France again until 1867, but his allegiance to the art of Barbizon did not waver. He continued to practice and to advocate the French style, and his opinions seem to have carried considerable weight in the community, among people who had the means to make important acquisitions. In April 1866, when the Parisian dealers Cadart and Luquet brought to Boston the *First Exhibition in Boston of Pictures, the Contributions of Artists of the French Etching Club* (an exhibition first shown in New York the previous month), the members of Hunt's society of artists and amateurs, the Allston Club, were overcome with admiration for Courbet's *Quarry* (fig. 22). Writing in the catalogue for the New York exhibition, the Parisian critic Jules Castagnary had predicted that the painting would "one day have a place in the Louvre," but the Bostonians were to preclude that possibility for the time being—perhaps as Cadart had intended when he published Castagnary's introduction—rallying in a matter of days to purchase the painting for themselves, at the then-astonishing cost of $5,000.[47]

The checklist of the exhibition held in the spring of 1866 by the Allston Club to celebrate its acquisition of *The Quarry* reveals the degree to which Bostonians were already profoundly interested in the works of the Barbizon School. In addition to Courbet's masterpiece, there were six landscapes by Corot lent by club treasurer Albion Bicknell, Thomas Robinson (a minor painter who worked with the important Boston-Providence

Fig. 22. Gustave Courbet, *The Quarry,* 1856, Museum of Fine Arts, Boston.

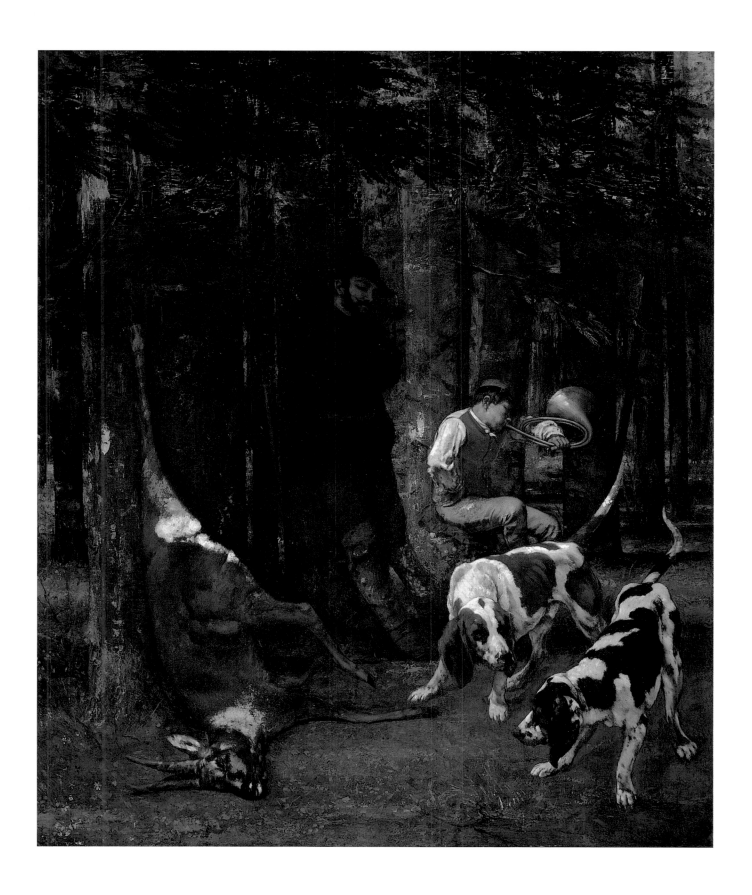

dealer Seth Vose to procure French paintings abroad), and Henry Sayles, who was to become the owner of *The Quarry* when the Allston Club disbanded a few years later. There was one picture by Diaz from the collection of Thomas G. Appleton; three by Millet, including *Noon* (Brimmer's *Harvesters Resting*) and *The Sower*, lent by Hunt; two Daubignys from Sayles's collection; two paintings by Rousseau; a painting of fowls by Jacque along with two *Portraits of Horses* by Rosa Bonheur; and two canvases by Troyon. The painter members of the club showed their own works, and in the catalogue Hunt, Bicknell, and Babcock described themselves as pupils of Couture; Hunt and Babcock also claimed their rank as pupils of Millet; Robinson was described as a pupil of Courbet, and Cole as a pupil of Emile-Charles Lambinet, an artist living in Normandy who was popular in America but who found little success in his native land.[48]

The enthusiasm of the Allston Club members for their new acquisition was not, however, universal. The critic of the *Boston Evening Transcript* devoted an article to the painting, a mix of praise for Courbet's talent and criticism of the work in question (which surely was one of only a handful of paintings by the artist that the reviewer could ever have seen), claiming, "The faults of this picture are obvious. There is no imaginative interest or suggestion, because the artist is a very great artist *without soul*. No concentration or fustio of elements in the white heat and forgetfulness of genius. It is heavy and uninteresting to the world at large. . . . But," he went on to say, *The Quarry* was "a whole academy to artists."[49] The critic recognized, if ironically, the significant role that artists' taste was to have in shaping Bostonians' collections.

"What care I for the Salon, what care I for honors, when the art students of a new and a great country know and appreciate and buy my works?" Courbet is reported to have said.[50] Millet could be equally content; in 1867 Hunt returned to France and brought with him to see Millet "an American who didn't speak a word of French" and who wanted desperately to purchase from Millet a pastel and a painting. (He left disappointed, as the one was destined for Gavet, Millet's most important client, and the other was not for sale.)[51] The unnamed American may have been Quincy Adams Shaw, who was certainly in Millet's studio at the end of 1871 or the beginning of 1872. Millet wrote on January 8, 1872: "An American gentleman and lady, M. and Mme. Shaw, of Boston, came to see me a while ago, to ask for a painting. . . . I am to do one for them. For a subject, they picked from among my drawings the *Priory of Vauville*."[52] The painting (cat. no. 58), which the collector and critic Etienne Moreau-Nélaton described as "one of Millet's most perfect works," became the first surely documented painting by the artist in the Shaw collection; by the end of the decade Shaw owned more than fifty works, including *The Sower*.[53]

New Arrivals

From the mid-1860s until the early 1880s, Boston could claim to be a significant center for the reception and study of French painting, and particularly for Barbizon landscape. The Cadart exhibition of 1866—in which Courbet's *Quarry* was first seen in Boston—also included another work, recorded only as *Sea Shore*, by the young Claude Monet, of whom few Americans had heard at the time. *Sea Shore* does not seem to have found a purchaser in Boston (though which of Monet's early seascapes was seen in the city has not been securely established). And when, in 1883, Durand-Ruel sent a group of paintings to the *American Exhibition of Foreign Products, Arts, & Manufactures* at Boston's Mechanics' Building, none of the three Monets, nor any of the Sisleys or Pissarros, seems to have found a willing buyer either. Bostonians, in the early 1880s, were still very much under the sway of Barbizon style—chiaroscuro, tone, and paintings that seemed to be "of the earth" were still very much prized. By the end of the decade, however, the Impressionist revolution began to make itself felt in Boston, and Bostonians grew more receptive to the idea of collecting works by Monet, the painter they came to see as the new prophet of the French landscape.

The enormous publicity surrounding Durand-Ruel's 1886 exhibition in New York, *Works in Oil and Pastel by the Impressionists of Paris*—which opened in April at the American Art Galleries and was transferred to the National Academy of Design in May and June—may have roused some interest among Bostonians in the artists of the Impressionist generation. But it is likely that the advice of trusted artists may again have played a more significant role in promoting Impressionism in Boston—as the enthusiasm of Hunt for Millet had spurred interest in Barbizon painting a generation before. One important point of contact must have been the American painter John Singer Sargent, who had been Monet's friend since the 1870s. Sargent had spent part of the summer of 1885 in France, almost certainly sketching Monet at work in Giverny at that time (fig. 23; the very painting on which Monet was working as he was painted by Sargent, *Meadow with Haystacks near Giverny*, cat. no. 112, was shown by Durand-Ruel in New York in 1886). In 1887, after a second summer visit to Monet at Giverny—during which he acquired two paintings by his friend—Sargent made a protracted visit to Boston, where his recent portraits and his superb genre picture *El Jaleo* were shown at the St. Botolph Club to great acclaim.[54] One scholar has suggested that Sargent's endorsement of Monet may have influenced the city's oldest gallery, Williams and Everett, to purchase from Durand-Ruel the *Road at La Cavée, Pourville* (cat. no. 103), the first picture by the artist to be owned by a Boston firm.[55]

Williams and Everett received *Road at La Cavée, Pourville* in early June 1888. The painting was ultimately acquired by Mr. and Mrs. Charles Fairchild, intimate friends of Sargent, who painted Mrs. Fairchild and their son and daughter during his Boston sojourn. It seems likely that the Fairchilds would have known of their friend's enthusiasm for Monet, and it is perhaps through Sargent's urging that they elected to purchase the painting. They may also have been encouraged by the response that another friend, the painter Dennis Miller Bunker, seems to have had to the work. Bunker, who is almost mute on the subject of Monet, probably saw such paintings as *Poppy Field in a Hollow near Giverny* (cat. no. 111) at the 1886 New York Impressionist exhibition, since he was exhibiting concurrently with the Society of American Artists there. He spent much of the summer of 1888 in England working with Sargent. On his return to Boston, he painted for Isabella Stewart Gardner his first wholly Impressionist work, *Chrysanthemums* (fig. 24), which blends the high color of *Poppy Field* with the radically foreshortened composition of the *Road at La Cavée*—the latter of which he could have seen either at the Williams and Everett Gallery or with the Fairchilds.[56]

Monet's name was certainly in the air in Boston in the late 1880s, and artists, above all, were responsible for building his local reputation. In October 1887, even before paintings by Monet were owned in Boston, "Greta," the critic of the *Art Amateur,* had already commented:

> Quite an American colony has gathered, I am told at Giverney [*sic*], seventy miles from
> Paris, on the Seine, the home of Claude Monet, including our Louis Ritter, W. L. Metcalf,
> Theodore Wendell, John Breck, and Theodore Robinson of New York. A few pictures just
> received from these young men show that they have all got the blue-green color of Monet's
> impressionism and "got it bad."[57]

And as the critic William Howe Downes reported in 1888, it was "not altogether impossible to find extremists who already avow openly their admiration for those mad outlaws, the Impressionists! There is such a thing as fashion in art," he opined, and went on to say—referring to Durand-Ruel—that "the Parisian merchant who foresaw the fame of the men of 1830 is now staking his fortune upon the next turn of the tide."[58]

Once the tide began to turn for Impressionism in Boston, it seems to have risen very quickly indeed. The summer of 1889 saw the opening of the Exposition Universelle in Paris, to mark the centenary of the French Revolution. Sargent was in Paris to visit the exposition—and presumably to take in Monet's most important exhibition to date, the show of some 140 paintings at the Galerie Georges Petit. Among the other American visitors to Monet's exhibition were two Bostonians, each of whom purchased a work by Monet about 1889. One of them, Desmond Fitzgerald, became a great devotee of the

Fig. 23. John Singer Sargent, American, 1856–1925, *Claude Monet Painting by the Edge of a Wood*, 1887, Tate Gallery, London.

Fig. 24. Dennis Miller Bunker, American, 1861–1890, *Chrysanthemums*, 1888, Isabella Stewart Gardner Museum, Boston.

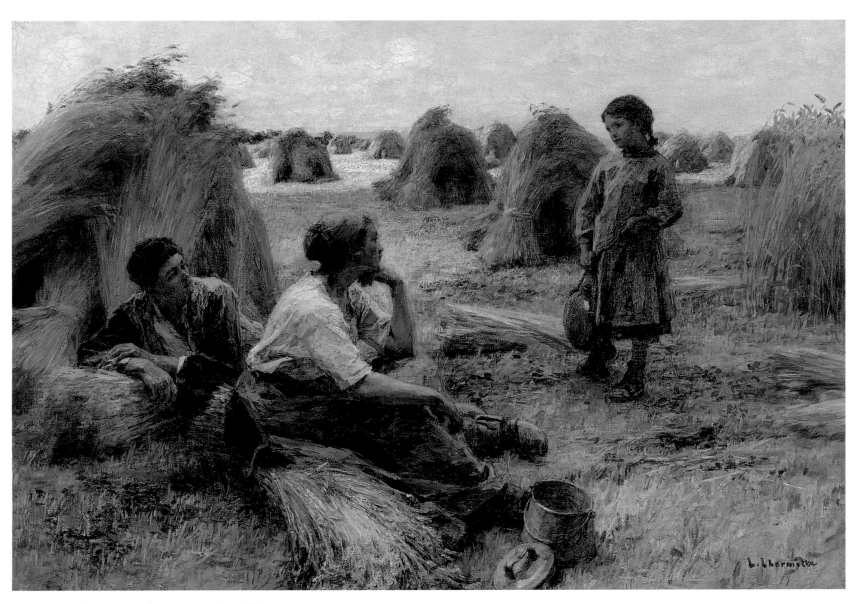

Fig. 25. Léon Lhermitte, French, 1844–1925, *Wheatfield (Noonday Rest)*, 1890, Museum of Fine Arts, Boston.

painter, writing about and organizing exhibitions of his work; he was eventually the owner of nine paintings by his idol. The other visitor was herself a painter, Lilla Cabot Perry, who was to become an intimate friend of Monet shortly thereafter.

Born in Boston, Lilla Cabot had married in 1874 Thomas Sergeant Perry, who was the brother-in-law of the artist John La Farge, who in turn was a friend of both Hunt and Cole. The Perrys settled in Paris in 1887, and Lilla received instruction from a variety of painters. "How well I remember meeting [Monet] when we first went to Giverny in the summer of 1889!" she wrote some years later. The Perrys were "enchanted" to meet the artist, "having seen that very spring the great Monet exhibition which had been a revelation to others besides myself. I had been greatly impressed by this (to me) new painter whose work had a clearness of vision and a fidelity to nature such as I had never seen before." Among the paintings that she saw in the exhibition was *Cap d'Antibes, Mistral* (1888; cat. no. 119), which was purchased by her brother, Arthur Tracy Cabot, in 1892. When the Perrys returned to Boston in the autumn of 1889, they brought with them a Monet—a view of the Normandy coast at Etretat—that Lilla believed to be "the first Monet ever seen in Boston."[59]

The Monet that had appeared in 1866 was of course long forgotten, and Mrs. Perry had overlooked the exhibition of three Monets in 1883. She also might not have known that Williams and Everett had bought *Road at la Cavée, Pourville* in the summer of 1888.[60] Her enthusiasm for Impressionism seems to have been shared by her fellow Bostonians, and not only by Fitzgerald. By the end of 1890, the year after Perry's return with her cherished Monet, there were many pictures by the artist in the hands of Boston collectors. Still, their newfound enthusiasm for Monet does not seem to have turned collectors from the painters whose reputations had been built through the Salon system. At the end of March, for instance, James Maurice Prendergast bought a Monet then identified as *"Winter Creuze"* (but later identified as *Entrance to the Village of Vétheuil in Winter*, cat. no. 89) for $950 from Williams and Everett; at the same time, he paid $2,500 for a much more conservative painting by Lhermitte—*Wheatfield (Noonday Rest)* (1890; fig. 25).

Similarly, in the fall of 1890, the painter-adviser Cole purchased Cazin's *Riverbank with Bathers* (1881, cat. no. 109) from the Galerie Georges Petit and three paintings by Monet from Durand-Ruel: *Boulevard Saint-Denis, Argenteuil, in Winter* (1875), *Old Fort at Antibes* (1888; figs. 26 and 14, both now in the collection of the MFA), and the *Seine at Lavacourt* (fig. 27, now in the collection of the Harvard University Art Museums).[61] Cole wrote to his patron that he had purchased "three pictures by Monet, representing three phases of his talent—I had the choice of about 50 pictures, so it was quite difficult to decide which to take—I paid for the three F 14500—and for the Cazin F 15000—so you see

Fig. 26. Claude Monet, *Boulevard Saint-Denis, Argenteuil,*
in Winter, 1875, Museum of Fine Arts, Boston.

Fig. 27. Claude Monet, *The Seine at Lavacourt*, 1880, Fogg Art Museum, Harvard University.

I have spent nearly all of your money."[62] It is worthy of note that even with Monet's considerable success, a large-scale Salon painting by the popular Cazin cost more in 1890 than three masterly Impressionist canvases.

Into the Light

"It breaks my heart to see all of my paintings leave for America," Monet had written to Durand-Ruel in 1888.[63] And although the Impressionists' works won the enthusiasm of at least a number of collectors in every part of the United States, they were nevertheless an easy target for satirists: "The Impressionists have been exhibiting here in force lately," wrote the critic of the Boston *Art Amateur* in May 1891, lamenting the passing of the Barbizon artists so long favored by Bostonians:

> But at last the news is circulated that leading Boston buyers of paintings—the first buyers, in other days of Millets, Corots, Diazes and Daubignys—are now sending to Paris for this sort of thing, and Impressionism becomes the fashion. Some of our leading landscape artists praise it and preach it; many of the younger painters practice it. . . . The old favorites, sticking to their

Fig 28. Claude Monet, *Valley of the Creuse (Gray Day)*, 1889, Museum of Fine Arts, Boston.

own styles, take back seats, and one almost wonders if all the pictures of the past are going to be taken out into Copley Square and burned. Titian and Veronese and the old masters have faded, we are told; Rembrandt is brown; even Corot is stuffy, and as for Daubigny and the rest of the modern French school of landscape, they are virtually black-and-white. Courbet and Hunt couldn't see color in nature as it really is. Tone, so much prized and labored for in the past, must go; Motley and Monet are your only wear.[64]

The writer cites some of the figures who were involved in the promotion of Impressionist "Motley and Monet" in Boston. Cole, he wrote, "imports a number of Monets for collectors of authority." They included Brooks, of course. The painters Frederic Porter Vinton and Robert Vonnoh were reported to be enthusiasts and backers of "the new light in art." But one name in his list of advocates stands out. "Mr. Fenellosa," he recounts, "expert in Japanese art, exults in numberless discourses on the increasing Japanese influence evident in the use of simple, pure tints and unconventional composition."[65]

Fig. 29. Katsushika Hokusai, Japanese, 1760–1849, *The Yoshitsune Horse-washing Waterfall at Yoshino,* about 1832, woodblock print, Museum of Fine Arts, Boston.

Ernest Francisco Fenellosa, curator of Japanese art at the Museum of Fine Arts from 1890 to 1896, had gone to Japan in 1878, soon after his graduation from Harvard, to lecture on Western philosophy at the Imperial University. Within a few years, with expert tutelage, he had become a distinguished connoisseur of Japanese art, and within a decade he had formed a notable collection of more than one thousand paintings.[66] He sold the collection in 1886 to Charles Goddard Weld, a Boston doctor, who placed it on deposit at the Museum in 1889—the same year in which Weld lent the institution his sunset landscape by Chintreuil (cat. no. 64). Fenellosa's advocacy of Monet's paintings by virtue of their dependency on Japanese compositional strategies and "simple, pure tints" suggests

another way in which Bostonians might have appreciated Monet's art—through their
shared partiality for Japanese art. Two paintings owned by Denman Ross, *Cliffs of the
Petites Dalles* (fig. 10) and *Valley of the Creuse (Gray Day)* by Monet (fig. 28), not to mention
his Degas *Landscape* (cat. no. 123), exhibit the qualities of design that critics in the nine-
teenth century associated with Japanese composition. Ross, whose tastes ranged far and
wide and included Japanese art, showed a particular interest in views of undulating cliffs
and valleys that have a pronounced resonance with landscape compositions by Katsushika
Hokusai, the great *ukiyoe* painter and printmaker (see fig. 29). Might Ross and other
Bostonians have come to appreciate Monet not only as the inheritor of Corot and Millet,
but also as a fellow devotee of the art of Japan?

Whether due to ties of affection or to affinities of taste, sales of Monet's paintings to
Bostonians continued steadily in 1891, and by March 1892, when the St. Botolph Club held
its solo exhibition of his work, it was said that there were forty paintings by the artist in
Boston collections.[67] Two of the paintings in the St. Botolph Club exhibition had already
been seen in public, for Anna Perkins Rogers had lent her Monets to the Museum the year
before. Following the exhibition, Ross's *Valley of the Creuse (Gray Day)* and two paintings
from Fitzgerald's collection joined three that had not been seen at the St. Botolph Club,
namely the *Valley of the Petite Creuse* (fig. 30) from Clara Kimball's collection and the
Fairchilds' *Road at La Cavée, Pourville* and *On the Cliff at Dieppe*, at the MFA, for what was,
in effect, a summer installation of works by Monet—which coincided, by accident or by
design, with Fenellosa's major exhibition of the works of Hokusai.[68]

In light of the local fascination for Monet's bravura painting, it is ironic that the first Impressionist landscape officially to enter the MFA's collection was a refined and elegant view of a racecourse in the Parisian suburbs by his chief rival, Edgar Degas. *Racehorses at Longchamp* (cat. no. 82), purchased in 1903, was in fact the first work by Degas to enter the collection of any American museum. The painting was sent to Boston by the New York branch of Durand-Ruel in late April 1903, at the time that the Museum was already considering the purchase of another picture by Degas, *Orchestra Musicians* (fig. 31). Samuel Dennis Warren, then president of the Museum, had asked the gallery to send the second painting to Boston and wrote to the Museum's director on April 23 requesting that he "kindly obtain any expert opinions as to its merits in comparison with the other."[69] There then followed a considerable debate, with some of the local painters consulted (such as Vinton) opting for *Racehorses*, and others (notably Frank W. Benson, Perry, and Tarbell) voting for *Musicians*. In the end, Warren purchased *Racehorses* from Durand-Ruel for $9,000, and the *Musicians* was returned to New York.[70]

The decision to buy the comparatively more conservative *Racehorses at Longchamp* over the more emotionally biting, spatially challenging *Orchestra Musicians* must be understood in the context of Boston's predilection for art of the countryside over art of the city, for sun-drenched fields over gaslit theaters. That partiality can be traced back as far as the 1860s, when—for all that Hunt had acquired, in *The Sower*, one of the most politically radical pictures of the century—Bostonians' love of rural subjects in the art of Millet, Corot, Diaz, Rousseau, and Daubigny had crystallized. That early preference for landscape beauty saw its natural conclusion in turn-of-the-century Boston's obsession with Monet.

For the next thirty years, Bostonians continued to acquire works by Monet—sometimes buying the painter's very latest efforts and on other occasions buying paintings completed many decades earlier. Sarah Choate Sears, for example, purchased a canvas from Monet's 1909 *Water Landscapes* exhibition during the run of the show. Alexander Cochrane bought two *Water Lilies* from Durand-Ruel in December 1909, a few months after the close of the exhibition (cat. nos. 153–54); Cochrane returned to Durand-Ruel the earlier of the two paintings, which was purchased by Mrs. Walter Scott Fitz in 1911 (and later donated to the Museum of Fine Arts by her son, Edward Jackson Holmes). In that same year, Mrs. Fitz purchased for the Museum a version of the *Morning on the Seine* (cat. no. 144). The descendants of Juliana Cheney Edwards assembled a superb group of Impressionist paintings in the first decades of the twentieth century, purchasing the first of eight Monets in 1907; among their gifts to the Museum, made in 1925 and 1939, were Monet's *Poppy Field in a Hollow Near Giverny*, *Grainstack (Sunset)*, and *Meadow at Giverny* (cat. nos. 111, 142, 113), as

Fig. 31. Edgar Degas, *Orchestra Musicians*, 1870–71, Städelsches Kunstinstitut, Frankfurt.

well as Corot's *Morning near Beauvais,* Pissarro's *Sunlight on the Road, Pontoise,* and Renoir's *Rocky Crags at L'Estaque* (cat. nos. 14, 90, 106).

The greatest benefactor of Boston's Impressionist collection, John Taylor Spaulding, bought only one Monet, but he bequeathed to the Museum in 1948 its greatest early work by the artist, the *Rue de la Bavolle, Honfleur* (cat. no. 79). Spaulding, who with his brother had assembled a staggering collection of some six thousand Japanese prints, was an astute connoisseur of Impressionism and a friend to the institution for which he had envisioned his collection of paintings. Purchasing key examples of the work of Cézanne, Pissarro, Renoir, and Sisley (cat. nos. 114, 87, 93, 107, 80), he regularly chose pictures that extended, rather than duplicated, the Museum's holdings. His counterpart in the assemblage of a vast collection of graphic art is another great benefactor, W. G. Russell Allen, who over several decades formed a wide-ranging collection of prints, from the Renaissance to the twentieth century. His gifts to the Museum began in 1923 and culminated in the bequest of some two thousand prints at his death in 1955. Among the masterworks from his collection discussed here are lithographs by Bresdin and Redon (cat. nos. 40, 145); Gauguin and Sérusier (cat. nos. 125–26); and Bonnard and Vuillard (cat. nos. 146, 148).

During the twentieth century—perhaps at the expense of the art of Picasso, Braque, Wassily Kandinsky, and Paul Klee—the Museum of Fine Arts became a considerable center for the study of Barbizon and Impressionist landscape. This is particularly true in the case of Monet: following an exhibition of more than ninety paintings by the artist at Boston's Copley Hall in 1905, the painter's first American museum exhibition was held at the MFA in 1911, featuring more than forty works. A memorial exhibition of some eighty canvases took place in 1927. In 1977, the groundbreaking exhibition *Monet Unveiled* marked a turning point in the technical analysis and appreciation of the artist's technique. Finally, two shows organized by the Museum with Monet scholar Paul Hayes Tucker, *Monet in the '90s* (1989) and *Monet in the Twentieth Century* (1998), explored in depth and in detail the artist's series from the Creuse pictures of 1889 to the phenomenal *Water Lilies* of the final years of his life.

Our understanding of the history and development of landscape art is constantly evolving. Recent books and exhibitions on the subject—whether broadly retrospective or tightly focused—suggest that much more is still to be discovered. At the beginning of the twenty-first century, we look back at the history of French landscape art—at the accomplishments of the great painters, draftsmen, printmakers, and photographers whose works are represented in this catalogue—and at the world in which these works were made and first understood. Looking to the past, we hope to recapture a light that will guide us into our own future.

NOTES

1. For a discussion of Valenciennes and the painted sketch, see Strick 1996, 79–87. See also Strick's text on ten Valenciennes paintings in Conisbee et al. 1996, 126–33.

2. See, for instance, Tinterow, Pantazzi, and Pomarède 1996, nos. 6–11, 20–26.

3. Michael Pantazzi, "Le plus grand paysagiste de notre temps," in Tinterow, Pantazzi, and Pomarède 1996, 195–207.

4. Anonymous critic quoted in Tinterow, Pantazzi, and Pomarède 1996, 268, no. 91; this author's translation from the French.

5. Stone Breakers was destroyed in World War II; A Burial at Ornans is in the collection of the Musée d'Orsay, Paris.

6. Murphy 1984, 32.

7. Philippe de Chennevières, quoted in Tinterow, Pantazzi, and Pomarède 1996, 195 and note 9; this author's translation from the French.

8. Ibid., 292 and note 7.

9. Wheelwright 1876, 269. See also Scharf 1968, 92.

10. See Murphy 1984, 169.

11. Vincent van Gogh to Theo van Gogh, June 29, 1875, in Van Gogh 2000, 1:28.

12. Monet to the journalist Thiébault-Sisson, 1900, quoted in Rewald 1973a, 38.

13. Monet to Boudin, June 3, 1859, quoted in Wildenstein 1974–91, 1:419; this author's translation from the French. Troyon's paintings were Return to the Farm and View Taken from the Heights of Suresnes (Musée d'Orsay and Musée du Louvre, Paris).

14. Quoted by Monet to Boudin, May 19, 1859, quoted in Kendall 1989, 18.

15. See House et al. 1995, 178.

16. Wildenstein 1974–91, 1: no. 34. See also House et al. 1995, 178.

17. Renoir's Cabaret (1866) is at the National Museum, Stockholm; Diana (1867) is at the National Gallery of Art, Washington, D.C.; Pissarro's riverbank views may be found at the Glasgow Art Gallery and Museum, Kelvingrove, the National Gallery of Scotland, Edinburgh, and the Art Institute of Chicago; Sisley's 1866 Marlotte is at the Albright-Knox Art Gallery, Buffalo, N.Y.; and Degas's Steeplechase is at the National Gallery of Art, Washington, D.C.

18. Quoted in Wildenstein 1974–91, 1:427; this author's translation from the French.

19. See Loyrette and Tinterow 1994, 436–38, and Stuckey 1995, 194. According to Wildenstein 1974–91, 1: no. 136, the rejected view of La Grenouillère was probably the work formerly in the Arnhold Collection, Berlin, presumed destroyed.

20. Arsène Houssaye to Karl Bertrand, in "Salon de 1870," L'Artiste (1870), 319, quoted in Loyrette and Tinterow 1994, 438; this author's translation from the French. Renoir's Bather is in the collection of the Museu de Arte de São Paulo Assis Chateaubriand, Brazil; Woman of Algiers is at the National Gallery of Art, Washington, D.C.

21. Leroy 1874, 79–80, quoted in Berson 1996, 1:26; this author's translation from the French. Impression: Sunrise is in the collection of the Musée Marmottan–Claude Monet, Paris.

22. For a critical review of the exhibition, see Paul Hayes Tucker, "The First Impressionist Exhibition in Context," in Moffett et al. 1986, 93–117, especially 106–10.

23. Silvestre 1874, 2–3, quoted in Berson 1996, 1:39; this author's translation from the French.

24. Monet to Hoschedé, February 15, 1882, .quoted in Kendall 1989, 100.

25. It is possible that the painting exhibited in 1882 was not the MFA canvas but another of the same subject, Wildenstein 1996, 2: no. 665.

26. For an extended discussion of the seventh Impressionist exhibition (1882), see Joel Isaacson, "The Painters Called Impressionists," in Moffett et al. 1986, 373–93.

27. Pissarro to Monet, June 12, 1883, in Pissarro 1980–91, 1:216–17, quoted in Zafran 1992, 4 and note 11.

28. The Artist's House is at the Art Institute of Chicago (Wildenstein 1996, 2: no. 284); The Customs House is at the Metropolitan Museum of Art, New York; and Low Tide is at the Museo Thyssen-Bornemisza, Madrid. Zafran 1992, 55 and note 13, identifies The Customs House exhibited in Boston with a work at the Brooklyn Museum of Art (Wildenstein 1996, 2: no. 740), but because that painting was bought from Monet by Durand-Ruel only in July 1883 and the paintings were shipped to Boston in June (according to Pissarro's letter), it must be correct (as Wildenstein states) that the picture is the Metropolitan Museum of Art canvas (Wildenstein 1996, 2: no. 735).

29. "The Picture-Galleries of the Foreign Exhibition," Boston Daily Advertiser, September 3, 1883, 4, quoted in Zafran 1992, 5 and note 15.

30. For a discussion of both of Monet's 1880s campaigns on the Riviera, see Pissarro 1997.

31. Monet to Hoschedé, February 1 and February 24, 1888, quoted in Kendall 1989, 126.

32. For a discussion of Monet's paintings of the Gare Saint-Lazare in the context of Manet's work, see Bareau 1998.

33. Octave Maus, in L'Art Moderne, 1889, quoted in Tucker 1989, 55. See Tucker's chapter 3, 41–67, for a discussion of the Creuse series and the exhibition of 1889.

34. For a discussion of Neo-Impressionism, see Rewald 1978, 73–132.

35. John House in Hayward Gallery 1985, 257.

36. Degas quoted in Vollard 1928, 91, quoted in Kendall 1987, 308.

37. Framed by the doorway in the photograph are Gérôme's Greek Slave (MFA accession number 87.410) and Bonnat's portrait Henry Lillie Pierce (MFA 98.1005). Homer's works are Fog Warning (MFA 94.72) and The Lookout (MFA 99.23). Above the door are The Sand Dunes of Essex (MFA 85.486), by William Lamb Picknell, along with three paintings of cows (MFA 87.48, 87.49, and 99.308) by John Bernard Johnston. The paintings by Constable are, at left, a work then on loan from Boston collector Henry Lee Higginson and, at right, The White Horse (MFA 95.1373), by British artist John Dunthorne, Jr., which was subsequently sold.

38. MFA 77.249. See Murphy 1984, no. 141.

39. See Murphy 1984, no. 39. The other Millets on view in the 1902 photograph are, from left to right, Laundresses (MFA 06.2421), Rabbit Warren, Dawn—apparently an oil version of the pastel composition in this volume (cat. no. 59)—and Knitting Lesson (MFA 06.2423).

40. Lhermitte's painting (MFA 92.2657) was created in 1892 and given to the Museum in the same year by J. Randolph Coolidge. Other identifiable works include: at bottom in the corner of the room, a painting by Michel (MFA Res.32.298) and above it, works by Cazin (MFA 17.3273) and Millet (MFA 93.1461); immediately to the left of the Cazin, a vertical landscape by Français (MFA 79.323); to the left of the Français, on the lowest level, a painting by or after Corot (MFA 94.136, subsequently sold).

41. Jules Champfleury, "Salon de 1846," quoted in Tinterow, Pantazzi, and Pomarède 1996, 268, no. 91; this author's translation from the French.

42. See Tucker 1989 for a thorough account of Monet's series and the exhibition of 1889.

43. Zafran 1992, 17 and notes 57–59.

44. Catalogues of the exhibited works were published as MFA 1902, 43–54, and MFA [1903], 69–89.

45. Murphy 1984, xix–xx; see also nos. 39, 40, 43, and 58.

46. See Fleming 1984, ix, xi–xii.

47. See Alexandra Murphy in Poulet and Murphy 1979; and Douglas E. Edelson, "Courbet's Reception in America before 1900," in Faunce and Nochlin et al. 1988, 68–69. Castagnary is quoted in Edelson 1990, 200.

48. See Allston Club 1866. In an email to this author of March 20, 2002, Alexandra Murphy noted that a large *Apple Orchard* by Lambinet was exhibited at the Boston Atheneum in 1860, and that the dealers Cadart and Luquet presented four paintings by the artist in an 1867 Boston exhibition. She related that "J. Foxcroft Cole wrote to critic William Downes in 1885 (letter now in the library of the Boston Athenaeum collection, not to be confused with the Boston Atheneum) retrospectively crediting the experience of seeing the *Apple Orchard* as well as other Lambinets at Williams and Everett, the Boston dealers, with inflaming in him the desire to paint. And as Cole later acted as an agent occasionally for the Providence and Boston dealer Seth Vose and directly to other Boston collectors, including Quincy Adams Shaw," Cole may be credited "with sustaining the Lambinet popularity during the 1860s." Six paintings by the artist are now in the collection of the MFA: *Young Man Fishing Beneath Willow Trees* (94.311), *Washerwomen* (17.1622), *Farmyard* (20.1868), *Fishing on the Banks of the Seine* (23.567), *Road through the Fields* (37.599), and *Village on the Sea* (37.600).

49. Quoted in Edelson 1990, 15.

50. Quoted in Downes 1888a, 504.

51. See Millet to Alfred Sensier, November 1867, in the Cabinet des Dessins, Musée du Louvre, Paris, referenced in Fleming 1984, xii and note 24.

52. Millet to Alfred Sensier, January 8, 1872, quoted in Moreau-Nélaton 1921, 3:84; this author's translation from the French. See also Fleming 1984, xii.

53. Moreau-Nélaton 1921, 3:84. See also Fleming 1984, xii.

54. *El Jaleo* is in the collection of the Isabella Stewart Gardner Museum. Sargent's first Monets were *Rough Seas at the Manneporte* (Wildenstein 1996, 3: no. 1036) and the landscape *Bennecourt* (Wildenstein 1996, 3: no. 1126). He later purchased *Gardener's House* (Wildenstein 1996, 2: no. 867) from Durand-Ruel, in 1891.

55. Frances Weitzenhoffer, "The Earliest American Collectors of Monet," in Rewald and Weitzenhoffer 1984, 87.

56. See Porat 1994, 172, 174. See also Erica E. Hirshler, "'From the School of Mud to the School of Open Air': The Metamorphosis of Dennis Miller Bunker," 19–89, and David Park Curry, "Reconstructing Bunker," 91–116, in Hirshler and Curry et al. 1994. This author is grateful to Erica E. Hirshler and David Park Curry for their discussion of Bunker's early assimilation of Impressionism.

57. Greta, "Boston Art & Artists," *Art Amateur*, October 17, 1887, 93, quoted in Zafran 1992, 13 and note 43.

58. Downes 1888b, 782.

59. See Perry 1927; also reprinted in Martindale 1990, 115–21.

60. Rewald and Weitzenhoffer 1984, 87; Wildenstein 1996, 2: no. 762 (Wildenstein incorrectly gives the location of Williams and Everett as New York instead of Boston). See letters of December 5 and 6, 2001, between Durand-Ruel et Cie., Paris, and George Shackelford, in the Department of Art of Europe's curatorial object file for MFA 24.1755, Museum of Fine Arts, Boston.

61. Daniel Wildenstein identifies a view of Vétheuil as having been owned by Brooks; see Wildenstein 1996, 2: no. 532. Records of the former Department of Paintings of the MFA reveal, however, that the painting now at Harvard University, Wildenstein 1996, 2: no. 540, was lent to the Museum along with the views of Antibes and Argenteuil (Wildenstein 1996, 3: no. 1161a and 2: no. 357a, respectively) by Brooks's daughter in 1920 (MFA loan registration cards from the files of the former Department of Paintings, temporary loan numbers 201.20, 202.20, and 203.20). Wildenstein does not record Brooks's ownership of the Harvard painting, but instead places Cole and Brooks in the provenance of another painting, no. 539. The ex-Brooks picture now at Harvard, distinguishable by the presence of three vertical reeds or sticks on the bank below the small island in the river, is properly illustrated as no. 540. It seems certain that the three pictures lent to the Museum by Brooks's heirs—Wildenstein nos. 1161a, 357a, and 540—are the ones purchased for him by Cole in Paris in 1890.

62. J. Foxcroft Cole to Peter Chardon Brooks, September 26, 1890, among the Brooks papers at the Massachusetts Historical Society, quoted in Zafran 1992, 17 and notes 57–58. Cole and Brooks were not the only Bostonians to buy both Cazin and Monet at the same time: the painter Anna Perkins Rogers, who was called Annette, was in Paris in June 1890 and purchased Cazin's *Farm beside an Old Road* (cat. no. 132) at the auction sale of the collection of Ernest May for about 6,200 francs; in mid-June, she bought Monet's *Snow at Argenteuil* (cat. no. 88) and *Fisherman's Cottage on the Cliffs at Varengeville* (cat. no. 105) from Durand-Ruel for 8,500 francs.

63. Monet to Durand-Ruel, April 11, 1888, quoted in Wildenstein 1974–91, 3:234; this author's translation from the French.

64. "Art in Boston," *Art Amateur* 24, no. 6 (May 1891), 141, quoted in Zafran 1992, 14–15 and note 45.

65. Ibid.

66. Morse 2001, 34–39.

67. D.F. [Desmond Fitzgerald]. 1892, n.p. Fitzgerald claimed, "This is probably the first time that an exhibition devoted wholly to Monet's works, has been held in this country, and as such, may become a notable art event. [He was incorrect, as an exhibition had been held at the Union League Club, New York, in 1891.] The exhibition becomes doubly interesting from the fact that these twenty pictures have been loaned wholly from Boston and vicinity, and that it would not be difficult to find here in Boston twenty more pictures by the same hand, were the gallery large enough to show them to advantage."

68. See Morse 2001, 34–39.

69. Samuel Dennis Warren to Edward Robinson, Esq., April 23, 1903, in the Department of Art of Europe's curatorial object file for MFA 03.1034, Museum of Fine Arts, Boston.

70. See notes and letters in the Department of Art of Europe's curatorial object files for MFA 03.1034 and in the Museum Archives, Museum of Fine Arts, Boston. Durand-Ruel stated that he was "perfectly willing for the other Degas to remain with the Museum for a few days longer, and hope that they will finally decide to purchase it at the price of $13,500, as I know they will never again have such an opportunity of acquiring a Degas of this quality and composition at such a price." Joseph Durand-Ruel to Samuel Dennis Warren, May 5, 1903, in the Department of Art of Europe's curatorial object file for MFA 03.1034.

Pierre-Henri de Valenciennes
French, 1750–1819

1. PIERRE-HENRI DE VALENCIENNES
Italian Landscape with Bathers, 1790
Oil on canvas
54 x 81.6 cm (21 ¼ x 32 ⅛ in.)
Gift of John Goelet 1980.658

Pierre-Henri de Valenciennes, born in Toulouse in 1750, was one of many French artists who went to Italy. These artists wanted to study the works of Renaissance masters and to absorb the flavor of the countryside around Rome that had inspired the great seventeenth-century French painters resident there, Claude Lorrain and Nicolas Poussin. Valenciennes went to Italy in 1777 and stayed there until 1784 or 1785, making Rome his base. While there, he painted and sketched in the city and the surrounding countryside, producing small, dazzlingly fresh views of rooftops, trees, and more distant vistas. These he used as study exercises, to train his eye and hand in the replication of objects in nature and their enveloping atmosphere (fig. 32).

Back in Paris, he began exhibiting at the Salon in 1787. The paintings he showed there, generally large in scale and finely finished, are thoughtful compilations of individual motifs often taken from his studies and meant to evoke faraway Italy (the trip from France to Italy at this time typically took two to three months), with golden light bathing cubic buildings, some with columned porticos. *Italian Landscape with Bathers* was shown in the Salon of 1791 along with four other canvases, two of which depicted mythological scenes. *Italian Landscape with Bathers* is a more generic view, the bathers taken from no particular story; their presence bespeaks warmth, ease, peace, and security.

This feeling of calm is incorporated into the very structure of the painting. A series of interconnecting diagonals leads the eye gradually from foreground to background, starting with the figure in the lower left corner and moving

Fig. 32. Pierre-Henri de Valenciennes, *At the Villa Farnese: Houses among the Trees*, Musée du Louvre, Paris.

from figure group to figure group. Once past the figures on the path, the way is toward ever greater light and height, culminating not in the buildings, the work of man, but gloriously on high with the work of nature. Such a zigzag route requires the viewer to take note of trees, rocks, buildings, and the varying light effects from shadow to full sunlight, and, in taking note, to appreciate the multiplicity of forms found in nature.

From at least the end of the sixteenth century, art students were trained to sketch and paint indoors. Although artists had both sketched and painted outdoors for centuries, this was not accepted practice in art schools and academies. Valenciennes firmly believed in the utility of sketching, in both pencil and oils, after nature. He wrote a treatise on painting, *Elements of practical perspective for the use of artists; followed by reflections and advice for the student of painting and particularly of the genre of landscape,* a book that continued to be consulted and recommended to young artists as late as 1883.[1] In it Valenciennes recommends careful observation of the natural world, the better to communicate the emotions that nature engenders.[2] The handbook articulated what would become common practice in the

nineteenth century, and in doing so changed the course of landscape painting.

Even if the motifs in Valenciennes's oil sketches appear in his finished works, the method of painting—fluid and spontaneous in the former, measured and slow in the latter—sets them apart. One viewer of the Salon of 1791 criticized Valenciennes for a slavish reliance on an idealizing, secondhand view of nature: "Now and then recall the beautiful [paintings by] Claude Lorrain, [Jacob van] Ruysdael, [Jan] Both, and Nicolas Poussin; these are your models and nature; paint after nature, and not after the studies in your room."[3]

Valenciennes's ideas were well regarded, and he was well placed to promulgate them. The most influential landscape painter of his time, he taught perspective at the state-funded art school, the Ecole des Beaux-Arts, from 1796 to 1800, and in 1812 was appointed professor of perspective there. Among his students were Jean-Victor Bertin and Achille Michallon, both of whom were Corot's teachers. FEW

1. *Eléments de perspective pratique à l'usage des artistes; suivis de la réflexions et conseils à un élève sur la peinture et particulièrement sur le genre du paysage.* First published in 1800, it was reprinted in 1820.

 In December 1883 Armand Guillaumin enclosed in a package that Camille Pissarro was sending to his son Lucien, in London, a copy of Valenciennes's book. Pissarro wrote: "It was made by the famous Valenciennes, it's old, it's still the best and the most practical, be sure to take into account the underlying principles." [Il est fait par le fameux Valenciennes, c'est ancien, c'est encore le meilleur et le plus pratique, tâche de te rendre compte des principes qui servent de base.] Pissarro 1980–91, 1:260; this author's translation from the French.

2. Strick 1996, 79–87.

3. "Rappelez-vous quelquefois les beaux Claude Lorrain, Ruysdael, Both et Nicolas Poussin; voilà vos modèles et la nature; peignez d'après elle, et non d'après des études dans votre chambre." Heim, Béraud, and Heim 1989, 43; this author's translation from the French.

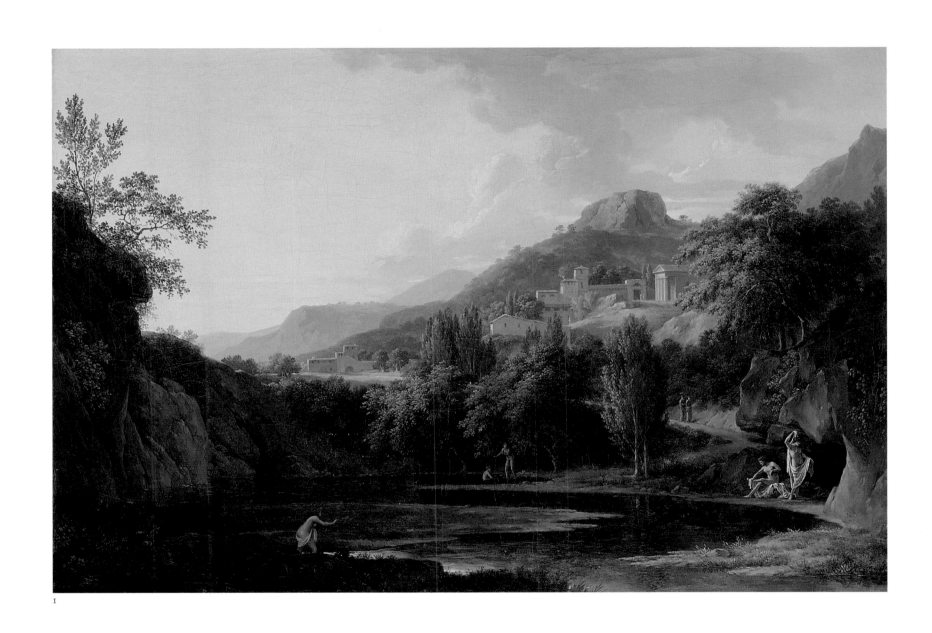

I

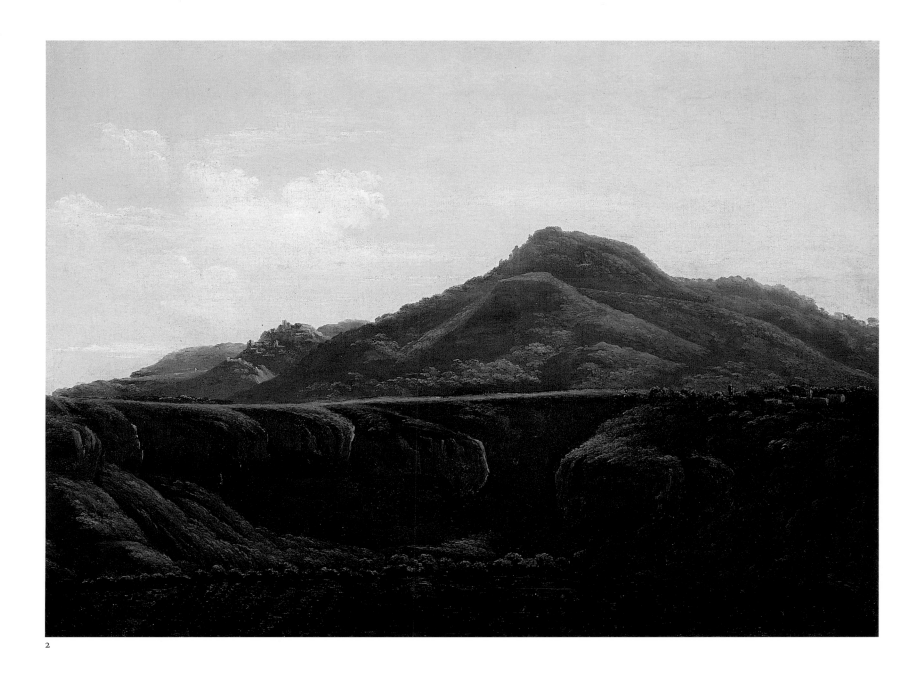

2

Jean-Joseph-Xavier Bidauld
French, 1758–1846

Théodore Caruelle d'Aligny
French, 1798–1871

Paul Huet
French, 1803–1869

Eugène Bléry
French, 1805–1887

2. Jean-Joseph-Xavier Bidauld
Monte Cavo from Lake Albano, about 1790
Oil on canvas
32.5 x 45.6 cm (12¾ x 18 in.)
Charles Edward French Fund 43.130

3. Théodore Caruelle d'Aligny
Study of a Great Tree, near Civita Castellana, 1826
Graphite pencil on cream wove paper
Sheet: 62.1 x 46.9 cm (24⁷⁄₁₆ x 18⁷⁄₁₆ in.)
Anonymous gift 1985.874

4. Théodore Caruelle d'Aligny
Rocky Landscape, probably about 1835
Pen lithograph on cream wove paper
Image: 22.2 x 31 cm (8¾ x 12¹³⁄₁₆ in.)
Lee M. Friedman Fund 1985.871

5. Théodore Caruelle d'Aligny
Italian Hills, about 1826–27
Oil on paper mounted on canvas
41.2 x 68.8 cm (16¼ x 27⅛ in.)
Seth K. Sweetser Fund 49.1730

6. Paul Huet
Landscape in the South of France, about 1838–39
Oil on paper mounted on panel
35.6 x 52.4 cm (14 x 20⅝ in.)
Fanny P. Mason Fund in memory of Alice Thevin 1987.257

7. Eugène Bléry
A Large Patch of Coltsfoot, 1843
Etching on chine collé
Platemark: 40 x 53 cm (15¾ x 20⅞ in.)
Lee M. Friedman Fund 1986.612

Valenciennes's treatise gave official sanction to the notion of painting directly from the landscape motif, outdoors. Yet he did not prescribe a method for making marks, so each artist responded to the demands of translating the natural world onto paper or canvas in individual ways.

Jean-Joseph-Xavier Bidauld was one of the artists who painted outdoors before the publication of Valenciennes's treatise, a fact that underlines the prevalence of the practice in the late eighteenth century. Born in 1758 in Carpentras, Bidauld started taking art lessons at the age of ten; by 1783 he was in Paris, copying paintings by northern masters and studying how nature actually looked during visits to the Forest of Fontainebleau. Like Valenciennes, he went to Italy, where he spent five years. Back in Paris by 1790, he exhibited at the Salon until 1844. Despite his advanced attitude toward painting in the open air, Bidauld was conservative in his painting technique, clinging over the decades to the somewhat dry, even formulaic style he favored in the later 1790s.

This view of Monte Cavo (cat. no. 2), most likely done shortly before Bidauld's return to Paris, about 1790, epitomizes his cool, atmospheric, luminous landscape style. Focusing his view on the mountain resulted in the pyramidal structure, a favorite compositional type of his.[1] This relatively simple form creates a sense of stasis, which Bidauld augments rather than enlivens with the detail built up in the blues and greens of water and foliage, set off by the luminous sky.

Lake Albano, southeast of Rome and most noted for the lakes filling a volcanic crater around the city, was the location of Castel Gandolfo, the summer residence of the pope since the seventeenth century. Bidauld focused on the strange, knobby forms projecting from the crater's walls, the sharp lines of the shadows cast by the landforms, and the way in which the buildings to the right and left were constructed so as to mimic the surrounding terrain. Few artists painted with the hushed clarity that Bidauld achieved.

Théodore Caruelle d'Aligny, unlike Bidauld, was presumably well acquainted with Valenciennes's treatise, having studied with a pupil of Valenciennes's. Living in Paris since the age of ten, Aligny showed regularly at the Salon beginning in 1822, received the Legion of Honor in 1842, and became a member of the Institut de France in 1862. He made his first trip to Italy in 1822 and stayed through 1827. While there, he chose an anonymous mountain to study and painted it with quick, summary strokes (cat. no. 5). The scrubbed-on color in the foreground gives the eye no purchase; it glides over muddy hills, finding both more light and more definition in the middle ground and the atmospheric background.

The painstaking detail of Aligny's large drawing of a tree near Civita Castellana (cat. no. 3) shows a complementary element in the landscapist's repertoire, compared with the simplification of the oil sketch. Valenciennes had cautioned that "all studies after nature," by which he meant atmosphere and the way light falls on such solid objects as trees, rocks, and bushes, "should be made in a period of two hours at the most," because "light and its shadows change continuously by virtue of the movement of the earth."[2] By contrast, the study of such solid objects can take a longer time, "because they are fixed."[3] Aligny's hard pencil traced the outlines of branches and foliage, filled in some with shadow and detail, and picked out clumps to render as decorative patterns, thereby creating a portrait of only some elements of the tree and its surroundings. Yet, just as Aligny's brush concentrated on the luminous middle ground and far hill at the expense of the elided foreground in *Italian Hills,* so did his pencil linger over those aspects of the tree

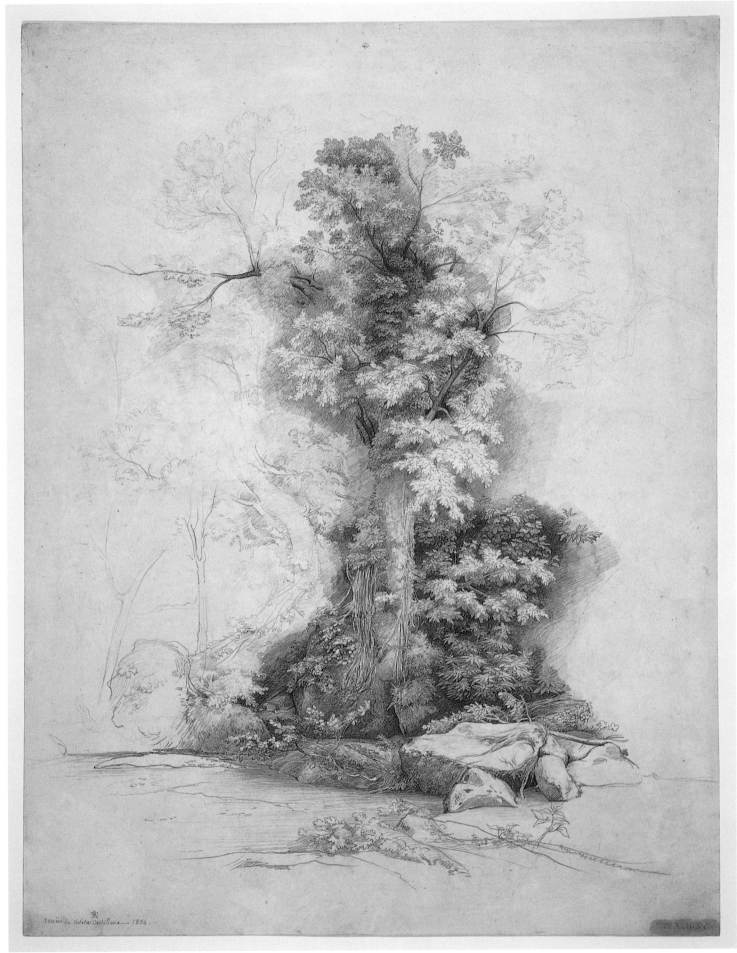

Ravine de Civita Castellana — 1826.

3

that interested him. The greater detail of foliage and the selective approach allowed Aligny the freedom to create a spiral of dark-and-light foliage rising around the trunk.

Aligny returned to Italy in 1834–35, and a site on this second trip seems to have inspired the pen lithograph *Rocky Landscape* (cat. no. 4). Like the precise lines of the graphite pencil, the unmodulated black lines of the pen lithograph (their fluency assured by the high polish of the lithographic stone) demonstrate Aligny's constant interest in form and structure. And, as in the drawing, where forms are manipulated to create an ascending spiral, here the tree branches are disposed to shape an arch through which the distant landscape is viewed. Although the view is unprepossessing, the lithograph conveys a knowing sense of the flattening, hot light of Italy and how rocks jut up from valley floors. Deep shadows under branches and on the protected faces of rocks contrast sharply with the paper, daringly left blank.

More detailed yet still stunningly evocative is Paul Huet's *Landscape in the South of France* (cat. no. 6). Poor health, both his wife's and his own, prompted repeated visits to the South of France (1833, 1838–41, 1844–45) and Italy (1841–43). The topography depicted in the painting suggests that Huet painted this riverine view sometime during one of those many trips. Drenched in sunlight, the landscape is organized by the winding river zigzagging to the mist-filled background. With its careful progression into depth, punctuated by the darker V-shaped riverbank in the middle ground, the composition is not unlike examples by the seventeenth-century painter Claude Lorrain (fig. 33). This small work by Huet shows naked children playing at the water's edge and two figures dancing, people enjoying themselves in a beneficent climate. Their abandon finds material expression in Huet's fluid marks. The ability to paint in thinned-down, easy strokes was important to

4

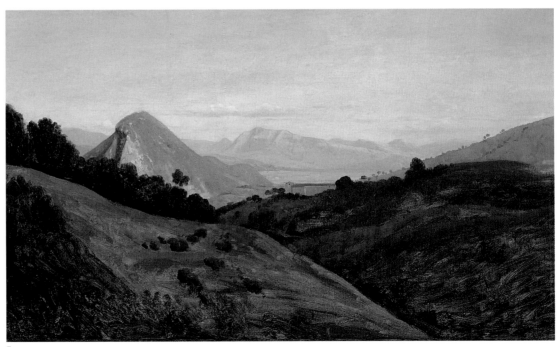

5

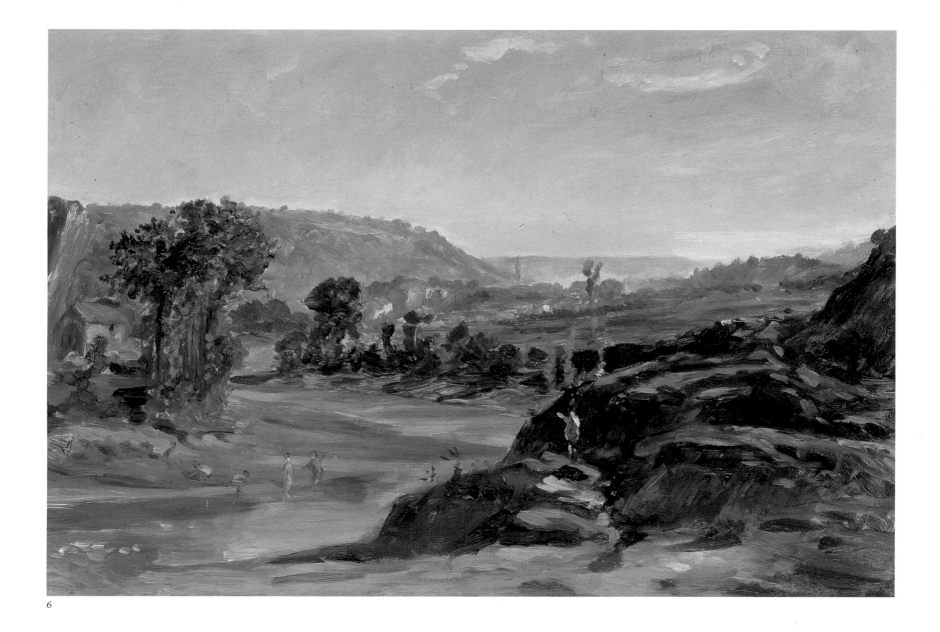

6

Fig. 33. Claude Lorrain, French, 1600–1682, *Landscape with a Temple of Bacchus,* 1644, National Gallery of Canada, Ottawa.

Huet, so he chose paper as his support. (The painting is now affixed to a panel.)

As happened often with artists from the North experiencing the light of the South for the first time, Huet despaired: "I am completely dazzled by this light, so keen and brilliant. I do not know if this glittering nature, well outside the bounds of my studies and my first affections, suits my talent." Without the softening and integrating humid light of the North, Huet explained in a letter to a friend, the landforms take on greater prominence: "Here the land is beautiful all on its own, and all its power, all its admirable delicacy of color, it draws from the sun and from the light."[4] Capturing this keen and brilliant light, which lends power to the landscape, was in no way beyond his means, as this painting admirably shows.

A different sensibility pervades Eugène Bléry's *Large Patch of Coltsfoot* (cat. no. 7). After a short detour as a private tutor in mathematics, Bléry found his calling in printmaking, in particular etching. Based in Paris, he made hundreds of prints, taking his motifs directly from nature. Only three were not made either directly from the motif or based on the drawings he made outdoors. He compiled a catalogue of his prints and gave his complete oeuvre to the Bibliothèque nationale in 1878; his catalogue remains the basis for all later writing on him and his work.[5]

Bléry concentrated on landscape views but did a number of renderings of plants. When publishing them, he grouped them according to his own taste. *A Large Patch of Coltsfoot* appeared with three depictions of other plants, burdock (Fr. *bardanne*), thistle (Fr. *chardon*), and finally bloodwort (Fr. *patience d'eau*) and brambles (Fr. *Roncé à la vanne*), in a portfolio called *Les quatres grandes plantes*. Made in 1842 and 1843, these are among the first of his plant etchings: the earliest is dated 1840; the last, 1877; and most of them were done by 1859. Bléry called these four

7

"very beautiful" *(très-belles).*[6] It is possible that *Les quatres grandes plantes* appeared in the Salon of 1843 as *Cadre de quatre plantes, gravées à l'eauforte: Tusorlage des torrents* [perhaps a mistranscription of *tussilages*, coltsfoot], *bardanne, chardon, patience d'eau.*[7]

These are all rangy plants that thrive in waste ground; some of them, like the thistle, can be pests when they invade cultivated fields or gardens. Yet all these plants have a long history of being used as herbal remedies—coltsfoot flowers were painted on doorposts in Paris to signal the location of an apothecary's shop.[8] However, Bléry grouped these plants, generally considered weeds, according to their physical, not medicinal, characteristics. The low and close-up vantage point in his plant etchings

monumentalizes each plant and shows it in all its detail, as if it were a botanical illustration. In his focus on uncultivated plants, Bléry's project was similar to Aligny's study of an individual tree; each artist celebrated the beauty to be found in the unspectacular. FEW

1. Gutwirth 1977, 149, 151.

2. Quoted in Galassi 1991, 27.

3. Ibid., 28.

4. Huet 1911, 115; this author's translation from the French.

5. Béraldi 1885–92, 2:96–97.

6. Ibid., 94–96, no. 144.

7. *Explication des ouvrages* 1843.

8. Information on individual plants taken from Grieve 2001, June 18 (coltsfoot) and October 2 (burdock and thistles). Sue Welsh Reed suggested the source.

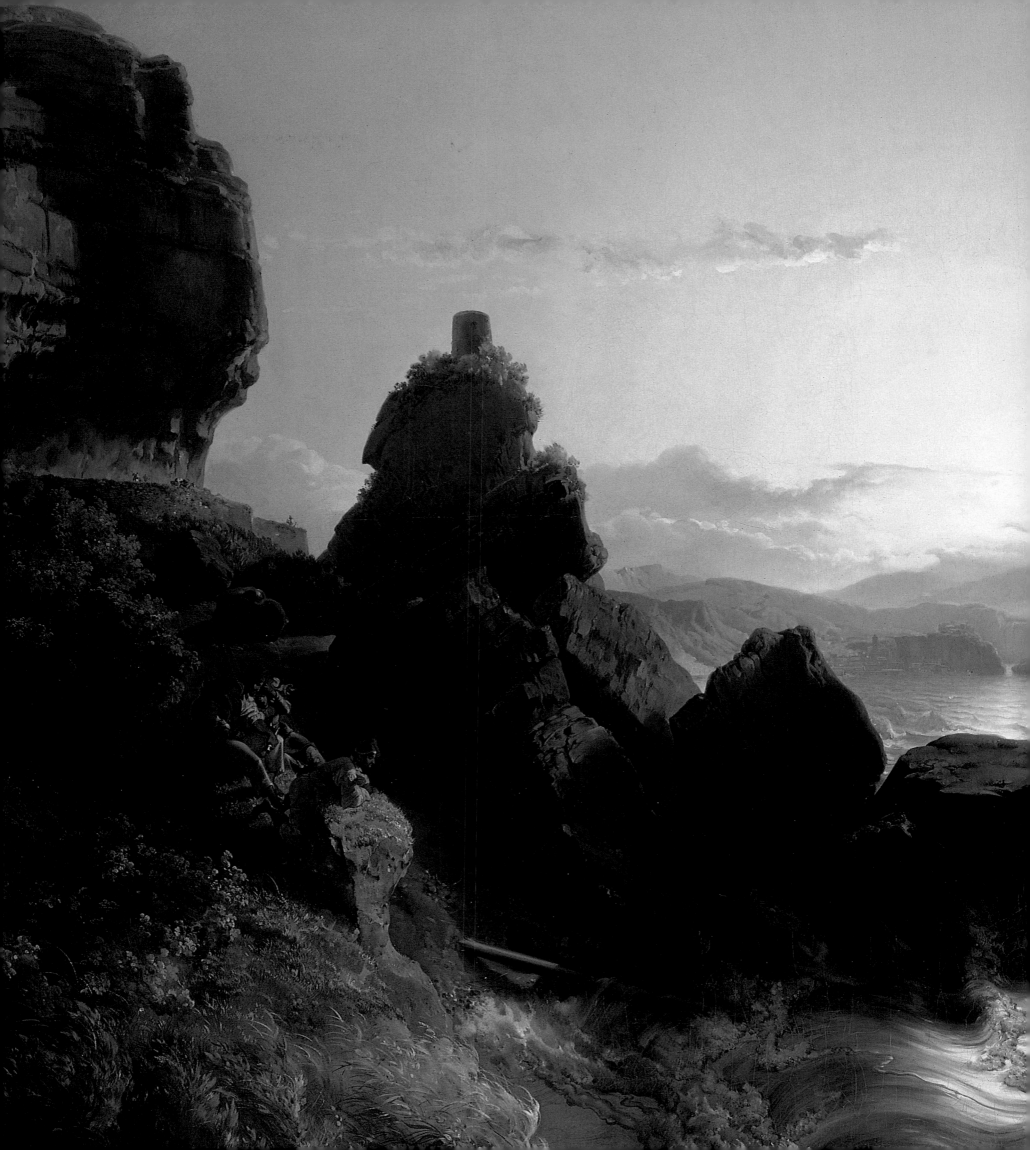

Lancelot-Théodore, comte du Turpin de Crissé
French, 1782–1859

Edouard Bertin
French, 1797–1871

8. Lancelot-Théodore, comte du Turpin
de Crissé
The Bay of Naples, 1840
Oil on canvas
97 x 146 cm (38 ⅛ x 57 ½ in.)
Charles H. Bayley Picture and Painting Fund
1980.3

9. Edouard Bertin
Landscape, Tivoli, mid-19th century
Black chalk heightened with white chalk on
blue wove paper
Sheet: 33.6 x 27.7 cm (13¼ x 10⅞ in.)
Lucy Dalbiac Luard Fund 1987.564

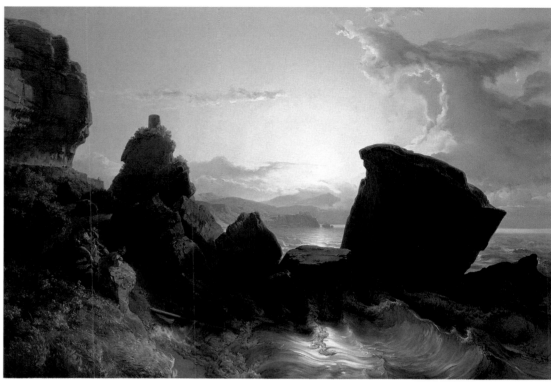

8

Lancelot-Théodore, comte du Turpin de Crissé, came from an old patrician family and grew up in Anjou. After his father fled the country in 1794, his mother supported the family by painting portrait miniatures. Turpin won a gold medal with his first submission to the Salon—a landscape—in 1806. After going to Italy in 1807–8, he became attached to the court of Josephine, serving as her chamberlain. The fall from power of Napoleon in 1814 allowed Turpin to paint full-time, but he resumed public service with the Bourbon government; its overthrow in 1830 ended Turpin's official career, and he left Paris for Angers. There he continued to paint and also to work on his collection of paintings, medals, Egyptian sculptures, Greek vases, and the like, which he had gathered on his travels to Italy and Switzerland (he visited Italy again in 1818, 1824, and 1830). He bequeathed his collection to the city of Angers.

Edouard Bertin first studied with the history painter Anne-Louis Girodet-Trioson but soon decided that pure history painting, which focused on narrative and the human figure, did not suit his temperament. Classes with the landscapists Bidauld and then Louis Etienne Watelet confirmed his choice of historical landscape painting. On returning from a five-year sojourn in Italy, he entered the studio of Jean-Victor Bertin (not a relation). There he met Corot and Aligny, and the three were in Rome at the same time in the mid-1820s, often painting together. When they exhibited paintings at the government-sponsored Salons in Paris in the early 1830s, the critics saw great similarities among their works. Bertin visited Italy many times, spending about ten cumulative years there and in other countries bordering the Mediterranean. Bertin, whose father founded the influential periodical *Journal des Débats,* enjoyed a success-

9

ful administrative and artistic career. After assuming leadership of his family's publication in 1854, he no longer exhibited at the Salon but continued to paint and draw. His best works are generally thought to be the large drawings he made in charcoal, often on gray or blue paper.[1]

In contrast to the views of Italy by Aligny and Bidauld, which were done as exercises to train the hand and eye in the transcription of nature, the works by Turpin de Crissé and Bertin offer a less direct notion of the trans-alpine country. Turpin's choice of Naples as the site of his painting announces his romanticized approach. Unlike Rome, famous for the remains of the fallen empire and the site of papal power, or Florence, with its concentration of Renaissance masterpieces, Naples was associated in the popular imagination with violence, both from the hand of man—brigands—and natural causes—Mount Vesuvius, the destroyer-preserver of Pompeii and Herculaneum. In the foreground of Turpin de Crissé's *Bay of Naples* (cat. no. 8), colorfully dressed figures gaze at the remains of a shipwreck in the waters crashing against rocks, a reminder of the overwhelming power of nature. Intent on their looking, the figures are unaware of (or perhaps immune to) the glorious sky, set off by the piled-up, eroded dark rocks. The center of the sky, bracketed by curving clouds on the right and a long-abandoned watchtower on the left, is the real subject of the painting. Luminous and pearlescent, the sunlight reaches across the flat-topped rock to illuminate the roiling water in the foreground and bathes the middle and backgrounds in a calming, unifying glow.

If Turpin de Crissé's figures are observing the sad result of nature's power, Bertin's monk is engrossed in his reading, seemingly oblivious of his surroundings (cat. no. 9). This large drawing, inscribed "Tivoli," is atypical of views of the site in that it depicts none of the identifying landmarks of Tivoli—the gardens belonging to the d'Este palace, for instance, or the high waterfalls. Unlike Turpin de Crissé's painting, Bertin's drawing was probably made on the spot. To emphasize the simplicity of the scene—rocky wall to the right, slender tree and vista to the left, path in the middle—Bertin closed the drawing at the top with an arch shape, the curve of which contributes a sense of expansiveness and calm. This arch, a recurring feature in both his paintings and drawings, imparts a decorative feel to the works, removing them from the immediacy of vision seen in the oil sketches by Bidauld or Aligny. This northerner's dream of Italy is achieved by subtle means. The relative lack of detail soothes the eye, as does the blue of the paper. By choosing blue paper and black and white chalks, Bertin could let his materials do much of his work for him. He needed only to establish outlines and highlights; the midtone of the paper largely did the rest.

Both of these works convey a sense that Italy is a land distant from France. The landforms are different, the light is different, the tenor of the countryside is different. They also share a sense of melancholy: in the case of the painting by Turpin de Crissé, it is a sadness arising from the humans' confrontation of the destructive power of nature; in the case of the drawing by Bertin, it is the awareness that the life of the monk, essentially elegiac, runs its course outside the parameters of the everyday, contemporary world. FEW

1. Conisbee et al. 1996, 210.

Narcisse-Virgile Diaz de la Peña
French, 1808–1876

10. NARCISSE-VIRGILE DIAZ DE LA PEÑA
Bohemians Going to a Fête, about 1844
Oil on canvas
101 x 81.3 cm (39 ¾ x 32 in.)
Bequest of Susan Cornelia Warren 03.600

Narcisse-Virgile Diaz de la Peña's career began with work in a porcelain factory, and he quickly became an independent painter. His orientalizing genre subjects were very popular, and he painted many works that he sold for a small amount each. The mid- to late 1830s were decisive years for him. He started painting in the Forest of Fontainebleau, where he met Rousseau, whose style influenced him greatly. Diaz combined his natural tendency toward genre figures such as gypsies, bathers, and mythological characters with a devotion to an honest depiction of landscape. His paintings were tremendously popular, he received medals and was elected to the Legion of Honor, and he was able to sell everything he painted. His success allowed him to help less fortunate colleagues, Millet, Rousseau, and Jongkind among them.

Diaz forms an important link in the history of French art. The subjects of his paintings look back to the eighteenth century and the *fête galante,* and the softened contours of his forms are evidence of his fondness for the work of Pierre-Paul Prud'hon (French, 1758–1823) and Correggio (Italian, about 1489?–1534). He brought scenes of the Forest of Fontainebleau to the Salon and made them available for popular consumption. And he met Monet, Renoir, Bazille, and Sisley near Barbizon in 1863. The younger artists understood the importance of Diaz's warm colors and individual brushstrokes. After years of living in Barbizon, he moved to Menton, on the Riviera, where he died.

10

Fig. 34. Théodore Rousseau, *Cattle Descending the Jura*, 1834–35, Musée de Picardie, Amiens.

This picture, with its strong emphasis on the landscape setting, demonstrates Diaz's indebtedness to Rousseau. More specifically, *Bohemians Going to a Fête* was painted in homage to Rousseau's 1834–35 *Cattle Descending the Jura* (fig. 34).[1] Unlike Rousseau's canvas, which was rejected from the Salon of 1836, Diaz's was accepted in 1844, displayed to great acclaim, and bought by the distinguished collector Paul Périer. Rousseau's painting may have been deemed too truthful, too real, too harsh. Diaz's, a happy blend of his earlier genre pictures and naturalistic landscapes, offers an escape into a fantasy view.

The forest canopy breaks just enough and in just the right place to allow a brilliant shaft of light to enter from the left. It picks out the trunks of twin birch trees at the left and a few of the colorfully dressed figures—particularly the young woman in the pink-red skirt and her attentive companion—and bursts with detail-obliterating force on the right-hand bank, a chiaroscuro effect that looks back to Rembrandt.

A critic who saw the painting in the Salon of 1844 was enthusiastic:

Here we have Diaz. This man does not fear the most brilliant light. His pictures are like a pile of precious stones. The reds, blues, greens, and yellows, all [are] pure tones and all combined in a thousand different ways, their brilliance gleaming from every point in his pictures; it is like a bed of poppies, tulips, bouquets scattered under the sun; it is like the fantastic palette of a great colorist. It is impossible to risk more and to succeed better.[2]

Forty years later, Diaz's work still found supporters:

In his sun-gilt landscapes Diaz put such figures as offered, by their costumes, a pretext for the wealth of his palette. The *Descent of the Bohemians* is the fullest expression of this style; here is all life and air; the band is coming down a steep path; through the foliage the sun rains down its beams and floods the whole picture with a transparent and luminous half-light; it is a perfect dazzle to the eye, like all the works of this great colorist.[3]

In their distance from the everyday world, with their mixture of northern and Italian peasant-style costumes, Diaz's bohemians nonetheless were grounded in reality for the artist and his viewers. For centuries in France the term *bohémien* meant "gypsy," because these wandering peoples were thought to have come from Bohemia. At the time Diaz painted this picture, the term had evolved to refer to creative figures—artists, writers, musicians—and people on the fringe of society, such as vagabonds.[4] These gypsies, funneling "out of the woods, a spatial device that perfectly suits their legendary oneness with nature,"[5] can be seen as a kind of self-portrait—the artist, outside society, in the forest, reveling in color and light. FEW

1. On Rousseau's painting, see Forges 1962, 85–90.

2. Thoré 1844, 398.

3. Wolff 1886, 47.

4. Brown 1978, 4.

5. Ibid., 287.

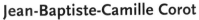

Jean-Baptiste-Camille Corot
French, 1796–1875

11. JEAN-BAPTISTE-CAMILLE COROT
Farm at Recouvrières, Nièvre, 1831
Oil on canvas
47.5 x 70.3 cm (18¾ x 27⅞ in.)
The Henry C. and Martha B. Angell Collection 19.82

12. JEAN-BAPTISTE-CAMILLE COROT
Forest of Fontainebleau, 1846
Oil on canvas
90.2 x 128.8 cm (35½ x 50¾ in.)
Gift of Mrs. Samuel Dennis Warren 90.199

After showing himself to be uninterested in business, Jean-Baptiste-Camille Corot was given money by his parents to devote himself to painting. He studied in the ateliers of Jean-Victor Bertin and Achille Michallon and then, from 1825 through 1828, visited Italy. There he painted small studies outdoors, something he had already been doing in France. He had a successful Salon career, showing in every exhibition from 1827 through the posthumous Salon of 1875. Up to about 1850 he often showed landscapes with subjects drawn from the Bible or classical mythology. After midcentury, however, he developed a softer style, with diaphanous foliage and indeterminate subject matter. This, often called his poetic or lyrical style, became extremely popular. He was an inveterate traveler, returning to Italy in 1834 and again in 1843, and visiting Switzerland, the Netherlands, and England. He stayed in Paris during the winters, working in his studio, but during the summer months he crisscrossed northern France, staying with his many friends and painting outdoors. He was a close friend of Daubigny and Millet; Chintreuil and Français considered themselves his pupils; and he gave advice to Berthe Morisot and Pissarro. Of an older generation and a classical bent, he never understood the painterly means of the Impressionists, although his insistence on transferring to canvas his impressions of nature connected him to the younger painters.

Like Valenciennes, Bidauld, Aligny, and Bertin, Corot traveled to Italy, hoping to ally himself with the great tradition of landscape painting that had developed there in the seventeenth century. Unlike them, however, Corot looked to other traditions as well in his search for appropriate models on which to base his art. One of these was seventeenth-century Dutch painting.

Nineteenth-century French commentators on art described the paintings made by the Dutch two centuries earlier as straightforward, naïve, and realistic.[1] Corot's *Farm at Recouvrières, Nièvre* (cat. no. 11) and *Forest of Fontainebleau* (cat. no. 12) are also aptly characterized with these words. Painted fifteen years apart, Corot's two paintings nonetheless have much in common. They are organized as a succession of horizontals marking recession into space, with a view into the distance, and their subjects are taken from everyday rural life: in one, clothes washing, child tending, firewood carrying; in the other, bringing cows to drink at a forest pool. In each case fairly close prototypes can be found in the earlier Dutch tradition: compare *Farm at Recouvrières* with a plate from the Small Landscapes series issued by Hieronymus Cock in 1561 (fig. 35). The print, one of a series celebrating the points of interest and humble beauties in the vicinity of Antwerp,[2] presages the painting's compositional structure of strips of land and water, a view into the distance to the left, and simple buildings nestled among trees.

Corot's view, though more animated and modulated with details of foliage, fallen tree limbs, and figures—not to mention color—is somehow starker. The tree trunk and broken latticework in the foreground are lined up with the picture plane; the farther bank of the stream traces an almost straight line across the picture; the corners of the buildings seem squarer, more true; even the limbs and foliage of the trees are tidier, less whimsical than in the print. Corot's

11

12

painting has regularized and clarified the earlier scene, imposing a measure of rationality. This approach results in a feeling of immediacy akin to the plein-air sketches he and his compatriots did, especially in Italy but also in France. That *Farm at Recouvrières* conveys an impression of freshness is particularly noteworthy because it was painted entirely in the studio, a practice that allowed for the seamless integration of the figures with the landscape surrounding them.[3]

Similarly close to an earlier precedent is Corot's *Forest of Fontainebleau*. Representative of the many forest scenes that could have served Corot as a model is Meindert Hobbema's *Farmland with a Pond and Trees* (fig. 36). Although Corot could not have known this image directly, it is an exemplary picture of its kind.[4] The focus in Corot's picture on the foreground pool, foliage, and cow to the left is balanced by the deep recession into space on the right, an arrangement found in reverse in his 1831 farm scene. The subject of *Forest of Fontainebleau*—cows being brought to a pool in the forest to drink—is hardly a subject at all; its quotidian nature borrows directly from the Dutch prototype. As with the comparison of Corot's farm scene with the earlier Dutch print, *Forest of Fontainebleau* rings changes on the scheme of Hobbema's painting. Where the Dutch painting delights in the contrast of dark, semihidden pockets of space and dazzling sunlight beyond, Corot's scene is illuminated more evenly. Where the Dutch trees on the left lean toward each other, as if consciously creating the shade for the cattle, Corot's trees stand straight, their limbs spread so that the foliage forms a screen across the middle ground, forcing attention to the foreground (again, a device used in the earlier farm scene, there with the buildings).

Forest of Fontainebleau was an important picture for Corot. It was the only one of the four canvases he submitted to the jury for the Salon of 1846 to be accepted (the others were views of

Fig. 35. Johannes van Doetechum, the Elder, Dutch, died 1605, and Lucas van Doetechum, Dutch, died after 1589, *Village with Pond and Church Tower*, 1561, etching, National Gallery of Art, Washington, D.C.

Fig. 36. Meindert Hobbema, Dutch, 1638–1709, *Farmland with a Pond and Trees,* about 1663–64, Taft Museum of Art, Cincinnati.

Italy), and for it he was made a knight in the Legion of Honor. Charles Baudelaire, the influential poet and critic, praised Corot's Salon work, comparing it with Aligny's paintings:

> But what, with M. Aligny, is a violent and philosophic dogma, is an instinctive habit and a natural turn of mind with M. Corot. . . . M. Corot is a harmonist rather than a colourist; and it is their very simplicity of colour, combined with their complete lack of pedantry, that gives such enchantment to his compositions. Almost all his works have the particular gift of unity, which is one of the requirements of memory.[5]

Corot's vision of this rock-edged pool in the Forest of Fontainebleau appeared to Baudelaire to be natural, straightforward, and direct, and so it is. The wonder of Corot's art is that it looks, to use Baudelaire's words, "instinctive" and "lack[ing] in pedantry" while drawing on and transforming a venerable, earlier tradition of landscape painting.[6] FEW

1. Chu 1974 remains the most thorough study of the subject, covering all genres. Herbert 1962 focuses on landscape.

2. Gibson 2000, 1–2, 39.

3. Tinterow, Pantazzi, and Pomarède 1996, 99.

4. For its provenance and an entry on it by Walter A. Liedtke, see Taft Museum 1995, 1:165–67.

5. Baudelaire 1965, 106.

6. Tinterow, Pantazzi, and Pomarède 1996, 211–12, no. 91, propose that *Forest of Fontainebleau* is a composite of oil sketches Corot had done some years before. So far as the truth of the genesis of a work of art can be known, it most likely lies in a combination of the analysis given here and that put forth in Tinterow, Pantazzi, and Pomarède 1996.

Jean-Baptiste-Camille Corot
French, 1796–1875

13. JEAN-BAPTISTE-CAMILLE COROT
Twilight, 1855–60
Oil on canvas
50.3 x 37 cm (19¾ x 14⅝ in.)
Bequest of Mrs. Henry Lee Higginson, Sr.,
in memory of her husband 35.1163

14. JEAN-BAPTISTE-CAMILLE COROT
Morning near Beauvais, about 1855–65
Oil on canvas
36 x 41.5 cm (14⅛ x 16⅜ in.)
Juliana Cheney Edwards Collection 39.668

15. JEAN-BAPTISTE-CAMILLE COROT
Souvenir of a Meadow at Brunoy, about 1855–65
Oil on canvas
90.6 x 115.9 cm (35⅝ x 45⅝ in.)
Gift of Augustus Hemenway in memory of
Louis and Amy Hemenway Cabot 16.1

16. JEAN-BAPTISTE-CAMILLE COROT
Young Woman and Death, 1854
Cliché-verre, salt print
Sheet: 18.3 x 13.3 cm (7³⁄₁₆ x 5¼ in.)
Gift of Mr. and Mrs. Peter A. Wick 63.2742

17. JEAN-BAPTISTE-CAMILLE COROT
Mother and Child in a Wooded Landscape, 1856
Cliché-verre, salt print
Sheet: 32.6 x 24.8 cm (12¹³⁄₁₆ x 9¾ in.)
Bequest of William P. Babcock, 1900 B1052.2/1

18. JEAN-BAPTISTE-CAMILLE COROT
The Gardens of Horace, 1855
Cliché-verre, salt print
Sheet: 34.8 x 27.1 cm (13¹¹⁄₁₆ x 10¹¹⁄₁₆ in.)
Bequest of William P. Babcock, 1900 B1052.2/2

Shortly after Corot painted *Forest of Fontainebleau,* his style became softer and monochromatic, a manner that is often labeled lyrical. The sturdy, purposeful peasants discharging their daily tasks in Corot's *Farm at Recouvrières, Nièvre* and *Forest of Fontainebleau* (cat. nos. 11–12) are replaced by figures, almost always women, doing nothing more strenuous than picking flowers or fruit. Generated as much by emotion as by observation, Corot's works, starting about 1848, explored mood; the transcription of actual locales correspondingly decreased in importance.

Twilight (cat. no. 13) shows two women gathering a round fruit from trees bordering a lake. The end of the day, when any wind has died down, is depicted by means of a darkening sky and the glass-smooth surface of the water. Ruddy tones associated with sunset appear, not in the sky, but in the surrounding foliage and in the clothing of the women.

Twilight is an evocative time of day, often marked by regret and nostalgia. Lines from the writings of such French Romantic poets as Alphonse de Lamartine and Alfred de Musset were often quoted in Salon reviews of Corot's paintings to convey the emotions evoked that were not possible to express in everyday prose. Lamartine's poetry in particular is suffused with a reverence for nature, as both a divine creation and a refuge for the troubled human spirit. Although no direct connection between Lamartine and Corot can be documented, none is needed: critics recognized that poetry and painting were each informed by an acknowledgment of nature's restorative power.

The affective power of a painting like *Twilight* derives from its successful embodiment of one of Corot's central maxims: "The first two things to study are the form, then the values."[1] *Twilight* carefully juxtaposes the masses (form) of the trees against the void of the lake and sky and then modulates the large forms

with a restricted palette of earth tones (values) relieved by the luminous sky.

Even though *Morning near Beauvais* (cat. no. 14) and *Souvenir of a Meadow at Brunoy* (cat. no. 15) are daytime pictures, they, too, emit an air of wistfulness. The titles of the paintings may localize the scenes, and the initial inspiration for them most likely arose from visits to the respective towns, yet Corot's vision of them is filtered through an idealizing, aestheticizing sensibility.

Looking at *Morning near Beauvais,* a picture of serene calm, one can easily understand why such fresh, evocative works were in enormous demand toward the end of Corot's life. A simple scene—on the right a stream with a red-roofed house on the far bank, an open meadow with scattered trees closed off in the middle distance by a screen of trees growing more thickly—is painted in the palette typical of the artist's late career. The overall silvery gray tonality is made up of a range of soft greens for the foliage and light browns and grays for trunks and branches. The whole is unified by the white sky and the discrete flecks of white throughout. One senses the freshness of early morning, the promise of a new day symbolized by the bare trees of spring.

After 1857 Corot frequently visited the city of Beauvais, about sixty-five kilometers (forty miles) northwest of central Paris. He had several friends there, among them Pierre-Adolphe Badin, a painter whom he had met in Italy and who was by then the director of the State Tapestry Manufactory in the city. In the early 1860s Corot stayed with Badin and, beginning in 1866, with a collector named Wallet.[2] Whereas a modern visitor might go to Beauvais to see what remains of the cathedral (an overambitious building plan resulted in the collapse of a large part of the superstructure in 1284 and the lantern tower in 1573), Corot was attracted to outlying areas of woods and streams.[3] The

13

house to the right and the fence at the base of the tree to the left proclaim the area to be domesticated, put to human use, although Corot was not concerned with exactly what that use was. A woman and a small child sit on the grass, protected and safe. *Morning near Beauvais* investigates the subtle interplay of shallow spaces divided laterally. Our attention is directed entirely to the foreground and middle ground, where a sense of intimacy, security, and well-being is created.

Although one can accept the bare trees at the right as being species that come into leaf later than the trees on the left, they are perhaps better understood as a pictorial device by which Corot was contrasting linearity with mass, spareness with fullness. Such explorations of difference are in keeping with the juxtaposition of near and far. In this way, the painting functions as both evocation and artifice.

Souvenir of a Meadow at Brunoy shares with *Morning near Beauvais* a similar screen of trees. Through it, a denser forest is visible, beyond which rises a hill capped by the buildings of a town. Figures are scattered across the fore- and middle ground: in the foreground at the left, a woman kneels, perhaps picking flowers; just above and to her right, a man walks deeper into the forest; two women, one holding the hand of a child, stop on a path to converse. A cow, at the right, looks out of the painting.

Corot produced many paintings similar to this one. They were popular in his day more for their evocation of mood than of place. The soft colors, green tending toward gray-brown, enlivened by spots of local color in the clothes the people wear and the pink-red flecks that sit on the surface, depict a scene that, despite its convincing sense of space and light, exists only in the imagination. The word *souvenir* in the title hints at the real subject of the picture: a recollection or remembrance of a meadow, not the meadow itself. Corot explained:

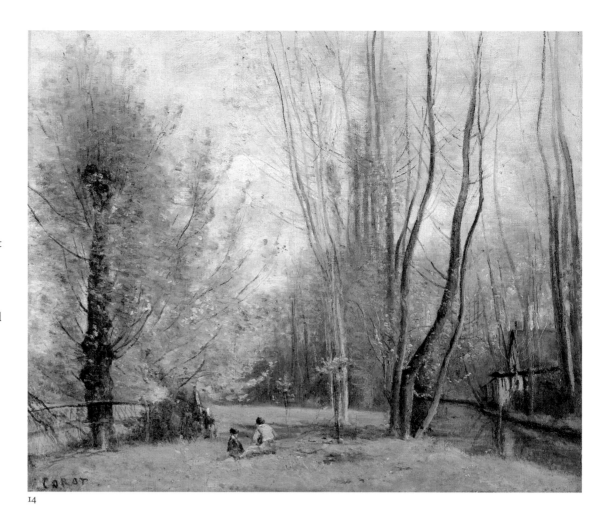

14

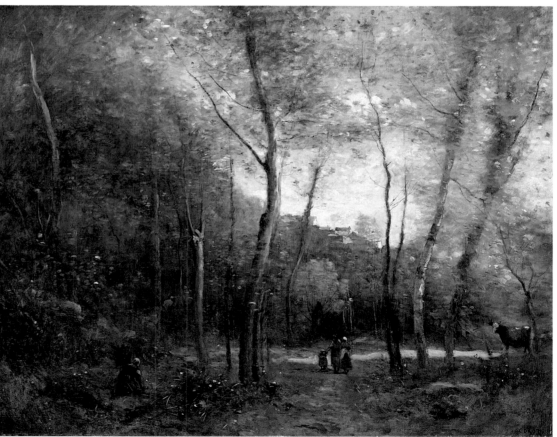

15

16

Beauty in art consists of truth, imbued with the impression we received from the contemplation of nature. . . . We must never forget to envelop reality in the atmosphere it first had when it burst upon our view. Whatever the site, whatever the object, the artist must submit to his first impression.[4]

The unpretentiousness and even insignificance of the scene—the people are not engaged in any specific activity—are belied by the painting's careful composition. Typical of Corot's later works is the shallow foreground. The light color of the meadow draws the eye into the painting, yet access to the meadow is mediated by the alternating forms of human figures, trees, and cow. Further recession into depth is denied by the edge of the woods beyond the meadow, and there is no visible way to get to the town on the hill, the bright facets of its masonry the ultimate goal of the viewer's eye. The surface of the picture is covered by large, slightly textured shapes: the receding foreground, the diagonal wedge of woods, the lighter sky. Corot set up a

sophisticated play of contrasts—surface versus depth, light versus dark, line (the tree trunks) versus pattern (the foliage). In this configuration the figures are place markers, much as they are in many seventeenth-century landscapes, meant to guide the eye through the scene.

In his sixth decade, Corot found a new vehicle through which to express his lyricism, a photography-based printmaking process called cliché-verre.[5] Cliché-verre is a perfect technique for an artist such as Corot, who was not interested in the chemistry or mechanics of traditional printmaking. In cliché-verre, a glass plate is prepared with a ground, either printer's ink or fogged collodion. Marks are made by scratching with a sharp instrument through the ground, which is often dusted with a white powder so the marks can be seen. The glass plate is placed on light-sensitive paper. When the plate is exposed to sunlight, the design prints on the paper.

Beginning in 1853, Corot became closely associated with a group of artists in Arras, northeast of Paris, who among them practiced lithography, drawing, photography, and painting. Under their influence he made his first cliché-verre in 1853, and by 1874 he had made a total of sixty-six, more than any other nineteenth-century artist. Evidently the freedom of the process appealed to him, and he used it both to reprise subjects he had treated before—in some instances replicating painted compositions (such as *The Little Shepherd,* a Salon painting from 1840 that was purchased by the state for the museum in Metz)—and to explore themes that did not appear in paint (such as *Young Woman and Death,* cat. no. 16). The cliché-verre technique offered Corot a printmaking process that corresponded to his experiments in paint to find means to express a quiet sense of spiritual tranquillity centered on nature.

These three clichés-verre, all printed in a rich golden brown and executed in the first few

years of Corot's acquaintance with the process, show a remarkable range of effects. *Young Woman and Death* is distinguished from *Mother and Child in a Wooded Landscape* (cat. no. 17) and *The Gardens of Horace* (cat. no. 18) by its thick, loopy lines, made by scratching through the ground with a blunt tip, such as the butt end of a paintbrush or a stick.[6] The density of the thick lines is relieved somewhat by the modulated passages created by smudges (fingerprints?) and a tonal haze caused by the varying thickness of the emulsion on the glass plate. The subject matter of *Young Woman and Death* also distinguishes it. While nostalgia, reverie, or an unspecified feeling of regret are often perceivable in Corot's art, such outright moralizing as is seen in this cliché-verre is unprecedented.[7]

More typical of Corot's work in both paint and prints in terms of subject matter are the large *Mother and Child in a Wooded Landscape* and *The Gardens of Horace.* Made with the pointed tool more commonly used to make clichés-verre, they show the artist's delight in creating texture. The evocative hazy quality in *Mother and Child in a Wooded Landscape* was made by the method known as *tamponnage,* a pricking of the emulsion with the stiff bristles of a brush to create a myriad of tiny holes. This technique achieves in the print the equivalent of Corot's famed soft-focus trees, such as those seen in *Souvenir of a Meadow at Brunoy.*

The nurturing aspect of nature, embodied in the mother's embrace of her child, is cast into an intellectual mode in *The Gardens of Horace.* In it, the Roman poet (65–68 B.C.) is all but subsumed by the intricate web of lines that describe the towering trees and enclosing landforms. As Corot enjoyed his visits to Arras, so Horace liked spending time at his country retreat in the Sabine Hills, northeast of Rome. There he could think, write, and read, as here, undisturbed.[8] FEW

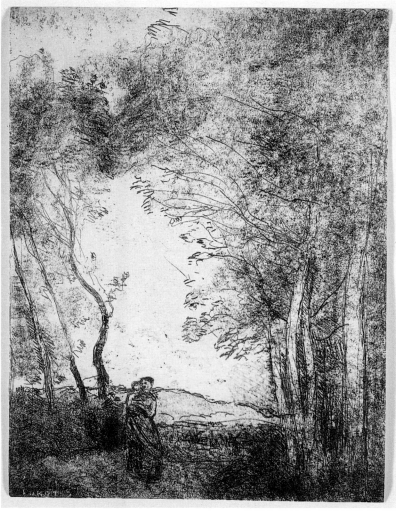

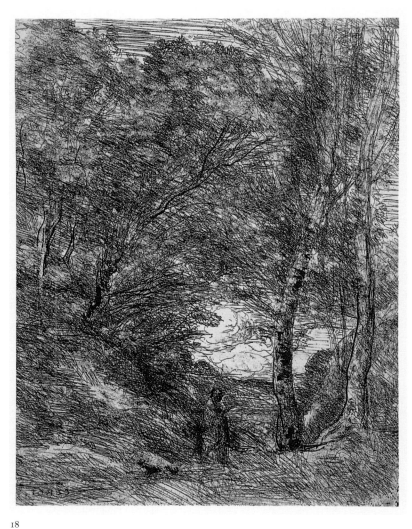

17 18

1. Cailler 1946, 1:82; this author's translation from the French.

2. Tinterow, Pantazzi, and Pomarède 1996, 222, 295–96.

3. Ibid., 296.

4. Quoted in Cailler 1946, 1:89, translated in Clarke 1991a, 109.

5. See Glassman and Symmes 1980 for the best overview of the process. The technical and historical information provided here was taken from this source, 29, 36–39. See Mason et al. 1982 for a concentrated look at nineteenth-century French clichés-verre.

6. Glassman and Symmes 1980, 56–57, cat. no. 14.

7. H. Diane Russell suggested, in conversation in 1986, that the Death figure is related to the seated Death in Giovanni Battista Tiepolo's (1696–1770) capriccio *Death Giving Audience*. See Russell 1972, cat. no. 8. It is not known whether the title is Corot's, but the titles of the clichés-verre are contemporary with their making. They come from Alfred Robaut, Corot's future biographer, who was one of the artists in Arras and thus close to Corot when he made the prints. Thus it is likely that Corot did not object to the title of this or any other print, and may well have suggested it himself.

8. Glassman and Symmes 1980, 61, cat. no. 22.

19

Théodore Rousseau

French, 1812–1867

19. THÉODORE ROUSSEAU
Pool in the Forest, early 1850s
Oil on canvas
39.5 x 57.4 cm (15½ x 22⅝ in.)
Robert Dawson Evans Collection 17.3241

20. THÉODORE ROUSSEAU
Gathering Wood in the Forest of Fontainebleau,
about 1850–60
Oil on canvas
54.7 x 65.3 cm (21½ x 25¾ in.)
Bequest of Mrs. David P. Kimball 23.399

21. THÉODORE ROUSSEAU
Wooded Stream, 1859
Oil on panel
53.2 x 74.5 cm (21 x 29⅜ in.)
Gift of Mrs. Henry S. Grew 17.1461

22. THÉODORE ROUSSEAU
The Oak Tree of the Rock, Forest of Fontainebleau,
1861
Etching in brown ink on cream laid paper
Image: 12.3 x 16.9 cm (4¹³⁄₁₆ x 6⅝ in.)
Bequest of William P. Babcock, 1900 B3950

23. THÉODORE ROUSSEAU
Cherry Tree at La Plante-à-Biau, 1862
Cliché-verre, salt print
Borderline: 21.7 x 27.6 cm (8⁹⁄₁₆ x 10⅞ in.)
Bequest of William P. Babcock, 1900 B3956.5/7

Fig. 37. Meindert Hobbema, Dutch, 1638–1709, *A Pond in a Forest,* 1668, Allen Memorial Art Museum, Oberlin College, Ohio.

Théodore Rousseau received traditional training first from a cousin and then from the landscapists Jean-Charles-Joseph Rémond and Guillaume-Lethière. He was already painting in the Forest of Fontainebleau in the late 1820s and traveled to the Auvergne, Normandy, Switzerland, and the Jura. His work was first accepted at the Salon in 1831. Rousseau visited Barbizon in 1836, which was also the year that the Salon jury first rejected his submissions, as it did in 1838, 1839, and 1840. Rousseau chose not to submit to the jury again for several years, showing the next time only in the unjuried Salon of 1849, when he won a first-class medal. By then his work had attracted the attention of the writers Charles Baudelaire and George Sand and, importantly, the critic Théophile Thoré. Rousseau divided his time between Barbizon, where Millet was his closest friend, and Paris, where he kept a studio and where he could stay involved in the art world. Barbizon and its environs became his chief subject matter, and his compositions show the influences of both seventeenth-century Dutch landscapes and Japanese prints. In 1866 the dealers Durand-Ruel and Brame bought his early sketches, which gave him sufficient money on which to live, and he was elected president of the jury for the Exposition Universelle of 1867.

Rousseau may have known the Forest of Fontainebleau better than any other painter. He painted all aspects of the forest: the edge where it meets the surrounding plain, as in *Gathering Wood in the Forest of Fontainebleau* (cat. no. 20), trees isolated on the plain (*Group of Oaks, Apremont, Forest of Fontainebleau,* Musée du Louvre, Paris), and the forest interior, as in *Pool in the Forest* (cat. no. 19).

In the serene *Pool in the Forest,* one looks beyond a dark foreground and past a screen of trees to a group of five cows and their herder enjoying the sun. A palette of earth tones—especially the ochers and oranges—contributes to the feeling of warmth; this is perhaps one of the last days of summer. Despite the immediate attraction of the sunlit glade and the dark, insistent verticals of the tree trunks, the eye is led gradually through the composition, slowed by a series of gentle curves. The lower edge of the pool is defined by rocks whose curve echoes that of the water's far edge. The leaning ocher-colored tree at the left points the way for the branches that join in an arch at the center. The very shapes of the trees, full and rounded, are another voice in the symphony of curves.

Steven Adams, in his book *The Barbizon School and the Origins of Impressionism,* relates the device of a framed view (here, the glade seen through the screen of trees) to contemporaneous book illustration, "in which bright, centrally placed motifs gradually bleed off into dark, surrounding frames. . . . It marks a clear interface between print-making, popular imagery and landscape paintings."[1] As Adams notes, Rousseau was not alone in using this compositional device (see, for example, Diaz's *Bohemians Going to a Fête,* cat. no. 10), and the increasing popularity of landscape paintings may be linked to the vogue for similarly composed, and more widely available, landscape views in prints.

Another source for the framed view was seventeenth-century Dutch landscape paintings,

20

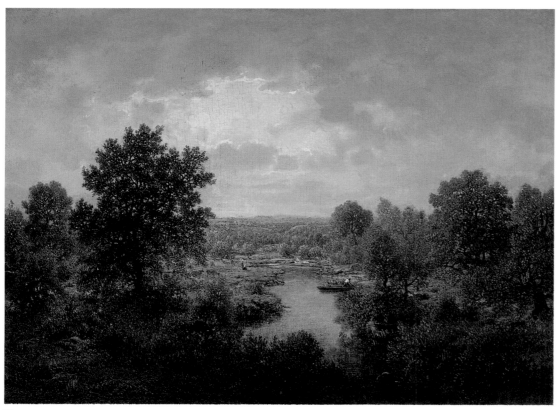

21

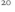

Fig. 38. Simon de Vlieger, Dutch, 1600–1653, *Sleeping Peasants near Fields (Parables of the Weeds)*, 1650–53, The Cleveland Museum of Art.

which were at the time also widely known and valued for their perceived verisimilitude. To nineteenth-century French eyes, Dutch landscapes such as Meindert Hobbema's *Pond in a Forest* (fig. 37) seemed almost haphazard; the artists, it was said, painted without selection or adjustment of what was in front of them. A picture like Rousseau's looked similarly casual to its audience, a glimpse of an otherwise overlooked corner of nature.

Despite immediate perceptions, Rousseau's *Pool in the Forest* is carefully composed and equally carefully painted, just as its Dutch prototypes were. The curves distributed throughout establish a slow, easy rhythm, allowing the viewer to discover, bit by bit, nature's beauties. This discovery is a hard-won prize, and the artist makes the process visible in his patient brushwork. Rousseau's fastidious paint handling makes one feel his concentration on, his dedication to, and his love for the view he paints.

Artists like Rousseau who went to the Forest of Fontainebleau to find subjects to paint were attracted to it for several reasons. Sixty-four kilometers (forty miles) to the southeast of Paris, it offered startlingly varied topography, from rocky gorges to open plains, from thick forests to paths and roadways. In addition, the forest was lived in and used by hard-working peasants, who for the painter animated and

humanized the land. Rousseau and his colleagues tried to paint what they saw in the forest, not idealizing but presenting the natural facts with a humble honesty. This humility allied them, again, with seventeenth-century Dutch landscapists, whose paintings were seen in the nineteenth century to embody naturalism and truth.

In *Gathering Wood in the Forest of Fontainebleau* (cat. no. 20), Rousseau shows a typical activity in the forest. The location is most likely the Plain of Chailly, at the northwestern edge of the forest. Women—destitute members of the community or wives of landless woodcutters—combed the forest for fallen branches that they would sell for a meager profit.[2] Rousseau's luminous painting shows faggot gathering as a group activity. A cart and horse in the middle ground seem to have some relation to the two women moving down the rain-soaked path toward the foreground. The foremost one rides a laden donkey, and the second woman carries on her back a huge bundle of sticks, called a faggot, as big as she is.

But the depiction of laboring peasants is not what really interested Rousseau. The human figures are incidental to the delineation of the physiognomy of the forest, especially the point at which the forest meets the plain. Taking his cue, as Corot did, from any number of seventeenth-century Dutch forest scenes, in which a concentration on elements in the foreground on one side of the painting is relieved by a view into the distance on the other side (fig. 38), Rousseau contrasts the dense, intricate foliage on the right with the expanse of plain crowned by an overarching sky. The central towering tree blocks the sun, with the result that the tree is silhouetted against the light. Its dark branches seem both to be given form by the light and to do battle with it. Rousseau here subsumes the figures into a radiant vision of nature's strength, variety, and vitality. His brush weaves a light-toned tapestry of color and texture, made visible by the light that shows at once the detail of the foreground and the seemingly endless plain stretching into the distance.

As indebted to seventeenth-century prototypes as Rousseau's paintings are, they are nonetheless unmistakably creations of the nineteenth century. Greg M. Thomas has proposed that Rousseau's paintings are ecological. These works, Thomas asserts, offer "a distinct new visual model in which people appear to be peripheral participants in an ideal, self-ordering, organic network of interdependent natural processes."[3] In *Wooded Stream* (cat. no. 21), an elevated viewpoint, a common device in Rousseau's landscapes, affords a wide view encompassing trees to either side of a meandering stream, distant hills, and an overarching sky, which covers more than half of the picture's surface. The sky in this painting is particularly glorious: gray clouds are pierced by a light-rimmed blue opening, the luminous effect of which is answered in the water. This light forms a core around which the other elements of the painting pivot. So focused is this light that the trees in the foreground are effectively—and illogically—cast into shadow. Tiny figures of people and cattle are scattered across the middle ground, those on the left small enough to be overlooked.

The smallness of the figures is significant. As in *Pool in the Forest*, the activities of man and woman in this depicted world are shown to be no more—and perhaps less—important than the flowing of the stream, the growing of the trees and scrub, and the beaming down of the sun's rays. All are interconnected parts of a larger system. In Rousseau's words, "For God and in return for the life he has given us, let us act such that in our works the manifestation of life is our first thought; let us make a man breathe, and a tree able actually to vegetate."[4] Each aspect of the natural world—and humankind is but one aspect—is worthy of regard, worthy of careful depiction. Some contemporary critics understood what Rousseau was trying to achieve:

What he wants to catch is the organic life of nature acting secretly everywhere . . . the impression he seeks to produce is that which one experiences when, transported to rustic seclusion, beyond the sight and affairs of people, one feels oneself so to speak living on the general life of nature that rustles in the air, flows from the heart of the earth, and vibrates in the smallest blade of grass as in the shifting crowns of grand forests.[5]

Rousseau submitted only one painting to the Salon of 1861, *The Oak Tree of the Rock, Forest of Fontainebleau*.[6] He was so proud of this painting that he made an etching after it, in reverse (cat. no. 22). It was published in the *Gazette des Beaux-Arts* as an unnumbered page facing the discussion of the Salon painting.[7] Dated May 1861, the etching distills the essence of the painting. The nervous but controlled lines of the print—some parallel, others densely hatched—effectively convey the welter of textures, and the blank paper denoting the sky stands in startling contrast to the silhouetted black tree trunks. The critic for the *Gazette des Beaux-Arts* complained that the painting had several faults: the sky was out of balance with the rest of the painting and thrust itself forward where it did not belong; the leaves of the mighty oak stretched like a uniform green fringe across the top of the painting; and, when seen up close, the brushwork dissolved into jumbled tones. No such accusations can be levied against the etching. Its smaller scale and reduced means result in an image of astonishing power.

That Rousseau made an etching after one of his paintings was highly unusual; he is known to have made only six prints. Two of them were clichés-verre, both done in 1862, probably at the urging of Eugène Cuvelier, one of the artists Corot associated with in Arras (see cat. nos. 24–26).[8] *Cherry Tree at La Plante-à-Biau* (cat. no. 23) is one of those clichés-verre. Rousseau approached the glass plate with the same kind of nervous energy as he did the cop-

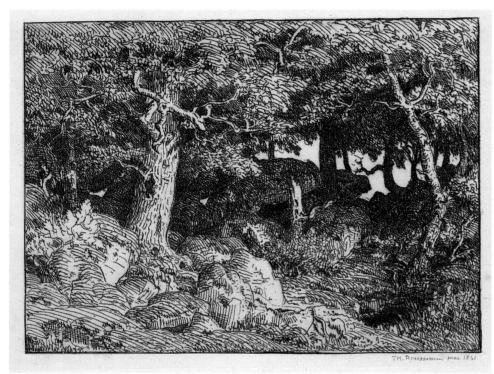

22

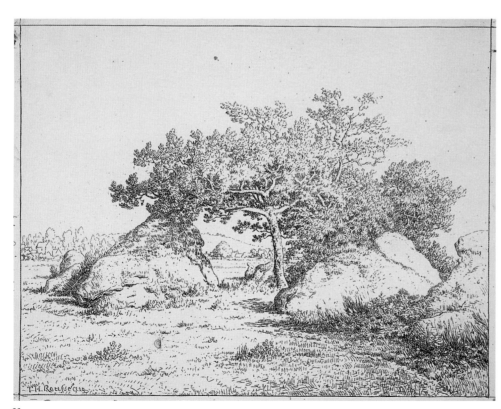

23

perplate. Probably with an etching needle, he made a myriad of jabs through the coating, leaving a field of marks resembling iron filings coerced into shapes by a magnet. Three huge rocks erupt from a flat plain that is bordered by a straggle of houses among trees. Not only has a cherry tree taken root among the boulders, it appears to have flourished. As in *The Oak Tree of the Rock,* Rousseau's concentration on a single tree heroizes it.

Trees formed one of the cornerstones of Rousseau's thinking. He explained his feelings about them in a letter of about 1863 to Alfred Sensier, his future biographer:

> If one can deny that they [trees] think, certainly they make us think, and in return for all the modesty that they make use of to elevate our thoughts, we owe them, as the price of their spectacle, not arrogant mastery, or pedantic and classical style, but all the sincerity of grateful care in the reproduction of their beings, for the powerful action they arouse in us. They only ask us, for all they give us to think about, not to disfigure them, not to deprive them of this air that they so need.[9]

Rousseau's prints and paintings embody his humility before these creatures. His art is an homage to the vast natural world in which he, as a human being, is but a tiny part. FEW

1. Adams 1994, 83.

2. For a fuller discussion of faggot gatherers, see Murphy 1984, 26–27, cat. no. 16, and 88–89, cat. no. 57.

3. Thomas 2000, 2.

4. Rousseau, as translated in Thomas 1999, 145.

5. Jean-Louis-Hippolyte Peisse, in *Le Constitutionnel,* July 31, 1849, quoted in Prospec Dorbec, "L'oeuvre de Théodore Rousseau aux Salons, de 1849 à 1867," *Gazette des Beaux-Arts,* 4th ser., 9 (1913): 108, translated in Thomas 2000, 89.

6. For a color reproduction, see Christie's, New York, November 19, 1998, lot 122.

7. Lagrange 1861, 136 and facing 136.

8. Melot 1980, 294.

9. Rousseau, as translated in Thomas 2000, App. B, 210.

Eugène Cuvelier
French, 1837–1900

Alphonse Jeanrenaud
French, before 1835–1895

24. Eugène Cuvelier
Lane in Fog, Arras, early 1860s
Photograph, salt print from paper negative, mounted
Sheet: 25.7 x 19.8 cm (10 ⅛ x 7 ¹³⁄₁₆ in.)
Lucy Dalbiac Luard Fund 1989.21

25. Eugène Cuvelier
At "La Reine Blanche," Forest of Fontainebleau, 1860s
Photograph, albumen print from paper negative, mounted
Sheet: 25.3 x 34.3 cm (9 ¹⁵⁄₁₆ x 13 ½ in.)
Sophie M. Friedman Fund and Gift of Mack and Paula Lee and William and Drew Schaeffer
1990.175

26. Eugène Cuvelier
Boundary of Barbizon, 1860s
Photograph, albumen print from paper negative, mounted
Sheet: 27.3 x 34 cm (9 ¹⁵⁄₁₆ x 13 ⅜ in.)
Frederick Brown Fund 1996.38

27. Alphonse Jeanrenaud
Cart in Forest Path, probably early 1860s
Photograph, albumen print from glass-plate negative, top corners rounded, unmounted
Sheet: 23 x 28 cm (9 ¹⁄₁₆ x 11 in.)
Prints, Drawings, and Photographs Curator's Discretionary Fund 2001.274

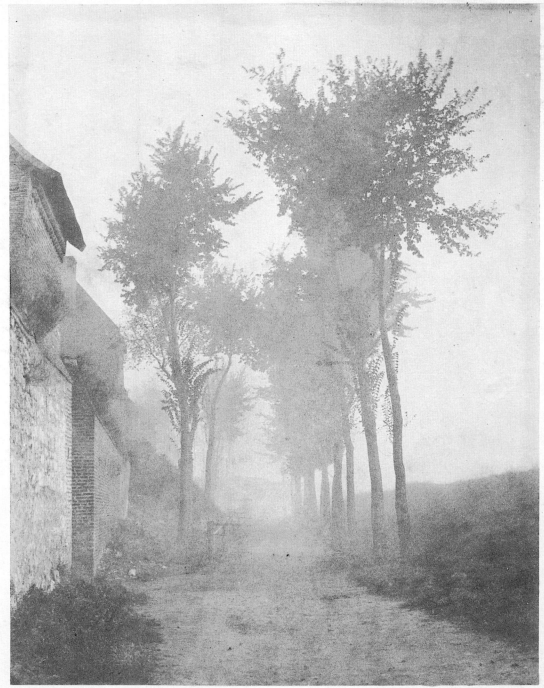

24

Like the painters, the photographers attracted to Barbizon and the some forty thousand acres of the Forest of Fontainebleau saw the area as an idyllic refuge, far away from the hardships of city life. With the new railroad in place by 1849, many came to walk the forest's paths, admire its great oaks, and pause in the sunlit openings between its trees. A number of photographers established personal friendships with the painters and worked side by side in the forest. The dialogue among their media is rich and thought-provoking.

Although Gustave Le Gray made a memorable group of photographs in Fontainebleau about 1850, it is Eugène Cuvelier who with his expressive views of the region, made in the next decade, became the photographer most closely identified with the area. Cuvelier was trained as a painter and introduced to photography by his father, Adalbert Cuvelier, the Arras vegetable oil and sugar refiner whose passion for art and photography led him to help reintroduce the cliché-verre and, through his friend Corot, inspire a fashion for the process among Barbizon

25

26

painters.[1] Young Eugène became skilled at cliché-verre early on and advised painters in the use of the technique, keeping many of the painters' glass plates and printing them on request.

In his youth, Eugène came to Barbizon frequently with his father and other Arras artists. He cemented his association with the region on March 7, 1859, by marrying Marie-Louise Ganne, daughter of the famous Barbizon innkeeper whose lodging walls were decorated with painters' sketches and whose public rooms had become a center for lively artistic discussions. Corot and Rousseau were the witnesses for the bridegroom, and Rousseau and Millet reportedly decorated a barn for the festivities.

Cuvelier became one of the most sensitive photographers of the region, and his photographs of the trees and paths have an unusual expressiveness that transmits, in theme and variation, his great devotion to the area. Surviving in part on family income, Cuvelier made few prints of his negatives. He appreciated the pictorial potential of paper negatives and worked with them long after most photographers had turned to glass. Cuvelier's preference for the aesthetic image akin to painting is exemplified by *Lane in Fog, Arras* (cat. no. 24) in which the subtly delineated forms, misty atmosphere, and hushed serenity are reminiscent of Corot. This photograph was taken near Cuvelier's hometown of Arras, and its softness and decorative massing of forms are very similar to the few landscape photographs that exist by his father, Adalbert. In his attention to the play of light and atmosphere, Cuvelier was touching on ideas that would later become the major themes of Impressionism.

Whereas many of Cuvelier's most magical evocations, such as *Lane in Fog*, were printed on salted paper, other examples of his photographs

evoke a dramatically different mood through the greater detail offered by printing on albumen-coated paper. In his depiction of the Forest of Fontainebleau location known as La Reine Blanche, famous for a succession of trees that stood there, Cuvelier used albumen paper to convey more intensely the harshness and angularity of awkwardly twisting branches and dense, overgrown foliage (see cat. no. 25).[2]

Cuvelier, like his painter friends, occasionally documented such humble subjects as farmyards, still lifes of dead game, and views around the town. In his *Boundary of Barbizon* (cat. no. 26), the photographer has focused on the border between the small village and the vast woods, controlled civilization versus untidy nature. He has also paid attention to the lively play of banded light and shadow over the road.

Other photographers who interpreted the Fontainebleau trees and Barbizon farms were influenced by Cuvelier's work. One of the most talented of these was Alphonse Jeanrenaud, a naval officer turned photographer who took pictures of a variety of subjects, a number of which he printed in an early form of photogravure. Jeanrenaud is best known for his painterly photographic landscapes, like *Cart in Forest Path* (cat. no. 27), a view of an abandoned cart and rutted road. Images such as this, with its poignant mood, reveal the photographer's expressive talent. Like Cuvelier, Jeanrenaud could combine bold compositions and delicate recording of light to evoke the artist's personal response to the woods as well as a sense of timelessness. AEH

27

1. Adalbert Cuvelier's interest in the cliché-verre, the hybrid process combining etching and photography, was shared with the painters Constant Dutilleux and Adolphe Grandguillaume. See the discussion of cat. nos. 16–18 and the glossary in this catalogue for an explanation of the technique. It is curious that although a handful of Adalbert Cuvelier's photographs exist today, no clichés-verre by him have been found, and only one cliché-verre by Eugène is known.

2. Claude-François Denecourt, a retired Napoleonic soldier, was devoted to the forest and started in the 1830s to groom its trails, marking them with blue arrows and naming all the prominent landmarks, including La Reine Blanche. Cuvelier would have been familiar with Denecourt's many well-known guides to the forest, published from 1840 into the 1870s, and it is interesting to consider Cuvelier's photographs as a visual counterpoint to Denecourt's writings. See, for example, C. F. Denecourt, *Guide du voyageur et de l'artiste à Fontainebleau; itinéraire du palais et de la forêt, avec les promenades les plus pittoresques, par C.-F. Denecourt*, 6th ed. (Paris: n.p., 1850), 30, for "Le Reine Blanche."

Eugène Isabey
French, 1803–1886

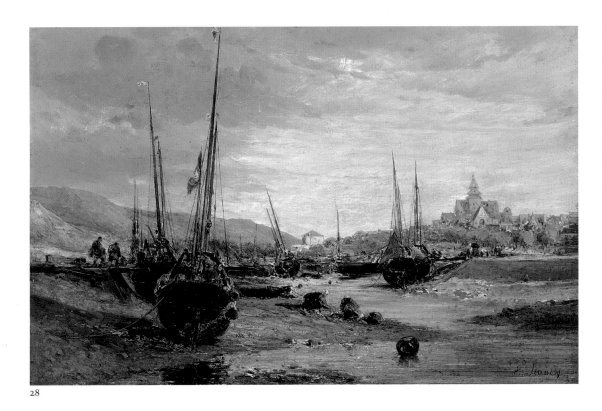

28

Fig. 39. Richard Parkes Bonington, English, 1801–1828, *Rouen,* before 1822, watercolor, The Wallace Collection, London.

28. Eugène Isabey
Harbor View, about 1850
Oil on canvas
33.3 x 47.9 cm (13 ⅛ x 18 ⅞ in.)
The Henry C. and Martha B. Angell Collection
19.101

29. Eugène Isabey
Stormy Weather, about 1836
Lithograph on cream wove paper
Image: 11.1 x 18.4 cm (4 ⅜ x 7 ¼ in.)
Samuel P. Avery Fund 21.10733

Eugène Isabey, son of Jean-Baptiste Isabey, a court painter to Napoleon, began exhibiting at the Salon in 1824, when he won a first-class medal. This auspicious beginning set the stage for his whole career. He exhibited regularly at the Salon until 1878 and was, in his turn, a court painter for Louis-Philippe. In this role he commemorated historic and diplomatic events. He

was drawn to the Normandy coast, traveling its length and painting its various ports his whole life. It is likely that in 1825 he went to England with Eugène Delacroix and the English artist Richard Parkes Bonington, from whom he adopted fresh colors and easy brushwork to depict marine subjects.[1] In 1828 he painted in Normandy with Huet. In 1844 he met Boudin, who exhibited Isabey's work in his frame shop in Le Havre. On a trip to the Netherlands in 1846, Isabey met Johan Barthold Jongkind, who became his pupil when the Dutchman moved to Paris later that year. The next year Isabey took Jongkind to Normandy. Isabey is also known for his lithographs, on which he worked concentratedly from 1825 to 1835, as well as for his luminous watercolors.

In *Harbor View* (cat. no. 28), Isabey shows us an inlet that at high tide functions as a harbor. Now, however, at low tide, the local people flock to the shore to wash clothes and load the

ships. This is a peaceful scene, showing everyday activities carried out following the rhythms of nature. A different kind of tradition, that of constructed artifacts, is present as well, emphasized through composition and color. The eye moves through the depicted space following a long zigzag course, starting at the lower left and ending at the high point of the eccentrically shaped steeple of the church. The dominant brown-blue tonality, sparked by the scattered reds of skirts, shirts, sail, and flags, is a subtle modulation of brown foreground, green middle ground, and blue background, a palette used by landscapists since the sixteenth century to indicate recession into depth.

Isabey took obvious delight in applying paint to canvas. He thinned the paint with enough medium to allow him to paint rapidly with squiggles and flourishes; three-dimensional strokes of paint are visible in the foreground, where his and the viewer's vision is clearest.

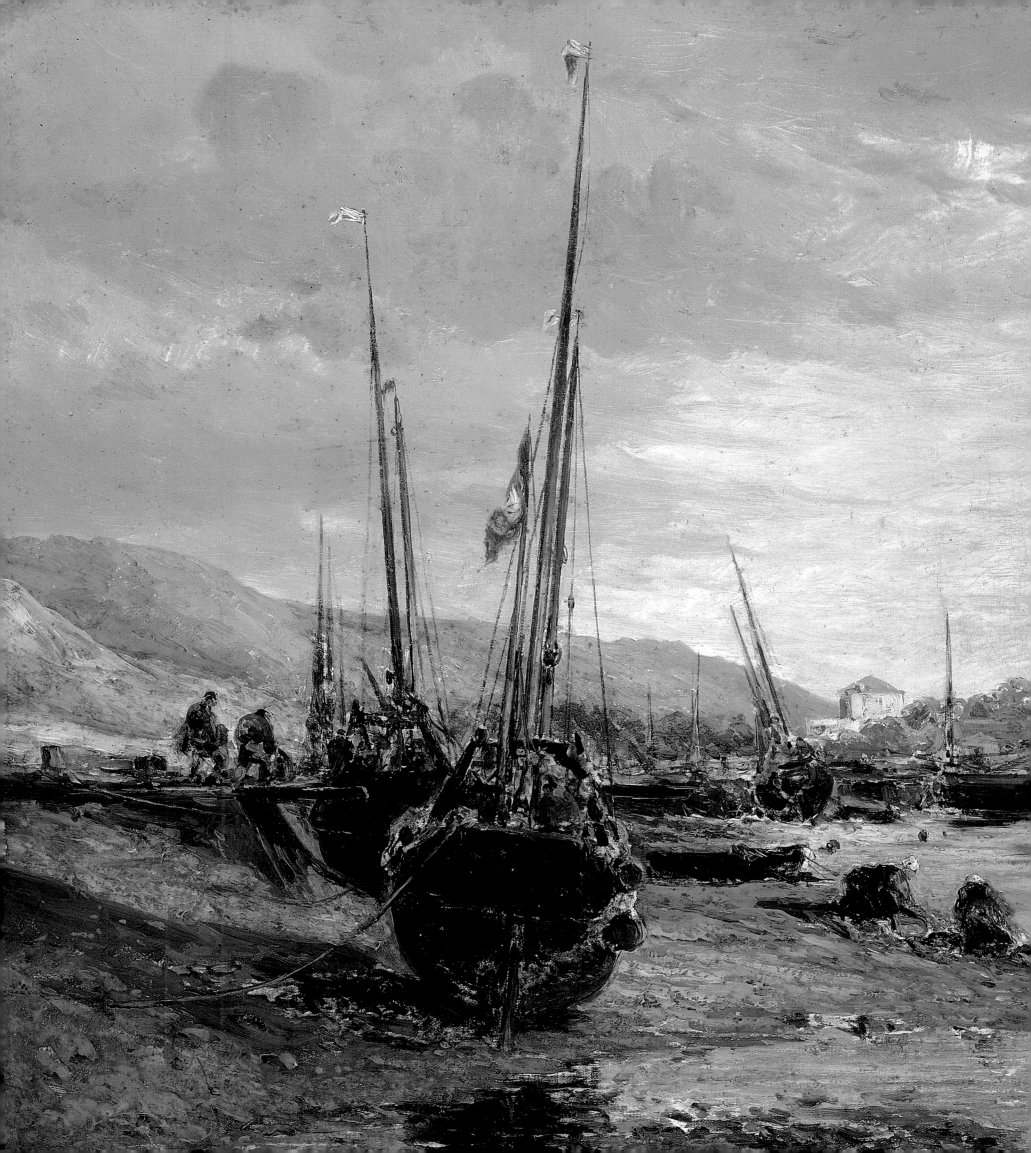

This active brushwork functions as an analogue for the activity of washerwomen and laders but also, and more important, for the activity of light and its interaction with air, water, and objects. For all its adherence to convention, Isabey's *Harbor View* is a careful study of these essential elements of landscape painting, rendered with an understanding of how, for example, sunlight glinting off water and mud actually looks.

Isabey had painted on the Channel coast since the very beginning of his career, but it was his acquaintance in the mid-1820s with Bonington that proved decisive. The English painter's free, fluid, and light-saturated oils and watercolors electrified the young French artists who saw them, including Isabey. Isabey's composition is more complicated than Bonington's often are: the patterns made by the masts activate the space in a linear fashion inherently foreign to Bonington's emphasis on luminosity—even when compared with such a picture as Bonington's *Rouen* (fig. 39, p. 86). Isabey's insistence on pattern can be seen in his repeated use of the same boat. Tipped at different angles or lined up behind each other, the boats are compositional devices rather than portraits of individual vessels. Isabey's brushwork, too, is more detail-oriented than the Englishman's. Still, Isabey's picture is full of light, and it betrays an affection for the workaday scene that is akin to Bonington's fondness for such Channel scenes.

Isabey reveals a different facet of his sensibility in the lithograph *Stormy Weather* (cat. no. 29). Made about 1836, at the peak of his activity in the medium, *Stormy Weather* shows Isabey in an unexpectedly experimental mood. He had made many lithographs before the mid-1830s, especially for the ambitious multivolume project of Baron Isidore Taylor and Charles Nodier, the *Voyages pittoresques et romantiques dans l'ancienne France.* This publishing venture had as its aim "to record in word and image the ruins and monu-

ments of France from the Middle Ages and earlier periods which were fast disappearing," so that in addition to their archaeological interest, the monuments could serve "as the source of poetic and patriotic emotions in the modern viewer."[2] The *Voyages pittoresques* exploited the relatively new process of lithography, which was introduced into France very early in the nineteenth century.[3] Able to be produced cheaply and in large editions, lithographs, both singly and in albums, were collected avidly by the newly established middle class.[4] The age of mass armchair travel had begun. Isabey contributed a succession of evocative yet convincing views of mountainous regions of France.

Isabey's *Stormy Weather,* however, shows no medieval ruins, no interesting scenery. In fact, it is difficult to say what *Stormy Weather* depicts. A body of water in the lower right is held back by a sluice. Two tracks—one traveling horizontally over the sluice, the other following the left edge of the water—converge. A lone figure is walking farther into the picture, a gun or fishing pole over his shoulder. With so little narrative and scenic detail to look at, the viewer can indulge, as the artist did, in the heady invocation of atmosphere and mood, created through the manipulation of tone.

Isabey explored the full range of tones available to him in the monochromatic lithography process, from the whites of the paper left bare, clustered in the middle of the small sheet, to the dark blacks in the lower third, made by using alternately a brush and a crayon. Scratching through the ink spread on the limestone from which the image would be printed, Isabey suggested light uneasily seeping through threatening clouds.

The superficial differences between *Harbor View* and *Stormy Weather*—calm versus turbulent weather, anecdotal detail versus virtually no detail, an attempt at localization (although the church steeple has yet to be identified) ver-

29

sus an anonymous site—demonstrate the extremes of artistic expression that could be evoked through an intense examination of the natural world. In each work, however, Isabey has paid careful attention to specific atmospheric effects. In each, too, a specific place is evoked. Whether the place depicted actually existed is not important. What matters is the authenticity of feeling, amply evinced in each. Where Rousseau was concerned with conveying to the viewer his sense of wonder before individual trees, so Isabey was true to his impressions of places where land and water meet. These lessons he was to impart to his students, Eugène Boudin and Johan Barthold Jongkind. They, in turn, were instrumental in the development of Claude Monet's art. FEW

1. Noon 1991, 11.

2. Grad and Riggs 1982, 17.

3. MFA 1996.

4. Chu 1990, especially 118, 120–21.

Gustave Le Gray
French, 1820–1882

Charles Paul Furne fils
French, active 1850–1870

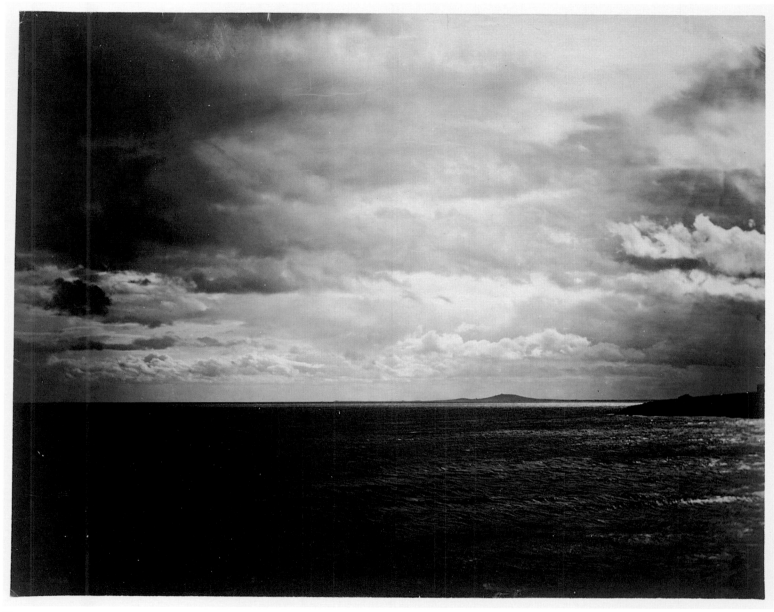

30

30. GUSTAVE LE GRAY
Cloudy Sky—Mediterranean with Mount Agde,
1856–59
Photograph, albumen print from glass-plate
negative, unmounted
Sheet: 31.1 x 39.7 cm (12¼ x 15⅝ in.)
Gift of Charles Millard in honor of Clifford S.
Ackley 1997.241

31. CHARLES PAUL FURNE FILS
Douarnenez, a Fishing Village in Brittany, 1858–59
Photograph, albumen print from glass-plate
negative, corners rounded, mounted
Sheet: 20.3 x 26.7 cm (8 x 10½ in.)
Gift of Jessie H. Wilkinson. Jessie H. Wilkinson
Fund 1998.74

Gustave Le Gray was one of the most brilliant photographers working in France in the middle decades of the nineteenth century, a leader in the field who inspired many to make art with the camera. He was a founding member of the Société héliographique and the Société française de la photographie, the two early French organizations where photographers could exchange ideas. Originally a painter, he had great insight into photography's expressive possibilities. As a master craftsman, he was an important experimenter with new negative materials and printing papers and was the author of an important treatise advocating his own method for coating paper negatives in wax before exposure. He was one of few who saw photography as a true art form and who refused to compromise the artistic goals they conceived for their medium.

Le Gray made impressive photographs of landscapes in the Forest of Fontainebleau, other sites around France, Egyptian ruins, Napoleon III's military camp at Chalons, portraits, and a small number of artistic nudes, but he may be best remembered for his monumental seascapes. *Cloudy Sky—Mediterranean with Mount Agde* (cat. no. 30) was one of a group of marine studies Le Gray took in the late 1850s along the southern French coast, looking out over the Gulf of Lions. Photographs like this, with their dramatic skies, dashing waves, and occasional graceful sailing ships, won Le Gray international acclaim. The large exhibition scale of the prints was new, and the tonal nuances in these photographs were pushed to their greatest expressive potential. The blank or mottled sky, a common problem of photographs of the period because of the emulsion's variable sensitivity to color, led Le Gray to use two negatives. One negative was correctly exposed for the sea, another exposed separately for the sky, and the two were skillfully (and probably, for the time, deceptively) joined along the horizon line.

31

The intensity of response to nature represented in *Cloudy Sky—Mediterranean with Mount Agde* recalls the ideals of Romanticism, an important aesthetic influence on mid-nineteenth-century photographers. (One of the characteristics of Romanticism was a heightened emotionalism.) In turn, photographic images had their own impact on painters such as Gustave Courbet, who sometimes modeled his oils after Le Gray's seascapes and other photographs. Photographs like Le Gray's marines also provided a deep well of imagery on which the future Impressionists could draw.

In contrast to Le Gray, Charles Paul Furne fils, a commercial photographer active in the 1850s and probably the 1860s, is relatively unstudied. He is known to have made numerous views of Paris and its environs, often issued in stereocard format, frequently in association with his photographer colleague Henry Tournier. Furne fils and Tournier were very productive and issued a monthly newsletter called *La Photographie, Journal des Publications Légalement Autorisées* from October 1858 until May 1859. On his own, Furne fils specialized in photographs of Brittany, publishing *Vues des côtes de Brétagne* and *Vues, monuments, estuaires de la Brétagne* in about 1857. This photograph of the Brittany town of Douarnenez (cat. no. 31), the small fishing village between Brest and Quimper, was probably taken not long after Le Gray's seascapes were first exhibited. With the toylike old village on the far side of the beach and the sails of the fishing boats fluttering in the wind, this magically clear image is wonderfully evocative and atmospheric. AEH

Charles Marville
French, 1816–about 1879

Louis-Rémy Robert
French, 1810–1882

32. CHARLES MARVILLE
Path in the Bois de Boulogne, 1858
Photograph, albumen print from glass-plate negative, mounted
Sheet: 26.9 x 36.4 cm (10 %₆ x 14 ⅜ in.)
Sophie M. Friedman Fund 1984.54

33. LOUIS-RÉMY ROBERT
The Baths of Apollo, Versailles, 1853
Photograph, albumen print from paper negative, mounted
Sheet: 31.8 x 25.8 cm (12 ½ x 10 ⅛ in.)
Lucy Dalbiac Luard Fund 1986.138

The new medium of photography, invented in 1839, was very versatile, and one of the many purposes to which it was quickly applied was the documentation of important historic sites both at home and abroad. In France, a fervently nationalistic country, the urge to represent monuments visually was especially strong and was supported by the regime of the Second Empire. Photographers such as Edouard-Denis Baldus, Charles Nègre, Henri le Secq, and Charles Marville seized the opportunity to earn ready governmental income documenting the architectural and topographic achievements of their nation. Sometimes this photographic documentation of the French national heritage fell into the domain of landscape.

Charles Marville, originally an illustrator in engraving and lithography, was one of several important nineteenth-century French photographers who brought a painter's eye to the medium. He took up photography about 1850 and worked on commission for the city of Paris for much of his long career. Marville's photographic oeuvre includes the recording of state events, buildings, and monuments, the reproduction of works of art, and numerous views of both old Paris and the construction of new Paris under the direction of Baron Georges Eugène Haussmann.

32

Marville's photographic documentation of the Bois de Boulogne was one of his first government projects. The former royal forest and hunting ground located at the western edge of the city had been given to its citizens by Napoleon III in 1848 and was dramatically redesigned by Haussmann from 1853 to 1858. Marville was evidently hired to promote the virtues of the new park. In *Path in the Bois de Boulogne* (cat. no. 32), he featured one of the park's gently curving walkways in the well-groomed woods. Although the season is autumn and the leaves have fallen, the pathway, with its low, iron fencing, is swept clean. This photograph was one of sixty grouped together in an album of views of the park that was exhibited in the Paris section of the Universal

Exposition in London in 1862 and was probably exhibited again with forty additional drawings in the Paris Exposition Universelle of 1867. Marville's many photographs of sylvan landscapes and his emphasis on dappled light connect him to Barbizon photographers such as Eugène Cuvelier and form another step toward the Impressionist vision.

Although Louis-Rémy Robert never photographed for the state, his capturing of landmarks of France's rich patrimony was equally celebratory. Robert was born into a family of artists and artisans employed at the Sèvres porcelain factory and, like Marville, came to photography thoroughly trained in aesthetics. Robert followed in his father's footsteps to become head of the Sèvres glass painting work-

NÉGATIF DE L'ROBERT PHOTOGRAPHIÉ ET ÉDITÉ PAR BLANQUART-EVRARD.

33

shop (1839–48), and was subsequently promoted to be in charge of painting and gilding (1848–71), and then to director (1871–79). At Sèvres, he worked closely with Henri-Victor Regnault, who was director of the factory from 1852 to 1871 and with whom he shared his burgeoning interest in photography. Robert and Regnault photographed some of the same subjects and may have explored the medium together. The knowledge of chemical interactions that Regnault and Robert gained from the manufacture of porcelain prepared them for the complicated chemistry of photography.

Robert was a photographic experimenter who enjoyed the problems posed by challenging subjects and light situations. He made expressive photographs of Sèvres porcelain that evoked the perfection of the factory's classical forms and luxurious glazes and were intended to record and promote the factory's finest productions. His enchanting views of the château and garden decoration of Versailles and Saint-Cloud share an exquisite luminosity and delicate sense of atmosphere. The picturesque Baths of Apollo in the gardens of the palace of Versailles were designed by the painter Hubert Robert in 1778. Hubert Robert carved out the grotto and incorporated earlier sculptures by various artists depicting the resting Apollo, the nymphs who tend him, and the god's steeds being groomed by tritons. Louis-Rémy Robert's photograph *The Baths of Apollo, Versailles* (cat. no. 33) was the first of thirteen views in the album *Souvenir de Versailles* (1853), printed and published by Louis Desiré Blanquart-Evrard, the great disseminator of many French photographic views of the period. AEH

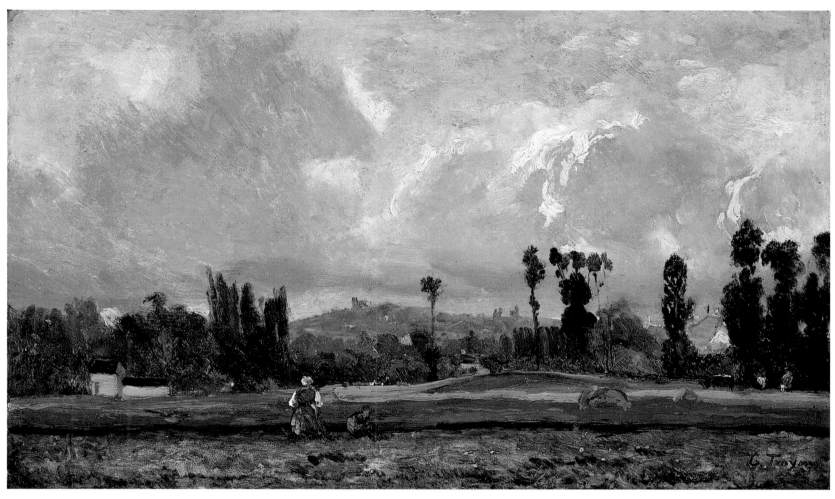

34

34. CONSTANT TROYON
Field outside Paris, 1845–51
Oil on paperboard
27 x 45.5 cm (10 ⅝ x 17 ⅞ in.)
The Henry C. and Martha B. Angell Collection
19.117

35. CONSTANT TROYON
Windswept Meadow with Shepherd and Flock,
about 1850
Black chalk on beige paper
Sheet: 25.4 x 35.4 cm (10 x 13 ¹⁵⁄₁₆ in.)
Gift of L. Aaron Lebowich and Harvey D.
Parker Collection, by exchange 63.263

36. ANTOINE VOLLON
Meadows and Low Hills
Oil on panel
28 x 46.2 cm (11 x 18 ⅛ in.)
Bequest of Ernest Wadsworth Longfellow
37.602

Constant Troyon was one of many nineteenth-century painters who were trained as porcelain decorators. (Diaz and Renoir were others.) Although he exhibited successfully at the Salon from 1833 with conventional landscape subjects, he was encouraged by Rousseau and Huet, whom he met in 1843, to paint more directly.

Because Troyon had already been painting outdoors, this advice was received more as validation than as a suggestion to try something new. Critical to Troyon's career was a trip to the Netherlands in 1847. In Amsterdam he saw the seventeenth-century animal paintings of Aelbert Cuyp and Paulus Potter, and he began to add animals to his landscapes. These became very popular with the public, not only in France but in England, the Netherlands, Germany, and Austria as well. To meet the demand, Troyon hired assistants to fill in the backgrounds so that he could concentrate on the animals, be they cows, sheep, or dogs. Troyon also painted pure

35

landscapes and in his later years frequently visited the Normandy coast. There, freed from market demands, he painted in a more exploratory fashion, recording variations in light. In 1849 he was the first of the artists associated with Barbizon and rural French subjects to be awarded the cross of the Legion of Honor.

Landscape subjects could be found quite close to home, even for an urban dweller. In the middle of the nineteenth century a field outside Paris could be as near as eight or nine kilometers (five to six miles) from Notre Dame or the Louvre. Visible in Troyon's *Fields outside Paris* (cat. no. 34) are low hills (perhaps those of Montmartre, at the northern edge of the city), poplars marking the boundaries of fields or properties, farmhouses and their outbuildings, three cows in the right middle ground, and two women to the left of the center foreground. Exactly what the women are doing cannot be determined, nor does it matter, for Troyon's pri-

mary interest lies in the active sky and in the establishment of a sense of place.

The low point of view taken by Troyon in *Fields outside Paris* heightens the immediacy of the scene. We are there, on the same plane as the women, in the middle of the field. This vantage point has the effect of breaking the composition into horizontal bands (a compositional ploy often used later, for similar agrarian subjects, by Pissarro). These are variously differentiated by texture and color—a thin, scrubbed-on muddy green foreground; a fluid farther field, maybe newly harvested, wetly brushed on in long brown horizontals; a still farther, greener field; the nervous, active, and brushy dark trees; and the blue hill, whose color announces its distance from the rest. Above all is a cloud-filled sky. The white impasto on the clouds to the right show the effects of the hidden sun breaking through.

Troyon delighted in the materiality of

paint. He obviously enjoyed its malleability, varying its stickiness with medium to make it flow more or less smoothly, depending on the effect he wanted. His choice of paperboard as support for this painting suggests outdoor execution, since this material was easier to transport than a stretched canvas.

The same low viewpoint and the same delight in materials animate Troyon's drawing *Windswept Meadow with Shepherd and Flock* (cat. no. 35). All surfaces of the black chalk were used: the sharpened tip for the outlines of clouds; the side rubbed roughly over the buff paper to sketch in masses of field, hills, and clouds; a blunter tip, used with more pressure, for the summary denotations of horizon and tree trunks. The evocation of clouds scudding across the sky is particularly masterly: faint but definite scalloped lines give form to vague smudges, and a believable skyscape takes shape. The rightward slant of the trees draws attention to the fact that the lines demarcating the clouds are all on the right and hence are the leading edges of the amorphous masses. The wind is strong enough to obliterate the individual bodies of the sheep. And the grasses through which the flock and the man walk are flattened across their path; passage must be difficult.

Antoine Vollon's *Meadows and Low Hills* (cat. no. 36) offers a rare look at Vollon the landscapist. Vollon began his career in his native Lyon in an enameling shop, copying the works of the eighteenth century onto decorative objects. He won awards in printmaking during his two-year period of study, from 1851 to 1852, at the Ecole des Beaux-Arts in Lyon, and by 1858 was exhibiting oil paintings in his hometown. He moved to Paris in 1859 and first exhibited at the Salon in 1864. His paintings were regularly purchased from the Salon by the state (1864, 1868, 1870, and 1875), and he had a successful official career, marked by awards at the Salon in

36

1865, 1868, and 1869 and at the Expositions Universelles of 1878 and 1900. He was named a knight in the Legion of Honor in 1870, an officer in 1878, and a commander in 1898. Associated with François Bonvin and Théodule Ribot, Vollon was best known for his still lifes, primarily of kitchen subjects, yet he was also fond of painting armor. His works are characterized by heavily loaded brushstrokes and dramatic lighting. He was equally adept at landscapes, often of farmyard subjects, and he also did portraits.

Toward the end of his life Vollon spent more time outside Paris, painting rural subjects. For this painting he used an extremely simple composition and consciously restricted means to achieve an effect of startling verisimilitude. Indeed, the composition of this view of meadows and low hills could hardly be simpler. More than half of the small panel is given over to a cloud-filled sky, painted so thinly that the grain of the wood shows through. The landforms

below are painted more thickly. In places the paint stands up in relief, as if mimicking the solidity of the ground and trees, in the same way that the thinness of the paint in the sky is analogous to the ephemerality of that element.

The evident rapidity of execution and the fact that the painting was done on an easily portable panel attest to its having been made outdoors. Vollon was interested not so much in capturing color and light as in exploring the effect of depth and recession. The expanse of the meadow is indicated by the tiny size and indistinct anatomy of the grazing cows (and perhaps sheep) and the tinier farm buildings farther away. The place at the far end of the meadow at which the land starts to rise is marked by a line of dark trees, which perhaps signal the presence of a stream or perhaps serve simply as boundary markers. The trees climbing the hill—their crowns progressively silhouetted against the sky—indicate increasing

distance, and those at the top of the hill are so far away that the artist registered them as mere puffs against the sky.

Vollon chose an overcast day on which to paint his small but expansive scene. Devoid of strong contrasts of sunlight and shadow, the field shows itself in a dark, rich palette of greens and browns, colors similar to those the artist used in his kitchen interiors and arrangements of armor. As in those paintings, too, the brushwork in the darker areas is fluid and loose. In his still lifes Vollon was not interested in microscopic detail; rather, he preferred to juxtapose larger masses of simplified textures, a predilection he transferred to his work outdoors. FEW

Jean-Léon Gérôme
French, 1824–1904

Constant Troyon
French, 1810–1865

Antoine-Louis Barye
French, 1795–1875

37. JEAN-LÉON GÉRÔME
Black Panther Stalking a Herd of Deer, 1851
Oil on canvas
52.3 x 74 cm (20 ⅝ x 29 ⅛ in.)
Anonymous Gift 30.232

38. CONSTANT TROYON
Hound Pointing, 1860
Oil on canvas
163.8 x 130.5 cm (64 ½ x 51 ⅜ in.)
Gift of Mrs. Louis A. Frothingham 24.345

39. ANTOINE-LOUIS BARYE
Stag and Doe
Watercolor on paper, mounted
Sheet: 21 x 28.2 cm (8 ¼ x 11 ⅛ in.)
Bequest of David P. Kimball in memory of his
wife Clara Bertram Kimball 23.526

The life of animals—apart from their usefulness to humankind—was a source of fascination for people in the nineteenth century. Animals represented instinct, power, savagery, and nobility in equal measures. Their essential foreignness constituted the principal aspect of their allure. In previous centuries animals had appeared in art as symbols of nobles or gods, as prey and attacker in hunting scenes (with the presence of men implied or actual), or as domesticated pets or prize livestock—in other words, always as an adjunct to the activities of humans. In the nineteenth century, animals, wild and tame, were valued for their very animality, their difference. Painting animals in a naturalistic way, appropriate to their species, gave them additional autonomy.

Jean-Léon Gérôme had great success with his paintings of orientalist and historicizing subjects—harems, mosques, caravans, scenes from imperial Rome—and the prints made after them, published and cannily marketed by his father-in-law, Adolphe Goupil. Gérôme made several trips to the Near East and Africa, but the first of these postdates by five years the execution of *Black Panther Stalking a Herd of Deer,* a painting the artist signed and dated in 1851 (cat. no. 37). Interest in the Middle East and northern Africa was at a high pitch at midcentury. Eugène Delacroix was only one of many artists to bring to France the colors, sights (including animals), almost palpable heat, smells, and sounds of these exotic places,[1] and photographs, deemed more truthful than paintings, showed that the region was, if anything, stranger than the scenes depicted in paintings. Gérôme studied with both Paul Delaroche and Charles Gleyre, each of whom was devoted to high technical finish and accuracy in historical re-creation. With this background and the availability of recently published volumes of lithographs and photographs of the Middle East,

plus his highly developed commercial sense, Gérôme began, with *Black Panther Stalking a Herd of Deer,* a lifelong engagement with painting large cats.

Corals, pinks, mauves, greens, and yellows fill the luminous sky, and laser-sharp rays of light shoot out from the barely hidden sun. Against this glow crouches the inky panther, its irregular but sinuous outline echoed in rocks and clouds on either side. So that the viewer not overlook the narrative of the painting, rocks in the lower left corner point to the herd of deer on their way to the waterside to drink.

Gérôme's later pictures of felines, especially lions, are more credibly portrayed than this one, presumably thanks to his increased familiarity with their appearance and their milieu. He was nonetheless proud of his black panther painting—its drama is undeniable—for at an unknown date he gave it to the critic Théophile Gautier, who appreciated narrative and descriptive art. Gautier had praised Gérôme's first submission to the Salon in 1847, *The Cock Fight,* singling out its "rare elegance" and "exquisite originality" and the artist's "fine and delicate handling of pencil and brush."[2] He remained supportive of Gérôme's art, and the gift must have been in appreciation. Gautier in turn liked the painting, for he kept it until his death.

Constant Troyon's dog in *Hound Pointing* (cat. no. 38) is also hunting, but he is under the orders of a human master, who has marked the hound as his property by means of the wide leather collar with a gleaming buckle. Monumental in scale, the dog is heroic, eagerly but patiently sniffing the air, the scents of which are complicated by the electricity of the coming storm. He is a controlled mass of dynamism, the forty-five-degree angle of back leg and back balanced by the horizontals of head and tail. This pose, and the stark markings of black and white (note how the black is clustered in the

37

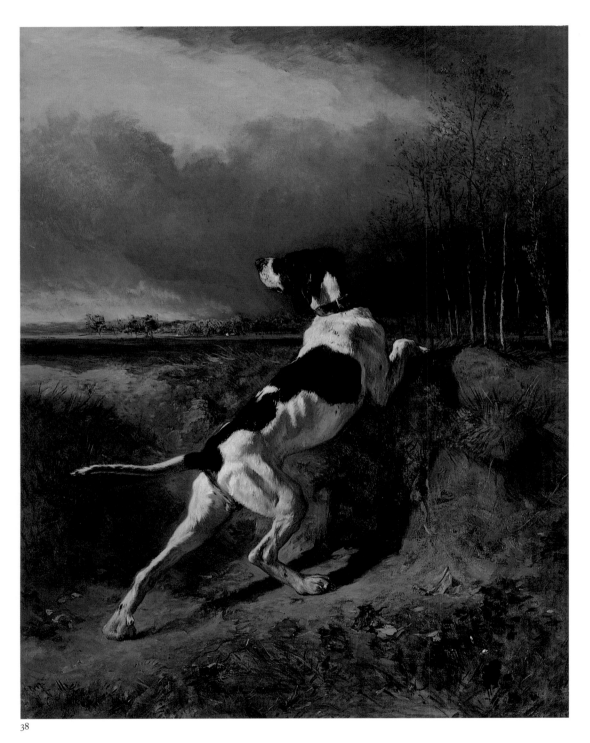

middle, so that the vibrant whites at the extremities act like pointers in various directions) activates the whole of this large painting. The tail and head, the horizontals of which usually contribute a calming, stabilizing influence to a painting, here become the entrance and exit points of a tight U-turn, shooting attention off to the left. The dog may well know his quarry; we never will. The landscape here is evocatively and summarily painted, so as not to distract too much from the noble dog. With its threatening sky, it has a power of its own.

Antoine-Louis Barye's reputation, both in his lifetime and in the present day, rests on his sculptures of wild animals, often depicted in acts of violence. Big cats eating smaller mammals or attacking crocodile-like creatures were offered in small scale in limited editions and were bought by middle- and upper-class customers alike. People were evidently eager to gaze on the bloody side of animal life.

Barye studied animal anatomy at the Jardin des Plantes, making drawings of both live animals and dead ones during dissections. Throughout his life he made watercolors of animals in landscape settings, not as studies for his sculptures but to be exhibited and sold. Indeed, Barye had included watercolors in his submissions to the Salon almost from the first, starting in 1831.

About 1840 Barye became friends with some of the artists who painted in the Forest of Fontainebleau, such as Jules Dupré and Théodore Rousseau. Barye was especially attracted by the more desolate parts of the forest, such as the Gorges d'Apremont, where he found "rocks sticking up from the sandy soil, the scanty, twisted vegetation, the heavy skies leaning low and charged with rain."[3] Despite its small size, Barye's watercolor of a stag and doe running through a rock-strewn

39

landscape is a powerful statement of animal
life (cat. no. 39). The upraised head of the doe,
mouth open, suggests flight from danger, sym-
bolized, perhaps, by the difficult-to-explain dra-
matic cleft in the rock above the stag.

Théophile Gautier, the critic to whom
Gérôme gave his panther, wrote that Barye's
watercolors were "no ordinary water-colours,
the brush [having] the firmness of the sculptor's
tool. . . . There are tones which come too near
the clay of his daily use; and his distances want
air."[4] Gautier meant his words as negative criti-
cism of Barye's often dark, pigment-saturated,
splotchy scenes. Yet Barye's watercolors are
rich, modulated evocations of the hard, perilous
life of animals in the wild. FEW

1. Stevens 1984.

2. Gautier, as translated in F. F. Hering, *The Life and
Works of Jean-Léon Gérôme* (New York, 1892), 52, quoted
in Zafran 1982, 104.

3. Charles Saunier, *Barye* (New York, 1926), 55, quoted in
Norelli 1988, 62.

4. Gautier in Saunier 1926, 58, quoted in Norelli 1988, 63.

40. RODOLPHE BRESDIN
The Good Samaritan, 1861
Pen lithograph on chine collé
Image: 56.4 x 44.4 cm (22 3/16 x 17 1/2 in.)
Bequest of W. G. Russell Allen 60.73

41. RODOLPHE BRESDIN
Mountain Landscape with Army in a Rocky Gorge,
1865
Pen and black ink on card with embossed bor-
der
Sheet: 10.3 x 14.8 cm (4 1/16 x 5 13/16 in.)
Gift of Dr. and Mrs. Irvin Taube and Sophie M.
Friedman Fund 1986.128

42. RODOLPHE BRESDIN
Mountain Stream, 1871
Etching and drypoint (roulette) on cream wove
paper
Platemark: 11.2 x 14.6 cm (4 7/16 x 5 3/4 in.)
Gift of David P. Becker 1998.40

43. ODILON REDON
Fear, 1866
Etching on cream wove paper
Image: 11 x 20 cm (4 5/16 x 7 7/8 in.)
Lee M. Friedman Fund 67.741

The self-taught draftsman and printmaker
Rodolphe Bresdin developed his idiosyncratic
vision within the bohemian milieu of Paris dur-
ing the 1840s. A number of artists and writers
noted his eccentric persona, which served as the
model for the impoverished engraver in *Chien-
Caillou* (1845), an early novella by Champfleury.
Through a series of restless moves between
Paris, Bordeaux, Toulouse, and even Canada,
Bresdin was constantly burdened by ill health, a
growing family, and a steadfast distaste for stan-
dard artistic ambition. He died alone in a garret
of the Sèvres porcelain factory without achiev-
ing any popular success, his posthumous reputa-
tion nurtured by his one noted student, Odilon
Redon, and a small circle of devoted admirers.

Bresdin's lithographic masterwork *The Good Samaritan* (cat. no. 40) garnered the only significant critical notice during the artist's life when it was shown at the Salon of 1861.[1] The print first appeared under the title *Abd el-Kader Aiding a Christian,* a reference to the famed Algerian emir imprisoned by the French in 1847, who, after being exiled to Damascus, was celebrated for saving thousands of Christians from massacre in July 1860.[2] Bresdin attached the title *The Good Samaritan* only in later printings, in effect expressing his gratitude for its continuing sales.

Precedents for the almost overwhelming forest in *The Good Samaritan* may be found in the work of Albrecht Altdorfer (German, about 1482/85–1538) and other Danube School artists, along with certain seventeenth-century Dutch landscapists. Contemporary publications provided other views of newly discovered forests and jungles in the Americas, and many French printmakers such as Rousseau (cat. no. 22), Bléry (cat. no. 7), and Bodmer (cat. no. 48) were exploring their own forests at the time.[3] Bresdin also appropriated several of the animals in the print by tracing graphic prototypes from illustrated books and periodicals. The camel ultimately derives from an illustration after the French painter Prosper Marilhat, and many of the creatures lurking in the undergrowth owe their origins to vignettes in a French edition of *The Swiss Family Robinson.*[4]

It seems almost miraculous that Bresdin accomplished such a coherent composition amid the welter of detail. He successfully tied all the elements together within his own landscape of the mind and executed them in the thinnest lines imaginable. Bresdin's lithograph, one of the largest from the nineteenth century, was printed by the noted Parisian firm Lemercier. The artist dedicated this impression to Aglaüs Bouvenne, the firm's technical director, an amateur engraver, and the compiler in 1895 of the first catalogue of Bresdin's prints.[5]

41

By comparison, *Mountain Landscape with Army in a Rocky Gorge* (cat. no. 41) and *Mountain Stream* (cat. no. 42) reveal Bresdin's love of the real landscapes of the Midi—in particular the rugged gorges of the Garonne and Tarn Rivers —where he spent a number of years during the 1850s. Specific inspiration for Bresdin's placement of solitary riders or vast armies in desolate scenes such as *Mountain Landscape* includes the influential 1834 painting by Alexandre-Gabriel Decamps, *The Defeat of the Cimbrians,* and illustrations after Adrien Dauzats of the French military campaigns in Algeria.[6] Bresdin's draftsmanship has precedents in the highly finished detail and evocative chiaroscuro of much contemporary wood-engraved book illustration. The artist effectively mobilized his army in this grand landscape on a small, decoratively embossed carte-de-visite (a calling card, a format Bresdin employed often), in his customary India ink using the finest of pen nibs, and on the most miniature scale.

Mountain Stream of 1871 similarly shows a harsh landscape with only a misty glimpse of a city in the far distance. The modern scholar Maxime Préaud finds a telling evocation of Rembrandt's chiaroscuro in the glowering skies and shadowy rocks and forests of Bresdin's work from this period.[7] This etching is one of a group that the artist later transferred to lithographic stones, a common procedure used to produce an image in a much larger edition more cheaply than the time-consuming intaglio printing process. This impression of the etching is one of only three known, and one of two in the earliest state, notable for its rich drypoint accents produced with a roulette. Bresdin's penchant for obsessively detailed depictions of rock, leaf, and cloud is amply revealed.

Odilon Redon met Bresdin in Bordeaux at an exhibition of the older artist's work during the summer of 1863 and soon began to study with him. Redon was a native of the city, and Bresdin had moved there that year. The younger

42

43

artist developed a lifelong friendship with his often importunate master, devoting an article in 1869 to Bresdin in the Bordeaux journal *La Gironde,* which includes many valuable personal reminiscences.[8] Although Redon's mature works do not directly reflect Bresdin's individual style, he always acknowledged its formative effect, especially toward favoring the imagination over an obligation to follow strict academic standards. Bresdin taught him the art of etching, and Redon's first works in the medium in the mid-1860s strongly reflect that influence. *Fear* (cat. no. 43), executed a year after Bresdin's *Mountain Landscape,* is placed in a similarly barren, rocky landscape. It depicts a lone horseman cradling a small child and pulling back at the edge of an apparent precipice, a subject surely inspired by Goethe's *Erlkönig* (Elf-king).[9] While the setting and figural grouping are indebted to Bresdin, the angular, faceted draftsmanship is entirely characteristic of Redon. DPB

1. See Préaud 2000, 66–71, for transcriptions of adulatory articles by Maxime du Camp, Théophile Thoré, and Théodore de Banville, among others.

2. Ibid., 67; see also Becker 1983.

3. For an excellent introduction to this subject, see Grad and Riggs 1982.

4. Becker 1983; Becker 1993; see also Préaud 2000, cat. nos. 35–37.

5. See Préaud 2000, cat. no. 1.

6. For the Decamps subject, see Préaud 2000, cat. nos. 124–25; the Dauzats illustrations appear in Nodier 1844.

7. Préaud 2000, cat. no. 100; see, for instance, Rembrandt's *Three Trees* (Bartsch 1797, no. 212) or *Large Tree next to a House* (or *The Small Gray Landscape,* Bartsch 1797, no. 207).

8. Redon 1869, 2. See also Redon 1986, 108–10, 135–40. For the most recent discussion of Redon's early life and relations with Bresdin, see Druick et al. 1994, especially chapter 1.

9. Harrison 1986, xxix and under cat. no. 7; Druick et al. 1994, 21, 58–61, suggest a further connection with Redon's removal, soon after his birth until the age of eleven, to a family estate outside Bordeaux.

Edouard-Denis Baldus
French, 1813–1882

44

44. EDOUARD-DENIS BALDUS
Bridge of Saint Bénézet, Avignon, early 1860s
Photograph, albumen print from glass-plate
negative, mounted
Sheet: 21.5 x 28.1 cm (8 ⁷⁄₁₆ x 11 ¹⁄₁₆ in.)
Gift of Mrs. George R. Rowland, Sr. 1986.767

45. EDOUARD-DENIS BALDUS
Mer de Glâce, Chamonix, about 1860
Photograph, albumen print from paper nega-
tive, mounted
Sheet: 30.9 x 42.5 cm (12 ³⁄₁₆ x 16 ¾ in.)
Sophie M. Friedman Fund 1989.23

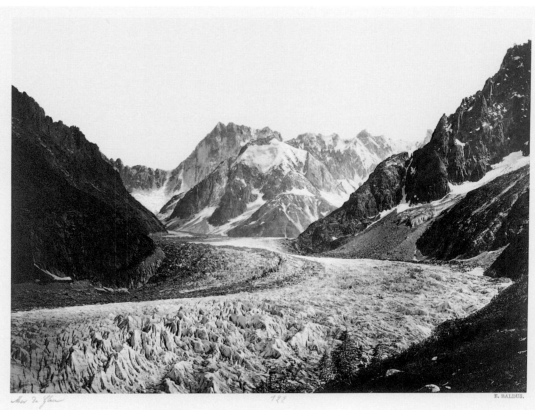

45

Fig. 40. Louis-Auguste Bisson, French, 1814–1876, and Auguste-Rosalie Bisson, French, 1826–1900, *Alpine View, Mer de Glâce,* about 1860, albumen print, Museum of Fine Arts, Boston.

Edouard-Denis Baldus often used the term "peintre-photographe" to describe himself. He and a number of his French contemporaries in the newly burgeoning field of photography had, in fact, begun their careers as painters but early on were drawn to the mysterious beauty of the calotype print, the negative-positive photographic process invented in 1839 by the Englishman William Henry Fox Talbot. Baldus first arrived in Paris from Prussia just one year prior to the announcement of Talbot's discovery, and he is known to have worked as a painter and copyist for nearly a decade before taking up photography in 1848 or 1849. The great speed with which he mastered the technique of making sharp photographic prints from unwieldy paper negatives is apparent when one realizes that only a few years after his earliest experi-

mentation with the medium, Baldus was chosen by the French government's Commission des monuments historiques to take part in the Missions héliographiques and was assigned the documentation of the historic architecture of Fontainebleau, Burgundy, the Rhône Valley, and Provence. He was also recognized for having discovered a refinement of the paper-negative process using gelatin, which gave his photographs the fine detail and tonal range that distinguished his work from that of his competitors.

One genre of topographical photography to become popular in France during the 1850s and 1860s was that of glacier and alpine views, a novel subject that had yet to be tackled by the French painters of the day. A number of these spectacular scenes were first photographed in the French Alps by the brothers Louis-Auguste

and Auguste-Rosalie Bisson, and then produced as large-format prints and published in 1860 as *Haute-Savoie: Le Mont-Blanc et ses glaciers.* Baldus also traveled to the Dauphiné, Savoy, and Côte d'Azur in about 1860, apparently without a commission, to photograph the regions' towns and the rugged landscapes that surrounded them. Although this project is difficult to date exactly, he may have been inspired to focus on these southeastern territories because they had only recently been annexed to France as a result of the Italian war with Austria.[1] The powerful images that resulted from this trip complement the awesome sublimity of his subjects, in this case the so-called Mer de Glâce, the famous glacier in the shadow of Mont Blanc, near Chamonix. Unlike the more standard view of the glacier made by the frères Bisson (fig. 40),

Baldus has carefully placed his camera so that the jagged, icy floe sweeps down through the center of the image (cat. no. 45), thus leaving out the distinctive promontory of the Grands-Charmoz at the right, which many photographers of the day chose to feature. As Baldus's friend the critic Ernest Lacan said of pictures like these: "His lens takes in spaces which the eye can scarcely measure."[2]

Baldus's *Bridge of Saint Bénézet, Avignon* (cat. no. 44) dates to the early 1860s and is one of a handful of images of Avignon that appear in a photographic album entitled *Chemins de fer de Paris à Lyon et à la Méditerranée,* for which he received a commission in 1861 from the director of the newly merged railroad companies. Baldus had worked in Avignon earlier in his career, first during the early 1850s while employed by the Missions héliographiques and then again in 1856, when he was called on by the government to document the city's devastating floods. This photograph of the city's twelfth-century bridge, celebrated in a popular children's song, records its few remaining arches reaching partway across the Rhône River, as well as the medieval chapel of Saint Nicolas on the bridge's second pier. Rather than focusing on the subject of the railroad itself, it is one of several images among the album's sixty-nine photographs that feature, instead, the architectural monuments of Provence. As one scholar has pointed out, Baldus cleverly sequenced the prints in the series in such a way as to suggest striking parallels between the engineering feats of the region's ancient and medieval structures and the purported subject of the album—the Second Empire railroad bridges, tracks, and tunnels that it was meant to commemorate.[3] Made from a glass plate rather than a paper negative, this image is a fine example of one of the artist's characteristically serene and balanced compositions. Its sharply angled shoreline and tangle of fishing boats at the water's edge beautifully set off the repeating curves of the bridge reflected in the limpid surface of the river. KEH

1. Daniel 1994, 76–77.

2. "Son objectif embrasse des espaces que l'oeil peut à peine mesurer." Lacan, *Esquisses photographiques à propos de l'Exposition Universelle et de la Guerre d'Orient,* 1856, quoted in Néagu and Heilbrun 1983, 74.

3. Daniel 1994, 80–90.

Gustave Courbet
French, 1819–1877

46. GUSTAVE COURBET
Stream in the Forest, about 1862
Oil on canvas
157 x 114 cm (61¼ x 44⅞ in.)
Gift of Mrs. Samuel Parkman Oliver 55.982

Gustave Courbet went to Paris in 1839, ostensibly to study law. He sporadically attended the Académie suisse, but he was essentially self-taught, having spent much time in the Musée du Louvre studying the old masters, particularly the Dutch, Venetian, and Spanish Schools. His submissions to the Salon in the early 1850s, such as *Burial at Ornans* (Musée d'Orsay, Paris), gave rise to controversy because of their use of everyday subject matter on a heroic scale. After 1855 his art became less polemic, and he painted more nudes, portraits, and landscapes. The nineteenth-century critic Edmond About explained that Courbet "affects not to choose, but to paint all which he meets, without preferring one thing before another. . . . His theory may be thus given: all objects are equal before painting."[1] Courbet, like many other artists, painted on the Normandy coast, first going to Le Havre in 1859, where he met Boudin. Courbet's involvement with the Paris Commune and his alleged role in the destruction of the Vendôme Column prompted his move to Switzerland in 1873.

For this picture Courbet used virtually the same palette that Rousseau had used to paint his *Pool in the Forest* (cat. no. 19), and the subject—water in the form of a pool or stream in the forest—is also closely comparable, but there the similarities end. Whereas Rousseau's painting is small and intimate in feel, Courbet's is large and assertive. Rousseau applied his paint in careful, minute touches of a brush, whereas Courbet spread his onto the canvas with a painting knife whose movement can be read in the long, tactile planes and ridges of paint.

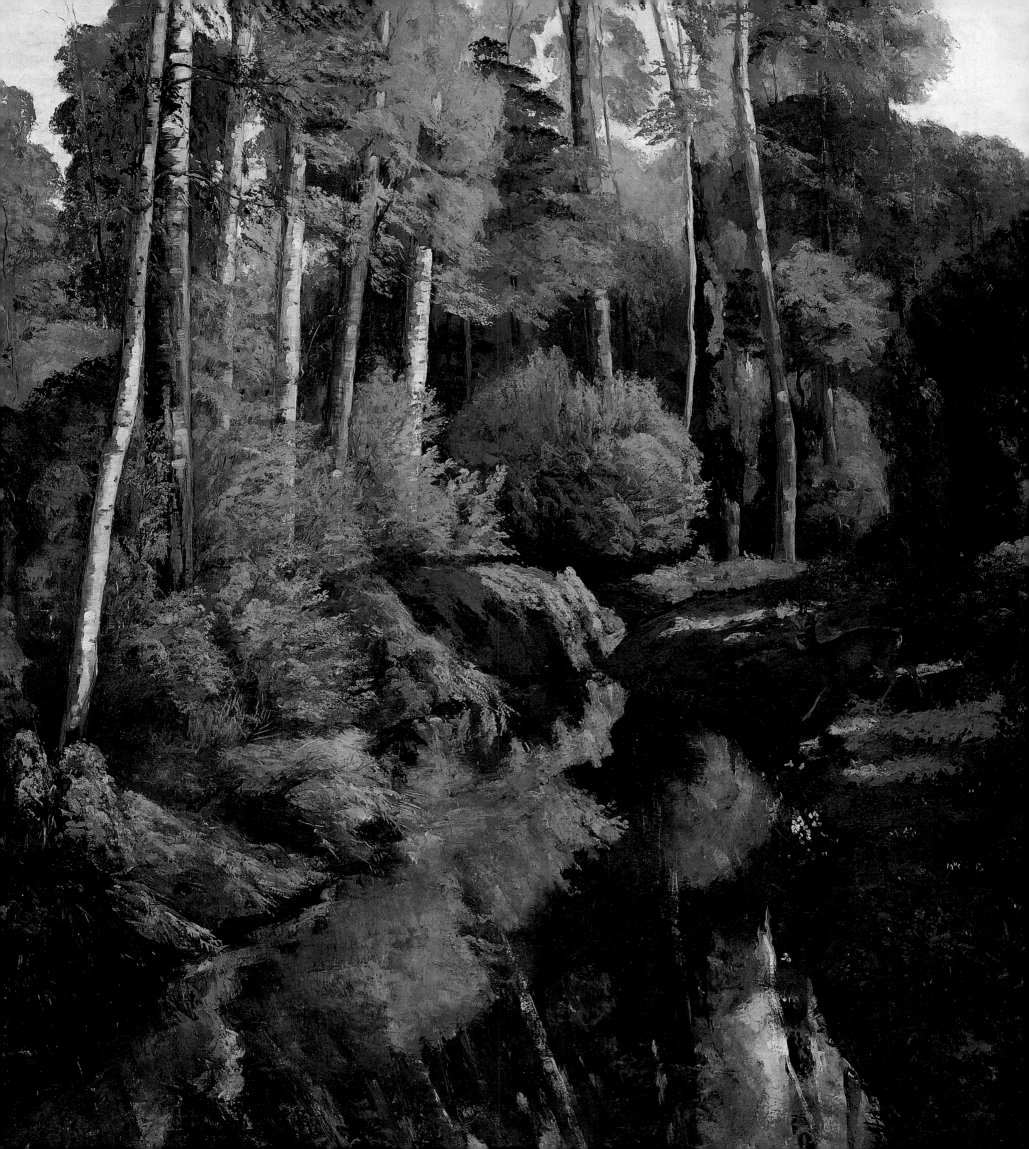

Courbet has situated the point of view of the scene in midair, suspended over the stream. We look down on a young deer, turning to stare at us, as if asking what we are doing in this secluded spot, and perhaps ready to defend the two younger deer in the underbrush behind. (This anecdotal touch, to which our attention is drawn by the splashes of red and white near the deer, argues for the picture's having been made for the market.) The high point of view also shows the stream's surface. The light-blue streak to the right is especially arresting. Meant to be read as a reflection of the sky, it becomes a shape divorced from the tangible world. Because the reflections of the tree trunks converge at the right side of the stream, the blue streak seems to point to the watery depths.

The sense of looking down is matched by a sense of looking up. This is a large painting, and its vertical format emphasizes the height of the slender trees. The trees seem especially lofty because their tops are cut off: even a meter-and-a-half-high (five-foot-high) canvas is not large enough to encompass their full height.

The art historian Anne Wagner has explained that Courbet's approach was geared toward satisfying his audience, which was made up primarily of people living in cities who could find visual respite in the cool colors and simple shapes of his scenes. In their quest for pictures of refreshing nature, his viewers were clearly able to accept the roughness of his technique. By insisting on the physicality of their surface, Courbet's landscapes, such as *Stream in the Forest,* balance delicately between the attempt to paint a fictive space that looks real and the urge to let the viewer see how the painting was made.[2] FEW

1. Edmond About, *Nos artistes au Salon de 1857,* quoted in Clement and Hutton 1879, 1:165.

2. Wagner 1981, 410–31.

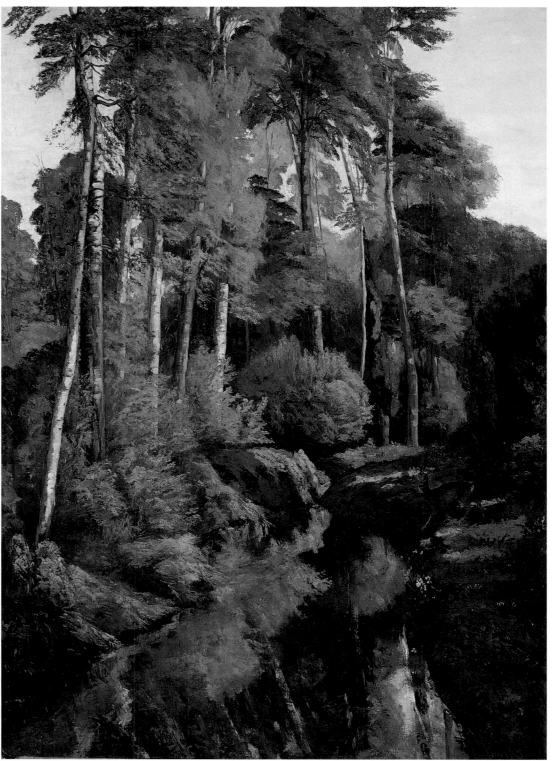

46

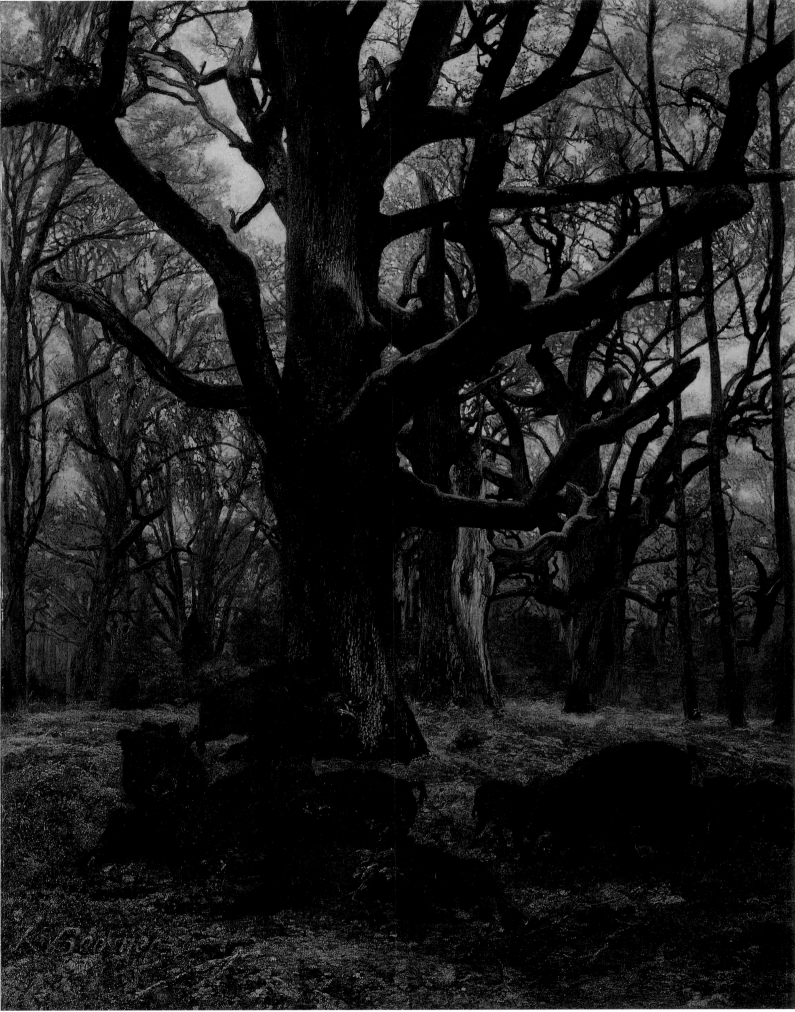

Karl Bodmer
Swiss (worked in France), 1809–1893

47. KARL BODMER
Oaks and Wild Boars, about 1865
Oil on canvas
134 x 106.8 cm (52¾ x 42 in.)
Bequest of Francis Skinner 06.3

48. KARL BODMER
Fox in the Hiding Place, 1858
Lithograph on chine collé
Image: 29 x 17.7 cm (11 ⁷⁄₁₆ x 6 ¹⁵⁄₁₆ in.)
Gift of Clifford S. Ackley in memory of Lillian
H. Stern 1984.182

Karl Bodmer had a long and successful career
in France primarily as a painter and illustrator
of animal subjects. In the United States during
the twentieth century, however, he was known
almost exclusively for his depictions of Native
Americans, subjects he studied while on an
expedition up the Missouri River with Prince
Maximilian of Wied-Neuwied, from 1832
through 1834. Largely self-taught, Bodmer had
an affinity for the Forest of Fontainebleau and
debuted at the Salon of 1850–51 with three paint-
ings of forest interiors. He was so closely identi-
fied with the forest that one of its venerable oak
trees acquired the name Bodmer Oak.[1] Bodmer
exhibited variations on this theme for two
decades, collecting praise from the critics and
prizes from the art establishment.

Oaks and Wild Boars (cat. no. 47) is typical
of his paintings in reflecting an intimate knowl-
edge of the subject. Bodmer frequented Bar-
bizon as early as 1849, when he decided to make
his career in France rather than Germany or his
native Switzerland, and he bought a house there
in 1856. The taxonomic impulse informing his
watercolors and drawings recording the ani-
mals, plants, people, landforms, and artifacts of
North America is evident in his work in France;
he was as much naturalist as artist. The tangle
of bare branches is echoed in the disorderly

48

heap of animals on the forest floor. In turn, the
power of the animals takes physical shape in
the thick, thrusting branches. The dull colors—
dark browns, ochers, and grays—contribute to
the informative mission of Bodmer's art.

Fox in the Hiding Place (cat. no. 48), a finely
worked lithograph from 1858, again displays
Bodmer's ability to capture the little-known
details in the lives of animals. Here, a fox has
been spied by its intended prey. Snarl though
the fox might, the ducks fly to safety. The
artist's contemporaries appreciated his com-
mand of his subject:

> He is an artist of consummate accomplish-
> ment in his own way, and of immense
> range. There is hardly a bird or quadruped
> of Western Europe that he has not drawn,
> and drawn, too, with a closeness of observa-
> tion satisfactory alike to the artist and natu-
> ralist. The bird or the beast is always the
> central subject with Karl Bodmer, but he

generally surrounds them with a graceful
landscape, full of intricate and mysterious
suggestions, with here and there some plant
in clearer definition, drawn with perfect
fidelity and care.[2]

Bodmer provided illustrations for books
and general and specialized journals, including
*L'Illustration, Le Monde illustré, La Chasse illus-
trée*, and *L'Art*, over several decades. *Fox in the
Hiding Place* appeared in the book *Les Artistes
anciens et modernes.* FEW

1. Claude Monet painted the tree. See his *Bodmer Oak,
Fontainebleau Forest, Chailly Road* (1865) at the
Metropolitan Museum of Art, New York, reproduced,
with a photograph of the tree by Gustave Le Gray, in
Tinterow and Loyrette 1994, 75, fig. 96, 423.

2. P. G. Hamerton, *Portfolio* (February 1873) quoted in
Clement and Hutton 1883, 1:70.

André Giroux

French, 1801–1879

Paul Gaillard

French, active 1850s/60s–1890

49. ANDRÉ GIROUX
Under the Arbor, about 1853
Photograph, salt print from paper negative, mounted
Sheet: 20 x 25.5 cm (7⅞ x 10 1/16 in.)
Anonymous Loan, Promised Gift 461.1974

50. ATTRIBUTED TO PAUL GAILLARD
Farmyard, 1850s
Photograph, albumen print from glass-plate negative, mounted
Sheet: 20 x 25.5 cm (7⅞ x 10 1/16 in.)
Anonymous Loan, Promised Gift 387.1974

André Giroux was the son of Alphonse Giroux, the maker of the camera equipment used by Louis-Jacques-Mandé Daguerre, inventor of the daguerreotype. Although the younger Giroux was trained as a painter, he, like many of his French contemporaries, was attracted to the medium of photography in the early 1850s, at the same moment that the paper negative was at the height of its popularity and collodion glass-plate technology was first being developed. He brought a painter's sensibility to his work, and his prints are often extensively retouched and richly toned. Critics of the day lauded Giroux for photographs like *Under the Arbor* (cat. no. 49), an image of a rustic, vine-covered barn, describing them as "ravishing landscapes and little pictures where nature seems to have posed for him."[1]

Specializing in these pastoral subjects, Giroux experimented with both paper and glass-plate negatives and would often liberally rework his negatives in his desire to give them the appearance of drawings, at times even scratching and stippling directly on them to make them look more like the clichés-verre of the period. In fact, Giroux went to unusual lengths to de-emphasize the mechanical aspect of his work and over the course of his career showed little inclination for the sharp and finely resolved

49

images to which his fellow photographers aspired. The necessarily long exposures of his paper-negative prints also resulted in shadowy forms, like the gently blurred figure seen here within the arbor—a picturesque effect he would certainly have admired and which can be seen in several other prints by him.

Paul Gaillard (see cat. no. 50) was one of the founding members of the Société française de photographie in 1854 and one of its directors during the 1860s. Little else is known of his career as a photographer, except that he was a wealthy amateur who also worked with both paper and glass-plate negatives.[2] Like Giroux, he seems to have made something of a specialty of bucolic landscapes, many of them taken at sites favored by the painters of the period, including

the Bois de Boulogne and the Forest of Fontainebleau. These picturesque views were very popular among French photographers at midcentury, and vignettes of barnyards, walled gardens, thatched cottages, and "still lifes" of primitive farm implements were highly sought after by artists and collectors who had come to admire such humble subjects in seventeenth-century Dutch genre scenes and the paintings of Millet, Daubigny, and Rousseau. Not surprisingly, this taste for unpretentious images of rural life steadily grew as more and more people left the countryside and moved to cities to find work during France's Industrial Revolution. Many of these new urban dwellers felt nostalgia for their agrarian roots, and this period of unprecedented growth and modernization only

50

51. JEAN-FRANÇOIS MILLET
Faggot Gatherers Returning from the Forest,
about 1854
Black conté crayon on cream wove paper
Sheet: 28.6 x 46.7 cm (11 ¼ x 18 ⅜ in.)
Gift of Martin Brimmer 76.437

52. JEAN-FRANÇOIS MILLET
End of the Day, 1852–54
Black conté crayon heightened with white chalk
on blue-gray laid paper
Sheet: 23.6 x 33.1 cm (9⁵⁄₁₆ x 13 ¹⁄₁₆ in.)
Gift of Martin Brimmer 76.439

53. JEAN-FRANÇOIS MILLET
Study for Shepherdess Knitting, 1862
Black conté crayon on dark cream wove paper
Sheet: 31.4 x 24.2 cm (12 ⅜ x 9 ½ in.)
Gift of Mrs. J. Templeman Coolidge 46.594

54. JEAN-FRANÇOIS MILLET
Shepherdess Knitting, 1862
Etching on dark cream laid paper
Platemark: 32 x 24 cm (12 ⅝ x 9 ⁷⁄₁₆ in.)
Gift of Gordon Abbott 21.10786

55. JEAN-FRANÇOIS MILLET
Farmstead near Vichy, 1866–67
Watercolor and pen and brown ink over
graphite pencil on dark cream laid paper
Sheet: 22 x 29 cm (8 ¹¹⁄₁₆ x 11 ⁷⁄₁₆ in.)
Bequest of Reverend Frederick Frothingham
94.316

56. JEAN-FRANÇOIS MILLET
Road from Malavaux, near Cusset, 1867
Watercolor and pen and brown ink over
graphite pencil on cream laid paper
Sheet: 11.2 x 16.2 cm (4 ⁷⁄₁₆ x 6 ⅜ in.)
Gift of Martin Brimmer 76.425

reinforced the vogue for photographs with
pastoral themes. This type of picture also had
precedents in England during the 1840s, for
example in one of the earliest photographically
illustrated books, William Henry Fox Talbot's
Pencil of Nature (1844–46). The book featured,
among other things, a calotype of a haystack
and ladder and another of a sunlit doorstep
flanked by a simple straw broom, both of which
prefigure works such as these by Giroux and
Gaillard. KEH

1. Société française de photographie, *Bulletin* (1858): 107,
quoted in Jammes and Janis 1983, 184.

2. See Jammes and Janis 1983, 180–81; Gaillard's calotypes
were praised by fellow photographer Eugène Durieu as
being of such high quality that they could sometimes be
mistaken for glass, a very great compliment for a pho-
tographer of the period.

51

Jean-François Millet was born to a farmer in the peasant community of Gruchy, on the coastal edge of the village of Gréville, in Normandy. He took lessons in nearby Cherbourg from the portrait painter Bon Du Mouchel and the history painter Lucien-Théophile Langlois. A municipal stipend from Cherbourg underwrote his study in Paris in the studio of the history painter Paul Delaroche in 1837, but Cherbourg withdrew Millet's stipend when he left that studio following his failure in the Prix de Rome competition. Millet spent the 1840s painting portraits and genre and pastoral scenes. In 1847 he met the collector Alfred Sensier, who became the artist's most constant supporter and, later, biographer. Millet used the money from a government commission to flee the cholera epidemic of 1849; he settled with his family, which came to include nine children, born between 1846 and 1863, in Barbizon, a village in the Forest of Fontainebleau. There he concentrated on the agricultural themes that brought him fame. He was closely associated with Rousseau, Troyon, and Diaz. His paintings sold well in the last decade of his life, and he received both public and private commissions. Although he was portrayed as a peasant-painter, Millet's early schooling with two village priests inculcated in him a thorough knowledge of Latin literature and a love of reading. A deep sense of tradition is palpable in his works, allied to a sincere love of the countryside.[1]

In Barbizon, Millet held to a daily routine that consisted of working in the garden in the morning, painting in the afternoon, and when the light in the studio faded, taking a walk. On these walks he observed the end-of-day activities of the local farmers and shepherds and the effects of twilight on the landscape. Rather than sketching from nature, he returned to the studio and set his distilled observations down on paper, often revising and improving their compositions in succeeding sheets. Captivated by the beauty and silence of the Forest of

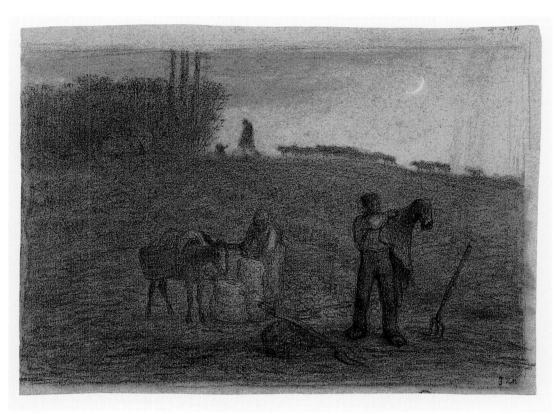

52

Fontainebleau, Millet approached landscape in the early 1850s with a stronger interest than ever before. He attempted to capture light effects that would communicate the atmosphere and mood of different times of day and improve the settings for his figures. His black conté crayon drawing *End of the Day* (cat. no. 52) depicts a farmer and his wife who have finished their work in the field and are packing up the vegetables they harvested to be carried home on their donkey's back. Their figures are almost lost in the dark and shadowed field. On the crest of the hill, a shepherd leads his sheep to a resting place for the night. This evocative drawing captures the end of the farm laborers' day.[2] The location of *End of the Day* was identified in the 1875 auction of Millet's studio effects (held in Paris after the artist's death) as La Plante-à-Biau, lying just outside the village of Barbizon. This hilly area with a stand of young

trees was also represented in Rousseau's cliché-verre *Cherry Tree* (cat. no. 23). Millet's motif of the sheep and shepherd, silhouetted on the horizon, appears often in his paintings and pastels of the 1850s and 1860s. His presentation of them as remote was based on real experience, for the men who tended the large, wandering herds were isolated from the local community.

The three women depicted in *Faggot Gatherers Returning from the Forest* (cat. no. 51) are also set apart from their rural community, both socially and visually. The woman in the foreground, dragging an enormously long walking stick, has a young face, a fact that further emphasizes her plight. These were the poorest women of the village, who gathered fallen branches from the forest floor and fastened this firewood into a faggot, which often was so large they could scarcely carry it on their backs. Millet saw them at the end of the day, leaving

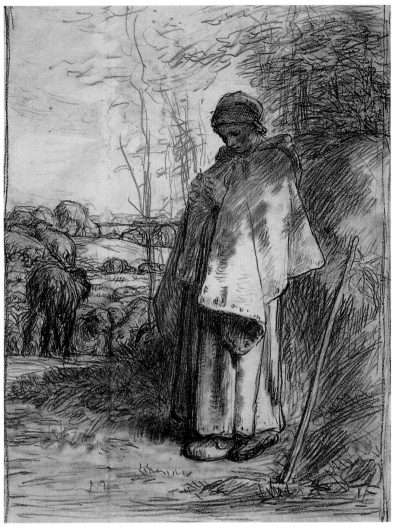

53

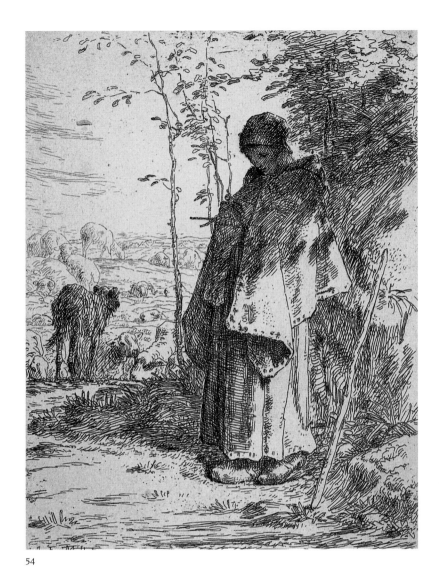

54

the Bas Bréau area of the forest, near the road to Barbizon. This particular image intensifies the dehumanization of the women. Defined by similar strokes of black conté crayon, the human bodies appear to unite with their burdens and merge with the tree trunks behind them.[3] Nature dominates in such drawings as this—peasants are subsumed into the landscape and become one with it.

In 1855 or 1856, at the urging of his patron Sensier, Millet made his first etchings for the market, with modest success. After a few years of concentrating on drawing and painting, he was encouraged to take up etching again by the noted print collector Philippe Burty. *Shepherdess Knitting* (cat. no. 54) was possibly a commission from Alfred Cadart, a prestigious print publisher and founder of the Société des Aquafortistes. Its large size, strong composition, and linear vitality make this Millet's most successful work in

this medium. Though the composition is dominated by the figure of a young shepherdess who quietly concentrates on her knitting, Millet consciously demonstrates his growing interest in landscape. A well-developed pastoral scene composed of a sheep-filled meadow and a distant village provides a detailed setting, while a huge rock serves as a backdrop for the figure itself. Millet makes the viewer aware of the omnipresence of nature by using dappled light and shade to create a leafy pattern on the shepherdess's thick cloak that suggests she is embraced by the foliage of the trees that rise above her. Millet treated the subject a number of times, but this image most strongly integrates landscape and figure.[4]

A figure painter by training, Millet had always included generalized landscape elements in his outdoor paintings of peasants. However, beginning in the early 1860s, landscape acquired

more importance in such works as *Shepherdess Knitting*. By 1863, encouraged by Rousseau, Millet began to depict pure landscapes, without any human figures. The opportunity to focus on the subject came during trips to Vichy in the summers of 1866 to 1868, when Millet and his wife spent a month at the spa in the hope of improving her delicate health. While his wife took the mineral waters, Millet walked about the surrounding countryside, making rapid pencil sketches in tiny sketchbooks. Back at the inn, he would go over the lines in pen and ink and sometimes add watercolor washes.

The two drawings *Farmstead near Vichy* (cat. no. 55) and *Road from Malavaux, near Cusset* (cat. no. 56) probably date from the 1867 trip. They are on larger sheets and finished to a degree that suggests they may have been completed at the Barbizon studio. *Farmstead near Vichy* depicts a farmhouse and outbuilding seen

behind a thick green hedge. Rising above the rooftops are three trees, each of a different species. The freely scribbled pen and ink lines resemble Millet's confident manner of etching as seen in *Shepherdess Knitting* and recall drawings by Rembrandt, whose work he admired. His interest in characterizing individual trees seems to reflect Rousseau's authoritative style (see cat. nos. 22 and 23). Millet's most inventive work during the last decade of his life is found in his landscapes. *Road from Malavaux, near Cusset* is highly original in its close-up study of ordinary, undramatic ground surfaces and anticipates such a work of the next century as Auguste Lepère's protoabstract *Saint-Jean-de-Monts* (cat. no. 127). Millet's interest in depicting what simple dirt has to tell is continued in paintings from his last years, including *Priory at Vauville, Normandy* (cat. no. 58).

Although Millet sold some drawings during his lifetime, he kept many to show to clients so that they could choose the subject of a commissioned painting. Thus, a large number of drawings were included in the 1875 auction of his studio effects. *End of the Day, Faggot Gatherers Returning from the Forest, Farmstead near Vichy,* and *Road from Malavaux, near Cusset* were among those purchased by Boston collectors at that sale and later donated to the Museum of Fine Arts. SWR and FEW

55

1. This text is based primarily on Alexandra Murphy's publications on Millet; see Murphy 1984 and Murphy et al. 1999.

2. It refines an earlier, rougher sketch, *Shepherd and Flock on the Edge of a Hill, Twilight* (93.1455), also in the Museum's collection.

3. A drawing in the Museum of the same subject from about 1850, *Faggot Carriers on the Edge of Fontainebleau Forest* (76.435), provides a grassy slope for the women emerging from the forest, which is less desolate than the bare, undefined space of the drawing under discussion.

4. The Museum owns two others: another black conté crayon drawing, *Shepherdess Knitting (Study for Shepherdess Knitting beside a Tree)* (76.432), and a pastel, *Shepherdess Knitting, outside the Village of Barbizon* (17.1494).

56

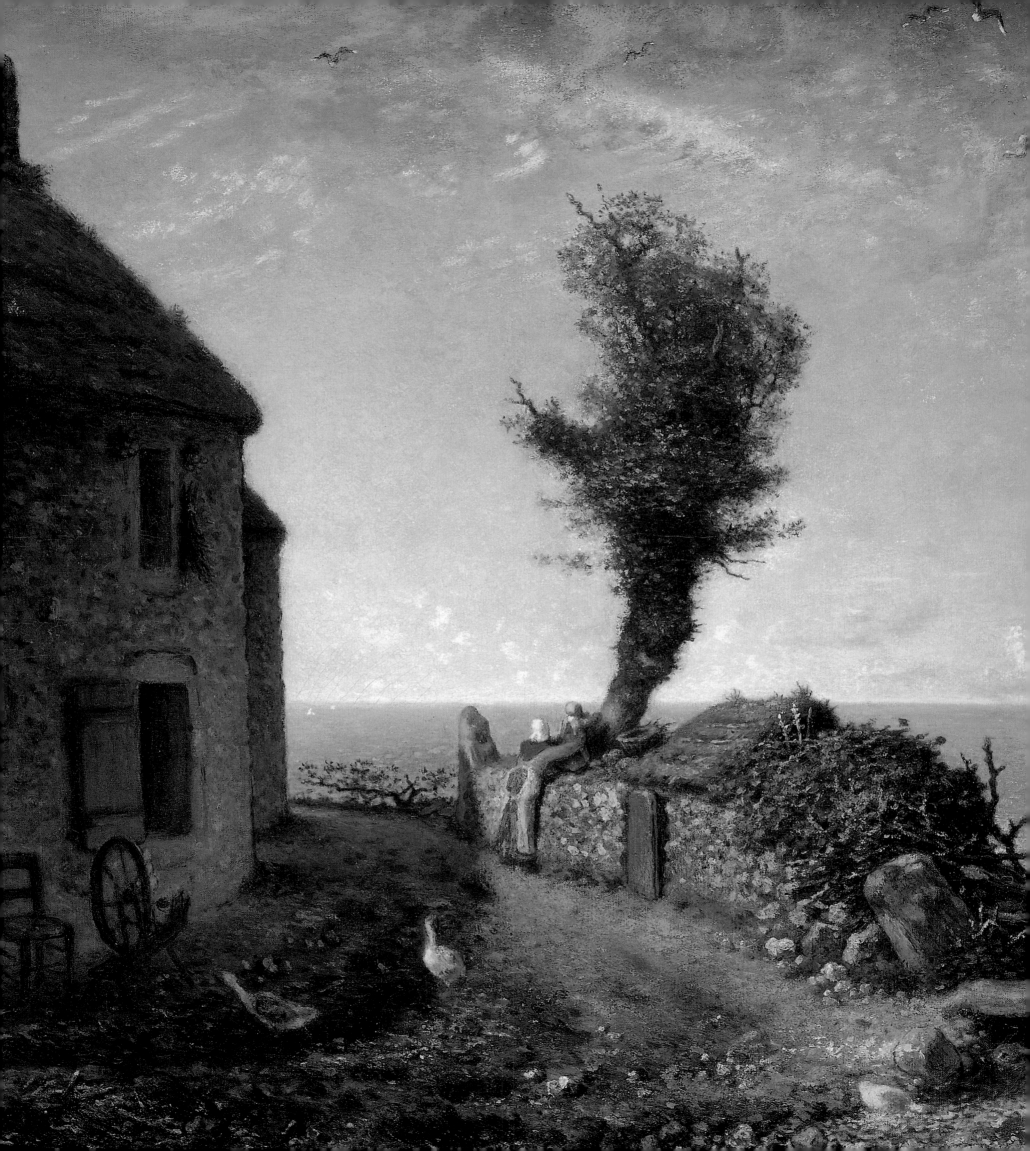

Jean-François Millet

French, 1814–1875

57. JEAN-FRANÇOIS MILLET
End of the Hamlet of Gruchy, 1866
Oil on canvas
81.5 x 100.5 cm (32⅛ x 39⅝ in.)
Gift of Quincy Adams Shaw through Quincy A.
Shaw, Jr., and Mrs. Marian Shaw Haughton
17.1508

58. JEAN-FRANÇOIS MILLET
Priory at Vauville, Normandy, 1872–74
Oil on canvas
90.9 x 116.7 cm (35⅞ x 46 in.)
Gift of Quincy Adams Shaw through Quincy A.
Shaw, Jr., and Mrs. Marian Shaw Haughton
17.1532

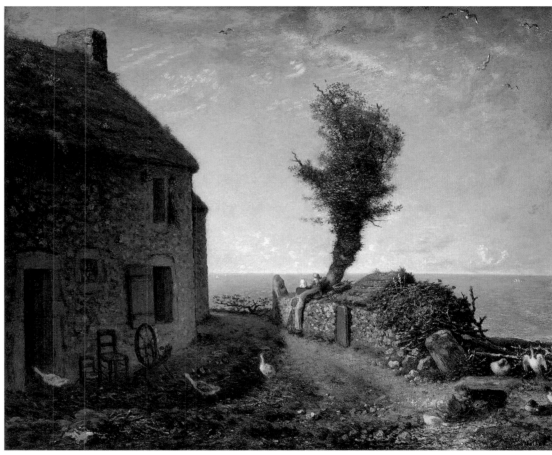

57

Millet is so intimately associated with Barbizon (he moved his family there from the capital in 1849) that his attachment to his native Normandy is sometimes overlooked. This painting of his coastal hometown, Gruchy (cat. no. 57), evinces a profound affection for the scene depicted,[1] particularly for "the habitual peacefulness of the place, where each act, which would be nothing anywhere else, here becomes an event."[2] The stone house stands at the end of the single street of the village, where land meets water. Domestic details abound: the two chairs by the spinning wheel, the family of ducks at the right, and the endearing procession of geese heading purposefully indoors, the last in line looking up as if to check the weather. Most poignant are the mother and child who have just vacated their chairs. In a letter, the artist described the scene. During a break from spinning, and to amuse the child,

> the woman picked him up and sat him on the little wall where he plays. . . . I would like to have the power to express for the viewer the thoughts that must enter, for life, the mind of a young child who has never experienced anything other than what I have just described, and how this child, later in his life, will feel completely out of place in a city environment.[3]

It is hard to avoid concluding that in this letter Millet was thinking of his own feelings when he lived in Paris.

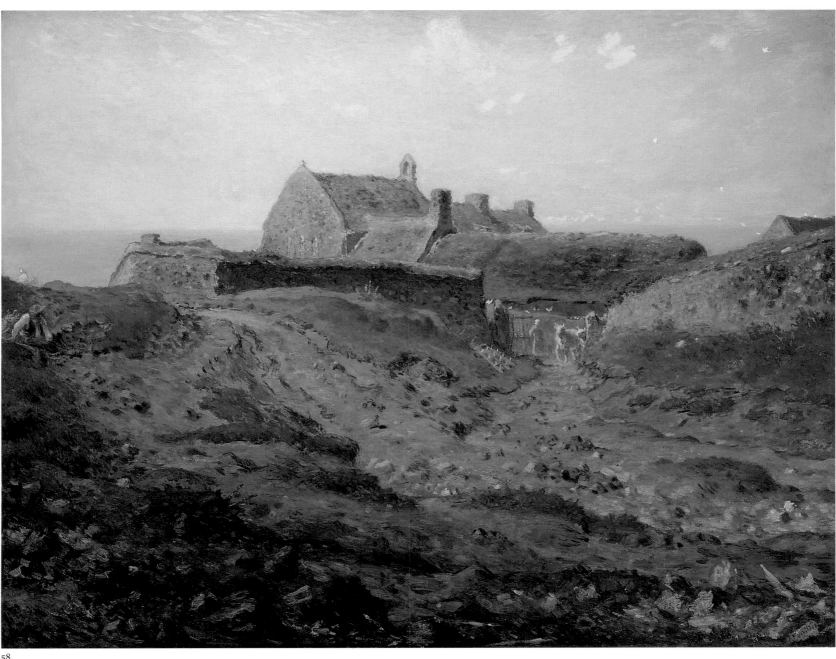

58

The child reaches for the tree—an elm, Millet tells us—that clings to the coastal soil. A symbol of tenacity and strength, by 1866 it nonetheless had succumbed to the winds off the channel.[4] It lives on in the painting, perched at the edge of Normandy, its home, yet reaching out, its limbs anthropomorphized as if yearning for the unknown. In another letter Millet described the view to be had standing by the elm:

> Suddenly one faces the great marine view and the boundless horizon. . . . Imagine the impressions that one can get from such a place. Clouds rushing through the sky, menacingly obscuring the horizon, boats sailing to faraway lands, tormented, beautiful, etc., etc.[5]

Millet's modifiers—menacingly, tormented, beautiful—betray an ambivalence about his home; perhaps he feels he should have stayed. Some of this ambivalence can be seen in the painting: the house is cast largely in shadow, and the geese are moving indoors (Millet told Théophile Silvestre that the house was the "constant goal" of the geese). The overwhelming impression, however, is one of contentment and delight in nature's beauty. Even this humble spot is beautiful. Millet lavishes color everywhere, from the flowers growing in the thatch of the roof to the blue-speckled stream to the lavenders and pinks in the sky and water. The entire scene sparkles with sunlight, evoking the clean, salty air of the sea.

Millet's painting of a priory at Vauville, Normandy, shows another structure from his native province and emphasizes the thriftiness of the rural French (cat. no. 58). The group of eleventh-century granite buildings, built at the edge of cliffs overlooking the English Channel, formed a priory, a religious institution headed by a prior, a rank one step below an abbot. As with many other religious buildings in France, it was removed from church control during the French Revolution. Not to let good buildings go to waste, local people converted the structures to the agricultural use Millet records here: the chapel was a barn for the farmer, who lived in another building.

Unlike his earlier depiction of the sea from his home in Gruchy, here only very little of the channel waters can be seen (to the left and right of the central buildings), yet the presence of the open water is felt intensely. The rocky, rutted foreground, up to the stone boundary wall, takes up the bottom half of the picture. Because this foreground, despite its details of rocks and grass, is untended, formless land, it directs attention to the priory and its horizontal lines of wall and roofs. This combination of unfocused space and horizontality powerfully suggests the expanse of sea beyond.

Millet is concerned with showing that these buildings and this land are being used. A woman opens the gate for the white cows on their way to pasture along the cliffs; perhaps the man sitting to the left is waiting for them. Chickens are visible close to the largest building. The teeth of a harrow lying on the hillside outside the wall sparkle in the sunlight: even this unpromising soil can be made to yield crops.

Just as these farmers are able to make a living at the edge of the continent, so is Millet able to make a ravishing painting from the same scrap of land. Darker colors at the bottom gradually give way to lighter colors as the space moves back through the farm buildings, beyond to the sea, and up to the sky. Likewise, brushstrokes become smaller and more even, enlivened by spots of bright white representing highlights on cows, chickens, and clouds.

Millet was pleased with this painting, if the following anecdote can be trusted. A young Canadian-born American painter named Wyatt Eaton befriended Millet at the end of the Frenchman's life. Eaton visited Millet at Barbizon in 1873 and saw *Priory at Vauville* on an easel.

It is reported that "the evident admiration and delight of the young man pleased Millet, who called him nearer, and bade him notice the simplicity of his execution, and the infinite variety of effect that can be produced by a few touches."[6] It is easy to agree with this assessment, particularly because the contrast of variety and simplicity is exactly what makes this painting so engaging. FEW and GTMS

1. The discussion of this painting is indebted to Murphy 1984, no. 111.

2. Millet to Théophile Silvestre, April 20, 1868, quoted in Murphy 1984, 243.

3. Ibid.

4. Millet to Alfred Sensier, February 6, 1866, quoted in Murphy 1984, 243.

5. Millet to Silvestre, April 18, 1868, quoted in Murphy 1984, 243.

6. Cartwright 1896, 339.

Jean-François Millet
French, 1814–1875

59. JEAN-FRANÇOIS MILLET
Rabbit Warren, Dawn, 1867
Pastel and black conté crayon on cream wove paper
49.5 x 59.5 cm (19½ x 23⅜ in.)
Gift of Quincy Adams Shaw through Quincy A. Shaw, Jr., and Mrs. Marian Shaw Haughton
17.1522

60. JEAN-FRANÇOIS MILLET
Primroses, 1867–68
Pastel on gray-brown wove paper
40.2 x 47.8 cm (15⅞ x 18⅞ in.)
Gift of Quincy Adams Shaw through Quincy A. Shaw, Jr., and Mrs. Marian Shaw Haughton
17.1523

61. JEAN-FRANÇOIS MILLET
Dandelions, 1867–68
Pastel on tan wove paper
40.2 x 50.2 cm (15⅞ x 19¾ in.)
Gift of Quincy Adams Shaw through Quincy A. Shaw, Jr., and Mrs. Marian Shaw Haughton
17.1524

Having experimented with pastel early in his career in the 1840s, Millet turned to the medium with greater seriousness in the 1860s, when he was commissioned by the collector Emile Gavet to produce a series of pastel paintings on themes of his own choice. Among the works that Millet made for Gavet in the initial years of their agreement is *Rabbit Warren, Dawn* (cat. no. 59). The pastel depicts a site in the Gorges d'Apremont, a hilly, boulder-strewn area of the Forest of Fontainebleau—in which Millet is said to have walked every day—near the village of Barbizon. As the light of dawn breaks over the high horizon, two rabbits have emerged from their burrows, at lower left, to nibble grasses on the hillside. One rabbit, its ears held back, lies close to the ground, its eye turned toward the viewer; another, its ears erect, sits alert near the very center of the composition. A third rabbit, performing a morning toilette, is silhouetted against a clump of branches at the right.

Like his drawing *End of the Day* (cat. no. 52), this pastel reveals Millet's interest in the moments between light and dark: he himself called *Rabbit Warren* by the title *crépuscule matin,* or "the twilight of morning." The crayon drawing that establishes the composition is visible throughout the landscape, while the sky is treated only with the palest strokes of chromatic color, blue streaked with yellow and pink. The earth below is rendered in murky hues of ocher, brown, and green. Through the central ledge of space defined between the bottom of the hill and the point where it rises to its boulder-topped summit, however, Millet introduces a subtle range of color contrasts: a bush at left, with dark green spiky leaves, bears flowers of deep plum rose tint; grizzled olive green grasses are highlighted with subtle touches of mauve; and at right, the claret red leaves or flowers on a scrubby bush contrast with a patch of deep verdigris moss or grass.

Millet's gentle attention to the most delicate effects of light, color, and texture, his discovery of majesty in the dawn, of mystery in the silent movements of the animals, reflects his almost pantheistic reverence for nature. Just after Christmas, 1865, Millet wrote to Gavet that Barbizon had experienced

> some superb effects of fog and hoarfrost so fairy-like it surpasses all imagination. The forest was marvellously beautiful in this attire, but I am not sure whether the most modest objects, the bushes and briars, tufts of grass, and little twigs of all kinds were not, in their way, the most beautiful of all. It is as if Nature wanted to make amends to them, showing that these poor things in all their humility are inferior to no other thing. At any rate, they have had three glorious days.[1]

The sense that the wonder of nature may be discovered in its quietest moments and experienced in the presence of its humblest elements pervades two of Millet's most moving landscape pastels, *Primroses* (cat. no. 60) and *Dandelions* (cat. no. 61), made for Gavet in 1867 or 1868. Both pictures show clumps of flowers against verdant backgrounds, and in both, the pastel is densely applied in painterly strokes, so that none of the preparatory drawing is visible. In *Primroses,* a group of common cowslips is seen at the edge of a dense, dark thicket, amid broken twigs and spiky leaves of grass; the deep browns and greens of the shadows are a brilliant foil for the bright yellow flowers with their pale green stems and sepals. Millet's dandelions are lit by a dappled ray of sunshine, so that their feathery white seed globes seem to glow from within; yellow sunlight strikes the turf at left and filters through the leaves of clover in the background. Time passes: a snail crawls upon a rock at the base of the cowslips, and downy dandelion seeds detach from their heads and fall toward the earth.

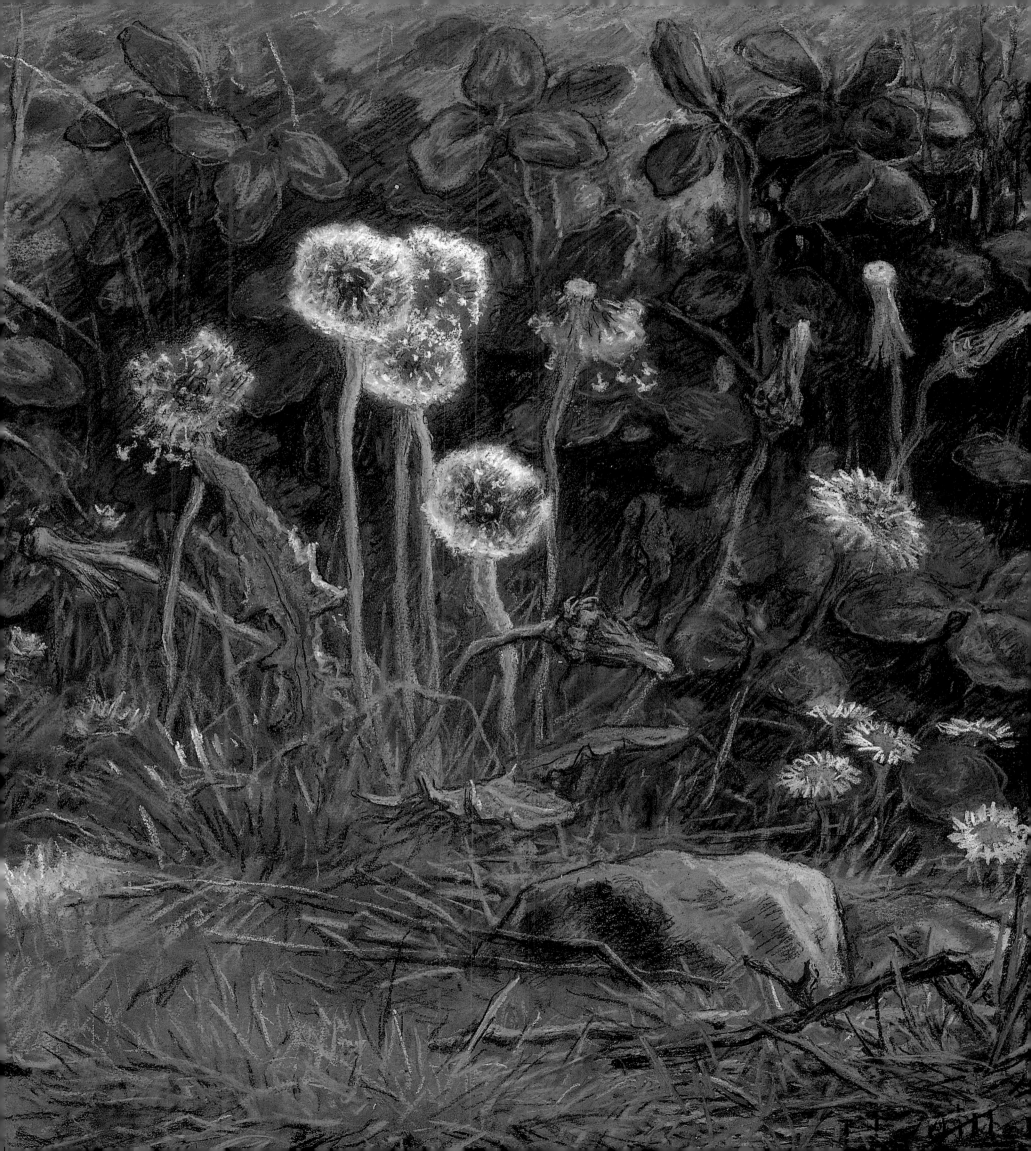

59

The closest parallel to Millet's vision of nature may lie in the writings of the American poet Walt Whitman. In a passage that corresponds closely to Millet's depiction of rabbits at dawn or flowers of wood or field, Whitman wrote of his joy at seeing the world around him waken to the day, as he went "out just after sunrise, and down towards the creek." He sensed "the fresh earth smells—the colors, the delicate drabs and thin blues of the perspective" as "the sun silently mounts in the broad clear sky, on his day's journey," feeling its rays "come streaming kissingly and almost hot on my face." Then came "the golden dandelions in endless profusion, spotting the ground everywhere. The . . . wild violets, with their blue eyes looking up and saluting my feet, as I saunter the wood-edge . . . the summer fully awakening."[2]

When in 1881 Whitman was taken to see the collection of Quincy Adams Shaw, he spent "two rapt hours" studying the marvels of Millet's art exhibited there. Among the works he must have seen are *Rabbit Warren, Dawn, Primroses,* and *Dandelions,* although he did not comment on any of them in the diary entry that he later published. He must have found in these humble subjects a harmony with his own writings on nature, just as he recognized the greatness of Millet's more overtly political paintings, notably *The Sower* (fig. 3). "Besides this masterpiece," he wrote,

there were many others . . . all inimitable, all perfect as pictures, works of mere art; and

then it seem'd to me, with that last impalpable ethic purpose from the artist (most likely unconscious to himself) which I am always looking for. If for nothing else, I should dwell on my brief Boston visit for opening to me the new world of Millet's pictures. Will America ever have such an artist out of her own gestation, body, soul?[3]

"American Democracy," he wrote a year later, "must either be fibred, vitalized, by regular contact with out-door light and air and growths, farm-scenes, animals, fields, trees, birds, sun-warmth and free skies, or it will certainly dwindle and pale."[4]

Who would be the American equivalent to Millet? Although William Morris Hunt, Boston's native son, would carry the banner of Barbizon painting in the years after his return from France, he was not the artist of Whitman's imagining. It was, instead, Hunt's contemporary the Boston-born painter Winslow Homer — whose awareness of and indebtedness to Millet remain to be studied—who would answer Whitman's call for an artist of "impalpable ethic purpose," "fibred, vitalized," by rugged nature.[5]
GTMS

1. Millet to Gavet, December 28, 1865, quoted in Murphy 1984, 197 (variations in translation). Murphy's analysis and interpretation of Millet's works inform this discussion.

2. Walt Whitman, "Bumble Bees," in *Specimen Days,* collected in Whitman 1982, 783–84.

3. Whitman, "Millet's Pictures—Last Items," in *Specimen Days,* collected in Whitman 1982, 903–4.

4. Whitman, "Nature and Democracy—Morality," in *Specimen Days,* collected in Whitman 1982, 925–26.

5. Erica Hirshler, Croll Senior Curator of Paintings, Art of the Americas, MFA, points out that Homer has a direct link to William Morris Hunt and the Boston partisans of Millet through Joseph Foxcroft Cole, a friend of Homer's since the 1850s.

60

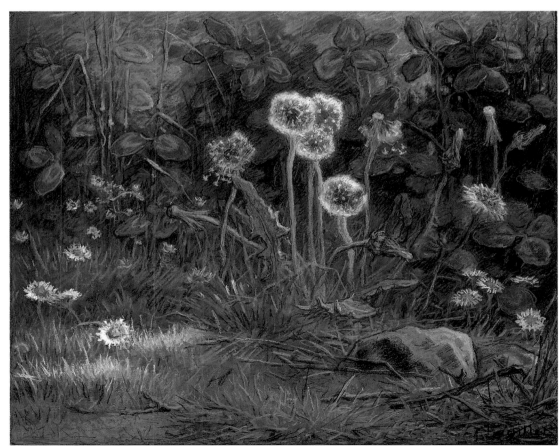

61

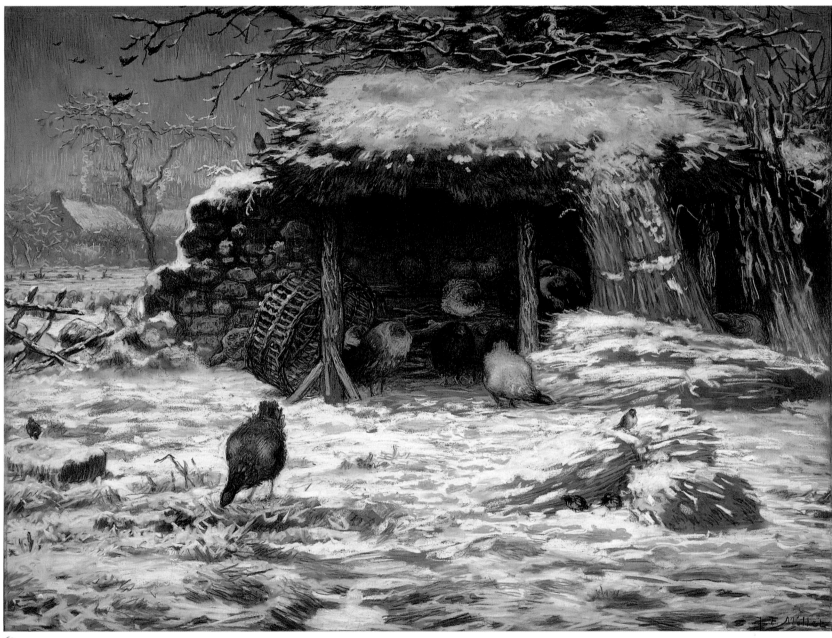

62

62. JEAN-FRANÇOIS MILLET
Farmyard in Winter, 1868
Pastel and black conté crayon on buff wove paper
68 x 88.1 cm (26¾ x 34⅝ in.)
Gift of Quincy Adams Shaw through Quincy A.
Shaw, Jr., and Mrs. Marian Shaw Haughton
17.1526

63. JEAN-FRANÇOIS MILLET
Farmyard by Moonlight, 1868
Pastel and black conté crayon on tan wove paper
70.9 x 86.7 cm (27⅞ x 34⅛ in.)
Gift of Quincy Adams Shaw through Quincy A.
Shaw, Jr., and Mrs. Marian Shaw Haughton
17.1525

Two magnificent pastels of 1868 transform a humble farmyard into a world of mystery and profound sentiment. Both were painted in pastel by Millet for his patron Emile Gavet and rank among his most important efforts in the medium, not only for their unusually grand scale—each is as large as most oil paintings by the artist—but also for their brilliance of execution. The two pastels were purchased after Gavet's 1875 sale of his Millet pastel collection by Quincy Adams Shaw, through whose heirs they were presented to the Museum of Fine Arts.

As Alexandra Murphy noted, *Farmyard by Moonlight* (cat. no. 63) may be Millet's most ambitious crayon drawing, executed on a larger scale than ever before.[1] Here the artist uses only a handful of crayons and chalks in an extremely reduced range of hues: black is everywhere, heightened with white, and touches of blue and pink are placed here and there. Between the coolness of the blues and the sparing warmth of the pinks is the tone of the warm taupe paper that lies beneath the pastel as a whole, providing the median tone for the blacks and whites, as well.

Human life is hardly hinted at in the composition. As Murphy recognized, the scene seems almost an illustration of Millet's favored line from a French translation of Milton's *Paradise Lost,* "the silence listens" [le silence écoute].[2] But it seems, as well, that Millet may have treasured the image not only for its evocation of the absence of sound but also for the challenge that it posed for the rendering of half-light, a recurring interest in his work. Millet's friend the critic Théophile Silvestre annotated a copy of Gavet's sale catalogue with commentaries on each work. Beside the entry for this work, there called *Cour de ferme la nuit* (Farmyard at Night), he wrote, "What Millet called the loveliness of shadow" [Ce que Millet appelait le bel ombreux].[3]

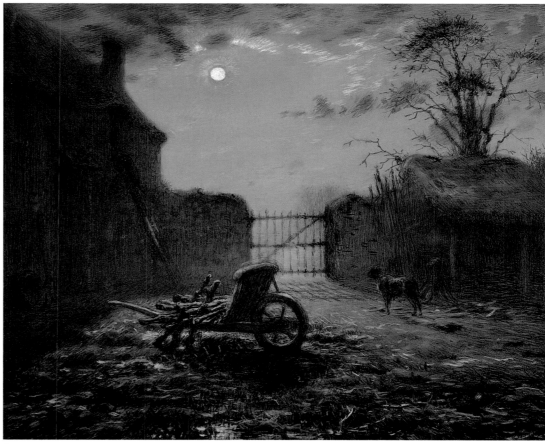

63

In contrast to *Farmyard by Moonlight,* dominated by coal-black shadow, the snowy image of *Farmyard in Winter* (cat. no. 62) is distinguished by the greater role that the artist gives to white. Millet's beloved black crayon retreats, here, to the shadows beneath the thatched roof of a farmyard roost for fowl. Strokes of pure white pastel mingle with carefully chosen touches of pink, yellow, ocher, and cool blue-gray in the foreground, on the roof of the hut, on the branches of the trees and houses in the background, and in the leaden sky. More vivid touches of green, yellow, and red highlight the stones on a broken wall, the fluffed-out feathers of a rooster, his cockscomb, and the breast of a robin. As in *Farmyard by Moonlight,* the color of the paper support plays an important role. Here, however, the paper is not used to establish broad areas of tone. Rather, the darker color of the paper beneath the strokes of white pastel gives the sense of the sleeping earth, now and then visible beneath the frost and drifted snow. GTMS

1. Murphy 1984, 201.

2. Ibid.

3. Silvestre 1875.

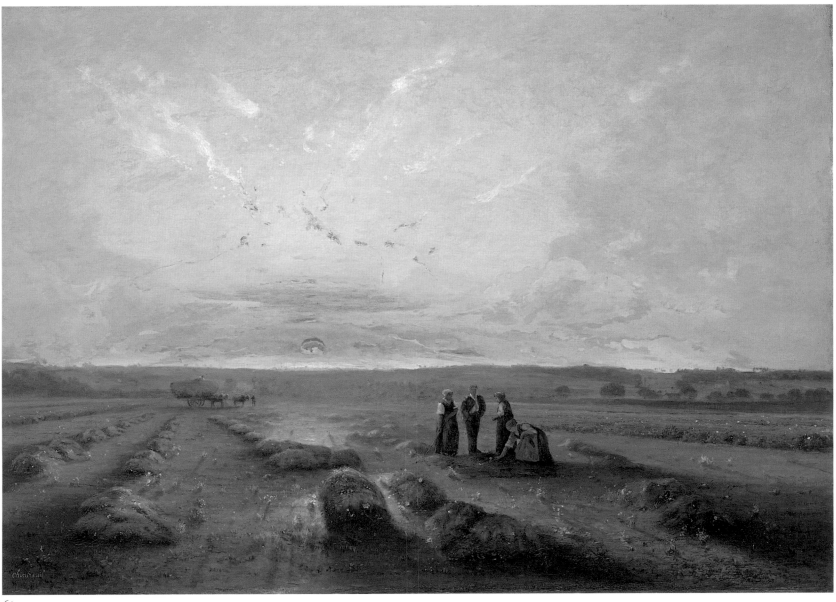

64

Antoine Chintreuil
French, 1816–1873

64. ANTOINE CHINTREUIL
Last Rays of the Sun on a Field of Sainfoin,
about 1870
Oil on canvas
95.8 x 134 cm (37¾ x 52¾ in.)
Gift of Mrs. Charles Goddard Weld 22.78

Antoine Chintreuil did not arrive in Paris until 1838, at which time he worked as a bookseller. The primary influence on his painting was that of Corot, whom he met in the 1840s; he listed himself as "a pupil of Corot" in the Salon catalogues throughout his career. However, he was probably mainly self-taught. He was dogged in his pursuit of an artistic career, weathering repeated rejections by the Salon jury in the mid-1840s. The years of the Second Republic and Second Empire were good to him, though: several of his paintings were bought by the state through the 1850s. His most productive period began in 1857, when he settled at Septeuil, near Mantes. After 1863, when he showed the three paintings that had been rejected by the Salon jury in the Salon des Refusés, his reputation grew. He received a medal at the Salon of 1867 and the Legion of Honor in 1870. Chintreuil was particularly known for weather and light effects, some of which were unusual. Georges Lafenestre wrote in the July 1873 issue of the *Gazette des Beaux-Arts*:

> M. Chintreuil loves to seize that which appears unseizable, to express that which seems inexpressible; the vegetable, geological, atmospheric complications attract him inevitably; his curious mind and his skillful brush are only at ease in the midst of the strange and unexpected; when he succeeds he creates prodigies.[1]

Such a prodigy is *Last Rays of the Sun on a Field of Sainfoin*, striking for its lurid yellow-orange sunset. More than four feet wide, the picture threatens to engulf the viewer by virtue of its size and luminosity. Chintreuil was attracted to sweeping vistas painted at large scale and dominated by strong light effects.[2] *Last Rays of the Sun* exemplifies this tendency. Here the field seems to stretch indefinitely to the low hills in the distance, and more than half of the canvas is given over to the sky.

In his attention to a specific light effect, Chintreuil showed himself a faithful follower of Corot, having learned from the master the importance of capturing the overall impression of a scene and ignoring any potentially distracting details. Yet Chintreuil's effect could hardly be more different from Corot's soft, silvery light. Chintreuil's effulgent sky "is more consonant with a belated spirit of Romanticism, a resonant hymn of praise and wonder before the varied majesties of nature,"[3] than it is a careful naturalistic study. The hot light does two things. In the sky and at the horizon it seems to take on material form, much as does the light of the English painter J. M. W. Turner, although there is no evidence that Chintreuil had seen the latter's paintings. And like the animating light of the German painter Caspar David Friedrich or of the midcentury American luminist painters such as Martin Johnson Heade,[4] it makes the piles of the harvested crop glow eerily. (This crop, mauve-colored and interspersed with pink flowers, is sainfoin, a perennial leguminous herb grown to feed livestock.) The novelist and journalist Emile Zola trenchantly described Chintreuil's accomplishment: "One senses an artist who is striving to go beyond the leaders of the Naturalist school of landscape painting and who, although faithfully copying nature, attempted to catch her at a special moment difficult to transcribe."[5] Chintreuil himself considered this an important painting and exhibited it at the Salon of 1870, having to borrow it back from a M. Fassin, in Reims, to whom he had already sold it. FEW

1. Georges Lafenestre in *Gazette des Beaux-Arts* (July 1873), quoted in Clement and Hutton 1879, 1:136.

2. For the best-known example, see his *Expanse*, measuring 102.2 by 201.9 cm (41¼ x 79½ in.), in the Musée d'Orsay, Paris.

3. Rosenblum 1989, 118.

4. Ibid.

5. Zola 1959, 204.

Jean-Baptiste-Camille Corot

French, 1796–1875

65. JEAN-BAPTISTE-CAMILLE COROT
Bacchanal at the Spring: Souvenir of Marly-le-Roi,
1872
Oil on canvas
82.1 x 66.3 cm (32⅜ x 26⅛ in.)
Robert Dawson Evans Collection 17.3234

66. JEAN-BAPTISTE-CAMILLE COROT
Bathers in a Clearing, about 1870–75
Oil on canvas
92 x 73.2 cm (36¼ x 28⅞ in.)
Gift of James Davis 76.4

67. JEAN-BAPTISTE-CAMILLE COROT
Sketch to Show How Six Paintings Should Be Hung,
1860s
Pen, brown ink, and brown wash on cream
ruled writing paper
Sheet: 10 x 7.8 cm (3¹⁵⁄₁₆ x 3¹⁄₁₆ in.)
Helen and Alice Colburn Fund 62.754

68. JEAN-BAPTISTE-CAMILLE COROT
*Landscape, with Large Tree on Left, Two Figures at
Right, One Holding Long Pole,* 1860s
Brush and brown wash on beige wove paper
Sheet: 7 x 9.5 cm (2¾ x 3¾ in.)
Helen and Alice Colburn Fund 62.753

69. JEAN-BAPTISTE-CAMILLE COROT
*Landscape, with Grove of Trees at Left, Two Men
with Long Poles at Right,* 1860s
Brush and brown wash on beige wove paper
Sheet: 5.9 x 10.3 cm (2³⁄₁₆ x 4¹⁄₁₆ in.)
Helen and Alice Colburn Fund 62.755

Fig. 41. Jean-Baptiste-Camille Corot, *Bacchante with a
Panther,* 1860, reworked about 1865–70, Shelburne
Museum, Vermont.

Throughout his long career, which spanned
the middle of the nineteenth century, Corot
remained faithful to the classical tradition.
Nymphs and bathers often animated his care-
fully observed landscapes, thereby linking
antiquity with the nineteenth century's interest
in optical verisimilitude and naturalism. In
Bacchanal at the Spring: Souvenir of Marly-le-Roi
(cat. no. 65), fictive figures disport themselves
in a forest glade. In the foreground a woman
reclines, leaning on a pitcher from which water
flows. Farther back, a figure wearing a red cap
(perhaps a satyr?) plays panpipes and a woman
raises a tambourine. A woman in pink dances to
the music and strikes a pose in front of a child
riding a leopard. To the right, a woman in blue
watches. Surely this is not a scene from every-
day life; this view makes visible the feeling that
one is not alone in a forest. These figures are
the animating spirits of the woods, embodying
the freshness and renewal that nature was
thought to offer the city-bound audience of
Corot's art.

Such figures can be found throughout
Corot's paintings, sometimes isolated and to
monumental effect, as in *Bacchante with a Pan-
ther* (fig. 41), or else integrated, as in the Boston
painting. The reclining figure with the pitcher
can be traced to the seventeenth century, as
in Nicolas Poussin's *Amor omnia vincit* (The

Cleveland Museum of Art), and still farther
back to Poussin's source on antique sarcophagi.
Some of Corot's contemporaries, more commit-
ted to the depiction of everyday life, however
raw, were unsympathetic to his inclusion of the
classical world. Emile Zola complained: "If
M. Corot agreed to kill off, once and for all, the
nymphs with which he populates his woods and
replace them with peasant women I would like
him beyond measure." Yet despite his grum-
bling, Zola seems to have understood Corot's
aims, for he went on: "I know that for this light
foliage, this humid and smiling dawn, one must
have the diaphanous creatures, dreams clothed
in vapours."[1] As Zola knew, such figures are
crucial to an understanding of Corot's art, in
which tradition played a large role.

The magic of Corot's *Bacchanal* depends
on the way it combines a deep-seated regard
for tradition with an extraordinarily sensitive
rendering of light and atmosphere. The glade
seems to be in semidarkness, a protected,
secluded spot for these mysterious goings-on.
A blue sky and white clouds overhead signal
clement weather. A patch of sky at the right
gives form to the birch tree, which is more
directly illuminated by a shaft of light striking
it from the left. This light connects near and far,
for the eye moves from the whitish bark to the
sun-struck clearing beyond. The brightness of
the farther glade and the light on the tree at the
right serve to make the enclosing trees seem
darker, and indeed the foliage is painted in dark
greens tending to browns, enlivened by Corot's
signature flecks of light-colored paint that sit
sparklingly on the surface. Corot's subtle modu-
lation of these hues, the product of a long life
spent studying the effects of light outdoors,
faithfully replicates the interior darkness of a
forest.

By contrast to the fully visualized fiction
of nymphs and child astride a leopard, Corot's
Bathers in a Clearing (cat. no. 66) looks tentative.

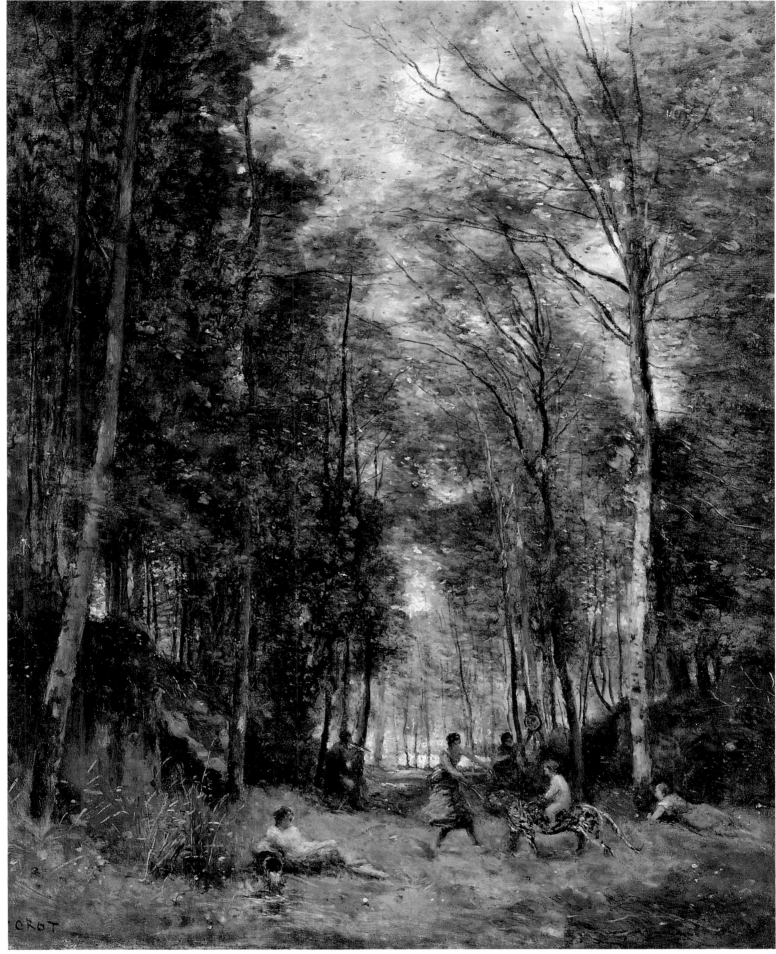

66

vagueness of my pictures. But why? Nature is in flux! We are in flux! Vagueness is the essence of life!"[2]

The theme of the bather—single or multiple female figures in the outdoors, nude or partly clothed—was a constant in Corot's career. How to integrate the figures with their surroundings, so that they do not look like cutouts pasted into place, was a problem Corot had wrestled with for years. *Bathers in a Clearing* represents the results of a lifetime of thinking about this problem.[3] These bathers are fully integrated into the glade by the river, with some of the brush strokes that form the undergrowth covering the contours of the figures.[4] They are thus joined inextricably to the landscape. Such a scene embodies ideas of Arcadia, a pleasant land where humans live in harmony with each other and the natural world, an idyllic realm aptly pictured by the softened contours, potential branches, and indistinguishable masses of foliage. This treatment relies on the viewer's subjective response to complete the artist's evocation of dream and mood.

The painting was appreciated by collectors as soon as the picture came on the art market following Corot's death. Only a little more than seven months after his studio sale, in early January 1876, the painting was accepted by the Trustees of the Museum of Fine Arts as a gift from the Bostonian James Davis. A daring choice for both Davis and the trustees at that time, *Bathers in a Clearing* epitomizes the poetic and classic aspects of Corot's long career.

Corot's drawings are a less appreciated aspect of his oeuvre. An inveterate sketcher, he drew in sketchbooks, on loose sheets, and on less formal supports such as cheap, lined paper (perhaps used for a receipt).[5] He sent sketches to friends to show them the paintings he was working on, made notations of the people and places he saw around him, and tried out ideas for future paintings.

Tree trunks peter out into thin air without bearing branches. Foliage appears either as a scrim from a stage set, as on the left, or as blots from a leaky pen, as along the limbs of the tree on the right. Pencil lines blocking in the primary masses of foliage of the tree on the right and indicating where further branches might go are still visible. The bathers themselves are little more than pinkish curves surmounted by round dark forms serving as heads. Although Corot did not sign the painting, indicating that it was

not ready for sale, he nonetheless left clues that he considered it as finished as it needed to be. The luminous sky, faintly streaked with pink, is, unlike the rest of the canvas, richly and thoughtfully textured with impasto. Corot's trademark red and pink flecks sit on the surface, deliberately placed. Thus the painting only appears to be unfinished; Corot worked on it as much as he wanted. He once said, defending himself against the criticism that his paintings were too sketchy: "I am reproached for the

He also was comfortable using a variety of drawing media. Early in his career he was partial to a hard graphite pencil, such as the type Aligny used to portray the tree near Civita Castellana (see cat. no. 3). Later on, in the 1850s and 1860s, he used charcoal or chalk, often on blue paper, to create moody, emotional effects. The drawings shown here, probably dating from the end of the artist's life, show him trying out a medium unusual for him, brush and brown wash. It is unfortunate that Corot did not make more drawings in brown wash, for the abbreviated forms created with the liquid medium well suited his simple compositions. The drawing of the single tree and the man with a long fishing pole conveys something of an Asian sensibility (cat. no. 68). The spareness of the forms, especially the lone tree, the emptiness of the space, and the figures of the men call to mind the long tradition in China of depicting hermit scholar-artists, withdrawn from the world of the court. The freedom with which forms are suggested finds a parallel in the blotlike treatment of the darkest tree in *Bathers in a Clearing*.

The best of Corot's mature work is characterized by the interplay of masses and empty space. His *Sketch to Show How Six Paintings Should Be Hung* (cat. no. 67) expands this notion of equipoise to a group of objects. Darks and lights call to and answer each other across the edges of their respective paintings. Trees mass in the center in the top register and move to the far sides in the middle. Framed differently, the six together constitute a dynamic group. Supported by the two horizontal paintings at the bottom, which may be in the most elaborate of the frames, the four vertical canvases are clustered into a towering block, its height accentuated by the trees within each picture. The visual weight of the massed interior edges and frames is, as is Corot's wont in individual canvases, balanced and, paradoxically, supported by the space between the two horizontal paintings

67

68

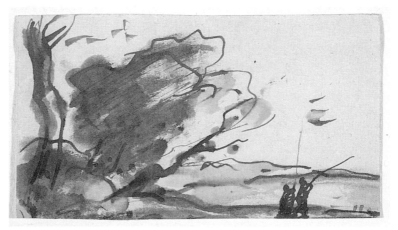

69

directly beneath. By no means a formal drawing—the lined paper speaks to the ad hoc circumstances of the image's creation.—*Sketch to Show How Six Paintings Should Be Hung* gives evidence of how a group of Corot's paintings could contrive to be greater than the sum of its parts. FEW

1. Zola 1974, 73, quoted in Clarke 1991a, 85.

2. Quoted in Claretie 1882–84, 1:106; this author's translation from the French.

3. In the sale catalogue of Corot's studio effects, Alfred Robaut, Corot's self-appointed biographer, dated this work to May 1874 and gave it the title *At Ville-d'Avray, the*

Valley behind the Property of the Master. Oddly, he included the bathers in neither the title nor the sketch he made of the work. See Robaut and Moreau-Nélaton 1905, 4:215, no. 210.

4. Jim Wright, paintings conservator at the Museum of Fine Arts, made this observation, important in establishing the fact that Corot himself painted the figures.

5. The Département des arts graphiques at the Musée du Louvre has about seventy-five percent of Corot's sketchbooks as well as hundreds of his drawings.

Charles-François Daubigny

French, 1817–1878

70. CHARLES-FRANÇOIS DAUBIGNY
Château-Gaillard at Sunset, about 1873
Oil on canvas
38.1 x 68.5 cm (15 x 27 in.)
Gift of Mrs. Josiah Bradlee 18.18

71. CHARLES-FRANÇOIS DAUBIGNY
The Boat-Studio, 1861
Etching on cream laid paper
Platemark: 13 x 17.8 cm (5 ⅛ x 8 ⁷⁄₁₆ in.)
Special Print Fund, 1916 M26211

72. CHARLES-FRANÇOIS DAUBIGNY
Tree with Crows, 1867
Etching on cream wove paper
Image: 18 x 27.4 cm (7 ⁷⁄₁₆ x 10 ¹³⁄₁₆ in.)
Frederick Keppel Memorial Bequest, 1913
M23423

73. CHARLES-FRANÇOIS DAUBIGNY
The Ford, 1863
Cliché-verre, salt print, reverse-printed
Sheet: 27.2 x 36.3 cm (10 ¹¹⁄₁₆ x 14 ⁵⁄₁₆ in.)
Stephen Bullard Memorial Fund 1997.106

Charles-François Daubigny's father was a landscape painter who had studied with Jean-Victor Bertin, Corot's first teacher. Thus, unlike many other artists, Daubigny did not have to overcome parental opposition in pursuit of his career. He worked variously as a decorator of ornamental objects and a restorer and went to Italy for six months in 1836. He had an active and respected career as a graphic illustrator beginning in 1838, the year he also began to exhibit in the Salon. In 1852 he met Corot, and the two remained close friends all their lives. In 1857 Daubigny launched his *botin,* or floating studio, which he piloted along the Seine, Marne, and Oise Rivers, painting directly from nature. He settled in Auvers in 1860. Daubigny began to be criticized for the roughness and unfinished quality of his paintings by the late 1850s. Despite some negative opinions, though, his works won medals and were purchased by the state. Daubigny's direct approach to painting nature also found expression in his championing the work of Pissarro, Cézanne, and Renoir when he was on the Salon jury in the late 1860s. Fleeing the Franco-Prussian War of 1870–71, he traveled in Holland and to London, where he met Monet, thereby forging another link between the generations.

This view from Château-Gaillard, perched high on chalk cliffs above the river Seine between Rouen and Paris, appealed to Daubigny (cat. no. 70). He painted it and its environs several times over a period of years beginning in 1869. The choice of a historic site is unusual for this artist. Château-Gaillard was built by the English king Richard I, the Lion-Hearted, in 1196 at Les Andelys in a futile attempt to protect Normandy (at that time under English rule) against a French invasion. In 1603 the castle was dismantled by order of the French king Henri IV. Any historical associations, however, are subsumed in the compositional possibilities the site offered: the ruins could as easily be a rock formation as a castle.

The effects of the setting sun were a draw for Daubigny, whose later career was a continual examination of atmospheric conditions. Bright orange picks out a turret of the ruins, and violets and mauves fill the water and tint the sky. Landforms are drawn in with liquid brushstrokes of olive green and teal blue. Single strokes lie flat on the surface, tracing a contour of a hill or, alternatively, functioning as calligraphy, as in the squiggle in the foreground. The coloristic focus is the setting sun, with its hot hues of orange and yellow; the surrounding landscape serves mainly as a framework for the study of color and tone.

This is one of four versions that Daubigny painted of the same prospect.[1] All are approximately the same size, and they present the elements—ruined castle, town below, and island in the river—with varying degrees of detail under different light conditions. For instance, the town that appears as a rather undifferentiated jumble here (decipherable only by the church spire) is legible in another version as orderly rows of buildings.[2] The summary treatment of the Boston version shows Daubigny's willingness to forgo description in favor of capturing an effect. Because the four views overlooking the Seine from the height of the chateau were done over a period of years and not as a concerted campaign, they cannot be considered a series, like Monet's later investigations of early morning on the Seine and of grainstacks (see cat. nos. 142–44). Yet Daubigny's exploration of effects from the same vantage point is testimony to the same spirit of study that animates Monet's canvases.

Château-Gaillard was one of many sites that Daubigny encountered on his trips on his botin.[3] Traveling during the summer months, he studied the rivers of France and their moods. The boat itself was built as a ferry. Flat-bottomed, it was eight and a half meters (twenty-eight feet) long, nearly two meters (six feet) broad, and drew only forty-six centimeters (eighteen inches) of water. Daubigny had it

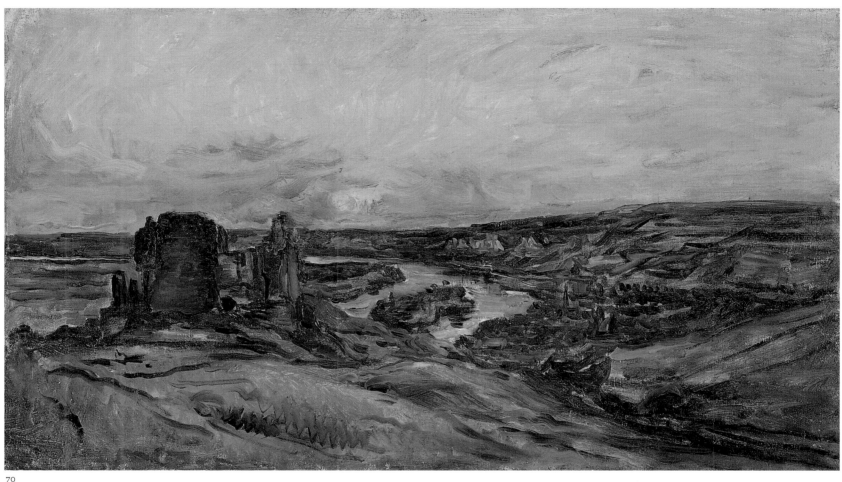

70

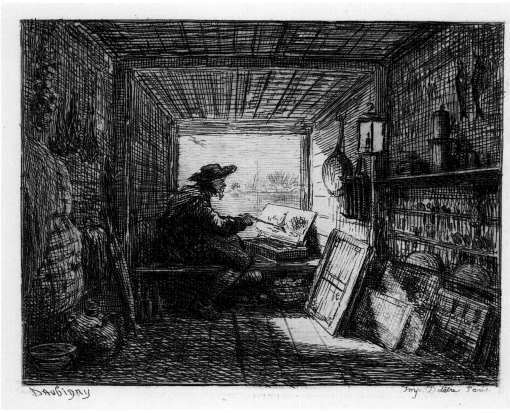

71

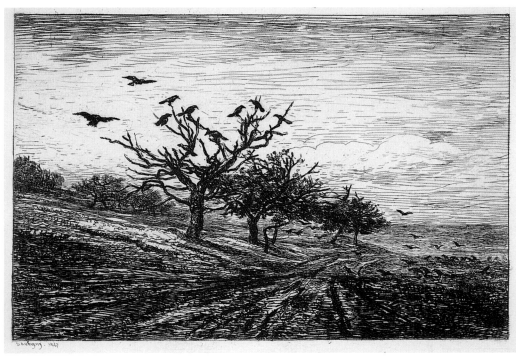

72

slightly refashioned, including having a cabin built at the stern, which we see in *The Boat-Studio* (cat. no. 71). This served as an all-purpose room, with storage along the sides.[4] *The Boat-Studio* shows Daubigny hard at work, the motif on his canvas visible on the far shore. He is surrounded by the necessities of daily life; thus provisioned with onions, fish, and cooking utensils, he was not tied to the hours and routines of the land-bound.

The Boat-Studio is one of a portfolio of fifteen prints Daubigny made after sketches illustrating his life on the water. Although many of the prints are lighthearted and even comical, this self-portrait of the artist takes its place in the centuries-old tradition of artists depicting themselves at work. Daubigny's boat-studio took him to places where he could paint, as honestly and truthfully as he could. His serious approach is announced in the word *Réalisme,* written across the back of the canvas in the lower right corner.

Daubigny had made prints since the beginning of his career, providing illustrations for sheet music and making reproductive prints after seventeenth-century paintings by Claude Lorrain and the Dutchman Jacob van Ruisdael as well as prints of his own devising. Yet despite his familiarity with printmaking processes and his evident facility, Daubigny made only about eighteen clichés-verre, seemingly all in the same year, 1862.[5] This concentration contrasts with Corot's more extended interest (see cat. nos. 16–18). Daubigny's *Ford* (cat. no. 73) reprises a motif he treated many times over the years. He has varied and enlivened it here by placing the glass plate on the paper with the collodion side up. Because the light refracts as it passes through the glass, lines lose definition. Edges dissolve, and a soft, almost fuzzy picture is created. By experimenting with the technique of cliché-verre, Daubigny's scene of endless work—note the slumped, defeated-looking pos-

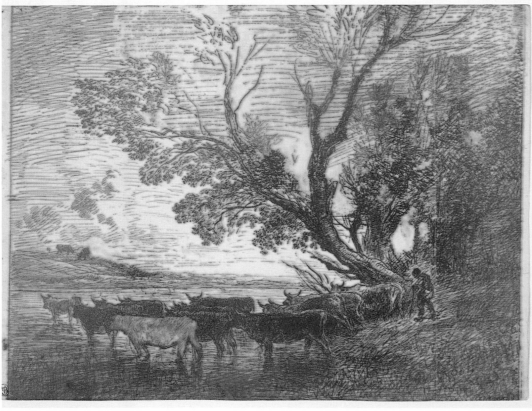

73

ture of the cowherd—is transformed into a scene of tranquillity.

No such softness informs the etching *Tree with Crows* (cat. no. 72). A stark, powerful image, it was one of the few prints Daubigny did that was not planned for publication.[6] It is distinctive in Daubigny's oeuvre for its ominous mood. The crows are large and black. They do not so much sit in as take over the foremost tree. The birds shown in flight and on the ground stretching to the right suggest others, perhaps in overwhelming numbers. Adding to the uneasy mood is the perspective: the ruts in the earth rush to the distance; the trees become rapidly smaller. Large numbers of birds on the ground are never a welcome sight for farmers, jealous of their precious seed. Daubigny shows a scene out of balance, with birds rather than people benefiting from the tilled earth. FEW

1. Hellebranth 1976, nos. 89–92.

2. Ibid., no. 89.

3. Grad 1980, 123–27.

4. For a full description, see Melot 1980, 280, quoting Wickenden 1913, 190–93.

5. The total number is uncertain; see Glassman and Symmes 1980, 39, note 23.

6. Melot 1980, 282, no. D.120. It is, however, related to a painting executed later, *L'effet de neige*, which appeared in the Salon of 1873. Fidell-Beaufort and Bailly-Herzberg 1975, 68, identify it as the countryside of Auvers.

François-Louis Français
French, 1814–1897

74. FRANÇOIS-LOUIS FRANÇAIS
Sunset, 1878
Oil on canvas
47.1 x 56.3 cm (18 ½ x 22 ⅛ in.)
Bequest of Ernest Wadsworth Longfellow
37.598

François-Louis Français began his career in Paris as an errand boy to the publisher Paulin in 1829. In 1834 he studied drawing and printmaking in the atelier of Jean Gigoux. For many years Français provided lithographs and wood engravings for a range of books, from Bernardin de Saint-Pierre's popular romantic novel *Paul et Virginie* to La Fontaine's fables to novels by his contemporaries George Sand and Honoré de Balzac. Also in 1834, Français began going to Barbizon. He became the pupil of Corot in 1836. Français's sympathy for the works of Corot and other midcentury landscapists informed his many lithographs done after their paintings. He enjoyed a long and successful career, exhibiting both paintings and lithographs at the Salon beginning in 1837. He received his first medal in 1841 and in 1853 was made a knight of the Legion of Honor. His landscapes trace a record of far-flung travels—the Italian countryside (he spent several years in Italy from 1846 through 1849, then returned in 1851, 1858–59, 1864–66, 1869, and 1873), the French provinces (from 1870 he wintered on the Riviera), and the Ile-de-France. Français's work was essentially hybrid, combining the calculation of neoclassical landscape with the study of nature.

By 1878, the date of this picture, Français had had a long career of working outdoors. In the early 1830s he painted in the environs of Paris with Huet; then, in the mid-1830s, he worked in the Forest of Fontainebleau, where he met Corot and Diaz. At midcentury he painted in various locations with Troyon, Corot, Courbet, Boudin, Jongkind, and Daubigny. Through these companions, Français became

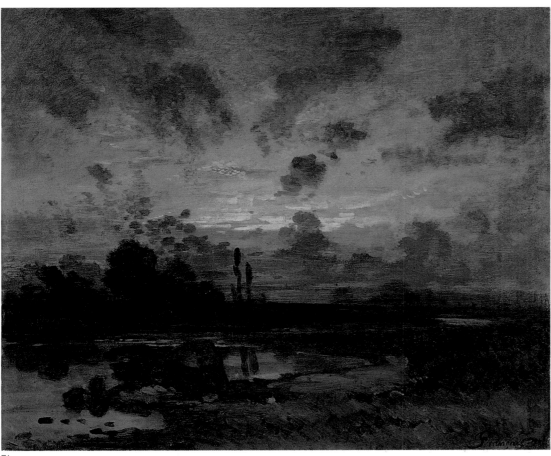

74

75. EUGÈNE BOUDIN
River Landscape with Houses and Bridge, late 1850s
Graphite pencil on dark cream laid paper
Sheet: 28.5 x 44.5 cm (11 ¼ x 17 ½ in.)
M. and M. Karolik Fund 1972.368

76. EUGÈNE BOUDIN
Harbor at Honfleur, 1865
Oil on paper mounted on panel
20.3 x 26.8 cm (8 x 10 ½ in.)
Anonymous Gift 1971.425

77. JOHAN BARTHOLD JONGKIND
Harbor Scene in Holland, 1868
Oil on canvas
42 x 56 cm (16 ½ x 22 in.)
Gift of Count Cecil Pecci-Blunt 61.1242

The son of a ship's captain, Eugène Boudin opened a framing and stationery shop with a partner in Le Havre in 1844. As was the custom before commercial art galleries were established, he exhibited in his window paintings by local artists. Troyon and Millet were two of these, and they persuaded him to try painting himself. The local art society gave Boudin a scholarship to study art in Paris. At its end, in 1854, he returned to the Normandy coast and painted directly from nature. He met Monet in 1858 and persuaded him, as he himself had been persuaded, to paint outdoors. In 1859 he became friends with Courbet and in 1862 with Jongkind, whose fresh vision of marine painting made a significant impact on him. His works were accepted regularly at the Salon beginning in 1859, and he showed several works in the first Impressionist exhibition in 1874. His reputation was secure after 1871, and he began to travel, visiting Belgium, the Netherlands, the South of France, and Venice. Despite his popular success and financial security (after 1883 Durand-Ruel held exclusive rights to his output), Boudin received official honors only late in life—a third-

familiar with the practice of closely observing effects in nature. The slow-moving river may be the Saône; after 1873 Français summered on that river at Plombières. In this painting he tackles the difficult and evanescent subject of the last moments of the setting sun, just before it sinks below the horizon completely, taking all light with it.

In contrast to Daubigny's *Château-Gaillard at Sunset* (cat. no. 70), whose titular focus is the ruined castle, Français's *Sunset* concentrates all attention on the sky. The landforms in this painting fade into steel gray–blue and brownish black beneath a sky aflame with pinks, salmons, yellows, and oranges. Français deftly captures the different colors refracted through and reflected off clouds of various shapes and at

different altitudes. The sky was worked with very thin paint, swept across the canvas with large brushes to capture the broad effects. The trees marking the far bank were, if not an afterthought, then not integral to the painting's conception, for they were added on top of the colored sky as dabs and strokes of darkness.

By 1878 artists were exhibiting their studies and sketches; these less formal works were no longer confined to the studio. The painting's careful signature and date suggest that this medium-size canvas was made for sale, either directly to a collector or through a dealer. Its appeal to collectors is evident: the Bostonian Ernest Wadsworth Longfellow bought it as early as 1884. FEW

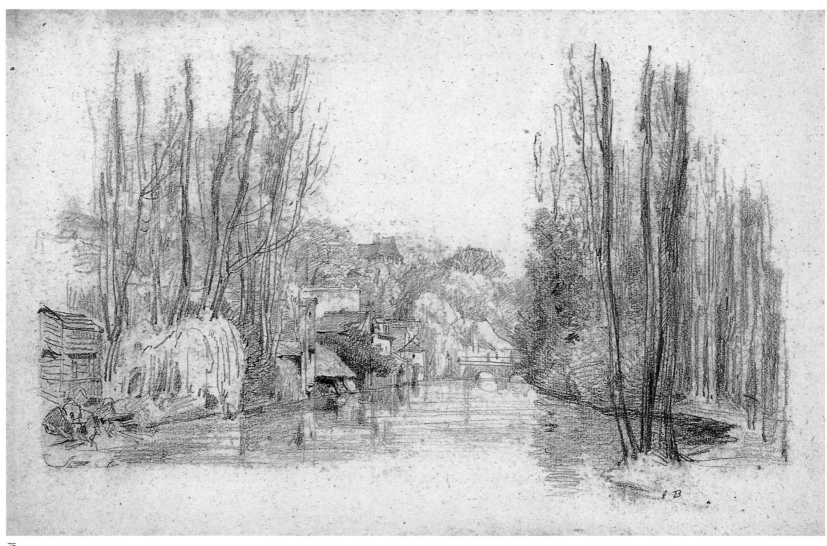

75

class medal at the Salon of 1881, a gold medal at the 1889 Exposition Universelle, and a knighthood in the Legion of Honor in 1892.

This drawing of the poplar-lined banks of a river converging on a bridge (cat. no. 75) was made in graphite, the same medium Aligny chose to depict a tree near Civita Castellana (cat. no. 3). Aligny used a harder graphite pencil because he was interested in fine outlines and hard edges in his portrait of a tree. Boudin, by contrast, used a softer medium to create a sense

of moist atmosphere. Details of both man-made and natural forms are simplified, even elided altogether, in this riverine tranquillity, broken by no sign of movement.

Ten to fifteen years later Boudin painted *Harbor at Honfleur* (cat. no. 76). His earlier propensity to see the world in geometries found more sure-footed grounding when he set up his easel so as to see a pier at a sharp angle. The atypical vantage point makes the pier spread out to fill the entire foreground of this tiny paint-

ing, only ten inches wide. It becomes almost abstract, a field for paint. Docked along two sides of the pier, the ships—a brig, a hermaphrodite brig, and a smaller coastal vessel[1]— instead of continuing the geometry, serve as a foil to it, their masts, spars, rigging, and sails offering an active alternative to the starkness of the wharf.

Boudin localizes this view by inscribing *Honfleur* in the lower left corner. Without the inscription, we would be at a loss to know

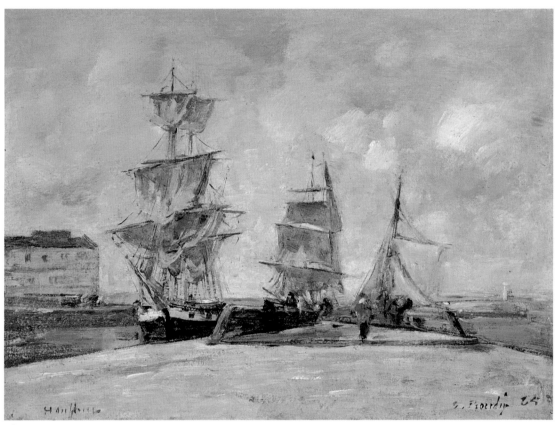

76

which of the many English Channel ports it represents. With it, we know that Boudin made the short trip from Le Havre, the large town on the northern shore of the Seine estuary, to the smaller town on the southern shore. The palette suggests that this is a summertime painting (Boudin often spent the summer months in his hometown). Light-colored paint gives the scene the effect of being light-filled. A contemporary wrote of Boudin:

> In his color, he consistently adopted the luminous, all-over light-toned palette, pioneered by Corot, which in the 1850s and 1860s was known as *peinture claire* or *peinture grise*; this means of conveying the effects of outdoor light was, Boudin remembered later, very unfashionable in those years, in contrast to the more theatrical, artificial effects

sought by most painters of seascapes. This *peinture claire* was to have a crucial influence on the emergence of Impressionism.[2]

Although Boudin never broke his brushstrokes into individual marks of color, as the Impressionists did, his distinctive touch (aptly described by the art historian Peter Sutton as "gently feathered, blended, and succinctly articulated")[3] suggests the movement of light through air. Here, the rapid brushwork animates the surface of the canvas. This makes the eye skip and hop from one stroke to another, a movement similar to that which the eye experiences in nature. It was this combination of peinture claire and active brushwork that so captivated the young Monet.

Both Boudin and the Dutchman Jongkind

spent their careers studying the ever-changing interplay of light, air, and water and developing painterly means to replicate what they saw. Jongkind's first teacher was the foremost Dutch landscape painter of the time, Andreas Schelfhout, with whom he studied in The Hague. A government stipend allowed Jongkind to go to Paris in 1846 for further study under Isabey. Early public success (acceptance at the Salon, a third-class medal in 1852, several purchases by the state, and support from the dealer Pierre Firmin-Martin) was cut short by the withdrawal of the Dutch stipend in 1853. Jongkind fell into debt, drank heavily, and returned to the Netherlands in 1855. A sale of works by Jongkind's artist friends in 1860 realized enough money to allow him to return to Paris. Once back, he met Joséphine Fesser-Borrhée. Her friendship and the support of her family gave Jongkind a new lease on life. He lived with them until his death (he died at their family home). They traveled frequently to the Normandy coast, where in 1862 he met the young Monet. He also returned to the Netherlands and visited the South of France and the Dauphiné. Jongkind's art was a path-breaking combination of compositional structures taken from the land- and seascape traditions of seventeenth-century Dutch art, a careful study of specific light conditions, and a free manner of painting.

In *Harbor Scene in Holland* (cat. no. 77), two brigantines (two-masted square-rigged sailing ships) are anchored on either side of a canal. Rowboats work the water between them. Judging from the brick houses at the right and the silhouettes of the drawbridge and windmill in the distance (a tug or barge is near the drawbridge), the scene is set in The Netherlands. The date of 1868 suggests that the view could have been taken in Rotterdam or Dordrecht (Jongkind visited those two cities in the fall of that year). Yet it is a generalized view rather

than a portrait of a particular canal done at a particular time, for Jongkind is not known to have painted oils outdoors. His evocative scenes are based on memory and sketches.

Unlike seventeenth-century Dutch marines, in which the surface of the canvas is covered with a uniformly worked layer of paint, Jongkind varied his brushwork to represent different materials. The elements in this canal view—sky and clouds, trees, buildings, ships and boats, and water—are each rendered with their own kind of brushstroke. The blue sky and gray and white clouds are painted with large, buttery strokes. The canal, in contrast, is made up of tiny dabs of color—surprisingly, with almost no blue. These flecks of color, as well as the swirling strokes in the sky, stand for water and sky but also proclaim their physical presence on the canvas. In addition, Jongkind depicts a complicated light effect, with the sun hidden behind clouds. The windmill is obscured, and the brigs are backlit, their hulls appearing as dark masses.

Jongkind's importance for the younger generation of landscapists was immense. Boudin and Monet appreciated his free and spontaneous brushwork. But where Boudin and Monet often worked in oils outdoors, Jongkind did not. Instead, he made sketches in pencil and watercolors from nature but preferred to compose his oil paintings in the studio. Boudin emulated the older artist, writing: "Jongkind began to make the public swallow a sort of painting whose rather tough skin hid an excellent and very tasty fruit."[4] Monet believed that one had "always something to gain from studying Jongkind's landscapes because he paints what he sees and what he feels with sincerity."[5] The critic Théophile Thoré was more explicit in stating his praise: "M. Jongkind's manner does not appeal to everyone, but it delights all who love spontaneous painting, in which strong feelings are rendered with originality. . . . I have always maintained that true painters work at speed,

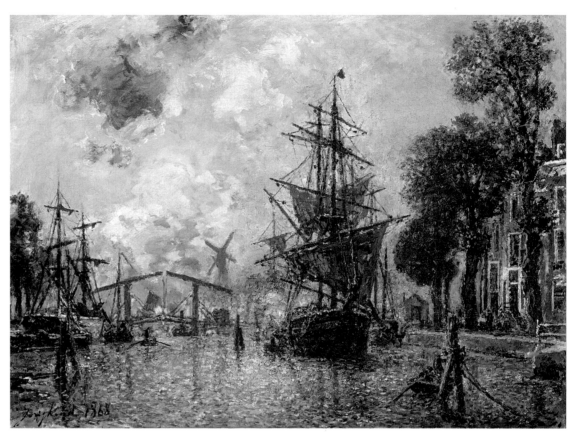

77

under the influence of impressions."[6] Boudin's and Monet's respect for Jongkind's work is testimony that the end result, the success of the painting, was more important to them than whether it was executed outdoors or in the studio. FEW

1. Sutton 1991, 40.

2. Leroi 1887, 32, translated by John House in Hamilton 1992, 17.

3. Sutton 1991, 20.

4. Boudin in *L'Art.* 1887, quoted in Jean-Aubry [1968], 116, translated in Cunningham 1977, 21.

5. Quoted in Cahen 1900, 41, translated in Hamilton 1992, 42.

6. Thoré in Boime 1971, 21, quoted in Cunningham 1977, 14.

Eugène Boudin
French, 1824–1898

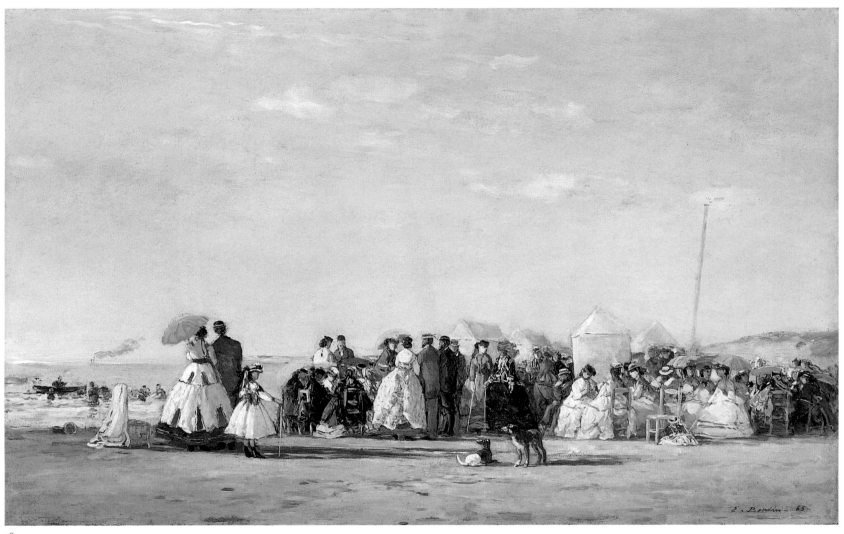

78

78. EUGÈNE BOUDIN
Fashionable Figures on the Beach, 1865
Oil on panel
35.5 x 57.5 cm (14 x 22⅜ in.)
Gift of Mr. and Mrs. John J. Wilson 1974.565

Boudin dedicated himself to painting the sea, its coastlines, and the human activities that take place in these locales. He began painting fashionable people on the beach at Trouville in 1862 and found that these horizontal pictures had a ready market. In them he combined popular anecdote, a keen eye for costume (here a preponderance of white), and an acute sense of seaside weather to produce pictures that complemented and coincided with the growing taste for tourism among the French middle and upper classes.

Boudin took care to individualize the figures he painted just enough so that their actions could be discerned, but not so much that they assumed more importance than the bright blue sky and sunny enveloping atmosphere. Here the viewer notes a steamship on the horizon, a form of technology related to the trains that brought these visitors to the coast. The steamship contrasts with the rowboat, whose occupant appears to be telling a story to the people surrounding him. The people on the beach stand or sit in conversational groups. It is most

Claude Monet
French, 1840–1926

likely a weekday, as there are relatively few men present (then as now, businessmen would join their vacationing families only on weekends). Particularly engaging are the young girl and the dogs. The girl's dress is simply a small-scale version of the type worn by the adults. Her imperious gesture with the walking stick reinforces the unchildlike nature of her costume. The dogs, facing alertly to the left, evince more animation and interest in the world around them than any of the almost fifty people represented.

Boudin understood the public appeal of these beach-side depictions. Between 1864 and 1869 he showed eleven paintings at the annual Salon, nine of which were of this type.[1] He painted such pictures throughout his life, one as late as 1896,[2] yet in a letter of August 1867 he complained about the essential vapidity of the subject matter: "Must I admit it? This beach at Trouville that till recently so delighted me, now, on my return [from Brittany], seems merely a ghastly masquerade. . . . When . . . one comes back to this band of gilded parasites who look so triumphant, one pities them a little, and also feels a certain shame at painting their idle laziness."[3] As delightful as this painting is, Boudin's feelings help explain why later he concentrated on less detailed, more atmospheric scenes. FEW

1. Tinterow and Loyrette 1994, 340.

2. Sutton 1991, 42.

3. Jean-Aubry [1968], 90, translated by John House in Hamilton 1992, 20.

79. CLAUDE MONET
Rue de la Bavolle, Honfleur, about 1864
Oil on canvas
55.9 x 61 cm (22 x 24 in.)
Bequest of John T. Spaulding 48.580

Monet's prodigious talent was first recognized by Boudin, whom he met in Le Havre in 1858. Boudin encouraged Monet to give up drawing caricatures and to paint outdoors, which he did in the company of both Boudin and Jongkind. Monet's short tenure (1862–64) in the atelier of Charles Gleyre was decisive, for not only did Gleyre encourage his students to go their own way, but it was there that Monet met Frédéric Bazille, Renoir, and Sisley. After limited success at the Salon during the 1860s, Monet became a leader of the group that exhibited independently of the Salon, the group called the Impressionists, after the title of one of his canvases. In the early part of his career, Monet's subjects came from the English Channel coast and the western suburbs of Paris. Later, he sought motifs farther afield, in places such as Norway, London, the South of France, and Venice. He was a canny businessman, playing dealers off one another and carefully orchestrating his exhibitions and their attendant publicity. He moved to Giverny in 1883 and in 1890 bought property there. He worked on the grounds for decades, diverting streams and maintaining a water garden. The area around Giverny and his gardens provided the subjects for his series of paintings of single motifs.

Monet painted in Honfleur during his summer trips to Normandy from Paris, where he lived beginning in 1859. Small streets like the *Rue de la Bavolle, Honfleur* would have been familiar to him from his boyhood in Le Havre, which lies to the north of Honfleur, across the estuary of the Seine. Bold patterns and sharp contrasts make his painting of this street immediately appealing. House fronts in shadow on

Fig. 42. Claude Monet, *Rue de la Bavolle, Honfleur,* about 1864, Städtische Kunsthalle, Mannheim.

the left focus, if not force, attention to the right-hand portion of the painting. As in *Woodgatherers at the Edge of the Forest* (fig. 7, p. 19), from about the same time, the lines forming the composition are in the shape of a large X. Because the subject matter here is a built environment rather than a glimpse of the natural world, the lines of the X are much more strongly delineated than was the case with the irregular shapes of trees and uneven ground. The eye easily leaps from the roof line on the left across the void of the street to the edge of the road in sunlight on the right; the invisible crossing of the X lies just above the head of the man in the street. Such a structure locks the pictorial elements firmly in place and gives the picture a sense of solidity and assurance.

This sense of solidity can also be found in Monet's palette and technique. The colors— browns, grays, ochers, and even blacks—recall the palettes of older painters such as Boudin and Corot. Broad, smooth strokes of ocher and gray mimic the effect of the sun falling directly on the siding and plaster of the houses, with architectural details firmly drawn in. Yet careful

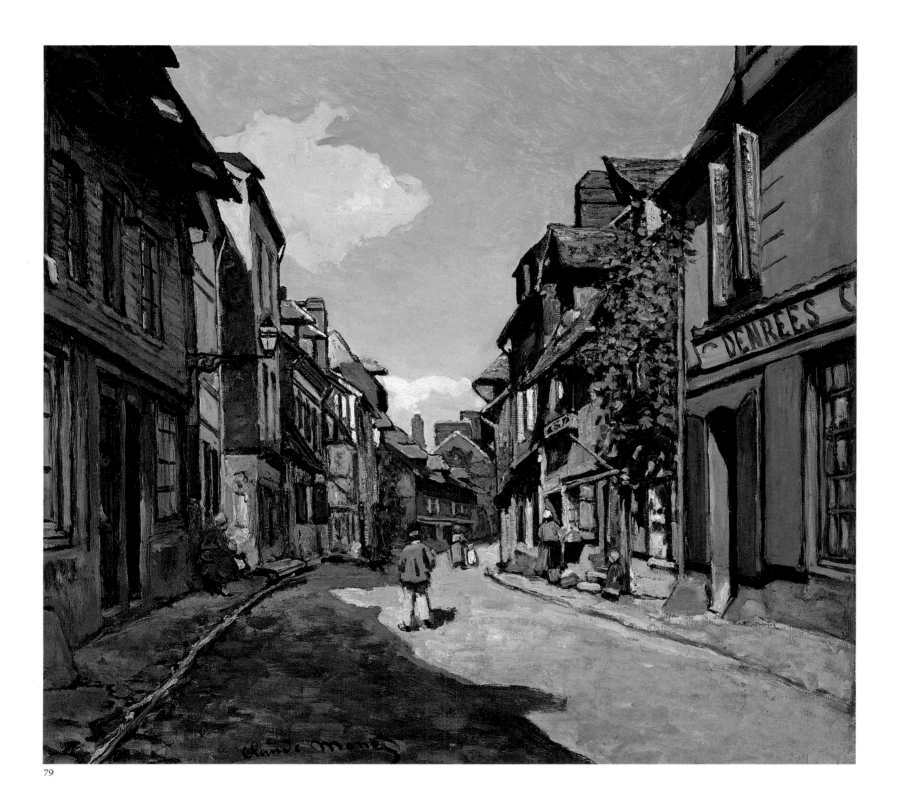

79

attention to subtler effects of light can also be found. Edges of roofs, dormers, and shutters sparkle against their more sober background; the dust and cobblestones of the street are rendered with shorter strokes applied with a smaller brush; the ivy so quivers with light that it looks as if it might detach itself from the wall.[1]

The subject matter of this painting ties it to the tradition of townscapes. Anecdotal details abound—a cloth hangs out a window to air, a

man peeks out of a doorway, a woman sitting outdoors is kept company by a black cat. Monet's interest in anecdote, in recording what he sees, is also evident in another painting of the same street, now in Mannheim (fig. 42, p. 141). The differences between the two are noticeable in the shadows and clouds and in the figures. The man in the doorway to the left in the Boston painting is replaced by a bolder woman in the Mannheim version, staring as if

she were watching the painter at work; the man in the middle of the road cedes to a woman and child nearer the viewer. Monet records these changes—"imaginable but not truly predictable," like changes in weather—dispassionately, as if he were a camera installed in the center of the street.[2] FEW

1. Poulet and Murphy 1979, cat. no. 2.

2. Isaacson 1984, 20–21.

Alfred Sisley
British (worked in France), 1839–1899

80. ALFRED SISLEY
Early Snow at Louveciennes, about 1870–71
Oil on canvas
54.9 x 73.7 cm (21 ⅝ x 29 in.)
Bequest of John T. Spaulding 48.600

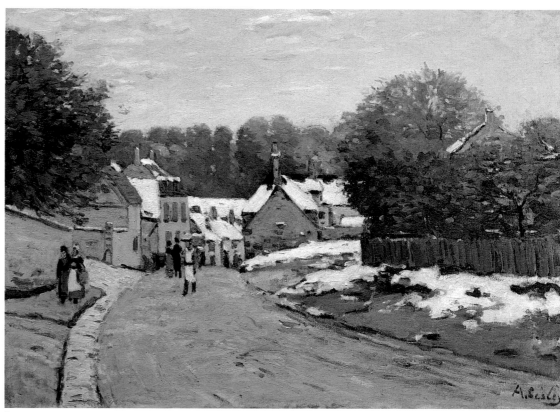

80

If we can deduce an artist's character from his paintings, Alfred Sisley seems to have had a quieter personality than the other Impressionists. The son of British parents living in Paris, he retained his British citizenship all his life. Sisley went to London in the late 1850s to prepare himself for a career in business. He used part of this time to visit museums, where he studied the work of British painters, particularly John Constable. On his return to Paris, his father was amenable to his studying art, and he entered Gleyre's studio in 1860, through an introduction from Bazille. There he met Monet and Renoir and with them painted in the countryside around Paris, especially the Forest of Fontainebleau. He had limited success at the Salon in the late 1860s and participated in four of the eight independent group shows. He moved often in the 1870s, always close to Paris. In 1880 he moved to the area where the Loing River empties into the Seine, beyond Barbizon and Fontainebleau, where he stayed until his death. The Franco-Prussian War ruined his father financially, and from 1871 on Sisley had to support himself, his mistress, and their two sons solely on the sales of his paintings. Despite a coterie of collectors, the dealings of Durand-Ruel and Georges Petit, and inclusion in major exhibitions, Sisley did not enjoy financial success. He concentrated on landscapes of the region in which he lived, and his canvases are marked by a calmness of mood and a brightness of palette.

Sisley probably moved with his growing family to Louveciennes, one of the many suburbs to the west of Paris, most likely at the end of 1871, to escape the aftermath of the upheavals following the Franco-Prussian War in Paris.[1] *Early Snow at Louveciennes* records a freak early snowfall, one light enough so that the snow's weight did not cause the tree branches, still in full leaf, to break. The unusual occurrence gave Sisley the opportunity to juxtapose close-toned, muted colors—browns, greens, ochers—with dazzling whites and vibrant reds.

The bank of trees rising behind the cluster of buildings gives the impression that Louveciennes was limited in scale, perhaps only this one street and one or two more. In fact it was quite large, boasting a train line and, a bit outside the village, a chateau Louis XV gave to his mistress Madame du Barry in 1769, the waterworks (see cat. no. 91), and the beginning of the aqueduct of Marly. Sisley's focus on the little rue de Voisins establishes his predilection for patient exploration of his surroundings, bit by bit over time. The art historian MaryAnne Stevens has suggested that Sisley's approach is logical, "an attempt to present a more or less extended panorama of a specific location through a sequence of individual paintings."[2] He was to stay in Louveciennes until the late winter or early spring of 1875 and continue to paint scenes of the village and its environs even after he no longer lived there. *Early Snow at Louveciennes* is distinguished in this group of about sixty paintings, not only because of its confident handling of space and color, but also because it is the first surviving canvas by Sisley of the area. FEW

1. Stevens and Cahn 1992, 102, 262.

2. Ibid., 82.

Edgar Degas

French, 1834–1917

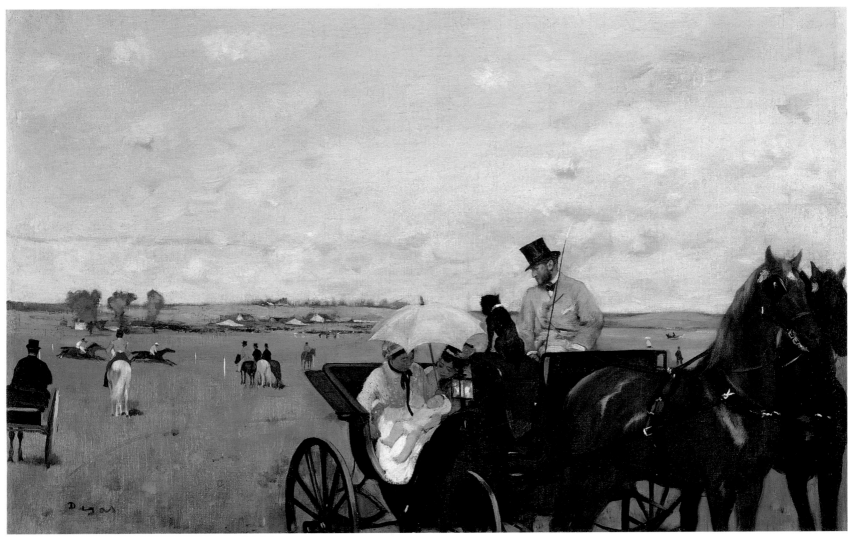

81

81. EDGAR DEGAS
At the Races in the Countryside, 1869
Oil on canvas
36.5 x 55.9 cm (14⅜ x 22 in.)
1931 Purchase Fund 26.790

82. EDGAR DEGAS
Racehorses at Longchamp, 1871, possibly reworked in 1874
Oil on canvas
34.1 x 41.8 cm (13⅜ x 16½ in.)
S. A. Denio Collection 03.1034

Degas's father, a banker interested in music and art, did not object much when his son wanted to pursue a career in art instead of the law. Degas first studied with Félix-Joseph Barrias and then, more importantly, with Louis Lamothe, a pupil of Jean-Auguste-Dominique Ingres. Ingres's supple draftsmanship and classical orientation were deciding factors in Degas's early development. From 1856 to 1859 Degas visited Italy, where he copied ancient and Renaissance works in Naples and Florence (in both cities he stayed with relatives) and in

Rome. On his return to Paris he painted portraits and scenes from history and modern life and was accepted at the Salon from 1865 to 1870. Increasingly, however, he joined groups of independent-minded artists who gathered at the Café de la Nouvelle Athènes and the Café Guerbois. He exhibited with the group known as the Impressionists in all but one of their eight shows, sharing with them an interest in Japanese prints, subjects of modern life, and innovation. Degas distinguished himself from almost all other progressive artists of the later

nineteenth century by the combination of his devotion to the figure and his constant technical experimentation. His increasingly poor eyesight led to work in bolder forms, as well as in the media of poetry and photography.

Because Degas exhibited with the Impressionist landscape painters, his art is often described in terms used for their canvases, that is, encompassing instantaneity of vision and depicting aspects of modern life. Yet despite Degas's interest in the body in motion, as evidenced in his depictions of ballerinas and people passing on the street, *At the Races in the Countryside* (cat. no. 81) and *Racehorses at Longchamp* (cat. no. 82) are curiously quiet, stilled visions. And although horse racing was indisputably a part of life in late-nineteenth-century France, it was primarily associated with the upper classes, not with the lives of working men and women.

At the Races in the Countryside is almost a misnomer: the three horses coursing at the left are engaged in an impromptu race, and the focus of the painting is the decidedly upper-class family group that is barely contained by the edges of the canvas. This is Degas's version of the Impressionists' capturing of a moment in time, although Degas's interest was spatial rather than temporal. Here, too, however, Degas confounds expectations, because the horses and carriage are going nowhere, lest the movement disturb the infant who has fallen asleep at his nursemaid's breast. The cropping of wheels and horses' legs and head does not suggest arrested motion as much as it conveys intimacy, a viewer's sudden coming upon of this tender familial scene. The mother of the child cranes around to look at her nursing infant; the father turns to watch; and even the family pet, a pert black miniature bulldog or pug, contemplates the women and baby under the umbrella. The family depicted was that of Degas's good friend Paul Valpinçon. Degas visited them dur-

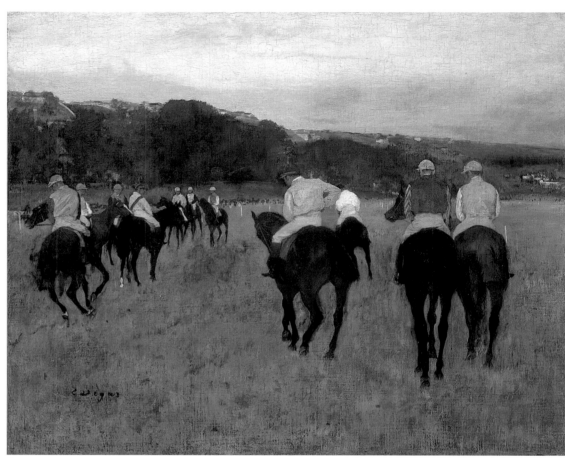

82

ing the summer of 1869 at Ménil-Hubert, the Valpinçons' estate in Normandy; the racetrack is Argentan, fifteen kilometers (nine miles) from the estate.[1]

The light blue and white of the sky, which covers more than half of the canvas, and largely unmodulated green of the sward are pleasing colors, evoking a lovely summer's day. The dark browns and blacks of the horses and carriage are relieved by the light-colored clothing of the Valpinçons; an especially tender color note is added by the nursemaid's mauve dress. Degas's affection for these people—Paul Valpinçon and Degas had been friends since childhood—is made manifest through color and composition.

Degas had no such personal link to the

scene when he painted *Racehorses at Longchamp*, a few years after the portrait of the Valpinçon family. Horse racing, a quintessentially aristocratic British sport, became extremely popular in France beginning in the 1830s. The French Jockey Club was founded in 1833, and the Société des steeplechases de France, in 1863. The racetrack here, visible in the mid-distance, is Longchamp, in the Bois de Boulogne, the huge park on the western edge of Paris. Identifiable is the village of Suresnes, whose buildings climb the slopes of Mont Valérien across the river Seine, here made invisible. The racetrack at Longchamp, the site of an abandoned convent, opened in 1857. Its proximity to Paris seems to have compensated for its short season: a week

in April, four days in late May or early June, and another short time in September.[2]

As he did in *At the Races in the Countryside*, Degas depicted an uncharacteristic moment in the life of the racetrack. And despite Degas's much-discussed interest in the study of motion, these horses, bred specifically for their speed, hardly move at all. The delicate shades of pink and mauve in the sky explain this paradoxical lethargy. It is the end of the day, the horses have run their races, and they and their jockeys are tired.

Across an expanse of richly textured turf are arrayed eleven brown and black horses and their riders, gaudily attired in their racing silks. If the animals were arranged as randomly as they appear to be at first glance, the painting would dissolve into visual incoherence. Degas exercises firm control over his creatures, in a way analogous to the discipline required of a winning racehorse. The bright caps of the jockeys cluster in two horizontal groups parallel to the distant racecourse. The horses on the left, their color barely modulated so that their forms read as silhouettes, plunge the eye deep into space. This diagonal recession is reinforced by the movement of the lighter middle horse. After the eye travels along the row of horses on the left, following the left-to-right reading pattern traditional in the West, it comes back to the lighter color of the middle horse and rider. This group, rather than directing attention to the foreground, takes the eye back into the distance. The blank foreground encourages the recession, because there is nothing close by on which the eye can focus. Degas could have seen such an empty foreground coupled with a rushing perspective in the Japanese prints he collected avidly.

Degas did not paint outdoors. The intense sense of place, of colors observed, can be attributed to his acute memory. Paul-André Lemoisne, a friend and cataloguer of the artist's work, reported on Degas's habits while visiting Normandy:

> As he looks at them, Degas's keen eye also registers the appearance of the countryside, the pale sea-green shore fringed with foam, the curve of a bank of golden sand, the outline of hills, a velvety meadow, the color of the sky. Later, back in the studio, the artist delights in re-creating some of these places from memory, attempting to reproduce the colors and outlines with his sticks of pastel.[3]

Although *Racehorses at Longchamp* is painted in oils rather than pastels, Lemoisne's comments are equally applicable to it. Like many of Corot's canvases, *Racehorses at Longchamp* is evidence that an artist need not paint at the site to be able to evoke a sense of place. FEW

1. See Boggs et al. 1988, 157–58, cat. no. 95, for a full discussion of the painting's origin and provenance.

2. Details on Longchamp and horse racing were taken from Poulet and Murphy 1979, 69, and Herbert 1988, 143, 152. For a further discussion of racetrack pictures by other artists, see Herbert 1988, 152–70.

3. Lemoisne 1946–49, 1:61, quoted in Loyrette 1988, 154.

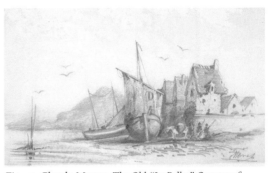

Fig. 43. Claude Monet, *The Old "Le Pollet" Quarter of Dieppe*, 1856–57, Museum of Fine Arts, Boston.

83. CLAUDE MONET
View of the Sea at Sunset, about 1862
Pastel on paper
15.3 x 40 cm (6 x 15¾ in.)
Bequest of William P. Blake in memory of his sister, Anne Dehon Blake 22.604

84. CLAUDE MONET
Broad Landscape, about 1862
Pastel on paper
17.4 x 36 cm (6⅞ x 14⅛ in.)
Bequest of William P. Blake in memory of his sister, Anne Dehon Blake 22.605

85. EDGAR DEGAS
Cliffs on the Edge of the Sea, 1869
Pastel on paper
44.3 x 58.5 cm (17⅜ x 23 in.)
Gift of Lydia Pope Turtle and Isabel Pope Conant in memory of their father, Hubert Pope
1980.390

Monet, renowned for his dexterity with a paintbrush, is hardly known for his graphic work. Yet throughout his career, he made pencil or chalk drawings—often loose, sketchy studies of the principal outlines of a motif that might later serve as schematic "maps" for a painted composition. At the beginning of his career, Monet was a particularly ardent draftsman. His first exhibited works, in fact, were a group of carica-

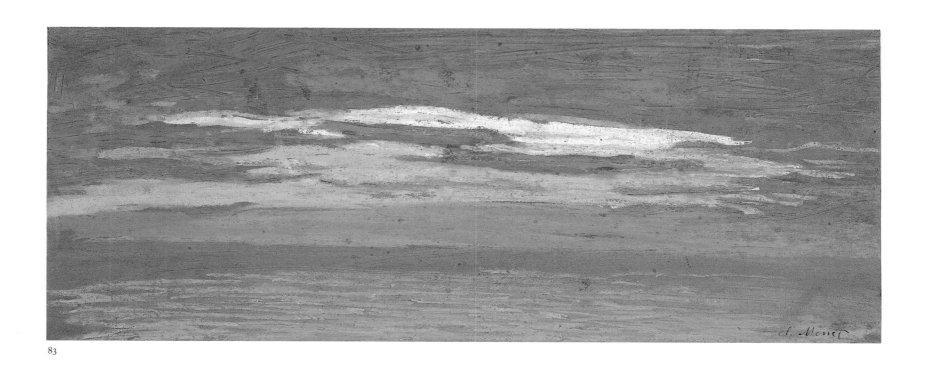

83

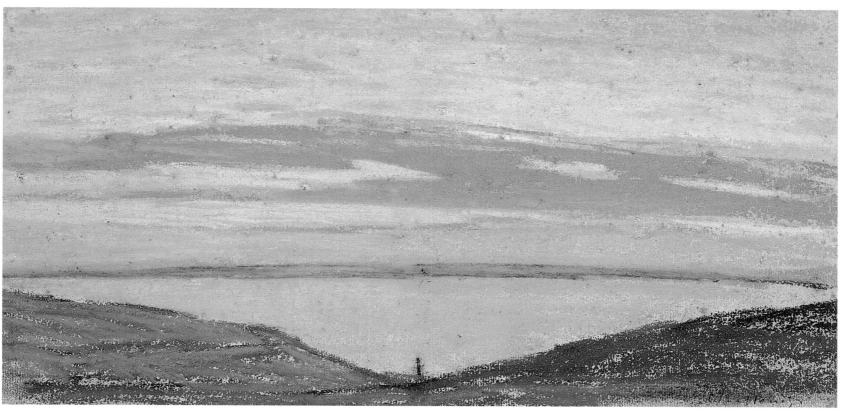

84

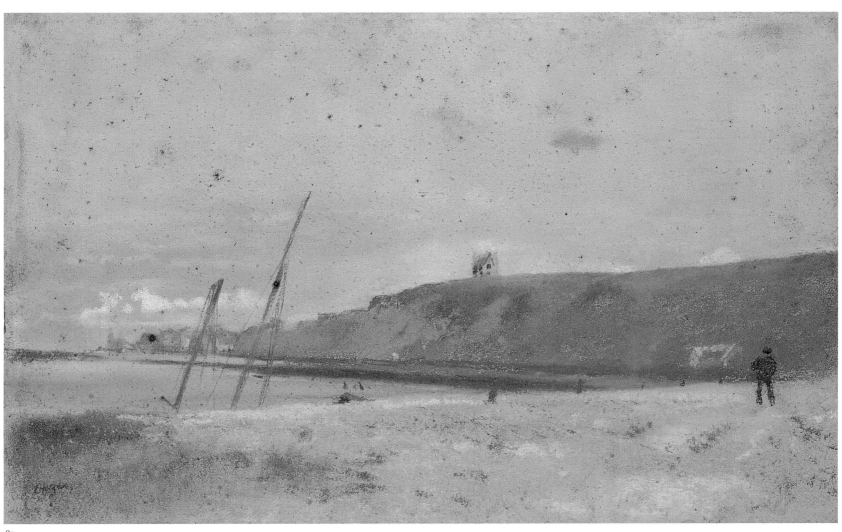

85

tures that he displayed in an artist's supply store in Le Havre.[1] Notebooks dated 1856 and 1857 record his impressions of the countryside around Le Havre in careful pencil sketches that resemble lithographic landscape vignettes.[2] A similar sheet, also dating from the very beginning of Monet's career, adapts the composition of one of Isabey's paintings or prints (cat. nos. 28–29) to depict Pollet, a fishermen's neighborhood near the port of Dieppe (fig. 43).

But these hesitant early drawings predate Monet's encounter with Boudin and his introduction to the idea of making pictures—not simply works on paper—in the open air. Working with the older artist, Monet focused, above all, on cloud and sky effects. Boudin wrote in his diary at the end of 1856 that he wanted "To swim in the open air. To attain the tenderness of the cloud. . . . These tendernesses of the sky that go as far as praise, as far as adoration: that is not an exaggeration."[3] A few years later, the poet and critic Charles Baudelaire praised Boudin's pastel studies of clouds and sea, and described them in his review of the 1859 Salon as "quickly and faithfully sketched" from the most fugitive elements of nature. He noted that the artist searched for "what is impossible to grasp in form or color," but that he documented each study with precise details of date, hour, and weather conditions. "In the end," Baudelaire wrote,

> all these clouds with fantastic and luminous forms, these yawning furnaces, these firmaments of black or violet satin . . . mount to the brain like a heady drink or the eloquence of opium. Curiously enough, it never once occurred to me in front of one of these liquid, aerial forms of magic to complain about the absence of man.[4]

Baudelaire might almost have been describing one of the pastels that Monet would execute a few years later in Normandy, such as *View of the Sea at Sunset* (cat. no. 83). With its carefully applied layers of pastel, it must have been worked up over a span of time during which the precise effect of the setting sun would necessarily have changed. Yet like one of Boudin's works, it seems to capture a distinct moment, an ephemeral effect of light and atmosphere. Here, the velvety surface of a blue-gray cloud, tinged with hints of reflected pink, opens onto a great blaze of yellow sunlight.

The pastel medium was almost more suitable than oil paint for noting a landscape effect very quickly. Pastels (and paper) were easily transported in a small box, could be worked without liquid medium (though water could be used to smear and liquefy them), and did not, in general, require the artist to wait before applying one hue over another. Thus in *View of the Sea at Sunset*, the streaks of pink above and yellow below could be applied directly and immediately over the bluish ground in order to describe the light reflected up onto the bank of cloud and down onto the rippling surface of the water. In *Broad Landscape* (cat. no. 84), which also dates to about 1862, the pastel is much thinner in application, suggesting that the view of clouds over a bay may have been very rapidly sketched, the paper still visible here and there across the sheet. Quickly executed landscape studies such as these, in both pastel and watercolor, were traditionally used in planning compositions executed in oils, but Monet—much like Boudin—seems to have turned to pastel for its own sake. He admired its mutability and efficiency, both qualities that helped him capture a fleeting impression.

For all this, Monet both exploited and respected the pastel medium. He turned to the *View of the Sea at Sunset*, for example, when he began to paint his *Towing of a Boat at Honfleur*, traditionally dated 1864 (and now with the Memorial Art Gallery of the University of Rochester), and ten years later at the first of the Impressionist exhibitions, he placed on view a number of landscapes executed in pastel, perhaps including one or both of the works shown here.[5] In the furor over Monet's audacity in presenting his *Boulevard des Capucines* and *Impression: Sunrise*, the pastels passed without comment.[6]

At the exhibition, Monet—known as a landscape painter—presented one genre scene, a large-scale interior showing a family sitting at a luncheon table (now in Frankfurt at the Städelsches Kunstinstitut und Städtische Galerie); in turn, Degas—already known for his figural compositions—exhibited one landscape painting, *At the Races in the Countryside* (cat. no. 81). Like Monet, Degas sent a number of works on paper to the exhibition, among them a pastel of a laundress and four works described as drawings—though these may have been highly finished, colored images. Had he chosen, Degas could have shown a work such as *Cliffs on the Edge of the Sea* (cat. no. 85), one of more than forty landscape pastels that he finished in the summer of 1869.[7]

Degas's pastel depicts a section of the coast of Normandy from a vantage point in the harbor of the fishing village of Dives-sur-Mer, looking northeast toward the tourist town of Houlgate, identified as a clump of buildings in the distance at left. (Beyond lies the larger town of Villers-sur-Mer, where Degas's friends the Morisots often spent their holidays.) The immediate foreground is occupied by a sandy, grassy bank that rises above the surface of the water lying out of our view. Strokes of blue pastel only hint at the inlet on either side of the sandy spit that enters the composition from the left-hand margin. With his typical taste for elision and ambiguity, Degas chooses a point of view that hides the form of a boat beached on the shore—traditionally the central motif in such a coastal scene—and gives his viewers only its masts and rigging at left, much as he would show only half the form of a distant gig in *At the Races in the Countryside*, or only a dancer's legs behind a lowering curtain.

The forms of the landscape reveal Degas's mastery of the pastel medium—he shaped masses of bank, beach, and hill, and defined tiny details such as the figures on the shore, distant buildings at the water's edge, and a villa perched at the top of the cliff, with care and skill. Above the landscape rises the gray-blue sky (now, unfortunately, somewhat blemished by tiny flecks of gray mold). Through the ceiling of cloud, patches of brilliant azure radiate, and at the horizon, at left, the sun shines on masses of billowing clouds. The depiction of the sky, in fact, suggests the keenness of Degas's sensitivity to the kinds of ephemeral effects of landscape that, according to tradition, he scorned. On the contrary, Degas's landscapes of 1869 such as *Cliffs on the Edge of the Sea* reveal not only his skill as a pastelist but his profound admiration for nature and light. It was Degas, after all, and not Boudin or Monet, who wrote in 1869 this subtle description of landscape:

> Villers-sur-Mer, sunset, cold and dull orange-pink, whitish green, neutral, sea like a sardine's back and lighter than the sky. Line of the seashore brown, the first pools of water reflecting the orange, the second reflecting the upper sky; in front, coffee-colored sand, rather somber.[8]

GTMS

1. Stuckey 1995, 186.

2. See Wildenstein 1974–91, 5:60–78, nos. D.1–104.

3. Boudin, December 3, 1856, quoted in Stuckey 1995, 186.

4. Quoted in Stuckey 1995, 187.

5. Murphy and Giese 1977 dated the pastels to 1870–74, noting that Monet exhibited several such works in 1874. Wildenstein 1974–91 notes that Monet himself told Durand-Ruel that he had drawn the works in 1862. See 5:219, pièce justificative 347.

6. See Berson 1996, 2:9–42, for the known criticism of the first Impressionist exhibition.

7. For the most thorough and informative discussion of Degas's activity as a landscape artist, see Kendall 1993; for an analysis of the 1869 pastels, see 85–107.

8. Quoted in Kendall 1993, 98, with variations by this author.

Claude Monet

French, 1840–1926

86. CLAUDE MONET
Ships in a Harbor, about 1873
Oil on canvas
50 x 61 cm (19 ⅝ x 24 in.)
Denman Waldo Ross Collection 06.117

Monet received early encouragement from
Boudin, who, living in Le Havre on the coast
of the English Channel, painted what he saw
around him, the shipping and harbor of the
bustling port. Monet, too, grew up in Le Havre,
so the marine motif was familiar to him. Thus
it is perhaps all the more surprising that he
could bring to the subject a fresh vision, some-
thing both he and Boudin did.

Monet's *Ships in a Harbor* was painted, or
at least begun, on an overcast day. The lack of
direct sunlight muted local colors and lent an
overall unifying tonality to the whole. Starting
with a pale gray ground, which provides a mid-
tone, Monet applied a closely hued selection of
blues, greens, purples, and a few touches of red-
dish brown, the latter of which harmonizes
with the pinks in the sky. These colors convey a
sense of dampness and a faint chill, conditions
to be expected at the seaside.

Perhaps most inventive is Monet's decision
to emphasize the surface of the water with a
network of horizontal strokes interwoven with
vertical squiggles. The undulating lines are an
apt analogue for the slight but constant move-
ments of the masts, prompted by the ever-fluid
water. In fact, the whole picture is in flux. The
varying thicknesses of the lines demarcating
masts, spars, and rigging give the sensation of
vibrating, calling their solidity into question.
The green hull of the largest boat merges with
the water and its reflection. The figures of
people and birds were made with flicks of the
brush. Aquiver and alive, *Ships in a Harbor* belies
its muted palette in its evocation of the fluid
relations among ships, water, and sky. FEW

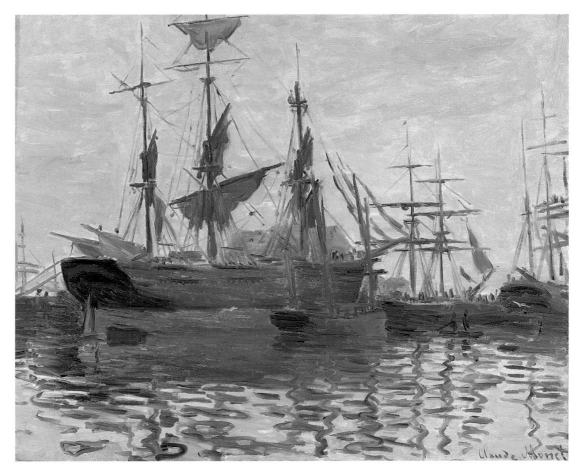

86

150

Camille Pissarro
French (born Danish West Indies), 1830–1903

Claude Monet
French, 1840–1926

87. Camille Pissarro
Pontoise, the Road to Gisors in Winter, 1873
Oil on canvas
59.8 x 73.8 cm (23 ½ x 29 in.)
Bequest of John T. Spaulding 48.587

88. Claude Monet
Snow at Argenteuil, about 1874
Oil on canvas
54.6 x 73.8 cm (21 ½ x 29 in.)
Bequest of Anna Perkins Rogers 21.1329

89. Claude Monet
Entrance to the Village of Vétheuil in Winter, 1879
Oil on canvas
60.6 x 81 cm (23 ⅞ x 31 ⅞ in.)
Gift of Julia C. Prendergast in memory of her
brother, James Maurice Prendergast 21.7

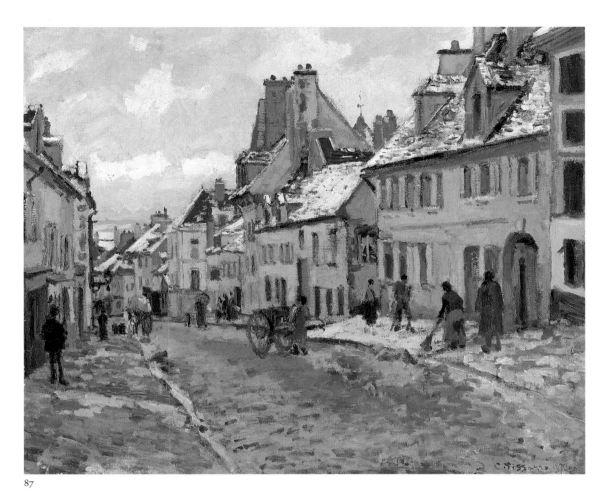

87

In northern Europe as in the northern United States, winter is a season of cold temperatures, snow and ice, and frequently overcast and even gloomy skies. Without foliage, trees and bushes stand spare and lean; grasses are dead and brown; flowers are gone. The light is duller, often grayer or bluer, than it is in warmer seasons. The moist air of northern France, so soft in the summer, in the winter shrouds forms in alienating whiteness. Even the built environment looks different, as if buildings shrink into themselves to keep warm. Such conditions intrigued Pissarro and Monet—the latter especially when he and his family moved to Vétheuil, a town farther down the Seine than Argenteuil and hence still relatively untouched by signs of modernity.[1]

Pissarro learned to draw when his parents sent him to Paris for schooling in 1841. After an unsettled period during which he first worked in his father's store and then went to Venezuela with the Danish painter Fritz Melbye, Pissarro returned to Paris in 1855, in time to see the Exposition Universelle. He enrolled in both the Ecole des Beaux-Arts and the less regimented

Académie suisse. Pissarro asked Camille Corot for advice, and aspects of the older painter's style can be seen in Pissarro's silvery palette and soft touch through the mid-1860s. After that time the more assertive style of Courbet is evident. Sporadic success at the Salon encouraged Pissarro to find alternative exhibition venues. He was the only artist to participate in all eight of the Impressionist group shows. By all accounts a generous and kindly man, he counseled Cézanne in the early 1870s and was himself influenced by the younger painters Seurat and Signac in the later 1880s. Although success came late to Pissarro, he continued to find challenging motifs for his paintings. He also left an impressive body of prints, many of which are technically innovative (see cat. nos. 97–101).

Pissarro preferred to live in the country rather than the city, and he settled in Pontoise, on the river Oise twenty-four kilometers (about fifteen miles) northwest of Paris, as early as 1866. He lived there periodically with his growing family until 1884, and so he is identified with the village and its surrounding countryside in the way that Corot is associated with Ville-d'Avray or Millet with Barbizon. More rural than Monet's Argenteuil, Pontoise was a provincial capital and market town, the place of transfer for the corn harvest from the Vexin region northwest of Pontoise to the navigable Oise.[2] In some paintings of Pontoise, Pissarro showed signs of its increasing modernization—smokestacks of a gasworks or a factory that distilled alcohol from sugar beets. In others he

emphasized the hilliness of the area; Pontoise is built on a plateau above the river. *The Road to Gisors in Winter* (cat. no. 87), in contrast, shows none of the particulars of the town—the view down a village street could have been taken in any number of villages, perhaps even Honfleur (see Monet's *Rue de la Bavolle, Honfleur*, cat. no. 79). The street we see here was, in fact, the widest road in Pontoise, leading from the river in a northwesterly direction toward Gisors, yet its relative anonymity freed Pissarro from depicting identifying characteristics to concentrate on the generic, traditional aspects of the town. A man pulls a cart without the benefit of a horse, his head down and his shoulders hunched with the strain; a woman sweeps the walkway free of snow with a broom made of twigs. (The descendants of these brooms, with the twigs now replaced by plastic, can be seen in the streets of Paris today.)

The overcast sky of winter in the village gave Pissarro the opportunity to focus on subtle color distinctions rather than on sharp contrasts of sunlight and shadow. The almost uniform color of the plaster-fronted buildings and the gray light forced Pissarro to find pictorial equivalents for the smallest differences of hue and value. The view he chose resulted in an interlocking pattern of rectangles, some smaller, others larger, the roof lines forming an uneven series of steps. Apart from rust red and olive green shutters, brick chimneys, and a few touches of blues and greens, the painting is a study of pale, midrange taupes, mushrooms, browns, beiges, and grays. The effect is that of a lightly tinted sepia photograph. The careful fitting together of parts and the rigorous geometry evident here were never far from Pissarro's sensibility, which was related to his admiration for Corot's work and to the similar predilections in Cézanne's emerging vision.

Pissarro's friend Monet had settled in Argenteuil, a town on the Seine downstream from Paris, after he returned from exile in

88

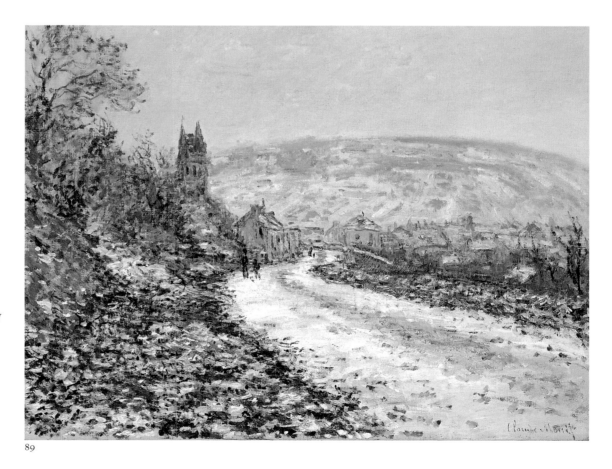

89

Fig. 44. Utagawa Hiroshige, Japanese, 1797–1858, *The Five Pines at Onakigawa*, 1856, color woodcut, Philadelphia Museum of Art.

England and Holland during the Franco-Prussian War. In two views of the town in winter, he explored varying conditions of light and atmosphere. The first of these, *Snow at Argenteuil* (cat. no. 88), depicts the first rapid snowfall of the season. Some leaves still cling to the trees, and grass in the meadow and along the path is not yet covered. Painted not far from his house in Argenteuil and probably begun outdoors, this work is one of the few that Monet made showing the actual fall of snow.[3] The flakes form a scrim that impedes vision: edges are blurred; expanses of walls are interrupted; stability, both visual and physical, is compromised. Monet created the indefinite forms in this painting over a light gray ground, visible between the quickly and thinly applied brushstrokes. Underlying this scene of change and momentariness is a stable and harmonious structure. The horizontal expanse of the meadow to the right is balanced by the vertical of the walls to the left. Although muted in color and partly obscured by tree branches, the church spire is the picture's center, rising from the cluster of snow-covered roofs at its base, the whites of which are sparked by the reds of the chimneys. Its vertical is grounded in the horizontal of the wall at the edge of the meadow.

A path or road leading into a town or village was a favorite compositional motif of the Impressionists. Its converging edges lent an immediate structure and dynamism to a painting, as well as establishing depth. Monet used it again in *Boulevard Saint-Denis, Argenteuil, in Winter* (fig. 26) and in the later *Entrance to the Village of Vétheuil in Winter*. The path, in all these paintings, situates the viewer in the scene. Fences, grassy meadows, or bushes act as framing devices, so that like the pedestrians (and like the artist himself, as he painted) we can feel our way through the cold, damp air and falling snow. Perhaps the frequent appearance of paths and roads leading into villages in Impressionist paintings, as Robert Herbert has suggested, underlines the painters' essentially touristic relation to the villages.[4] Pissarro may have lived in Pontoise, Sisley in Louveciennes, and Monet in Argenteuil and later Vétheuil, but they were painting for the Paris market. These paths and roads were ways in for outsiders.

At Vétheuil Monet painted none of the suburban gardens (see cat. no. 92) or sailboat regattas that had fascinated him at Argenteuil. In the snow scene he painted there in 1879, a sweep of country road leading into the village, bordered by messy stretches of grasses and weeds sodden with melting snow, takes up the bottom half of the picture (cat. no. 89). The edges of the road materialize out of dabs and flicks of the brush, and Monet has found myriad colors in the unpromising terrain—various blues and greens, reds and oxbloods, whites and ochers. All are unified by the medium light-brown color of the canvas priming, left visible in places just as the grasses and ground peek through the melting snow. The eye is not held by the colors and texture present in the foreground but rushes past, only to be stopped by the phalanx of houses constituting the village, their rectilinear forms hastily sketched in blue. The outlines of plowed fields on the hill beyond

subtly continue the architectural forms, in their turn terminated by the great curve of the hill, even more lightly drawn in with long, thin strokes, like those of a pastel.

The rushing perspective to the middle ground is not new to Monet's oeuvre; it was present in *Rue de la Bavolle, Honfleur* (cat. no. 79) and in *Boulevard Saint-Denis, Argenteuil, in Winter*. It replicates lived experience: we look where we are going, at the goal of our journey, rather than examine the weeds along the way. Yet here the perspective is exaggerated, with the point of view chosen so that the roadway covers what seems a disproportionate area of the canvas. Monet could have seen such a composition in nineteenth-century Japanese woodblock prints that were being imported into France in large numbers. Utagawa Hiroshige's *Five Pines at Onakigawa*, from the One Hundred Views of Famous Places in Edo series, is one such example (fig. 44). It directs the viewer's eye immediately to the middle and background, more or less skipping over the foreground, so that the picture as a whole is perceived at a glance. In a circular pattern of borrowing, Hiroshige used an exaggerated form of European one-point perspective, initially introduced to Japan via Dutch landscape prints. When Monet used Hiroshige's foreshortened foreground, he was able to retain the atmospheric qualities—the *enveloppe* of air—that were so important to him.[5] FEW

1. See Moffett et al. 1998 for a full discussion of Impressionist snow scenes.

2. Brettell 1990 provides a complete discussion of Pissarro's activities in the town. See also Brettell's "Pissarro, Cézanne, and the School of Pontoise," in Brettell et al. 1984, 175–205, especially 175–82.

3. Moffett et al. 1998, 96.

4. Herbert 1988, 219.

5. Needham 1975, 117.

Camille Pissarro
French (born Danish West Indies), 1830–1903

Alfred Sisley
British (worked in France), 1839–1899

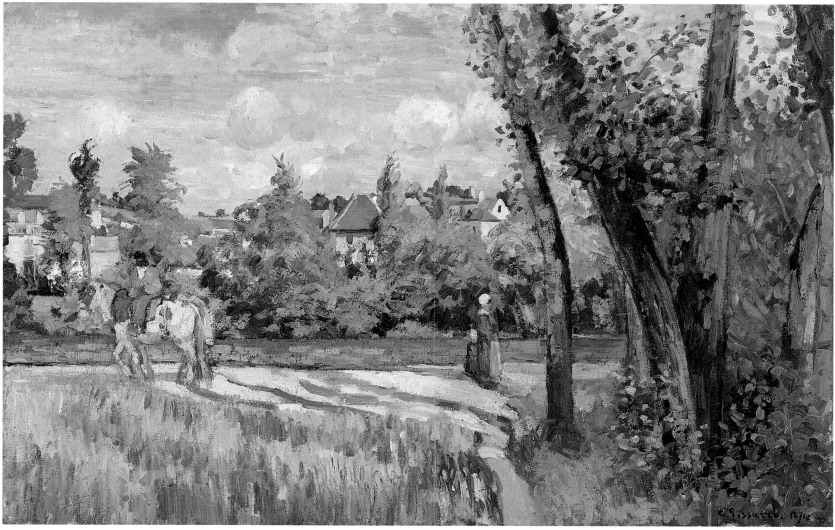

90

90. CAMILLE PISSARRO
Sunlight on the Road, Pontoise, 1874
Oil on canvas
52.3 x 81.5 cm (20⅝ x 32⅛ in.)
Juliana Cheney Edwards Collection 25.114

91. ALFRED SISLEY
Waterworks at Marly, 1876
Oil on canvas
46.5 x 61.8 cm (18¼ x 24⅜ in.)
Gift of Miss Olive Simes 45.662

A rigorous geometry, based on horizontals, underlies both Pissarro's *Sunlight on the Road, Pontoise* and Sisley's *Waterworks at Marly.* Painted within two years of each other, these works emphasize the structure that gives form to their discrete brushstrokes, whether the subject is a landscape or a manmade building. *Sunlight on the Road, Pontoise* (cat. no. 90) depicts a simple moment in the country. A woman and child walk hand in hand down a country road. A man on horseback looks back

at the pair. A stand of trees fills the foreground to the right, and slate-roofed cottages peek through the lush green foliage in the background. Beginning in 1874 Pissarro started to concentrate on rural subjects, following the advice of his friend the critic Théodore Duret, who urged him to "follow your own path of rustic nature."[1]

Pissarro's redirected focus was accompanied by a change in technique. The brushwork of *Sunlight on the Road, Pontoise* is varied and

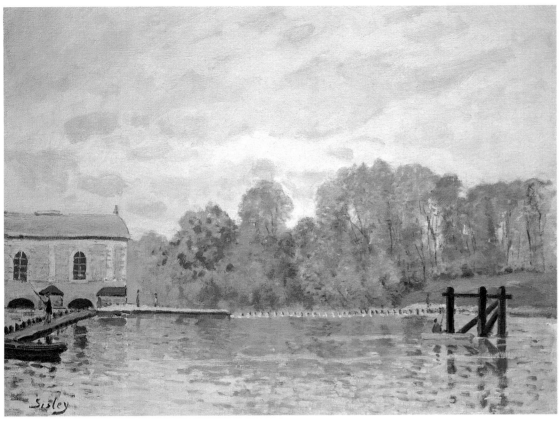

91

dense, with different strokes used to depict different textures, each kind of stroke relegated to a specific purpose: upright for grasses; long, creamy strokes for sunlight and shadow on the road; dabs for leaves; and horizontals for the blue of the sky and circular for clouds. Lighter blues, greens, and yellows are dispersed relatively evenly over the left side of the picture surface, emphasizing the darker, cooler clump of trees to the right. As in many of Corot's pictures, there is virtually no subject, simply people walking and riding along the road. The interest of the picture lies rather in the way it is painted, with careful, constructive strokes, akin to the way Cézanne was beginning to paint (see cat. no. 114 for a later painting by Cézanne).

The considered disposition of brushstrokes,

each to its appropriate texture or surface, is matched by the strict geometry Pissarro found in, or imposed on, the seemingly casual scene. Most obvious are the horizontals of the riverbank, its relative darkness answering the canted shapes of the slate roofs above. The tree trunks offer softened verticals to harmonize with the horizontal, while the thick carpet of grasses lends a more unified texture in contrast to the more varied brushwork of the trees beyond the wall.

Such geometry finds its manmade equivalent in Sisley's *Waterworks at Marly* (cat. no. 91). The waterworks were originally built in the late seventeenth century to lift water from the Seine to the aqueduct at Louveciennes. The aqueduct carried the water to the parks at near-

by Versailles and Marly (another royal residence), where it filled the famous fountains. Sisley did not depict the historic waterworks, however, for they were replaced between 1855 and 1859 by a new system, and it is the end of the brick building containing six iron wheels and twelve forcing pumps that Sisley painted here. The site clearly intrigued him, for he painted at least six other views of it.[2] Sisley used the structure provided by the architecture and walkways to lay out his painting in large, bold shapes. The horizontals of the building and especially the walkway and row of posts reaching across the water give order to the trees with their autumn foliage; although they actually recede at a diagonal along the river, they appear as a uniform screen across the painting, blocking the view and concentrating attention on the foreground. Horizontal lines convey a sense of peace, an evenness of temperament, which here is reinforced by the presence of the recreational fishermen. At right and left, the fishermen take matter-of-fact advantage of the combination at Marly of the vestiges of the ancien régime and Napoleon III's more recent empire and the technology that served both reigns.

Sisley's palette, particularly in his early career, was often blond in tonality. Pale grays, blues, greens, and ochers frequently dominate his scenes of water and sky. Here the foliage, touched with yellows and pinks, harmonizes with the pink of the bricks, and the colors are carried throughout the bottom of the painting in the reflections in the water. The frankly pretty color scheme calls to mind paintings of the previous century, suggesting that *Waterworks at Marly* is Sisley's tribute to a past age. FEW

1. Quoted in House et al. 1995, 214, from Pissarro and Venturi 1939, 1:26.

2. Stevens and Cahn 1992, 122, cat. no. 20.

Claude Monet
French, 1840–1926

Pierre-Auguste Renoir
French, 1841–1919

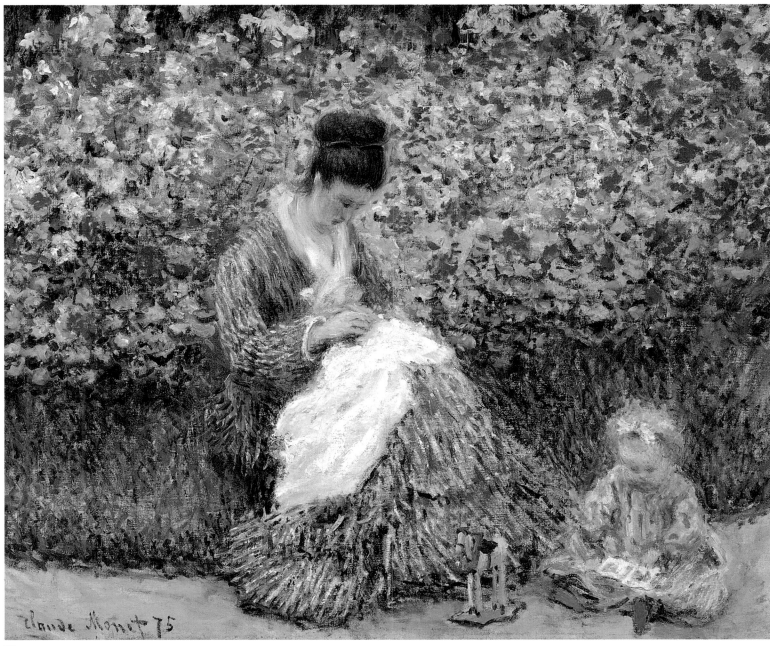

92

92. CLAUDE MONET
Camille Monet and a Child in the Artist's Garden in Argenteuil, 1875
Oil on canvas
55.3 x 64.7 cm (21 ¾ x 25 ½ in.)
Anonymous gift in memory of Mr. and Mrs. Edwin S. Webster 1976.833

93. PIERRE-AUGUSTE RENOIR
Woman with a Parasol and Small Child on a Sunlit Hillside, 1874–76
Oil on canvas
47 x 56.2 cm (18 ½ x 22 ⅛ in.)
Bequest of John T. Spaulding 48.593

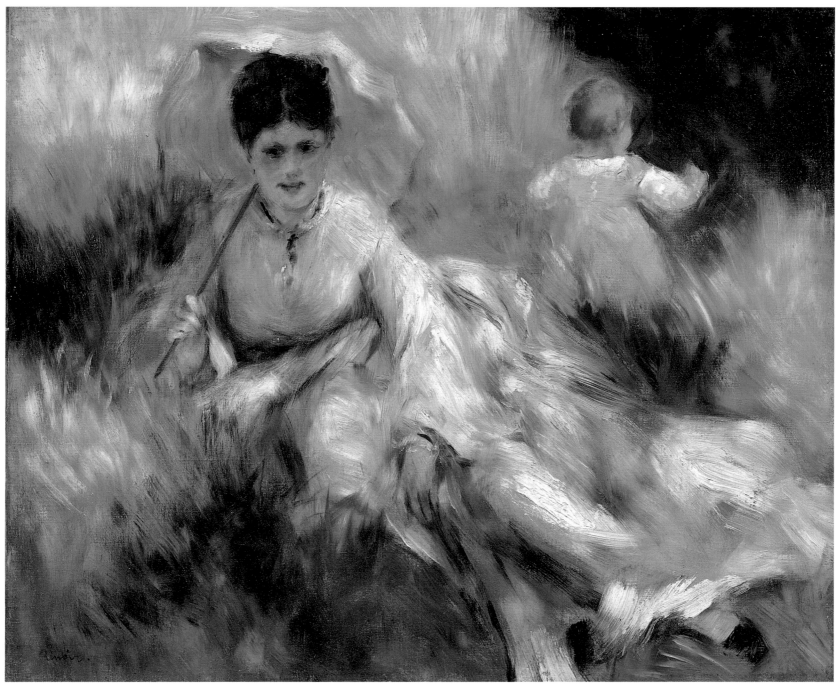

93

The men who painted the scenes of urban and rural France in the late nineteenth century were family men. Unlike Corot and Rousseau, for example, who had no children, Monet, Sisley, Pissarro, and Renoir had families for whom they had to provide. When these artists wanted to paint the human figure in a landscape setting (a problem Corot had worked on for years; see cat. no. 66), they often used their family members as models. Monet's *Camille Monet and a*

Child in the Artist's Garden in Argenteuil (cat. no. 92) is one of the most popular paintings by the artist in the Museum's collection. The subject is immediately appealing. A pretty young woman in a fashionable striped dress sits in a lush garden, sewing. At her feet sits a small child, engagingly adorned with a pink ribbon that holds back his blond hair, looking at a picture book. A toy horse, wearing a green collar, waits its turn for attention. The day is sunny, the air soft and

warm. It is a picture of secluded domesticity.

A pictorial rigor underlies the peacefulness of this scene. Monet's insistence on pattern making, so evident in the earlier *Rue de la Bavolle, Honfleur* (cat. no. 79), is no less marked here. The picture is composed simply. Horizontal bands of flowers, grass, and pathway establish the pictorial space. Over these bands are painted the triangles of the two figures. A geometric order has been imposed on the seem-

ing vagaries of nature. Yet a curious tension reigns in this garden. Because blue is a cool color and therefore gives the impression of receding from the eye, the figures, despite their position in front of the flowers, seem to sink back into them. And because pink and red are warm colors and seem to advance toward the eye, the flowers appear to collapse the intervening space, enveloping the young woman and making her part of the garden.

The painting testifies to the flight of middle-class Parisians to the suburbs after mid-century. The art historian Paul Hayes Tucker has amply discussed this trend and Monet's part in it in his book *Monet at Argenteuil*.[1] The figures seen here are indeed urban people transposed to a suburban setting. The young woman, Monet's first wife, Camille, wears city, not country, clothes, and the toy horse comes from a shop in Paris, not a father's workbench. The garden belonged to the second house Monet rented in Argenteuil, on the boulevard Saint-Denis, a road that runs a block away from and parallel to the railway line to Paris. The seclusion and quiet that pervade this painting are exactly the qualities city dwellers sought in their suburban retreats, yet one wonders, with the train tracks a short block away, how peaceful the garden really was.

Such a question, however, is altogether beside the point, for Monet painted exactly what he wanted us to see. The simple composition evokes a sense of permanence and stability. The combination of young woman and child (who is too young to be the Monets' first son, Jean, born in 1867) proclaims both domesticity and the promise of future generations. Yet, while this painting is resolutely of its time, the imagery recalls the medieval convention of the *hortus conclusus*, an enclosed garden in which the Virgin and Child sit at their ease. This association is underscored by the blue color of

Fig. 45. Edouard Manet, French, 1832–1883, *The Railway*, 1873, National Gallery of Art, Washington.

Camille's striped dress, for the Virgin is traditionally depicted wearing a blue mantle. A deceptively simple painting, *Camille Monet and a Child in the Artist's Garden in Argenteuil* is at once ingratiating and manipulative, seamlessly blending tradition and the present in a careful tapestry of flickering brushstrokes, evocative of a perfect summer's day.

Of all the paintings produced by the artists associated with the Impressionist movement, Renoir's are the most immediately appealing. His scenes often include people—frequently young women and children—with whom we, as viewers, can identify. At age thirteen Renoir was apprenticed to the porcelain painters Lévy Frères in Paris, where his family had moved in 1844. He worked for a manufacturer of window blinds and other decorative objects in 1858, and in 1860 applied for and received permission to copy paintings in the Louvre. In 1862 he entered both the Ecole des Beaux-Arts and the studio of Charles Gleyre, where he met such other progressively minded painters as Bazille, Sisley, and Monet. They painted together during the summers in the Forest of Fontainebleau, and Renoir showed in the group's independent exhibitions in 1874, 1876, 1877, and 1882. However, he was

also a faithful adherent of the classical tradition and submitted to the Salon regularly. His primary subject matter was the figure, and he experimented with portraits, genrelike scenes, and bathers. In the early 1880s he traveled to Italy, North Africa, and the South of France. The Renaissance art and light he experienced there prompted him to adopt a brighter and more colorful palette, which he joined to an increased emphasis on line and structure. In poor health for some time, he wintered in the South of France, and in 1907 he bought property in Cagnes and had a house built there, where he died.

In *Woman with a Parasol and Small Child on a Sunlit Hillside* (cat. no. 93) the pretty, dark-haired young woman smiles welcomingly under her pink parasol. If it were possible to step into a painting, such an invitation would be hard to resist. Renoir's depiction of a hillside in summer conveys a sense of fullness and ease that can be complete only with the inclusion of the human figure: without the young woman and child—the one relaxing, the other exploring—the scene would hold no interest for us.

Renoir's rapid yellow and green brushstrokes mimic the lushness of summer grasses so tall that the woman sinks into them (notice the blades curving over her right arm holding the parasol). The small child toddling off on a mission of his own is equally enveloped by the grasses. The unconcern evinced by the woman for the child's whereabouts is a sign, not of her inattention, but of the evident security of the surroundings. A beautiful summer's day holds no dangers. What it does hold is what Renoir shows us: color and light combining inextricably, color as light and light as color. Renoir took special care with the dress, which is not so much the white it initially appears as it is blues and grays, yellows and pinks—all the colors, that is, that he saw in the shadow in which the

Edgar Degas

French, 1834–1917

woman is reclining. As though this were a portrait, Renoir flatters the sitter's fashion sense by detailing the narrow black ribbon and ruffle trimming the neckline and cuff.

Yet, despite the sunny nature of the picture, there seem to be some unresolved questions and tensions. The pose of the woman, propped as she is on one elbow, with that arm holding the parasol, seems awkward, and perhaps finally painful. The movement of the child toward the upper right of the canvas, continuing the diagonal that begins in the lower left corner, opens the pictorial space into the unknown, symbolized by the dark, indeterminate corner. It is the country equivalent of Edouard Manet's *Railway* (fig. 45). Both paintings feature a young woman whose gaze out of the picture establishes a relationship with the viewer, and a child whose attention is so intently directed toward an obscure goal that it turns its back. Although the woman in Renoir's painting clearly establishes that the spot where she reclines is soft and agreeable—a small segment of *pays doux*—the child's movement shows that there is more to see and explore beyond the confines of the picture space. FEW

1. Tucker 1982, 125–53.

94

94. EDGAR DEGAS
Beside the Sea, 1876–77
Monotype on cream wove paper
Platemark: 11.8 x 16.2 cm (4⅝ x 6⅜ in.)
Gift of Mr. and Mrs. Peter A. Wick 1993.1015

95. EDGAR DEGAS
The Path up the Hill, 1877–79
Monotype on cream wove paper
Platemark: 11.6 x 16.1 cm (4⁹⁄₁₆ x 6⁵⁄₁₆ in.)
Fund in memory of Horatio Greenough Curtis
24.1688

About 1876 Degas and his friend the Viscount Ludovic Lepic, an artist who had exhibited with the Impressionists, began to experiment with metal etching plates, printer's inks, and papers. Degas had been making prints since the late 1850s, but by the 1870s he was searching for new ways to use time-honored media. Lepic, a talented printmaker following the example of Rembrandt, had tried using broadly applied swaths of ink rather than etched lines to vary the mood conveyed by each pulling of a print. Together, Degas and Lepic abandoned the notion of etching or engraving a matrix in the plate to establish the printed design and decided to make works that were, as Degas later described them, "drawings made with thick ink and then printed." The resulting images in mod-

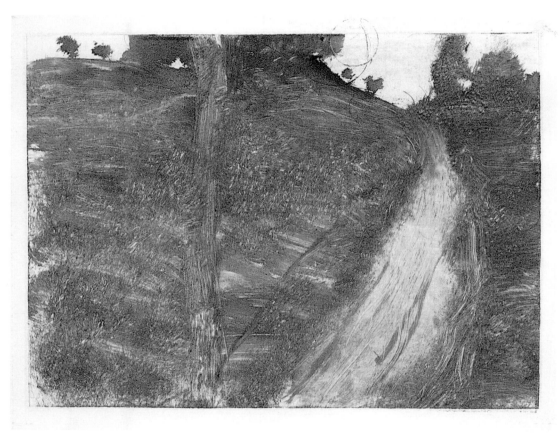

95

ern times have been called monotypes, as usually only one impression of the "drawing" can be successfully printed.[1]

In a matter of two years, Degas made more than a hundred monotypes. As he experimented with the procedure, he evolved two basic ways of working. Among the earlier prints, a work like *Beside the Sea* (cat. no. 94) is in what scholars have called Degas's "light field manner," meaning that the monotype was made by placing dark ink onto a light background. Degas began *Beside the Sea* in his Paris studio by selecting a smooth metal plate of copper or steel. Using printer's ink diluted with spirits, he painted a drawing onto the working surface—in this case the metal plate instead of a sheet of paper. Working from memory and imagination, he

drew the figure of a woman on the left of the metal plate, facing right with an umbrella in her hand. He placed a seaside villa to her right in the middle distance, and beyond on the horizon, the distant form of a steamer trailing a plume of smoke. The drawing was worthy of the greatest Japanese calligrapher. Satisfied with the design, Degas applied a sheet of moistened paper to the plate and ran the two through a heavy printing press. Once peeled away, the paper bore the lines that Degas had painted on metal—but, of course, the woman no longer faced right but left, as the printed image was the reverse of the drawing.

Degas's second working method is exemplified by *The Path up the Hill* (cat. no. 95), which may have been made slightly later. Taking a

plate of virtually identical dimensions—perhaps even the same sheet of metal—Degas proceeded in a different fashion. He filled his brush with printer's ink and painted all but the very top of the plate with broad strokes of black. The inked portion of the design became the land; the untouched plate served to suggest the sunlit sky. To give definition to the dark form of the landscape, Degas then wiped and stippled the silver-black ink. A dry brush was dragged through the medium to give horizontal dimension to the ground; the same brush was punched across the surface to suggest the texture of grass and drawn upward through the ink to suggest the trunk of a tree. The path itself was wiped away with a brush, a rag, or the artist's fingers. Ruts were then drawn into the path with a brush, and trees were indicated as blobs at the horizon. This way of working, in which form is pulled into light from an inky base, is called Degas's "dark field manner."

The notion of light and dark corresponds with Degas's considerable ambitions as a printmaker at the end of the 1870s. His experimentation with the monotype process stoked his passion for more traditional printmaking techniques. Following the Impressionist exhibition of 1877, Degas, Mary Cassatt, and Pissarro envisioned a publication on the glories of printed Impressionism, for which Degas proposed the title *Le Jour et la nuit* (Day and night). Although the publication never came into being, it inspired the artists to do some of their most adventuresome work (see cat. nos. 97–101). At the height of their engagement with the transcription of light effects through the means of color, they pioneered what Barbara Shapiro has rightly called "black-and-white Impressionism."[2] GTMS

1. For the groundbreaking study of Degas's work in the medium, see Janis [1968]. For a discussion of the early landscape monotypes, see Kendall 1993, 128–32.

2. Shapiro 1997, 244.

Camille Pissarro
French (born Danish West Indies), 1830–1903

96. CAMILLE PISSARRO
The Quarry at the Hermitage, Pontoise, 1878
Black chalk on blue wove paper
Sheet: 33.7 x 20.7 cm (13 ¼ x 8 ⅛ in.)
Gift of Barbara and Burton Stern in memory of
Lillian H. and Bernard E. Stern 1985.348

97. CAMILLE PISSARRO
Wooded Landscape at the Hermitage, Pontoise, 1879
Soft-ground etching and aquatint on cream wove
paper, first state
Platemark: 21.6 x 26.7 cm (8 ½ x 10 ½ in.)
Lee M. Friedman Fund 1971.267

98. CAMILLE PISSARRO
Wooded Landscape at the Hermitage, Pontoise, 1879
Soft-ground etching and aquatint on beige laid
paper, fifth state
Platemark: 21.6 x 26.7 cm (8 ½ x 10 ½ in.)
Lee M. Friedman Fund 1971.268

99. CAMILLE PISSARRO
Wooded Landscape at the Hermitage, Pontoise, 1879
Soft-ground etching and aquatint on cream Japanese
paper, sixth state
Platemark: 21.6 x 26.7 cm (8 ½ x 10 ½ in.)
Katherine E. Bullard Fund in memory of Francis
Bullard, Prints, Drawings and Photographs Curator's
Discretionary Fund, Anonymous gifts, and Gift of
Cornelius C. Vermeule III 1973.176

100. CAMILLE PISSARRO
Twilight with Haystacks, 1879
Aquatint with drypoint and etching on cream wove
paper
Platemark: 10.5 x 18.1 cm (4 ⅛ x 7 ⅛ in.)
Lee M. Friedman Fund 1974.533

101. CAMILLE PISSARRO
Twilight with Haystacks, 1879
Aquatint with drypoint and etching in Prussian blue
on beige laid paper
Platemark: 10.5 x 18.1 cm (4 ⅛ x 7 ⅛ in.)
Lee M. Friedman Fund 1983.220

96

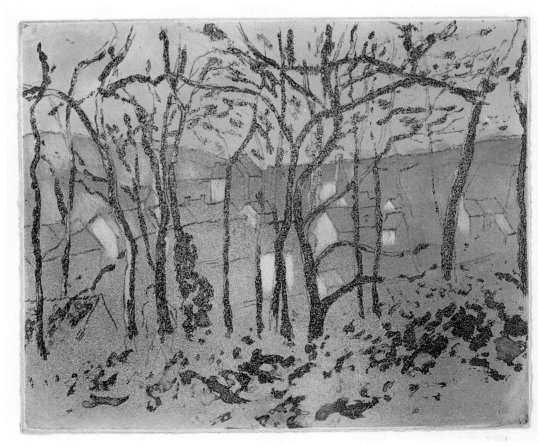

97

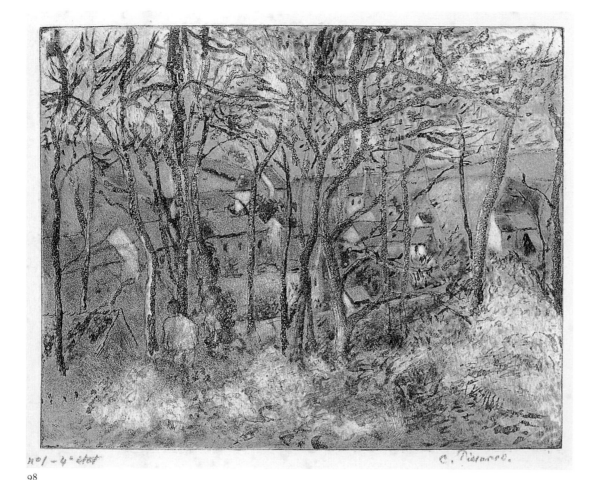

98

When Pissarro moved with his wife, Julie, his eldest son, Lucien, and a small daughter, Minette, to the village of Pontoise at the beginning of 1866, he found a distinct geography and motifs in the area that pleased him greatly: the markets and fairs in the town itself, the banks along the river Oise, the fields filled with orchards, and the hilly terrain of L'Hermitage (an older section of the village). Except for a short stay in 1869 in nearby Louveciennes, Pissarro traveled about the area, sketching regularly, until 1870, when he was forced to flee with his family to England with the outbreak of the Franco-Prussian War. By the summer of 1872, however, Pissarro was back in Pontoise, where he remained for a decade, working with his favorite motifs. At the same time, he lightened his palette, trusted his sensations, and for the most part advocated working outdoors. In conjunction with his becoming an Impressionist artist, Pissarro believed that constant drawing served as both an agreeable activity and an intelligent preparation for painting. More than a thousand sheets document his drawing campaigns and provide an impressive body of visual information. Many of them reveal a footpath bordered by lush vegetation and an intricate screen of trees, or a hillside that boldly lifts the horizon line of the composition and frames the scene.

The Quarry (cat. no. 96) is representative of Pissarro's recording of Pontoise's special topography, in this case a niche within an overhanging hillside covered with a stand of leafless trees. By sketching the scene on a large sheet of blue paper, the artist conveys a simple, poetic charm to a particular locale. Pissaro favored special papers and, in fact, printed many of his etchings on pages removed from old ledgers. This composition represents Pissarro's affection for drawing, an almost daily occupation, or it may have served as a study to be worked up later into a painting.

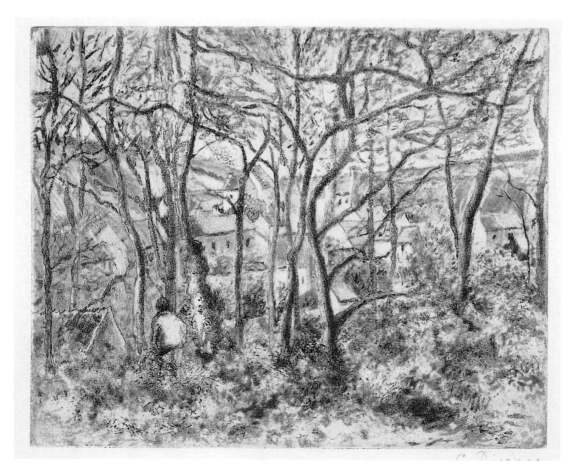

99

While Pissarro favored the rural geography of Pontoise as subject matter, he also maintained close ties to artistic circles in Paris. He visited friends regularly and attended Emile Zola's Thursday night dinners, along with Cézanne and other artists and writers. In the spring of 1879, with the printmaker Félix Bracquemond as artistic adviser, Degas invited Pissarro, along with Mary Cassatt, to join him in launching a journal of original prints to be called *Le Jour et la nuit* (Day and night). Pissarro enthusiastically acquired a new set of skills for the project, becoming proficient in working with both copper and zinc plates, and some thirty impressions from about twenty plates testify to this productive period of working with his Parisian colleagues. As the title of the journal suggests, all three artists were able to transfer strokes of painted colors onto etching plates to create, in a small format, a distinctive form of black-and-white Impressionism.

Of all the Impressionists, however, it was Pissarro who most diligently and successfully translated his pictorial ideas into printed images. For the first time in the nineteenth century, the etching medium, with all its most creative ramifications, was explored artistically for its own sake. Its role as a means to reproduce paintings was rejected; instead, the intention to fashion impressionistic, painterly images without obvious contours or noticeable etched lines was brilliantly achieved. Pissarro created many unusual texture and light effects and a broad range of tonal values, all by unconventional means. The methods used were so inventive, individual, and closely blended that they are not easily analyzed.

The most significant feature of Pissarro's prints was his innovative commitment to making series of impressions that often developed through progressive stages.[1] These three states of the print *Wooded Landscape at the Hermitage, Pontoise* (cat. nos. 97–99) are part of such a series and were among Pissarro's contributions to *Le Jour et la nuit*. To produce them, he first scraped and polished the printing plate. He then added layers of aquatint and soft-ground lines with drypoint accents that mimicked the textured, overlaying brushstrokes of a painted prototype similar to *The Côte des Boeufs at L'Hermitage* (fig. 56, p. 219) in its use of an elevated hillside and densely worked screen of trees.[2] The first state of the print (cat. no. 97) established the key structural forms: the silhouettes of the houses, the contour of the Pontoise hillside, and a figure on the left intersected by a tree trunk. A small amount of scraping introduced the light, cube-shaped homes, and then a screen of bare, thin trees was brushed on the plate with a lift-ground, in which acid and aquatint were the underlying techniques. This unique trial proof was printed on a heavy paper favored by Degas and bears a red stamp on its verso signifying that it was found in Degas's studio after his death.

Pissarro did not stop here, however. The fifth state of the print (cat. no. 98) showed the artist less reliant on the painting and more involved with various etching techniques. Here he has experimented with radically scraping and polishing the gray matrix on the plate, toning down the distinct tree trunks and removing some of the heavy underbrush work in the foreground of the image. The next, final, state (cat. no. 99), professionally printed by Jacques Salmon in an edition of fifty, reflects the Impressionist aesthetic of light, color, and tactility. No longer dependent upon the painting, Pissarro could be more concerned with combining textures (in the many different types of foliage, for example) and with varying the effects of light and shade. The artist felt so strongly about his efforts with Degas that he willingly exhibited four states of the *Wooded Landscape* mounted on yellow paper at the fifth Impressionist exhibition in 1880.

The closest collaboration between Degas and Pissarro is seen in the small but outstanding etching *Twilight with Haystacks* of 1879 (cat. nos. 100–101). A few impressions were printed by a professional printer in black and white, and even without color they convey a powerful effect of tone and light. To produce the painterly print shown here, for example, Pissarro made creative use of the etching, drypoint, and aquatint processes, with many small touches of acid brushed directly onto the plate and incorporated into the image (see cat. no. 100). The artist also chose to suggest a sinking sun on the copper plate so that the haystacks and the two small figures on the curving road could cast deep, naturalistic shadows.

With the unusual intervention of Degas as printer, other impressions were produced in various colors that suggest the intense hues found in many of Pissarro's paintings—brown, red, and blue.[3] As a group, these color landscapes call to mind Monet's series of painted haystacks, and by special inking, they reflect in small format the same modification of light and atmosphere. It is worth noting, however, that Monet did not attempt his haystack sequence until nearly a decade after Pissarro and Degas had completed these distinctive prints.[4] BSS

1. See Shapiro 1980, 191–234.

2. The original painting, *Wooded Landscape at the Hermitage*, is now in the collection of the Nelson-Atkins Museum of Art, Kansas City.

3. One example of the landscape, now in the Bibliothèque nationale, was printed on the verso of a wedding invitation dated June 17, 1879 (Paris). An inscription in the margin in Pissarro's hand states: "printed by Degas" [imp. par Degas]. Degas and Pissarro were working closely together at this time, and one can posit that Degas picked up a discarded invitation in his studio and used the sheet to print an example in brown.

4. Melot 1977, 16.

Pierre-Auguste Renoir
French, 1841–1919

Claude Monet
French, 1840–1926

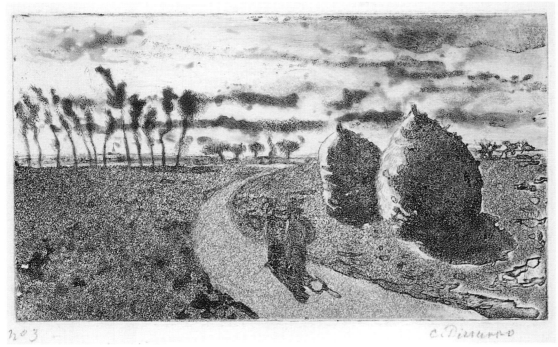

100

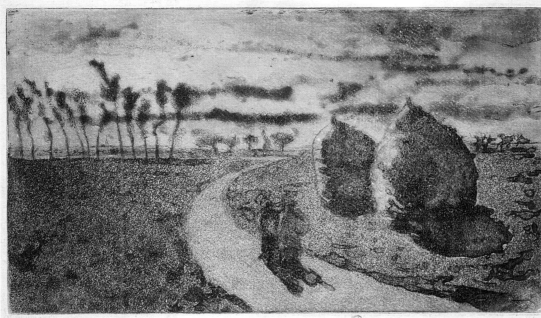

101

102. PIERRE-AUGUSTE RENOIR
The Seine at Chatou, 1881
Oil on canvas
73.5 x 92.5 cm (28 ⅞ x 36 ⅜ in.)
Gift of Arthur Brewster Emmons 19.771

103. CLAUDE MONET
Road at La Cavée, Pourville, 1882
Oil on canvas
60.4 x 81.5 cm (23 ¾ x 32 ⅛ in.)
Bequest of Mrs. Susan Mason Loring 24.1755

Renoir's *Seine at Chatou* and Monet's *Road at La Cavée, Pourville* make an intriguing pair. Both depict the intersection of land and water on a summer's day, blue skies above and white clouds proclaiming clement weather. The lush vegetation that almost fills each canvas is rendered with a flurry of minute brushstrokes. The colors, while not identical, were chosen from the midrange of tones—pinks, greens, blues, and yellows leaning toward the pastel end. It is the differences between them, however, that help us to characterize the individual accomplishments of each artist.

Painted in April or May 1881, after Renoir's return from Algeria and before his second trip to Italy, *The Seine at Chatou* (cat. no. 102) places the viewer among grasses and pink-flowering trees on the banks of the Seine near Chatou, a small town about sixteen kilometers (nine and one half miles) west of Paris and a short distance north of Bougival. The Seine was a popular subject for writers, painters, and photographers alike, who often depicted it as a favored locus of Parisian and provincial leisure activity.[1] This painting, however, is not as much about people and their activities as it is about the landscape, the weather, and the atmosphere, all bursting with the color and vitality of spring.

Both banks of the river are covered with lush foliage. Renoir emphasizes the suburban, rather than rural, character of the locale. The

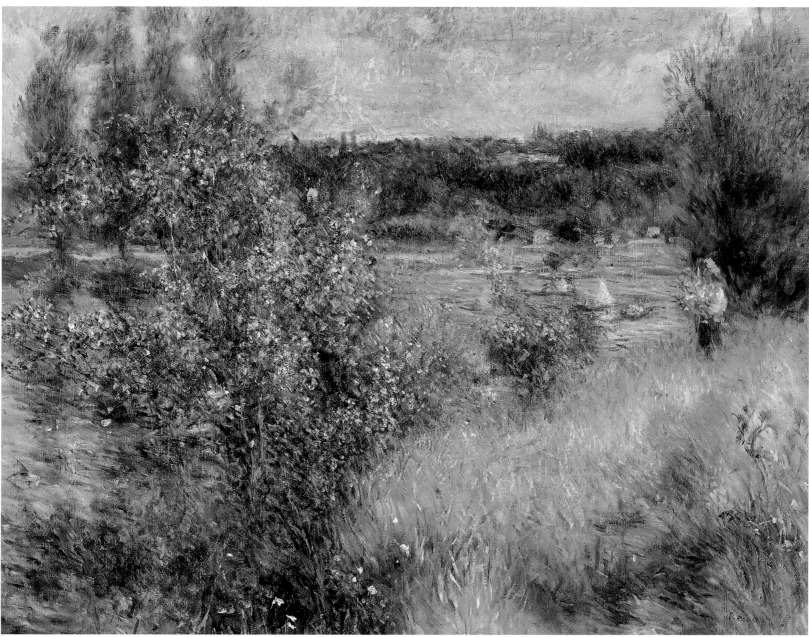

102

houses on the far bank resemble villas that spread along the Seine in the late nineteenth century, and the sailboats are leisure, not working, craft. The girl or young woman with her armful of flowers, likewise, is at leisure. This quiet moment in summer is animated solely by the active brushstrokes. Different touches—dabs, interweaving verticals, horizontals, and diagonals—demarcate to some degree different textures and surfaces—sky, water, grasses, flowering buds—but, as the art historian John House has noted, there is "no overriding order."[2] The effect is of sparkle and dazzle,

as if the sun were so bright, the weather so hot, that the whole natural world and everything in it was set atremble. So alive is the surface, in fact, that there is no single focal point. The eye alternates between the flowering tree at the left and the figure at the right, neither one offering visual or psychological rest. This, despite the receding diagonals that posit the figure at their meeting point: the brightest grasses lead to the figure, whose orange-red hat establishes the nearer end of a diagonal marked by equally bright orange-red shapes leading to the left end of the far bank.

About 1871 Renoir had painted the same location, focusing on some of the villas across the river (fig. 46). A quiet scene, it is characterized by bold, loose, and fluid brushstrokes reminiscent of the work of Daubigny. In the earlier painting Renoir was concerned with the water and its reflections and refractions of light, whereas in this later one nature's fecundity and vitality were his focus.

Monet, too, painted a picture of nature's lushness, but his vision is much more ordered and rational, relying on a favorite device of his, the X shape (cat. no. 103). He had begun to

166

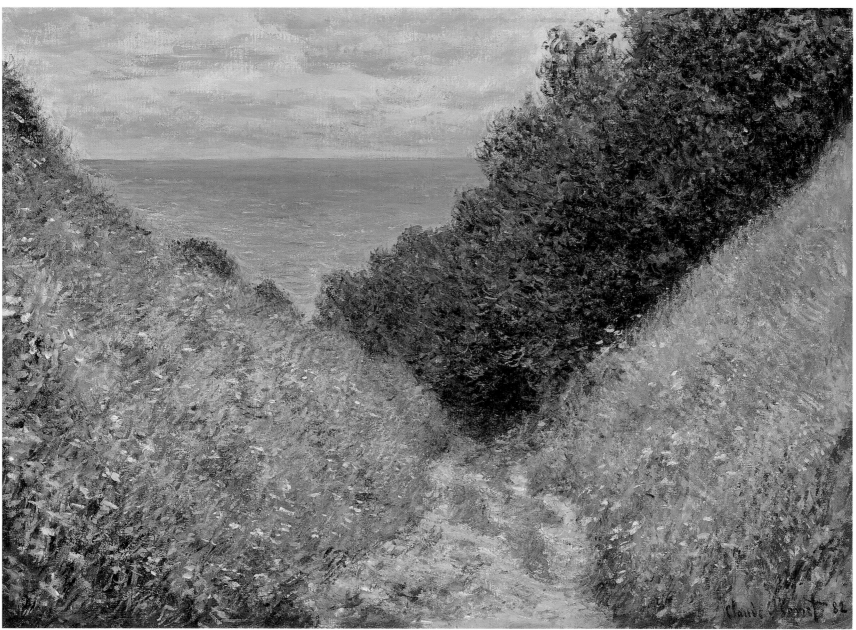

103

Fig. 46. Pierre-Auguste Renoir, *The Seine at Chatou*, about 1871, Art Gallery of Ontario, Toronto.

experiment with X-shaped compositions as early as 1863–64 (see fig. 7 and cat. no. 79). Here, almost twenty years later, he has refined the schema and simultaneously clothed it in an active surface pattern of indescribable subtlety. A grass-tufted path leads between hills to dip below, or turn to skirt, a wall of trees. The darker foliage of the trees separates the light-toned regions of foreground grasses and distant water and also denies access to the shore: the path must lead there, but how?

The large, simple triangle shapes and the softened rectangle of the foliage serve as suit-ably bland containers for the welter of colored marks. One of the great joys of looking at Monet's paintings is being able to trace the activity of his brush, the various ways in which he applied paint, and the many different colors of paint he applied. The pastel pinks, mauves, greens, and blues, so soft that they look as if they have been wafted onto the canvas, make the coarse seaside grasses seem pliant to the touch, almost silky. If Monet did not arrange his brushstrokes into areas of pattern, as Pissarro and Cézanne did, here they are nonetheless more discrete and form defining than Renoir's.

Claude Monet
French, 1840–1926

Pierre-Auguste Renoir
French, 1841–1919

Fig. 47. Claude Monet, *The Sheltered Path*, 1873, Philadelphia Museum of Art.

Where Renoir offers a vision of bursting life, Monet gives us nature submitted to an idea.

Despite the uncertain continuance of Monet's path, this is a welcoming, pleasant place. The path nestles between two soft mounds. In the Western tradition, landforms are often discussed in sensuous terms in relation to the human body. The topos of Mother Earth is evoked, and the import can be nurturing, or sexual, or both. By this date Monet's paintings only rarely included the human figure. If one were present here, as in the much more straightforward *Sheltered Path* of 1873 (fig. 47), the scene would take on an anecdotal air, and the force of the geometry and suggestiveness of the landforms would be diminished. Without a figure, *Road at La Cavée, Pourville* invites, seduces, comforts, and promises, on an optical as well as an animal level, the component parts of which are impossible to disentangle. FEW

1. See Brettell 1996.

2. House et al. 1995, 260, cat. no. 98.

104. CLAUDE MONET
Seacoast at Trouville, 1881
Oil on canvas
60.7 x 81.4 cm (23⅞ x 32 in.)
The John Pickering Lyman Collection. Gift of Miss Theodora Lyman 19.1314

105. CLAUDE MONET
Fisherman's Cottage on the Cliffs at Varengeville, 1882
Oil on canvas
60.5 x 81.5 cm (23⅞ x 32⅛ in.)
Bequest of Anna Perkins Rogers 21.1331

106. PIERRE-AUGUSTE RENOIR
Rocky Crags at L'Estaque, 1882
Oil on canvas
66.5 x 81 cm (26⅛ x 31⅞ in.)
Juliana Cheney Edwards Collection 39.678

107. PIERRE-AUGUSTE RENOIR
Landscape on the Coast, near Menton, 1883
Oil on canvas
65.8 x 81.3 cm (25⅞ x 32 in.)
Bequest of John T. Spaulding 48.596

The essential difference between the art of Renoir and Monet seen in *The Seine at Chatou* (cat. no. 102) and *Road at La Cavée, Pourville* (cat. no. 103)—overall lushness versus geometry—is even more apparent in this grouping of two paintings by each artist. Painted within only a few years of each other, Monet's paintings were done on his beloved Normandy coast, whereas Renoir's show him exploring completely new terrain at the other end of France—the Mediterranean.

In Monet's *Seacoast at Trouville* (cat. no. 104) the central motif is a single tree, deformed by the constant buffeting of onshore winds. The artist has focused so intently on it that the rest of the canvas serves as a mere backdrop. Because the horizon line is effaced in a haze of creamy blue strokes, there is no sense of reces-

Fig. 48. Théodore Rousseau, *Oak Trees in the Gorge of Apremont*, about 1850–52, Musée du Louvre, Paris.

sion into the distance. Such an abstract field behind the tree deprives it of volume, so that it reads as a flat pattern on the surface. This pattern is so dominant that its outline determines the shapes of other forms in the painting. Not only do the low blue bushes that extend from one edge of the canvas to the other echo the general form of the tree's foliage, but the very ground answers the bending motion in low hillocks parallel or related to the tree's angle. Although the tree's form is dominant and determines so many other shapes in the painting, the tree in itself is almost ephemeral, for it is barely rooted in the soil. The wind on the English Channel coast is so strong that it seems to be able to pry tree roots from the ground, and this tree looks as if it is about to be blown away.

The painting is thus an exercise in pattern making rather than a naturalistic description of a place. What is lacking here—because Monet had no intention of including it—is the personality and even sentimentality that an earlier artist such as Théodore Rousseau invested in his portraits of isolated trees (fig. 48).[1] Rousseau made heroes of his trees. They become massive, overwhelming presences, reducing to insignificance the humans or animals taking shelter under their spreading branches. The other forms in the landscape—trees, cows, and people—appear very small, as if seen from a great

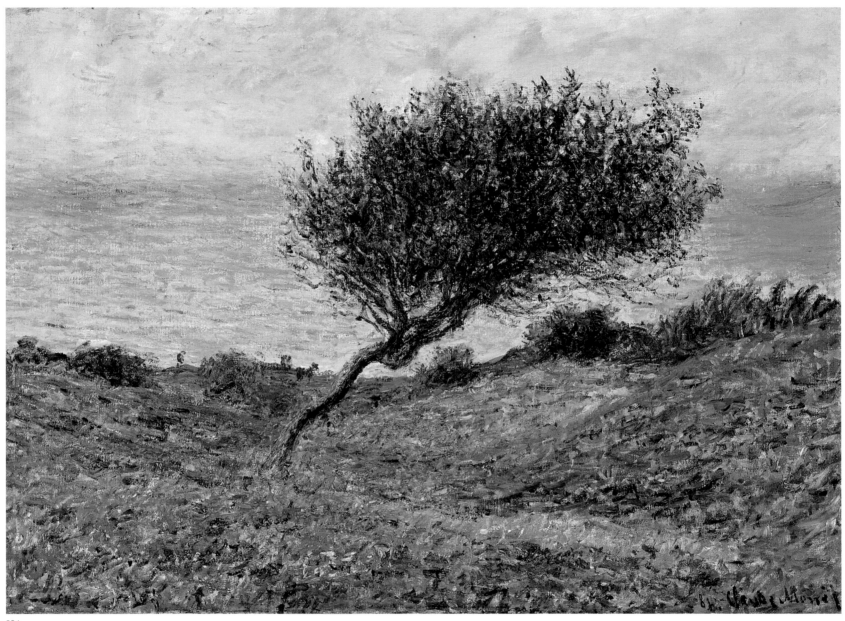

104

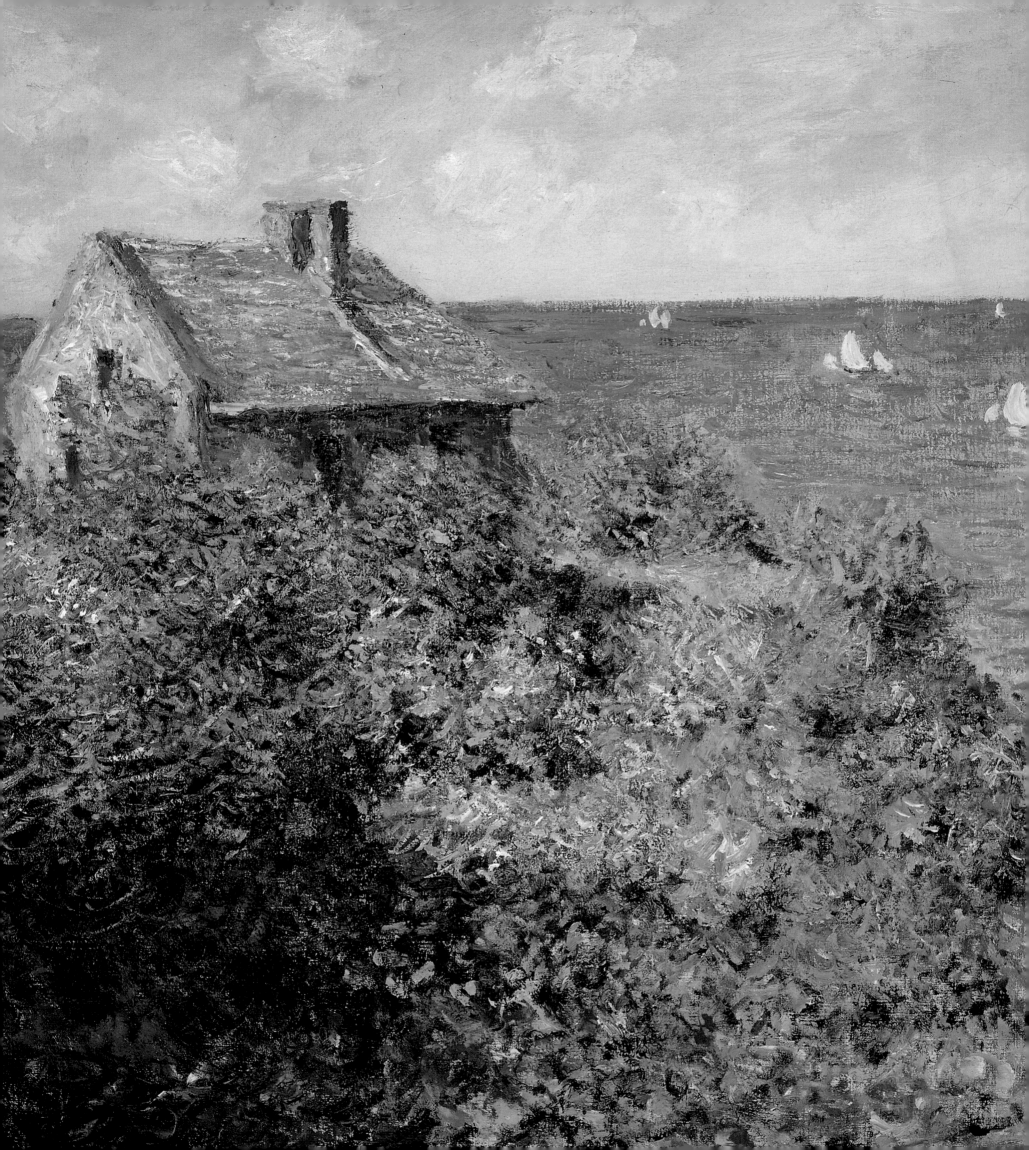

distance, the distance being determined by how far back the artist had to go in order to see all of the central trees. As naturalistic as Rousseau's scene is, in its careful description of light, shadow, and plants, it is informed by the artist's awestruck wonder in the face of nature's majesty. No such humility underpins Monet's picture. He sees natural forms as a starting point, elements to be manipulated to serve optical and pictorial ends. The artist's will, not the natural world, is primary.

Monet was a restless man. Summertime often drew him to the English Channel coast, and in 1881 and 1882 he explored the area around Dieppe, situated about ninety-six kilometers (fifty-eight miles) along the coast east of Le Havre. He liked Pourville and Varengeville, west of Dieppe, because they were smaller and less pretentious and, most important, their cliffs offered more compelling motifs.[2] It is impossible to know whether the motifs Monet painted were in one or the other town—what mattered was his confrontation with nature, not the built environment.

Still, it is sometimes useful to give focus to a scene. For this purpose, Monet particularly liked the stone cabins that had been built during the Napoleonic era as posts from which to observe coastal traffic. In Monet's day they were used by fishermen for storage. The door and flanking windows anthropomorphize the building in *Fisherman's Cottage on the Cliffs at Varengeville* (cat. no. 105), giving it a nose and two eyes. In this sunny picture (Monet was in the Dieppe area from mid-June to early October) the cottage turns into a teasing redhead, playing a game of hide-and-seek.

We may see the cottage, but we cannot reach it, for there is no path. Indeed, all we can do is admire the view out to sea (on which the cottage seems to turn its back). The channel, dotted with recreational yachts, sparkles in the distance. The cottage, especially its roof, is given an orange hue, which it may truly have possessed but which makes a striking complementary contrast with the blue of the water on the horizon. The tangle

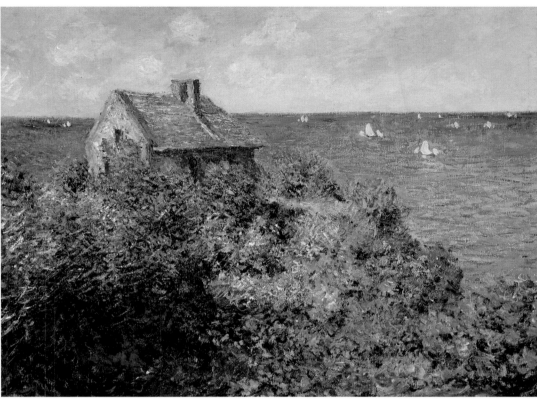

105

of high-summer vegetation is created with layers of brushstrokes—myriad greens, salmons, blues, and turquoises—so complex that Monet could not have completed the canvas on site but must have taken it back to the studio. The vegetation is enlivened and simultaneously grounded and brought forward by the red of the poppies, the only plant species at which one can guess. The lush vegetation offers no purchase for the eye, so we look out to the water, where our vision is directed to the horizon by the diagonal line formed by three of the boats. In contrast to the flickering brushwork of the vegetation, the sails are made of comparatively large strokes of creamy white paint that lies flat on the canvas, thwarting to some extent the expected sense of recession. A complicated painting, *Fisherman's Cottage on the Cliffs at Varengeville* was made for the market, specifically for the dealer Durand-

Ruel. Monet and his dealer found that these pictures sold easily, especially after the success of similar subjects at the seventh Impressionist group exhibition, in March 1882.

Rocky Crags at L'Estaque (cat. no. 106) documents an important point in the development of Renoir's art. At the end of the 1870s, Renoir, along with his independent-minded colleagues, was becoming dissatisfied with the techniques of Impressionism.[3] Looking for greater compositional structure, and realizing that firm outlines were not anathema to him, he went to Italy in October 1881. "I am in a fever to see the Raphaels," he wrote.[4] A few months later, in mid-January 1882, he was with Cézanne at L'Estaque, west of Marseilles. There they worked together. In a letter, he described his excitement at experiencing the strong sun of southern France:

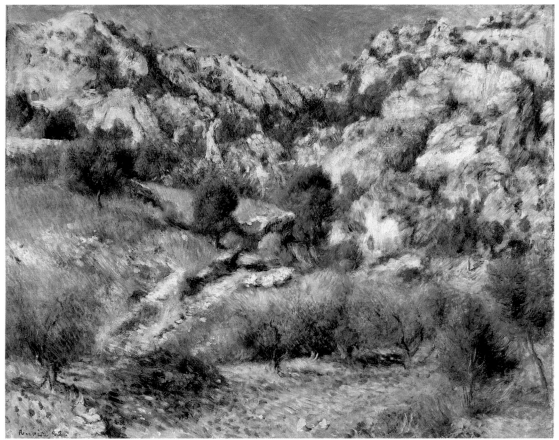

106

to a naturalistic vision by making the brush follow the contours of the forms depicted. Here, in the areas of most active brushwork, we observe Renoir "not bothering any more with the small details." In this "perpetual sunshine," Renoir painted how the sun obliterates details in a way that he did not see in the moister air of the environs of Paris. Still, underlying the trees and grasses exploded into tiny, regular strokes is a firm sense of geology, of how the flatlands rise gently to the grassy hillside and how the hillside abruptly meets the towering crags.

Renoir's vision of these rocks is easier to understand than Cézanne's version of a similar scene (fig. 49). Cézanne's forms are more schematic, less naturalistic; his palette is less varied, less ingratiating. The blue of his sky is deeper, more insistent. Yet Cézanne's influence is palpable in Renoir's painting, from the concentration devoted to a small slice of nature to the patient building-block approach to painting. Later landscapes by Renoir do not have so firm a structure, nor so keen an appreciation for the solidity of the earth.

Renoir returned to southern France when he and Monet traveled together on the Riviera coast from Marseille to Genoa in the last two weeks of December 1883. In *Landscape on the Coast, near Menton* (cat. no. 107), painted at that time, Renoir's long, fluid brushstrokes in mid-to-dark greens are analogues for the individual leaves and blades of grass set in motion by the wind, just as the yellow-green color used throughout represents the hot southern sun. To give visual snap to the picture, he used the chromatic complementaries of dark red and green (as well as smaller touches of blue and orange), a technique he could have borrowed from the colorful canvases of Eugène Delacroix, an artist he greatly admired. This time in the South of France, with Monet rather than with Cézanne, Renoir seems to have been somewhat less interested in the structure of his painting; certainly, compared with *Rocky Crags at L'Estaque*

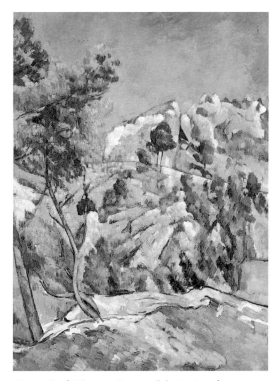

Fig. 49. Paul Cézanne, *Bottom of the Ravine*, about 1879, The Museum of Fine Arts, Houston.

I am in the process of learning a lot. . . . I have perpetual sunshine and I can scrape off and begin again as much as I like. This is the only way to learn, and in Paris one is obliged to be satisfied with little . . . am staying in the sun . . . while warming myself and observing a great deal, I shall, I believe, have acquired the simplicity and grandeur of the ancient painters. . . . Thus as a result of seeing the out-of-doors, I have ended up by not bothering any more with the small details that extinguish rather than kindle the sun.[5]

Rocky Crags at L'Estaque testifies to what Renoir was learning. Painted in bold strokes of creamy white, the rocks are given form by the intervening ochers and greens of vegetation. Set off against the brilliant blue of the sky, the whites advance visually and constitute the most solid part of the picture. And, because this is Renoir painting, not Cézanne, the rocks are rendered with caressing brushstrokes and are modulated with clefts and vegetation. They are simultaneously firm and lush. The grassy lower slopes and the trees are painted with comparatively small, parallel strokes, a technique Renoir was learning from Cézanne, although he clings

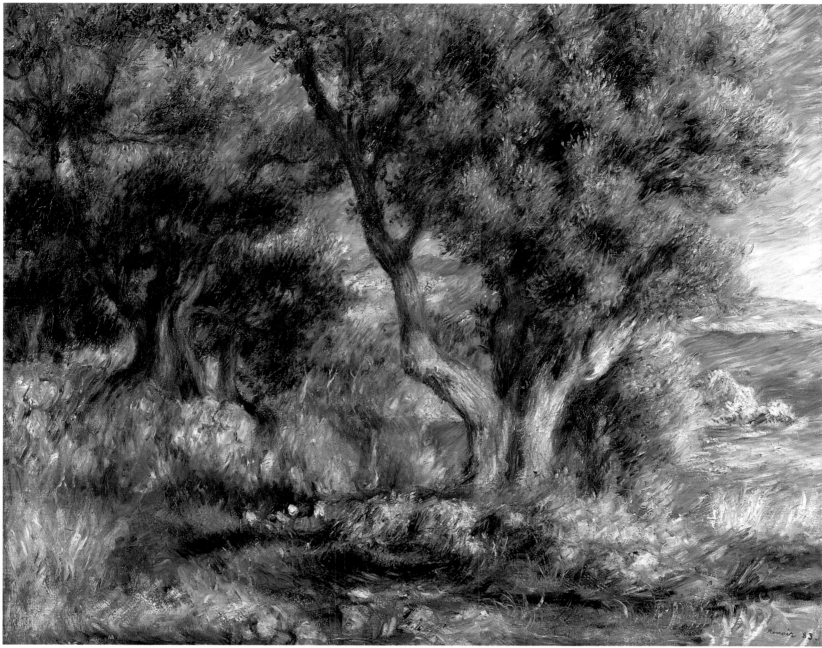

107

the recession into depth in *Landscape on the Coast, near Menton* is less clearly delineated. The movement of foliage, light, and water overwhelmed all other considerations, with the result that the viewer can imagine the feel of hot air and wind ruffling hair and clothes.

In this insistence on movement and air, Renoir's view of the Mediterranean coast stands in sharp contrast to Monet's, as evidenced by Monet's 1884 painting of the same region (fig. 13). Although Monet's *Cap Martin, near Menton* was painted, not on the trip with Renoir, but on Monet's next trip to the South, which he made alone beginning the following month, it shows

well enough the differences between the sensibilities of the two artists. Monet's large brushstrokes, among the loosest he would use on any of his trips to the Mediterranean, flatten volumes so that they appear as patterns on the surface. This is particularly true where the trees at the left form a kind of window onto the mountains. The view to the right shows clearly that the mountains are at a distance, yet the abstracted brushstrokes through the aperture read like a backdrop, compressing the intervening space to nothing. In Renoir's view, in contrast, the distance reads as distance. In addition, *Landscape on the Coast, near Menton* acknowledges

that humans are part of the landscape. Renoir has painted his view in such a way that it allows us into the scene, and once we are there, it provides the sensory pleasures of heat and moving air. Renoir was concerned with aspects of picture making, to be sure, but he was also concerned with the human element in his art, even when it is not overtly expressed. FEW

1. Tinterow and Loyrette 1994, 71, 73.

2. Herbert 1994, 44.

3. Isaacson 1980.

4. Quoted in Hayward Gallery 1985, 300.

5. Renoir to Mme Charpentier, quoted in Florisoone 1938b, 36, translated in Rewald 1973a, 463–64.

Paul Cézanne
French, 1839–1906

Jean Charles Cazin
French, 1841–1901

François-Louis Français
French, 1814–1897

108. PAUL CÉZANNE
The Pond, about 1877–79
Oil on canvas
47 x 56.2 cm (18 ½ x 22 ⅛ in.)
Tompkins Collection 48.244

109. JEAN CHARLES CAZIN
Riverbank with Bathers, about 1882
Oil on canvas
131.2 x 147 cm (51 ⅜ x 57 ⅞ in.)
Peter Chardon Brooks Memorial Collection;
Gift of Mrs. Richard M. Saltonstall 20.593

110. FRANÇOIS-LOUIS FRANÇAIS
Morning on the Banks of the Sèvre at Clisson, 1884
Watercolor over graphite pencil on cream wove paper
Sheet: 48 x 60 cm (18 ⅞ x 23 ⅜ in.)
Bequest of Mrs. Arthur Croft 01.6233

Paintings of rivers, their banks, and the activities that took place on and near them were a staple of landscape art in France. Rivers were essential routes of transport, and both larger and smaller streams offered city dwellers welcome respite from the heat and dust of summer. People who lived in more rural areas also appreciated the cleansing and soothing properties of water, as is demonstrated in these three depictions of water meeting land.

Cézanne's *Pond* (cat. no. 108) dates from the end of the 1870s, when he was beginning to formulate his distinctive parallel brushstroke. In the late 1850s Cézanne studied law for three years in his native Aix; at the same time, however, he took lessons in the free municipal drawing school. His father finally relented and allowed him to go to Paris in the summer of 1861, but he was soon unhappy there and returned home, where he worked in his father's bank. Restless, he was back in Paris in 1862, enrolled again at the Académie suisse, and showed in the Salon des Refusés of 1863. He

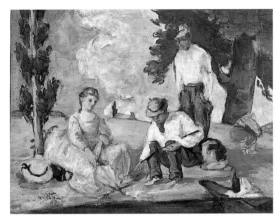

Fig. 50. Paul Cézanne, *Picnic on a River,* about 1872–75, Yale University Art Gallery, New Haven, Connecticut.

came to know Pissarro, who introduced him to painting outdoors and a new way of applying paint, as well as to Monet, Renoir, and others. After 1864 Cézanne would divide his time between Paris and Aix. Thanks to his prosperous family, he was able to devote himself to his art. Cézanne's early paintings are marked by romantic, violent, and erotic themes and a deep regard for the old masters. Although Cézanne showed with the independent artists in 1874 and 1877, his vision of structure and solidity was at odds with theirs of sensuousness and spontaneity. He withdrew physically and artistically, living in Aix and no longer showing his work. Only in 1895 did Ambroise Vollard hold an exhibition of Cézanne's paintings in Paris, an event that introduced Cézanne's work to a new generation of young artists.

In *The Pond* six people—two couples and two men by themselves—relax by the side of a pond or river. It is an enigmatic scene. The couple at the far left appears to have come from the city; the woman's square-necked, puff-sleeved blue dress and the man's light-colored top hat and jacket contrast with the simpler clothes worn by the others, setting them apart. One man naps as if lost to exhaustion; another, in a straw hat, sits in a boat. No food is present,

so these people are not on a picnic, yet the man at the left makes a half-hearted attempt to fish.

This unsatisfactory attempt to read a story into the painting demonstrates how beside the point such a narrative is. Cézanne was certainly capable of painting a story, as *Picnic on a River* (fig. 50) demonstrates. There the woman is in a prettier dress and has brought a parasol and a straw hat trimmed with a black ribbon. The sleeping figure is more realistically portrayed (his body actually takes up space, rather than simply tracing a two-dimensional pattern on the grass), and a wine bottle in the lower right may explain the cause of the nap. Three of the four people are clustered together, as if sharing a common purpose. Mary Tompkins Lewis has explained how paintings such as *Picnic on a River* derive from eighteenth-century *fêtes galantes* in the manner of Antoine Watteau.[1]

Although vestiges of a Provençal rococo revival may remain in *The Pond,*[2] Cézanne's brushstrokes here have moved beyond description or a careful delineation of form to become almost independent marks. From early 1872 until the spring of 1874, Cézanne, under Pissarro's watchful eye, stayed in Auvers and began to paint outdoors. He used lighter and brighter colors and adopted Pissarro's technique of placing small strokes of pure color next to each other. Cézanne's version of the broken brushstroke—patches of parallel strokes, here predominantly blue and green—calls attention to itself and hence to the fiction of the scene, not only to the fiction of the one depicted but, with its awkward and confusing passages and inconsistencies in scale, to the fiction of any painted space. *The Pond* allows us to see Cézanne trying to meld a newly learned technique with traditional iconography and realizing that the technique is more important to him than the story.

Jean Charles Cazin was of an entirely different artistic temperament. He studied under

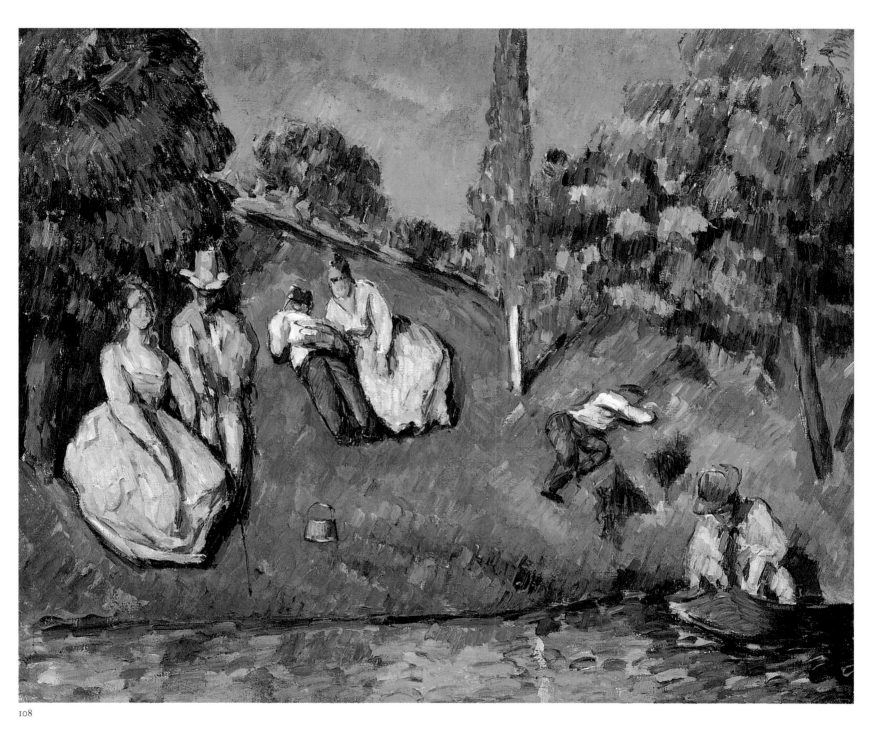

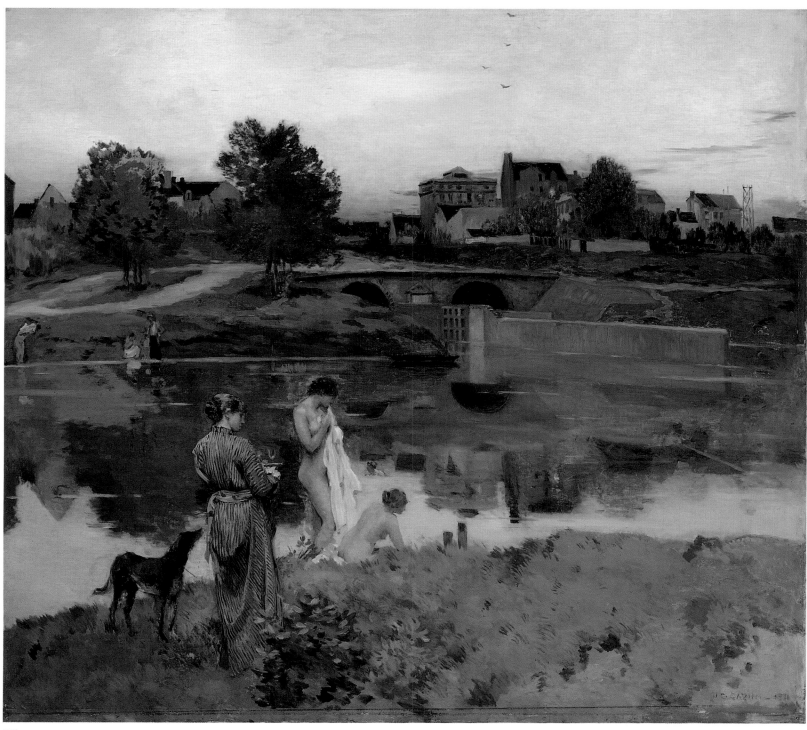

109

Horace Lecoq de Boisbaudran at the Ecole des arts décoratifs in Paris. His early training was as a draftsman for prints, architectural projects, and designs for porcelain and other ceramics. In 1886 he became a professor of drawing at the Ecole d'architecture as well as director of the Ecole des Beaux-Arts in Tours and curator of the Musée du Tours. Like many other artists, he fled to England in 1871 during the Franco-Prussian War. Between 1871 and 1875 he traveled to Italy and Holland. In 1872 he sketched with Daubigny and Monet in Holland—a formative experience that made him decide to devote his efforts to painting. Returning to France in 1875, he settled in Equihen, Picardy, on the coast of the English Channel. He painted history paintings until about 1888, when he turned to purer landscapes. His works were highly acclaimed for the science and precision of their execution, no doubt a result of his early experiences as a draftsman. Cazin debuted at the Salon of 1876 and also exhibited at the Salon of 1879. He took part in the Expositions Universelles of 1889 and 1900 in Paris, where he received a gold medal and grand prize respectively. He was named knight of the Legion of Honor in 1882 and officer in 1889. Although critics and Salon judges praised his history paintings, it was his landscapes that were most popular with collectors.

Cazin's history paintings were mainly sub-

jects drawn from the Bible, with the figures appearing in contemporary dress. This practice may explain why his *Riverbank with Bathers* (cat. no. 109) was given the title *Pharaoh's Daughter Bathing in the Nile* when it was exhibited at Copley Hall in Boston in 1897. *Riverbank with Bathers* is a curious amalgam of ideal nudes (the standing one is haloed in blue), naturalistic setting, and a bizarre pairing of an inquisitive dog and a woman carrying a tray of glasses and biscuits. (The ghostly boatman in the river had been painted over but increasingly can be seen as the upper layers of paint become more translucent.) The woman and dog—she dressed in vaguely East Asian garb, the dog, elegant of line—introduce a note of avant-garde aestheticism hard to explain on the banks of a river in rural France. Yet such incongruities fade before an appreciation of the suavity of paint handling that so successfully evokes the end of day.

The mixture of traditional subject matter—nudes bathing (see Valenciennes's version, cat. no. 1)—and somewhat progressive paint handling made Cazin's pictures very popular; this work was in Boston by 1890. It received an enthusiastic endorsement from the critic Theodore Child in *Harper's New Monthly Magazine* in May 1890:

> "La Marne" [the title under which the painting was exhibited in the Exposition Universelle in 1889] is a late evening effect. The sunset is lost in a dark haze below the horizon, while the vault of heaven is still illumined with vertical rose-colored rays. There is a bridge, a lock, the bank lined with trees, and beyond them the mass of cottages, above which rise the finer houses of the wealthy. The river, calm and vitreous, reflects with intensity the mirage of the landscape and sky, while in the foreground are figures of female bathers and of a handmaiden carrying refreshments on a tray. The nude figures are exquisite in silhouette and in unconsciousness of pose. In its splendid harmony

110

of gray, green, and rose, this picture is a complete and definitive vision of evening calm at the river-side, familiar, and yet grave and impressive, for the hour has something of melancholy in it.[3]

François-Louis Français's *Morning on the Banks of the Sèvre at Clisson* (cat. no. 110) records another moment of leisure at water's edge. Whereas Monet, Renoir, and Sisley painted rivers around Paris, Français chose his motifs away from the capital. The Sèvre River is in western France, emptying into the Loire at Nantes. In this watercolor, a young woman in blue looks up and twists around; perhaps the bird flying to shore made a noise that startled her. Français was as adept in watercolors as in oils (see cat. no. 74) in the convincing portrayal of light effects. Here he has taken on the chal-

lenge of showing sunlight intensified by its reflection off water filtering through leaves. Backlit, some leaves are turned into silhouettes; others are made translucent. Beams of light that have broken through the foliage sit as white flecks on inner leaves and the grass. The color harmonies of blue and green suggest the coolness of the riverbank, and the whites and yellows foretell the coming heat of afternoon. FEW

1. Lewis 1989, 88–112.

2. The painting was given the title *Scène champêtre* in the list of Gustave Caillebotte's paintings that were bequeathed to the French state at his death in 1894. It did not go to the state, either because it was refused or because the family retained it. See Poulet and Murphy 1979, 85, cat. no. 43.

3. Child 1890, 828.

III

Claude Monet
French, 1840–1926

III. CLAUDE MONET
Poppy Field in a Hollow near Giverny, 1885
Oil on canvas
65.2 x 81.2 cm (25 ⅝ x 32 in.)
Juliana Cheney Edwards Collection 25.106

II2. CLAUDE MONET
Meadow with Haystacks near Giverny, 1885
Oil on canvas
74 x 93.5 cm (29 ⅛ x 36 ¾ in.)
Bequest of Arthur Tracy Cabot 42.541

II3. CLAUDE MONET
Meadow at Giverny, 1886
Oil on canvas
92 x 81.5 cm (36 ¼ x 32 ⅛ in.)
Juliana Cheney Edwards Collection 39.670

Monet moved to Giverny, a hamlet between Paris and Rouen, in April 1883. The countryside in that part of Normandy is tame and rolling, having been smoothed and shaped by the Seine. There Monet found a combination of motifs, light, and foliage that provided him with seemingly endless ideas for paintings. In *Meadow with Haystacks near Giverny* (cat. no. 112), a painting of primarily blue, green, and violet hues, the eye is drawn to the lighter and brighter streaks of yellow. These represent sunlight that has broken through the trees on the right, trees that glow from within with captured light. Color and light had always been Monet's primary interests; at Giverny in the mid-1880s, he began to give himself up entirely to their exploration. This could well be the same meadow of *Meadow at Giverny* (cat. no. 113), but here the view takes in haystacks, which have turned pink in the late afternoon light. Not an untended expanse filled with wildflowers, the land is put to human and animal use. But Monet is more interested in the haystacks for their formal properties, and he has carefully cropped the one farthest to the left and aligned it with two others in a diagonal recession.

112

Texture, too, is seen as an integral component of color and light. Blues, greens, oranges, and yellows appear haphazardly scattered on the ground to simulate the effect of light bouncing off the unevenness of the cut stubble; in fact, close observation reveals a careful manipulation of paint to create texture that is then colored with more strokes of paint—a painstaking rather than spontaneous process.[1] Texture of a different kind can be seen in the diagonal brushstrokes that unify the upper half of the painting, moving from the blue-green foliage through the smoother creamy white sky.

Monet wanted the public to believe that his paintings represented solitary confrontations with nature. A painting by the American artist John Singer Sargent, however, proves that this was not always the case (fig. 23, p. 45). It is evident that Monet went to the meadow accompanied not only by a professional colleague, Sargent, but also by a woman, variously identified as Blanche or Suzanne Hoschedé, the daughter of Monet's companion, Alice. The trio may have brought a picnic lunch, so domestic does Sargent's scene appear, with the woman absorbed in needlework or a book. Monet's letters written in the summer of 1885 describe his progress on this painting from late June to late August,[2] proof that it was not the result of a single campaign. The sense of companionship evinced by Sargent's painting—although the painters do not face one another, each was aware of the other—makes the intellectual, formal, and aesthetic rigor of Monet's work all the more impressive.

Poppy Field in a Hollow near Giverny (cat. no.

111) looks as if it depicts a crop, for the concentration of the red color suggests that the flowers had been sown in a trapezoidal shape. Indeed, in some paintings by Monet, poppies appear in wheat fields so thickly that they color the whole, as in *Field of Poppies* at the Art Institute of Chicago. There the flower is an interloper, taking up space where wheat could grow, reducing the farmer's yield,[3] but here the flower seems to be on its own. Yet Monet's concern is not to record agricultural practices but to make a painting.

The fields around Giverny, whether filled or gloriously empty, were so familiar to Monet that he could use the forms he found there to experiment with the basics of picture making. As the art historian John House has explained, "The simple formal structure of the subject becomes just an armature for the elaboration of the surface; by inflexions of brushwork and gradations of colour Monet could define the space and articulate the surface while bypassing composition in its traditional sense."[4] Here, the wider end of the rich carpet of poppies seems to propel the viewer into the space. In the middle ground a bowl-shaped valley rises smoothly from the center to the top of the hills, seven-eighths of the way up the canvas, leaving space at the top for only a narrow strip of sky. Hillside and poppies form a symmetrical chalicelike shape, the curved hillside resting on the stable base of poppies.

This simple description belies the complexity and even ambiguity of the painting. As evidenced by the curved top edges of the triangles on either side—green, ocher, and pink on the left and pale greens on the right—and the area at the top of the poppies joining them, the bowl shape is meant to be read as continuing into the foreground. But any contour of land is negated. As the trapezoid establishes depth and movement into space, it simultaneously fights with what it has created. So much red-orange in one place has a flattening effect. Rising up, the geo-metric shape proclaims the two-dimensionality of the picture plane. The eye is drawn to the flurry of red brushstrokes, made with discrete jabs of the brush. It gratefully escapes from the hot busyness of the poppies to the coolness surrounding them on three sides, but it is an escape into unknown territory. Once drawn into the picture by the red carpet, the viewer can go no farther. What had seemed an inviting hollow dissolves into amorphousness with no comfortable purchase on the real world.[5] Fully three-quarters of the picture is painted with long brushstrokes, vertical in the lateral triangles, horizontal and diagonal in the hillside. The eye slips along, having been given nothing for which to stop. Salmon hues on the upper slopes make the eye circle back to the carpet of red at the bottom, where the circuit starts again. At first glance, the symmetrical geometry of *Poppy Field in a Hollow near Giverny* promises calm and stasis. Yet with restless brushwork and optical excitement caused by complementary colors, Monet moves the act of painting away from a realist approach, with its goal of representing the seen world, toward manipulation of the picture surface for optical and aesthetic effect.

In *Meadow at Giverny* (cat. no. 113) horizontal bands of color undulate across the vertical canvas—purplish green alternating with greenish yellow in the lower half, and pinkish yellow and pinkish white in the upper half. Two vertical elements—trees—interrupt the gentle waves. It is difficult to describe adequately a painting of such visual complexity and sophistication. A connection to the observed world is offered by the trees that break free of the prismatic waves, mimicking the human posture, and by the horizon line, the break between meadow and farther trees, which is placed relatively high on the picture plane. This high placement frustrates the attempt to read the picture as a naturalistic scene with recession into depth, for it tips up the picture plane and forces us to read the colored bands as adhering to the sur-face. These bands—the meadow itself—are a hypnotic field of carefully planned strokes. Blues and lavenders are layered on top of greens and spill over onto hotter yellows. The darker bands, we come to realize, are to be read as shadows of trees. Thus the cooler lavenders and blues are shadows, not springtime flowers. The pink-mauve color of the trees—poplars can be inferred from the long, thin shadows—betokens autumn foliage. Colors are placed one on top of another, creating a built-up, crusty surface in the foreground and a wispy, tracerylike effect against the sky. The painting is evidently the result not of a single outing but of a premeditated, thought-out campaign.[6]

Meadow at Giverny does not have an obvious focal point: no figure, structure, or natural feature attracts the viewer's attention. The high-keyed palette and, especially, the insistence on pattern further contribute to our sense of it as a decorative painting, in the best sense of the term—as a work concerned, above all, with the very qualities of color and pattern. It is also a painting of loneliness. The tree just left of center in the background frees itself from its neighbors. Were the tree a human figure, it could be described as displaying itself against the sky in a gesture of defiance or triumph. A tree is not a human being, of course, yet the temptation to read the one for the other is strong. This tree is isolated, mirroring the position of the viewer looking at this deserted, if colorful, meadow. FEW

1. Herbert 1979, 92, 94, figs. 1–2, and passim.

2. Wildenstein 1974–91, 2: letters 578 and 581. The date of Sargent's painting, much discussed in the literature on the artist, was first conclusively given as 1885 in Simpson 1993, 1:314–16.

3. Brettell et al. 1984, 260, cat. no. 103.

4. House 1986, 54.

5. Thanks for this observation go to Nicole R. Myers, research assistant, Department of Art of Europe, Museum of Fine Arts, Boston.

6. For an analytical explanation of Monet's method, see Herbert 1979, 90–108.

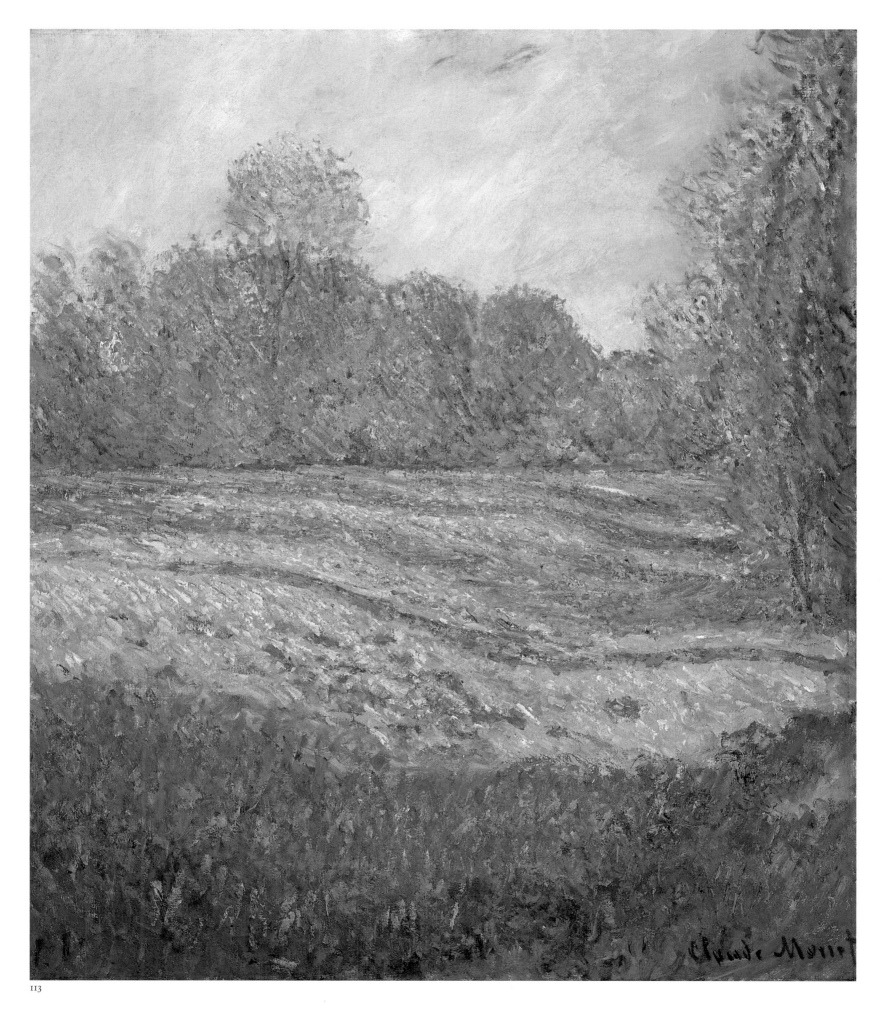

113

Paul Cézanne
French, 1839–1906

Paul Gauguin
French, 1848–1903

114. PAUL CÉZANNE
Turn in the Road, about 1881
Oil on canvas
60.5 x 73.5 cm (23 ⅞ x 28 ⅞ in.)
Bequest of John T. Spaulding 48.525

115. PAUL GAUGUIN
Entrance to the Village of Osny, 1883
Oil on canvas
60 x 72.6 cm (23 ⅝ x 28 ⅝ in.)
Bequest of John T. Spaulding 48.545

When Sisley and Monet painted roads leading into villages (see cat. nos. 80, 88–89), their pictures included an attainable goal; the viewer can imagine reaching the comfort and amenities of the village in question. Their essentially rational way of constructing a painting betrays roots in the naturalistic, realistic mode: even in the obvious picture- and pattern-making of Monet's *Entrance to the Village of Vétheuil in Winter* (cat. no. 89), for example, there is still the sense that the observed world is the basis of the painterly creation.

With Cézanne and Gauguin, one senses a loosening of the bonds to reality. In Cézanne's *Turn in the Road* (cat. no. 114), the viewer's expectation that the road would lead to the town are thwarted. Cézanne painted a picture; he did not transcribe the visible world in a necessarily objective manner. His intent was understood by the German poet Rainer Maria Rilke. Rilke noted that Cézanne's work as a painter

> so . . . reduced a reality to its color content that it resumed a new existence in a beyond of color, without any previous memories. . . . [People] accept, without realizing it, that he represented apples, onions, and oranges purely by means of color (which they still regard as a subordinate means of painterly expression), but as soon as he turns to landscape they start missing the interpretation, the judgment, the superiority.[1]

Turn in the Road shows just what its title says, an unpaved road in the country, curving along a wall behind which are clustered the houses of a village, probably Valhermay, between Auvers and Pontoise.[2] Cézanne took nothing on faith. Intuitively, the artist knew that the road stayed the same width in the course of its curve; empirically, he did not, and so he painted what he saw, the road disappearing as it made the bend. Likewise, Cézanne made no attempt to rationalize the houses behind the wall. No pattern of roads or even passageways can be read from the jumble of roofs and walls. What, for example, is happening behind the three taller trees to the right? Space is flattened so that the wall surface with windows and a door is in a continuous plane with the wall that belongs to the ocher roof second from the right, but our experience of the world tells us that that cannot be so. Such inconsistencies did not trouble Cézanne. His colors, bereft of "previous memories," make up a world seen afresh.

Cézanne's world, as lush and verdant as it is, nonetheless seems a deserted and somewhat forbidding place. We are to look at this village but not enter it. The tree trunks in the foreground form a screen, through which we gain only a partial view of the village. The wall keeps us out, and even if we were to hop over it, only one house has a door. There are no people with whom to identify. Rilke understood that Cézanne sought to represent the physical world "purely by means of color." Rilke's perception—that Cézanne found chromatic equivalents for the phenomenal world—succinctly explains the painter's approach to his art. *Turn in the Road* first startles and then seduces with its color, its white houses, its tawny road, and its brilliant and nuanced greens.

Gauguin's *Entrance to the Village of Osny* (cat. no. 115) is not as radical as Cézanne's vision nor as abstracted as his own work would become within just a few years. It is, after all, a relatively

early work by a stockbroker-turned-painter. Before Gauguin worked in a bank in Paris, he spent four years in Lima, Peru, with his mother's family and six years as a sailor, putting in at ports around the world. While a stockbroker, he began to collect Impressionist paintings and began to paint, exhibiting with the independent painters in 1879, 1880, 1881, and 1882. The collapse of the stock market in 1883 cost him his job, and, despite the responsibilities of his growing family, he turned to painting full-time, selling his collection to make a living.

From June 15 to July 5, 1883, Gauguin visited Pissarro in Osny, a village on the northwestern edge of Pontoise, and it is likely that this painting was at least started and perhaps even finished at that time. The painting was found among Pissarro's effects after his death, when the dealer Durand-Ruel bought some canvases from Madame Pissarro. Durand-Ruel explained to John T. Spaulding, the donor of the picture to the Museum of Fine Arts, Boston, that among them was "one that was unsigned which we knew was not by Pissarro but resembled a cross between Pissarro and Guillaumin."[3] Madame Pissarro made the identification. It is not surprising that the sophisticated dealer Durand-Ruel did not recognize this work as one by Gauguin, because the artist himself was very reluctant to acknowledge his early works.[4] While Pissarro was still in Pontoise, in the summer of 1881, Cézanne (who lived there at the time), Gauguin, and Armand Guillaumin all visited him. Gauguin, as the most inexperienced of the group and an amateur (he was still employed by a bank), could easily have absorbed techniques from the other artists.

Entrance to the Village of Osny shows a road plunging into the village, which, like Van Gogh's *Houses at Auvers* (cat. no. 130), is a mix of tile- and thatch-roofed houses. Tilled fields cover the slopes of the surrounding hills. The subject, a farming village with no discernible narrative, is

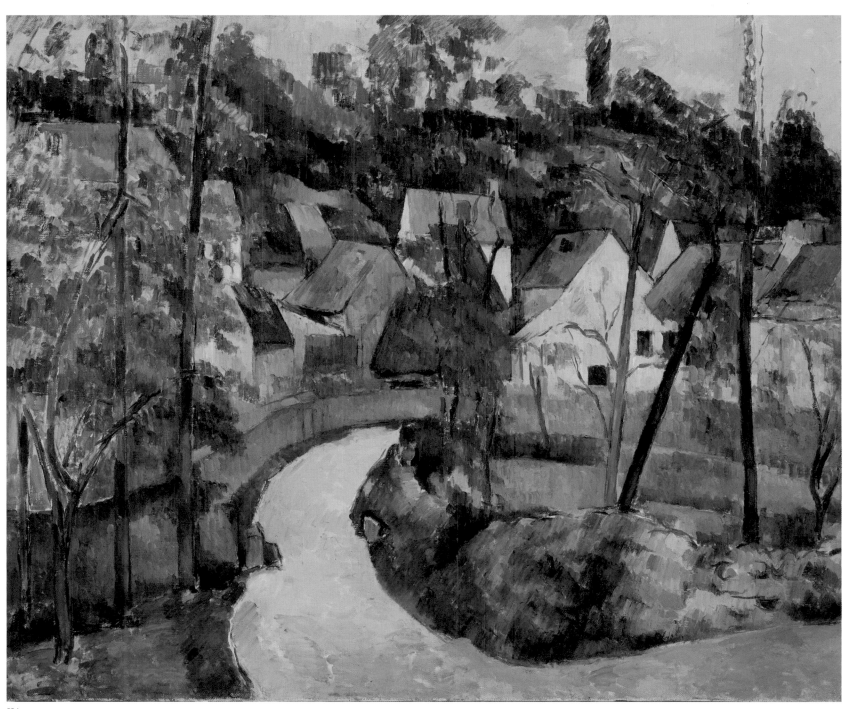

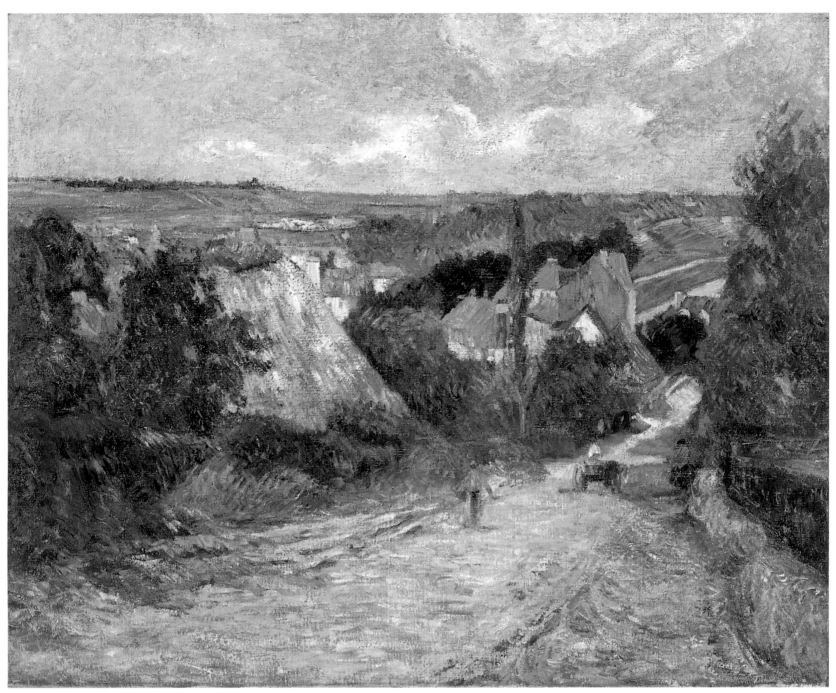

115

very much like those Pissarro favored. The treatment, however, is not. Gauguin used a rough canvas, which he did not cover completely with paint, evidently because he liked the resulting uneven effect. The road, which stretches the full width of the canvas, peters out; it is not clear where the figures are going. With no goal, the eye lifts to the jumble of roofs, where there is no order or design; so, too, with the fields and line of boundary trees. Gauguin's patches of color do not read as the equivalents of elements in the natural world.

Despite its hesitancies and its dependence on others' art (Guillaumin's brash color, Pissarro's small, rhythmic brushstrokes), this painting by Gauguin nonetheless contains certain marks of bravado, including the unwillingness to create a legible space. The pinkish thatched roof jumps out from the overall dark green–brown and blue palette. The pink color brings out the other pinks and purples scattered throughout, colors Gauguin would use almost as signature hues in his paintings of the South Seas. The road is a bold stroke—a wide swath of many colors. A rhythm across the canvas is established by the chimney rising from the thatched roof almost like a flame, the skinny poplar to right of center, and the mass of greenery at the right edge. These verticals, in concert with the strong horizontal of the hillcrest, keep the color patches in check and presage Gauguin's extreme pattern-making in his later works. FEW

1. Rilke 1985, 46.

2. See Brettell et al. 1984, 194, 200, cat. no. 72.

3. Durand-Ruel to Spaulding, January 9, 1933, in the Department of Art of Europe's curatorial object file for MFA 48.545, Museum of Fine Arts, Boston.

4. Stuckey 1988.

Camille Pissarro
French (born Danish West Indies),
1830–1903

Fig. 51. Camille Pissarro, *Standing Peasant Girl*, about 1884, black chalk and watercolor, Whitworth Art Gallery, Manchester, England.

116

116. CAMILLE PISSARRO
Turkey Girl, 1884
Tempera on paper
81 x 65.5 cm (31⅞ x 25¾ in.)
Juliana Cheney Edwards Collection 39.673

A growing family and the need for more spacious accommodations forced Pissarro to move in the spring of 1884 to Eragny-sur-Epte, a small village close to Gisors and two hours from Paris. In choosing a new location, he was also motivated by the constant desire to find interesting motifs—these he discovered in Eragny. A

large garden, the river Epte, surrounding meadows, tree-covered hills, and an appealing village provided Pissarro with much subject matter and inspired him to produce over a period of nearly twenty years more than two hundred paintings, hundreds of drawings and watercolors, many pastels, and at least one hundred and fifty prints. Pissarro's Eragny compositions are mostly of female workers at their labors; they do not include the wooded landscapes, steep hillsides, and winding paths that he had found so appealing in Pontoise (cat. nos. 96–101).

Turkey Girl of 1884 was most likely created

in Eragny and represents a local view in which a tranquil field leads to a broad horizon punctuated by a distinct church spire. Its subject, however, draws on Jean-François Millet's repertoire of young peasant women standing by a tree, watching over sheep or poultry (cat. nos. 53–54).[1] Although Pissarro often referred to Millet as "too biblical," or moralistic, for his tastes, he was respectful and admiring of the artist's work; indeed, *Turkey Girl* echoes Millet's style and technique. The columnar quality of the guardian is reinforced by the tree trunk, and in Pissarro's composition, the solemn setting is

Mary Cassatt
American (worked in France), 1844–1926

Camille Pissarro
French (born Danish West Indies), 1830–1903

offset by a lively gaggle of turkeys that peck for food. Pissarro's attitude toward rural life, that "there is joy in agricultural labor," is demonstrated in this fresh composition and is representative of his views concerning the harmony of rural communities.

Pissarro also made a black chalk study heightened with watercolor (fig. 51) for *Turkey Girl* that predicts almost exactly the pose and setting of the finished painting. During the 1880s, he commonly used colored chalks or pastels for figure studies, many of which were drawn on colored papers. By contrast, the finished *Turkey Girl* is a large-scale figure composition made with tempera and bears comparison with the artist's oil paintings of the same period. The spectrum of colors is dominated by blue, with the addition of pale yellow strokes and touches of red. The light palette is in vivid contrast to the solemn, dark color schemes favored by Millet. The figures in both the study and the painting are variants of stock poses Pissarro composed during the 1880s, probably because of the lack of female models in the countryside. It is worth noting that Pissarro's peasant figures and the farm activities they performed were not necessarily created outdoors; according to Richard Thomson, these "truthful" rural images were very likely fabricated within the confines of the artist's studio.[2] BSS

1. Thomson 1990, 51.
2. Ibid., 56.

117. MARY CASSATT
Gathering Fruit, about 1893
Color drypoint and aquatint printed from three plates on cream laid paper
Platemark: 42 x 29.8 cm (16 9/16 x 11 3/4 in.)
Gift of William Emerson and The Hayden Collection, Charles Henry Hayden Fund 41.813

118. CAMILLE PISSARRO
Church and Farm at Eragny-sur-Epte, 1894–95
Color etching on cream laid paper
Platemark: 15.8 x 24.7 cm (6 1/4 x 9 3/4 in.)
Ellen Frances Mason Fund 34.583

In June 1874, the Pennsylvania-born Mary Cassatt settled in Paris, and by 1877 her parents and sister had joined her to live abroad permanently. Although Cassatt never renounced her American citizenship, she spent the whole of her maturity as an artist in France, only occasionally traveling back to the United States. A chance encounter with Edgar Degas encouraged her to follow his path and join the Impressionist artists. She would first exhibit with them in 1879. In the aftermath of that exhibition, Cassatt joined Degas and Pissarro in an intense exploration of printmaking, creating some of the most daring and inventive images of the nineteenth century (see cat. nos. 96–101). She returned to printmaking at the end of the 1880s, but it was in the next year that her imagination was once again fired to move her work in a new direction.

Cassatt attended an immense exhibition organized by Siegfried Bing, a dealer in Asian works of art, in the spring of 1890. Thrilled by the more than seven hundred Japanese prints (mounted individually and in albums) and some four hundred illustrated books in the show, Cassatt shared her enthusiasm with Berthe Morisot and Degas. It was from this experience that Cassatt was inspired to create a set of ten color prints that drew on the motifs and style practiced by her preferred artist, Kitagawa Utamaro (1753–1806). Cassatt appropriated the

theme of mother and child, which had been treated with affection by the Japanese artist, however, she abandoned the woodcut technique of the Japanese craftsmen and adopted the intaglio techniques of drypoint and aquatint for her color prints.

Pissarro had the opportunity to see Cassatt's remarkable portfolio when he and Cassatt exhibited together at Galerie Durand-Ruel in April 1891. On two occasions during the run of the exhibition, he wrote to his son Lucien that Cassatt had achieved remarkable results with her "mat tone, subtle, delicate, without stains or smudges: adorable blues, fresh rose, etc." He added that the "result is admirable, as beautiful as Japanese work, and it's done with colored printer's ink."[1] As Pissarro's admiration suggested, the set of ten images were a boost for Cassatt's reputation, and within two years she attempted nine more color prints, including *Gathering Fruit* (cat. no. 117), shown here. (Degas, meanwhile, was at work on his own series of color monotypes, some of which would be exhibited at Durand-Ruel in November 1892; see cat. nos. 121–23.)

A change of lifestyle whereby Cassatt and her mother spent more time in the French countryside (her father and sister were now deceased) encouraged the artist to present women and children increasingly in outdoor settings.[2] She employed this favorite theme when she was commissioned in the summer of 1892 to design a monumental mural, to be called *Modern Woman,* for the 1893 Chicago World's Columbian Exposition as a companion piece to a second mural, entitled *Primitive Woman.*[3] The two pieces—vast lunettes depicting landscapes figured with women, ancient and modern—were placed opposite each other in the great hall of the Woman's Building. Cassatt's composition was painted in bright colors and depicted women in contemporary dress plucking apples from the tree of knowledge. Once the mural was shipped, Cassatt produced a painting, *Child*

117

Picking Fruit, and two prints, *The Banjo Lesson* and *Gathering Fruit,* to serve as advertisements for the Chicago project.[4] The Cassatt specialist Judith Barter suggests that the scene in *Gathering Fruit*—one woman standing on a ladder passing an apple to a child held by a second—symbolizes the community of female relationships as well as the passing of knowledge from one generation to the next.[5]

The setting for *Gathering Fruit* is not a flourishing landscape but a compact place contained by a brick wall covered by an espaliered pear tree and a grapevine. A path and open doorway pierce the flat space to reveal a garden and a sundial in the distance.[6] Cassatt may have moved her women and children outdoors, but she retained the calm elegance and suggestion of an interior space that may be found in her earlier set of ten drypoints and aquatints. *Gathering Fruit* is a continuation of her interest in the role of the modern woman, and its gardenlike setting aligns it with the work of her Impressionist friends, notably Monet and Renoir, who painted women and children in the landscape more than a decade before (see cat. nos. 92–93).

Although Cassatt's friend Pissarro had conveyed in 1891 his wish to make a series with her of market scenes and peasants in the fields, he realized that the fine aquatint box and the good printer that were her excellent "assistants" in the production of her color prints were far beyond his means. With the exception of the color impressions of *Twilight with Haystacks,* printed in 1879 by Degas (cat. nos. 100–101), it was not until 1894, when Pissarro purchased a press from the printer Auguste Delâtre, that he devised his own method of making color etchings. In his barn studio in Eragny, Pissarro embarked on a modest but labor-intensive method using four copper plates, three of which were covered respectively with red, yellow, and blue ink. Each of these three plates was printed in turn over the fourth, the key plate that outlined in black or gray the

118

initial composition. The subtle ink variations and alterations in the registration and printing of the four plates created different effects of color, light, and atmosphere in a single motif.

The magic of making prints is that the intensity and color relationships of the subject can be altered with each printing. Unlike painting, in which the last layer of pigment covers previous changes, each state taken from an etching plate permanently records the artist's alterations. For *Church and Farm at Eragny-sur-Epte* (cat. no. 118), Pissarro made two drawings and developed a black-and-white etching through six states (or stages) before he attempted the series of color editions. The mood of the various impressions changed with the layering of the three primary colors, extending the atmospheric effects of each color print. The overall rose tonality of this particular impression of *Church and Farm at Eragny-sur-Epte* suggests a warm, glowing sunset.

In Eragny, Pissarro explored the pastoral view from his studio window frequently, looking across the meadows toward the hamlet of Bazincourt. *Church and Farm at Eragny-sur-Epte* is a choice representation of the artist's affection for the "true poem of the countryside."[7] Loys Delteil, the cataloguer of Pissarro's printed oeuvre, dated this etching to 1890; however, Pissarro's purchase of the printing press in 1894, and a painting of the exact motif dated 1895, suggests that the print was made after the painting was completed.[8] BSS

1. Pissarro 1980–91, 3:55.

2. Barter et al. 1998, 87.

3. *Primitive Woman* was commissioned from another American artist living abroad, Mary MacMonnies.

4. *Gathering Fruit*, called *Le Potager* when it was exhibited in Paris in 1893, was very similar to *Child Picking Fruit* in subject, costume, and coloration.

5. Barter et al. 1998, 94.

6. Mathews and Shapiro 1989, 157.

7. Thomson 1990, 81.

8. The painting is in the Musée d'Orsay, Paris.

119. CLAUDE MONET
Cap d'Antibes, Mistral, 1888
Oil on canvas
66 x 81.3 cm (26 x 32 in.)
Bequest of Arthur Tracy Cabot 42.542

120. CLAUDE MONET
Valley of the Creuse (Sunlight Effect), 1889
Oil on canvas
65 x 92.4 cm (25⅝ x 36⅜ in.)
Juliana Cheney Edwards Collection 25.107

As Monet grew older, his paintings became simpler. He began to focus on a single, isolated motif, the better to record the changes in color and light wrought on it by different times of day and fluctuations in weather. Not only are *Cap d'Antibes, Mistral* and *Valley of the Creuse (Sunlight Effect)* set in locales basically unfamiliar to Monet—the Mediterranean and the central part of France—but both constitute one of a number of paintings done of the exact same site. *Cap d'Antibes, Mistral* (cat. no. 119) is one of three paintings of these very same trees that Monet made during his four-month sojourn in Antibes, from January through May 1888. (He made thirty-nine paintings during this period.) This was Monet's third visit to the Riviera. He went first with Renoir, in December 1883; then alone to Bordighera, in northwest Italy, for about ten weeks in 1884 (see fig. 13, p. 29). With Alice (now his second wife), he made a final trip to Venice, from October through December 1908. These repeated visits are evidence of Monet's fascination with the region, which afforded, among other things, a comfortable distance from family, friends, and dealers.[1]

The component parts of *Cap d'Antibes, Mistral,* like those of its two companion pieces,[2] are easily itemized: a narrow strip of pink foreground on which grow grasses and trees of pink, green, and purple; a strip of blue-green water dotted with pleasure craft; the snowy

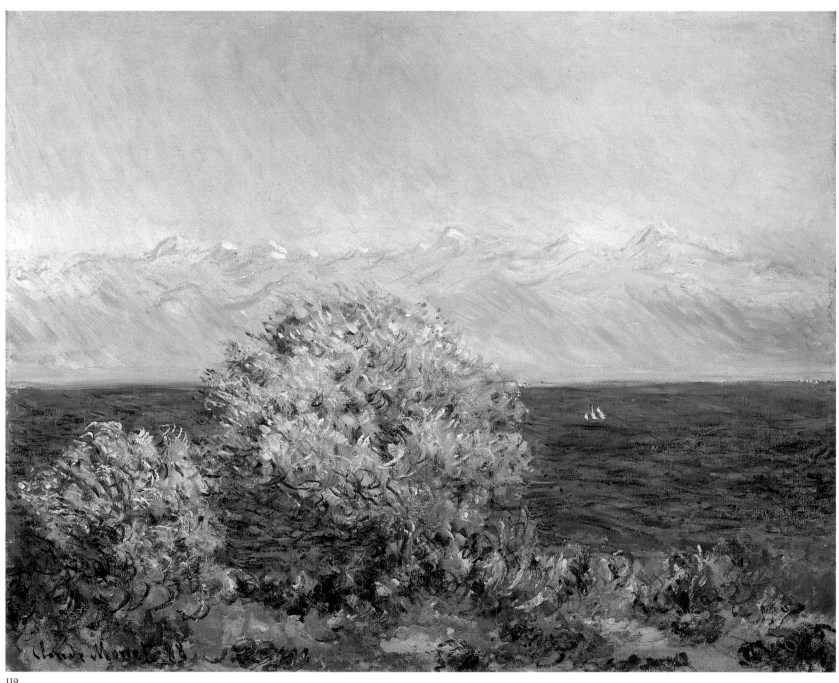

119

maritime Alps terminating the expanse of water; and a strip of sky. Each of the three works is distinguished by varying color tonalities and brushwork. The Boston example is further characterized by its wind-blown appearance, representing the current of the mistral, the strong, cold, northerly wind of southern France. The long, loose brushstrokes that depict the foliage are carried over into the water, mountains, and sky, as if to suggest that the wind is capable of smoothing the large surfaces of those different elements as easily as it agitates the more pliable grasses and leaves.

In painting similar versions of a subject over time, Monet sought to record the atmospheric conditions of each moment. And as those conditions changed, so did the perceptions of the painter. In Joachim Pissarro's words:

> Seriality [the painting of more than one version of a single subject] emphasizes the natural uniqueness of painting, not only in its subject matter (representing a fragment of the real that is constantly under flux) but also in its temporality (reflecting a moment of the creative individuality that cannot be repeated).[3]

Underlying the fluctuation of color and light that so riveted Monet, however, is the rigorous horizontal structure of strips piled one on top of the other. Monet's reduction looks forward to the sparer, starker vision of Ferdinand Hodler's late views of Lake Geneva (fig. 52). Hodler, like Monet, painted many scenes of an expanse of water terminated by a range of mountains, seen at different times of day. Concerned with recording psychic rather than atmospheric nuances, Hodler eliminated all but the narrowest strip of foreground and showed no boats on the lake. In contrast to the later Swiss painter, Monet, rooted in the nineteenth century, supposed that a view must have a viewer and made the trees, with their wind-tossed foliage, stand in as surrogates.

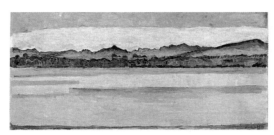

Fig. 52. Ferdinand Hodler, Swiss, 1853–1918, *Lake of Geneva and the Range of Mont-Blanc, at Dawn*, 1918, Musée d'art et d'histoire, Ville de Genève.

With a few notable exceptions, Monet was not particularly adventuresome when it came to choosing motifs to paint. In general, he used what he saw around him. His painting campaigns away from home were usually initiated by someone else, whether as an invitation to stay with a friend or to investigate the possibility of a commission. His trip to the valley of the Creuse River in 1889, for example, was instigated by his friend the critic Gustave Geffroy. Geffroy took the painter to meet the poet Maurice Rollinat, who admired Monet's work.[4]

Rollinat lived in Fresselines, a tiny village that looked down on the confluence of the Petite Creuse and Grande Creuse Rivers in the Massif Central, a rugged and sparsely inhabited region in the middle of France. The area intrigued Monet. Used to the Seine, flowing quietly through its gentle, domesticated banks, he found the Creuse wild, even formidable. He had not brought supplies with him; inspired, he returned to Giverny to fetch paints and canvases. Once back, he set to work. By the time he left Fresselines in mid-May, he had completed two dozen paintings.

This view of rounded hills strewn with boulders, the river rushing between them (cat. no. 120), was the one Monet deemed most expressive of the area around Fresselines: ten of the two dozen canvases resemble *Valley of the Creuse (Sunlight Effect)* in their configuration of hills, water, and sky (see also *Valley of the Creuse*

[*Gray Day*], fig. 28, p. 50). This particular painting, however, differs from the others in showing the scintillating effects of bright sun. The Museum of Fine Arts uses the artist's titles, and it is important to note that for this painting Monet specified sunlight. On March 11 he wrote to his future wife, Alice Hoschedé, that if the weather remained fine, he would stay in Fresselines fifteen or twenty days. As it happened, he stayed for a much longer time: his last letter to her from there was dated May 15. He wrote to her almost every day, and the letters are a litany of complaints about the weather: rain, wind, even snow. The canvases painted in sunny weather were the most problematic for him. As he explained on April 4: "I have some [paintings] done in the sun, but it's been such a long time since they were begun that I'm concerned that when there is another sunny day I'll find that the effects are quite changed."[5]

The colors used for the hillsides—medium to light greens, yellows, and pinks—combined with the puffy clouds tinged with pink, almost globular in shape, suggest the freshness of spring. On the foremost hill, thick swirls of mauve paint define facets of the boulders, which catch the sun coming from the left. The force of the sun on the flank of the surface of the hill on the right, beyond the river, is strong enough to minimize individual forms, so Monet rendered it as a mass of broken and scumbled brushstrokes. Each successive hill is painted in an increasingly summary fashion, culminating in the farthest hill, which appears as a single hue of blue.

Valley of the Creuse (Sunlight Effect) was meant to be seen as one of a series. In June, only a month after Monet left Fresselines, he showed at least fourteen from the campaign—five of the site of *Sunlight Effect*—in a joint exhibition with the sculptor Auguste Rodin at the Galerie Georges Petit. *Sunlight Effect* could well have been one of the exhibited works. Seen

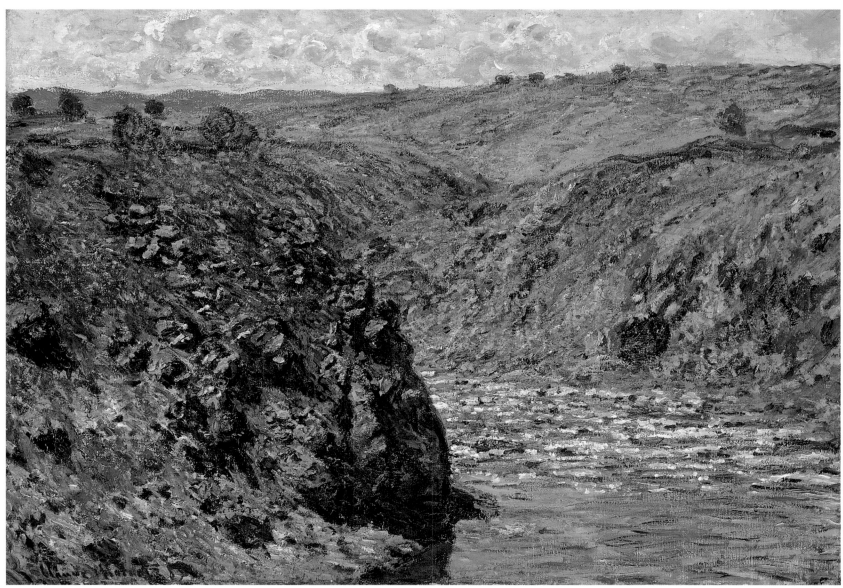

120

together, the different views of the Creuse sig-
naled a shift in Monet's emphasis. No longer
intent on capturing a single instantaneous
moment in time, by 1889 Monet was investigat-
ing the continually shifting *enveloppe* of colored
air that surrounds forms in nature.[6] Thus *Sunlight
Effect* functions on two levels: as one element of a
composite portrait of the Creuse River Valley
and as a sensitive response to the rare sunshine at
Fresselines in the spring of 1889. FEW

1. For a thorough discussion of Monet and his activities on
the Mediterranean, see Pissarro 1997.

2. Ibid., cat. no. 63 (Hill-Stead Museum, Farmington,
Conn.) and cat. no. 65 (private collection, France).

3. Ibid., 20.

4. House 1986, 12.

5. "J'en ai bien quelques-unes par soleil, mais depuis si
longtemps qu'elles sont commencées j'ai bien peur que le
jour où il y aura enfin du soleil je trouve mes effets bien
transformés." Wildenstein 1974–91, 3:243, letter 937; this
author's translation from the French.

6. House 1986, 15.

Edgar Degas
French, 1834–1917

121. EDGAR DEGAS
Autumn Effect, 1890
Color monotype on beige wove paper
Sheet: 29.8 x 40 cm (11¾ x 15¾ in.)
Gift of her children in memory of Elizabeth
Paine Metcalf 1992.565

122. EDGAR DEGAS
Landscape, 1890
Pastel over color monotype on dark cream laid
paper
31.1 x 41.3 cm (12¼ x 16¼ in.)
Denman Waldo Ross Collection 09.296

123. EDGAR DEGAS
Landscape, 1892
Pastel over color monotype on cream wove
paper
26.7 x 35.6 cm (10½ x 14 in.)
Denman Waldo Ross Collection 09.295

121

In the autumn of 1890, Degas and his friend the sculptor Albert Bartholomé set off from Paris in a tilbury for Burgundy. Their destination was the village of Diénay, near Dijon, where their friend Georges Jeanniot, also an artist, had a small château. Along the way, they passed through fields and alongside rolling hills and cliffs, arriving at Jeanniot's about a week after their departure. On finishing the welcoming meal, Degas asked to be taken to his friend's attic studio, announcing, "I have been wanting for so long to make a series of monotypes!"[1] He set to work, returning to the medium more than a decade after the creation of his first landscape prints—all completed before 1880—to bring forth some of the most astonishing images of his career.

As Jeanniot described the afternoon some years later, Degas was single-minded as soon as he was given a metal plate, inks, brushes, and pads:

Once supplied with everything he needed, without waiting, without allowing himself to be distracted from his idea, he started. With his strong but beautifully-shaped fingers, his hand grasped the objects, the tools of his genius, handling them with a strange skill and little by little one could see emerging on the metal surface a small valley, a sky, white houses, fruit trees with black branches, birches and oaks, ruts full of water after the recent downpour, orangey clouds dispersing in an animated sky, above the red and green earth.[2]

As his friend's account makes clear, Degas was no longer working with black and white but

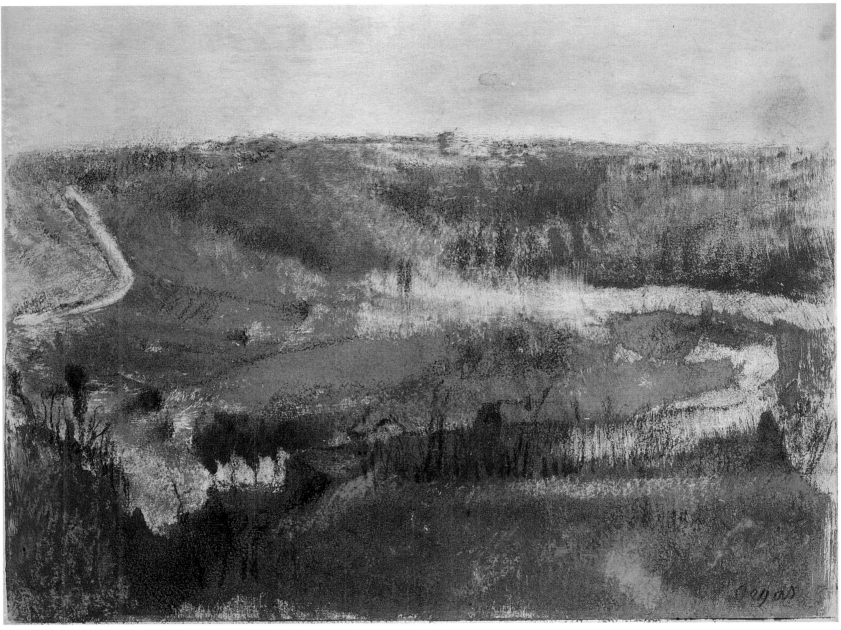

122

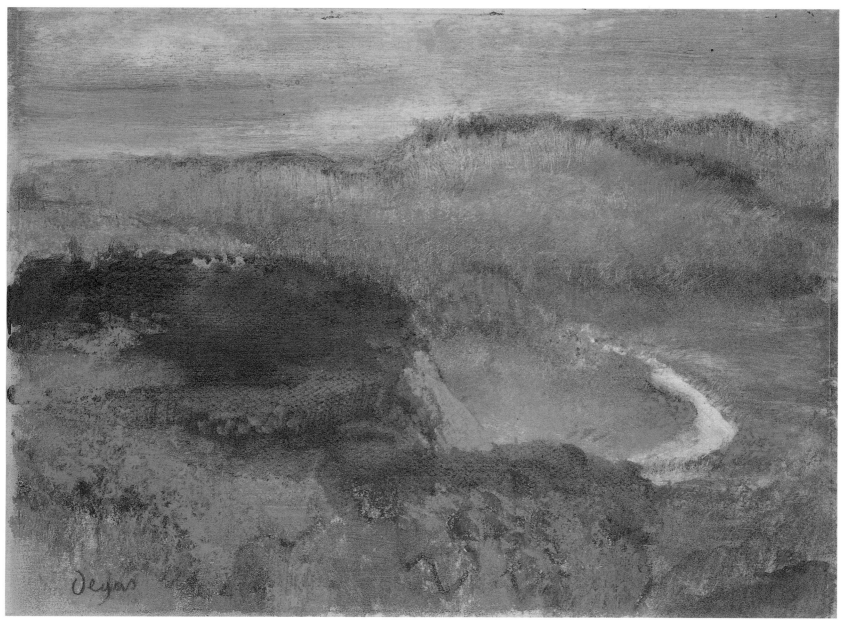

123

with color, freely mixing tints to create landscapes in which orange, green, and red, for instance, were combined on one plate.

Among the monotypes that were finished by Degas in Jeanniot's studio is *Autumn Effect* (cat. no. 121), a misty evocation of a hillside seen along Degas's route. To create the image, Degas first laid down a scumbled pattern of dark purple brushstrokes, then attacked them with a dry brush, or perhaps with rags or with his fingers, shifting the purple medium (undoubtedly artist's oil colors) until he achieved the basic outline of an undulating hill. He then applied a thin layer of paint in a complementary color, golden yellow, washing the hill with a haze of sunlight, or a suggestion of yellowed foliage. The resulting landscape, when printed, reads as thin veils of color, virtually formless, but brilliantly suggestive of the countryside in autumn. Not since the late work of the English painter J. M. W. Turner (1775–1851) had anything like this been attempted in landscape.

Degas managed to make nearly fifty impressions in all between his visit to Burgundy in September 1890 and the autumn of 1892. *Autumn Effect,* like the other experimental landscapes thought to have been printed at Diénay, measures about thirty by forty centimeters; all these images may have been pulled from the same metal plate. Another print, *Landscape* (cat. no. 122), shares that dimension and was probably one of the sheets printed in Burgundy, subsequently enhanced with pastel touches. Jeanniot described landscape images like this one emerging from the ink, and that Degas immediately began to use pastels "to finish off the prints." He commented:

> It is here, even more than in the making of the proof, that I would admire his taste, his imagination, and the freshness of his memories. He would remember the variety of shapes, the construction of the landscape, the unexpected oppositions and contrasts; it was delightful.[3]

Degas's color monotypes were unknown to all but a select few for two years. But by the last months of 1892, Degas had formed a plan for these landscapes. Back in Paris, he had printed many more monotypes, and almost all of these were enhanced with pastel. In the second *Landscape* (cat. no. 123) shown here, for example, the rosy streaks of printed ink in the sky are heightened with pastel strokes of blue, and an undulating cliff in the foreground printed in tones of deepest green is embellished with strokes of rich pink and coral red.[4] Sometimes his embellishments hid nearly every trace of the colored inks that formed the basis of the composition. Degas placed twenty-one of these, plus three landscapes entirely executed in pastel, on exhibition at the Galerie Durand-Ruel in November 1892, in the only solo exhibition the artist ever organized for himself.

Such critics as Gustave Geffroy, surprised to find an exhibition of landscapes by the master of the dance, the racecourse, and the female nude, nonetheless recognized that

> Degas necessarily remains Degas in front of fields, hills, water, skies. He brings his understanding of the movement and flexibility of bodies to the construction and shaping of the land, to hollowing out ravines and to raising hillocks. . . . It is the same eye that sees and the same brain that understands.

Geffroy was convinced that the pastels resulted from Degas's acute powers of observation, noting that "A man who is an artist has passed in front of all this, and has brought to life those visions of an instant that, without him, would have remained unknown, born and swallowed up in unconsciousness."[5] But for Degas, these monotypes were the consummate products of the artist's imagination working in concert with memory, freed, as he told Jeanniot, "from the tyranny which nature imposes."[6] GTMS

1. Degas to Georges Jeanniot, quoted in Kendall 1993, 146. For a discussion of the Diénay monotypes and Degas's 1892 exhibition of landscapes, see 145–229.

2. Georges Jeanniot, quoted in Kendall 1993, 146.

3. Ibid.

4. The Boston monotype (Janis [1968], no. 284), long recognized to be the pendant to a monotype in the collection of the Metropolitan Museum of Art (Janis [1968], no. 285), was exhibited at the Museum of Fine Arts, Boston, in 1997 beside another monotype in a private collection (Janis [1968], no. 288), in conjunction with a presentation of Asian-inspired landscape paintings by Roy Lichtenstein. This author and Barbara Shapiro recognized that Janis [1968], no. 288 was, in fact, the first state of the design. After it was printed, the foreground cliff was added, changing the composition dramatically. From this design, the Boston monotype was pulled; the New York sheet, which preserves features of both images, greatly reduced in definition, was printed last. All three were subsequently embellished with pastel, making the identification of them as a cognate trio more difficult.

5. Gustave Geffroy, quoted in Kendall 1993, 224.

6. Georges Jeanniot, quoted in Shackelford 1984, 62. Degas wrote to his family in December 1892 that he had organized "at Durand-Ruel a little exhibition of twenty-six imaginary landscapes." See Janis [1968], xxvii.

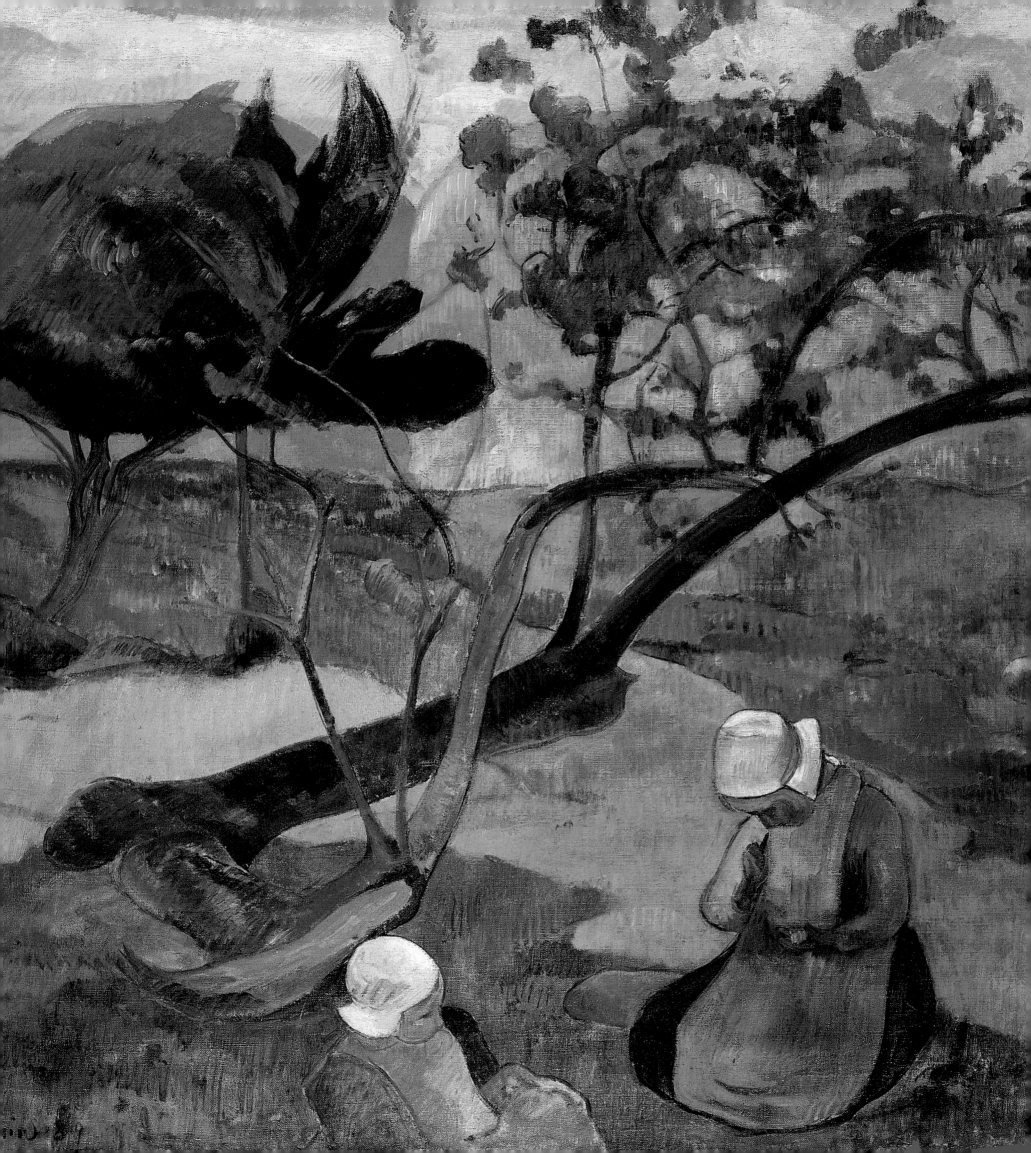

Paul Gauguin
French, 1848–1903

Paul Sérusier
French, 1864–1927

124. PAUL GAUGUIN
Landscape with Two Breton Women, 1889
Oil on canvas
72.4 x 92 cm (28 ½ x 36 ¼ in.)
Gift of Harry and Mildred Remis and Robert
and Ruth Remis 1976.42

125. PAUL GAUGUIN
Women Washing Clothes, 1889
Zincograph on yellow wove paper, hand
colored
Image: 21 x 26 cm (8 ¼ x 10 ¼ in.)
Bequest of W. G. Russell Allen 60.310

126. PAUL SÉRUSIER
Breton Landscape, 1893
Color lithograph on yellow wove paper
Image: 23.2 x 30.1 cm (9 ⅛ x 11 ⅞ in.)
Bequest of W. G. Russell Allen 60.742

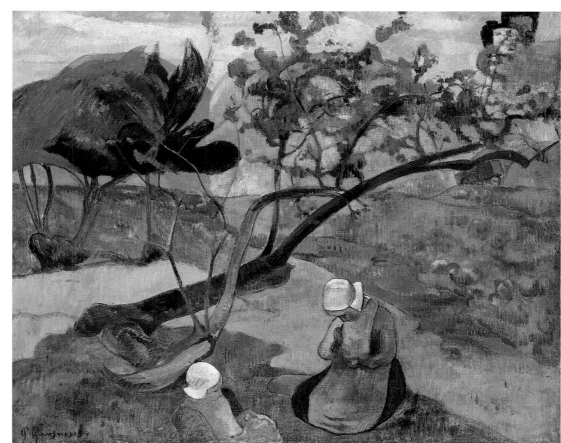
124

Gauguin's *Landscape with Two Breton Women* and *Women Washing Clothes* of 1889 are a far cry from *Entrance to the Village of Osny* of 1882–83 (cat. no. 115), a work that the artist, still an amateur and follower of Pissarro, had painted in the Impressionist style. In the half-dozen years that intervened, Gauguin lost his job as a broker in the stock market crash of 1883 and embraced art as a career, gradually selling his Impressionist painting collection to support his family. He turned his back on Paris, moreover, and sought to escape civilization in favor of what he imagined to be unspoiled areas of primitive cultures. He spent extended periods of time between 1886 and 1891 working in or near Pont-Aven, an artists' colony since the 1860s near the southern coast of Brittany. His subject matter included Breton peasants dressed in distinctive traditional costume, farms, and seaside landscapes. At times he drew on memories of his travels in 1887 to the Caribbean island of Martinique and in 1888 to Arles in southern France, the latter of which he left after two months of attempting to live and work alongside the increasingly troubled Vincent van Gogh.

In Brittany, Gauguin forged a bold and more decorative style of painting. Instead of using small, variegated strokes of paint to suggest forms in light in the Impressionist manner, he began to use flattened space, rhythmic and defined shapes, and brilliant colors to produce images that were meant to be emotional interpretations of nature. His work at this time was

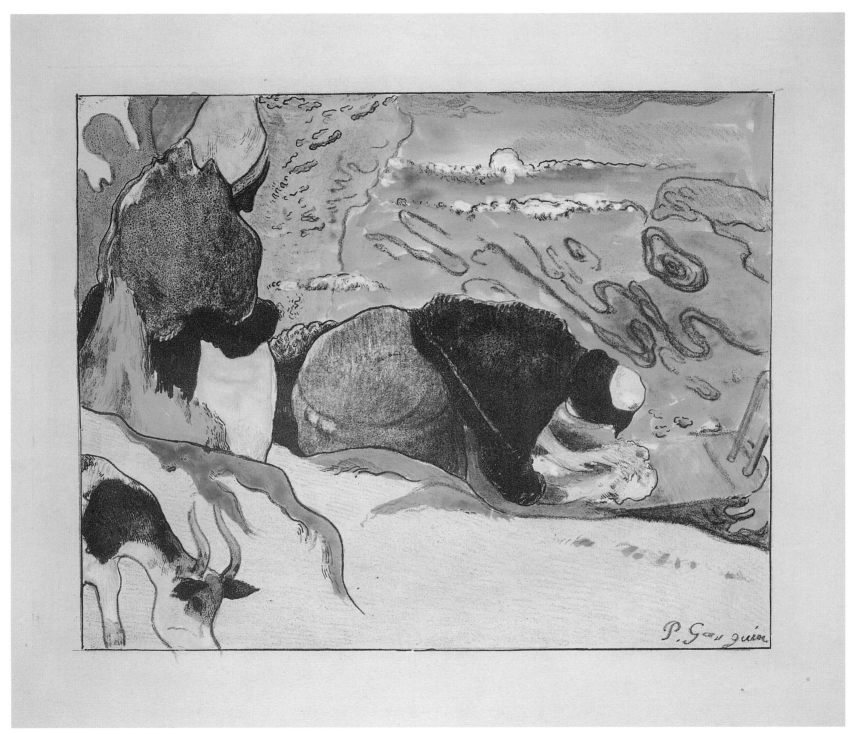

125

influenced by the beliefs of medieval Christianity and ancient paganism that coexisted in contemporary Brittany, as well as such physical reminders of the region's Celtic and Druidic past as its monumental stone formations. Other painters, including Emile Bernard, Armand Séguin, and Paul Sérusier, embraced this new style that developed around Gauguin in Pont-Aven; Sérusier named it Synthetism because it was a synthesis of realism, individual subjectivity, and decorativeness. Some of the self-proclaimed Synthetist artists worked in this manner for many years, whereas Gauguin changed and developed, largely in response to new stimuli from his extended stays in Tahiti from 1891 to 1893 and 1895 to 1901.

Landscape with Two Breton Women (cat. no. 124) was painted in Pont-Aven in the summer of 1889. Here, on a ground composed of strips and triangular patches in clear hues of green, yellow, and red, two young women dressed in local costume are seated in the sparse shade of the attenuated branches of a tree. One figure appears to be praying, but she is eating something, quite possibly the red fruit of the tree. Tall golden haystacks are glimpsed in the distance. The serene, meditative, and timeless quality of the image, the abstraction of the young women's silhouettes, the freely drawn, distorted shapes of the trees, the ornamental patterns of grass, and the prominent crossed diagonals of the overall design represent a strong break with Impressionism. Yet in this work, Gauguin maintained the overlapping brushstrokes from his earlier painting style, thereby providing inviting textures that enliven the surface of the canvas.

When Gauguin attempted to participate in the official exhibition for Paris's Exposition Universelle of 1889 with works similar to *Landscape with Two Breton Women*, he was rejected as being too avant-garde. Nevertheless, recognizing that the event (for which the Eiffel Tower was built) offered a prime opportunity to gain

126

public exposure, Gauguin and a small group of other artists found a spot to hang their paintings on the fairgrounds at Monsieur Volpini's Café des Arts. In addition, two of the artists, Gauguin and Bernard, each provided a set of prints that could be seen on request. Gauguin's set of eleven zincographs (similar to lithographs but printed from zinc plates) were his first prints, deriving most of their subjects from recent paintings of Brittany, Arles, and Martinique.[1] He prepared the plates in Paris in the early months of 1889 and had them printed by the lithographer Edward Ancourt in a small edition of about thirty impressions on large sheets of vivid yellow paper.

Women Washing Clothes (cat. no. 125) is typical of the so-called Volpini set of prints in its use of both lithographic crayon and liquid tusche. The tusche, employed largely as a wash applied with brushes, marvelously suggests the woolly texture of the shawl of the woman at the left. Although the composition corresponds to that of a painting executed in Arles, the caps, dresses, and distinctive wooden washboard are typically Breton. The simplified, monumental forms of the figures, virtually faceless, also bring to mind the massive standing stones of the region, remnants of its pagan past.

Gauguin infrequently depicted pure landscape, yet landscape was often an important element of his work as it is here, forming a shallow backdrop against which the women per-

Auguste Lepère
French, 1849–1918

Henri Rivière
French, 1864–1951

form their tasks. Like Millet (in cat. nos. 51, 52), Gauguin conveys the peasant's burden of unending labor. A goat, busily grazing in the corner, lightens the content. The ornamental patterns in the waves and the overall flatness of the image reflect Gauguin's appreciation of the design and aesthetics of Japanese prints.[2] Few complete portfolios of the Volpini prints sold; Gauguin gave away both sets and individual prints to friends, and occasionally made an impression very special by coloring it with watercolors, as here.

Paul Sérusier first met Gauguin in Pont-Aven in 1888 after completing a classical education, at his wealthy family's insistence, at the Lycée Condorcet in Paris, and then after his family relented, training in art at the Académie Julian. The younger artist enthusiastically embraced Gauguin's flat, simplified forms and bold colors and became active and influential in Brittany, serving as Gauguin's and Synthetism's closest disciple. He also promoted Gauguin's work to a group of Parisian artists that included himself, Pierre Bonnard, Ker-Xavier Roussel, and Edouard Vuillard. These young painters had met in art school and privately called themselves Nabis, the Hebrew word for "prophets," because they predicted a new era in art (see cat. nos. 146–48).[3] A student of philosophy, Sérusier acted as the theorist and spokesman for both the Nabi and Synthetist artists. He was a painter of modest talents, largely interested in color, who was obsessed with the growing tendency to make abstract art. Like the other Nabis, he worked in Paris designing theater sets, costumes, and programs and decorating homes with murals, but he also maintained a studio in Brittany during the 1890s.

Sérusier made only a few prints, and they were generally rather crudely drawn and primitive in spirit. *Breton Landscape* (cat. no. 126), a lithograph of 1893, decidedly pays homage to Gauguin and demonstrates the continuation of

a Pont-Aven style that remained relatively unchanged from that of the late 1880s. The high horizon, tilted ground, and geometric shapes of the fields echo elements in Gauguin's *Landscape with Two Breton Women,* as do the soft, overlapping crayon strokes, whereas the use of bright yellow paper clearly emulates *Women Washing Clothes* and the other zincographs Gauguin made in 1889. Sérusier used two separate lithographic stones for *Breton Landscape,* one printed in brown and the other in green ink. Shoots of green in the foreground promise new growth in this otherwise desolate scene. Compared with Gauguin, Sérusier had more immediate success with his print, for it was selected for publication in *L'Estampe originale,* a quarterly anthology that appeared from January 1892 through March 1895 and provided good exposure for printmakers.
SWR

1. Gauguin would not seriously take up printmaking again until 1893 with his magnificent woodcuts of Tahitian subjects.

2. Although Gauguin undoubtedly knew Japanese prints from Paris, he also would have seen them recently when he was in Arles with Van Gogh, who had a large collection. See Brettell et al. 1988, 174. The yellow paper Gauguin used to print his zincographs resembled not only the paper often used earlier for French advertising posters but also that used for the covers of Japanese woodblock-printed books (*manga*) and independent Japanese woodblock prints that were very popular in France in the later nineteenth century (see cat. no. 128). See also Boyle-Turner 1986, 37, 40.

3. In 1891, when Gauguin held an auction of his work to help finance his first trip to Tahiti, these artists, as well as Sérusier and other friends and admirers, banded together to purchase *Landscape with Two Breton Women.*

127. Auguste Lepère
Saint-Jean-de-Monts, 1900–5
Black and red chalk and opaque watercolor on prepared artist's board
Sheet: 23 x 37.6 cm (9 1/16 x 14 13/16 in.)
Francis Welch Fund 1988.371

128. Henri Rivière
The Chéruette Beacon at Low Tide, Saint-Briac, Brittany, 1890
Color woodcut on beige Japanese paper
Block/image: 22.7 x 35.2 cm (8 15/16 x 13 7/8 in.)
Stephen Bullard Memorial Fund by sale of duplicate 1983.225

Born in Paris, Auguste Lepère wished to be a painter. However, his sculptor father, who recognized the need to earn a living, apprenticed him at the age of thirteen to a wood engraver. Throughout much of the nineteenth century, this method of printmaking was used to make black-and-white illustrations. Traditionally, the design was drawn by an artist and cut in fine white lines on an end-grain block of wood by a specially trained craftsman; the engraved block could then be inked and the image printed in a press at the same time as the type. Lepère's skill at both designing and cutting blocks enabled him to do both jobs, leading to a successful career. Through much of his life, he executed more than one thousand wood engravings, which appeared in popular weekly magazines and books. He also managed to have his paintings accepted regularly at the Salons. By the 1890s he had gained financial security. As illustrations based on photography gradually took the place of wood engravings designed by artists, Lepère turned to making individual prints—etchings, lithographs, and woodcuts (cut on planks of wood so that the design itself stands out in relief)—producing many handsome works for sale. Lepère led the way in promoting original woodcuts and original wood

engravings, designed and cut by the artist, and he arranged for prominent exhibitions of such works in the late 1880s and early 1890s. By the mid-1890s many artists were making their own woodcuts and wood engravings, even such an individualist as Paul Gauguin.

By and large, Lepère's wood engravings depicted urban scenes and were produced in Paris during the winter. However, for much of his life he kept a summer residence at Saint-Jean-de-Monts, a village located on the Atlantic coast north of La Rochelle, in the Vendée. There he captured village events as well as the marshes and sand dunes of the local landscape in drawings, pastels, and paintings. It was often these works, made not as commissions but as personal choices, that he exhibited in the annual Paris Salons. *Saint-Jean-de-Monts* (cat. no. 127) is a mixed-media drawing, combining blue and white opaque watercolor with black and red-brown chalks, which records a landscape that must have been very familiar to the artist.[1] With his back to the sea, he has represented the humpy sand dunes—the *monts* (hills) of the town's name—with their sparse vegetation. Tiny windmills may be observed in the distance, working to grind grain or pump water from the marshes that lie inland from the beach. The subject is decidedly lacking in drama and is drawn honestly and humbly. In making a work of art from a nondescript landscape, Lepère joins the company of Jean-François Millet (cat. nos. 56 and 58) and Edgar Degas (cat. no. 95). Lepère's paintings have yet to be systematically published, and it is not possible to say whether this drawing is a study for a painting or a finished work in itself. He began to exhibit drawings at the 1904 Salon and throughout that decade showed subjects of dunes and Saint-Jean-de-Monts.[2]

Japanese woodcuts played a role in France's revival of interest in the medium. Following the opening of Japan to the West in 1854, Japanese

127

128

objects ranging from scrolls and sculptures to fans and kimonos, and in particular easily exportable prints, were collected enthusiastically in Europe and were especially popular in France. The first major exhibition of these kinds of objects took place in 1883 at a prominent Parisian art gallery and coincided with the publication of a major book on Japanese art.[3] Subsequent public exhibitions of Japanese prints took place in Paris, ranging from a large one held at the Exposition Universelle of 1889 to smaller ones such as that which Van Gogh, himself a collector, mounted in an artists' café in 1887.[4] Japanese prints were admired by many avant-garde artists and can be seen as still-life elements in paintings by Degas, Gauguin, Monet, and others. Japonisme, or the cult of Japanese art in the late nineteenth century, is a rich topic that describes a range of European borrowings from Japanese art.[5] *The Chéruette Beacon at Low Tide, Saint-Briac, Brittany* (cat. no. 128), by Henri Rivière, and *Gathering Fruit* (cat. no. 117), by Mary Cassatt, are two examples of works that emulate Japanese woodcuts with their flattened perspective, unusual point of view, and abrupt cropping.

Largely a self-taught painter, Rivière enjoyed a long and successful career as a printmaker. Like Paul Signac, his childhood friend, he was born in Paris to a middle-class family. The two young artists shared a studio in Montmartre in the early 1880s. Rivière soon gained attention with his shadow-theater productions for the Chat Noir, an artists' cabaret, and his first prints (made in 1889 and 1890) were color lithographs, views of Paris made to illustrate programs for avant-garde plays produced at the Theâtre-Libre.[6] Not satisfied with merely borrowing stylistic elements from Japanese prints, Rivière taught himself to cut and print woodblocks using traditional Japanese techniques. He cut a separate block for each color and printed each one in sequence, brushing

water-based pigments on the block and printing it by laying a piece of imported Japanese paper on the top of the block and rubbing with a flat wooden implement. After several years of intense activity, he produced nearly twenty views of Brittany that he exhibited in 1892. Since these prints contained from six to ten colors apiece, each printed from a different block, he had time to print only ten impressions of every design.[7] In the late 1880s, at the same time that he was working on the Brittany woodcuts, Rivière was also sketching the Eiffel Tower under construction. His aim was to produce thirty-six views of this imposing new symbol of Paris in the same woodcut technique and with similarly bold compositions as those that Katsushika Hokusai had used for his thirty-six views of Mount Fuji. In the mid-1890s Rivière switched to the less time consuming medium of lithography in order to produce larger editions, retaining the eloquent but labor-intensive Japanese-style color woodcut only for major individual works.

This view of Saint-Briac from the Breton series shows its shallow harbor at low tide, with attention focused on the beacons, or spindles, that are strategically placed to warn sailors of rocks hidden at high tide.[8] The blue areas of water clearly exhibit a characteristic Japanese printing technique, which allows for varying the density of the transparent paint and retains the marks of the brush. The small rocky island in the foreground and the vertical beacons are the only elements that interrupt the horizontal bands of water, land, and sky. The brilliant contrasting colors, unusual composition, and decorative patterns in the clouds and water emulate the aesthetics and conventions of Japanese woodblock prints. In the Asian tradition, Rivière marked his print with a red rectangle containing his initials—it closely resembles the signature stamps used by Japanese artists.
SWR

1. In 1904 Lepère depicted his own, whitewashed house in the village, using the same combination of media: gouache, pastel, and black chalk on a board thirty by forty-one centimeters. A color reproduction of this drawing, taken from a 1995 catalogue of the Galerie Antoine Laurencin, Paris, is in the Lepère documentation files at the Musée d'Orsay, Paris.

2. For more information on Lepère's life and work in the Vendée, see Vital 1988.

3. The gallery was that of Georges Petit; Louis Gonse wrote the two-volume work *L'Art japonais* (1883). See Cate 1975, 53.

4. The Paris dealer Siegfried Bing's important 1888 exhibition should also be noted; see Baas and Field 1983, 10.

5. See note 3 and Ives 1974.

6. For more about these entertainments, see Shapiro et al. 1991, 109–66.

7. Baas and Field 1983, 73.

8. Signac also represented these beacons in the 1890 painting *The Beacons at Saint-Briac, Opus 210* (Collection of Mr. and Mrs. Donald B. Marron, New York); see Ferretti-Bocquillon et al. 2001, no. 50.

Vincent van Gogh
Dutch (worked in France), 1853–1890

129

129. VINCENT VAN GOGH
Ravine, 1889
Oil on canvas
73 x 91.7 cm (28 ¾ x 36 ⅛ in.)
Bequest of Keith McLeod 52.1524

130. VINCENT VAN GOGH
Houses at Auvers, 1890
Oil on canvas
75.5 x 61.8 cm (29 ¾ x 24 ⅜ in.)
Bequest of John T. Spaulding 48.549

Van Gogh was the son of a Protestant minister, and the importance of leading a moral, useful life was early impressed on him. He tried several different professions—art dealer, teacher, minister, and missionary—before deciding in 1880 to become a painter. His training was spotty; he worked under his cousin Anton Mauve in The Hague, on his own, and in Antwerp. He joined his brother Theo in Paris in the spring of 1886. There he met many of the progressive painters, including Pissarro, Degas, Gauguin, Signac, Seurat, and Henri de Toulouse-Lautrec. His art, previously dark in palette and moralistic in subject matter, changed dramatically under the twin influences of Impressionism and Japanese prints, becoming light and bright. Van Gogh was emotionally unstable, and when Paris became too much for him, in February 1888 he went to Arles, in the South of France. Gauguin joined him there for a while. After a year's internment in an asylum, Van Gogh returned north in May 1890. Always productive, he continued to paint until he killed himself in July. Paradoxically, given his worldwide reputation now, his work was little known and he sold but one painting during his lifetime.

The title of *Ravine* (cat. no. 129) is based on Van Gogh's references to it in letters.[1] He painted it in early October 1889 and wrote about it in a letter to the painter Emile Bernard. "Such subjects," he explained, "certainly have a fine melancholy, but then it is fun to work in rather wild places, where one has to dig one's easel in between the stones lest the wind should blow the whole caboodle over."[2] Van Gogh referred to this painting as a study and contrasted it with the version he painted a few months later (now in the Rijksmuseum Kröller-Müller, Otterlo), which he characterized as having "closer drawing and there is more controlled passion and more color in it."[3] This picture was not yet dry, so Vincent did not send it to his brother Theo with others in January 1890. Theo included the October version in the group of ten paintings by Vincent he sent to the Salon des Indépen-

dants, which ran from March 19 through April 27. It was a great success there. Gauguin liked it so much he offered to trade something of his own for it. He wrote to Van Gogh:

> In subjects from nature you are *the only one who thinks*. I talked about it with your brother, and there is one that I would like *to trade with you for one thing of your choice*. The one I am talking about is a mountain landscape. Two travelers, very small, seem to be climbing there in search of the unknown. There is in this work an emotion *à la* Delacroix, and very suggestive color. Here and there, red touches like lights, the whole in a violet tone. It is beautiful and grandiose. I talked about it for a long time with Aurier, Bernard and many others. They all give you their compliments.[4]

Because the painting is now unvarnished, the color harmonies that the viewer sees are close if not identical to what Van Gogh's fellow artists saw. Paint streams down the canvas. To left and right are violet-colored rock faces; they converge at a roiling green stream. Barely visible are two women making their way up a path that seems to disappear. A green eminence abruptly closes the view at the back. Flamelike bushes, in red, green, and ocher, punctuate the mountainsides. The colors are relatively equal in value; there are no strong contrasts, as there are in the later version. The paleness of the figures, blending with the rock face, gives the picture an unworldly air. Gauguin's words about the women articulate well the inchoate sense of yearning this painting embodies.

It was shortly after the Salon des Indépendants that Van Gogh left the South of France. He settled in Auvers, near the river Oise, where Dr. Gachet, an eccentric physician and art collector, lived. At Pissarro's urging, Gachet promised Van Gogh's brother Theo that he would look after the painter. Van Gogh was not the first artist to paint in Auvers. Auvers is close to Pontoise, an area in which Pissarro had worked happily some years earlier; Cézanne visited Pissarro there and was encouraged by him to

paint outdoors. The region's artistic heritage was therefore rich, but Van Gogh may have valued it more for its proximity to his brother and young family in Paris and for its enabling him to live on his own. There was much to interest the artist, including the older cottages and newer houses, the surrounding rich fields, the flowers, the church (mentioned in guidebooks of the time), and the sympathetic Dr. Gachet himself.

In *Houses at Auvers* (cat. no. 130), Van Gogh has painted a sunny day in June or July, with puffy white clouds in a blue sky. Like works by Pissarro (cat. no. 90, for example), this one shows a peaceful village integrated into the surrounding countryside: the thatched roofs help tie together the manmade and natural worlds. In his very first letter to Theo from Auvers, Van Gogh noted that thatched roofs were "getting rare."[5] His concentration on the roof in the left foreground evinces his fondness for the old-fashioned material. Certainly compared with the red- and green-tiled roofs, the thatched one is richer, more nuanced, and subtler.

The thick strokes of paint overall, but particularly in the thatched roof, can be likened to colored threads. Van Gogh had a box containing balls of yarn that he manipulated to create and observe the resulting color harmonies. He thought of himself as an artisan.[6] His careful application of paint was an attempt to ally his work with that of other craftspeople. His color and touch were put at the service of suggesting surfaces; tile roofs are painted differently from thatch, bricks differently from plaster. Likewise, puffy clouds receive individual treatment, and fields are differentiated from trees. Van Gogh gave each motif its due. FEW

1. Hulsker 1996, 416.

2. Van Gogh 1958, 3:521, letter B20, first half of October 1889.

3. Ibid., 243, letter 243.

4. Gauguin, quoted in Hulsker 1996, 430.

5. Van Gogh 1958, 3:273.

6. See Silverman 1994, 137–68, 465–73, especially 163–68.

131

Henri-Joseph Harpignies
French, 1819–1916

Jean Charles Cazin
French, 1841–1901

131. HENRI-JOSEPH HARPIGNIES
Evening at Saint-Privé, 1890
Oil on canvas
73.7 x 54.5 cm (29 x 21½ in.)
Bequest of Ernest Wadsworth Longfellow
23.486

132. JEAN CHARLES CAZIN
Farm beside an Old Road, about 1890
Oil on canvas
65.1 x 81.6 cm (25⅝ x 32⅛ in.)
Bequest of Anna Perkins Rogers 21.1330

The attention lavished on the Impressionist painters in recent years has overshadowed the reputations of many landscape artists who, in their lifetimes, were widely esteemed and whose works were avidly collected. Because Impressionism was so popular at the end of the twentieth and now at the beginning of the twenty-first century, it is important to remember those artists who enjoyed an equal measure of success one hundred years ago. Harpignies and Cazin are two of these now-eclipsed artists whose paintings deserve a fresh examination.

Extremely long-lived, Harpignies studied with the landscapist Jean-Alexis Achard after working for his father. He and Achard visited the Netherlands and Belgium to avoid the Revolution of 1848, and then Harpignies traveled to Italy from 1849 to 1852. He returned there from 1863 to 1865. He had a successful career at the Salon from 1853 to 1912, winning medals in 1866, 1868, and 1869. He received a knighthood in the Legion of Honor in 1875, was named an officer in 1883, a commander in 1901, and grand officer in 1911. In 1883 the art dealers Arnold & Tripp began to commission and sell his works, an arrangement that freed Harpignies from financial worries and increased his productivity. In the mid-1850s Harpignies was particularly drawn to Corot's work, whose

132

silvery tonalities he adopted until about the early 1870s. His concurrent work in watercolor can be said to have brightened his palette and given it more individuality. After about 1885 he was increasingly influential as a watercolorist. From 1878 he lived in Saint-Privé, on the river Yonne, wintering in Nice after 1885. Harpignies was unaffected by the developments in landscape painting. He remained true to a midcentury aesthetic of straightforward transcription, marked by his distinctive stylization.

Both Harpignies and Cazin transcribed the elusive, evocative end of day, yet in very different ways. At first glance, *Evening at Saint-Privé*

(cat. no. 131) appears to be a portrait of trees. The vertical orientation of the canvas, reminiscent of portraits, reinforces this impression. Yet the cropping of the composition—the tops of the trees are cut off by the upper edge of the canvas—emphasizes the decorative quality, in which patterns that lie flat on the picture's surface take precedence over description. A contemporary of the artist explained:

> While accepting the modern feeling for air and sunlight, he never forgot the primary rhythmical purpose of a picture—that it must before all else be a pattern. So in his paintings we always find this sense of

rhythm and pattern accentuated with a true French love for clarity of expression, for gravity of mood, and for that logical, temperate balance, that love of proportion for its own sake.[1]

As true as these words are, this painting by Harpignies, done near his house at Saint-Privé on the river Yonne southeast of Paris, conveys the effect of looking out from the relative darkness of a forest to a brighter area in the distance. With the sun hidden, the light picks out the tops and right sides of the trees on the far bank. The river itself is a smooth, reflective surface. The subtle nuancing of light throughout and the contrast of dark forms against a blue sky changing ever so slightly to rose recall the artist's watercolors, in which luminosity is of prime importance.

Whereas Harpignies's paintings remained untouched by new thinking about color and time that characterized much of the art produced at the end of the nineteenth century, Cazin's paintings responded to recent developments. In *Farm beside an Old Road* (cat. no. 132), as in *Riverbank with Bathers* (cat. no. 109), Cazin applied paint in discrete strokes, akin to Daubigny's broad brushwork, which sometimes verges on calligraphy (see cat. no. 70).

Farm beside an Old Road reveals itself only slowly. A road at the right carves a broad arc past a cluster of farm buildings into low hills beyond. Behind the buildings, to the left, are the conical forms of grainstacks, familiar to us from Monet's paintings (see cat. nos. 142–43), and beyond them smoke from smoldering fires. Thick pinkish clouds cover hints of blue sky as day gives way to night. A thin, quick brushstroke of orangish red peeks through the clouds just above the horizon, suggesting the final rays of the setting sun. The autumnal browns, ochers, and oranges of the earth, along with the grainstacks and empty fields, indicate that it is past harvest time.

Cazin may be doing more than painting a view of a farm along a little-used road. The forms here seem to subside into, and be absorbed by, the surrounding land. The buildings, for example, seem to be intimately connected with the earth. Although they are multistory structures, their roofs do not break above the crest of the hills, and the side of the roofs aglow with the setting sun slope sharply toward the ground. Twilight and the end of the growing season combine to suggest another kind of end, the gradual abandonment of the countryside for urban areas. If this interpretation has merit, Cazin's painting is an elegy to a vanishing way of life. FEW

1. Holmes 1909, 76, 81.

133. PAUL SIGNAC
View of the Seine at Herblay, Opus 203, 1889
Oil on canvas
33.2 x 46.4 cm (13⅛ x 18¼ in.)
Gift of Julia Appleton Bird 1980.367

134. PAUL SIGNAC
Port of Saint-Cast, Opus 209, 1890
Oil on canvas
66 x 82.5 cm (26 x 32½ in.)
Gift of William A. Coolidge 1991.584

Spurning the profession of architect, which his family wanted him to follow, Paul Signac was largely self-taught as a painter. He met Georges Seurat in 1884, and Seurat's ideas about a scientific approach to painting, based on the aesthetic theories of the chemist Charles Henry, transformed Signac's art. He adopted Seurat's style of divisionism, or pointillism, a method of painting in small, separate touches of color. After Seurat died in 1891 Signac assumed the leadership of the loose group of painters called the Neo-Impressionists, in part because of his writings, which included *D'Eugène Delacroix au néo-impressionnisme* (1899) and, with Henri-Edmond Cross, a translation of parts of John Ruskin's *Elements of Drawing* (1889). To ally his paintings with music, a common goal among artists and writers in the late nineteenth century, Signac assigned his paintings opus numbers between 1887 and 1893. He moved to Saint-Tropez in 1892, where he could indulge his favorite subjects—marines and views of ports. Despite his adherence to theory, Signac did not paint in a consistent divisionist style throughout his career. Instead, his touch loosened and became quite free, especially in the studies—often in watercolor—he made outdoors. Signac was an active member of the Société des Indépendants, formed in 1884, and he exhibited his work throughout Europe as well. His bright, mosaiclike brushstrokes of about 1904 informed

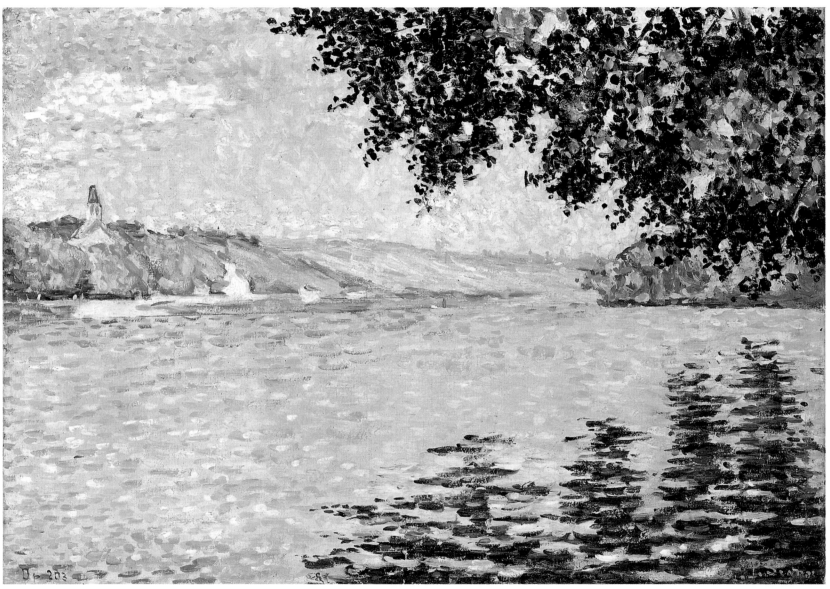

133

Fig. 53. Paul Signac, *The Seine at Herblay*, 1889, Musée d'Orsay, Paris.

P. Signac 90 Op. 205

134

Henri Matisse's art at that time.

Signac was an admirer of Monet's paintings, and like Monet he was attracted to sites on the water. He did not live at Herblay, close to where the Seine meets the Oise, nor did he map the region in a series of paintings, as Sisley did with Louveciennes and Monet did with Argenteuil, Giverny, and Vétheuil. However, Signac visited the town, downstream from Paris, in August and September 1889 and made six paintings and three studies there.[1] The configuration of the town is seen more clearly in a panoramic view (fig. 53). Rising in steps are bathhouses (or washhouses) moored in the river; houses looking out over the water; and, thrusting above the crest of the hill, the tower of a church.[2] In the Boston painting (cat. no. 133) the view is seen from a position under a tree whose branches hang over the water. The village seems to dissolve in color and light. Barely articulated, it looks bleached and isolated.[3]

Signac's divisionism is put to good use here. Divisionism was developed as a way of applying the scientific analysis of color to painting, so that color would have as much brilliance as possible. An example can be seen in the reflection of the foliage, where orange and blue, opposites on the color wheel, are juxtaposed so that they vibrate to best advantage. Paintings done in this manner often look as though a veil has been dropped over the scene. Each small touch of color, no matter how vivid, necessarily denies the possibility of large areas of hue. Even in this painting, with its fairly large oblong strokes and concentration of midnight blue in the overhanging foliage and its reflection, the individual brushstrokes make the scene scintillate before our eyes.

It was thought that in its application of scientific principles to painting, divisionism would depersonalize art, removing from it the subjective, expressive element. This was not to be. Signac's brushwork, appearing in some places as dots and in others as oblongs or sketchy strokes, shows how he responded in different ways to the light reflecting off various surfaces. A particularly lovely passage is in the foliage, where blossoms shimmer against the dark blue leaves—or is it sunlight that has coagulated there, quivering? The brushwork in *The Seine at Herblay* (fig. 53) is more controlled, less spontaneous, and more truly divisionist. This is not to say that the painting in Boston is an unmediated response to nature; pencil lines carefully demarcate the shoreline and the crest of the hill. But despite the pencil lines, the premeditated use of color opposites, and the light gray priming left bare to provide a sense of transparency and depth as well as a midtone that mutes the contrast of colors, Signac allowed himself the luxury of painterly touches. These are in evidence in the already mentioned brushy reflection and in the more thickly painted farther hill, where no dots can be seen. Perhaps the Boston picture was done on the spot, and *The Seine at Herblay* indoors, where the relative freedom of plein-air work was replaced by the intellectual rigor of the studio.

Painted shortly after the scene at Herblay, *Port of Saint-Cast* (cat. no. 134) belongs to one of two series, each consisting of four paintings, that Signac exhibited in 1891 in Brussels and Paris under the group titles *Le Fleuve* (The river) and *La Mer* (The sea). Monet, who earlier had begun working on his Creuse Valley (cat. no. 120) and Belle Isle series, may have provided the inspiration for these landscapes by Signac. In this stilled vision of a port on the northern coast of Brittany, Signac rendered the natural world as pattern. Contours are straightened or simplified so that shapes like the bluff to the right or the shoreline in the foreground become elemental. Diagonals take the viewer through the painting: from the lower left, the shoreline leads to the reflection of the hill, which changes direction to lead to the bluff. Together with the sliver of a promontory on the left, the tip of the large hill points toward the sailing vessels, whose forms rhyme with those of the town on the far shore.

The small, meticulously placed brushstrokes, juxtaposing primary and secondary colors, create a fluctuating visual resonance and evoke the physical and visual textures found in nature, from the graininess of the sand to the shimmering reflections on the water. The influence of Japanese woodblock prints is detectable in the flattened picture plane and in the large areas that give the appearance of being unified colors. Signac had visited an exhibition of Japanese art in Paris shortly before going to Brittany. His companion, the critic Arsène Alexandre, remembered, "We spent a long time looking at the landscapes of Hiroshige."[4] Signac, along with others who were dissecting the visual world into its fundamental components of color and light, including Henri Edmond Cross (cat. no. 139), influenced the unconventional color and bold forms championed by Signac's friend and follower Henri Matisse. FEW

1. Ferretti-Bocquillon et al. 2001, 303.

2. For another view of Herblay by Signac, see his 1889–90 *Sunset at Herblay* (Glasgow Art Gallery and Museum).

3. The painting was identified by Murphy 1985, 263, as showing Vétheuil, undoubtedly because the church tower so closely resembles that at Vétheuil. However, the church at Vétheuil is on a level with the riverbank, not on a slope, as at Herblay.

4. Arsène Alexandre, "Chronique d'aujourd'hui," *Paris*, March 19, 1892, 2, quoted in Ferretti-Bocquillon et al. 2001, 157.

Charles Angrand
French, 1854–1926

Paul Signac
French, 1863–1935

Henri Edmond Cross
French, 1856–1910

135. CHARLES ANGRAND
Farmyard, 1892
Black conté crayon on cream laid paper
Sheet: 47.5 x 62.4 cm (18 ¹¹/₁₆ x 24 ⁹/₁₆ in.)
Gift of her children in memory of
Elizabeth Paine Metcalf 1992.566

136. PAUL SIGNAC
Les Andelys, 1897–98
Color lithograph on cream wove paper
Image: 30 x 45 cm (11 ¹³/₁₆ x 18 in.)
Anonymous gift 1971.709

137. PAUL SIGNAC
Boats, 1897–98
Color lithograph on cream wove paper
Image: 23.5 x 39.8 cm (9 ¼ x 15 ¹¹/₁₆ in.)
Anonymous gift 54.721

138. PAUL SIGNAC
Boats, 1897–98
Color lithograph on cream wove paper, trial
proof, annotated by the artist
Sheet: 39 x 53.5 cm (15 ⅜ x 21 ¹/₁₆ in.)
Gift of Peter A. Wick 55.576

139. HENRI EDMOND CROSS
The Promenade, 1897
Color lithograph on cream Chinese paper
Image/sheet: 28 x 40.7 cm (11 x 16 in.)
Bequest of W. G. Russell Allen 60.98

Like Paul Signac, Charles Angrand and Henri Edmond Cross followed the lead of Georges Seurat and painted in a divisionist, or pointillist, style (see cat. nos. 133–34). Signac and Cross also each made a small number of lithographs that expressed their theories of color and its application in the divisionist manner. Angrand adopted Seurat's distinctive way of drawing with black conté crayon on rough textured paper, using continuous tones rather than lines to create his images. Thus each in his own way paid homage to Seurat while at the same time developing an individual style.

Angrand was born in the farming village of Criquetot-sur-Ouville, in the Caux region of Normandy, north of the Seine River. His father held the respected position of schoolmaster. Following in his father's footsteps, Angrand attended a teachers' college in Rouen from 1872 to 1874 and remained there as a tutor at the Lycée Corneille until 1881. He had already decided to be a painter, and he began to exhibit in Rouen while studying at its Académie de peinture et de dessin under Gustave Morin and later Edmond Lebel. Lebel's academic taste for dark tonalities made him unsympathetic to Angrand's work, which displayed the paler colors of his idol, Camille Corot. Denied a scholarship to the Ecole des Beaux-Arts in Paris, Angrand moved to the capital anyway, painting and supporting himself once again by teaching at the Collège Chaptal.

Angrand painted urban and rural subjects in the divisionist style, exhibiting both in Rouen and in Paris at the Salons des Indépendants starting in 1884. He became one of Seurat's few close friends, and they painted together on the island of the Grande Jatte. After Seurat's death Angrand stopped painting and until 1895 worked only in black and white, creating a body of drawings, many of which depict Norman farms. In 1896 he moved back to Saint-Laurent en Caux, where he lived the rest of his life as a sin-

Fig. 54. Georges Seurat, French, 1859–1891, *Head of a Woman,* study for the painting *Sunday Afternoon on the Island of La Grande Jatte,* about 1884–85, black conté crayon, Smith College Museum of Art, Northampton, Massachusetts.

gle man, devoted to his nieces and nephews and traveling only as far as Paris to see and participate in exhibitions. He corresponded regularly with his closest colleagues, Maximilian Luce, Cross, and Signac, whose picture postcards mailed from afar provided him with armchair travels. These divisionist artists, along with Théo van Rysselberghe and Hippolyte Petitjean, were first called Neo-Impressionists by the critic Félix Fénéon in 1886. For a few years beginning in December 1892 they held their own exhibitions, but sales were poor and the project ceased at the end of December 1894. The Société des Indépendants, with its annual exhibitions, served them and other avant-garde artists well for many decades. Angrand exhibited at the annual Salon des Indépendants with some regularity until 1925, the year before his death. Although he returned to oil painting about 1906 and also worked in pastel, his contributions to

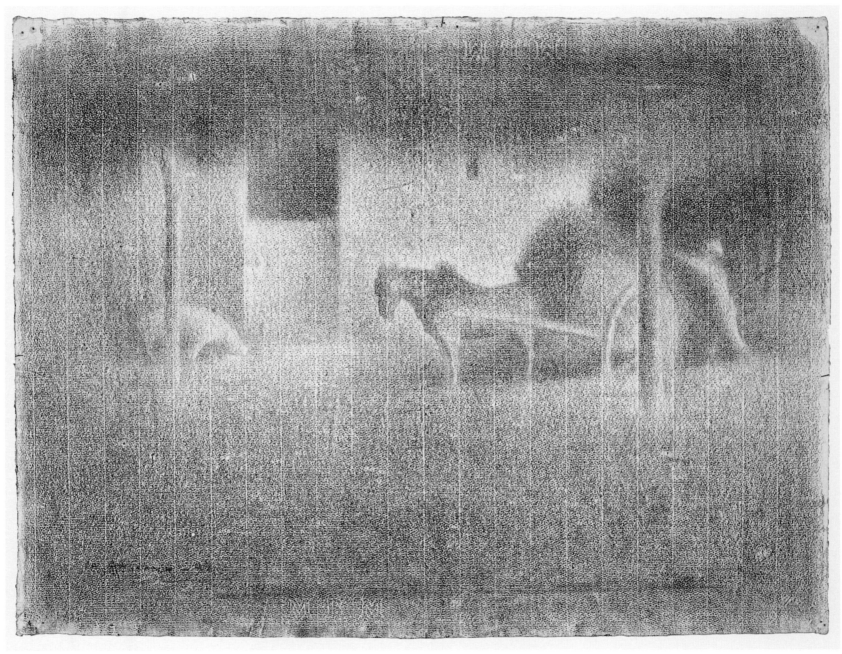

135

the salons were primarily large black-and-white drawings.

In the introduction to the 1925 catalogue of a retrospective exhibition of Angrand's work, Signac wrote of Angrand's "happy drawings: vacations on the farm, all the joys of the fields, the squadron of ducks, the peaceful life of hens," and noted particularly his attention to the "unrecognized philosopher, the pig."[1] One of these neglected thinkers is represented sniffing the ground at the left in *Farmyard* (cat. no. 135). In this handsome sheet, the light and dark tonalities almost magically conjure up the ghostly forms of the farmyard and its occupants —the pig and a farmer unloading hay from his horse-drawn wagon. Misty, serene, and somewhat mysterious, the image resembles other drawings of farm animals in their outdoor surroundings and human activities indoors that Angrand drew in the 1890s. These luminous images, a number of them dated 1892, are drawn with black conté crayon on paper whose texture is clearly visible; the laid and chain lines, as well as the prominent watermark of the paper's manufacturer, Michallet, read as white lines.[2] Angrand drew no lines with his black crayon, but only broad areas of tone, in a manner similar to that which Seurat used for his numerous studies for paintings, such as the charming *Head of a Woman* (fig. 54). Critics appreciated the mystery and melancholy of the drawings, but simultaneously criticized them for slavishly recalling Millet and Seurat.[3] After the turn of the century Angrand adopted a more linear style of draftsmanship, softened, however, by his experience of Seurat and the tonal mode.[4]

Signac, unlike Seurat and Angrand, made few large black-and-white, finished drawings. He painted many watercolors for exhibition and sale, but otherwise tended to make modest sketches. However, Signac made more prints than any other divisionist painter, although the

136

total is not large—twenty lithographs and seven etchings, spread over the years 1887 to 1927. The most coherent group is the color lithographs he made from 1897 to 1898 at the Paris workshop of the masterly lithographer Auguste Clot, who also printed lithographs by Pierre Bonnard, Ker-Xavier Roussel, and Edouard Vuillard (cat. nos. 146–48). Signac's set of six landscapes, executed with the same meticulous strokes as his paintings, was issued by Gustave Pellet in about 1898 but had little commercial success. Pellet, who became a print publisher in 1886, issued some of Clot's greatest productions, including these colorful landscapes by Signac and others by Luce, as well as Henri de Toulouse-Lautrec's *Elles* (Women).[5] Four of Signac's lithographs are views of harbors. Of these, three were based on drawings or paintings of Holland, where he visited for the first time in 1896; one represents a Saint-Tropez quayside.[6] The remaining two, dis-

cussed here, differ somewhat; one represents the river Seine, and the other is a view of clipper ships on open water.

The composition of *Les Andelys* (cat. no. 136) repeats that of a painting Signac executed in 1886, *The Laundresses* (*Petit Andely*), and a related drawing.[7] These three works depict the banks of the Seine with its picturesque chalk cliffs near the towns of Petit and Grand Andely, which lie between Paris and Rouen. Women kneel to wash at the river's edge, and a tall factory chimney and a storage tank, however small, record the artist's interest in the industrial landscape. The lithograph, printed in seven pale powdery colors, exhibits a uniform surface treatment that is offset by the variations in direction of the strokes. These follow the planes of the landscape—horizontal on the river's surface, diagonal on hills and rooftops. This provides a sense of rhythm and vitality to the pic-

ture surface more in keeping with Signac's painting style of the late 1890s than with the more regular horizontal bands of small strokes he used earlier, such as in *Port of Saint-Cast* (cat. no. 134).

Signac was a passionate sailor and over his lifetime owned some thirty boats, using them for both cruising and racing. In his early years he kept a barge on the Seine, enabling him to stay in rural areas such as Les Andelys. He also sailed in the waters off France, including the coasts of Brittany and Normandy, and the Mediterranean, where he lived in Saint-Tropez for many summers between 1892 and 1922. A large part of Signac's oeuvre consists of river views and seascapes, almost always occupied by well-characterized marine vessels. His lithograph *Boats* (cat. no. 137) evokes his love of the water and nostalgia for the past. He creates a stately array of square-riggers, seaworthy old sailing vessels used for long-distance hauls throughout the world. He presents the ships as blue silhouettes that seem about to be absorbed into a rosy sunset. They are seen not as an orderly flotilla, but as individual boats, sailing different courses. No painting or drawing of this composition is known, and Signac probably recollected a scene he had observed near a busy international harbor such as Bordeaux or Marseille. As in *Les Andelys*, he gently animates the surface by varying the direction of the marks. There is some debate as to whether or not Signac worked directly on the stones; he may have provided transfer drawings and watercolors for Clot to work from. However, there is no question about the artist's concern with the final appearance of the prints. A working proof of *Boats* in the Museum of Fine Arts' collection records the artist's numerous penciled comments to Clot, including requests to adjust the color of many of the individual tiny rectangles (cat. no. 138).

The third of these divisionist artists, Henri

137

138 (detail)

Edmond Cross, was born in Douai, in the northeast of France, to an English mother and French father named Delacroix. He changed his name when he began to exhibit in the 1880s, to avoid confusion not so much with the famous deceased Eugène Delacroix as with a contemporary painter Henri Eugène Delacroix. As a child, Cross's artistic abilities were recognized by a physician cousin, Auguste Soins, who ensured that he received lessons at the art academy in Lille. By 1881 Cross was living in Paris and had his conventional portraits and still lifes accepted at the Salon. Cross turned to landscape after he spent part of several winters with his parents and Dr. Soins in Monaco and the Alpes-Maritimes. In 1884 Cross first exhibited with the Indépendants. There he met Seurat, Angrand, and Signac. In 1891 he moved permanently to the Mediterranean coast of France, and he built a house at Saint-Clair near Lavandou in 1892, the year that his good friend Signac moved to nearby Saint-Tropez. Cross kept in close contact with the Parisian art world and exhibited regularly with the avant-garde artists of his generation. While he never gave up the divisionist style, his watercolors—like those of Signac—were more loosely painted. After 1900 his health seriously deteriorated and he painted relatively little.

The Promenade (cat. no. 139) was published by the Parisian art dealer Ambroise Vollard in his 1897 *Album d'estampes originales de la Galerie Vollard*, an anthology of artist's prints, in which Bonnard's *Boating* (cat. no. 146) also appeared. Cross creates an idealized vision of life by the Mediterranean, where young women in white robes gesture expressively as they pass along a row of cypress trees that gracefully bend in the southern breeze. Below the cliff, fishing boats with sails furled lie at anchor. The dreamlike existence represented here acknowledges the utopian views held by Cross.[8]

Henri Matisse got to know Cross during

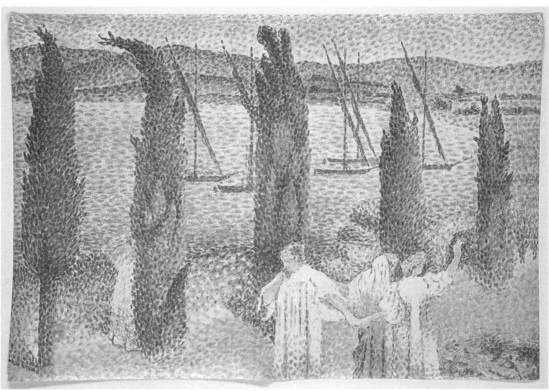

139

the summer of 1904 when he stayed in Saint-Tropez with Signac. This poetic image and its divisionist technique very likely inspired Matisse to produce such an important work as his 1904–5 *Luxe, Calme, et Volupté* (Musée National d'Art Moderne, Paris), with its female bathers on a cliff overlooking the sea. Cross's only other color lithograph, *Nursemaids on the Champs-Elysées*, was made in 1898 for the art periodical *Pan*, which was published in Berlin, where his paintings as well as those by Angrand and Signac were exhibited and well received.

SWR

1. The exhibition was held at the Galerie Dru, Paris, from March 23 to April 9, 1925. Signac's introduction is cited by Joan Ungersma-Halperin in her preface to Angrand 1988, 9.

2. For reproductions of some of these drawings, see Angrand 1988, 362, 363, 368, and [Lespinasse] 1982, 41.

3. One such example is the unnamed writer in *La Revue Indépendante*, April 1892, cited in [Lespinasse] 1982, 43.

4. See reproductions in Angrand 1988, 381, 397.

5. See Pat Gilmour et al., "Cher Monsieur Clot . . . Auguste Clot and His Role as a Colour Lithographer," in Gilmour 1988, 129–182. Signac's prints, traditionally dated to 1894–95, were actually made from 1897 to 1898; Wick 1962; Gilmour 1990.

6. For the Holland images, see Kornfeld and Wick 1974, nos. 8, 11, 12; for Saint-Tropez, see no. 9.

7. For the painting, see Cachin and Nonne 2000, 124 (private collection, Paris); for the drawing, see Wick 1962, 87, fig. 2 (private collection, New York).

8. Angrand, Signac, and Cross shared anarchist sympathies, and some of their works of art were produced to illustrate anarchist journals or as paintings and prints that supported the cause. However, their political views had relatively little effect on their pure landscapes.

Pierre-Auguste Renoir
French, 1841–1919

Camille Pissarro
French (born Danish West Indies),
1830–1903

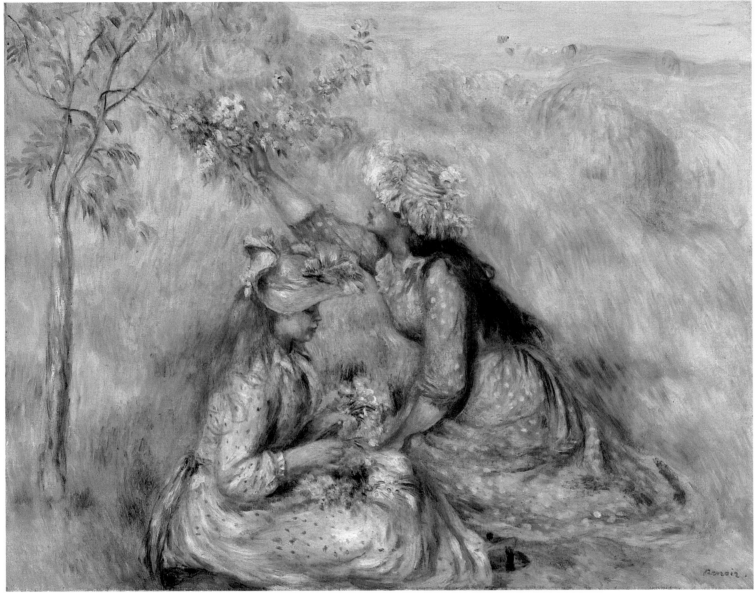

140

140. PIERRE-AUGUSTE RENOIR
Girls Picking Flowers in a Meadow, about 1890
Oil on canvas
65 x 81 cm (25⅝ x 31⅞ in.)
Juliana Cheney Edwards Collection 39.675

Fig. 55. François Boucher, French, 1703–1770, *Spring,* 1745,
The Wallace Collection, London.

141. CAMILLE PISSARRO
Morning Sunlight on the Snow, Eragny-sur-Epte,
1894
Oil on canvas
82.3 x 61.5 cm (32⅜ x 24¼ in.)
The John Pickering Lyman Collection. Gift
of Miss Theodora Lyman 19.1321

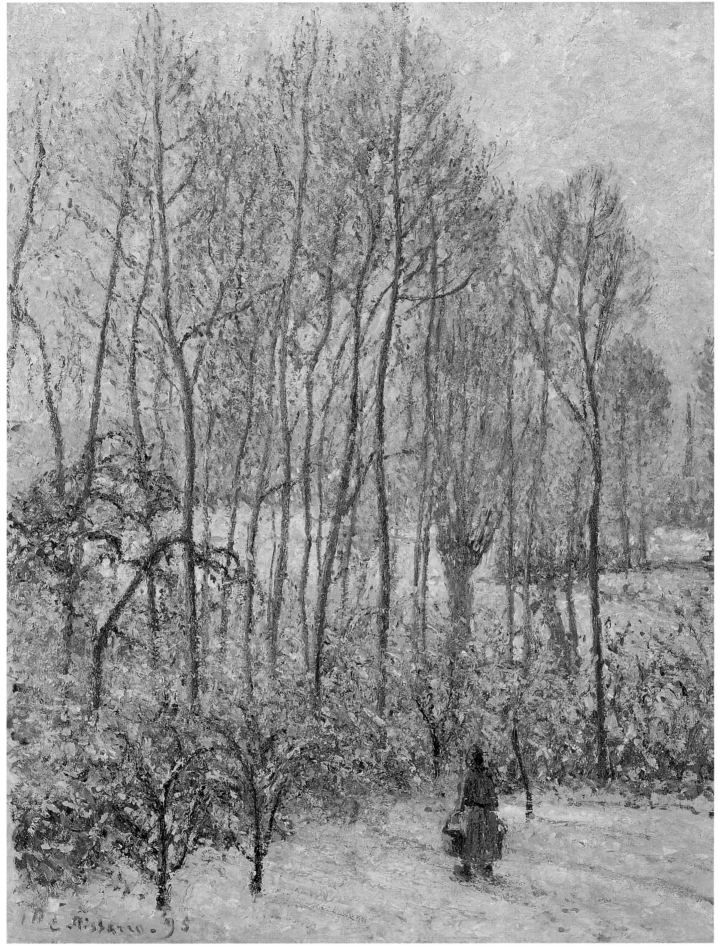

141

By the 1890s Renoir and Pissarro, like Monet, were exploring different ways of transcribing the landscape. Pattern and decorative color were used to convey the artists' emotional, rather than visual, response to the observed scene. In *Girls Picking Flowers in a Meadow* (cat. no. 140) Renoir felt free to dispense with the transcription of an actual place altogether and gives us a wistful vision of springtime. His painting is so soft, in both touch and color, that the viewer can be excused for not seeing at first how strictly composed it is. Set against an expanse of green and yellow (so unarticulated in terms of recession that it looks like a backdrop), the two girls form a triangle. This stable geometric shape has been used in figure compositions in the West since the Renaissance as a means of suggesting permanence. Just as Raphael (1483–1520) did in many of his depictions of the Madonna, Renoir knits the outline of the triangle together by pairing the girls' profiles and posing their arms in such a way that they form an echoing smaller triangle within the larger enclosing shape. The geometric form finds greater materiality in the strict vertical of the curiously short tree trunk. Such is the chromatic as well as emotional harmony of the whole, however, that logical questions—how could the tree be so short? why are there no flowers left in the meadow?—seem out of place.

Renoir also found a way to paint scenes from modern life that linked them to the history of art. *Girls Picking Flowers in a Meadow* recalls imagery from eighteenth-century France, such as the girls outdoors in François Boucher's *Spring* (fig. 55). Through juxtaposition and gesture Renoir relates the sexuality of the adolescent girls to the flowering sapling. With its clothed figures, Renoir's version may be more innocent than Boucher's, but the meaning of the season—a time of rebirth and regrowth—is still legible. Perhaps the hats the girls wear are an additional homage to the eighteenth century.

Whereas the girls' dresses are simple, everyday wear, the hats are quite extraordinary. The straw hat with blue ribbons (on the left) is a complicated affair, bent and crimped into a fantastic shape, and the ruffles on the pink hat turn it into a cloud around the dark-haired girl's head. The hats are not necessarily ones that the girls themselves would have worn—Renoir may have had them made expressly for his models.[1] They suit well the atmosphere of charm and youth that the painting evokes.

If springtime seems especially suited to Renoir's evolving aesthetic, snow scenes continually intrigued Pissarro. Here the artist has translated to canvas with perfect accuracy the sparkle, crispness, and crustiness of an early morning in winter (cat. no. 141). Pissarro probably painted the scene from inside his house, but he nonetheless knew how to convey the way light looks outdoors when its effect is magnified by reflection off snow and by refraction through ice- and frost-covered branches. Pastel pinks and blues dominate the canvas; only up close are purples, oranges, and greens visible. The woman carrying a bucket is understandably transfixed by the myriad colors, glancing light, and spiky textures.

Pissarro had long been fascinated with the complex spatial problems presented by a mediating screen of trees. Corot, too, had explored the problem, as can be seen in two of his works in this catalogue, *Morning near Beauvais* (cat. no. 14) and *Souvenir of a Meadow at Brunoy* (cat. no. 15). Pissarro may have adopted the motif from his early teacher. Pissarro, however, made the screen of trees a principal motif, both in paintings and in prints (cat. nos. 97–99).[2] It is seen to particularly good effect here, where the trees are bare and the palette is pale. *The Côte des Boeufs at L'Hermitage* (fig. 56) is similarly constructed, though its browner palette and blocked view into the distance seem to clog the picture's surface. The orientation of these two

Fig. 56. Camille Pissarro, *The Côte des Boeufs at L'Hermitage*, 1877, National Gallery, London.

canvases emphasizes the verticality of the trees, making them seem impossibly tall and thin. The screen of trees, by affording a glimpse of the distance yet denying immediate access to it, weaves foreground and distance together into a single two-dimensional pattern: the background becomes the interstices between the trees.

The intricate and textured surface of the painting testifies to the extended labor Pissarro lavished on the canvas. Tiny flecks of paint were placed quickly but deliberately. Pinks are balanced with blues, and optically heavier purples, oxbloods, and greens are clustered toward the bottom of the canvas, echoing the colors worn by the lone figure. Glancing out the window and deciding to paint the scene may have been an instantaneous decision, but the planning and execution surely constituted a plotted-out intellectual exercise. FEW

1. Hayward Gallery 1985, 251.

2. Isaacson 1992, 320–24.

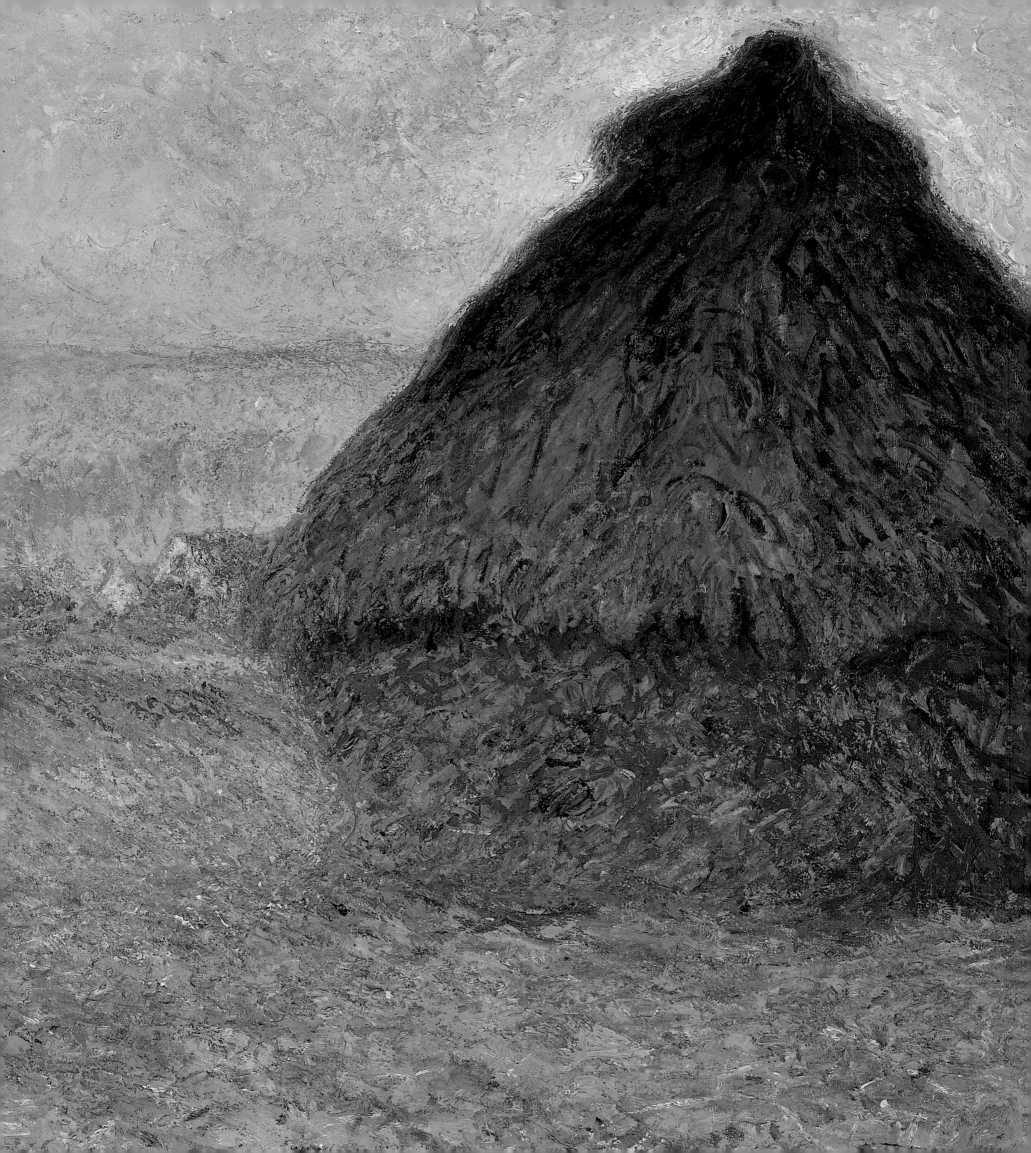

Claude Monet
French, 1840–1926

142. CLAUDE MONET
Grainstack (Sunset), 1891
Oil on canvas
73.3 x 92.6 cm (28⅞ x 36½ in.)
Juliana Cheney Edwards Collection 25.112

143. CLAUDE MONET
Grainstack (Snow Effect), 1891
Oil on canvas
65.4 x 92.3 cm (25¾ x 36⅜ in.)
Gift of Misses Aimée and Rosamond Lamb in
memory of Mr. and Mrs. Horatio A. Lamb
1970.253

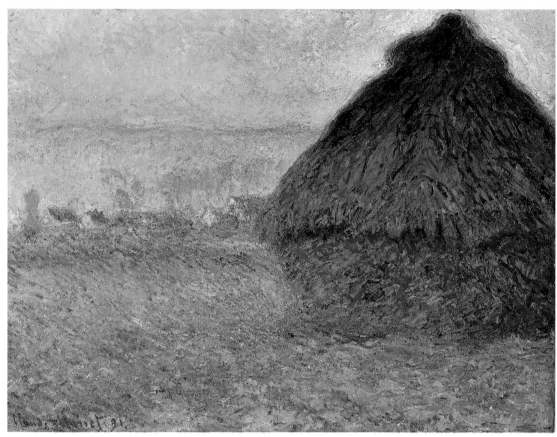

142

Grainstack (Sunset) and *Grainstack (Snow Effect)* belong to a series of at least twenty-five canvases that Monet painted of the subject (some with one stack and others with two) from 1890 to 1891. The artist showed fifteen of them at the Galerie Durand-Ruel in May 1891.[1] The cumulative effect of seeing so many at once can be exhilarating. The variety of light, colors, and textures wrested from a single motif is astounding, producing a sensation somewhat like the calm induced by a group of Abstract Impressionist paintings by Mark Rothko (1903–1970) or Clyfford Still (1904–1980). Seeing only two paintings of a grainstack, as here, has its own rewards, however. In isolation from their many relatives vying for attention, the individual works can be studied at leisure, their various aspects noted with care.

Each painting shows a stack of grain, carefully constructed and thatched to protect the precious harvest from moisture and rodents. Its upright sides and conical roof tower to a height of four and a half or six meters (fifteen or twenty feet) and relate it formally to the buildings stretching across the middle of the canvas, whose roofs were similarly thatched. The relation between the constructed forms goes beyond their shape, however. The stacks represent the wealth of the people who lived in the distant buildings and the prosperity and security of the country at large, for France continued to identify itself as an agrarian nation. The edges of the stacks' roofs intersect with the houses, as if to underscore the connection.

Grainstack (Sunset) (cat. no. 142) is aflame. Despite a palette that includes pale pastels of

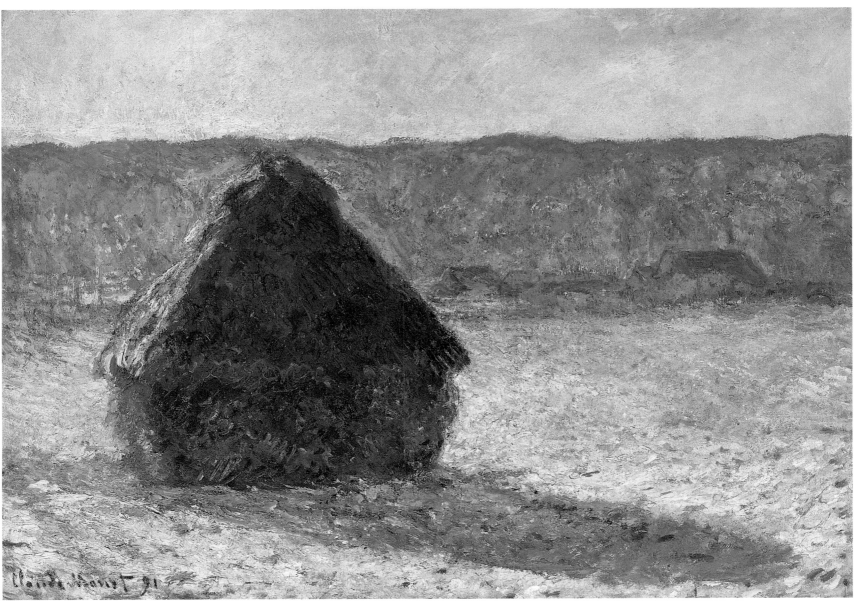

143

yellows, pinks, blues, and purples, hot oranges, reds, and burning yellows predominate. The yellows in particular have a tangible presence; yellow paint is thickest along the contour of the stack's cone, as if the sunlight were caught in the thatch and had piled up there. The materiality of the sunlight is emphasized by the much smoother surface of the conical roof facing the viewer. There the brushstrokes are long and disjunctive and make up the darkest part of the picture. The contrast is startling—and distinctly antinaturalistic. The upright wall of the stack that the viewer sees could not possibly be the hot orange Monet painted it; it was, after all, in shadow. Likewise, the ends of the buildings glow with bluish white under the light orange roofs; they, too, face away from the sun.

In *Grainstack (Snow Effect)* (cat. no. 143), whatever reality Monet saw in the field was accommodated to his artistic vision. Whereas the stack seen in the setting sun rises triumphantly above the tops of the background hills, the stack in this snow scene seems to contract into itself for warmth, soaking up the yellow light that gilds the snow around it. Cool colors and blue and white (admittedly modulated with pinks and yellows) surround the stack, which seems by contrast all the warmer in its coat of pink-laden mauves and orangy browns.

A fulgent grainstack in one scene, one huddling for warmth in the other, these two paintings of a simple form in a flat meadow suggest the possibilities Monet saw before him. Monet used the grainstacks as a vehicle through which his emotions would have an outlet. "In short," he wrote on October 7, 1890, "I am more and more driven by the need to render what I feel."[2] Monet achieved his goal: these grainstacks, shown alone in a field, are emotion made visible. FEW

1. Tucker 1989, 65–105. Tucker's discussion is the basis of much of this entry.

2. Quoted in Geffroy 1924, translated in Stuckey 1985, 157.

Claude Monet
French, 1840–1926

144. CLAUDE MONET
Morning on the Seine, near Giverny, 1897
Oil on canvas
81.4 x 92.7 cm (32 x 36 ½ in.)
Gift of Mrs. W. Scott Fitz 11.1261

Monet traveled as far north as Norway and as far south as Venice to look for different motifs, but he always returned to the places he knew best. He painted the river Seine in Paris, Argenteuil, Vétheuil, and where it emptied into the English Channel. He turned to it again in 1896 and 1897 for a series of canvases showing how it looked at dawn.

This version is notable for its softness. Its colors of pinkish mauve, cool blues, and greens are matched with large, simple, and rounded shapes. With the point of view suspended over the water, we are made to feel weightless, perhaps even bodiless. Almost symmetrical reflections threaten to disorient us, but Monet has left clues—the slight but discernible greater definition of outline and form in the sky—to let us know which way is up.

Lilla Cabot Perry, an American painter and journalist who met Monet in 1889 when she and her husband began spending their summers in Giverny, remembered the series when she wrote about Monet after his death: "They were painted from a boat, many of them before dawn, which gave them a certain Corot-like effect, Corot having been fond of painting at that hour."[1] In one of the many eulogies written after Corot's death in 1875, his early-morning habits were extolled. René Ménard explained that

> Corot is par excellence the painter of morning. He can render with more felicity than anybody else the silvery light on dewy fields, the vague foliage of trees mirrored in calm water. He was not fond of the noonday light, and it was always in the earliest morning that he went out to paint from nature.[2]

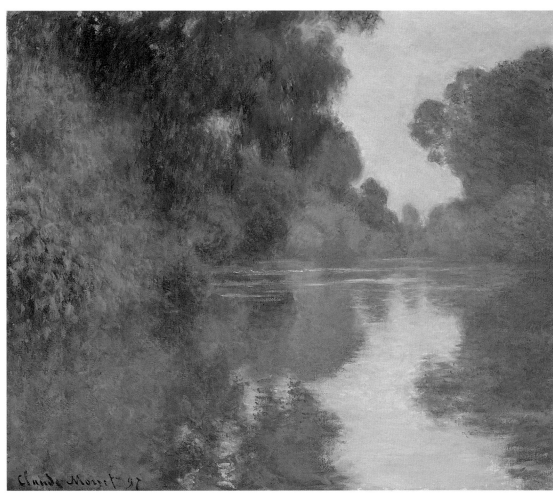

144

Ménard quoted from a letter purportedly written by the artist himself:

> A landscape-painter's day is delightful. He gets up early, at three in the morning, before sunrise; he goes to sit under a tree, and watches and waits. There is not much to be seen at first. Nature is like a white veil, upon which some masses are vaguely sketched in profile. . . . The chilly leaves are moved by the morning air. One sees nothing: everything is there. The landscape lies entirely behind the transparent gauze of the ascending mist, gradually sucked by the sun, and permits us to see, as it ascends the silver-

Fig. 57. Jean-Baptiste-Camille Corot, *Souvenir of Mortefontaine,* 1864, Musée du Louvre, Paris.

Odilon Redon
French, 1840–1916

striped river, the meadows, the cottages, the far-receding distance. At last you can see what you imagined at first.[3]

When Perry evoked Corot, she was doubtless thinking of his *Souvenir of Mortefontaine* (fig. 57), which has been in the collection of the Musée du Louvre since 1889. Monet too must have been thinking of this work when he painted *Morning on the Seine*, and Ménard's words describe the later work perhaps better than the earlier one. We can imagine no greater homage.
FEW

1. Perry 1927, 120, quoted in Stuckey 1985, 184, and Tucker 1989, 231. Tucker's chapter is the most sensitive treatment of the Morning on the Seine series.

2. René Ménard in *Portfolio* (October 1875) quoted in Clement and Hutton 1879, 1:161.

3. Quoted in *Portfolio* (October 1875) quoted in Clement and Hutton 1879, 1:161. Clarke 1991a, 89, points out that the passage, which he gives in a slightly different translation, was actually written by Arthus Stevens, under the pen name of J. Graham, in "Un étranger au Salon," of 1864. Clarke cites Moreau-Nélaton (in Robaut and Moreau-Nélaton 1905, 1:225–26), who wrote that Corot was shown the letter and "was allegedly amused by it and did not repudiate it."

145. ODILON REDON
Tree, 1892
Lithograph on chine collé
Image / chine collé: 47.7 x 31.9 cm (18¾ x 12⁹⁄₁₆ in.)
Bequest of W. G. Russell Allen 60.699

Odilon Redon's reflections on his life in his 1922 autobiography (published posthumously), *A soi-même* (To myself), describe his art as directly related to his psychology and early experiences. Born in Bordeaux in 1840, he was sent at a very young age to Peyrelebade, a small sixteenth-century château and wine-producing estate owned by his father. It is believed that Redon's parents sent him there due to frail health to be raised by his uncle in relative solitude and surrounded by nature, and it was not until 1851, when Redon was eleven, that they brought him back to Bordeaux to live with the family and attend school. According to the Redon specialists Douglas Druick and Peter Kort Zegers, research suggests that the artist may have suffered from epilepsy—a disease that then carried with it a terrible social stigma. Druick and Zegers explain that "Redon's childhood was the source of psychological trauma leaving permanent scars and . . . to understand his outlook on life and art, we must consider the structuring potential of these early events."[1]

The young Redon's interest in the visual arts, especially printmaking, was strengthened by his lifelong friendship with and tutelage under Rodolphe Bresdin (see cat. nos. 40–42), whom he met in Bordeaux in 1863. Redon made numerous etchings under Bresdin's guidance that display the teacher's style and technique (most notably *Fear*, cat. no. 43), and Bresdin taught him a love of the earlier printmaking masters Albrecht Dürer and Rembrandt. Corot, who urged Redon to study nature with sensitivity and humility, was also an early and significant influence on the young artist.

From September 1870 until he was dismissed in 1871 due to exhaustion, Redon served as a soldier in the Franco-Prussian War. This experience led to his adoption of an artist's life. He wrote, "At that moment, I became conscious of my natural gifts. . . . That was the true date when I discovered my will."[2] After he returned to Bordeaux, he often made trips to Peyrelebade and first conceived his series of *noirs*—several hundred charcoal drawings and lithographs that were to be his main artistic occupation until the early 1890s.

About 1874 Redon became acquainted with Henri Fantin-Latour, who in 1876 taught him a new method of making lithographs. Fantin-Latour introduced Redon to a special transfer paper on which one could draw with a lithographic crayon and from which the finished drawing could be mechanically transferred onto the lithography stone, thus relieving the artist of the more tedious and unwieldy aspects of the process. The technique allowed Redon to create lithographic prints that suggest the look of chalk or charcoal drawings, and he was immediately attracted to it because it was a way to "multiply" his drawings.

Lithography soon became a major form of expression for Redon, and his first album of lithographs, *Dans le rêve* (In dreams), created after drawings made at Peyrelebade, was published in 1879. Between 1879 and 1899 he produced twelve lithographic albums, several with strong literary associations. For example, Gustave Flaubert's *Tentation de Saint Antoine* (The temptation of Saint Anthony) of 1874 served as the source for Redon's albums in 1888, 1889, and 1896—prints that were not merely illustrations but interpretations of the text. A similar series of lithographs from 1882 drew from the work of (and was dedicated to) Edgar Allan Poe. By the end of the 1890s, Redon also began to experiment with color lithography. He made many single lithographs as well as a series of drawings

after Charles Baudelaire's collection of poems *Les fleurs du mal* (Flowers of evil), which were later reproduced in an album.[3]

Redon's work from this period took an approach to subject matter and composition that associated him with the European movement called Symbolism—a term used to describe trends in both art and literature, which were closely related at the time. Symbolism essentially claims that objective or real facts must be transformed into symbols of the artist's inner experience. The Symbolist painter or printmaker thus not only sees the objects he depicts but also sees past them to a significance and reality far deeper than what is indicated by superficial appearance. Subject matter for the Symbolists became increasingly visionary, mysterious, and dreamlike in its representation.

Redon's Symbolist works often represent a transformation of nature observed through his imagination. The artist explained his interest in nature when he wrote:

> I have always felt the need to copy nature in small objects, particularly the casual or accidental. It is only after making an effort of will to represent with minute care a grass blade, a stone, a branch, the face of an old wall, that I am overcome by the irresistible urge to create something imaginary. External nature, thus assimilated and measured, becomes—by transformation—my source, my ferment. To the moment following such exercises I owe my best works.[4]

The image of a lone tree, for example, became a symbolic reflection of the artist's secluded childhood at Peyrelebade and the solitude he found there in nature. Trees were repeated again and again throughout Redon's career in different media and were part of the artist's complex personal iconography, along with other repeated forms such as the centaur (cat. no. 150).[5] The tree shown here, solitary against a blank background and represented in an incredi-

145

bly delicate and almost mysterious manner, was printed in 1892, the same year that the art critic and writer Albert Aurier published his article "Les Symbolistes" in *La Revue Encyclopédique*, in which he ranked Redon with Gauguin and Van Gogh, thus establishing Redon as one of the foremost artists of the period.[6] Despite such critical acclaim, Redon never became popular with the general public. However, numerous collectors came to subscribe to his lithographic publications, and the Parisian literary avant-garde, including Emile Hennequin, Joris-Karl Huysmans, and Stéphane Mallarmé, championed his work for its imaginative and dreamlike interpretations of reality and its creation of haunting and poetic visual imagery. Redon's Symbolist work was also much admired by the Nabis artists (see cat. nos. 146–48) and Henri Matisse, among others. JK

1. Druick et al. 1994, 17–22.

2. Quoted in Eisenman 1992, 72.

3. MoMA 1961, 26–29; see also Druick et al. 1994, 16–28, 120–25, 193–94; and Redon 1986.

4. Odilon Redon, *Confidences d'artiste*, 1909, quoted in MoMA 1961, 23.

5. For a discussion of Redon's tree images, see Eisenman 1992, 31–44, and Druick et al. 1994, 31, 66–68, 230.

6. Aurier's career as an art critic began with his entry into Symbolist literary circles in Paris in the 1880s. From 1890 to 1892 Aurier wrote his most substantial art criticism, including major articles on Van Gogh in January 1890 and Gauguin in March 1891. Aurier championed Symbolist artists for rejecting academic procedure and communicating ideas through symbolic form, as discussed in his last major article, "Les Symbolistes," of 1892. Aurier 1892, 474–86.

Pierre Bonnard
French, 1867–1947

Ker-Xavier Roussel
French, 1867–1944

Edouard Vuillard
French, 1868–1940

146. PIERRE BONNARD
Boating, 1896–97
Color lithograph on cream Chinese paper
Image: 25.7 x 47.5 cm (10 ⅛ x 18 ¹¹/₁₆ in.)
Bequest of W. G. Russell Allen 60.68

147. KER-XAVIER ROUSSEL
Woman in Red in a Landscape, 1898
Color lithograph on cream Chinese paper
Image: 23.5 x 35.4 cm (9 ¼ x 13 ¹⁵/₁₆ in.)
Gift of Mrs. Frederick B. Deknatel 1985.858

148. EDOUARD VUILLARD
Crossing the Field, 1899
Color lithograph on cream Chinese paper
Image: 25.3 x 34.3 cm (9 ¹⁵/₁₆ x 13 ½ in.)
Bequest of W. G. Russell Allen 60.108

Pierre Bonnard was born near Paris to a middle-class family that had a summer home in the country, where he learned to love animals and the outdoors. To please his father, he studied law and in 1889 became a lawyer. However, his true desire was to be a painter, and two years earlier he had enrolled in art classes at the Académie Julian. There he met two young artists who had been friends for a decade, Ker-Xavier Roussel—Bonnard's exact contemporary, also from a moderately well-to-do family—and Edouard Vuillard, a year younger and the son of a widowed seamstress. The three artists would remain friends; stylistically, they were most closely related in the 1890s, when they belonged to the Nabis.

The Nabis were founded by Paul Sérusier, who returned from Pont-Aven in 1888 charged with energy from having worked with Paul Gauguin. He introduced a group of painters in their twenties to a new way of working, based on Gauguin's use of flat, decorative, and colorful forms (see cat. nos. 124–25). Traditional, realist paintings as taught in art schools did not satisfy these young men, who aspired to be more avant-garde. Several of them, including Bonnard, Roussel, and Vuillard, became enamored with the work of Impressionist painters—especially Monet, Renoir, and Pissarro—and emulated some of their stylistic elements, such as lighter colors, open brushwork, and small or dotted strokes. Young and idealistic, the group privately named themselves the Nabis, derived from the Hebrew word for prophet or visionary. They held regular meetings and had initiation rites, secret names, and passwords. To a lesser or greater degree, there were elements of mysticism as well as Symbolism in their pictures.

Nabi artists firmly believed that art should be incorporated into daily life. Until about 1900 they functioned as a collective, working on a range of projects that included not only easel pictures and interior murals, but also theater sets and programs, prints, book illustrations, and posters. They also designed utilitarian objects including lamps, ceramics, textiles, and folding screens. The human figure was nearly always primary in the work of the Nabis, but landscape could play an important and often equal role, especially in the large panels painted to decorate the walls of their patrons' private homes. The work of each artist had a distinctive character: that of Maurice Denis was the most Christian; Paul Ranson's, with its Buddhas, tigers, and sinuous forms, was the most exotic; Bonnard's and Vuillard's, with images of contemporary life, were the most secular. After 1900 their styles began to mature and diverge, and eventually some of the artists moved away from Paris to complete their careers elsewhere.[1]

Bonnard was the most productive printmaker of the Nabis, creating over 250 lithographs between 1889 and 1902, including more than thirty printed in three or more colors.[2] His involvement, along with Henri de Toulouse-Lautrec, in the hands-on process of preparing lithograph stones to make posters helped to change the face of color lithography. The medi-

146

147

um grew increasingly sophisticated in its techniques and in its abilities to relate closely to painting styles. Long after working in lithography Bonnard acknowledged that color printing informed his own painting, saying, "I've discovered a lot that applies to painting by doing color lithography. When you have to judge tonal relationships by juggling with four or five colors, superimposing them or juxtaposing them, you learn a great deal."³

Bonnard's lithograph *Boating* (cat. no. 146) was made for the art dealer Ambroise Vollard and was published in Vollard's 1897 *Album d'estampes originales*. (Bonnard designed the cover of the album, which also included Roussel's *Landscape with a House* and *The Promenade* by Henri Edmond Cross, cat. no. 139). Vollard had taken up print publishing shortly after 1895, and in the next few years he enthusiastically commissioned a large number of color lithographs,

including four sets of twelve prints each from the Nabi painters Denis, Roussel, Vuillard, and Bonnard, as well as individual prints such as *Boating*. Almost without exception these were printed by the lithographer Auguste Clot, a master of the medium in color. Most of the subjects reflected what the artists were painting at the time—dreamy Symbolist figures by Denis, contemporary interiors by Vuillard, and urban views by Bonnard. However, in a few of the images, notably those by Roussel, the outdoors played a major role. This is also true of Bonnard's *Boating*.

In *Boating* Bonnard depicted rowers on the water and picnickers on the banks of the Seine at Chatou, a popular recreation area on the western outskirts of Paris. To clearly distinguish this lithograph from his recent posters and to underscore its artistic validity and painterly qualities, Bonnard used the composition of an

1896 oil painting, *Boating at Chatou*.⁴ In the print he exploited the white of the paper to evoke light, glinting off the rippled surface of the water and dissolving the crisscrossed trusses of the bridge. With its depiction of leisure and its wonderful sense of fresh air, *Boating* pays homage to paintings that Renoir made a decade and a half earlier, at the height of the Impressionist movement (see cat. no. 102).⁵

Bonnard's contemporary Roussel was permitted to go to art school directly after completing secondary school. He attended the Ecole des Beaux-Arts and the Académie Julian but was dissatisfied with the conventional realist teaching at both institutions. He had been friends with Vuillard since 1877, when they were secondary students at the Lycée Condorcet in Paris, and in 1893 he married Vuillard's sister, Marie. Roussel joined the Nabis in 1888, and in addition to easel paintings he designed stained glass and painted murals. He was already advanced enough in 1889 to show with Gauguin and the Synthetists at Volpini's café (see cat. no. 125). In 1892 he created his first lithograph, a portrait of Vuillard, and in 1893 he made a color lithograph that was close to Denis's Symbolist style.

Woman in Red in a Landscape (cat. no. 147) is one of the set of twelve landscape lithographs that Vollard commissioned from Roussel. They were intended for publication in 1899 as *L'Album de paysage* (Album of landscapes); however, Roussel took years to finish the prints, and they never appeared as a complete album. In this print, a tiny salmon red figure stands at the end of a path before an orchard of green trees bearing red fruit. Gray trees and a blue sky complete a picture that brilliantly demonstrates the luminous qualities of blank white paper and the power of color as it is found in paintings by Monet. In homage to Impressionism, patches of dappled strokes suggest forms rather than defining them with linear means. Roussel's only

other lithographs to be printed in significant numbers were produced in the 1890s, during his Nabi years. Subsequently, he made some fifty lithographs and twenty-five etchings that almost exclusively depict landscapes peopled by nymphs and fauns. These prints are extremely rare, a sign that printmaking was a private affair for him.[6]

Vuillard, like Bonnard and Roussel, studied painting at the Académie Julian and was one of the original Nabis. A lifelong bachelor, the artist lived with his mother until her death in 1928, and she helped support him until his own career was established. He frequently painted his family and friends in the rooms of their modest apartment. Vuillard's closest artist friend was Roussel, and he maintained long-term social relationships with numerous other artists and patrons. Like the other Nabis, Vuillard designed theater scenery—in his case for Symbolist dramas by Ibsen and Strindberg—as well as decorative works such as stained glass. In the early 1890s several wealthy patrons commissioned him to paint sets of decorative panels to be installed in the dining or living rooms of their mansions.

Though Vuillard made a few etchings and sixty lithographs throughout his life, only about twenty are color lithographs. *Paysages et intérieures* (Landscapes and interiors), his set of twelve color lithographs commissioned by Vollard, was printed by Auguste Clot in an edition of one hundred and exhibited in February 1899. Vuillard's paintings of that time show a preoccupation with filling a shallow picture plane with decorative patterns—wallpapers and fabrics in stripes, florals, and abstract designs. In some of his lithographs of interiors, Vuillard deliberately chose eye-catching color combinations such as wallpaper with red designs on a pink ground.[7] The only true landscape in the set, *Crossing the Field* (cat. no. 148), is printed from five seductive colors, including cool blue,

148

green, and violet. It exhibits some of the artist's fascination with textures in the striated grass and in the small repeated forms of people walking in a line through the meadow. The sky is somewhat more realistically portrayed, but its unmodulated blue shapes suggest a flatness that is antinatural. Impressionist paintings are recalled by the clear pastel colors and the matte surface of this lithograph, in which the inks have been absorbed by the fine fibers of the Chinese paper. Like Bonnard, Vuillard may have found that working with color lithography affected his painting techniques: about 1900 his paint surfaces became less glossy, as he turned to painting more frequently with oil on absorbent cardboard or with distemper (glue-based paint) on canvas. SWR

1. For an overview of Nabi work in many media, see Cogeval, Frèches-Thory, and Genty 1998.

2. These numbers are based on a survey of illustrations in Bouvet 1981; see also Ives, Giambruni, and Newman 1989, 3.

3. Bonnard's grandnephew Antoine Terrasse published this undated quotation in his 1967 book on the artist; it has been variously translated. This version appears in Bouvet 1981, 8; a slight variant is in Ives, Giambruni, and Newman 1989, 25.

4. Private collection; reproduced in Ives, Giambruni, and Newman 1989, 23, cat. no. 52, pl. 30.

5. These paintings include *Oarsmen at Chatou*, 1879, National Gallery of Art, Washington, D.C.; reproduced in Ives, Giambruni, and Newman 1989, 23, pl. 31.

6. For Roussel's print oeuvre, see Alain 1968 and Christian von Heusinger's section on prints in Kunsthalle Bremen 1965.

7. Roger-Marx 1990, nos. 36–38.

Eugène Atget

French, 1857–1927

149. EUGÈNE ATGET
Versailles, 1902
Photograph, gold-toned albumen print from
glass-plate negative, unmounted
Sheet: 18.1 x 21.8 cm (7 ⅛ x 8 ⁹⁄₁₆ in.)
Helen B. Sweeney Fund 1989.322

149

Eugène Atget pursued several different professions—sailor, soldier, actor, and painter—before finally taking up photography in about 1888. Surprisingly little is known of Atget's early years. He was born near Bordeaux and orphaned at an early age. By the time this image was made in 1902, however, he had established himself in Paris as a photographer specializing in views of the old sections of the city, many of which were slated for demolition. He modestly described his photographs as "documents for artists" and set out to create a systematic inventory of his chosen subjects using a large-format camera and tripod and cumbersome glass-plate negatives. He organized his work, which was typically made "on spec" and only rarely commissioned, into a number of different series, grouping them under headings such as Landscape-Documents, Old France, Picturesque Paris, Art in Old Paris, and Interiors. Atget's photographs were sought after as source material by painters, architects, set designers, and craftsmen, as well as by the city's archivists and librarians, who recognized the significance of his documentation of the architectural and cultural heritage of France at the turn of the century.

Atget returned to certain sites over and over during the course of his career. Just twenty-two and a half kilometers (fourteen miles) southwest of Paris, Versailles was one of his favorite places, and he photographed it many times, as part of his Environs series, over a span of twenty-five years. More than the looming facade of the palace itself, Atget was drawn to André Le Nôtre's (1613–1700) surrounding gardens, with their geometric plantings, waterways, fountains, marble sculpture, and urns. This richly toned albumen print, made only one year after the

photographer's first visit to Versailles, records the carefully manicured Tapis vert, the main allée between the king's residence and the Grand Canal and Basin of Apollo. In 1624 Louis XIII had purchased a small piece of land on the current site in order to build what he envisioned as a simple hunting lodge, but by the 1660s his son Louis XIV had commenced its transformation into the lavish château and grounds that visitors can still see today. The realization of Le Nôtre's elaborate landscape designs involved converting thousands of acres of swampland into sweeping vistas and imposing a rigorous, classical order on what had once been untamed countryside. As such, Versailles's gardens seem to have been a subject, according to one Atget scholar, that perfectly fulfilled the photographer's own "orderly ideal . . . laid out in three-dimensional reality."[1]

In this particular image, Atget has carefully positioned his camera in order to capture the verdant swath of lawn on the left and the massive white vase set off against the black curtain of trees at the right. The vertiginous rush of the grand promenade and the dramatic diminution in scale of the sculpture along its edge—both greatly enhanced by Atget's use of a wide-angle lens—contrast with the graphic shape of the decorative urn. The sharply receding V of the allée is beautifully echoed in the bright slice of sky that parts the deep foliage on either side. This composition is even more remarkable when one imagines the view as the photographer would originally have seen it—upside down and reversed on the camera's mirrorlike ground glass. KEH

1. Szarkowski and Hambourg 1983, 18.

Odilon Redon
French, 1840–1916

150. ODILON REDON
Centaur, 1895–1900
Pastel on canvas
73 x 60.2 cm (28 ¾ x 23 ¾ in.)
Gift of Laurence K. Marshall 64.2206

Centaur is a masterpiece of Odilon Redon's late
style, displaying the artist's audacious use of
color and remarkable manipulation of pastel.
Here, it is twilight in a landscape of dreams.
The setting sun turns the sky into an explosion
of flower colors: geranium, marigold, larkspur,
and delphinium. A solitary tree, bare-limbed,
stands bleak against the brilliant sky. Beside it,
to the left, a looming rock glows with the
vibrant colors of azure, cobalt, and lapis lazuli.
Between the stone and the tree, his head silhou-
etted in profile above the horizon, stands a lone
figure, the mythological man-horse, the cen-
taur. In his outstretched right hand he holds a
delicate arrow, its feathers barely visible as tiny
strokes of white; the same white follows the
outline of his fragile bow, held in his left hand
at his side. In the foreground, strange flowers or
leaves emerge from the ground, touched with
delicate strokes of pink, yellow, green, and blue.
Rivaling Degas in the variety of touch and mark
at his command, Redon works the pastel against
the unaccustomed medium of a primed canvas,
thick and opaque in the sky, thin and diffuse in
the foreground, coaxing light and color from
the drab gray and setting the tree and the cen-
taur's flank into deep brown shadow.

The principal elements of the composi-
tion—the lone tree, the great stone, the cloudy
sky, and the centaur himself—relate to themes
that the artist had treated since the beginning
of his career. Rocky outcroppings figure promi-
nently in Redon's prints and drawings of the
1860s, in such works as the etching *Fear* of 1866
(cat. no. 43), as well as in oil sketches of the
1880s.[1] Isolated trees spread their branches
against the sky in paintings of the 1860s, in the

150

artist's moody lithographs and charcoal drawings of the 1870s and 1880s, and in a delicate lithograph of 1892 (cat. no. 145).[2] Likewise, the centaur has a distinguished place in the artist's iconography. One of his earliest drawings made in 1863, for instance, shows such a beast resting against a rock, gazing at a cloud; another drawing, dating from about 1875, shows the centaur taking aim with bow and arrow at clouds (the motif was later repeated in pastel and oil).[3] This unusual theme has its roots in the myth of the centaur's origins, in which a beast—half man and half horse—is born to Ixion, a ne'er-do-well resident of Olympus, and a cloud that was sent to him by Zeus in the form of Zeus's wife, Hera. As Pindar related,

> the man in his ignorance chased a sweet
> fake and lay with a cloud, for its form was
> like the supreme celestial goddess. . . . The
> hands of Zeus set it as a trap for him, a
> beautiful misery. . . . She bore to him, with-
> out the blessing of the Graces, a monstrous
> offspring—there was never a mother or a
> son like this—honored neither by men nor
> by the laws of the gods. She raised him and
> named him Centaurus.[4]

Douglas Druick and Peter Zeghers have argued convincingly that the centaur and the cloud had a complex personal significance for Redon. The artist related his own confused feelings of abandonment by his mother to the story of Achilles, who was educated by the centaur Chiron when his mother refused to care for him. The nurturing centaur, child of the cloud, takes aim at the maternal symbol in Redon's early images, but by the turn of the twentieth century, as in the Boston *Centaur*, the cloud became altogether more luminous and beneficent. "I have never loved my mother so much as when I saw her again, completely reduced to infantilism; she is touching," Redon wrote to a friend in 1908. "By opening my eyes wider on all things," he later wrote, "I have learned that in

the process of unfolding, life . . . can also reveal joy."[5]

Redon's considerable gifts as a painter, draftsman, and printmaker of landscape subjects have been overshadowed by the darkly emotional figure studies with which he is identified in the public imagination—scenes of decapitated heads, floating, cell-like globes with eyes or ears, and mysterious spiders with demonic faces. Even in his so-called *noirs* (as he described his black chalk and charcoal drawings), he turned often to landscape themes, drawing beautiful studies of tree trunks inflected with Corot's soft light. But even his most innocuous oil sketches of such themes were transformed in the studio into haunting images. For Redon, in such works as *Centaur*, the earth and the sky, the dark and the light, were actors in an ominous spiritual drama.[6] GTMS

1. See Druick et al. 1994, chap. 1, figs. 51, 59, 62, 65; for 1880s sketches, see chap. 3, fig. 77. See also Wildenstein 1992–98, 3: nos. 1877–1906 for rocky landscapes.

2. See Druick et al. 1994, chap. 1, figs. 6, 67, 80; chap. 2, fig. 2A, 72.

3. See Wildenstein 1992–98, 2: nos. 1235, 1251, 1250, 1252.

4. Pindar [1915] 1946, 175, Pythian Ode II, line 44 and following.

5. See Druick et al. 1994, 45–47; Redon's writings are cited in Druick et al. 1994, 24.

6. See Druick et al. 1994, chap. 3, especially 165–66.

151. PAUL GAUGUIN
French, 1848–1903
Women and a White Horse, 1903
Oil on canvas
73.2 x 91.7 cm (28 ⅞ x 36 ⅛ in.)
Bequest of John T. Spaulding 48.547

In the spring of 1891, Gauguin left France for the South Seas, seeking a terrestrial paradise emotionally and geographically more remote from the art center of Paris than any other place he had ever worked before—Martinique, Brittany, or Provence, for example. He settled in Tahiti, where he was to remain for the next two years, painting the landscape and people of his newfound land—a place that both fell short of and exceeded his expectations.

Gauguin had hoped to find an untouched Eden populated by native peoples of great dignity and simplicity, but he found instead a thriving French colony in which the Tahitians wore, often as not, clothing of European design provided by Catholic missionaries. All the same, he was awestruck by the beauty of the world around him. "The landscape, with its pure, intense colors, dazzled and blinded me," he wrote later, and

> It was so simple . . . to paint what I saw, to
> put a red or a blue on my canvas without
> so much calculation! Golden forms in the
> streams enchanted me; why did I hesitate to
> make all of that gold and all of that sunny
> joy flow on my canvas? Old European habits,
> expressive limitations of degenerate races![1]

Gauguin's words recall those of Monet when, encountering the brilliance of Mediterranean light, he felt his "palette rather poor. Here . . . [one] would need tones of gold and diamonds."[2]

In fact, Monet's last Mediterranean landscapes, painted at Antibes in 1888, were first shown by Gauguin's dealer, Theo van Gogh, in the autumn of that year, and his *Cap d'Antibes, Mistral* (cat. no. 119) was presented at an exhibi-

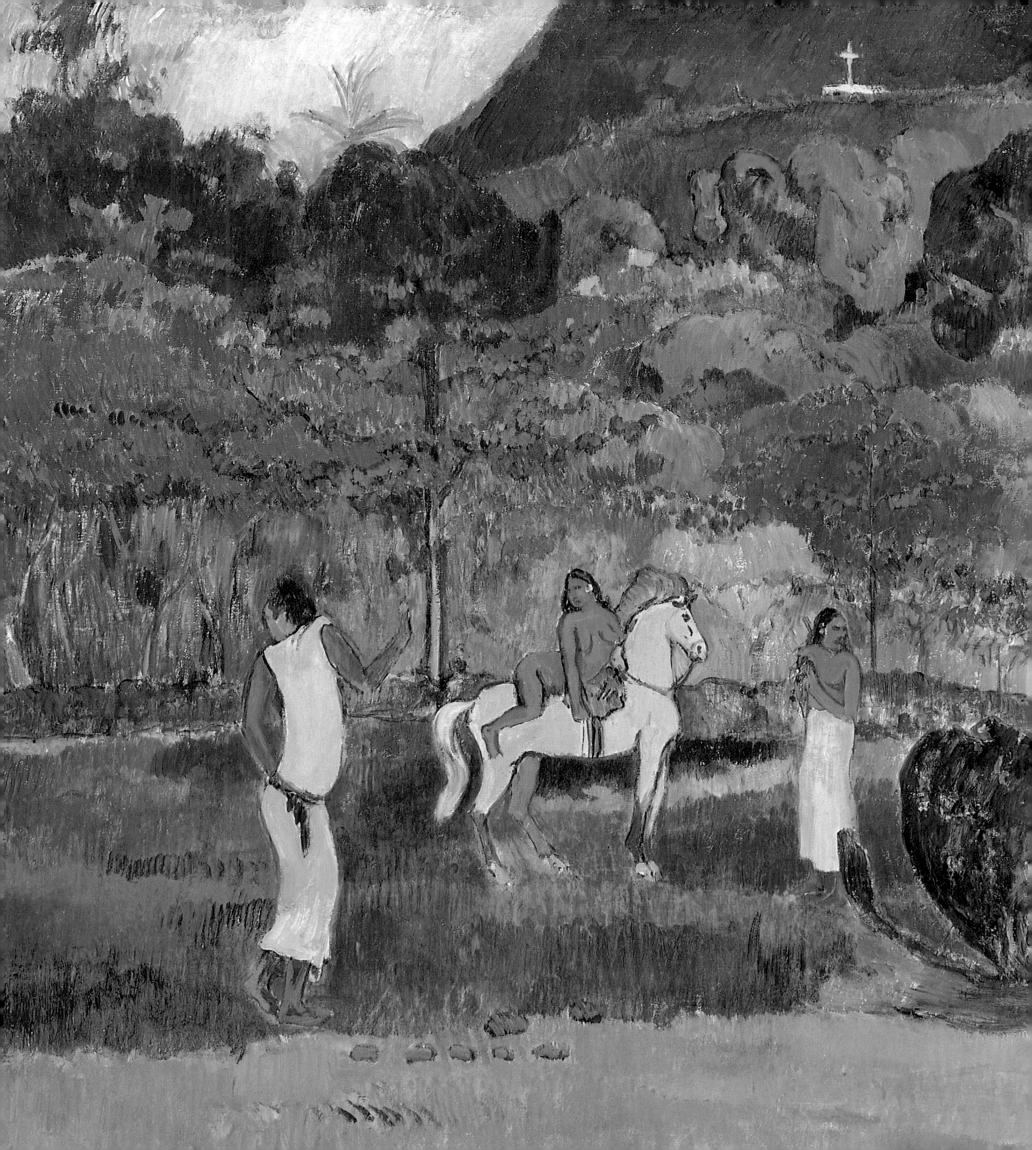

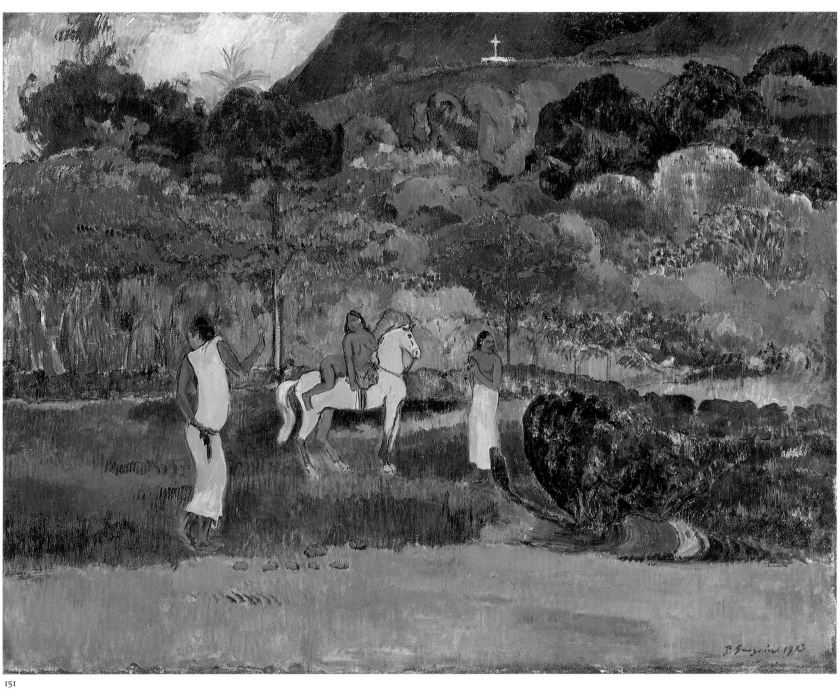

151

Fig. 58. Paul Gaugin, *Fatata te Moua*, 1892, The State Hermitage Museum, Saint Petersburg.

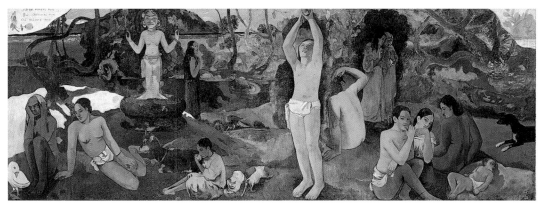

Fig. 56. Paul Gaugin, *Where Do We Come From? What Are We? Where Are We Going?* 1897–98, Museum of Fine Arts, Boston.

tion Gauguin must have seen in June 1889. Although by 1889 Gauguin was in rebellion against the conventions of Impressionism as represented by Monet, he might have recalled Monet's vividly colored views of mountains and trees when he set about painting such works as the 1892 canvas to which he gave the title *Fatata te Moua* (Against the mountain, fig. 58). Bands of unified color unite the foreground of the view, while in the background, against the rising land, a glorious mango tree spreads its branches, its foliage depicted by the artist as a billowing cloud of yellow and green.

After a sojourn in France from August 1893 until June 1895, Gauguin sailed back to the Pacific, never to return to his native land. Most of his Tahitian paintings are focused on the human figure, but that figure is most often placed in a landscape setting, more or less clearly defined and more or less abstracted. The paintings of his final years in Tahiti and in the Marquesas are marked, in general, by a steady abandonment of any sense of the topographical, and yet again and again Gauguin found the elements of his abstraction in nature itself. Thus in his monumental *Where Do We Come From? What Are We? Where Are We Going?* of 1897–98 (fig. 59), he presents, in effect, two landscapes—

one of sunshine and clearly defined shadow at left and another of a murky nocturnal underwood at right. If the view of a distant mountain seems to be a record of an actual topographical feature, the gloomy glade at right, with two figures emerging from an enigmatic cloud, may be a transcription of a more visionary experience. Gauguin believed in landscape as a realm of mystery and power. He said that he "left an important part to the great voice of the earth," and that he was searching for "the harmony of human life and animal and plant lives."[3]

Among the last of Gauguin's landscapes is *Women and a White Horse*, painted in the final months of his life. Thinly executed in delicately applied washes of color, it seems to return to the spirit of his first Tahitian paintings. As in *Fatata te Moua*, the landscape is conceived as a series of bands of color, rising to a high horizon. At the center of this late painting, Gauguin places a great wave of brilliantly colored foliage, moving from deep coral red at left to golden orange, to ocher yellow and citrus yellow-green at right. In the middle ground, two native women in white garments flank a third, who is nude and lying astride a white horse. Like the horse and rider at the left in *Fatata te Moua*, this equine form is a distant but faithful quotation of

one of the steeds from the procession of worshipers on the Parthenon frieze. Thus in Gauguin's art, the South Sea is a place of contrasts. His figures are both Polynesian and European, for they are island natives yet they are the Graces of ancient Greece. Furthermore, they inhabit a world, like the realm that Gauguin posits in *Where Do We Come From?* that is fundamentally paradoxical. The landscape resounds with the "great voice of the earth," yet it is watched over by the cross of a Christian church. GTMS

1. Gauguin, manuscript of *Noa Noa* (Musée du Louvre, Département des arts graphiques, fonds du Musée d'Orsay, Paris), quoted in Brettell et al. 1988, 248.

2. Monet in 1884, quoted in Pissarro 1997, 38.

3. Gauguin, quoted by the critic André Fontainas about 1900, in Prather and Stuckey 1987, 286.

Claude Monet

French, 1840–1926

152. CLAUDE MONET
The Water Lily Pond, 1900
Oil on canvas
90 x 92 cm (35⅛ x 36½ in.)
Given in memory of Governor Alvan T. Fuller
by the Fuller Foundation 61.959

153. CLAUDE MONET
Water Lilies, 1905
Oil on canvas
89.5 x 100.3 (35¼ x 39½ in.)
Gift of Edward Jackson Holmes 39.804

154. CLAUDE MONET
Water Lilies, 1907
Oil on canvas
89.3 x 93.4 cm (35⅛ x 36¾ in.)
Bequest of Alexander Cochrane 19.170

In 1890, Monet purchased the house in which he had been living at Giverny since 1883 and its attached garden. He began extensive work on the flowerbeds and fruit and vegetable gardens near the house right away, transforming the property into a gentleman's estate. Long rows of brilliantly colored flowers on either side of a great allée of fir trees lined the main path between the house itself and the garden gate, which opened onto the road that led from the village of Vernon to Gasny. Beyond the road lay a railroad, and beyond that a marshy plot of land crossed by the tiny Ru River, a tributary of the Seine. Monet bought this plot of land in 1893 and immediately began work on his water garden, a little world of his own creation that was to inspire the painter to create the most radical landscapes of his career.

At the point where the pathway from the house entered the garden, the Ru was dammed to fill a pond, which Monet would plant with water lilies. To link the north and south pathways around this pond, he constructed a wooden bridge in Japanese style. A few paintings of

the bridge date from 1895, but in 1899 and 1900 he began to paint the motif repeatedly, subtly varying its position on the canvas.

In the bridge paintings of 1900, including *The Water Lily Pond* (cat. no. 152), Monet heightened the palette of his 1899 compositions, adding tones of deep red, violet, and vivid orange to the greens, yellows, and blues of the foliage. Beneath the bridge, Monet shows the pond itself, a sheet of water reflecting the long sunstruck branches of a weeping willow. Their vertical mirror reflections are crossed by the horizontal "islands" of water lily foliage in blue and green, studded with white and pink flowers. The tension the painter establishes between the verticals and horizontals extends to his depiction of space. The surface of the water recedes into depth, but Monet's emphatic brushwork, not only in the lily pond but also in the willow, the foreground foliage, and the bridge itself, seems chosen to remind the viewer that the painting is a series of vigorous marks on a flat surface.

This dynamic tension between vertical and horizontal, between depth and flatness, distinguishes the paintings that Monet made of the pond some years later, beginning in 1903 and continuing through the summer of 1908. *Water Lilies* (cat. no. 153) marks the moment, in 1905, when Monet eliminated altogether any reference to the bank, focusing his attention on the surface of the water itself. Large floating clusters of foliage and flowers in tones of pink, white, and yellow intersect the shadowy vertical reflections of the trees on the opposite shore and the glowing sky between them. In a canvas of two years later (cat. no. 154), Monet maintained a similar point of view and compositional structure but responded to a different time of day and changing conditions of light. The trees cast into shade in the 1905 canvas are here bathed in gentle light, and the sky, which was rosy pink, mauve, and lavender in the earlier composition, is here shot through with strokes

of blue, from deep cornflower to palest turquoise.

When Monet's *Water Lilies* were exhibited at Durand-Ruel in May 1909 with the subtitle *Series of Water Landscapes,* critics saw them as a phenomenal achievement. The paintings represented a revolutionary departure from the conventions of landscape painting as it had been practiced since the Renaissance because the fundamental relationship of earth to sky—based on the principle of the horizon as the location of a perspectival vanishing point—had been abandoned. In his review of the exhibition, the critic Roger Marx proclaimed:

> No more earth, no more sky, no limits now; the dormant and fertile waters completely cover the field of the canvas; light overflows, cheerfully plays upon a surface covered with verdigris leaves. . . . Here the painter deliberately broke away from the teachings of Western tradition by not seeking pyramidal lines or a single point of focus. The nature of what is fixed, immutable, appears to him to contradict the very essence of fluidity; he wants attention diffused and scattered everywhere.[1]

This critical description of Monet's *Water Lilies* might be interpreted as an attempt to place the painter at the vanguard of abstraction. According to Marx, Monet stated that "The indeterminate and the vague are modes of expression that have a reason for existing and have their own characteristics"; they might constitute, in effect, an aesthetic system in which "sensations become lasting." But, teetering at the brink of acknowledging his fluid veils of paint as the raison d'être of his art—of espousing, that is, the principle of "art for art's sake"—Monet pulled back, asserting his dependence on observing the world around him. "The richness I achieve comes from nature, the source of my inspiration. . . . I aspire to no other destiny than to work and live in harmony with her laws."[2]

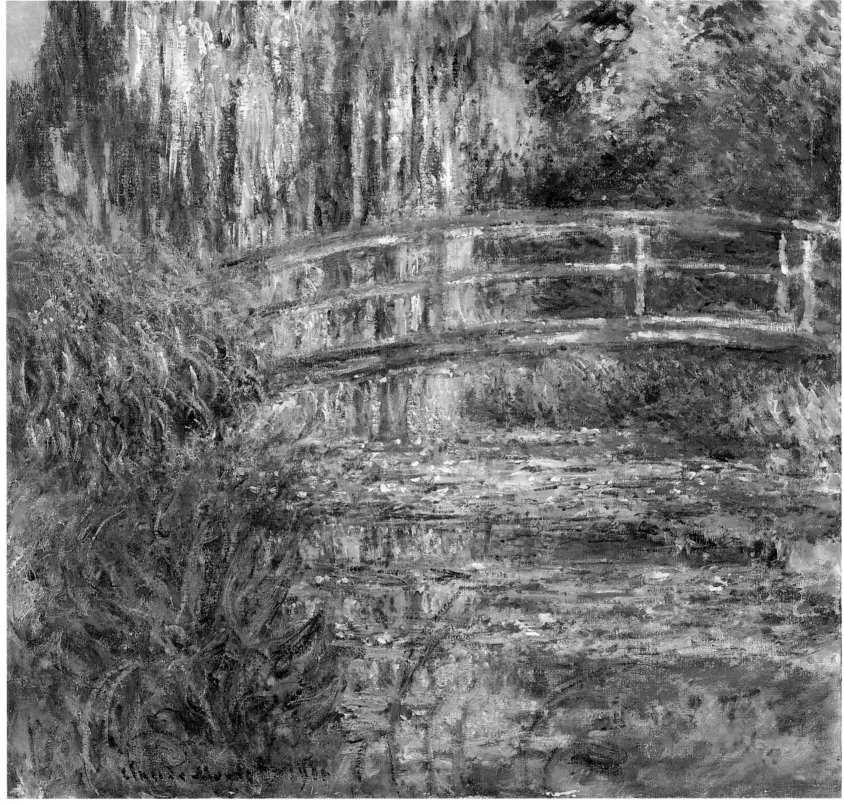

152

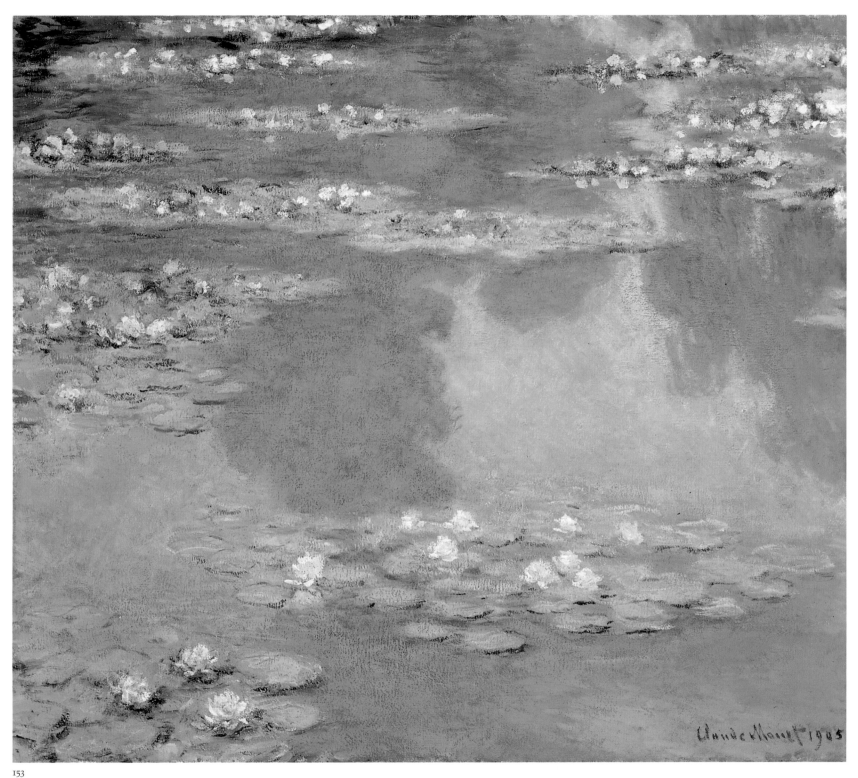

153

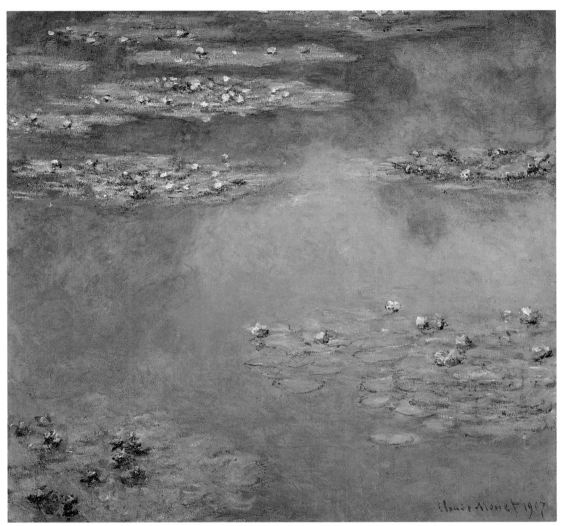

154

Throughout his career, nonetheless, Monet was intensely aware of the ability of painting both to honor nature, her beauties, and her laws and to manipulate human emotion and intellect on a purely aesthetic level. His late work—not only the two *Water Lilies* shown here but also the great cycle of decorations executed for the French state in the aftermath of World War I— is rooted in his direct observation of his garden at Giverny. It is also a profound meditation on the affective power of color and form as plastic means of retaining the sensation—vague or intense—resulting from that encounter. "Beauty in art consists of truth," Corot had said, "imbued with the impression we received from the contemplation of nature. . . . We must never forget to envelop reality in the atmosphere it first had when it burst upon our view. Whatever the site, whatever the object, the artist must submit to his first impression."[3]
GTMS

1. Roger Marx, "'Les Nymphéas' de M. Claude Monet," *Gazette des Beaux-Arts* (June 1909), quoted in Stuckey 1985, 265. See also Tucker et al. 1998, 37–50.

2. Monet, as reported by Roger Marx, in Stuckey 1985, 266–67. This discussion is indebted to Paul Tucker in Tucker et al. 1998, 50.

3. Corot in Cailler 1946, 1:89, translated in Clarke 1991a, 109.

Catalogue authors

DPB David P. Becker

KEH Karen E. Haas

AEH Anne E. Havinga

JK Joanna Karlgaard

SWR Sue Welsh Reed

GTMS George T. M. Shackelford

BSS Barbara Stern Shapiro

FEW Fronia E. Wissman

Note to the Reader

ORGANIZATION

The documentation section is arranged alphabetically by artist and then by catalogue number.

SOURCES

This documentation was compiled from the Museum's curatorial object files. Entries for all works by Claude Monet have been augmented using information from the most recent catalogue raisonné on Monet, Wildenstein 1996. Provenance and exhibition histories listed in Wildenstein 1996 cannot in all cases be verified by the information available in the Museum's object files.

PROVENANCE

In the provenance section, a semicolon after a name or clause designates a continuous sequence or known connection between two owners. A period denotes an unknown mode of transfer or a gap in the chain of ownership.

For many prints, the provenance can be traced back only to the dealer who sold the print or to the collector who gave it to the Museum. When a former owner is known by a mark, it is noted.

PRINT AUTHORITY SOURCES

Catalogues raisonnés used as authority sources for the prints are cited in author-catalogue number form (e.g., Breeskin 157). The standard abbreviations for these catalogues raisonnés are as follows:

Béraldi—Béraldi, Henri. 1885–92. *Les graveurs du dix-neuvième siècle: Guide de l'amateur d'estampes modernes.* 12 vols. Paris: Librairie L. Conquet.

Breeskin—Breeskin, Adelyn D. 1948. *The Graphic Work of Mary Cassatt: A Catalogue Raisonné.* New York: H. Bittner.

Curtis—Curtis, Atherton. 1939. *Catalogue de l'oeuvre lithographié de Eugène Isabey.* Paris: Paul Prouté.

Delteil—Delteil, Loys. 1906–30. *Le peintre-graveur illustré (dix-neuvième et vingtième siècles).* 32 vols. Paris: Chez l'auteur.

Guérin—Guérin, Marcel. 1927. *L'oeuvre gravé de Gauguin.* 2 vols. Paris: H. Floury.

Harrison—Harrison, Sharon R. 1986. *The Etchings of Odilon Redon: A Catalogue Raisonné.* New York: Da Capo.

Janis—Janis, Eugenia Parry. [1968]. *Degas Monotypes: Essay, Catalogue, and Checklist*. Exh. cat. [Cambridge, Mass.]: Fogg Art Museum, Harvard University.

Johnson—Johnson, Una E. 1944. *Ambroise Vollard Editeur, 1867–1939*. New York: Wittenborn.

Kornfeld—Mongan, Elizabeth, Eberhard W. Kornfeld, and Harold Joachim. 1988. *Paul Gauguin: Catalogue Raisonné of His Prints*. Bern: Galerie Kornfeld.

Kornfeld and Wick—Kornfeld, Eberhard W., and Peter A. Wick. 1974. *Catalogue raisonné de l'oeuvre gravé et lithographié de Paul Signac*. Bern: Kornfeld & Klipstein.

Mellerio—Mellerio, André. 1913. *Odilon Redon*. Paris: Société pour l'étude de la gravure française.

Roger-Marx—Roger-Marx, Claude. 1990. *The Graphic Work of Edouard Vuillard*. Trans. Susan Fargo Gilchrist. Reprint, San Francisco: A. Wofsy Fine Arts.

Salomon—Alain [pseud]. 1968. *Introduction à l'oeuvre gravé de K. X. Roussel par Alain accompagnée de vingt-huit dessins en fac-similé et suivie d'un essai de catalogue par Jacques Salomon*. Paris: Mercure de France.

Van Gelder—Van Gelder, Dirk. 1976. *Rodolphe Bresdin: Monographie et catalogue raisonné de l'oeuvre gravé*. 2 vols. The Hague: Martinus Nijhoff.

SELECTED EXHIBITIONS

In the selected exhibitions section, if the object's inclusion in a particular exhibition can not be confirmed, a question mark in parentheses follows the listing. The exhibition number for the object, if known, follows the exhibition title. The catalogue number follows the catalogue reference, if known. In either of these cases, if the number can not be confirmed, it is followed by a question mark.

The following exhibitions, drawn extensively or entirely from the collections of the Museum of Fine Arts, Boston, are cited in abbreviated form. The author-date citations listed in parentheses refer to the exhibition catalogues.

1939–40 *Juliana Cheney Edwards Collection*
Boston, Museum of Fine Arts, December 1, 1939–January 15, 1940, *Juliana Cheney Edwards Collection* (Cunningham 1939b).

1973 *Impressionism: French and American*
Boston, Museum of Fine Arts, June 15–October 14, *Impressionism: French and American* (MFA 1973a).

1977–78 *Monet Unveiled*
Boston, Museum of Fine Arts, November 22, 1977–February 22, 1978, *Monet Unveiled: A New Look at Boston's Paintings* (Murphy and Giese 1977).

1979–80 *Corot to Braque*
Atlanta, High Museum of Art, April 20–June 17, 1979; Tokyo, Seibu Art Museum, July 28–September 19, 1979; Nagoya, Nagoya City Art Museum, September 29–October 31, 1979; Kyoto, National Museum of Modern Art, November 13, 1979–January 15, 1980; Denver, Denver Art Museum, February 13–April 20, 1980; Tulsa, The Philbrook Art Center, May 25–July 25, 1980; Phoenix, Phoenix Art Museum, September 19–November 23, 1980, *Corot to Braque: French Paintings from the Museum of Fine Arts, Boston* (Poulet and Murphy 1979).

1983–84 *Masterpieces of European Painting*
Tokyo, Isetan Museum of Art, October 21–December 4, 1983; Fukuoka, Fukuoka Art Museum, January 6–29, 1984; Kyoto, Kyoto Municipal Museum of Art, February 25–April 8, 1984, *Bosuton Bijutsukan ten: Runessansu kara inshōha made* (Masterpieces of European Painting from the Museum of Fine Arts, Boston) (Nippon Television 1983).

1984 *Jean-François Millet*
Boston, Museum of Fine Arts, March 28–July 1, *Jean-François Millet: Seeds of Impressionism* (Murphy 1984).

1984–85 *Jean-François Millet Exhibition*
Tokyo, Nihonbashi Takashimaya Art Gallery, August 9–September 30, 1984; Sapporo, Hokkaido Museum of Modern Art, October 9–November 11, 1984; Yamaguchi, Yamaguchi Prefectural Museum of Art, November 22–December 23, 1984; Nagoya, Matsuzakaya Museum of Art, January 4–29, 1985; Kyoto, Kyoto Municipal Museum of Art, February 28–April 14, 1985; Kofu, Yamanashi Prefectural Museum of Art, April 23–May 19, 1985, *Mire ten, Bosuton Bijutsukan zō* (Jean-François Millet Exhibition from the Museum of Fine Arts, Boston) (Nippon Television and MFA 1984).

1985 *IBM Gallery*
New York, IBM Gallery of Science and Art, June 10–July 27, *Jean-François Millet*.

1989 *From Neoclassicism to Impressionism*
Kyoto, Kyoto Municipal Museum of Art, May 30–July 2; Sapporo, Hokkaido Museum of Modern Art, July 15–August 20; Yokohama, Sogo Museum of Art, August 30–October 10, *Bosuton Bijutsukan ten: Jyūkyū seiki furansu kaiga no meisaku* (From Neoclassicism to Impressionism: French Paintings from the Museum of Fine Arts, Boston) (Kyoto Museum, Kyoto Shimbun, and MFA 1989).

1991–92 *Claude Monet: Impressionist Masterpieces*
Baltimore, The Baltimore Museum of Art, September 21, 1991–January 19, 1992, *Claude Monet: Impressionist Masterpieces from the Museum of Fine Arts, Boston*.

1992 *Crosscurrents*
Boston, Museum of Fine Arts, February 19–May 17, *European and American Impressionism: Crosscurrents*.

1992–93 *Monet and His Contemporaries*
Tokyo, Bunkamura Museum, October 17, 1992–January 17, 1993; Kobe, Hyogo Prefectural Museum of Modern Art, January 23–March 22, 1993, *Mone to inshōha: Bosuton Bijutsukan ten* (Monet and His Contemporaries from the Museum of Fine Arts, Boston) (Bunkamura Museum and MFA 1992).

1995 *The Real World*
Yokohama, Yokohama Sogo Museum of Art, April 27–July 24; Chiba, Chiba Sogo Museum of Art, August 4–September 17; Nara, Nara Sogo Museum of Art, September 27–November 5, *Bosuton Bijutsukan no shihō: Jyūkyū seiki yōroppa no kyoshō* (The Real World: Nineteenth-Century European Paintings from the Museum of Fine Arts, Boston) (Sogo Museum and MFA 1994).

1999 *Monet, Renoir, and the Impressionist Landscape*
Nagoya, Nagoya / Boston Museum of Fine Arts, April 17–September 26, *Mone, Runowāru to inshōha no fūkei* (Monet, Renoir, and the Impressionist Landscape) (Nagoya / Boston and MFA 1999).

2000–2 *Monet, Renoir, and the Impressionist Landscape*
Ottawa, National Gallery of Canada, June 2–August 27, 2000; Richmond, Virginia Museum of Fine Arts, September 19–December 10, 2000; Houston, The Museum of Fine Arts, January 21–April 15, 2001; Dublin, National Gallery of Ireland, January 22–April 14, 2002, *Monet, Renoir, and the Impressionist Landscape* (Shackelford and Wissman 2000).

Théodore Caruelle d'Aligny
French, 1798–1871

3. *Study of a Great Tree, near Civita Castellana,* 1826
Graphite pencil on cream wove paper
Sheet: 62.1 x 46.9 cm (24 7/16 x 18 7/16 in.)
Anonymous gift 1985.874

PROVENANCE
Artist's estate stamp (Lugt 6). By 1979, private collection, France. By 1983, with Hazlitt, Gooden & Fox, London, *Nineteenth-Century French Drawings,* cat. no. 14; private collection, Maine; 1985, gift of anonymous donor.

SELECTED EXHIBITIONS
1978 • Orléans, Musée des Beaux-Arts, February 28–April 20; Dunkerque, Musée des Beaux-Arts, April 25–June 20; Rennes, Musée des Beaux-Arts, June 25–September 4, *Théodore Caruelle d'Aligny et ses compagnons,* no. 37.
1994 • Boston, Museum of Fine Arts, *Trees,* April 7–July 2.

4. *Rocky Landscape,* probably about 1835
Pen lithograph on cream wove paper
Image: 22.2 x 31 cm (8 3/4 x 12 13/16 in.)
Lee M. Friedman Fund 1985.871

PROVENANCE
Artist's estate stamp (Lugt 6); Alfred Beurdeley stamp (Lugt 421); by 1985, R. E. Lewis, Inc., San Rafael, Calif.; 1985, sold by Lewis to the MFA.

SELECTED EXHIBITION
1996 • Boston, Museum of Fine Arts, January 10–July 7, *Lithography's First Half Century: The Age of Goya and Delacroix,* no. 66, pl. 44.

5. *Italian Hills,* about 1826–27
Oil on paper mounted on canvas
41.2 x 68.8 cm (16 1/4 x 27 1/8 in.)
Seth K. Sweetser Fund 49.1730

PROVENANCE
By the early 1940s, anonymous dealer, Paris; sold by anonymous dealer to the Melander Shakespeare Society, Santa Barbara, Calif. [1]; consigned by Melander Shakespeare Society to Parke-Bernet Galleries, New York; 1949, sold by Parke-Bernet at Plaza Auction Room, New York, and bought by Julius H. Weitzner, London and New York [2]; 1949, sold by Weitzner to the MFA.

NOTES
1. According to a letter of February 25, 1950, from Rudolph Holzapfel of the Melander Shakespeare Society to W. G. Constable of the MFA in curatorial file, this work was purchased in Paris by the society "eight to ten years ago" by a dealer who did not supply any data about the painting.
2. According to a letter of January 5, 1950, from Weitzner to W. G. Constable in curatorial file.

SELECTED EXHIBITIONS
1987–88 • Memphis, The Dixon Gallery and Gardens, November 22, 1987–January 3, 1988; Oberlin, Ohio, Allen Memorial Art Museum, Oberlin College, January 17–March 13, 1988; Louisville, Ky., J. B. Speed Art Museum, March 27–May 15, 1988, *From Arcadia to Barbizon: A Journey in French Landscape Painting* (Simpson 1987), no. 18.
1996–97 • Washington, D.C., National Gallery of Art, May 26–September 2, 1996; Brooklyn, The Brooklyn Museum, October 11, 1996–January 12, 1997; St. Louis, The St. Louis Art Museum, February 21–May 18, 1997, *In the Light of Italy: Corot and Early Open-Air Painting* (Conisbee et al. 1996), no. 81.

SELECTED REFERENCES
Murphy 1985, 2; Ramade 1986, 125, fig. 12; Galassi 1991, 118, pl. 144.

Charles Angrand
French, 1854–1926

135. *Farmyard,* 1892
Black conté crayon on cream laid paper
Sheet: 47.5 x 62.4 cm (18 11/16 x 24 9/16 in.)
Gift of her children in memory of Elizabeth Paine Metcalf 1992.566

PROVENANCE
Elizabeth Paine Card Metcalf, Boston; 1992, gift of Metcalf's children.

Eugène Atget
French, 1857–1927

149. *Versailles,* 1902
Photograph, gold-toned albumen print from glass-plate negative, unmounted
Sheet: 18.1 x 21.8 cm (7 1/8 x 8 9/16 in.)
Helen B. Sweeney Fund 1989.322

PROVENANCE
Robert Klein Gallery, Boston; 1989, sold by Robert Klein Gallery to the MFA.

SELECTED EXHIBITION
1998–99 • Boston, Museum of Fine Arts, November 21, 1998–May 23, 1999, *French Photography: Le Gray to Atget.*

SELECTED REFERENCES
Szarkowski and Hambourg 1983, vol. 3; Borcoman 1984, 67, 130–31.

Edouard-Denis Baldus
French, 1813–1882

44. *Bridge of Saint Bénézet, Avignon,* early 1860s
Photograph, albumen print from glass-plate negative, mounted
Sheet: 21.5 x 28.1 cm (8 7/16 x 11 1/16 in.)
Gift of Mrs. George R. Rowland, Sr. 1986.767

PROVENANCE
Lee Gallery, Boston; 1986, sold by Lee Gallery to the MFA.

SELECTED EXHIBITIONS
1989 • Boston, Museum of Fine Arts, October 7–December 17, *Capturing an Image: Collecting 150 Years of Photography.*
1998–99 • Boston, Museum of Fine Arts, November 21, 1998–May 23, 1999, *French Photography: Le Gray to Atget.*

SELECTED REFERENCES
Jammes and Janis 1983, 139–42; Daniel 1994, 80–90.

45. *Mer de Glâce, Chamonix,* about 1860
Photograph, albumen print from paper negative, mounted
Sheet: 30.9 x 42.5 cm (12 3/16 x 16 3/4 in.)
Sophie M. Friedman Fund 1989.23

PROVENANCE
William L. Schaeffer, Chester, Conn.; 1989, sold by Schaeffer to the MFA.

SELECTED EXHIBITION
1998–99 • Boston, Museum of Fine Arts, November 21, 1998–May 23, 1999, *French Photography: Le Gray to Atget.*

SELECTED REFERENCES
Jammes and Janis 1983, 139–42; Néagu and Heilbrun 1983; Daniel 1994, 76–77.

Antoine-Louis Barye
French, 1795–1875

39. *Stag and Doe*
Watercolor on paper, mounted
Sheet: 21 x 28.2 cm (8 1/4 x 11 1/8 in.)
Bequest of David P. Kimball in memory of his wife Clara Bertram Kimball 23.526

PROVENANCE
February 7–12, 1876, Barye sale, Paris, probably no. 147; James F. Sutton, New York; April 7, 1892, American Art Association, sale, New York, no. 57; David P. Kimball, Boston; 1923, bequest of David P. Kimball.

SELECTED EXHIBITION
1992 • Boston, Museum of Fine Arts, April 8–June 29, *Neoclassical and Romantic Works on Paper.*

Edouard Bertin
French, 1797–1871

9. *Landscape, Tivoli,* mid-19th century
Black chalk heightened with white chalk on blue wove paper
Sheet: 33.6 x 27.7 cm (13 1/4 x 10 7/8 in.)
Lucy Dalbiac Luard Fund 1987.564

PROVENANCE
Artist's estate stamp (Lugt suppl. 238a). Eric G. Carlson, New York; 1987, sold by Carlson to the MFA.

SELECTED EXHIBITION
1992 • Boston, Museum of Fine Arts, April 8–June 29, *Neoclassical and Romantic Works on Paper.*

Jean-Joseph-Xavier Bidauld
French, 1758–1846

2. *Monte Cavo from Lake Albano,* about 1790
Oil on canvas
32.5 x 45.6 cm (12 3/4 x 18 in.)
Charles Edward French Fund 43.130

PROVENANCE
About 1870–80, purchased from anonymous collection or dealer in France by Seth Morton Vose, Boston; about 1870–80 until 1943, with Vose Galleries, Boston (as Achille Michallon); 1943, sold by Vose Galleries to the MFA.

SELECTED EXHIBITIONS
1950 • Detroit, The Detroit Institute of Arts, February 1–March 5, *French Painting from David to Courbet* (Detroit 1950), no. 68.

1978 • Boston, Museum of Fine Arts, May 2–August 27, *French Paintings from the Storeroom and Some New Acquisitions.*

1978 • New York, Wildenstein Galleries, October 17–November 22, *Romance and Reality: Aspects of Landscape Painting* (Wildenstein 1978), no. 2.

1996–97 • Washington, D.C., National Gallery of Art, May 26–September 2, 1996; Brooklyn, Brooklyn Museum of Art, October 11, 1996–January 12, 1997; St. Louis, The St. Louis Art Museum, February 21–May 18, 1997, *In the Light of Italy: Corot and Early Open-Air Painting* (Conisbee et al. 1996), no. 30.

SELECTED REFERENCES
Gutwirth 1977, 150, fig. 4; Murphy 1985, 19; Simpson 1987, 51; Kitson et al. 1990, 245, fig. 14; Zafran 1998, 168–69, no. 75.

Eugène Bléry
French, 1805–1887

7. *A Large Patch of Coltsfoot,* 1843
Etching on chine collé. Béraldi 144
Platemark: 40 x 53 cm (15¾ x 20⅞ in.)
Lee M. Friedman Fund 1986.612

Karl Bodmer
Swiss (worked in France), 1809–1893

47. *Oaks and Wild Boars*
Oil on canvas, about 1865
134 x 106.8 cm (52¼ x 42 in.)
Bequest of Francis Skinner 06.3

PROVENANCE
By 1872–1906, Francis Skinner, Boston; 1906, bequest of Francis Skinner.

SELECTED EXHIBITIONS
1866 • Paris, *Salon*, called *Bande de sangliers sous la haute futaie*, no. 189?

1872 • Boston, Boston Athenaeum, no. 191.

1873 • Boston, Boston Athenaeum, no. 205 (lent as *The Wild Boars of the Forest*).

SELECTED REFERENCE
Murphy 1984, 21.

48. *Fox in the Hiding Place,* 1858
Lithograph on chine collé. Delteil 90
Image: 29 x 17.7 cm (11⁷⁄₁₆ x 6¹⁵⁄₁₆ in.)
Gift of Clifford S. Ackley in memory of Lillian H. Stern 1984.182

Pierre Bonnard
French, 1867–1947

146. *Boating,* 1896–97
Color lithograph on cream Chinese paper. Roger-Marx 44
Image: 25.7 x 47.5 cm (10⅛ x 18¹¹⁄₁₆ in.)
Bequest of W. G. Russell Allen 60.68

SELECTED REFERENCE
Ives, Giambruni, and Newman 1989, 21–23.

Eugène Boudin
French, 1824–1898

75. *River Landscape with Houses and Bridge,* late 1850s
Graphite pencil on dark cream laid paper
Sheet: 28.5 x 44.5 cm (11¼ x 17½ in.)
M. and M. Karolik Fund 1972.368

PROVENANCE
Robert Light & Co., Boston; 1972, sold by Robert Light & Co. to the MFA.

SELECTED EXHIBITIONS
1990 • Boston, Museum of Fine Arts, July 13–August 19, *Boudin in Boston.*

1991 • Salem, Mass., Peabody Museum, May 17–September 16, *Eugène Boudin: Impressionist Marine Paintings* (Sutton 1991), 34–35, illus., unnumbered entries, pl. 3.

76. *Harbor at Honfleur,* 1865
Oil on paper mounted on panel
20.3 x 26.8 cm (8 x 10½ in.)
Anonymous Gift 1971.425

PROVENANCE
By 1929, private collection (or anonymous dealer), Paris; 1929–71, Rowland Burdon-Muller, Lausanne and Boston; 1971, gift of anonymous donor.

SELECTED EXHIBITIONS
1991 • Salem, Mass., Peabody Museum, May 17–September 16, *Eugène Boudin: Impressionist Marine Paintings* (Sutton 1991), 40–41, pl. 6.

1992–93 • *Monet and His Contemporaries* (Bunkamura Museum and MFA 1992), not in catalogue.

1999 • *Monet, Renoir, and the Impressionist Landscape* (Nagoya/Boston and MFA 1999), no. 22.

2000–2 • *Monet, Renoir, and the Impressionist Landscape* (Shackelford and Wissman 2000), no. 22.

SELECTED REFERENCES
Schmit 1973, no. 339; Murphy 1985, 30.

78. *Fashionable Figures on the Beach,* 1865
Oil on panel
35.5 x 57.5 cm (14 x 22⅝ in.)
Gift of Mr. and Mrs. John J. Wilson 1974.565

PROVENANCE
With Cadart & Luquet, Paris. With Galerie Georges Petit, Paris; probably by 1930s, sold by Galerie Georges Petit to Dr. Francisco Llobet (d. 1959), Buenos Aires [1]; 1959, inherited by Mme Inès Llobet de Gowland (daughter); by 1961, sold by Gowland to Drs. Fritz and Peter Nathan, Zurich; by 1962, sold by Drs. Fritz and Peter Nathan to Mr. and Mrs. John J. Wilson, Boston; 1974, gift of Mr. and Mrs. John J. Wilson.

NOTE
1. According to a letter of December 3, 1962, from Peter Nathan to Perry T. Rathbone of the MFA, Llobet was a well-known collector of Impressionist painting in South America. There is some dispute as to the exact time Llobet purchased the painting. In a letter of June 22, 1962, to Perry T. Rathbone in curatorial file, Peter Nathan writes that Llobet most likely purchased the painting between 1920 and 1925 from Galerie Georges Petit in Paris (though not at an auction sale), while Rathbone in a letter to Nathan of December 14, 1962, argues that Llobet probably did not do so until after 1930.

SELECTED EXHIBITIONS
1966 • New York, Hirschl & Adler Galleries, Inc., November 2–26, *Eugène Boudin, 1824–1898*, no. 7.

1990 • Boston, Museum of Fine Arts, July 13–August 19, *Boudin in Boston.*

1991 • Salem, Mass., Peabody Museum, May 17–September 16, *Eugène Boudin:*

Impressionist Marine Paintings (Sutton 1991), unnumbered entries, pl. 7.

1992 • *Crosscurrents.*

1995 • *The Real World* (Sogo Museum and MFA 1994), no. 37.

1999 • *Monet, Renoir, and the Impressionist Landscape* (Nagoya/Boston and MFA 1999), no. 2.

2000–2 • *Monet, Renoir, and the Impressionist Landscape* (Shackelford and Wissman 2000), no. 23.

SELECTED REFERENCES
Schmit 1973, no. 345; Murphy 1985, 30.

Rodolphe Bresdin
French, 1822–1885

40. *The Good Samaritan,* 1861
Pen lithograph on chine collé.
Van Gelder 100
Image: 56.4 x 44.4 cm (22³⁄₁₆ x 17½ in.)
Bequest of W. G. Russell Allen 60.73

SELECTED REFERENCE
Becker 1983.

41. *Mountain Landscape with Army in a Rocky Gorge,* 1865
Pen and black ink on card with embossed border
Sheet: 10.3 x 14.8 cm (4¹⁄₁₆ x 5¹³⁄₁₆ in.)
Gift of Dr. and Mrs. Irvin Taube and Sophie M. Friedman Fund 1986.128

PROVENANCE
Galerie Gosselin, Paris; 1986, sold by Galerie Gosselin to the MFA.

SELECTED EXHIBITION
1992 • Boston, Museum of Fine Arts, January 8–March 22, *The Art of Drawing.*

42. *Mountain Stream,* 1871
Etching and drypoint (roulette) on cream wove paper. Van Gelder 130
Platemark: 11.2 x 14.6 cm (4⁷⁄₁₆ x 5¾ in.)
Gift of David P. Becker 1998.40

SELECTED EXHIBITION
1987 • Boston, Museum of Fine Arts, April 17–July 26, *Printmaking: The Evolving Image*, no. 38.

SELECTED REFERENCE
Préaud 2000.

Mary Cassatt
American (worked in France), 1844–1926

117. *Gathering Fruit,* about 1893
Color drypoint and aquatint printed from three plates on cream laid paper. Breeskin 157
Platemark: 42 x 29.8 cm (16 9/16 x 11 3/4 in.)
Gift of William Emerson and The Hayden Collection, Charles Henry Hayden Fund 41.813

SELECTED REFERENCE
Mathews and Shapiro 1989, no. 15, ninth state.

Jean Charles Cazin
French, 1841–1901

109. *Riverbank with Bathers,* about 1882
Oil on canvas
131.2 x 147 cm (51 5/8 x 57 7/8 in.)
Peter Chardon Brooks Memorial Collection; Gift of Mrs. Richard M. Saltonstall 20.593

PROVENANCE
By 1889, Antonin Proust. By 1890, with Galerie Georges Petit, Paris; September 25, 1890, sold by Galerie Georges Petit and bought by J. Foxcroft Cole, Boston, for Peter Chardon Brooks, Boston; November 1890–1919, Peter Chardon Brooks, Boston; 1919–20, inherited by Mrs. Richard M. Saltonstall, Chestnut Hill, Mass. (daughter); 1920, gift of Mrs. Richard M. Saltonstall.

SELECTED EXHIBITIONS
1882 • Paris, *Salon,* hors catalogue.

1889 • Paris, *Exposition Universelle* (Exposition Universelle [1889]), no. 280, called *La Marne.*

1897 • Boston, Copley Hall, March 5–28, *Loan Exhibition of One Hundred Masterpieces,* no. 2, called *Pharaoh's Daughter Bathing in the Nile.*

1997 • London, National Gallery, July 2–September 28, *Seurat and the Bathers* (Leighton et al. 1997), no. 66.

SELECTED REFERENCES
Album artistique 1882; Child 1890, 828; Child 1892, 50; Bénédite 1901, 32, opp. 76; Marcel [1905], 316, 318; MFA 1921, 78, no. 188; Edgell 1949, 58; MFA 1955, 11; Murphy 1985, 47.

132. *Farm beside an Old Road,* about 1890
Oil on canvas
65.1 x 81.6 cm (25 5/8 x 32 1/8 in.)
Bequest of Anna Perkins Rogers 21.1330

PROVENANCE
By 1890, Ernest May, Paris; June 4, 1890, sold at May sale (Chevallier), Paris, no. 6, and bought by Anna P. Rogers, Boston; 1890–1921, Anna P. Rogers, Boston; 1921, bequest of Anna P. Rogers.

SELECTED EXHIBITIONS
1889 • Paris, *Exposition Universelle de 1889* (Exposition Universelle de 1889 [1889]), no. 280(?).

1903 • Boston, Copley Hall, *A Loan Collection of Pictures by Old Masters and Other Painters* (Copley Society 1903), no. A1.

2000–02 • *Monet, Renoir, and the Impressionist Landscape* (Shackelford and Wissman 2000), no. 53.

SELECTED REFERENCES
Trumble 1890, 131; "Vente E. May" 1890, 179; Trumble 1893, 300; Murphy 1985, 47.

Paul Cézanne
French, 1839–1906

108. *The Pond,* about 1877–79
Oil on canvas
47 x 56.2 cm (18 1/2 x 22 1/8 in.)
Tompkins Collection 48.244

PROVENANCE
By 1894, acquired from the artist by Gustave Caillebotte (d. March 8, 1894), Paris [1]; about 1894, inherited by Martial Caillebotte, Paris (brother) [2]; inherited by G. (Albert?) Chardeau, Paris (nephew). 1948, with Matignon Art Galleries, Inc. (André Weil Gallery), Paris and New York; 1948, sold by Matignon Art Galleries to the MFA.

NOTES
1. Most or all of Caillebotte's estate was bequeathed to the French state, which refused much of it. It is unclear whether this painting was included in the bequest. However, if it was included in the bequest, it was subsequently rejected.
2. Martial Caillebotte negotiated with the French state regarding his brother's bequest. He received the rejected portion of the bequest.

SELECTED EXHIBITIONS
1905 • Paris, Grand Palais, *Salon d'Automne,* no. 319?, called *Bord de rivière.*

1949 • Manchester, N.H., The Currier Gallery of Art, October 8–November 6, *Monet and the Beginnings of Impressionism: Twentieth Anniversary Exhibition* (Currier Gallery of Art [1949]), no. 27.

1950 • Richmond, Virginia, Museum of Fine Arts, October–November, *Impressionists and Post-Impressionists.*

1952 • Montreal, Montreal Museum of Fine Arts, March 7–April 13, *Six Centuries of Landscape* (Montreal Museum 1952), no. 55.

1956 • The Hague, Gemeentemuseum, June–July, *Paul Cézanne, 1839–1906* (Haags [1956]), no. 11.

1956 • Zurich, Kunsthaus Zurich, August–October, *Cézanne,* no. 21.

1956–57 • Cologne, Kunsthaus Lempertz, December 1, 1956–January 31, 1957, *Cézanne: Ausstellung zum Gedenken an sein 50. Todesjahr* (Wallraf-Richartz 1956), no. 6.

1970 • New York, The Metropolitan Museum of Art, May 29–July 26, *One Hundred Paintings from the Boston Museum* (MFA [1970]), no. 64.

1971 • Washington, D.C., The Phillips Collection, February 27–March 28; Chicago, The Art Institute of Chicago, April 17–May 16; Boston, Museum of Fine Arts, June 1–July 3, *Cézanne: An Exhibition in Honor of the Fiftieth Anniversary of The Phillips Collection* (Rewald 1971), no. 4.

1973 • *Impressionism: French and American* (MFA 1973a), unnumbered entry.

1978 • Boston, Museum of Fine Arts, May 2–August 27, *French Paintings from the Storerooms and Some Recent Acquisitions.*

1978 • St. Petersburg, Fla., Museum of Fine Arts, September 30–November 5; Montgomery, Ala., Montgomery Museum of Art, November 17–December 31, *Symbolist Roots of Modern Painting.*

1979–80 • *Corot to Braque* (Poulet and Murphy 1979), no. 43.

1983–84 • *Masterpieces of European Painting* (Nippon Television 1983), no. 53.

1992 • *Crosscurrents.*

1996 • Tokyo, Tobu Museum of Art, March 30–June 30, *Inshoha wa koshite umareta: Akademisumu kara Kurube, Mune, Mone, Runowaru* (The Birth of Impressionism) (Tobu Bijutsukan 1996), no. 149.

1997 • Glasgow, McLellan Galleries, Burrell Collection, Glasgow Museums, May 23–September 7, *The Birth of Impressionism: From Constable to Monet* (Glasgow Museums 1997), 24–25, 31, unnumbered entry.

1999 • *Monet, Renoir, and the Impressionist Landscape* (Nagoya/Boston and MFA 1999), no. 36.

2000–02 • *Monet, Renoir, and the Impressionist Landscape* (Shackelford and Wissman 2000), no. 34.

SELECTED REFERENCES
Bernard 1921, 21, pl. 41; Bernard 1926, opp. 64; Venturi 1936, 1:116, no. 232; 2: no. 232, pl. 63; "Enriching U.S. Museums" 1948, 31; Edgell 1949, 51; Lindsay 1969, fig. 32; MFA [1970], 93, 95, no. 63; Geist 1975, 9; Berhaut 1978, 251; Shiff 1984, 115, fig. 24; Murphy 1985, 48; Kendall 1988, 108; Lewis 1989, 109, fig. 52; Rewald 1996, 172, fig. 224.

114. *Turn in the Road,* about 1881
Oil on canvas
60.5 x 73.5 cm (23 7/8 x 28 7/8 in.)
Bequest of John T. Spaulding 48.525

PROVENANCE
Julien Tanguy, Paris (?). By 1894, Théodore Duret, Paris (critic, friend, and biographer of the artist); March 19, 1894, sold at Duret sale, Galerie Georges Petit (Chevallier), Paris, no. 3, and bought by Paul-César Helleu (painter, d. 1927), Paris; by 1926, sold by Helleu to Claude Monet, Giverny; 1926/27, inherited by Michel Monet, Giverny; 1926/27, sold at Monet estate sale and bought by Paul Rosenberg & Co., Paris, for Wildenstein & Co.; 1926/27, Wildenstein & Co., New York; 1927, sold by Wildenstein to John Taylor Spaulding (d. 1948), Boston; 1927–48, John Taylor Spaulding, Boston; 1948, bequest of John Taylor Spaulding.

SELECTED EXHIBITIONS
1928 • New York, Wildenstein Galleries, *Paul Cézanne,* no. 14, called *Environs d'Aix-en-Provence.*

1929 • Cambridge, Mass., Fogg Art Museum, Harvard University, March 6–April 6, *Exhibition of French Painting of the Nineteenth and Twentieth Centuries* (Fogg Art Museum [1929]), no. 5.

1931–32 • Boston, Museum of Fine Arts, May 26, 1931–October 27, 1932, *Collection of Modern French Paintings, Lent by John T. Spaulding.*

1934 • Chicago, The Art Institute of Chicago, June 1–November 1, *A Century of Progress* (AIC 1934), no. 292, called *Environs d'Aix-en-Provence.*

1948 • Boston, Museum of Fine Arts, May 26–November 7, *The Collections of John Taylor Spaulding, 1870–1948* (MFA 1948), no. 8.

1949 • Cambridge, Mass., Fogg Art Museum, Harvard University, February 1–September 15, *Student Exhibition.*

1950 • Springfield, Mass., Springfield Museum of Fine Arts, January 15–February 19, *In Freedom's Search* (Springfield Museum 1950), no. 4.

1952 • Chicago, The Art Institute of Chicago; New York, The Metropolitan Museum of Art, February–March, *Cézanne: Paintings, Watercolors, and Drawings, a Loan Exhibition* (AIC 1952), no. 42.

1954 • Edinburgh, Royal Scottish Academy, August–September; London, The Tate Gallery, September 29–October 27, *An Exhibition of Paintings by Cézanne* (Gowing et al. 1954), no. 26.

1959 • New York, Wildenstein Galleries, November–December, *A Loan Exhibition of Paul Cézanne,* no. 19.

1971 • Washington, D.C., The Phillips Collection, February 27–March 28; Chicago, The Art Institute of Chicago, April 17–May 16; Boston, Museum of Fine Arts, June 1–July 3, *Cézanne: An Exhibition in Honor of the Fiftieth Anniversary of the Phillips Collection* (Rewald 1971), no. 11.

1973 • *Impressionism: French and American* (MFA 1973a), unnumbered entry.

1974 • Tokyo, National Museum of Western Art; Kyoto, Municipal Museum; Fukuoka, Prefectural Culture Center Museum, March 29–August 6, *Exhibition of the Work of Paul Cézanne,* no. 29.

1984–85 • Los Angeles, Los Angeles County Museum of Art, June 28–September 16, 1984; Chicago, The Art Institute of Chicago, October 18, 1984–January 6, 1985; Paris, Grand Palais, February 8–April 22, 1985, *A Day in the Country: Impressionism and the French Landscape* (Brettell et al. 1984), no. 72.

1992 • *Crosscurrents.*

1993 • Tübingen, Kunsthalle, January 16–April 27, *Cézanne: Gemälde* (Adriani 1993), no. 27.

1995–96 • London, Hayward Gallery, May 18–August 28, 1995; Boston, Museum of Fine Arts, October 4, 1995–January 14, 1996, *Impressions of France: Monet, Renoir, Pissarro, and Their Rivals* (House et al. 1995), no. 96.

1995–96 • Paris, Grand Palais, September 25, 1995–January 7, 1996; London, The Tate Gallery, February 8–April 28, 1996; Philadelphia, Philadelphia Museum of Art, May 26–August 18, 1996, *Cézanne* (Cachin et al. 1995), no. 76 (Philadelphia venue only).

1999 • *Monet, Renoir, and the Impressionist Landscape* (Nagoya/Boston and MFA 1999), no. 37.

2000–2 • *Monet, Renoir, and the Impressionist Landscape* (Shackelford and Wissman 2000), no. 35.

SELECTED REFERENCES
Watson 1928, 33, 35–36; Pope 193c, 122; Venturi 1936, 1:136, no. 329, 2: pl. 90, no. 329; Novotny [1937], pl. 33; Vollard 1937, pl. 30; Goldwater 1938, 149; Cogniat 1939, pl. 36; Lhôte 1939, no. 44; Wilenski 1940, 10–11, 75, pl. 15A; Jewell 1944, 43; Dame 1948, 12; Edgell 1949, 51; Cooper 1954, 378–79; Raynal 1954, 55; Gowing 1956, 185–92; Erpel 1958, 20–21; Lhôte 1958, no. 43; Boisdeffre [1966], 198; Andersen 1967, 139, note 22; Bodelsen 1968, 345; Ikegame 1969, no. 18; MFA 1973b, no. 33; Bizardel 1974, 152, 155, fig. 11; Venturi 1978, 82; Murphy 1985, 48; MFA 1986, 78; Rewald 1996, 330, no. 490.

Antoine Chintreuil
French, 1816–1873

64. *Last Rays of the Sun on a Field of Sainfoin,* about 1870
Oil on canvas
95.8 x 134 cm (37¾ x 52¼ in.)
Gift of Mrs. Charles Goddard Weld 22.78

PROVENANCE
About 1870, M. Fassin, Reims. By 1889–1911, Charles G. Weld (d. 1911), Boston; 1911–22, inherited by Mrs. Charles Goddard Weld (widow, d. 1922), Boston; 1922, bequest of Mrs. Charles Goddard Weld.

SELECTED EXHIBITIONS
1870 • Paris, Salon, no. 571.

1874 • Paris, Ecole nationale des Beaux-Arts, April 25–May 15, *Tableaux, études et dessins de Chintreuil exposés à l'Ecole des Beaux-Arts* (Ecole nationale 1874), no. 208.

1999 • *Monet, Renoir, and the Impressionist Landscape* (Nagoya/Boston and MFA 1999), no. 14.

2000–2 • *Monet, Renoir, and the Impressionist Landscape* (Shackelford and Wissman 2000), no. 11.

SELECTED REFERENCES
De la Fizelière, Champfleury, and Henriet 1874, 66, no. 408; Murphy 1985, 51.

Jean-Baptiste-Camille Corot
French, 1796–1875

11. *Farm at Recouvrières, Nièvre,* 1831
Oil on canvas
47.5 x 70.3 cm (18¾ x 27⅝ in.)
The Henry C. and Martha B. Angell Collection 19.82

PROVENANCE
Given by the artist to M. Pons (owner of the farm depicted in the painting). By 1895, with Aimé Diot, Paris (dealer, also known as MM. Diot et Tempelaere); 1895, sold by Diot to Dr. Henry Clay Angell (d. 1911), Boston; 1895–1911, Dr. Henry Clay Angell, Boston; 1911–19, inherited by Martha Bartlett Angell (widow, d. 1919), Boston; 1919, gift of Martha Bartlett Angell.

SELECTED EXHIBITIONS
1908 • Boston, Copley Hall, March, *French School of 1830* (Copley Society 1908), no. 56.

1915 • Boston, Museum of Fine Arts, opening February 3, *Robert Dawson Evans Memorial Galleries Opening Exhibition.*

1962–63 • San Francisco, California Palace of the Legion of Honor, September 24–November 4, 1962; Toledo, Ohio, The Toledo Museum of Art, November 20–December 27, 1962; Cleveland, The Cleveland Museum of Art, January 15–February 24, 1963; Boston, Museum of Fine Arts, March 15–April 28, 1963, *Barbizon Revisited* (Herbert 1962), no. 3.

1979–80 • *Corot to Braque* (Poulet and Murphy 1979), no. 4.

1983–84 • *Masterpieces of European Painting* (Nippon Television 1983), no. 34.

1987–88 • Memphis, The Dixon Gallery and Gardens, November 22, 1987–January 3, 1988; Oberlin, Ohio, Allen Memorial Art Museum, Oberlin College, January 17–March 13, 1988; Louisville, Ky., J. B. Speed Art Museum, March 27–May 15, 1988, *From Arcadia to Barbizon: A Journey in French Landscape Painting* (Simpson 1987), no. 35.

1989 • *From Neoclassicism to Impressionism* (Kyoto Museum, Kyoto Shimbun, and MFA 1989), no. 17.

1992–93 • *Monet and His Contemporaries* (Bunkamura Museum and MFA 1992), no. 1.

1996–97 • Paris, Galeries Nationales du Grand Palais, February 27–May 27, 1996; Ottawa, National Gallery of Canada, June 21–September 22, 1996; New York, The Metropolitan Museum of Art, October 29, 1996–January 19, 1997, *Corot* (Tinterow, Pantazzi, and Pomarède 1996), no. 39.

SELECTED REFERENCES
Robaut and Moreau-Nélaton 1905, 2:104, no. 292; MFA 1921, no. 201; Cunningham 1936, 100; Edgell 1949, 10–11; MFA 1955, 14; Leymarie 1966, 49; Chu 1974, 21; Murphy 1985, 59.

12. *Forest of Fontainebleau,* 1846
Oil on canvas
90.2 x 128.8 cm (35½ x 50¾ in.)
Gift of Mrs. Samuel Dennis Warren
90.199

PROVENANCE
1846–72, with the artist; February 26, 1872, contributed by the artist to the Corot (Anastasi) sale, Boussaton, Paris, no. 26, to benefit Auguste Anastasi [1]. 1872, Alfred Robaut, Paris. 1878, with anonymous dealer. 1881, Ferdinand Barbédienne, Paris. By 1884–86, Beriah Wall, Providence, R.I.; April 4, 1886, sold at Wall sale, American Art Galleries, New York, no. 263, and bought by Vose Galleries, Providence and Boston, on behalf of Mrs. Susan Cornelia Warren, Boston; 1886–90, Mrs. Susan Cornelia Warren, Boston (d. 1901, 67 Mount Vernon St.); 1890, gift of Mrs. Warren.

NOTE

1. This was known as the Anastasi sale, but he was not the owner; various artists contributed paintings to the sale.

SELECTED EXHIBITIONS

1846 • Paris, *Salon*, no. 422.

1875 • Paris, Ecole des Beaux-Arts, *Corot*, no. 74.

1878 • Paris, Durand-Ruel, *Maîtres Modernes*.

1886 • Providence, R.I., *Loan Exhibition in Aid of the First Light Infantry*, no. 96.

1946 • Philadelphia, Philadelphia Museum of Art, *Corot, 1796–1875* (PMA 1946), no. 24.

1950 • Detroit, The Detroit Institute of Arts, February 1–March 5, *French Painting from David to Courbet* (Detroit 1950), no. 75.

1952 • Venice, *Twenty-sixth Biennale*, no. 21.

1960 • Chicago, The Art Institute of Chicago, October 5–November 13, *Corot, 1796–1875: An Exhibition of His Paintings and Graphic Works* (AIC 1960), no. 63.

1962–63 • San Francisco, California Palace of the Legion of Honor, September 24–November 4, 1962; Toledo, Ohio, The Toledo Museum of Art, November 20–December 27, 1962; Cleveland, Cleveland Museum of Art, January 15–February 24, 1963; Boston, Museum of Fine Arts, March 15–April 28, 1963, *Barbizon Revisited* (Herbert 1962), no. 10.

1968–69 • Paris, Petit Palais, November 23, 1968–March 17, 1969, *Baudelaire* (Calvet et al. 1968), no. 181.

1969 • New York, Wildenstein Galleries, October 30–December 6, *Corot* (Wildenstein 1969), no. 28.

1979–80 • *Corot to Braque* (Poulet and Murphy 1979), no. 3.

1985 • Boston, Museum of Fine Arts, February 13–June 2, *The Great Boston Collectors: Paintings from the Museum of Fine Arts, Boston* (Troyen and Tabbaa 1984), no. 30.

1991–92 • Manchester, N.H., The Currier Gallery of Art, January 29–April 28, 1991; New York, IBM Gallery of Science and Art, July 30–September 28, 1991; Dallas, Dallas Museum of Art, November 10, 1991–January 5, 1992; Atlanta, High Museum of Art, January 29–March 29, 1992, *The Rise of Landscape Painting in France: Corot to Monet* (Champa, Wissman, and Johnson 1991), no. 19.

1996–97 • Paris, Galeries Nationales du Grand Palais, February 20–May 20, 1996; Ottawa, National Gallery of Canada, June 20–September 20, 1996; New York, The Metropolitan Museum of Art, October 15, 1996–January 12, 1997, *Corot* (Tinterow, Pantazzi, and Pomarède 1996), no. 91.

SELECTED REFERENCES

Dumesnil 1875, 41; Robaut 1881, nos. 2, 5, and note 3; Wall 1884, 14, no. 27; American Art Assoc. 1886, 92, no. 263; Downes 1888b, 784–85; Van Rensselaer 1889a, 256; Van Rensselaer 1889b, 158, 176; Thurwanger 1892, 692; Geffroy and Alexandre 1903, cxvii; Robaut and Moreau-Nélaton 1905, 1:109–10, 2:185, no. 502, 4:168, 281, 361, no. 422; Moreau-Nélaton 1924, 1:60, fig. 97; Cunningham 1936, 100–102; Edgell 1949, 10–11; Foucart 1964, 347; Baudelaire 1965, 106, note 1; Leymarie 1966, 70; Hours [1972], 78; Murphy 1985, 58; Potterton 1991, 47–48.

13. *Twilight*, 1855–60
Oil on canvas
50.3 x 37 cm (19¾ x 14⅝ in.)
Bequest of Mrs. Henry Lee Higginson, Sr., in memory of her husband 35.1163

PROVENANCE

With Goupil and Co., New York. By 1903–8, collection of Major Henry Lee Higginson, Sr., Boston (d. 1919); 1919, inherited by Alexander Higginson, Boston; 1935, inherited by Mrs. Henry Lee Higginson, Sr. (widow of Major Henry Lee Higginson), Boston; 1935, bequest of Mrs. Higginson.

SELECTED EXHIBITIONS

1903 • Boston, Copley Hall, *A Loan Collection of Pictures by Old Masters and Other Painters* (Copley Society 1903), no. 28.

1908 • Boston, Copley Hall, March, *French School of 1830* (Copley Society 1908), no. 24 or 84.

1940 • Colorado Springs, Colo., Colorado Springs Fine Arts Center, January; Boston, St. Botolph Club, March 16–April 16; New London, Conn., Lyman Allen Museum, Connecticut College, November 17–December 15.

1979–80 • *Corot to Braque* (Poulet and Murphy 1979), no. 5.

1983–84 • *Masterpieces of European Painting* (Nippon Television 1983), no. 35.

SELECTED REFERENCES

Robaut and Moreau-Nélaton 1905, 2:216, no. 614; MFA 1955, 14; Murphy 1985, 60.

14. *Morning near Beauvais,* about 1855–65
Oil on canvas
36 x 41.5 cm (14⅛ x 16⅜ in.)
Juliana Cheney Edwards Collection 39.668

PROVENANCE

By 1886, John Saulnier, Bordeaux, France; June 5, 1886, Saulnier (posthumous) sale at Hôtel Drouot, Paris, no. 21, called *Paysage: Matinée environs de Beauvais*; 1886, with Boussod Valadon et Cie., Paris, no. 2717 (probably bought at Saulnier sale). June 1, 1901–July 31, 1903, with Knoedler & Co., London, no. 9546, called *Prairie boisée près ruisseau*. July 31, 1903–December 1906, F. Isman, Philadelphia; by December 31, 1906, purchased from Isman by Knoedler & Co., New York; December 31, 1906, sold by Knoedler to Robert J. Edwards, (d. 1924), Boston (probably for his sister Hannah Marcy Edwards), called *The Brook in the Woods*; 1906–29, Hannah Marcy Edwards (sister, d. 1929), Boston; 1931–38, inherited by Grace M. Edwards (sister, d. 1938), Boston; 1939, bequest of Hannah Marcy Edwards [1].

NOTE

1. Juliana Cheney Edwards (d. 1917?) was an art collector who left her objects to her three children: Robert Jacob Edwards (d. 1924), Hannah Marcy Edwards (d. 1929), and Grace M. Edwards (d. 1938). The siblings, each of whom was an independent collector of artworks, agreed that all of their mother's paintings and the paintings that they each collected would be bequeathed to each other and ultimately to the MFA. Most likely stipulated by their wills, some objects were bequeathed to the Museum by Robert or Hannah despite the fact that their younger sister, Grace, was in final possession of the works of art. All the objects, regardless of who initially acquired them, were left to the MFA as a memorial collection honoring the mother, Juliana.

SELECTED EXHIBITIONS

1886 • Paris, May, *Maîtres du siècle*, no. 45.

1929 • Atlanta, High Museum of Art, April 20–June 17.

1939–40 • *Juliana Cheney Edwards Collection* (Cunningham 1939b), no. 4.

1972 • Providence, R.I., Museum of Art, Rhode Island School of Design, February 3–March 5, *To Look on Nature: European and American Landscape, 1800–1874* (Brown University 1972), unnumbered entries, pl. 35.

1979–80 • *Corot to Braque* (Poulet and Murphy 1979), no. 7.

1989 • *From Neoclassicism to Impressionism* (Kyoto Museum, Kyoto Shimbun, and MFA 1989), no. 18.

1992 • *Crosscurrents*.

1992–93 • *Monet and His Contemporaries* (Bunkamura Museum and MFA 1992), no. 2.

1999 • *Monet, Renoir, and the Impressionist Landscape* (Nagoya/Boston and MFA 1999), no. 1.

2000–2 • *Monet, Renoir, and the Impressionist Landscape* (Shackelford and Wissman 2000), no. 1.

SELECTED REFERENCES

Robaut and Moreau-Nélaton 1905, 2:310, no. 1012; MFA 1955, 14; Murphy 1985, 60.

15. *Souvenir of a Meadow at Brunoy,* about 1855–65
Oil on canvas
90.6 x 115.9 cm (35⅝ x 45⅝ in.)
Gift of Augustus Hemenway in memory of Louis and Amy Hemenway Cabot 16.1

PROVENANCE

By 1875, Louis Latouche, Paris, called *Chemin de village*. By 1882?, Seth M. Vose, Westminster Gallery, Providence, R.I. By 1887, William Hemenway, Boston; inherited by Louis and Amy Hemenway Cabot, Boston; by 1916, inherited by Augustus Hemenway, Milton, Mass.; 1916, gift of Augustus Hemenway.

SELECTED EXHIBITIONS

1875 • Paris, Ecole nationale des Beaux-Arts, *Corot*, no. 193 (as *Chemin de village*).

1878 • Paris, Durand-Ruel, *Maîtres Modernes*, no. 120.

1890 • Boston, Museum of Fine Arts, *Loan Exhibition*.

1915 • Boston, Museum of Fine Arts, opening February 3, *Robert Dawson Evans Memorial Galleries Opening Exhibition*.

1940 • San Francisco, Palace of Fine Arts, *Golden Gate International Exposition* (Golden Gate 1940), no. 245.

1953–54 • New Orleans, Isaac Delgado Museum of Art, October 17, 1953–January 10, 1954, *Masterpieces of French Painting through Five Centuries, 1400–1900* (Isaac Delgado Museum of Art 1954), no. 63.

1999 • *Monet, Renoir, and the Impressionist Landscape* (Nagoya/Boston and MFA 1999), no. 1.

2000–02 • *Monet, Renoir, and the Impressionist Landscape* (Shackelford and Wissman 2000), no. 1.

SELECTED REFERENCES
Durand-Gréville 1887, 67; Thurwanger 1892, 700; Robaut and Moreau-Nélaton 1905, 3:380, no. 2417, 4:276, 281; MFA 1916, 4; MFA 1921, 86–87, no. 214; Edgell 1949, 11; Murphy 1985, 58.

16. *Young Woman and Death,* 1854
Cliché-verre, salt print. Delteil 45
Sheet: 18.3 x 13.3 cm (7 3/16 x 5 1/4 in.)
Gift of Mr. and Mrs. Peter A. Wick
63.2742

SELECTED EXHIBITION
1980 • Detroit, The Detroit Institute of Arts, July 12–August 21, 1980; Houston, The Museum of Fine Arts, September 11–October 23, 1980, *Cliché-verre: Hand-Drawn, Light-Printed, a Survey of the Medium from 1829 to the Present* (Glassman and Symmes 1980), no. 14.

17. *Mother and Child in a Wooded Landscape,* 1856
Cliché-verre, salt print. Delteil 59
Sheet: 32.6 x 24.8 cm (12 11/16 x 9 3/4 in.)
Bequest of William P. Babcock, 1900
B1052/1

SELECTED REFERENCE
Glassman and Symmes 1980.

18. *The Gardens of Horace,* 1855
Cliché-verre, salt print. Delteil 58
Sheet: 34.8 x 27.1 cm (13 11/16 x 10 11/16 in.)
Bequest of William P. Babcock, 1900
B1052.2/2

SELECTED REFERENCE
Glassman and Symmes 1980.

65. *Bacchanal at the Spring: Souvenir of Marly-le-Roi,* 1872
Oil on canvas
82.1 x 66.3 cm (32 3/8 x 26 1/8 in.)
Robert Dawson Evans Collection 17.3234

PROVENANCE
1872, Emile Gavet, Paris (presumably acquired from the artist). Marquis Fressinet de Bellanger collection, Paris, no. 79. By 1875, with Galerie Georges Petit, Paris; 1875, sold by Galerie Georges Petit to Arthur Tooth & Sons, London and New York; 1875–98, with Arthur Tooth & Sons, London and New York; March 1898, sold by Arthur Tooth & Sons and bought by H. S. Henry, Philadelphia; 1898–1907, H. S. Henry, Philadelphia; January 25, 1907, sold at Henry sale, *Paintings of the Men of 1830,* American Art Association, New York, no. 4, and bought by Robert Dawson Evans (d. 1909), Boston; 1909, Mrs. Robert Dawson Evans (Maria Antoinette Hunt, d. 1917); 1917, inherited by Abby and Belle Hunt (daughters); 1917, bequest of Abby and Belle Hunt.

SELECTED EXHIBITIONS
1875 • Paris, Ecole nationale des Beaux-Arts, *Corot,* no. 12.

1895 • Paris, Palais Galliéra, *Centenaire de Corot,* no. 79.

1908 • Boston, Copley Hall, March, *French School of 1830* (Copley Society 1908), no. 15.

1914 • New York, *The Men of 1830* (Wickenden 1914), no. 4.

1915 • Boston, Museum of Fine Arts, opened February 3, *Robert Dawson Evans Memorial Galleries Opening Exhibition.*

1916 • Cleveland, The Cleveland Museum of Art, June 6–September 20, *Inaugural Exhibition* (CMA 1916), no. 9.

1940 • Colorado Springs, Colo., Colorado Springs Fine Arts Center, January; Boston, St. Botolph Club, March 16–April 16; New London, Conn., Lyman Allen Museum, Connecticut College, November 17–December 15.

1942 • New York, Wildenstein Galleries, November 11–December 12, *The Serene World of Corot: An Exhibition in Aid of the Salvation Army War Fund* (Wildenstein 1942), no. 68.

1946 • Philadelphia, Philadelphia Museum of Art, *Corot, 1796–1875* (PMA 1946), no. 74.

1960 • Chicago, The Art Institute of Chicago, October 5–November 13, *Corot, 1796–1875: An Exhibition of His Paintings and Graphic Works* (AIC 1960), no. 135.

1962–63 • San Francisco, California Palace of the Legion of Honor, September 24–November 4, 1962; Toledo, Ohio, The Toledo Museum of Art, November 20–December 27, 1962; Cleveland, The Cleveland Museum of Art, January 15–February 24, 1963; Boston, Museum of Fine Arts, March 15–April 28, 1963, *Barbizon Revisited* (Herbert 1962), no. 18.

1972 • New York, Shepherd Gallery, April 22–June 10, *The Forest of Fontainebleau: Refuge of Reality* (Ittman et al. 1972), no. 18.

1999 • *Monet, Renoir, and the Impressionist Landscape* (Nagoya/Boston and MFA 1999), no. 3.

2000–2 • *Monet, Renoir, and the Impressionist Landscape* (Shackelford and Wissman 2000), no. 3.

2001 • Madrid, Museo Thyssen-Bornemisza, June 26–October 21, *Corot: El Parque de los Leones en Port-Marly, 1872* (Pickvance 2001), no. 5.

SELECTED REFERENCES
Roger-Milès 1896, no. 39; Robaut and Moreau-Nélaton 1905, 2:53–54, no. 97, 3:330, no. 2201, 4:269, 291; Moreau-Nélaton 1924, 2:53, fig. 227; Fosca 1930, no. 87; Murphy 1985, 59.

66. *Bathers in a Clearing,* about 1870–75
Oil on canvas
92 x 73.2 cm (36 1/4 x 28 7/8 in.)
Gift of James Davis 76.4

PROVENANCE
Until 1875, with the artist (d. 1875); May 26–28, 1875, sold at Corot posthumous sale, Hotêl Drouot, Paris, no. 210, and bought by Rosimont (titled in sales catalogue as *A Ville-d'Avray, le vallon derrière la propriété du maître, mai 1874*); 1875, Rosimont. With Gustave Détrimont, Paris. By 1876, James Davis, Boston (possibly acquired from Détrimont); 1876, gift of Davis.

SELECTED EXHIBITIONS
1942 • Norfolk, Va., Norfolk Museum of Arts and Sciences.

1989 • *From Neoclassicism to Impressionism* (Kyoto Museum, Kyoto Shimbun, and MFA 1989), no. 19.

1994 • Tokyo, National Museum of Western Art, September 20–November 27, *Paris en 1874: L'Année de l'Impressionisme* (Yomiuri Shimbun 1994), no. 57.

SELECTED REFERENCES
Clement and Hutton 1883, 1:159; Mollett 1890, 106; Robaut and Moreau-Nélaton 1905, 3:228, no. 1966, 4:29, 215, no. 210; Murphy 1985, 57.

67. *Sketch to Show How Six Paintings Should Be Hung,* 1860s
Pen, brown ink, and brown wash on cream ruled writing paper
Sheet: 10 x 7.8 cm (3 15/16 x 3 1/16 in.)
Helen and Alice Colburn Fund 62.754

PROVENANCE
Dr. Victor Simon, Paris; Mme Cécile Simon-Roland; April 11, 1962, sold Sotheby's London, no. 21; 1962, sold by Colnaghi's, London, to the MFA.

68. *Landscape, with Large Tree on Left, Two Figures at Right, One Holding Long Pole,* 1860s
Brush and brown wash on beige wove paper
Sheet: 7 x 9.5 cm (2 3/4 x 3 3/4 in.)
Helen and Alice Colburn Fund 62.753

PROVENANCE
Dr. Victor Simon, Paris; Mme Cécile Simon-Roland; April 11, 1962, sold Sotheby's London, no. 21; 1962, sold by Colnaghi's, London, to the MFA.

69. *Landscape, with Grove of Trees at Left, Two Men with Long Poles at Right,* 1860s
Brush and brown wash on beige wove paper
Sheet: 5.9 x 10.3 cm (2 5/16 x 4 1/16 in.)
Helen and Alice Colburn Fund 62.755

PROVENANCE
Dr. Victor Simon, Paris; Mme Cécile Simon-Roland; April 11, 1962, sold Sotheby's London, no. 21; 1962, sold by Colnaghi's, London, to the MFA.

Gustave Courbet
French, 1819–1877

46. *Stream in the Forest*, about 1862
Oil on canvas
157 x 114 cm (61¾ x 44⅞ in.)
Gift of Mrs. Samuel Parkman Oliver 55.982

PROVENANCE
After 1862, Potter Dekens, Brussels. With Galerie Allard (probably Joseph Allard), Paris. Until January 4, 1923, Meyer Goodfriend (New York?); January 4, 1923, sold at Meyer Goodfriend sale, American Art Galleries, New York, no. 61, called *Paysage avec biches*, and bought by Wildenstein and Co., London, New York, and Paris. With Paul Rosenberg & Co., New York (?). By 1936–55, Sir A. Chester Beatty (d. 1968), London; March 1955, acquired from Beatty by Paul Rosenberg & Co., New York; 1955, sold by Paul Rosenberg & Co. to the MFA.

SELECTED EXHIBITIONS
1936 • London, Anglo-French Art and Travel Society, *Masters of Nineteenth-Century Painting*, no. 29.

1937 • Paris, Palais des Beaux-Arts, *Chefs-d'oeuvre de l'art français*, no. 280.

1939 • Belgrade, Prince Paul Museum, *French Painting of the Nineteenth Century*, no. 26.

1957 • New York, Paul Rosenberg & Co., February 6–March 2, *Masterpieces Recalled: A Loan Exhibition of Nineteenth- and Twentieth-Century French Paintings* (benefit exhibition for the League for Emotionally Disturbed Children, Inc.) (Paul Rosenberg 1957), no. 5.

1959–60 • Philadelphia, Philadelphia Museum of Art, December 16, 1959–February 14, 1960, *Gustave Courbet* (PMA 1959), no. 68.

1979–80 • *Corot to Braque* (Poulet and Murphy 1979), no. 21.

1983–84 • *Masterpieces of European Painting* (Nippon Television 1983), no. 40.

1988–89 • Brooklyn, N.Y., The Brooklyn Museum; Minneapolis, The Minneapolis Institute of Arts, November 1988–April 1989, *Courbet Reconsidered* (Faunce et al., 1988), no. 37.

1992 • *Crosscurrents*.

1992–93 • *Monet and His Contemporaries* (Bunkamura Museum and MFA 1992), no. 14.

1999 • *Monet, Renoir, and the Impressionist Landscape* (Nagoya/Boston and MFA 1999), no. 17.

2000–2 • *Monet, Renoir, and the Impressionist Landscape* (Shackelford and Wissman 2000), no. 17.

SELECTED REFERENCES
Meier-Graefe 1921a, pl. 58; Léger 1929, pl. 52; MacOrlan 1951, pl. 44; Comstock 1956, 144–43; Cooper 1960, 245; Fitzwilliam Museum 1960, 157; Werner 1960, 47; Delestre 1961, 1–5, no. 27; Murphy 1985, 64; Adams 1994, 6, 154, fig. 1.

Henri Edmond Cross
French, 1856–1910

139. *The Promenade*, 1897
Color lithograph on cream Chinese paper. Johnson 40
Image/sheet: 28 x 40.7 cm (11 x 16 in.)
Bequest of W. G. Russell Allen 60.98

Eugène Cuvelier
French, 1837–1900

24. *Lane in Fog, Arras*, early 1860s
Photograph, salt print from paper negative, mounted
Sheet: 25.7 x 19.8 cm (10⅛ x 7¹¹⁄₁₆ in.)
Lucy Dalbiac Luard Fund 1989.21

PROVENANCE
By 1988, with Harry Lunn; 1988, sold by Lunn to Charles Isaacs, Malvern, Pa.; 1989, sold by Charles Isaacs to the MFA.

SELECTED EXHIBITIONS
1989 • Boston, Museum of Fine Arts, October 7–December 17, *Capturing an Image: Collecting 150 Years of Photography*.

1997 • Stuttgart, Staatsgalerie, March 8–August 31, *Eugène Cuvelier* (Staatsgalerie, Stuttgart 1996), 89, 148, no. II/11.

1998–99 • Boston, Museum of Fine Arts, November 21, 1998–May 23, 1999, *French Photography: Le Gray to Atget.*

SELECTED REFERENCE
Daniel 1996.

25. *At "La Reine Blanche," Forest of Fontainebleau*, 1860s
Photograph, albumen print from paper negative, mounted
Sheet: 25.3 x 34.3 cm (9¹⁵⁄₁₆ x 13½ in.)
Sophie M. Friedman Fund and Gift of

Mack and Paula Lee and William and Drew Schaeffer 1990.175

PROVENANCE
1860s–1989, New England private collection; 1989, sold by the private collection to the Lee Gallery, Winchester, Mass.; 1990, partial gift, partial sale from the Lee Gallery to the MFA.

SELECTED EXHIBITION
1998–99 • Boston, Museum of Fine Arts, November 21, 1998–May 23, 1999, *French Photography: Le Gray to Atget*.

SELECTED REFERENCES
Daniel 1996; Staatsgalerie, Stuttgart 1996, 144, no. 343.

26. *Boundary of Barbizon*, 1860s
Photograph, albumen print from paper negative, mounted
Sheet: 27.3 x 34 cm (9¹¹⁄₁₆ x 13⅜ in.)
Frederick Brown Fund 1996.38

PROVENANCE
1860s–1989, New England private collection; 1989, sold by private collection to the Lee Gallery, Winchester, Mass.; 1996, sold by the Lee Gallery to the MFA.

SELECTED EXHIBITIONS
1997 • Stuttgart, Staatsgalerie, March 8–August 31, *Eugène Cuvelier* (Staatsgalerie, Stuttgart 1996), 142, no. 303.

1998–99 • Boston, Museum of Fine Arts, November 21, 1998–May 23, 1999, *French Photography: Le Gray to Atget.*

SELECTED REFERENCE
Daniel 1996.

Charles-François Daubigny
French, 1817–1878

70. *Château-Gaillard at Sunset*, about 1873
Oil on canvas
38.1 x 68.5 cm (15 x 27 in.)
Gift of Mrs. Josiah Bradlee 18.18

PROVENANCE
By 1918, Mr. and Mrs. Josiah Bradlee, Boston; 1918, gift of Mrs. Josiah Bradlee.

SELECTED EXHIBITIONS
1999 • *Monet, Renoir, and the Impressionist Landscape* (Nagoya/Boston and MFA 1999), no. 16.

2000–2 • *Monet, Renoir, and the Impressionist Landscape* (Shackelford and Wissman 2000), no. 16.

SELECTED REFERENCES
Sterling and Adhémar 1958–61, no. 523, pl. 158; Fidell-Beaufort and Bailly-Herzberg 1975, 202, no. 162; Hellebranth 1976, no. 90; Murphy 1985, 71.

71. *The Boat-Studio*, 1861
Etching on cream laid paper. Delteil 111
Image: 10.2 x 13.4 cm (4 x 5¼ in.); platemark: 13 x 17.8 cm (5⅛ x 8¹⁄₁₆ in.)
Special Print Fund, 1916 M26211

72. *Tree with Crows*, 1867
Etching on cream wove paper. Delteil 120, second state
Image: 18 x 27.4 cm (7¹⁄₁₆ x 10¹³⁄₁₆ in.); platemark: 21.5 x 29.6 cm (8⁷⁄₁₆ x 11⅝ in.)
Frederick Keppel Memorial Bequest, 1913 M23423

73. *The Ford*, 1863
Cliché-verre, salt print, reverse-printed. Delteil 139
Sheet: 27.2 x 36.3 cm (10¹¹⁄₁₆ x 14³⁄₁₆ in.)
Stephen Bullard Memorial Fund 1997.106

PROVENANCE
Alfred Beurdeley stamp (Lugt 421).

SELECTED EXHIBITIONS
1980 • Detroit, The Detroit Institute of Arts, July 12–August 21; Houston, The Museum of Fine Arts, September 11–October 23, *Cliché-verre: Hand-Drawn, Light-Printed, a Survey of the Medium from 1829 to the Present* (Glassman and Symmes 1980), no. 40.

Edgar Degas
French, 1834–1917

81. *At the Races in the Countryside*, 1869
Oil on canvas
36.5 x 55.9 cm (14⅜ x 22 in.)
1931 Purchase Fund 26.790

PROVENANCE
September 17, 1872, sold by the artist to Durand-Ruel, Paris; October 12, 1872, sent to Durand-Ruel, London; April 25, 1873, sold by Durand-Ruel to Jean-Baptiste Faure through Charles Deschamps, Paris; 1873–93, Jean-Baptiste Faure, Paris; January 2, 1893, sold by Jean-Baptiste Faure to Durand-Ruel; March 29, 1918, deposited with the Durand-Ruel family, Les Balans; December 20, 1926, sold by Durand-Ruel, New York, to the MFA.

SELECTED EXHIBITIONS

1872 • London, 168 New Bond Street, October–November, *Fifth Exhibition of the Society of French Artists*, no. 113, called *At the Races.*

1873 • London, 168 New Bond Street, *Sixth Exhibition of the Society of French Artists*, no. 79, called *A Race Course in Normandy.*

1874 • Paris, 35, boulevard des Capucines, April 15–May 15, *Première exposition de la Société anonyme des Artistes Peintres, Sculpteurs, Graveurs,* no. 63, called *Aux courses en Province.*

1899 • Saint Petersburg, *Exhibition of Paintings Organized by "Mir Iskousstva,"* no. 81.

1903–04 • Vienna, *Secession.*

1905 • London, Grafton Galleries, January–February, *Pictures by Boudin, Cézanne, Degas, Manet, Monet* (exhibited by Durand-Ruel) (Grafton Galleries 1905), no. 57.

1917 • Zurich, Kunsthaus, October 5–November 14, *Französische Kunst des 19. und 20. Jahrhunderts,* no. 88.

1922 • Paris, Musée des arts décoratifs, May 27–July 10, *Le décor de la vie sous le second empire,* no. 57.

1924 • Paris, Galerie Georges Petit, April 12–May 2, *Exposition Degas* (Galerie Georges Petit 1924), no. 40.

1929 • Cambridge, Mass., Fogg Art Museum, Harvard University, March 6–April 6, *Exhibition of French Painting of the Nineteenth and Twentieth Centuries* (Fogg Art Museum [1929]), no. 25.

1933 • Chicago, The Art Institute of Chicago, June 1–November 1, *A Century of Progress* (AIC 1933), no. 282.

1936 • Philadelphia, Philadelphia Museum of Art, *Degas, 1834–1917* (PMA 1936), no. 21.

1937 • Paris, Musée du Louvre, l'Orangerie de Tuileries, March–April, *Degas* (Musée de l'Orangerie 1937), no. 14.

1937 • Paris, Palais National des Arts, *Chefs-d'oeuvre de l'art français* (Palais National 1937), no. 301.

1938 • Cambridge, Mass., Fogg Art Museum, Harvard University, April 20–May 21, *The Horse: Its Significance in Art* (Fogg Art Museum [1938]), no. 147.

1939 • San Francisco, Golden Gate International Exposition, *Masterworks of Five Centuries* (Golden Gate 1939), no. 147.

1946–47 • Toledo, Ohio, The Toledo Museum of Art, November–December, 1946; Toronto, Art Gallery of Toronto, January–February 1947, *Development of French Culture for 200 Years* (Toledo Museum [1946]), no. 42.

1955 • Paris, Musée de l'Orangerie, April 20–July 3, *De David à Toulouse-Lautrec: Chefs-d'oeuvre des collections américaines* (Musée de l'Orangerie 1955), no. 20.

1958 • Los Angeles, Los Angeles County Museum of Art, March, *An Exhibition of Works by Edgar Hilaire Germain Degas, 1834–1917* (LACMA [1958]), no. 17.

1958 • Brussels, Palais International des Beaux-Arts, August 8–October 19, *Man and Art.*

1973 • *Impressionism: French and American* (MFA 1973a), no. 4.

1974–75 • New York, The Metropolitan Museum of Art, December 12, 1974–February 10, 1975, *Impressionism: A Centenary Exhibition* (Dayez-Distel et al. 1974), no. 13.

1983–84 • *Masterpieces of European Painting* (Nippon Television 1983), no. 48.

1985 • Boston, Museum of Fine Arts, February 13–June 2, *The Great Boston Collectors: Paintings from the Museum of Fine Arts, Boston* (Troyen and Tabbaa 1984), no. 39.

1986 • Washington, D.C., National Gallery of Art, January 17–April 6; San Francisco, The Fine Arts Museums of San Francisco, April 19–July 9, *The New Painting: Impressionism, 1874–1886* (Moffett et al. 1986), no. 4.

1988–89 • Paris, Grand Palais, February 9–May 16, 1988; Ottawa, National Gallery of Canada, June 27–August 28, 1988; New York, The Metropolitan Museum of Art, September 27, 1988–January 8, 1989, *Degas* (Boggs et al. 1988), no. 95.

1992 • *Crosscurrents.*

1994–95 • Paris, Grand Palais, April 19–August 8, 1994; New York, The Metropolitan Museum of Art, September 19, 1994–January 8, 1995, *Impressionnisme: Les origines, 1859–1869* (Loyrette and Tinterow 1994), no. 66.

1995 • *The Real World* (Sogo Museum and MFA 1994), no. 38.

1998 • Washington, D.C., National Gallery of Art, April 12–July 12, *Degas at the Races* (Boggs et al. 1998), no. 38.

1999 • New Orleans, New Orleans Museum of Art, May 1–August 9; Copenhagen, Ordrupgaard, September 16–November 28, *Degas and New Orleans: A French Impressionist in America* (Feigenbaum et al. 1999), no. 18.

2000–2 • *Monet, Renoir, and the Impressionist Landscape* (Shackelford and Wissman 2000), no. 32.

SELECTED REFERENCES

Carjat 1874, 3; Chesneau 1874, 2; Mauclair 1903, 35; Sickert 1905, 101; Grappe 1911, 18; Jamot 1918, 137–38; Lafond 1918–19, 1:141, 2:42; Liebermann 1918, 6; Hertz 1920, 29, 97; Meier-Graefe 1923, 35, pl. 21; Jamot 1924, 81, 141, pl. 32; Lemoisne 1924, 27; Jenks 1927, 2–3; Manson 1927, 20, 46, pl. 18; "Carriages at the Races" 1929, 34; Degas 1931, 65, note 1; Rivière 1935, 174; Barazetti 1936, 43; Venturi 1939, 2:194; Wilenski 1940, 5, 9, 31, pl. 9A; Gammell [1946], pl. 59; Lemoisne 1946–49, 1:85, 2: no. 281; Rewald 1946, 264; Edgell 1949, 45; Rich 1951, 52; Fosca 1954, 34–39; Shinoda 1957, 57–58, pl. 93; Cabanne 1958, 23, 27, 35, 48, 97, 110; Boggs 1962, 37, 46, 92–93, note 66, pl. 72; Scharf 1962, 191, fig. 7; Pickvance 1963, 257; Coke 1964, 15, 69, note 34; Wildenstein 1968, 2; MFA [1970], 80, no. 52; Russoli and Minervino 1970, no. 203; Clark 1973, 314, fig. 244; MFA 1973b, no. 7; Rewald 1973a, 311; Sutton 1975, 6, fig. 3; Hüttinger 1977 [1988], 62; Dunlop 1979, 93, no. 84; Harris 1979, 64; Kelder 1980, 129, 157, 160; Canaday 1981, 237, fig. 282; McMullen 1984, 194–96; Sutton 1984, 286, fig. 11; Murphy 1985, 75; MFA 1986, 67; Sutton 1986, 144, fig. 115; Clarke 1991b, 16, fig. 3; Bailey 1997, 70, fig. 82; Benfey 1997, 76–77; Rathbone and Shackelford 2001, 26, fig. 19.

82. *Racehorses at Longchamp,* 1871, possibly reworked in 1874
Oil on canvas
34.1 x 41.8 cm. (13⅜ x 16½ in.)
S. A. Denio Collection 03.1034

PROVENANCE

By 1900, Bernheim-Jeune, Paris; February 10, 1900, sold by Bernheim-Jeune to Durand-Ruel, Paris; 1900–1, with Durand-Ruel, Paris, no. 5689; February 20, 1901, sold by Durand-Ruel, Paris, to Durand-Ruel, New York; March 27, 1901, sold by Durand-Ruel, New York, to William H. Moore, New York. By 1903, with Durand-Ruel, New York, no. 2494; 1903, sold by Durand-Ruel to the MFA.

SELECTED EXHIBITIONS

1911 • Cambridge, Mass., Fogg Art Museum, Harvard University, April, *Loan Exhibition of Paintings and Pastels by H. G. E. Degas,* no. 10.

1929 • Cambridge, Mass., Fogg Art Museum, Harvard University, March 6–April 6, *Exhibition of French Painting of the Nineteenth and Twentieth Centuries* (Fogg Art Museum [1929]), no. 32.

1935 • Kansas City, Mo., William Rockhill Nelson Gallery of Art and Mary Atkins Museum of Fine Arts, March 31–April 28, *One Hundred Years of French Painting, 1820–1920* (William Rockhill 1935), no. 21.

1937 • Paris, Musée du Louvre, l'Orangerie de Tuileries, March–April, *Degas* (Musée de l'Orangerie 1937), no. 12.

1938 • Cambridge, Mass., Fogg Art Museum, Harvard University, April 20–May 21, *The Horse: Its Significance in Art* (Fogg Art Museum [1938]), no. 16.

1938 • Amsterdam, Stedelijk Museum, July–September, *Honderd jaar Fransche kunst* (Stedelijk Museum [1938]), no. 98.

1939 • New York, Knoedler & Co., January 9–28, *Views of Paris: Loan Exhibition of Paintings* ([Knoedler] [1939]), no. 28.

1947 • Cleveland, The Cleveland Museum of Art, February 5–March 9, *Works by Edgar Degas* (CMA 1947), no. 31.

1949 • New York, Wildenstein Galleries, April–May, *A Loan Exhibition of Degas for the Benefit of the New York Infirmary* (Wildenstein 1949), no. 29.

1957 • Fort Worth, Tex., Fort Worth Art Center, January 7–March 3, *Horse and Rider* (Fort Worth 1957), no. 103.

1960 • Richmond, Va., Virginia Museum of Fine Arts, April 1–May 15, *Sport and the Horse* (Virginia Museum [1960]), no. 59.

1968 • New York, Wildenstein Galleries, March 21–April 27, *Degas' Racing World: A Loan Exhibition of Paintings, Drawings, and Bronzes, for the Benefit of the National*

Museum of Racing, Saratoga (Wildenstein 1968), no. 5.

1973 • *Impressionism: French and American* (MFA 1973a), no. 5.

1977–78 • Boston, Museum of Fine Arts, November 8, 1977–January 15, 1978, *The Second Greatest Show on Earth: The Making of a Museum* (MFA [1977]), no. 25.

1978 • Richmond, Va., Virginia Museum of Fine Arts, May 23–July 9, *Degas* (Virginia Museum 1978), no. 8.

1978 • New York, Acquavella Galleries, November 1–December 3, *Edgar Degas* (Acquavella Galleries 1978), no. 10.

1979–80 • *Corot to Braque* (Poulet and Murphy 1979), no. 35.

1982–83 • Washington, D.C., National Gallery of Art, December 5, 1982–March 6, 1983, *Manet and Modern Paris* (Reff 1982), no. 72.

1985 • Boston, Museum of Fine Arts, February 13–June 2, *The Great Boston Collectors: Paintings from the Museum of Fine Arts, Boston* (Troyen and Tabbaa 1984), no. 38.

1988–89 • Paris, Grand Palais, February 9–May 16, 1988; Ottawa, National Gallery of Canada, June 27–August 28, 1988; New York, The Metropolitan Museum of Art, September 27, 1988–January 8, 1989, *Degas* (Boggs et al. 1988), no. 96.

1998 • Washington, D.C., National Gallery of Art, April 12–July 12, *Degas at the Races* (Boggs et al. 1998), no. 49.

1999 • *Monet, Renoir, and the Impressionist Landscape* (Nagoya/Boston and MFA 1999), no. 32.

2001 • Atlanta, High Museum of Art, March 3–May 27; Minneapolis, The Minneapolis Institute of Arts, June 16–September 9, *Degas and America: The Early Collectors* (Dumas and Brenneman [2001]), no. 29.

SELECTED REFERENCES
Grappe 1911, 20–23, 48; Lemoisne [1911?], 77–79, pl. 31; Lafond 1918–19, 2:42; Thiébault-Sisson 1918, 3; Hertz 1920, 100, 108; Manson 1927, 28, 46, pl. 48; Waldman 1927, 95, 470; "Carriages at the Races" 1929, 34; Wilenski 1931, 272; Mauclair 1937, fig. 48; Wolf 1938, 117; Lemoisne 1946–49, 1:86, no. 334, 2:174, no. 334; Edgell 1949, 44; Fosca 1954, 39–40; Cabanne 1958, 28, 48, 110, 126, pl. 45 (detail); Novotny 1960,

pl. 168B; Bodelson 1968, 345; Russoli and Minervino 1970, no. 384; Novotny 1971, pl. 294; Dunlop 1979, 118, no. 108; Brettell and McCullagh 1984, 54; Fairley 1984, 21–22, 127; McMullen 1984, 239; Sutton 1984, fig. 6; Murphy 1985, 74; Lipton 1986, 23, fig. 12; Pyle 1986, xv, fig. 9; Sutton 1986, 144, fig. 114; Brettell et al. 1988, 489; Shackelford and Wissman 2000, 14, fig. 4.

85. *Cliffs on the Edge of the Sea,* 1869
Pastel on paper
44.3 x 58.5 cm (17⅜ x 23 in.)
Gift of Lydia Pope Turtle and Isabel Pope Conant in memory of their father, Hubert Pope 1980.390

PROVENANCE
July 2–4, 1919, Degas studio sale (4th), no. 59b. Collection Nunès and Fiquet, Paris. By 1928, with Alexander Reid, Reid and Lefevre, London; 1928, bought from Reid and Lefevre by Herbert Pope, Chicago; inherited by Lydia Pope Turtle and Isabel Pope Conant (daughters); by 1980, Lydia Pope Turtle, Bedford and Brookline, Mass.; 1980, gift of Lydia Pope Turtle and Isabel Pope Conant.

SELECTED REFERENCES
Galerie Georges Petit 1918–19, 4:53, no. 59b; Lemoisne 1946–49, 2:112–13, no. 217; Murphy 1985, 77; Kendall 1993, 91, fig. 70.

94. *Beside the Sea,* 1876–77
Monotype on cream wove paper. Janis 264
Platemark: 11.8 x 16.2 cm (4⅝ x 6⅜ in.)
Gift of Mr. and Mrs. Peter A. Wick 1993.1015

PROVENANCE
November 22–23, 1918, Degas studio sale, Galerie Manzi-Joyant, Paris, no. 300; Gustave Pellet; Maurice Exteens; 1930, Marcel Guérin (Lugt suppl. 1872b); with Gérald Cramer, Geneva; 1952, sold by Cramer to Mr. and Mrs. Peter A. Wick, Boston; 1993, gift of the Wicks.

SELECTED EXHIBITIONS
1968 • Cambridge, Mass., Fogg Art Museum, April 25–June 14, *Degas Monotypes* (Janis [1968]), no. 61, checklist no. 264.

1988–89 • Paris, Grand Palais, February 9–May 16, 1988; Ottawa, National Gallery of Canada, June 27–August 28, 1988; New York, The Metropolitan Museum of Art, September 27–January 8, 1989, *Degas* (Boggs et al. 1988), cat. no. 152.

1994 • New York, The Metropolitan Museum of Art, January 21–April 3; Houston, The Museum of Fine Arts, April 24–July 3, *Degas Landscapes*.

SELECTED REFERENCE
Kendall 1993, 128, fig. 106.

95. *The Path up the Hill,* 1877–79
Monotype on cream wove paper. Janis 267
Platemark: 11.6 x 16.1 cm (4⁹⁄₁₆ x 6⁵⁄₁₆ in.)
Fund in memory of Horatio Greenough Curtis 24.1688

PROVENANCE
November 22–23, 1918, Degas studio sale, Galerie Manzi-Joyant, Paris, no. 308; Sagot-LeGarrec, Paris; 1924, sold by Sagot-LeGarrec to MFA.

SELECTED EXHIBITIONS
1968 • Cambridge, Mass., Fogg Art Museum, April 24–June 14, *Degas Monotypes* (Janis [1968]), cat. no. 64, checklist no. 267.

1985 • London, Hayward Gallery, May 15–July 7, *Edgar Degas: The Painter as Printmaker* (complementary exhibition of monotypes, no cat.).

1994 • New York, The Metropolitan Museum of Art, January 21–April 3; Houston, The Museum of Fine Arts, April 24–July 3, *Degas Landscapes*.

SELECTED REFERENCE
Kendall 1993, 131, fig. 111.

121. *Autumn Effect,* 1890
Color monotype on beige wove paper
Sheet: 29.8 x 40 cm (11¾ x 15¾ in.)
Gift of her children in memory of Elizabeth Paine Metcalf 1992.565

PROVENANCE
1893, Durand-Ruel, Paris; Maurice Exteens; Paul Brame and César de Hauke, Paris; Sir Robert Abdy, London; Valentine Abdy, Paris; La Galerie de L'Oeil, Paris; E. V. Thaw and Co., New York; by 1968, R. M. Light & Co., Boston; Elizabeth Paine Card Metcalf, Boston; 1992, gift of Metcalf's children.

SELECTED EXHIBITIONS
1968 • Cambridge, Mass., Fogg Art Museum, April 24–June 14, *Degas Monotypes* (Janis [1968]), cat. no. 75, checklist no. 299.

1994 • Houston, Museum of Fine Arts, April 24–July 3, *Degas Landscapes* (not in catalogue).

122. *Landscape,* 1890
Pastel over color monotype on dark cream laid paper
31.1 x 41.3 cm (12¼ x 16¼ in.)
Denman Waldo Ross Collection 09.296

PROVENANCE
June 2, 1893, purchased from the artist by Durand-Ruel, Paris; 1893–94, with Durand-Ruel, Paris, no. 2771; October 25, 1894, sold by Durand-Ruel, Paris, to Durand-Ruel, New York, no. 1241; November 17, 1894, sold by Durand-Ruel, New York, to Denman Waldo Ross, Cambridge, Mass.; 1909, gift of Denman Waldo Ross.

SELECTED EXHIBITIONS
1892 • Paris, Durand-Ruel, November, *Paysage de Degas.*

1897 • Boston, Copley Hall, March 5–28, *Loan Exhibition of One Hundred Masterpieces,* no. 11.

1911 • Cambridge, Mass., Fogg Art Museum, Harvard University, April 1–15, *Loan Exhibition of Paintings and Pastels by H. G. E. Degas,* no. 12.

1968 • Cambridge, Mass., Fogg Art Museum, Harvard University, April 25–June 14, *Degas Monotypes* (Janis [1968]), no. 69, checklist no. 279 (provenance and exhibition history mistakenly interchanged with cat. no. 70).

1973 • *Impressionism: French and American* (MFA 1973a), no. 11 (exhibited as a pair with Degas's *Landscape* [09.295]).

SELECTED REFERENCES
Manson 1927, 46; Lemoisne 1946–49, 3: no. 1055; Russoli and Minervino 1970, no. 983; Murphy 1985, 75; Kendall 1993, 170–71, fig. 151.

123. *Landscape,* 1892
Pastel over color monotype on cream wove paper
26.7 x 35.6 cm (10½ x 14 in.)
Denman Waldo Ross Collection 09.295

PROVENANCE
June 2, 1893, purchased from the artist by Durand-Ruel, Paris; 1893–94, with Durand-Ruel, Paris; October 25, 1894, transferred from Durand-Ruel, Paris, to Durand-Ruel, New York; November 17, 1894, sold by Durand-Ruel, New York, to Denman Waldo Ross, Cambridge, Mass.; 1909, gift of Denman Waldo Ross.

Column 1

SELECTED EXHIBITIONS

1892 • Paris, Durand-Ruel, November, *Paysage de Degas.*

1897 • Boston, Copley Hall, March 5–28, *Loan Exhibition of One Hundred Masterpieces,* no. 10.

1911 • Cambridge, Mass., Fogg Art Museum, Harvard University, April 1–15, *Loan Exhibition of Paintings and Pastels by H. G. E. Degas,* no. 11.

1968 • Cambridge, Mass., Fogg Art Museum, Harvard University, April 25–June 14, *Degas Monotypes* (Janis [1968]), no. 70, checklist no. 284 (provenance and exhibition history mistakenly interchanged with cat. no. 69).

1972 • New York, The Metropolitan Museum of Art, October 12–December 15.

1973 • *Impressionism: French and American* (MFA 1973a), no. 11 (exhibited as a pair with Degas's *Landscape* [09.296]).

1974 • Boston, Museum of Fine Arts, June 20–September 1, *Edgar Degas: The Reluctant Impressionist* (Shapiro [1974]), no. 106.

1980–81 • New York, The Metropolitan Museum of Art, October 16–December 7; Boston, Museum of Fine Arts, January 24–March 22, *The Painterly Print: Mono-types from the Seventeenth to Twentieth Century* (Metropolitan 1980b), no. 31.

SELECTED REFERENCES

Manson 1927, 46; Lemoisne 1946–49, 3: no. 1045; Russoli and Minervino 1970, no. 958; Janis 1973, [178–79]; Murphy 1985, 75; Sutton 1986, 280; Boggs et al. 1988, 504; Kendall 1993, 193–94, fig. 172.

Narcisse-Virgile Diaz de la Peña
French, 1808–1876

10. *Bohemians Going to a Fête,* about 1844
Oil on canvas
101 x 81.3 cm (39¾ x 32 in.)
Bequest of Susan Cornelia Warren
03.600

PROVENANCE

Until 1846, Paul Périer, Paris; December 19, 1846, sold at Périer sale, Bonnefons, Paris, no. 4, and bought by M. A. Mosselman;

Column 2

December 4, 1849, sold at Mosselman sale, Rolin, Paris, no. 86, and bought by Getting. Mme André Edouard, Paris. With Arnold and Tripp, Paris. 1868–73, with Laurent-Richard, Paris; April 7, 1873, sold at Laurent-Richard sale, Paris, and bought by Gustave Viot, Paris; 1886, Viot sale, Paris. By 1893, Mrs. Samuel Dennis Warren (d. 1901), Boston; 1901, inherited by Miss Susan Cornelia Warren, Boston; January 8, 1903, sold at Warren sale, American Art Association, New York, no. 113, and bought by Samuel Putnam Avery (dealer, d. 1904), New York, for the MFA; June 13, 1903, sold by Samuel Putnam Avery to the MFA.

SELECTED EXHIBITIONS

1844 • Paris, *Salon,* no. 553.

1877 • Paris, Ecole nationale des Beaux-Arts, *Diaz de la Peña,* no. 6.

1893 • Chicago, *World Columbian Exposition,* no. 2913.

1897 • Boston, Copley Hall, March 5–28, *Loan Exhibition of One Hundred Masterpieces,* no. 24.

1901 • Boston, St. Botolph Club, no. 17.

1902 • Boston, Museum of Fine Arts, *Paintings from the Collection of the Late Mrs. Samuel Dennis Warren,* no. 35.

1962–63 • San Francisco, California Palace of the Legion of Honor, September 24–November 4, 1962; Toledo, Ohio, The Toledo Museum of Art, November 20–December 27, 1962; Cleveland, The Cleveland Museum of Art, January 15–February 24, 1963; Boston, Museum of Fine Arts, March 15–April 28, 1963, *Barbizon Revisited* (Herbert 1962), no. 38.

1965 • Indianapolis, Herron Museum of Art, February 21–April 11, *The Romantic Era: Birth and Flowering, 1750–185c* (Art Association of Indianapolis [1965]), no. 48.

1979–80 • *Corot to Braque* (Poulet and Murphy 1979), no. 10.

1995 • *The Real World* (Sogo Museum and MFA 1994), no. 10.

1999 • *Monet, Renoir, and the Impressionist Landscape* (Nagoya/Boston and MFA 1999), no. 6.

2000–2 • *Monet, Renoir, and the Impressionist Landscape* (Shackelford and Wissman 2000), no. 6.

Column 3

SELECTED REFERENCES

Explication des ouvrages 1844, 70, no. 35; "Salon de 1844" 1844, 1–2; Silvestre 1856, 225; Claretie 1875, 17; Claretie 1876, 26–27; Ballu 1877, 294, 298; Silvestre 1878, 219; Claretie 1882–84, 1:228; Wolff 1883, no. 35; Stranahan 1888, 253; "'The Descent of the Gypsies'" 1890, 176–77; Mollett 1890, 97, 124, appendix; Frapp 1903, 34; La Farge 1903, 127–29; Tomson 1903, 161–62; La Farge 1908 119; MFA 1921, 96; MFA 1955, 19; Grate [1959], 207; Durbé and Damigella 1969, 19, no. 28; Bouret 1972, 105; Bouret 1973, 105, 122; Murphy 1985, 82.

François-Louis Français
French, 1814–1897

74. *Sunset,* 1878
Oil on canvas
47.1 x 56.3 cm (18½ x 22⅛ in.)
Bequest of Ernest Wadsworth Longfellow
37.598

PROVENANCE

By 1884?, Ernest Wadsworth Longfellow, Boston; 1937, bequest of Ernest Wadsworth Longfellow.

SELECTED EXHIBITIONS

1989 • *From Neoclassicism to Impressionism,* no. 36.

1999 • *Monet, Renoir, and the Impressionist Landscape* (Nagoya/Boston and MFA 1999), no. 13.

2000–2 • *Monet, Renoir, and the Impressionist Landscape* (Shackelford and Wissman 2000), no. 12.

SELECTED REFERENCE

Murphy 1985, 101.

110. *Morning on the Banks of the Sèvre at Clisson,* 1884
Watercolor over graphite pencil on cream wove paper
Sheet: 48 x 60 cm (18⅞ x 23⅝ in.)
Bequest of Mrs. Arthur Croft 01.6233

PROVENANCE

1898, Français estate sale, no. 153/171; Gardner Brewer, Mass.; Mrs. Arthur Croft; 1901, bequest of Mrs. Arthur Croft.

SELECTED EXHIBITION

1977 • Boston, Museum of Fine Arts, June 4–September 4, 1977, *Watercolor in Nineteenth-Century Europe.*

Column 4

Charles Paul Furne fils
French, active 1850–1870

31. *Douarnenez, a Fishing Village in Brittany,* 1858–59
Photograph, albumen print from glass-plate negative, corners rounded, mounted
Sheet: 20.3 x 26.7 cm (8 x 10½ in.)
Gift of Jessie H. Wilkinson. Jessie H. Wilkinson Fund 1998.74

PROVENANCE

Robert Hershkowitz, Sussex, England; 1998, sold by Robert Hershkowitz to the MFA.

SELECTED EXHIBITION

1998–99 • Boston, Museum of Fine Arts, November 21, 1998–May 23, 1999, *French Photography: Le Gray to Atget.*

SELECTED REFERENCE

Daniel 1992, 24–27 and notes 54, 55.

Attributed to Paul Gaillard
French, active 1850s/60s–1890

50. *Farmyard,* 1850s
Photograph, albumen print from glass-plate negative, mounted
Sheet: 20 x 25.5 cm (7⅞ x 10¹/₁₆ in.)
Anonymous Loan, Promised Gift 387.1974

PROVENANCE

Gérard Lévy, Paris; sold by Lévy to current anonymous lender; promised gift to MFA.

SELECTED EXHIBITION

1998–99 • Boston, Museum of Fine Arts, November 21, 1998–May 23, 1999, *French Photography: Le Gray to Atget.*

SELECTED REFERENCES

Trillat et al. 1979; Jammes and Janis 1983, 180–81.

Paul Gauguin
French, 1848–1903

115. *Entrance to the Village of Osny,* 1882–83
Oil on canvas
60 x 72.6 cm (23⅝ x 28⅝ in.)
Bequest of John T. Spaulding 48.545

PROVENANCE

July 1883, given by the artist to Camille Pissarro (painter, d. 1903), Eragny-sur-Epte; by 1903, sold by Pissarro to Jean-Baptiste

Faure (d. 1914), Paris; by 1903–14, Jean-Baptiste Faure; 1914, purchased at the Faure estate sale by Durand-Ruel, Paris, no. 4520; 1914–21, with Durand-Ruel, Paris and New York; March 3, 1921, sold by Durand-Ruel to John Taylor Spaulding (d. 1948), Boston; 1921–48, John Taylor Spaulding, Boston; 1948, bequest of John Taylor Spaulding.

SELECTED EXHIBITIONS

1931–32 • Boston, Museum of Fine Arts, May 26, 1931–October 27, 1932, *Collection of Modern French Paintings, Lent by John T. Spaulding.*

1948 • Boston, Museum of Fine Arts, May 26–November 7, *The Collections of John Taylor Spaulding 1870–1948* (MFA 1948), no. 29.

1950 • Springfield, Mass., Springfield Museum of Fine Arts, January 15–February 19, *In Freedom's Search* (Springfield Museum 1950), no. 8.

1954 • Houston, The Museum of Fine Arts, March 27–April 25, *Paul Gauguin: His Place in the Meeting of East and West* (MFA Houston [1954]), no. 4.

1955 • Cambridge, Mass., Fogg Art Museum, Harvard University, May 2–31, *From Sisley to Signac: A Museum Course Exhibition* (Fogg [1955]), no. 7.

1960 • Paris, Galerie Charpentier, January 7–February 28, *Gauguin*, no. 13.

1960 • Munich, Haus der Kunst, April 1–May 29, *Paul Gauguin* (Haus der Kunst [1960]), no. 11.

1960 • Vienna, Belvedere Museum, June 1–July 31, *Gauguin*, no. 2.

1963 • Hamburg, Kunstverein, May 4–July 14, *Wegbereiter der modernen Malerei: Cézanne, Gauguin, Van Gogh, Seurat* (Kunstverein [1963]), no. 38.

1963 • Berlin, Orangerie des Schlosses Charlottenburg, September 28–November 24, *Ile de France und ihre Maler: Ausstellung veranstaltet von der Nationalgalerie in der Orangerie des Schlosses Charlottenburg Berlin* (Staatliche Museen [1963]), no. 27.

1973 • *Impressionism: French and American* (MFA 1973a), no. 13.

1979–80 • *Corot to Braque* (Poulet and Murphy 1979), not in catalogue.

1992 • *Crosscurrents.*

1995–96 • London, Hayward Gallery, May 18–August 28, 1995; Boston, Museum of Fine Arts, October 4, 1995–January 14, 1996, *Impressions of France: Monet, Renoir, Pissarro, and Their Rivals* (House et al. 1995), no. 104.

1999 • *Monet, Renoir, and the Impressionist Landscape* (Nagoya/Boston and MFA 1999), no. 56.

2000–2 • *Monet, Renoir, and the Impressionist Landscape* (Shackelford and Wissman 2000), no. 62.

SELECTED REFERENCES

Malingue 1948, 76; Edgell 1949, 73; Van Dovski 1950, 338, no. 9; Estienne 1953a, 27; [Huyghe et al. 1960], 111; Reidemeister 1963, 82; Wildenstein 1964, no. 121; Roskill [1970], 16, 254, note 3, under "Impressionism"; Murphy 1985, 111.

124. *Landscape with Two Breton Women,* 1889
Oil on canvas
72.4 x 92 cm (28½ x 36¼ in.)
Gift of Harry and Mildred Remis and Robert and Ruth Remis 1976.42

PROVENANCE

1889–91, with the artist, Paris; February 23, 1891, sold at Gauguin sale, Hôtel Drouot, Paris, no. 23, and bought through Ker-Xavier Roussel, Paris (d. 1940, address: 94 rue de la Victoire); 1891–1905, jointly owned by Roussel, Paul Sérusier, Maurice Denis, Pierre Bonnard, Edouard Vuillard, Frédéric Henry, and Julien Magnin [1]; 1905–40, acquired by either K.-X. Roussel or Edouard Vuillard, Paris [2]; 1940–54, inherited by Jacques Roussel, Paris (son of Roussel and nephew of Vuillard, address: 35 rue Washington); 1954, sold by Roussel and bought by Georges Maratier for Jean Davray, Paris; 1954–64, Jean Davray, Paris; 1964, sold by Davray to Alex Maguy, Paris (address: 69 rue de Faubourg Ste-Honoré); 1964, sold by Maguy to Harry and Mildred Remis, Boston; 1976, gift of Harry Remis.

NOTES

1. Based on the correspondence of Frédéric Henry (an architect and intimate friend of Edouard Vuillard) from November 17 and December 24, 1905, it is possible that Pierre Hermant (a composer), Paul Percheron (a businessman and mystic), and Henri Roussel (K.-X. Roussel's

brother, a doctor) were also joint owners of this painting (letter from Juliet Bareau to Barbara Shapiro, March 11, 1985).
2. Upon the death of their close friend Julien Magnin (who was in possession of the painting at the time of his death in October 1905), the joint owners drew lots to establish sole ownership of the work of art. It is uncertain whether the painting fell to Vuillard or to Roussel. It should be noted that the family of Vuillard and Roussel claim that Sérusier, Denis, Bonnard, Vuillard, and Roussel bought this picture jointly to help Gauguin, planning to rotate the painting among themselves for specified periods of time. The family claims that this arrangement soon grew impossible and it was Vuillard who finally paid back the other four owners and kept the painting for himself. When he died, his nephew (also Roussel's son) Jacques Roussel inherited it (letter from Daniel Wildenstein to Barbara Shapiro January 28, 1976).

SELECTED EXHIBITIONS

1964 • Paris, Galerie de l'Elysée, June 2–30, *Sept Tableaux Rares*, unnumbered entry in exhibition pamphlet.

1976 • Boston, February–March, *From Impressionism to Symbolism—Paul Gauguin.*

1987 • Tokyo, The National Museum of Modern Art, March 6–May 17; Aichi, Aichi Prefectural Art Gallery, June 12–28, *Paul Gauguin [in Search of Paradise]* (Tokyo Shimbun 1987), no. 35.

2001–2 • Chicago, The Art Institute of Chicago, September 22, 2001–January 13, 2002; Amsterdam, Van Gogh Museum, February 9–June 2, 2002, *Van Gogh and Gauguin: The Studio of the South* (Druick et al. 2001), no. 55.

SELECTED REFERENCES

Natanson 1951, 33; Rewald 1956, 475; Leymarie 1963, 225–26; Rewald 1978, 442, 444; Murphy 1985, 112.

125. *Women Washing Clothes,* 1889
Zincograph on yellow wove paper, hand colored. Guérin 6; Kornfeld 10 A.a
Image: 21 x 26 cm (8¼ x 10¼ in.)
Bequest of W. G. Russell Allen 60.310

SELECTED EXHIBITIONS

1987 • Boston, Museum of Fine Arts, October 17–December 13, *Gauguin and His*

Circle in Brittany: The Prints of the Pont-Aven School.

1993 • Boston, Museum of Fine Arts, June 2–October 31, *The Age of Art Nouveau.*

SELECTED REFERENCES

Boyle-Turner 1986, 44–45; Mongan, Kornfeld, and Joachim 1988, 11–12, 34–35.

151. *Women and a White Horse,* 1903
Oil on canvas
73.2 x 91.7 cm (28⅞ x 36⅛ in.)
Bequest of John T. Spaulding 48.547

PROVENANCE

Gustave Fayet, Igny, France. Moll (?). October 31, 1908, bought by Bernheim-Jeune, Paris. 1909, Ambroise Vollard, Paris. Probably by 1929, with Paul Rosenberg & Co., Paris; possibly by 1929, sold by Rosenberg to John Taylor Spaulding (d. 1948), Boston; 1929?–48, John Taylor Spaulding, Boston; 1948, bequest of John Taylor Spaulding.

SELECTED EXHIBITIONS

1927 • Berlin, Galerie Thannhauser, October, *Paul Gauguin*, no. 79.

1928 • Basel, Kunsthalle, July–August, *Paul Gauguin, 1848–1903* (Kunsthalle 1928), no. 91.

1930 • Amsterdam, Stedelijk Museum, *Van Gogh and His Contemporaries*, no. 176.

1931–32 • Boston, Museum of Fine Arts, May 26, 1931–October 27, 1932, *Collection of Modern French Paintings, Lent by John T. Spaulding.*

1936 • New York, Wildenstein Galleries, March 20–April 18, *Paul Gauguin, 1848–1903: A Retrospective Loan Exhibition* (Wildenstein [1936]), no. 46.

1936 • Cambridge, Mass., Fogg Art Museum, Harvard University, May 1–21, *Paul Gauguin* (Fogg 1936), no. 45.

1948 • Boston, Museum of Fine Arts, May 26–November 7, *The Collections of John Taylor Spaulding 1870–1948* (MFA 1948), no. 31.

1949 • Cambridge, Mass., Fogg Art Museum, Harvard University, February 1–September 15, *Paul Gauguin.*

1949 • Paris, Musée de l'Orangerie, July–October, *Gauguin: Exposition du centenaire* (Musée de l'Orangerie 1949), no. 59.

1950 • Minneapolis, The Minneapolis Institute of Arts, *Gauguin in Tahiti.*

1952 • Montreal, Montreal Museum of Fine Arts, March 7–April 13, *Six Centuries of Landscape* (Montreal 1952), no. 59.

1955 • Edinburgh, Royal Scottish Academy, August 21–September 18; London, The Tate Gallery, September 30–October 26, *Gauguin: An Exhibition of Paintings, Engravings, and Sculpture* (Arts Council [1955]), no. 65.

1955 • Oslo, Kunstnerforbundet, November 11–December 1, *Paul Gauguin*, no. 36.

1956 • New York, Wildenstein Galleries, April 5–May 5, *Loan Exhibition: Gauguin* (Wildenstein [1956]), no. 53.

1959 • Chicago, The Art Institute of Chicago, February 12–March 29; New York, The Metropolitan Museum of Art, April 23–May 31, *Gauguin: Paintings, Drawings, Prints, Sculpture* (AIC 1959), no. 70.

1969–70 • Philadelphia, University Museum, University of Pennsylvania, October 15–December 15, 1969; Stockholm, Ethnographic Museum, January 1969–February 1970, *Paul Gauguin*.

1973 • San Diego, Fine Arts Gallery of San Diego, October 7–November 25, *Dimensions of Polynesia* (Teilhet [1973]), no. XII.12.

1998–99 • Essen, Folkwang Museum, June 17–October 18, 1998; Berlin, Neue Nationalgalerie, October 31, 1998–January 10, 1999, *Paul Gauguin: Das verlorene Paradies* (Költzsch 1998), no. 61.

SELECTED REFERENCES
Frankfurter 1936, 5; Gauguin [1936], 166; Wilenski 1947, 354; Edgell 1949, 6, 73; Van Dovski 1950, 355, no. 397; Wildenstein 1964, no. 636; Mandel 1972, no. 454; Murphy 1985, 112; Maurer 1998, 192, no. 386.

Jean-Léon Gérôme
French, 1824–1904

37. *Black Panther Stalking a Herd of Deer,* 1851
Oil on canvas
52.3 x 74 cm (20⅝ x 29⅛ in.)
Anonymous Gift 30.232

PROVENANCE
By 1873, given by the artist to Théophile Gautier (art critic); January 14–16, 1873, sold at Gautier sale, Hôtel Drouot (Escribe), Paris, no. 36, and purchased by R. W. Sears, Boston. By 1930, with an anonymous collection; 1930, gift of an anonymous donor.

SELECTED EXHIBITIONS
1943 • Cambridge, Mass., Fogg Art Museum, Harvard University (?).

1962 • Cambridge, Mass., Busch-Reisinger Museum, Harvard University, April 26–June 16, *Rivers and Seas: Changing Attitudes toward Landscapes, 1700–1962,* no. 31.

1996 • Boston, Museum of Fine Arts, June 26–October 15, *Hanging to Complement an Egyptian Object. Falcon.*

SELECTED REFERENCES
Catalogue des tableaux 1873, 10, no. 36; Hering 1892, 242; Rosenthal 1982, 78, fig. 77; Murphy 1985, 116; Ackerman 1986, no. 39.

André Giroux
French, 1801–1879

49. *Under the Arbor,* about 1853
Photograph, salt print from paper negative, mounted
Sheet: 20 x 25.5 cm (7⅞ x 10 1/16 in.)
Anonymous Loan, Promised Gift
461.1974

PROVENANCE
Gérard Lévy, Paris; sold by Lévy to current anonymous lender; promised gift to MFA.

SELECTED EXHIBITION
1998–99 • Boston, Museum of Fine Arts, November 21, 1998–May 23, 1999, *French Photography: Le Gray to Atget.*

SELECTED REFERENCES
Jammes and Janis 1983, 183–85; Brettell et al. 1984.

Henri-Joseph Harpignies
French, 1819–1916

131. *Evening at Saint-Privé,* 1890
Oil on canvas
73.7 x 54.5 cm (29 x 21½ in.)
Bequest of Ernest Wadsworth Longfellow
23.486

PROVENANCE
By 1901, with Obach and Co., London; May 5, 1901, sold at Obach sale and bought by Knoedler & Co., London; 1901–3, with Knoedler & Co., London, no. 2689; 1903, sold by Knoedler & Co. to Morris J. Hirsch, London; 1904, sold by Morris J. Hirsch to Knoedler & Co.; March 1904. sold by Knoedler & Co. to Ernest Wadsworth Longfellow (d. 1923), Boston; 1904–23, Ernest Wadsworth Longfellow, Boston; 1923, bequest of Longfellow.

SELECTED EXHIBITIONS
n.d. • New York, Union League Club.

1999 • *Monet, Renoir, and the Impressionist Landscape* (Nagoya/Boston and MFA 1999), no. 19.

2000–2 • *Monet, Renoir, and the Impressionist Landscape* (Shackelford and Wissman 2000), no. 19.

SELECTED REFERENCES
Murphy 1985, 129; Wilmerding 1986, 231, fig. 3.

Paul Huet
French, 1803–1869

6. *Landscape in the South of France,* about 1838–39
Oil on paper mounted on panel
35.6 x 52.4 cm (14 x 20⅝ in.)
Fanny P. Mason Fund in memory of Alice Thevin 1987.257

PROVENANCE
Until April 15, 1878, Huet collection, Paris; April 15–17, 1878, sold at Huet sale, Paris, and bought by Durand-Ruel, Paris. Private collection, Paris (?). Probably by 1986, sold by a private collector to Galerie de la Scala, Paris; 1987, sold by Galerie de la Scala to the MFA.

SELECTED EXHIBITIONS
1999 • *Monet, Renoir, and the Impressionist Landscape* (Nagoya/Boston and MFA 1999), no. 4.

2000–2 • *Monet, Renoir, and the Impressionist Landscape* (Shackelford and Wissman 2000), no. 4.

Eugène Isabey
French, 1803–1886

28. *Harbor View,* about 1850
Oil on canvas
33.3 x 47.9 cm (13⅛ x 18⅞ in.)
The Henry C. and Martha B. Angell Collection 19.101

PROVENANCE
Until 1882, with Doll and Richards, Inc., Boston; March 23–24, 1882, sold at Doll and Richards, Inc., sale, Boston, no. 35. called *Entrance to a Port.* Until 1904, Louis Ralston, Boston; 1904, Dr. Henry Clay Angell (d. 1911), Boston; 1911, inherited by Martha B. Angell (widow, d. 1919), Boston; 1919, gift of Martha B. Angell.

SELECTED EXHIBITIONS
1952 • Hartford, Conn., Wadsworth Atheneum, *The Romantic Circle.*

1962 • Cambridge, Mass., Busch-Reisinger Museum, Harvard University, April 26–June 16, *Rivers and Seas: Changing Attitudes toward Landscapes, 1700–1962,* no. 56.

1967 • Cambridge, Mass., Fogg Art Museum, Harvard University, November 22–December 29, *Eugène Isabey: Paintings, Watercolors, Drawings, Lithographs* (Fogg Art Museum [1967]), no. 14.

1989 • *From Neoclassicism to Impressionism* (Kyoto Museum, Kyoto Shimbun, and MFA 1989), no. 13.

1990 • Boston, Museum of Fine Arts, July 13–August 19, *Boudin in Boston.*

1991 • Salem, Mass., Peabody Museum, May 17–September 16, *Eugène Boudin: Impressionist Marine Paintings* (Sutton 1991), unnumbered entries, pl. 1.

1992–93 • *Monet and His Contemporaries* (Bunkamura Museum and MFA 1992), no. 4.

1999 • *Monet, Renoir, and the Impressionist Landscape* (Nagoya/Boston and MFA 1999), no. 5.

2000–2 • *Monet, Renoir, and the Impressionist Landscape* (Shackelford and Wissman 2000), no. 5.

SELECTED REFERENCES
Miquel 1980, no. 540; Murphy 1985, 136.

29. *Stormy Weather,* about 1836
Lithograph on cream wove paper.
Curtis 81
Image: 11.1 x 18.4 cm (4⅜ x 7¼ in.)
Samuel P. Avery Fund 21.10733

SELECTED EXHIBITION
1996 • Boston, Museum of Fine Arts, January 10–July 7, *Lithography's First Half Century: The Age of Goya and Delacroix,* no. 65.

Alphonse Jeanrenaud
French, before 1835–1895

27. *Cart in Forest Path,* probably early 1860s
Photograph, albumen print from glass-plate negative, top corners rounded, unmounted
Sheet: 23 x 28 cm (9 ⅟₁₆ x 11 in.)
Prints, Drawings, and Photographs Curator's Discretionary Fund 2001.274

PROVENANCE
André Jammes, Paris; October 27, 1999, Sotheby's New York, sold to Robert Klein, Boston; 2001, sold by Robert Klein to the MFA.

SELECTED REFERENCES
Jammes and Sobieszek 1969, illus. no. 115 (variant); The Art Institute of Chicago 1977, no. 71; Auer and Auer 1985; Heilbrun 1986, illus., 65.

Johan Barthold Jongkind
Dutch (worked in France), 1819–1891

77. *Harbor Scene in Holland,* 1868
Oil on canvas
42 x 56 cm (16 ½ x 22 in.)
Gift of Count Cecil Pecci-Blunt 61.1242

PROVENANCE
By 1920, Ferdinand Blumenthal. By at least 1961, Count Cecil Pecci-Blunt, Rome (address: 3 Piazza Arcoeli); 1961, given by Count Cecil Pecci-Blunt to the MFA.

SELECTED EXHIBITIONS
1910 • Paris, Galerie Georges Petit, May, *Exposition de chefs-d'oeuvre de l'école française,* no. 107.

1979–80 • *Corot to Braque* (Poulet and Murphy 1979), not in catalogue (Phoenix venue only).

1990 • Boston, Museum of Fine Arts, July 13–August 19, *Boudin in Boston.*

1991 • Salem, Mass., Peabody Museum, May 17–September 16, *Eugène Boudin: Impressionist Marine Paintings* (Sutton 1991), pl. 4.

1992 • *Crosscurrents.*

1999 • *Monet, Renoir, and the Impressionist Landscape* (Nagoya/Boston and MFA 1999), no. 20.

2000–2 • *Monet, Renoir, and the Impressionist Landscape* (Shackelford and Wissman 2000), no. 20.

SELECTED REFERENCES
Roger-Milès 1920, 105, plate following 104; Hefting 1975, 198, no. 448; Murphy 1985, 153.

Gustave Le Gray
French, 1820–1882

30. *Cloudy Sky—Mediterranean with Mount Agde,* 1856–59
Photograph, albumen print from glass-plate negative, unmounted
Sheet: 31.1 x 39.7 cm (12 ¼ x 15 ⅝ in.)
Gift of Charles Millard in honor of Clifford S. Ackley 1997.241

PROVENANCE
André Jammes; 1971, Lucien Goldschmidt, New York; Charles W. Millard III; 1997, gift of Millard to the MFA.

SELECTED EXHIBITION
1998–99 • Boston, Museum of Fine Arts, November 21, 1998–May 23, 1999, *French Photography: Le Gray to Atget.*

SELECTED REFERENCES
Janis 1987, illus., 73; Jacobson 2001, 45, no. 13; Aubenas et al. 2002, 127, no. 147.

Auguste Lepère
French, 1849–1918

127. *Saint-Jean-de-Monts,* 1900–05
Black and red chalk and opaque watercolor on prepared artist's board
Sheet: 23 x 37.6 cm (9 ⅟₁₆ x 14 ¹³⁄₁₆ in.)
Francis Welch Fund 1988.371

PROVENANCE
Galerie Jacques Fischer/Chantal Kiener, Paris; 1988, sold by Galerie Jacques Fischer/Chantal Kiener to the MFA.

Charles Marville
French, 1816–about 1879

32. *Path in the Bois de Boulogne,* 1858
Photograph, albumen print from glass-plate negative, mounted
Sheet: 26.9 x 36.4 cm (10 ⅗ x 14 ⅜ in.)
Sophie M. Friedman Fund 1984.54

PROVENANCE
Robert Hershkowitz, London; 1984, sold by Hershkowitz to the MFA.

SELECTED EXHIBITIONS
1984 • Boston, Museum of Fine Arts, April 7–July 1, *Trees.*

1989 • Boston, Museum of Fine Arts, October 7–December 17, *Capturing an Image: Collecting 150 Years of Photography.*

1998–99 • Boston, Museum of Fine Arts, November 21, 1998–May 23, 1999, *French Photography: Le Gray to Atget.*

SELECTED REFERENCES
Metropolitan Museum of Art 1980a, no. 99; Jammes and Janis 1983, 214–17; Jay 1995, 329.

Jean-François Millet
French, 1814–1875

51. *Faggot Gatherers Returning from the Forest,* about 1854
Black conté crayon on cream wove paper
Sheet: 28.6 x 46.7 cm (11 ¼ x 18 ⅜ in.)
Gift of Martin Brimmer 76.437

PROVENANCE
May 10–11, 1875, sold at Millet studio sale, Hôtel Drouot, Paris, no. 127, and bought by Richard Hearn for Martin Brimmer (1829–1896); 1876, gift of Martin Brimmer.

SELECTED EXHIBITIONS
1956 • Washington, D.C., The Phillips Gallery, March.

1956 • Great Britain, The Arts Council of Great Britain, circulated June 15–September 15, *Drawings by Jean-François Millet,* no. 51.

1975–76 • Paris, Grand Palais, October 17, 1975–January 5, 1976 (Herbert 1975), no. 172; London, Hayward Gallery, January 22–March 7, 1976, *Jean-François Millet* (Herbert 1976), no. 96.

1984 • *Jean-François Millet* (Murphy 1984), no. 57.

1984–85 • *Jean-François Millet Exhibition* (Nippon Television and MFA 1984), no. 29 (Tokyo, Sapporo, and Yamaguchi venues only).

1999–2000 • Williamstown, Mass., Sterling and Francine Clark Art Institute, June 18–September 7, 1999; Amsterdam, Van Gogh Museum, October 26, 1999–January 5, 2000; Pittsburgh, The Frick Art Museum, February 10–April 23, 2000, *Jean-François Millet: Drawn into the Light* (Murphy et al. 1999), no. 21.

52. *End of the Day,* 1852–54
Black conté crayon heightened with white chalk on blue-gray laid paper

Sheet: 23.6 x 33.1 cm (9 ⅗ x 13 ⅟₁₆ in.)
Gift of Martin Brimmer 76.439

PROVENANCE
1875, Millet studio sale, Hôtel Drouot, Paris, May 10–11, no. 125, bought by Richard Hearn for Martin Brimmer (1829–1896); 1876, gift of Martin Brimmer.

SELECTED EXHIBITIONS
1984 • *Jean-François Millet* (Murphy 1984), no. 42.

1984–85 • *Jean-François Millet Exhibition* (Nippon Television and MFA 1984), no. 25 (Tokyo, Sapporo, and Yamaguchi venues only).

53. *Study for Shepherdess Knitting,* 1862
Black conté crayon on dark cream wove paper
Sheet: 31.4 x 24.2 cm (12 ⅜ x 9 ½ in.)
Gift of Mrs. J. Templeman Coolidge 46.594

PROVENANCE
Paul Marmontel; January 25–26, 1883, sold Hôtel Drouot, Paris, no. 187; by 1908, John Templeman Coolidge, Jr. (1856–1945), Boston; Mrs. J. Templeman Coolidge; 1946, gift of Mrs. J. Templeman Coolidge.

SELECTED EXHIBITIONS
1984 • *Jean-François Millet* (Murphy 1984), no. 92.

1984–85 • *Jean-François Millet Exhibition* (Nippon Television and MFA 1984), no. 50 (Tokyo, Sapporo, and Yamaguchi venues only).

1987 • Boston, Museum of Fine Arts, April 15–July 26, *Printmaking: The Evolving Image,* no. 37.

54. *Shepherdess Knitting,* 1862
Etching on dark cream laid paper.
Delteil 18
Platemark: 32 x 24 cm (12 ⅜ x 9 ⅟₁₆ in.)
Gift of Gordon Abbott 21.10786

SELECTED EXHIBITION
1987 • Boston, Museum of Fine Arts, April 15–July 26, *Printmaking: The Evolving Image,* no. 37.

SELECTED REFERENCE
Murphy 1984, no. 93.

55. *Farmstead near Vichy,* 1866–67
Watercolor and pen and brown ink over graphite pencil on dark cream laid paper
Sheet: 22 x 29 cm (8 ⅟₁₆ x 11 ⅞ in.)
Bequest of Reverend Frederick Frothingham 94.316

PROVENANCE

May 10–11, 1875, sold at Millet studio sale, Hôtel Drouot, Paris, no. 104, and bought by Reverend Frederick Frothingham, Milton, Mass.; 1894, bequest of Reverend Frederick Frothingham.

SELECTED EXHIBITIONS

1956 • Washington, D.C., The Phillips Gallery, March.

1956 • Great Britain, The Arts Council of Great Britain, circulated June 15–September 15, *Drawings by Jean-François Millet*.

1984 • *Jean-François Millet* (Murphy 1984), no. 127.

1984–85 • *Jean-François Millet Exhibition* (Nippon Television and MFA 1984), no. 68 (Tokyo, Sapporo, and Yamaguchi venues only).

1999–2000 • Williamstown, Mass., Sterling and Francine Clark Art Institute, June 18–September 7, 1999; Amsterdam, Van Gogh Museum, October 26, 1999–January 5, 2000; Pittsburgh, The Frick Art Museum, February 10–April 23, 2000, *Jean-François Millet: Drawn into the Light* (Murphy et al. 1999), no. 68.

56. *Road from Malavaux, near Cusset,* 1867
Watercolor and pen and brown ink over graphite pencil on cream laid paper
Sheet: 11.2 x 16.2 cm (4⁷⁄₁₆ x 6⅜ in.)
Gift of Martin Brimmer 76.425

PROVENANCE

May 10–11, 1875, Millet studio sale, Hôtel Drouot, Paris, no. 91, bought by Richard Hearn for Martin Brimmer (1829–1896); 1876, gift of Martin Brimmer.

SELECTED EXHIBITIONS

1956 • Washington, D.C., The Phillips Gallery, March.

1956 • Great Britain, The Arts Council of Great Britain, circulated June 15–September 15, *Drawings by Jean-François Millet*, no. 64.

1977–78 • College Park, Md., University of Maryland Art Gallery, October 26–December 4, 1977; Louisville, Ky., January 9–February 19, 1978; Ann Arbor, Mich., University of Michigan Museum of Art, April 1–May 14, 1978, *From Delacroix to Cézanne* (De Leiris and Smith 1977), no. 120.

1984 • *Jean-François Millet* (Murphy 1984), no. 123.

1984–85 • *Jean-François Millet Exhibition* (Nippon Television and MFA 1984), no. 64 (Tokyo, Sapporo, and Yamaguchi venues only).

57. *End of the Hamlet of Gruchy,* 1866
Oil on canvas
81.5 x 100.5 cm (32⅛ x 39⅝ in.)
Gift of Quincy Adams Shaw through Quincy A. Shaw, Jr., and Mrs. Marian Shaw Haughton 17.1508

PROVENANCE

By 1868, Paul Monmartel; May 11–14, 1868, sold at Monmartel sale, Hôtel Drouot, Paris, no. 55. With Hector Henri Clement Brame, Paris. By 1873, with Jean-Baptiste Faure, Paris; June 7, 1873, sold at Faure sale, Galerie Georges Petit, 26 boulevard des Italiens, Paris, no. 26. By 1879, with Durand-Ruel, Paris; 1879, probably acquired from Durand-Ruel by Quincy Adams Shaw, Boston; 1917, gift of Quincy Adams Shaw through Quincy A. Shaw, Jr., and Mrs. Marian Shaw Haughton.

SELECTED EXHIBITIONS

1866 • Paris, *Salon*, no. 1376.

1889 • New York, American Art Association, *The Works of Antoine-Louis Barye . . . His Contemporaries and Friends for the Benefit of the Barye Monument Fund* (American Art Galleries 1889), no. 553.

1918 • Boston, Museum of Fine Arts, opened April 18, *Quincy Adams Shaw Collection* (MFA 1918a), no. III.

1975–76 • Paris, Grand Palais, October 17, 1975–January 5, 1976 (Herbert 1975), no. 193; London, Hayward Gallery, January 22–March 7, 1976 *Jean-François Millet* (Herbert 1976), no. 112.

1984 • *Jean-François Millet* (Murphy 1984), no. III.

1984–85 • *Jean-François Millet Exhibition* (Nippon Television and MFA 1984), no. 58.

1985 • *IBM Gallery*.

1995–96 • London, Hayward Gallery, May 18–August 28, 1995; Boston, Museum of Fine Arts, October 4, 1995–January 14, 1996, *Impressions of France: Monet, Renoir, Pissarro, and Their Rivals* (House et al. 1995), no. 12.

1999 • *Monet, Renoir, and the Impressionist Landscape* (Nagoya/Boston and MFA 1999), no. II.

2000–02 • *Monet, Renoir, and the Impressionist Landscape* (Shackelford and Wissman 2000), no. 13.

SELECTED REFERENCES

About 1866; Chesneau 1875, 429; Piedagnel 1876, 62, 8c; Burty 1877, 280–81; Strahan 1879, 3:86; Sensier and Mantz 1881, 290–94, 311; Durand-Gréville 1887, 68; Ady 1896, 290–92, 309; Marcel 1901, 74–78; Gensel 1902, 58; Rolland 1902, 107; Peacock 1905, 116–18; MFA 1918b, 15; Moreau-Nélaton 1921, 2:182, 3:1–2, 5, 53, 91, fig. 214; Tabarant 1942, 383; Edgell 1949, 19–20; Fermigier 1977, 19; Bühler 1985, 2551–56; Murphy 1985, 197.

58. *Priory at Vauville, Normandy,* 1872–74
Oil on canvas
90.9 x 116.7 cm (35⅞ x 46 in.)
Gift of Quincy Adams Shaw through Quincy A. Shaw, Jr., and Mrs. Marian Shaw Haughton 17.1532

PROVENANCE

1874–1908, acquired from the artist by Quincy Adams Shaw, Boston (commissioned in 1872); 1908–17, inherited by Quincy A. Shaw, Jr., and Mrs. Marian Shaw Haughton, Boston; 1917, gift of Quincy Adams Shaw through Quincy A. Shaw, Jr., and Mrs. Marian Shaw Haughton.

SELECTED EXHIBITIONS

1918 • Boston, Museum of Fine Arts, opened April 18, *Quincy Adams Shaw Collection* (MFA 1918a), no. 25.

1984 • *Jean-François Millet* (Murphy 1984), no. 149.

1984–85 • *Jean-François Millet Exhibition* (Nippon Television and MFA 1984), no. 80.

1985 • *IBM Gallery*.

1999 • *Monet, Renoir, and the Impressionist Landscape* (Nagoya/Boston and MFA 1999), no. 12.

2000–2 • *Monet, Renoir, and the Impressionist Landscape* (Shackelford and Wissman 2000), no. 14.

SELECTED REFERENCES

Sensier and Mantz 1881, 348–49, 352, 362, 363; Durand-Gréville 1887, 68; Mantz 1887, 32; Ady 1896, 331–32, 334, 339, 344; Peacock 1905, 132; MFA 1918b, 15; Moreau-Nélaton 1921, 3:78–79, 84, 87, 102, 104, fig. 272; Murphy 1985, 201.

59. *Rabbit Warren, Dawn,* 1867
Pastel and black conté crayon on cream wove paper
49.5 x 59.5 cm (19½ x 23⅜ in.)
Gift of Quincy Adams Shaw through Quincy A. Shaw, Jr., and Mrs. Marian Shaw Haughton 17.1522

PROVENANCE

By 1875, Emile Gavet; June 11–12, 1875, sold at Gavet sale, Hôtel Drouot, Paris, no. 70, and bought by Durand-Ruel, Paris and New York; 1875, with Durand-Ruel, Paris and New York. By 1917, Quincy Adams Shaw, Boston; 1917, gift of Quincy Adams Shaw through Quincy A. Shaw, Jr., and Mrs. Marian Shaw Haughton.

SELECTED EXHIBITIONS

1875 • Paris, 7 rue St. Georges, *Dessins de Millet provenant de la collection de M. G. [Gavet]* (*Catalogue des dessins de Millet* 1875), no. 24.

1918 • Boston, Museum of Fine Arts, opened April 18, *Quincy Adams Shaw Collection* (MFA 1918a), no. 47.

1984 • *Jean-François Millet* (Murphy 1984), no. 130.

1984–85 • *Jean-François Millet Exhibition* (Nippon Television and MFA 1984), no. 69.

1985 • *IBM Gallery*.

SELECTED REFERENCES

Soullié 1900b, 108; Guiffrey 1913, 547; Moreau-Nélaton 1921, 3:20–21, fig. 247; Murphy 1985, 200.

60. *Primroses,* 1867–68
Pastel on gray-brown wove paper
40.2 x 47.8 cm (15⅞ x 18⅞ in.)
Gift of Quincy Adams Shaw through Quincy A. Shaw, Jr., and Mrs. Marian Shaw Haughton
17.1523

PROVENANCE

1868–1875, acquired from the artist by Emile Gavet, Paris (commissioned in 1867); June 11–12, 1875, sold at Gavet sale, Hôtel Drouot, Paris, no. 47, and bought by Détrimont (probably for Quincy Adams Shaw). By 1917, Quincy Adams Shaw, Boston; 1917, gift of Quincy Adams Shaw through Quincy A. Shaw, Jr., and Mrs. Marian Shaw Haughton.

SELECTED EXHIBITIONS

1918 • Boston, Museum of Fine Arts, opened April 18, *Quincy Adams Shaw Collection* (MFA 1918a), no. 49.

1962–63 • San Francisco, California Palace of the Legion of Honor, September 24–November 4, 1962; Toledo, Ohio, The Toledo Museum of Art, November 20–December 27, 1962; Cleveland, The Cleveland Museum of Art, January 15–February 24, 1963; Boston, Museum of Fine Arts, March 15–April 28, 1963, *Barbizon Revisited* (Herbert 1962), no. 75.

1975–76 • Paris, Grand Palais, October 1, 1975–January 5, 1976 (Herbert 1975), no. 197; London, Hayward Gallery, January 20–March 20, 1976, *Jean-François Millet* (Herbert 1976), no. 115.

1984 • *Jean-François Millet* (Murphy 1984), no. 135.

1999–2000 • Williamstown, Mass., Sterling and Francine Clark Art Institute, June 18–September 7, 1999; Amsterdam, Van Gogh Museum, October 22, 1999–January 5, 2000; Pittsburgh, The Frick Art Museum, February 10–April 23, 2000, *Jean-François Millet: Drawn into the Light* (Murphy et al. 1999), no. 77.

SELECTED REFERENCES

Burty 1877, 308; Strahan 1879, 3:87; Greta 1881, 72; Soullié 1900b, 100; Guiffrey 1913, 547; Cary 1918, 266; MFA 1918b, 18; Moreau-Nélaton 1921, 3:17–18, fig. 237; Durbé and Damigella 1969, 22, 86, pl. LX; Pollock 1977, 77, no. 54; Iida 1979, 130; Murphy 1985, 200; Fermigier 1991, 104, 138.

61. *Dandelions,* 1867–68
Pastel on tan wove paper
40.2 x 50.2 cm (15⅞ x 19¾ in.)
Gift of Quincy Adams Shaw through Quincy A. Shaw, Jr., and Mrs. Marian Shaw Haughton 17.1524

PROVENANCE

1868–75, acquired from the artist by Emile Gavet, Paris (commissioned in 1867); June 11–12, 1875, sold at Gavet sale, Hôtel Drouot, Paris, no. 94, and bought by Carlin. By 1917, Quincy Adams Shaw, Boston; 1917, gift of Quincy Adams Shaw through Quincy A. Shaw, Jr., and Mrs. Marian Shaw Haughton.

SELECTED EXHIBITIONS

1875 • Paris, 7 rue St. Georges, *Dessins de Millet provenant de la collection de M. G.*

[Gavet] (*Catalogue des dessins de Millet* 1875), no. 46.

1918 • Boston, Museum of Fine Arts, opened April 18, *Quincy Adams Shaw Collection* (MFA 1918a), no. 48.

1963 • Philadelphia, Philadelphia Museum of Art, May 1–June 9, *A World of Flowers.*

1984 • *Jean-François Millet* (Murphy 1984), no. 136.

1984–85 • *Jean-François Millet Exhibition* (Nippon Television and MFA 1984), no. 71.

1985 • *IBM Gallery.*

SELECTED REFERENCES

Burty 1877, 308; Strahan 1879, 3:87; Greta 1881, 72; Soullié 1900b, 120; Guiffrey 1913, 547; Cary 1918, 266; Moreau-Nélaton 1921, 3:18, fig. 239; Murphy 1985, 200; Manoeuvre 1996, 46; Murphy et al. 1999, 110.

62. *Farmyard in Winter,* 1868
Pastel and black conté crayon on buff wove paper
68 x 88.1 cm (26¾ x 34⅜ in.)
Gift of Quincy Adams Shaw through Quincy A. Shaw, Jr., and Mrs. Marian Shaw Haughton 17.1526

PROVENANCE

1868–75, acquired from the artist by Emile Gavet, Paris (commissioned in 1868); June 11–12, 1875, sold at Gavet sale, Hôtel Drouot, Paris, no. 10, and bought by Durand-Ruel, Paris and New York; 1875, with Durand-Ruel, Paris and New York. By 1917, Quincy Adams Shaw, Boston; 1917, gift of Quincy Adams Shaw through Quincy A. Shaw, Jr., and Mrs. Marian Shaw Haughton.

SELECTED EXHIBITIONS

1918 • Boston, Museum of Fine Arts, opened April 18, *Quincy Adams Shaw Collection* (MFA 1918a), no. 45.

1962–63 • San Francisco, California Palace of the Legion of Honor, September 24–November 4, 1962; Toledo, Ohio, The Toledo Museum of Art, November 20–December 27, 1962; Cleveland, The Cleveland Museum of Art, January 15–February 24, 1963; Boston, Museum of Fine Arts, March 15–April 28, 1963, *Barbizon Revisited* (Herbert 1962), no. 74.

1975–76 • Paris, Grand Palais, October 1, 1975–January 5, 1976 (Herbert 1975), no. 199; London, Hayward Gallery, January 20–

March 20, 1976, *Jean-François Millet* (Herbert 1976), no. 117.

1984 • *Jean-François Millet* (Murphy 1984), no. 138.

1999–2000 • Williamstown, Mass., Sterling and Francine Clark Art Institute, June 18–September 7, 1999; Amsterdam, Van Gogh Museum, October 22, 1999–January 5, 2000; Pittsburgh, The Frick Art Museum, February 10–April 23, 2000, *Jean-François Millet: Drawn into the Light* (Murphy et al. 1999), no. 78 (Williamstown venue only).

SELECTED REFERENCES

Strahan 1879, 3:87; Soullié 1900b, 121; Guiffrey 1913, 547; Moreau-Nélaton 1921, 3:39, fig. 253; Murphy 1985, 200; Manoeuvre 1996, 48–49.

63. *Farmyard by Moonlight,* 1868
Pastel and black conté crayon on tan wove paper
70.9 x 86.7 cm (27⅞ x 34⅛ in.)
Gift of Quincy Adams Shaw through Quincy A. Shaw, Jr., and Mrs. Marian Shaw Haughton 17.1525

PROVENANCE

1868–75, acquired from the artist by Emile Gavet, Paris (commissioned in 1868); June 11–12, 1875, sold at Gavet sale, Hôtel Drouot, Paris, no. 48, and bought by Détrimont (probably for Quincy Adams Shaw). By 1917, Quincy Adams Shaw, Boston; 1917, gift of Quincy Adams Shaw through Quincy A. Shaw, Jr., and Mrs. Marian Shaw Haughton.

SELECTED EXHIBITIONS

1875 • Paris, 7 rue St. Georges, *Dessins de Millet provenant de la collection de M. G.* [Gavet] (*Catalogue des dessins de Millet* 1875), no. 12.

1918 • Boston, Museum of Fine Arts, opened April 18, *Quincy Adams Shaw Collection* (MFA 1918a), no. 44.

1975 • Washington, D.C., National Collection of Fine Arts, Smithsonian Institution, January 23–April 20, *American Art in the Barbizon Mood* (Bermingham 1975), no. 9.

1984 • *Jean-François Millet* (Murphy 1984), no. 137.

SELECTED REFERENCES

Strahan 1879, 3:86; Greta 1881, 72; Yriarte 1885, 39; Murphy 1985, 200.

Claude Monet
French, 1840–1926

79. *Rue de la Bavolle, Honfleur,* about 1864
Oil on canvas
55.9 x 61 cm (22 x 24 in.)
Bequest of John T. Spaulding 48.580

PROVENANCE

By 1867, private collection. By 1897, Aimé Diot, Paris; March 8–9, 1897, sold at Diot sale, Hôtel Drouot, Paris, no. 102, called *Une rue.* About 1901, with Arthur Tooth & Sons, London (not in Tooth stock records; probably in Paris stock); November 21, 1902, bought from Tooth & Sons by Durand-Ruel, Paris; 1902–12, with Durand-Ruel, Paris; August 12, 1912, bought from Durand-Ruel by Galerie Thannhauser, Munich, called *Rue de village, Normandie, 1865.* 1915, Oscar Schmitz, Dresden. 1936–40, with Wildenstein and Co., Paris; 1940–48, bought from Wildenstein by John Taylor Spaulding (d. 1948), Boston; 1948, bequest of John Taylor Spaulding.

SELECTED EXHIBITIONS

1905 • Weimar, Grossherzögliches Museum, March, *Monet, Manet, Renoir, und Cézanne,* no. 1.

1928 • Berlin, Galerie Thannhauser, February 15–March (day unknown), *Claude Monet* (Galerie Thannhauser 1928), no. 7.

1932 • Zurich, Kunsthaus, *Sammlung Oscar Schmitz,* no. 33.

1936 • Paris, Wildenstein Galleries, *La Collection Oscar Schmitz* (Schmitz 1936), no. 40.

1948 • Boston, Museum of Fine Arts, May 26–November 7, *The Collections of John Taylor Spaulding, 1870–1948* (MFA 1948), no. 59.

1949 • Cambridge, Mass., Fogg Art Museum, Harvard University, February 1–September 15, *Student Exhibition.*

1949 • Manchester, N.H., The Currier Gallery of Art, October 8–November 6, *Monet and the Beginnings of Impressionism: Twentieth Anniversary Exhibition* (Currier Gallery of Art [1949]), no. 34.

1952 • Zurich, Kunsthaus, May 10–June 15 (Besson and Wehrli [1952]), no. 3; Paris, Galerie des Beaux-Arts, June 19–July 17; The Hague, Gemeentemuseum, July 24–September 22, *Claude Monet* (Haags

[1952]), no. 2 (Zurich and The Hague venues only).

1953 • Kansas City, Mo., William Rockhill Nelson Gallery of Art and Mary Atkins Museum of Fine Arts, *Twentieth Anniversary Exhibition.*

1957 • Edinburgh, Royal Scottish Academy, August 6–September 15; London, The Tate Gallery, September 26–November 3, *Claude Monet* (Tate Gallery [1957]), no. 8.

1972 • Providence, R.I., Museum of Art, Rhode Island School of Design, February 3–March 5, *To Look on Nature: European and American Landscape, 1800–1874* (Brown University 1972), unnumbered entries, pl. 46.

1973 • *Impressionism: French and American* (MFA 1973a), no. 26.

1975 • Chicago, The Art Institute of Chicago, March 15–May 11, *Paintings by Monet* (Masson, Seiberling, and Marandel 1975), no. 5.

1977–78 • *Monet Unveiled* (Murphy and Giese 1977), no. 2.

1980 • Paris, Grand Palais, February 8–May 5, *Hommage à Claude Monet (1840–1926)* (Adhémar, Distel, and Gache-Patin 1980), no. 13.

1983–84 • *Masterpieces of European Painting* (Nippon Television 1983), no. 56.

1985 • Boston, Museum of Fine Arts, February 13–June 2, *The Great Boston Collectors: Paintings from the Museum of Fine Arts, Boston* (Troyen and Tabbaa 1984), no. 52.

1985 • Williamstown, Mass., Sterling and Francine Clark Art Institute, June 8–October 6, *Monet in Massachusetts* (Brooks 1985), unnumbered entry.

1991–92 • *Claude Monet: Impressionist Masterpieces.*

1992 • *Crosscurrents.*

1992–93 • *Monet and His Contemporaries* (Bunkamura Museum and MFA 1992), no. 21.

1994–95 • Paris, Grand Palais, April 19–August 8, 1994; New York, The Metropolitan Museum of Art, September 19, 1994–January 8, 1995, *Impressionnisme: Les origines, 1859–1869* (Loyrette and Tinterow 1994), no. 124 (New York venue only).

1995–96 • London, Hayward Gallery, May 18–August 28, 1995; Boston, Museum of Fine Arts, October 4, 1995–January 14, 1996, *Impressions of France: Monet, Renoir, Pissarro and Their Rivals* (House et al. 1995), no. 57.

1996 • Tokyo, Tobu Museum of Art, March 30–June 30, *Inshoha wa kosaite umareta: Akademisumu kara Kurube, Mune, Mone, Runowaru* (The Birth of Impressionism) (Tobu Bijutsukan 1996), no. 120.

1999 • *Monet, Renoir, and the Impressionist Landscape* (Nagoya/Boston and MFA 1999), no. 39.

2000–2 • *Monet, Renoir, and the Impressionist Landscape* (Shackelford and Wissman 2000), no. 39.

SELECTED REFERENCES
Biermann 1913, 325, fig. 21; Modernen 1916, 31, pl. 16; Scheffler 1921, 178, 186; Dormoy 1926, 342; Malingue 1943, 22, 33, 145, no. 33; Rewald 1946, 119; Reuterswärd 1948, 281; Edgell 1949, 55; Seitz 1960, 19, 22, nos. 15, 16; Rewald [1961], 128; MFA [1970], 85, no. 56; Champa 1973, 60, note 5; MFA 1973b, no. 10; Rewald 1973a, 128; Wildenstein 1974–91, 1: no. 33; Weisberg et al. 1975, 117, fig. 31; Isaacson 1978, 55, 193–95, no. 7; Goldstein 1979, 224; Dufwa 1981, 119–21, 188, fig. 95; Tucker 1982, 27, 29, fig. 12; Isaacson 1984, 19–22, fig. 2; Murphy 1985, 209; Murphy and Giese 1985, 12, no. 2; Howard 1989, 35; Kendall 1989, 37; Rouart [1990], 20; Milner 1991, 27; Wildenstein 1996, 2: no. 33.

83. *View of the Sea at Sunset,* about 1862
Pastel on paper
15.3 x 40 cm (6 x 15¾ in.)
Bequest of William P. Blake in memory of his sister, Anne Dehon Blake 22.604

PROVENANCE
August 25, 1891, sold by the artist to Durand-Ruel, Paris; 1891–1907, with Durand-Ruel, Paris, no. 1429; September 7, 1907, sold by Durand-Ruel to William P. Blake, Boston; 1907–21, William P. Blake, Boston; 1921, bequest of William P. Blake.

SELECTED EXHIBITIONS
1874 • Paris, 35, boulevard des Capucines, April 15–May 15, *Première exposition de la Société anonyme des Artistes Peintres, Sculpteurs, Graveurs.*

1906 • Paris, Bernheim-Jeune, October–November, *Claude Monet* (?).

1927 • Boston, Museum of Fine Arts, January 11–February 6, *Claude Monet: Memorial Exhibition* (MFA 1927), no. 2.

1973 • *Impressionism: French and American* (MFA 1973a), no. 27.

1977–78 • *Monet Unveiled* (Murphy and Giese 1977). no. 3.

SELECTED REFERENCES
Greenberg 1957, 136; Wildenstein 1974–91, 5:219 (pièces justicatives nos. 346–47), no. P34; Gordon and Forge 1983, 140, 292; Murphy 1985, 206; Murphy and Giese 1985, 13, no 3; Bunkamura Museum and MFA 1992, 52, fig. 22.

84. *Broad Landscape,* about 1862
Pastel on paper
17.4 x 36 cm (6⅞ x 14⅛ in.)
Bequest of William P. Blake in memory of his sister, Anne Dehon Blake 22.605

PROVENANCE
August 25, 1891, sold by the artist to Durand-Ruel, Paris; 1891–1907, with Durand-Ruel, Paris, no. 1936; September 7, 1907, sold by Durand-Ruel to William P. Blake, Boston; 1907–21, William P. Blake, Boston; 1921, bequest of William P. Blake.

SELECTED EXHIBITIONS
1874 • Paris, 35, boulevard des Capucines, April 15–May 15, *Première exposition de la Société anonyme des Artistes Peintres, Sculpteurs, Graveurs* (?).

1906 • Paris, Bernheim-Jeune, October–November, *Claude Monet* (?).

1927 • Boston, Museum of Fine Arts, January 11–February 6, *Claude Monet: Memorial Exhibition* (MFA 1927), no. 1.

1973 • *Impressionism: French and American* (MFA 1973a), no. 28.

1977–78 • *Monet Unveiled* (Murphy and Giese 1977), no. 4.

1991–92 • *Claude Monet: Impressionist Masterpieces.*

SELECTED REFERENCES
Wildenstein 1974–91, 5:219 (pièces justicatives nos. 346–47), no. P32; Murphy 1985, 206; Murphy and Giese 1985, 13, no. 4; Bunkamura Museum and MFA 1992, 62, fig. 23.

86. *Ships in a Harbor,* about 1873
Oil on canvas
50 x 61 cm (19⅝ x 24 in.)
Denman Waldo Ross Collection 06.117

PROVENANCE
1880, purchased from the artist by Durand-Ruel, Paris, no. 1234. By 1893, Erwin Davis, New York; March 16, 1893, sold by Davis to Durand-Ruel, New York; 1893–97, with Durand-Ruel, New York, no. 1032; May 28, 1897, sold by Durand-Ruel to Denman W. Ross, Cambridge, Mass.; 1897–1906, Denman W. Ross collection, Cambridge, Mass.; 1906, gift of Denman W. Ross.

SELECTED EXHIBITIONS
1895 • New York, Durand-Ruel, January 12–27, *Tableaux de Claude Monet* (Durand-Ruel 1895), no. 41, called *Marine.*

1895 • Boston, St. Botolph Club, February 4–16, *Claude Monet,* no. 1.

1899 • Boston, St. Botolph Club, February 6–23, *Monet* (St. Botolph [1899]), no. 25.

1905 • Boston, Copley Hall, March 28–April 9, *Monet-Rodin* (Copley Society 1905), no. 34.

1911 • Boston, Museum of Fine Arts, August, *Monet* (MFA 1911), no. 43.

1927 • Boston, Museum of Fine Arts, January 11–February 6, *Claude Monet: Memorial Exhibition* (MFA 1927), no. 8.

1973 • *Impressionism: French and American* (MFA 1973a), no. 29.

1977–78 • *Monet Unveiled* (Murphy and Giese 1977), no. 5.

1991 • Salem, Mass., Peabody Museum, May 17–September 16, *Eugène Boudin: Impressionist Marine Paintings* (Sutton 1991), pl. 13.

1991–92 • *Claude Monet: Impressionist Masterpieces.*

1992 • *Crosscurrents.*

SELECTED REFERENCES
MFA 1906, 11, 35; Borgmeyer [1913], 21; MFA 1921, no. 357; Fels 1929, 236; Reuterswärd 1948, 281; Wildenstein 1974–91, 1: no. 259; Murphy 1985, 204; Murphy and Giese 1985, 14, no. 5; Bunkamura Museum and MFA 1992, 55, fig. 17; Wildenstein 1996, 2: no. 259.

88. *Snow at Argenteuil,* about 1874
Oil on canvas
54.6 x 73.8 cm (21½ x 29 in.)
Bequest of Anna Perkins Rogers 21.1329

PROVENANCE

April 29, 1890, purchased from the artist by Durand-Ruel, Paris, no. 305; June 14, 1890, sold by Durand-Ruel to Anna Perkins Rogers, Boston; 1890–1921, Anna Perkins Rogers, Boston; 1921, bequest of Anna Perkins Rogers.

SELECTED EXHIBITIONS

1879 • Paris, 28 avenue de l'Opéra, April 10–May 11, *Quatrième exposition de peinture,* no. 159.

1892 • Boston, St. Botolph Club, March 28–April 9, *Monet* (D.F. 1892), no. 19.

1899 • Boston, St. Botolph Club, February 6–23, *Monet* (St. Botolph [1899]), no. 6.

1903 • Boston, Copley Hall, *A Loan Collection of Pictures by Old Masters and Other Painters* (Copley Society 1903), no. A8.

1905 • Boston, Copley Hall, March 28–April 9, *Monet-Rodin* (Copley Society 1905), no. 6.

1911 • Boston, Museum of Fine Arts, August, *Monet* (MFA 1911), no. 38.

1927 • Boston, Museum of Fine Arts, January 11–February 6, *Claude Monet: Memorial Exhibition* (MFA 1927), no. 3.

1940 • San Francisco, Palace of Fine Arts, *Golden Gate International Exhibition* (Golden Gate 1940) no. 286.

1947 • Wellesley, Mass., Wellesley College Art Museum, May 8–25, *Loan Exhibition of Paintings and Prints since 1860,* unnumbered entry.

1949 • Boston, Symphony Hall.

n.d. • Boston, Lincoln House, *Loan Exhibition of Pictures.*

1957 • Edinburgh, Royal Scottish Academy, August 6–September 15; London, The Tate Gallery, September 26–November 3, *Claude Monet* (Tate Gallery [1957]), no. 41.

1973 • *Impressionism: French and American* (MFA 1973a), no. 30.

1976 • New York, Acquavella Galleries, October 27–November 28, *Claude Monet* (Acquavella Galleries 1976), no. 22.

1977–78 • *Monet Unveiled* (Murphy and Giese 1977), no. 6.

1979–80 • *Corot to Braque* (Poulet and Murphy 1979), no. 46.

1985 • Williamstown, Mass., Sterling and Francine Clark Art Institute, June 8–October 6, *Monet in Massachusetts* (Brooks 1985), unnumbered entry.

1989 • *From Neoclassicism to Impressionism* (Kyoto Museum, Kyoto Shimbun, and MFA 1989), no. 68.

1991–92 • *Claude Monet: Impressionist Masterpieces.*

1992 • *Crosscurrents.*

1992–93 • *Monet and His Contemporaries* (Bunkamura Museum and MFA 1992), no. 22.

1995 • Chicago, The Art Institute of Chicago, July 22–November 26, *Claude Monet: 1840–1926* (Stuckey 1995), no. 43.

1996 • Tokyo, Tobu Museum of Art, March 30–June 30, *Inshoha wa koshite umareta: Akademisumu kara Kurube, Mune, Mone, Runowaru* (The Birth of Impressionism) (Tobu Bijutsukan 1996), no. 144.

1998–99 • Washington, D.C., The Phillips Collection, September 19, 1998–January 3, 1999; San Francisco, Fine Arts Museums of San Francisco at the Center for the Arts at Yerba Buena Gardens, January 30–May 2, 1999; Brooklyn, The Brooklyn Museum, May 27–August 29, 1999, *Impressionists in Winter: Effets de Neige* (Moffett et al. 1998), no. 9.

2000–2 • *Monet, Renoir, and the Impressionist Landscape* (Shackelford and Wissman 2000), no. 40.

SELECTED REFERENCES

Reuterswärd 1948, 282; Seitz 1960, 29, 100, 101; MFA 1973b, no. 9; Wildenstein 1974–91, 1: no. 348, 5:29; Petrie 1979, 52; Tucker 1982, 48–49; Gordon and Forge 1983, 64–65, 84; Murphy 1985, 205; Murphy and Giese 1985, 15, no. 6; Stuckey 1985, 58, 104; House 1986, 168, pl. 203; Wildenstein 1996, 2: no. 348.

89. *Entrance to the Village of Vétheuil in Winter,* 1879
Oil on canvas
60.6 x 81 cm (23⅞ x 31⅞ in.)
Gift of Julia C. Prendergast in memory of her brother, James Maurice Prendergast
21.7

PROVENANCE

February 1880, sold by the artist to M. Bascle, Paris; May 3, 1890, sold at Charles Bonnemaison-Bascle sale, Hôtel Drouot, Paris, no. 33. By at least May 1891, Williams and Everett, Boston [1]; July 1891, sold by Williams and Everett to James M. Prendergast (d. 1899), Boston; 1899, inherited by Julia C. Prendergast (sister), Boston; 1921, gift of Julia C. Prendergast.

NOTE

1. According to a letter of May 25, 1891, from Williams and Everett to James M. Prendergast in MFA curatorial file.

SELECTED EXHIBITIONS

1899 • Boston, St. Botolph Club, February 6–23, *Monet* (St. Botolph [1899]), no. 7.

1905 • Boston, Copley Hall, March 28–April 9, *Monet-Rodin* (Copley Society 1905), no. 91.

1941 • New London, Conn., Lyman Allen Museum, Connecticut College.

1945 • New London, Conn., Lyman Allen Museum, Connecticut College.

1949 • Boston, Symphony Hall.

1952 • Boston, Simmons College, November 3–10, *Mid-Century Jubilee.*

1956 • Binghamton, N.Y., Robertson Memorial Center, *Impressionist Painting.*

1957 • St. Louis, City Art Museum of St. Louis, September 25–October 22; Minneapolis, The Minneapolis Institute of Arts, November 1–December 1, *Claude Monet: A Loan Exhibition* (City Art Museum 1957), no. 36.

1960 • New York, The Museum of Modern Art, March 7–May 15; Los Angeles, Los Angeles County Museum of Art, June 14–August 7, *Claude Monet: Seasons and Moments* (Seitz 1960), no. 20.

1960 • Portland, Ore., Portland Art Museum, September 8–October 2, *Impressionist Paintings.*

1973 • *Impressionism: French and American* (MFA 1973a), no. 34.

1975 • Chicago, The Art Institute of Chicago, March 15–May 11, *Paintings by Monet* (Masson, Seiberling, and Marandel 1975), no. 50.

1977–78 • *Monet Unveiled* (Murphy and Giese 1977), no. 10.

1991–92 • *Claude Monet: Impressionist Masterpieces.*

1992–93 • *Monet and His Contemporaries* (Bunkamura Museum and MFA 1992), no. 26.

1995–96 • London, Hayward Gallery, May 18–August 28, 1995; Boston, Museum of Fine Arts, October 4, 1995–January 14, 1996, *Impressions of France: Monet, Renoir, Pissarro, and Their Rivals* (House et al. 1995), no. 94.

1999 • *Monet, Renoir, and the Impressionist Landscape* (Nagoya/Boston and MFA 1999), no. 41.

2000–2 • *Monet, Renoir, and the Impressionist Landscape* (Shackelford and Wissman 2000), no. 42.

SELECTED REFERENCES

Reuterswärd 1948, 121, 283; Rouart [1958], 73; Wildenstein 1974–91, 1: no. 509; Isaacson 1978, 23, 109, 211, no. 61; Seiberling 1981, 52; Tucker 1982, 155, fig. 126; Murphy 1985, 205; Murphy and Giese 1985, 21, no. 11; Wildenstein 1996, 2: no. 509.

92. *Camille Monet and a Child in the Artist's Garden in Argenteuil,* 1875
Oil on canvas
55.3 x 64.7 cm (21¾ x 25½ in.)
Anonymous gift in memory of Mr. and Mrs. Edwin S. Webster 1976.833

PROVENANCE

October 1875, acquired from the artist by Clément Courtois, Mulhouse. Julius Oehme, Paris. 1900, with Durand-Ruel, Paris and New York. 1905–27, Desmond Fitzgerald, Boston; April 21, 1927, sold at Fitzgerald sale, American Art Association, New York, no. 187, and bought by Edwin S. Webster, Boston. 1972–76, private collection, New York; 1976, gift of an anonymous donor.

SELECTED EXHIBITIONS

1905 • Boston, Copley Hall, March 28–April 9, *Monet-Rodin* (Copley Society 1905), no. 29.

1911 • Boston, Museum of Fine Arts, August, *Monet* (MFA 1911), no. 36.

1914 • Boston, Copley Hall, March, *Portraits by Living Painters, Loan Collection* (Copley Society 1914), no. 46.

1939 • Boston, Museum of Fine Arts, June 9–September 10, *Art in New England:*

Paintings, Drawings, and Prints, from Private Collections in New England (MFA 1939), no. 82.

1945 • New York, Wildenstein Galleries, April 11–May 12, *A Loan Exhibition of Paintings by Claude Monet, for the Benefit of the Children of Giverny* (Wildenstein [1945]), no. 22.

1949 • Manchester, N.H., The Currier Gallery of Art, October 8–November 6, *Monet and the Beginnings of Impressionism: Twentieth Anniversary Exhibition* (Currier Gallery of Art [1949]), no. 46.

1977–78 • *Monet Unveiled* (Murphy and Giese 1977), no. 8.

1978 • Tokyo, National Museum of Western Art, April 25–June 11; Kyoto, Kyoto National Museum, June 20–August 9; Nagoya, Nagoya City Museum, August 20–September 18, *Human Figures in Fine Arts: Boston Museum Exhibition* (Kokuritsu Seiyo Bijutsukan 1978), no. 35.

1983 • San Diego, Timken Art Gallery, May 17–June 12, *Selected French Paintings*.

1989 • *From Neoclassicism to Impressionism* (Kyoto Museum, Kyoto Shimbun, and MFA 1989), no. 69.

1991–92 • *Claude Monet: Impressionist Masterpieces*.

1992 • *Crosscurrents*.

1992–93 • *Monet and His Contemporaries* (Bunkamura Museum and MFA 1992), no. 23.

1994 • Tokyo, Bridgestone Museum of Art, February 11–April 7; Nagoya, Nagoya City Art Museum, April 16–June 12; Hiroshima, Hiroshima Museum of Art, June 18–July 31, *Monet: A Retrospective* (Tucker, Fukaya, and Miyazaki 1994), no. 25.

1995 • *The Real World* (Sogo Museum and MFA 1994), no. 42.

1999 • *Monet, Renoir, and the Impressionist Landscape* (Nagoya/Boston and MFA 1999), no. 40.

2000–2 • *Monet, Renoir, and the Impressionist Landscape* (Shackelford and Wissman 2000), no. 41.

SELECTED REFERENCES

Geffroy 1920, 68; Reuterswärd 1948, 87; Seitz 1960, 102–3; Bortolatto 1972, 96–97; Wildenstein 1974–91, 1: no. 382, 5:30; Tucker 1982, 149, fig. 121; Murphy 1985,

209; Murphy and Giese 1985, 17, no. 8; Sagner-Düchting 1990, 79; Wildenstein 1996, 2: no. 382.

103. *Road at La Cavée, Pourville,* 1882
Oil on canvas
60.4 x 81.5 cm (23¾ x 32⅛ in.)
Bequest of Mrs. Susan Mason Loring
24.1755

PROVENANCE

October 10, 1882, probably sold by the artist to Durand-Ruel, Paris; 1883, sold by Durand-Ruel, Paris. March 9, 1888, sold by Girard, Paris (address: 8 rue d'Uzès) to Durand-Ruel, Paris, no. 1445. July 11, 1888, sold by Durand-Ruel, Paris, to Durand-Ruel, New York, nos. 408 and 345; June 6, 1888, sold by Durand-Ruel to Williams and Everett, Boston. By 1898, Charles Fairchild, New York (address: 39 Wall Street); December 3, 1898, consigned by Fairchild to Durand-Ruel, New York, no. 5765; October 22, 1900, sold by Fairchild to Durand-Ruel, New York, no. 2373; April 3, 1903, sold by Durand-Ruel, New York, to William Caleb Loring, Boston; by 1924, inherited by Mrs. Susan Mason Loring, Boston; 1924, bequest of Mrs. Susan Mason Loring [1].

NOTE

1. Susan Mason Loring's niece, Mrs. Harriet C. Binney, maintained possession of the painting through 1955.

SELECTED EXHIBITIONS

1883 • Paris, Durand-Ruel, March 1–25, *Exposition des oeuvres de Claude Monet,* no. 24 (?).

1883 • London, Dowdeswell and Dowdeswell's (organized by Durand-Ruel), April–June, *La Société des impressionistes,* no. 34.

1902 • New York, Durand-Ruel. February 11–25, *Claude Monet* (Durand-Ruel 1902), no. 13.

1905 • Boston, Copley Hall, March 28–April 9, *Monet-Rodin* (Copley Society 1905), no. 35.

1957 • Cambridge, Mass., Fogg Art Museum, Harvard University, *French Painting.*

1960 • Boston, Metropolitan Boston Arts Center, Institute of Contemporary Art, May–August, *The Image Lost and Found* (Messer 1960), no. 5.

1973 • *Impressionism: French and American* (MFA 1973a), no. 38.

1977–78 • *Monet Unveiled* (Murphy and Giese 1977), no. 15.

1991–92 • *Claude Monet: Impressionist Masterpieces*.

1992 • *Crosscurrents*.

1992–93 • *Monet and His Contemporaries* (Bunkamura Museum and MFA 1992), no. 30.

1998 • Graz, Neue Galerie am Landesmuseum Joanneum, September 4–November 30, *Chemins de l'impressionnisme: Normandie-Paris, 1860–1910* (Tapié 1998), no. 40.

1999 • *Monet, Renoir, and the Impressionist Landscape* (Nagoya/Boston and MFA 1999), no. 44.

2000–2 • *Monet, Renoir, and the Impressionist Landscape* (Shackelford and Wissman 2000), no. 45.

SELECTED REFERENCES

Geffroy 1922, 107; Wildenstein 1974–91, 2: no. 762; Gordon and Forge 1983, 138; Murphy 1985, 206; Murphy and Giese 1985, 27, no. 16; Stuckey 1985, 95–97; Kendall 1989, 137; Wildenstein 1996, 2: no. 762.

104. *Seacoast at Trouville,* 1881
Oil on canvas
60.7 x 81.4 cm (23⅞ x 32 in.)
The John Pickering Lyman Collection.
Gift of Miss Theodora Lyman 19.1314

PROVENANCE

June 1882, probably sold by the artist to Durand-Ruel, Paris; August 1883, sold by Durand-Ruel, Paris, to Galerie Georges Petit, Paris. By 1888, Leroux, Paris; February 27–28, 1888, sold at Leroux sale, Hôtel Drouot, Paris, no. 61, and bought by Durand-Ruel, Paris; 1888, probably sold by Durand-Ruel to Mrs. Catholina Lambert, Paterson, N.J.; February 28, 1899, sold by Lambert to Durand-Ruel, New York; 1899–1907, with Durand-Ruel, New York, no. 2122; April 13, 1907, sold by Durand-Ruel, New York, to John Pickering Lyman, Portsmouth, N.H.; 1907–14, John Pickering Lyman (d. 1914), Portsmouth, N.H.; 1914–19, inherited by Miss Theodora Lyman (d. 1919), Portsmouth, N.H.; 1919, gift of Theodora Lyman.

SELECTED EXHIBITIONS

1882 • Paris, 251, rue Saint-Honoré, March, *Septième Exposition des Artistes Indépendants,* no. 84.

1886 • Brussels, February 6, *Société des XX*.

1886 • New York, American Art Galleries, April; National Academy of Design, May–June, *Works in Oil and Pastel by the Impressionists of Paris* (American [1886]), no. 268.

1907 • Boston, Walter Kimball Gallery, March 12–30, *Monets from the Durand-Ruel Collection* (Walter Kimball 1907), no. 13.

1910 • New York, Lotos Club, December, *Paintings by French and American Luminists,* no. 19?

1915 • Boston, Museum of Fine Arts, opened February 3, *Robert Dawson Evans Memorial Galleries Opening Exhibition.*

1927 • Boston, Museum of Fine Arts, January 11–February 6, *Claude Monet Memorial Exhibition* (MFA 1927), no. 9.

1939 • Williamstown, Mass., Lawrence Hall, Williams College.

1941 • Norfolk, Va., Norfolk Museum of Arts and Sciences, February 2–March 30; Colorado Springs, Colo., Colorado Springs Fine Arts Center, May 15–July 1, *French Impressionists: Spring Exhibition* (Norfolk Museum 1941), no. 6.

1963 • Wellesley, Mass., Wellesley College, Jewett Arts Center, January 1–May 1.

1965 • Albuquerque, University of New Mexico Art Gallery, February 9–March 14; San Francisco, M. H. de Young Memorial Museum, March 30–May 5, *Impressionism in America* (Junior League 1965), 6.

1973 • *Impressionism: French and American* (MFA 1973a), no. 36.

1977–78 • *Monet Unveiled* (Murphy and Giese 1977), no. 13.

1979–80 • *Corot to Braque* (Poulet and Murphy 1979), no. 48.

1991–92 • *Claude Monet: Impressionist Masterpieces*.

1992 • *Crosscurrents*.

1992–93 • *Monet and His Contemporaries* (Bunkamura Museum and MFA 1992), no. 27.

1999 • *Monet, Renoir, and the Impressionist Landscape* (Nagoya/Boston and MFA 1999), no. 42.

2000–2 • *Monet, Renoir, and the Impressionist Landscape* (Shackelford and Wissman 2000), no. 43.

SELECTED REFERENCES
"Collection de tableaux . . ." 1888, 1; "Faits-divers" 1888, 2; Alexandre 1908, 98; MFA 1920a, 2; MFA 1921, no. 361; Bertram 1931, pl. 7; Venturi 1939, 1:220–21; Reuterswärd 1948, 289; Seitz 1960, 30; Wildenstein 1974–91, 1:443 (letter no. 222), no. 687, 5:36; Murphy 1985, 205; Murphy and Giese 1985, 23, no. 13; Berson 1996, 2:206, 223, VII–84; Wildenstein 1996, 2: no. 687.

105. *Fisherman's Cottage on the Cliffs at Varengeville*, 1882
Oil on canvas
60.5 x 81.5 cm (23⅞ x 32⅛ in.)
Bequest of Anna Perkins Rogers 21.1331

PROVENANCE
October 1882, probably sold by the artist to Durand-Ruel, Paris; August 1883, sold by Durand-Ruel, Paris, to Galerie Georges Petit, Paris. By 1890, M. de Porto-Riche; May 14, 1890, sold at M. de Porto-Riche sale, Galerie Georges Petit, and bought by Durand-Ruel, Paris, no. 22; June 14, 1890, sold by Durand-Ruel to Anna Perkins Rogers, Boston; 1890–1921, Anna Perkins Rogers, Boston; 1921, bequest of Anna Perkins Rogers.

SELECTED EXHIBITIONS
1892 • Boston, St. Botolph Club, March 28–April 9, *Monet* (D.F. 1892), no. 1.

1899 • Boston, St. Botolph Club, February 6–23, *Monet* (St. Botolph [1899]), no. 24.

1903 • Boston, Copley Hall, *A Loan Collection of Pictures by Old Masters and Other Painters* (Copley Society 1903), no. A9.

1905 • Boston, Copley Hall, March 28–April 9, *Monet-Rodin* (Copley Society 1905), no. 3.

1911 • Boston, Museum of Fine Arts, August, *Monet* (MFA 1911), no. 33.

1927 • Boston, Museum of Fine Arts, January 11–February 6, *Claude Monet: Memorial Exhibition* (MFA 1927), no. 10.

1945 • New York, Wildenstein Galleries, April 11–May 12, *A Loan Exhibition of Paintings by Claude Monet, for the Benefit of the Children of Giverny* (Wildenstein [1945]), no. 44.

1946 • Colorado Springs, Colo., Colorado Springs Fine Arts Center, November 5–December 9, *French Paintings of the Nineteenth Century*, unnumbered entry in exhibition pamphlet.

1955 • Atlanta, Atlanta Art Association Galleries, September 2–October 4; Birmingham, Ala., Birmingham Museum of Art, October 16–November 5, *Painting: School of France* (Atlanta Art Association [1955]), no. 21.

1960 • New York, The Museum of Modern Art, March 7–May 15; Los Angeles, Los Angeles County Museum of Art, June 14–August 7, *Claude Monet: Seasons and Moments* (Seitz 1960), no. 29.

1960 • Portland, Ore., Portland Art Museum, September 8–October 2, *Impressionist Paintings*.

1971 • Hagerstown, Md., Washington County Museum of Fine Arts, September 1–30, *Claude Monet* (Fortieth Anniversary Exhibition) (Washington County [1971]), no. 7.

1973 • *Impressionism: French and American* (MFA 1973a), no. 34.

1977–78 • *Monet Unveiled* (Murphy and Giese 1977), no. 14.

1985 • Auckland, Auckland City Art Gallery, April 29–June 9; Sydney, Art Gallery of New South Wales, June 21–August 4; Melbourne, National Gallery of Victoria, August 14–September 29, *Claude Monet: Painter of Light* (Auckland City 1985), no. 12.

1989 • *From Neoclassicism to Impressionism* (Kyoto Museum, Kyoto Shimbun, and MFA 1989), no. 70.

1991–92 • *Claude Monet: Impressionist Masterpieces*.

1992–93 • *Monet and His Contemporaries* (Bunkamura Museum and MFA 1992), no. 29.

1995–96 • London, Hayward Gallery, May 18–August 28, 1995; Boston, Museum of Fine Arts, October 4, 1995–January 14, 1996, *Impressions of France: Monet, Renoir, Pissarro, and Their Rivals* (House et al. 1995), no. 100.

1999 • *Monet, Renoir, and the Impressionist Landscape* (Nagoya/Boston and MFA 1999), no. 43.

2000–2 • *Monet, Renoir, and the Impressionist Landscape* (Shackelford and Wissman 2000), no. 44.

SELECTED REFERENCES
Venturi 1939, 1:62; Reuterswärd 1948, 284; Wildenstein 1974–91, 2: no. 805, 5:98; Herbert 1979, 108; Murphy 1985, 205; Murphy and Giese 1985, 26, no. 15; House 1986, 120, pl. 151; Herbert 1988, 300, fig. 307; Rapetti 1990, 66, pl. 44; Fourny-Dargère 1992, no. 15; Herbert 1994, 48, 54, figs. 1, 56, 57; Wildenstein 1996, 2: no. 805.

III. *Poppy Field in a Hollow near Giverny*, 1885
Oil on canvas
65.2 x 81.2 cm (25⅝ x 32 in.)
Juliana Cheney Edwards Collection
25.106

PROVENANCE
September 1885, purchased from the artist by Durand-Ruel, Paris. 1886, Mrs. Albert Spencer, New York; March 24, 1911, sold by Spencer to Durand-Ruel, Paris; 1911, transferred from Durand-Ruel, Paris, to Durand-Ruel, New York; August 23, 1911, sold by Durand-Ruel, New York, to Arthur B. Emmons, Newport, R.I.; January 14–15, 1920, sold by Emmons at American Art Association, Plaza Hotel, New York, no. 31, and bought by Durand-Ruel, New York, for Robert J. Edwards, Boston; 1920–24, Robert J. Edwards (d. 1924), Boston; by 1925, inherited by Hannah Marcy Edwards (sister, d. 1929), Boston, and Grace M. Edwards (sister, d. 1938), Boston; 1925, bequest of Robert J. Edwards [1].

NOTE
1. See note 1 to the provenance for Corot's *Morning near Beauvais*, cat. no. 14, p. 246.

SELECTED EXHIBITIONS
1886 • New York, American Art Galleries, April; National Academy of Design, May–June, *Works in Oil and Pastel by the Impressionists of Paris* (American [1886]), no. 270.

1891 • New York, Union League Club, February, *Monet*, no. 66.

1927 • Boston, Museum of Fine Arts, January 11–February 6, *Claude Monet: Memorial Exhibition* (MFA 1927), no. 14.

1939–40 • *Juliana Cheney Edwards Collection* (Cunningham 1939b), no. 34.

1942 • Montreal, Montreal Museum of Fine Arts, February 5–March 8, *Masterpieces of Painting* (Montreal 1942), no. 70.

1944 • Williamstown, Mass., Lawrence Hall, Williams College.

1948 • Springfield, Mass., Springfield Museum of Fine Arts, October 7–November 7, *Fifteen Fine Paintings* (Springfield Museum 1948), unnumbered entry.

1961 • Phoenix, Phoenix Art Museum, February 1–26, Oakland, Oakland Art Museum, March 5–31, *One Hundred Years of French Painting, 1860–1960* (Phoenix 1961), no. 64.

1973 • *Impressionism: French and American* (MFA 1973a), no. 41.

1977–78 • *Monet Unveiled* (Murphy and Giese 1977), no. 18.

1978 • New York, The Metropolitan Museum of Art, April 19–July 9; St. Louis, The St. Louis Art Museum, late July–September 15, *Monet's Years at Giverny: Beyond Impressionism, 1883–1926* (Metropolitan 1978), no. 5.

1983 • Montclair, N.J., Montclair Art Museum, October 1–November 30, Evanston, Ill., Terra Museum; Seattle, Henry Art Gallery, University of Washington, *Down Garden Paths: The Floral Environment in American Art* (Gerdts 1983), 82, 137 (Montclair venue only).

1985 • Boston, Museum of Fine Arts, February 13–June 2, *The Great Boston Collectors: Paintings from the Museum of Fine Arts, Boston* (Troyen and Tabbaa 1984), no. 46.

1991–92 • *Claude Monet: Impressionist Masterpieces*.

1992 • *Crosscurrents*.

1992–93 • *Monet and His Contemporaries* (Bunkamura Museum and MFA 1992), no. 33.

2001–2 • Pushkin, Pushkin State Museum of Fine Arts, November 26, 2001–February 10, 2002; St. Petersburg, Hermitage, March 1–May 15, 2002, *Claude Monet*.

SELECTED REFERENCES
Forthuny 1920, 179; Cunningham 1939b, 105; Reuterswärd 1948, 284; Edgell 1949, 57; Seitz 1960, 124–25; Rouart et al. 1972, 54; MFA 1973b, no. 12; Wildenstein 1974–91, 2:

no. 1000; Joyes et al. 1975, 54; Keller 1982, no. 61; Seitz 1982, 46; Gordon and Forge 1983, 139; Gerdts 1984, 86–87, pl. 88; Rewald and Weitzenhoffer 1984, 72; Murphy 1985, 207; Murphy and Giese 1985, 29, no 18; Stuckey 1985, 126–27, 144; House 1986, 71–72, pl. 109; Alphant 1993, 357; Gerdts 1993, 66; Orr, Tucker, and Murray 1994, 21–22, fig. 8; Wildenstein 1996, 3: no. 1000.

112. *Meadow with Haystacks near Giverny,* 1885
Oil on canvas
74 x 93.5 cm (29⅛ x 36¾ in.)
Bequest of Arthur Tracy Cabot 42.541

PROVENANCE
December 1885, purchased from the artist by Durand-Ruel, Paris. 1886, with Bernheim-Jeune, Paris. 1886, Durand-Ruel, Paris and New York, no. 792. 1897, Eastman Chase, Boston. 1899–1942, Dr. Arthur Tracy Cabot, Boston; 1942, bequest of Arthur Tracy Cabot.

SELECTED EXHIBITIONS
1886–87 • New York, American Art Galleries, December 1886–January 1887, *Modern Paintings,* no. 82.

1887 • New York, National Academy of Design, May 25–June 30, *Celebrated Paintings by Great French Masters* (National Academy 1887), no. 156.

1895 • New York, Durand-Ruel, January 12–27, *Tableaux de Claude Monet* (Durand-Ruel 1895), no. 33, called *La Pré à Giverny.*

1899 • Boston, St. Botolph Club, February 6–23, *Monet* (St. Botolph [1899]), no. 2.

1905 • Boston, Copley Hall, March 28–April 9, *Monet-Rodin* (Copley Society 1905), no. 95.

1911 • Boston, Museum of Fine Arts, August, *Monet* (MFA 1911), no. 13.

1954 • Cambridge, Mass., Busch-Reisinger Museum, Harvard University, February 12–March 20, *Impressionism and Expressionism* (Harvard University [1954]), no. 9.

1955 • Winnipeg, Winnipeg Art Gallery, October 11–30, *Modern European Art since Manet* (Winnipeg [1955]), no. 57.

1973 • *Impressionism: French and American* (MFA 1973a), no. 43.

1977–78 • *Monet Unveiled* (Murphy and Giese 1977), no. 20.

1979–80 • *Corot to Braque* (Poulet and Murphy 1979), no. 47.

1982–83 • Memphis, The Dixon Gallery and Gardens, November 21–December 23, 1982; Evanston, Ill., Terra Museum of American Art, January 8–February 13, 1983; Worcester, Mass., Worcester Art Museum, March 3–April 30, 1983, *An International Episode: Millet, Monet, and Their North American Counterparts* (Meixner 1982), no. 30.

1985 • Auckland, Auckland City Art Gallery, April 29–June 9; Sydney, Art Gallery of New South Wales, June 21–August 4; Melbourne, National Gallery of Victoria, August 14–September 29, *Claude Monet: Painter of Light* (Auckland City 1985), no. 14.

1991–92 • *Claude Monet: Impressionist Masterpieces.*

1992–93 • *Monet and His Contemporaries* (Bunkamura Museum and MFA 1992), no. 32.

1995–96 • London, Hayward Gallery, May 18–August 28, 1995; Boston, Museum of Fine Arts, October 4, 1995–January 14, 1996, *Impressions of France: Monet, Renoir, Pissarro, and Their Rivals* (House et al. 1995), no. 107.

1999 • *Monet, Renoir, and the Impressionist Landscape* (Nagoya / Boston and MFA 1999), no. 45.

2000–2 • *Monet, Renoir, and the Impressionist Landscape* (Shackelford and Wissman 2000), no. 46.

SELECTED REFERENCES
Fels 1929, 235; Reutersward 1948, 286; Wildenstein 1974–91, 2: no. 995; Herbert 1979, 92, 94–95, figs. 1–2; Seiberling 1981, 87; Murphy 1985, 208; Murphy and Giese 1985, 32, no. 20; Stuckey 1985, 370; Fairbrother 1986, 51, fig. 17; House 1986, 94, 96, 238, note 30, pl. 132; De Veer and Boyle 1987, 202, fig. 235; Gerdts 1993, 68, fig. 59; Herbert 1994, 97, 99, 132, fig. 106; Wildenstein 1996, 3: no. 995.

113. *Meadow at Giverny,* 1886
Oil on canvas
92 x 81.5 cm (36¼ x 32⅛ in.)
Juliana Cheney Edwards Collection
39.670

PROVENANCE
1898, purchased from the artist by Galerie Georges Petit, Bernheim-Jeune, and Montaignac, Paris (?). With Jos Hessel, Paris. By 1914, Alexandre Berthier, prince de Wagram (d. 1918), Paris; April 14, 1914, sold by Berthier and bought by Durand-Ruel, Paris, no. 10519; 1914–15, with Durand-Ruel, Paris; November 11, 1915, transferred from Durand-Ruel, Paris, to Durand-Ruel, New York, no. 3897; March 20, 1916, sold by Durand-Ruel, New York, to Hannah Marcy Edwards (d. 1929), Boston; 1916–29, Hannah Marcy Edwards, Boston; 1931–38, inherited by Grace M. Edwards (sister, d. 1938), Boston; 1939, bequest of Hannah M. Edwards [1].

NOTES
1. See note 1 to the provenance for Corot's *Morning near Beauvais,* cat. no. 14, p. 246.

SELECTED EXHIBITIONS
1902 • New York, Durand-Ruel, February 11–25, *Claude Monet* (Durand-Ruel 1902), no. 21 (?).

1916 • Boston, Brooks Reed Gallery, March, [*Tableaux Durand-Ruel*].

1919–20 • Boston, Museum of Fine Arts, December 1919–January 1920, *Impressionist and Barbizon Schools.*

1927 • Boston, Museum of Fine Arts, January 11–February 6, *Claude Monet Memorial Exhibition* (MFA 1927), no. 48.

1939–40 • *Juliana Cheney Edwards Collection* (Cunningham 1939b), no. 37.

1945 • New York, Wildenstein Galleries, April 11–May 12, *A Loan Exhibition of Paintings by Claude Monet, for the Benefit of the Children of Giverny* (Wildenstein [1945]), no. 52.

1949 • Boston, Symphony Hall.

1971 • Hagerstown, Md., Washington County Museum of Fine Arts, September 1–30, *Claude Monet* (Fortieth Anniversary Exhibition) (Washington County [1971]), no. 5.

1973 • *Impressionism: French and American* (MFA 1973a), no. 42.

1974–75 • Berkeley, Calif., University Art Museum, University of California.

1977–78 • *Monet Unveiled* (Murphy and Giese 1977), no. 19.

1979–80 • *Corot to Braque* (Poulet and Murphy 1979), no. 50.

1984 • Miami, Center for Fine Arts, January 12–April 22, *In Quest of Excellence* (Van der Marck [1984]), no. 119.

1991–92 • *Claude Monet: Impressionist Masterpieces.*

1992–93 • *Monet and His Contemporaries* (Bunkamura Museum and MFA 1992), no. 38.

1999 • *Monet, Renoir, and the Impressionist Landscape* (Nagoya / Boston and MFA 1999), no. 46.

2000–2 • *Monet, Renoir, and the Impressionist Landscape* (Shackelford and Wissman 2000), no. 47.

SELECTED REFERENCES
Reutersward 1948, 285; Wildenstein 1974–91, 2: no. 1083; Murphy 1985, 208; Murphy and Giese 1985, 30–31, no. 19; Wildenstein 1996, 3: no. 1083.

119. *Cap d'Antibes, Mistral,* 1888
Oil on canvas
66 x 81.3 cm (26 x 32 in.)
Bequest of Arthur Tracy Cabot 42.542

PROVENANCE
1890, purchased from the artist by Durand-Ruel, Paris and New York. 1892, J. Eastman Chase, Boston. About 1903–42, Mr. and Mrs. Arthur Tracy Cabot, Boston; 1942, bequest of Arthur Tracy Cabot.

SELECTED EXHIBITIONS
1889 • Paris, Galerie Georges Petit, June–July, *Monet-Rodin,* no. 125, called *Au cap d'Antibes, par vent de mistral, 1888.*

1903 • Boston, Copley Hall, *A Loan Collection of Pictures by Old Masters and Other Painters* (Copley Society 1903), no. A12.

1905 • Boston, Copley Hall, March 28–April 9, *Monet-Rodin* (Copley Society 1905), no. 37.

1911 • Boston, Museum of Fine Arts, August, *Monet* (MFA 1911), no. 3.

1945 • Wellesley, Mass., Farnsworth Museum, Wellesley College.

1949 • Boston, Symphony Hall.

1957 • Edinburgh, Royal Scottish Academy, August 6–September 15; London, The Tate Gallery, September 26–November 3, *Claude Monet* (Tate Gallery [1957]), no. 86.

1959–60 • Cologne, Wallraf-Richartz Museum, November 1, 1959–May 1, 1960.

1973 • *Impressionism: French and American* (MFA 1973a), no. 46.

1977–78 • *Monet Unveiled* (Murphy and Giese 1977), no. 24.

1979–80 • London, Royal Academy of Arts, November 17, 1979–March 16, 1980, *Post-Impressionism: Cross-Currents in European Painting* (Royal Academy 1979), no. 25.

1985 • Williamstown, Mass., Sterling and Francine Clark Art Institute, June 8–October 6, *Monet in Massachusetts* (Brooks 1985), unnumbered entry.

1989–90 • Paris, Musée Rodin, November 14, 1989–January 21, 1990, *Claude Monet–Auguste Rodin: Centenaire de l'exposition de 1889* (Musée Rodin [1989]), no. 17.

1991–92 • *Claude Monet: Impressionist Masterpieces.*

1992–93 • *Monet and His Contemporaries* (Bunkamura Museum and MFA 1992), no. 37.

1995–96 • London, Hayward Gallery, May 18–August 28, 1995; Boston, Museum of Fine Arts, October 4, 1995–January 14, 1996, *Impressions of France: Monet, Renoir, Pissarro, and Their Rivals* (House et al. 1995), no. 112.

1997–98 • Fort Worth, Tex., Kimbell Art Museum, June 8–September 7, 1997; Brooklyn, The Brooklyn Museum of Art, October 10, 1997–January 18, 1998, *Monet and the Mediterranean* (Pissarro 1997), no. 138.

1999 • *Monet, Renoir, and the Impressionist Landscape* (Nagoya / Boston and MFA 1999), no. 47.

2000–1 • Paris, Grand Palais, September 19, 2000–January 15, 2001, *Méditerranée: De Courbet à Matisse, 1850–1925* (Cachin and Nonne 2000), no. 54.

2000–2 • *Monet, Renoir, and the Impressionist Landscape* (Shackelford and Wissman 2000), no. 48 (Ottawa and Houston venues only).

SELECTED REFERENCES
Fels 1929, 235; Reuterswärd 1948, 285; Wildenstein 1974–91, 3: no. 1176; Murphy and Giese 1977, 37; Murphy 1985, 208; Murphy and Giese 1985, 36–37, no. 24; House 1986, 168–69, fig. 206; Kendall 1989, 165; Küster 1992, no. 17; Wildenstein 1996, 3: no. 1176.

120. *Valley of the Creuse (Sunlight Effect)*, 1889
Oil on canvas
65 x 92.4 cm (25⅝ x 36⅜ in.)
Juliana Cheney Edwards Collection
25.107

PROVENANCE
June 1889, bought from the artist by Boussod, Valadon et Cie., Paris. 1891, with Williams and Everett, Boston. By 1905, James F. Sutton, New York; January 17, 1917, sold at Sutton sale, American Art Association, Plaza Hotel, New York, no. 153, and bought by Durand-Ruel, New York; 1917–24, with Durand-Ruel, New York, no. 4066; February 2, 1924, sold by Durand-Ruel, New York, to Grace M. Edwards (d. 1938), Boston (probably purchased for her brother Robert J. Edwards); 1924, Robert J. Edwards (d. 1924), Boston; by 1925, inherited by Hannah Marcy Edwards (sister, d. 1929) and Grace M. Edwards, Boston; 1925, bequest of Robert J. Edwards [1].

NOTES
1. See note 1 to the provenance for Corot's *Morning near Beauvais*, cat. no. 14, p. 246.

SELECTED EXHIBITIONS
1889 • Paris, Galerie Georges Petit, June–July, *Monet-Rodin*, no. 128 (?).

1905 • Boston, Copley Hall, March 28–April 9, *Monet-Rodin* (Copley Society 1905), no. 28.

1920 • Boston, Brooks Reed Gallery, March, [*Tableaux Durand-Ruel*].

1922 • Baltimore, Mount Royal Avenue Building, April 1–10, *French Impressionist Paintings.*

1923 • Providence, R.I., Rhode Island School of Design, April.

1927 • Boston, Museum of Fine Arts, January 11–February 6, *Claude Monet Memorial Exhibition* (MFA 1927), no. 12.

1939–40 • *Juliana Cheney Edwards Collection* (Cunningham 1939b), no. 36.

1957 • St. Louis, City Art Museum of St. Louis, September 25–October 22; Minneapolis, The Minneapolis Institute of Arts, November 1–December 1, *Claude Monet: A Loan Exhibition* (City Art Museum 1957), no. 72.

1973 • *Impressionism: French and American* (MFA 1973a), no. 49.

1976 • New Haven, Conn., Yale University Art Gallery, February 1–March 15.

1977–78 • *Monet Unveiled* (Murphy and Giese 1977), no. 25.

1985 • Boston, Museum of Fine Arts, February 13–June 2, *The Great Boston Collectors: Paintings from the Museum of Fine Arts, Boston* (Troyen and Tabbaa 1984), no. 47.

1990 • Boston, Museum of Fine Arts, January 27–April 30; Chicago, The Art Institute of Chicago, May 19–August 12; London, Royal Academy of Arts, July 9–December 9, *Monet in the '90s: The Series Paintings* (Tucker 1989), no. 1.

1991–92 • *Claude Monet: Impressionist Masterpieces.*

1992 • *Crosscurrents.*

1992–93 • *Monet and His Contemporaries* (Bunkamura Museum and MFA 1992), no. 39.

1998 • South Hadley, Mass., Mount Holyoke College Art Museum, September 1–December 13, *On the Nature of Landscape.*

SELECTED REFERENCES
Malingue 1943, 113; Reuterswärd 1948, 286; Rewald 1973b, [100]; Wildenstein 1974–91, 3: no. 1219, 5:47; Gordon and Forge 1983, 124; Murphy 1985, 207; Murphy and Giese 1985, 38–39, no. 25; House 1986, 98, pl. 134; Alphant 1993, 455; Levine 1994, 117, fig. 57; Tucker 1995, 135–36; Wildenstein 1996, 3: no. 1219.

142. *Grainstack (Sunset)*, 1891
Oil on canvas
73.3 x 92.6 cm (28⅞ x 36½ in.)
Juliana Cheney Edwards Collection 25.112

PROVENANCE
September 1891, possibly purchased from the artist by Hamman for Knoedler & Co., London. By 1917, James F. Sutton, New York; January 17, 1917, sold at Sutton sale, American Art Association, New York, no. 156, and purchased by Durand-Ruel, New York and Paris; 1917, sold by Durand-Ruel, New York, to Robert J. Edwards (d. 1924), Boston; 1917–24, Robert J. Edwards, Boston; by 1925, inherited by Hannah Marcy Edwards (sister, d. 1929) and Grace M. Edwards (sister, d. 1938), Boston; 1925, bequest of Robert J. Edwards [1].

NOTE
1. See note 1 to the provenance for Corot's *Morning near Beauvais*, cat. no. 14, p. 246.

SELECTED EXHIBITIONS
1891 • Paris, Durand-Ruel, May 4–16, *Oeuvres récentes de Claude Monet*, no. 5.

1905 • Boston, Copley Hall, March 28–April 9, *Monet-Rodin* (Copley Society 1905), no. 66.

1919–20 • Boston, Museum of Fine Arts, December 1919–January 1920, *Impressionist and Barbizon Schools.*

1927 • Boston, Museum of Fine Arts, January 11–February 6, *Claude Monet Memorial Exhibition* (MFA 1927), no. 16.

1939–40 • *Juliana Cheney Edwards Collection* (Cunningham 1939b), no. 38.

1942 • Lubbock, Tex., Texas Technological College of Art Institute.

1942 • Santa Barbara, Calif., Santa Barbara Museum of Art.

1949 • Boston, Symphony Hall.

1950–51 • Boston, School of the Museum of Fine Arts.

1954 • Cambridge, Mass., Busch-Reisinger Museum, Harvard University, February 12–March 20, *Impressionism and Expression-ism* (Harvard University [1954]), no. 8.

1955 • Cambridge, Mass., Fogg Art Museum, Harvard University, May 2–31, *From Sisley to Signac: A Museum Course Exhibition* (Fogg [1955]), no. 15.

1957 • Cambridge, Mass., Fogg Art Museum, Harvard University, *French Painting.*

1957 • Edinburgh, Royal Scottish Academy, August 6–September 15; London, The Tate Gallery, September 26–November 3, *Claude Monet* (Tate Gallery [1957]), no. 93.

1960 • New York, The Museum of Modern Art, March 7–May 15; Los Angeles, Los Angeles County Museum of Art, June 14–August 7, *Claude Monet: Seasons and Moments* (Seitz 1960), no. 50.

1960 • Portland, Ore., Portland Art Museum, September 8–October 2, *Impressionist Paintings.*

1973 • *Impressionism: French and American* (MFA 1973a), no. 50.

1977–78 • *Monet Unveiled* (Murphy and Giese 1977), no. 29.

1978 • New York, The Metropolitan Museum of Art, April 19–July 9; St. Louis, The St. Louis Art Museum, late July–September 15, *Monet's Years at Giverny: Beyond Impressionism 1883–1926* (Metropolitan 1978), no. 14.

1979–80 • Copenhagen, Ordrupgaard, November 16, 1979–January 1, 1980, *Monet i Giverny* (Ordrupgaardsamlingen 1979), no. 4.

1983 • Paris, Centre Culturel du Marais, April 8–July 17, *Claude Monet au temps de Giverny* (Centre Culturel [1983]), no. 43.

1984–85 • Los Angeles, Los Angeles County Museum of Art, June 28–September 16, 1984; Chicago, The Art Institute of Chicago, October 18, 1984–January 6, 1985; Paris, Grand Palais, February 8–April 22, 1985, *A Day in the Country: Impressionism and the French Landscape* (Brettell et al. 1984), no. 104.

1985 • Williamstown, Mass., Sterling and Francine Clark Art Institute, June 8–October 6, *Monet in Massachusetts* (Brooks 1985), unnumbered entry.

1986 • Madrid, Museo Español de Arte Contemporáneo, April 29–June 30, *Claude Monet*, no. 69.

1990 • Museum of Fine Arts, Boston, January 27–April 30; Chicago, The Art Institute of Chicago, May 19–August 12; London, Royal Academy of Arts, July 9–December 9, *Monet in the '90s: The Series Paintings* (Tucker 1989), no. 30.

1991–92 • *Claude Monet: Impressionist Masterpieces.*

1992 • *Crosscurrents.*

1992–93 • *Monet and His Contemporaries* (Bunkamura Museum and MFA 1992), no. 41.

1995–96 • Dallas, Dallas Museum of Art, May 18, 1995–January 14, 1996.

1997–98 • Göteborg, Göteborgs Konstmuseum, October 11, 1997–January 6, 1998, *Claude Monet: Tolv mästerverk* (Göteborgs 1997), no. 7.

1999 • *Monet, Renoir, and the Impressionist Landscape* (Nagoya/Boston and MFA 1999), no. 48.

2000–2 • *Monet, Renoir, and the Impressionist Landscape* (Shackelford and Wissman 2000), no. 49.

2001 • Canberra, National Gallery of Australia, March 9–June 11; Perth, Art Gallery of Western Australia, July 6–September 16, *Monet and Japan* (National Gallery of Australia 2001), no. 22 (Perth venue only).

SELECTED REFERENCES
"Claude Monet Exhibit Opens" 1905, 9; Geffroy 1922, 189; Reuterswärd 1948, 286; Seitz 1956, 40; Seitz 1960, 35, 138–39; Greenberg 1961, 37–46; Wildenstein 1974–91, 3: no. 1289, 5:48, 200 (letter nos. 2833, 2835–37); Herbert 1979, 106, fig. 18; Kelder 1980, 213; Seiberling 1981, 94, 97, 360, fig. 14, no. 33; Gordon and Forge 1983, 162; Moffett 1984, 153, fig. 67; Rewald and Weitzenhoffer 1984, 139–60, fig. 67; Auckland City 1985, 22, fig. 13; Murphy 1985, 207; Murphy and Giese 1985, 44–45, no. 29; House 1986, 28, 98, 128, 176, 178, 197, 199, fig. 162; Smith [1994], 102–03, fig. 64; Tucker 1995, 141, 143; Wildenstein 1996, 3: no. 1289; Tucker et al. 1998, 5–6, fig. 5.

143. *Grainstack (Snow Effect),* 1891

Oil on canvas
65.4 x 92.3 cm (25¾ x 36⅜ in.)
Gift of Misses Aimée and Rosamond Lamb in memory of Mr. and Mrs. Horatio A. Lamb 1970.253

PROVENANCE
May 9, 1891, sold by the artist to Durand-Ruel, Paris; June 30, 1891, sold by Durand-Ruel to Mr. and Mrs. Horatio A. Lamb, Boston: 1891–1950, Mr. and Mrs. Horatio A. Lamb, Boston; 1950–70, inherited by Misses Aimée and Rosamond Lamb (daughters), Boston; 1970, gift of Misses Aimée and Rosamond Lamb.

SELECTED EXHIBITIONS
1891 • Paris, Durand-Ruel, May 4–16, *Oeuvres récentes de Claude Monet*, no. 8.

1892 • Boston, St. Botolph Club, March 28–April 9, *Monet* (D.F. 1892), no. 16.

1905 • Boston, Copley Hall, March 28–April 9, *Monet-Rodin* (Copley Society 1905), no. 39.

1911 • Boston, Museum of Fine Arts, August, *Monet* (MFA 1911), no. 19.

1957 • Boston, Museum of Fine Arts, January 9–February 19, *A Tribute to Claude Monet* (?).

1960 • New York, The Museum of Modern Art, March 7–May 15; Los Angeles, Los Angeles County Museum of Art, June 14–August 7, *Claude Monet: Seasons and Moments* (Seitz 1960), no. 51.

1973 • *Impressionism: French and American* (MFA 1973a), no. 51.

1977–78 • *Monet Unveiled* (Murphy and Giese 1977), no. 30.

1980 • Washington, D.C., National Gallery of Art, May 25–September 1, 1980, *Post-Impressionism: Cross-Currents in European and American Painting, 1880–1906* (National Gallery 1980), no. 26.

1990 • Museum of Fine Arts, Boston, January 27–April 30; Chicago, The Art Institute of Chicago, May 19–August 12; London, Royal Academy of Arts, July 9–December 9, *Monet in the '90s: The Series Paintings* (Tucker 1989), no. 24.

1992 • *Crosscurrents.*

1991–92 • *Claude Monet: Impressionist Masterpieces.*

1998–99 • Washington, D.C., The Phillips Collection, September 19, 1998–January 3, 1999; San Francisco, The Fine Arts Museums of San Francisco at the Center for the Arts at Yerba Buena Gardens, January 30–May 2, 1999; Brooklyn, The Brooklyn Museum, May 27–August 29, 1999, *Impressionists in Winter: Effets de Neige* (Moffett et al. 1998), not in catalogue.

2001 • Canberra, National Gallery of Australia, March 9–June 11; Perth, Art Gallery of Western Australia, July 6–September 16, *Monet and Japan* (National Gallery of Australia 2001), no. 24.

SELECTED REFERENCES
Denoinville 1901, 67; Vauxcelles 1922, 235; Wildenstein 1974–91, 3: no. 1280; Joyes et al. 1975, 58; Isaacson 1978, 221, no. 97; Gordon and Forge 1983, 160; Auckland City 1985, 22, fig. 12; Murphy 1985, 209; Murphy and Giese 1985, 44, 46, no. 30; House 1986, 128, fig. 161; Smith [1994], 102–03, fig. 63; Wildenstein 1996, 3: no. 1280; Heinrich 2001, 67, 184.

144. *Morning on the Seine, near Giverny,* 1897

Oil on canvas
81.4 x 92.7 cm (32 x 36½ in.)
Gift of Mrs. W. Scott Fitz 11.1261

PROVENANCE
1897–1909, with the artist, Giverny, France; June 18, 1909, purchased from the artist by Durand-Ruel, Paris; October 22, 1909, sold by Durand-Ruel to James Viles, Chicago; 1909–11, James Viles, Chicago; March 1, 1911, sold by Viles to Durand-Ruel, Paris and New York; March 7, 1911, sold by Durand-Ruel to Mrs. Walter Scott Fitz (Henrietta Goddard Wigglesworth, d. 1927), Boston; 1911, gift of Mrs. Walter Scott Fitz.

SELECTED EXHIBITIONS
1898 • Paris, Galerie Georges Petit, June–July, *Claude Monet*, no. 50 (?).

1900 • New York, Durand-Ruel, April, *Exhibition of Paintings: Claude Monet and Pierre Auguste Renoir* (Durand-Ruel [1900]), no. 16.

1909 • New York, Durand-Ruel, November, *Monet?*.

1910 • Boston, Walter Kimball Gallery, March 7–26, *Monets from the Durand-Ruel Collection* (Walter Kimball 1910), no. 7.

1911 • Boston, Museum of Fine Arts, August, *Monet* (MFA 1911), no. 45.

1919 • Boston, Walter Kimball Gallery, *Monet*, no. 27.

1927 • Boston, Museum of Fine Arts, January 11–February 6, *Claude Monet: Memorial Exhibition* (MFA 1927), no. 19.

1949 • Boston, Symphony Hall.

1968 • New York, Acquavella Galleries, October 24–November 30, *Four Masters of Impressionism: Monet, Pissarro, Renoir, Sisley* (Acquavella Galleries 1968), no. 58.

1970 • Tokyo, Magasin Tokyu, October 2–21; Osaka, Magasin Daimaru, October 27–November 1; Fukuoka, Magasin Iwataya, November 17–29, *Claude Monet* (Asahi Shimbun 1970), no. 16.

1973 • *Impressionism: French and American* (MFA 1973a), no. 55.

1977–78 • *Monet Unveiled* (Murphy and Giese 1977), no. 34.

1978 • New York, The Metropolitan Museum of Art, April 19–July 9; St. Louis, The St. Louis Art Museum, late July–September 15, *Monet's Years at Giverny: Beyond Impressionism, 1883–1926* (Metropolitan 1978), no. 27.

1983 • Paris, Centre Culturel du Marais, April 8–July 17, *Claude Monet au temps de Giverny* (Centre Culturel [1983]), no. 36.

1983–84 • *Masterpieces of European Painting* (Nippon Television 1983), no. 57.

1985 • Auckland, Auckland City Art Gallery, April 29–June 9; Sydney, Art Gallery of New South Wales, June 21–August 4; Melbourne, National Gallery of Victoria, August 14–September 29, *Claude Monet: Painter of Light* (Auckland City 1985), no. 26.

1990 • Museum of Fine Arts, Boston, January 27–April 30; Chicago, The Art Institute of Chicago, May 19–August 12; London, Royal Academy of Arts, July 9–December 9, *Monet in the '90s: The Series Paintings* (Tucker 1989), no. 83.

1991–92 • *Claude Monet: Impressionist Masterpieces.*

1992–93 • *Monet and His Contemporaries* (Bunkamura Museum and MFA 1992), no. 43.

1998 • Ann Arbor, Mich., University of Michigan Museum of Art, January 25–March 15; Dallas, Dallas Museum of Art, March 28–May 17; Minneapolis, The Minneapolis Institute of Arts, May 30–July 26, *Monet at Vétheuil, The Turning Point* (Dixon, McNamara, and Stuckey 1998), not in catalogue (Dallas venue only).

1999 • *Monet, Renoir, and the Impressionist Landscape* (Nagoya/Boston and MFA 1999), no. 49.

2000–2 • *Monet, Renoir, and the Impressionist Landscape* (Shackelford and Wissman 2000), no. 50.

2001–2 • Hamburg, Hamburger Kunsthalle, September 28, 2001–January 6, 2002, *Monet's Legacy.*

SELECTED REFERENCES

MFA 1921, no. 363; Geffroy 1922, 260; Venturi 1939, 1:424; Reuterswärd 1948, 283; Edgell 1949, 56; Seitz 1960, 144–45; Coplans [1968], 28, fig. 4b; Rouart et al. 1972, 58, 60; Wildenstein 1974–91, 3:302 (pièce justica-tive no. 144), no. 1481, 4:377 (letter no. 1897); Joyes et al. 1975, 59; Isaacson 1978, 156, 224, no. 111; Sutton 1978, 85; Tucker 1982, 166, fig. 148; Murphy 1985, 204; Murphy and Giese 1985, 50–51, no. 34; Stuckey 1985, 196; Alphant 1993, 578; Wildenstein 1996, 3: no. 1481; Tucker et al. 1998, 8, fig. 11.

152. *The Water Lily Pond*, 1900
Oil on canvas
90 x 92 cm (35⅛ x 36½ in.)
Given in memory of Governor Alvan T. Fuller by the Fuller Foundation 61.959

PROVENANCE

December 1900, purchased from the artist by Léonce Rosenberg, Paris. By 1923, Léon Orosdi, Paris [1]; May 25, 1923, sold at Orosdi posthumous sale, Hôtel Drouot, no. 41, and bought by Durand-Ruel, Paris; 1923–27, with Durand-Ruel, Paris and New York; November 27, 1927, sold by Durand-Ruel to Alvan Tufts Fuller (governor, d. 1958), Boston; 1927–58, Alvan T. Fuller, Boston; 1958–61, with the Fuller Foundation, Inc., Boston; 1961, gift of the Fuller Foundation.

NOTE

1. Orosdi purchased almost all his paint-ings from Bernheim-Jeune, but it cannot be said with certainty that this particular work came from that dealer.

SELECTED EXHIBITIONS

1927 • Boston, Museum of Fine Arts, Jan-uary 11–February 6, *Claude Monet: Memorial Exhibition* (MFA 1927), no. 52.

1928 • Boston, Boston Art Club, *The Fuller Collection*, no. 15.

1957 • Boston, Museum of Fine Arts, Jan-uary 9–February 19, *A Tribute to Claude Monet.*

1959 • Boston, Museum of Fine Arts, February 6–March 22, *A Memorial Exhibi-tion of the Collection of the Honorable Alvan T. Fuller* (MFA 1959), no. 37.

1961 • Palm Beach, Fla., Society of the Four Arts, January 7–29, *Paintings in the Collection of Alvan T. Fuller* (Society of the Four Arts [1961]), no. 28.

1973 • *Impressionism: French and American* (MFA 1973a), no. 56.

1977–78 • *Monet Unveiled* (Murphy and Giese 1977), no. 35.

1979–80 • *Corot to Braque* (Poulet and Murphy 1979), no. 51.

1985 • Boston, Museum of Fine Arts, February 13–June 2, *The Great Boston Collectors: Paintings from the Museum of Fine Arts, Boston* (Troyen and Tabbaa 1984), no. 57.

1985 • Williamstown, Mass., Sterling and Francine Clark Art Institute, June 8–

October 6, *Monet in Massachusetts* (Brooks 1985), unnumbered entry.

1986 • Basel, Kunstmuseum, July 19–October 19, *Claude Monet: Nymphéas* (Geelhaar et al. 1986), no. 11.

1990 • Museum of Fine Arts, Boston, January 27–April 30; Chicago, The Art Institute of Chicago, May 19–August 12; London, Royal Academy of Arts, July 9–December 9, *Monet in the '90s: The Series Paintings* (Tucker 1989), no. 93.

1991–92 • *Claude Monet: Impressionist Masterpieces.*

1992 • *Crosscurrents.*

1992–93 • *Monet and His Contemporaries* (Bunkamura Museum and MFA 1992), no. 45.

1994 • Tokyo, Bridgestone Museum of Art, February 11–April 7; Nagoya, Nagoya City Art Museum, April 16–June 12; Hiroshima, Hiroshima Museum of Art, June 18–July 31, *Monet: A Retrospective* (Tucker, Fukaya, and Miyazaki 1994), no. 69.

1998–99 • Boston, Museum of Fine Arts, September 20–December 27, 1998; London, Royal Academy of Arts, January 23–April 18, 1999, *Monet in the Twentieth Century* (Tucker et al. 1998), no. 3.

1999 • Paris, Musée de l'Orangerie, May 6–August 2, *Monet: Le cycle des nymphéas* (Musée de l'Orangerie 1999), no. 8.

2000–2 • *Monet, Renoir, and the Impressionist Landscape* (Shackelford and Wissman 2000), no. 51.

2001 • Canberra, National Gallery of Australia, March 9–June 11; Perth, Art Gallery of Western Australia, July 6–September 16, 2001, *Monet and Japan* (National Gallery of Australia 2001), no. 32 (Perth venue only).

SELECTED REFERENCES

"Carnet d'un collectionneur . . ." 1923, 3; Feuillet 1923, 11; "Revue des ventes . . ." 1923, 3; T. 1923, 89; Reuterswärd 1948, 288; "La Chronique des Arts" 1962, no. 151; Rouart et al. 1972, 155; Wildenstein 1974–91, 4:349 (letter nos. 1580–81), 427 (pièces jus-ticatives nos. 151–52), no. 1630; Murphy and Giese 1977, 52, no. 35; Kelder 1980, 219; Seiberling 1981, 240; Murphy 1985, 209; Murphy and Giese 1985, 52, no. 35; Tucker 1989, 277, 280; Wildenstein 1996, 4: no. 1630; Georgel 1999, 4–25.

153. *Water Lilies*, 1905
Oil on canvas
89.5 x 100.3 (35¼ x 39½ in.)
Gift of Edward Jackson Holmes 39.804

PROVENANCE

1905–9, with the artist, Giverny, France; June 1909, purchased from the artist by Durand-Ruel, Paris and New York, and Bernheim-Jeune, Paris; December 10, 1909, sold by Durand-Ruel to Alexander Cochrane, Boston; December 21, 1901, sold by Cochrane to Durand-Ruel, Paris and New York; 1901–11, with Durand-Ruel, Paris and New York; 1911, sold by Durand-Ruel to Mrs. Walter Scott Fitz (Henrietta Goddard Wigglesworth, d. 1927), Boston; 1911–27, Mrs. Walter Scott Fitz, Boston; 1927–31, Estate of Mrs. Walter Scott Fitz; 1931–39, inherited (?) by Edward Jackson Holmes (d. 1950), Boston; 1939, gift of Edward Jackson Holmes.

SELECTED EXHIBITIONS

1909 • Paris, Durand-Ruel, May 6–June 5, *Monet. Nymphéas*, no. 8.

1909 • New York, Durand-Ruel, Novem-ber, *Monet?*.

1910 • Boston, Walter Kimball Gallery, March 7–26, *Monets from the Durand-Ruel Collection* (Walter Kimball 1910), no. 5.

1911 • New York, Durand-Ruel, February 8–25, *Tableaux de Claude Monet à différentes périodes*, no. 17.

1927 • Boston, Museum of Fine Arts, January 11–February 6, *Claude Monet: Memorial Exhibition* (MFA 1927), no. 51.

1941 • Norfolk, Va., Norfolk Museum of Arts and Sciences, February 2–March 30; Colorado Springs, Colo., Colorado Springs Fine Arts Center, May 15–July 1, *French Impressionists: Spring Exhibition* (Norfolk Museum 1941), either this paint-ing or *Water Lilies* 19.170 (cat. no. 154) was no. 8.

1960 • New York, The Museum of Modern Art, March 7–May 15; Los Angeles, Los Angeles County Museum of Art, June 14–August 7, *Claude Monet: Seasons and Moments* (Seitz 1960), no. 106.

1960 • Portland, Ore., Portland Art Museum, September 8–October 2, *Impressionist Paintings.*

1963 • Philadelphia, Philadelphia Museum of Art, May 1–June 9, *A World of Flowers.*

1968 • Buenos Aires, Museo Nacional de Bellas Artes, May 15–June 5; Santiago, Museo de Arte Contemporaneo de la Universidad de Chile, June 26–July 17; Caracas, Museo de Bellas Artes, August 4–25, *De Cézanne a Miró* (MoMA 1968), unnumbered entry, pp. 10–11.

1969 • Omaha, Joslyn Art Museum, April 10–June 1, *Mary Cassatt among the Impressionists* (JAM [1969]), no. 35.

1973 • *Impressionism: French and American* (MFA 1973a), no. 57.

1977–78 • *Monet Unveiled* (Murphy and Giese 1977), no. 37.

1978 • New York, The Metropolitan Museum of Art, April 19–July 9; St. Louis, The St. Louis Art Museum, late July–September 15, *Monet's Years at Giverny: Beyond Impressionism 1883–1926* (Metropolitan 1978), no. 40.

1983–84 • *Masterpieces of European Painting* (Nippon Television 1983), no. 58.

1985 • Auckland, Auckland City Art Gallery, April 29–June 9; Sydney, Art Gallery of New South Wales, June 21–August 4; Melbourne, National Gallery of Victoria, August 14–September 29, *Claude Monet: Painter of Light* (Auckland City 1985), no. 35.

1991–92 • *Claude Monet: Impressionist Masterpieces.*

1992–93 • *Monet and His Contemporaries* (Bunkamura Museum and MFA 1992), no. 46.

1998–99 • Boston, Museum of Fine Arts, September 20–December 27, 1998; London, Royal Academy of Arts, January 23–April 18, 1999, *Monet in the Twentieth Century* (Tucker et al. 1998), no. 28.

1999 • Paris, Musée de l'Orangerie, May 6–August 2, *Monet: Le cycle des nymphéas* (Musée de l'Orangerie 1999), no. 13.

SELECTED REFERENCES

Venturi 1939, 1:422–25; Edgell 1949, 8; Francis 1960, 195; Rouart et al. 1972, 27, 158; MFA 1973b, no. 13; Wildenstein 1974–91, 4:376–77 (letter nos. 1885, 1887–88, 1891, 1897), 429 (pièce justicatives nos. 213, 218–19, 233), no. 1671; Isaacson 1978, 175, 228, no. 130; Sutton 1978, 88; Kelder 1980, 185; Seiberling 1981, 240; Centre Culturel [1983], fig. 83; Rewald and Weitzenhoffer 1984, 227, fig. 89; Murphy 1985, 208; Murphy and Giese 1985, 54, 56, no. 37;

House 1986, 106, fig. 140; MFA 1986, 74; Milner 1991, 2–3; Wildenstein 1996, 4: no. 1671.

154. *Water Lilies,* 1907
Oil on canvas
89.3 x 93.4 cm (35⅛ x 36¾ in.)
Bequest of Alexander Cochrane 19.170

PROVENANCE

1907–9, with the artist, Giverny, France; June 1909, purchased from the artist by Durand-Ruel, Paris and New York, and Bernheim-Jeune, Paris; December 1909, sold by Durand-Ruel to Alexander Cochrane (d. 1919), Boston; 1909–19, Alexander Cochrane, Boston; 1919, bequest of Alexander Cochrane.

SELECTED EXHIBITIONS

1909 • Paris, Durand-Ruel, May 6–June 5, *Monet. Nymphéas,* no. 30.

1927 • Boston, Museum of Fine Arts, January 11–February 6, *Claude Monet: Memorial Exhibition* (MFA 1927), no. 20.

1941 • Norfolk, Va., Norfolk Museum of Arts and Sciences, February 2–March 30; Colorado Springs, Colo., Colorado Springs Fine Arts Center, May 15–July 1, *French Impressionists: Spring Exhibition* (Norfolk Museum 1941), either this painting or *Water Lilies* 39.804 (cat. no. 153) was no. 8.

1949 • Boston, Symphony Hall.

1973 • *Impressionism: French and American* (MFA 1973a), no. 58.

1977–78 • *Monet Unveiled* (Murphy and Giese 1977), no. 38.

1998–99 • Boston, Museum of Fine Arts, September 20–December 27, 1998; London, Royal Academy of Arts, January 23–April 18, 1999, *Monet in the Twentieth Century* (Tucker et al. 1998), no. 33.

1992 • *Crosscurrents.*

1999 • Paris, Musée de l'Orangerie, May 6–August 2, *Monet: Le cycle des nymphéas* (Musée de l'Orangerie 1999), no. 17.

SELECTED REFERENCES

MFA 1919, 44; MFA 1921, no. 364; Venturi 1939, 1:421–26; Reuterswärd 1948, 288; Rouart et al. 1972, 160; Wildenstein 1974–91, 4:376–77 (letter nos. 1885, 1887–88, 1890–91, 1897), 429 (pièce justicative no. 213), no. 1697; Seiberling 1981, 240; Murphy 1985, 204; Murphy and Giese 1985, 55–56, no. 38; Tucker 1995, 194; Wildenstein 1996, 4: no. 1697.

Camille Pissarro
French (born Danish West Indies), 1830–1903

87. *Pontoise, the Road to Gisors in Winter,* 1873
Oil on canvas
59.8 x 73.8 cm (23½ x 29 in.)
Bequest of John T. Spaulding 48.587

PROVENANCE

Until 1925, with Durand-Ruel, Paris; 1925, purchased from Durand-Ruel by John Taylor Spaulding (d. 1948), Boston; 1948, bequest of John Taylor Spaulding.

SELECTED EXHIBITIONS

1939 • Boston, Museum of Fine Arts, June 9–September 10, *Art in New England: Paintings, Drawings, and Prints, from Private Collections in New England* (MFA 1939), r.o. 92.

1948 • Boston, Museum of Fine Arts, May 26–November 7, *The Collections of John Taylor Spaulding, 1870–1948* (MFA 1948), r.o. 64.

1949 • Cambridge, Mass., Fogg Art Museum, Harvard University.

1949 • Manchester, N.H., The Currier Gallery of Art, October 8–November 6, *Monet and the Beginnings of Impressionism: Twentieth Anniversary Exhibition* (Currier Gallery of Art [1949]), no. 18.

1963 • Berlin, Orangerie des Schlosses Charlottenburg, September 28–November 24, *Ile de France und ihre Maler: Ausstellung veranstaltet von der Nationalgalerie in der Orangerie des Schlosses Charlottenburg Berlin* (Staatliche Museen [1963]), no. 15.

1973 • *Impressionism: French and American* (MFA 1973a), no. 62.

1979–80 • *Corot to Braque* (Poulet and Murphy 1979), no. 32.

1980–81 • London, Hayward Gallery, October 31, 1980–January 11, 1981; Paris, Grand Palais, January 30–April 27, 1981; Boston, Museum of Fine Arts, May 19–August 9, 1981, *Camille Pissarro, 1830–1903* (Brettell et al. 1980), no. 25.

1983–84 • *Masterpieces of European Painting* (Nippon Television 1983), no. 44.

1985 • Boston, Museum of Fine Arts, February 13–June 2, *The Great Boston Collectors: Paintings from the Museum of Fine Arts, Boston* (Troyen and Tabbaa 1984), no. 53.

1989 • *From Neoclassicism to Impressionism* (Kyoto Museum, Kyoto Shimbun, and MFA 1989), no. 44.

1992 • *Crosscurrents.*

1994–95 • Jerusalem, Weisbord Exhibition Pavilion, Israel Museum, October 11, 1994–January 9, 1995, *Camille Pissarro: Impressionist Innovator* (Pissarro and Rachum 1995), no. 41.

1997 • Glasgow, McLellan Galleries, Burrell Collection, Glasgow Museums, May 23–September 7, *The Birth of Impressionism: From Constable to Monet* (Glasgow Museums 1997), 26, unnumbered entry.

1999 • *Monet, Renoir, and the Impressionist Landscape* (Nagoya/Boston and MFA 1999), no. 27.

2000–2 • *Monet, Renoir, and the Impressionist Landscape* (Shackelford and Wissman 2000), no. 27.

SELECTED REFERENCES

Watson 1925, 336, 344; Pope 1930, 98, 103; Pissarro and Venturi 1939, 1:107, no. 202, 2: pl. 41, no. 202; Edgell 1949, 35; Rewald [1954], pl. 19; MFA 1955, 52; Reidemeister 1963, 55; Rewald 1963, 88, no. 202; Preutu 1974, 39; Murphy 1985, 229.

90. *Sunlight on the Road, Pontoise,* 1874
Oil on canvas
52.3 x 81.5 cm (20⅝ x 32⅛ in.)
Juliana Cheney Edwards Collection 25.114

PROVENANCE

Jean-Baptiste Faure, Paris (not in the Faure sale of April 29, 1878). G. Faure (?); by 1919, sold by either Jean-Baptiste Faure or G. Faure to Durand-Ruel, New York and Paris, no. 4258 [1]. By 1924, Robert J. Edwards (d. 1924), Boston; by 1925, inherited by Hannah Marcy Edwards (sister, d. 1929) and Grace M. Edwards (sister, d. 1929), Boston; 1925, bequest of Robert J. Edwards [2].

NOTES

1. According to a note in the object file, Herbert Elfers of Durand-Ruel verbally relayed the following information to C. C. C. at the MFA: "Bought from G. Faure by Durand-Ruel." It is not clear whether or not this was a misunderstanding for "J. Faure."

2. See note 1 to the provenance for Corot's *Morning near Beauvais,* cat. no. 14, p. 246.

SELECTED EXHIBITIONS
1904 • Paris, Durand-Ruel, *Pissarro*, no. 31.

1919 • New York, Durand-Ruel, *Recently Imported Works by Pissarro*, no. 6.

1939–40 • *Juliana Cheney Edwards Collection* (Cunningham 1939b), no. 43.

1944 • Williamstown, Mass., Lawrence Hall, Williams College Museum.

1951 • Milwaukee, Milwaukee Art Institute, October 8–November 15, *Masters of Impressionism* ([Milwaukee 1951]), no. 3.

1965 • New York, Wildenstein Galleries, March 25–May 1, *C. Pissarro* (Wildenstein 1965), no. 25.

1973 • *Impressionism: French and American* (MFA 1973a), no. 63.

1979–80 • *Corot to Braque* (Poulet and Murphy 1979), no. 31.

1983–84 • *Masterpieces of European Painting* (Nippon Television 1983), no. 45.

1985 • Boston, Museum of Fine Arts, February 13–June 2, *The Great Boston Collectors: Paintings from the Museum of Fine Arts, Boston* (Troyen and Tabbaa 1984), no. 45.

1992 • *Crosscurrents*.

1995–96 • London, Hayward Gallery, May 18–August 28, 1995; Boston, Museum of Fine Arts, October 4, 1995–January 14, 1996, *Impressions of France: Monet, Renoir, Pissarro, and Their Rivals* (House et al. 1995), no. 75.

1996 • Tokyo, Tobu Museum of Art, March 30–June 30, *Inshoha wa koshite umareta: Akademisumu kara Kurube, Mune, Mone, Runowaru* (The Birth of Impressionism) (Tobu Bijutsukan 1996), no. 141.

1999–2000 • Stuttgart, Staatsgalerie Stuttgart, December 11, 1999–May 1, 2000, *Camille Pissarro* (Becker et al. 1999), no. 27.

2000–2 • *Monet, Renoir, and the Impressionist Landscape* (Shackelford and Wissman 2000), no. 28.

SELECTED REFERENCES
Cunningham 1939a, 8; Pissarro and Venturi 1939, 1:115, no. 255, 2: no. 255, pl. 51. Edgell 1949, 33; MFA 1973b, no. 28; Murphy 1985, 229; MFA 1986, 76; Brettell 1990, 171, fig. 149.

96. *The Quarry at the Hermitage, Pontoise,* 1878
Black chalk on blue wove paper
Sheet: 33.7 x 20.7 cm (13¼ x 8⅛ in.)
Gift of Barbara and Burton Stern in memory of Lillian H. and Bernard E. Stern
1985.348

PROVENANCE
1959, O'Hana Gallery, London; 1961, Guido R. Rahr, Manitowoc, Wisc.; Eric G. Carlson, New York; 1985, sold by Eric G. Carlson to the MFA.

SELECTED EXHIBITION
1888 • Boston, Museum of Fine Arts, summer, *Nineteenth-Century European Drawings.*

97. *Wooded Landscape at the Hermitage, Pontoise,* 1879
Soft-ground etching and aquatint on cream wove paper, first state. Delteil 16
Platemark: 21.6 x 26.7 cm (8½ x 10½ in.)
Lee M. Friedman Fund 1971.267

SELECTED REFERENCE
Shapiro 1973, nos. 6–11.

98. *Wooded Landscape at the Hermitage, Pontoise,* 1879
Soft-ground etching and aquatint on beige laid paper, fifth state. Delteil 16
Platemark: 21.6 x 26.7 cm (8½ x 10½ in.)
Lee M. Friedman Fund 1971.268

SELECTED REFERENCE
Shapiro 1973, nos. 6–11.

99. *Wooded Landscape at the Hermitage, Pontoise,* 1879
Soft-ground etching and aquatint on cream Japanese paper, sixth state. Delteil 16
Platemark: 21.6 x 26.7 cm (8½ x 10½ in.)
Katherine E. Bullard Fund in memory of Francis Bullard, Prints, Drawings and Photographs Curator's Discretionary Fund, Anonymous gifts, and Gift of Cornelius C. Vermeule III 1973.176

SELECTED REFERENCE
Shapiro 1973, nos. 6–11.

100. *Twilight with Haystacks,* 1879
Aquatint with drypoint and etching on cream wove paper. Delteil 23
Platemark: 10.5 x 18.1 cm (4⅛ x 7⅛ in.)
Lee M. Friedman Fund 1974.533

SELECTED EXHIBITION
1987 • Boston, Museum of Fine Arts, April 15–July 26, *Printmaking: The Evolving Image*, no. 43a.

101. *Twilight with Haystacks,* 1879
Aquatint with drypoint and etching in Prussian blue on beige laid paper.
Delteil 23
Platemark: 10.5 x 18.1 cm (4⅛ x 7⅛ in.)
Lee M. Friedman Fund 1983.220

SELECTED EXHIBITION
1987 • Boston, Museum of Fine Arts, April 15–July 26, *Printmaking: The Evolving Image*, no. 43.

116. *Turkey Girl,* 1884
Tempera on paper
81 x 65.5 cm (31⅞ x 25¾ in.)
Juliana Cheney Edwards Collection 39.673

PROVENANCE
By 1914, with Durand-Ruel, Paris and New York. 1914, probably sold by Durand-Ruel to Hannah Marcy Edwards (d. 1929), Boston; 1914–29, Hannah Marcy Edwards, Boston; 1931–38, inherited by Grace M. Edwards (sister, d. 1938), Boston; 1939, bequest of Hannah M. Edwards [1].

NOTE
1. See note 1 to the provenance for Corot's *Morning near Beauvais*, cat. no. 14, p. 246.

SELECTED EXHIBITIONS
1903 • New York, Durand-Ruel, *Pissarro,* no. 29.

1919–20 • Boston, Museum of Fine Arts, December 1919–January 1920, *Impressionist and Barbizon Schools.*

1939–40 • *Juliana Cheney Edwards Collection* (Cunningham 1939b), no. 44.

1945 • New London, Conn., Lyman Allen Museum, Connecticut College.

1949 • Boston, Symphony Hall.

1973 • *Impressionism: French and American* (MFA 1973a), no. 64.

1980–81 • London, Hayward Gallery, October 31, 1980–January 11, 1981; Paris, Grand Palais, January 30–April 27, 1981; Boston, Museum of Fine Arts, May 19–August 9, 1981, *Camille Pissarro, 1830–1903* (Brettell et al. 1980), not in catalogue.

1990 • Birmingham, England, City Museum and Art Gallery, March 8–April 22; Glasgow, The Burrell Collection,

May 4–June 17, *Camille Pissarro: Impressionism, Landscape, and Rural Labour* (Thomson 1990), no. 38.

SELECTED REFERENCES
MFA 1920, 121; Pissarro and Venturi 1939, 1:277, no. 1414, 2: fig. 1414.

118. *Church and Farm at Eragny-sur-Epte,* 1894–95
Color etching on cream laid paper.
Delteil 96
Platemark: 15.8 x 24.7 cm (6¼ x 9¾ in.)
Ellen Frances Mason Fund 34.583

SELECTED REFERENCE
Shapiro 1973, illus., unpaginated.

141. *Morning Sunlight on the Snow, Eragny-sur-Epte,* 1894
Oil on canvas
82.3 x 61.5 cm (32⅜ x 24¼ in.)
The John Pickering Lyman Collection. Gift of Miss Theodora Lyman 19.1321

PROVENANCE
April 10, 1894, purchased from the artist by Durand-Ruel, Paris, no. 1789; 1894–1910, with Durand-Ruel, Paris; 1910, sold by Durand-Ruel to John Pickering Lyman (d. 1914), Portsmouth, N.H.; 1910–14, John Pickering Lyman, Portsmouth, N.H.; 1914–19, inherited by Miss Theodora Lyman, Portsmouth, N.H.; 1919, gift of Miss Theodora Lyman.

SELECTED EXHIBITIONS
1915 • Boston, Museum of Fine Arts, opened February 3, *Robert Dawson Evans Memorial Galleries Opening Exhibition.*

1945 • New London, Conn., Lyman Allen Museum, Connecticut College.

1945 • New York, Wildenstein Galleries, *Camille Pissarro and His Influence,* no. 32.

1946 • Chicago, Arts Club of Chicago.

1949 • Boston, Symphony Hall.

1956 • South Hadley, Mass., Mount Holyoke College, *French and American Impressionism,* no. 19.

1964 • Iowa City, University of Iowa, Gallery of Art, November 8–December 8, *Impressionism and Its Roots* (University of Iowa [1964]), no. 39.

1973 • *Impressionism: French and American* (MFA 1973a), no. 67.

1979–80 • *Corot to Braque* (Poulet and Murphy 1979), no. 30.

1980–81 • London, Hayward Gallery, October 31, 1980–January 11, 1981; Paris, Grand Palais, January 30–April 27, 1981; Boston, Museum of Fine Arts, May 19–August 9, 1981, *Camille Pissarro, 1830–1903* (Brettell et al. 1980), no. 74.

1984 • Tokyo, Isetan Museum of Art, March 9–April 8; Fukuoka, Fukuoka Art Museum, April 25–May 20; Kyoto, Kyoto Municipal Museum of Art, May 26–July 1, *Retrospective Camille Pissarro* (Isetan Museum 1984), no. 49.

1990 • Birmingham, England, City Museum and Art Gallery, March 8–April 22; Glasgow, The Burrell Collection, May 4–June 17, *Camille Pissarro: Impressionism, Landscape, and Rural Labour* (Thomson 1990), no. 98.

1992–93 • *Monet and His Contemporaries* (Bunkamura Museum and MFA 1992), no. 47.

1999 • *Monet, Renoir, and the Impressionist Landscape* (Nagoya / Boston and MFA 1999), no. 29.

2000–2 • *Monet, Renoir, and the Impressionist Landscape* (Shackelford and Wissman 2000), no. 30.

SELECTED REFERENCES
Thieme and Becker 1933, 27:109; Pissarro and Venturi 1939, 1:63, 207, no. 911, 2: no. 911, pl. 185; MFA 1973b, no. 27; Murphy 1985, 229; Moffett et al. 1998, 50, fig. 8.

Odilon Redon
French, 1840–1916

43. *Fear*, 1866
Etching on cream wove paper. Mellerio 6; Harrison 7, first state
Image: 11 x 20 cm (4 ⁵/₁₆ x 7 ⁷/₈ in.);
platemark: 14 x 22.3 cm (5 ½ x 8 ¾ in.)
Lee M. Friedman Fund 67.741

145. *Tree*, 1892
Lithograph on chine collé. Mellerio 120
Image / chine collé: 47.7 x 31.9 cm (18 ¾ x 12 ⁹/₁₆ in.)
Bequest of W. G. Russell Allen 60.699

150. *Centaur*, 1895–1900
Pastel on canvas
73 x 60.2 cm (28 ¾ x 23 ¾ in.)
Gift of Laurence K. Marshall 64.2206

PROVENANCE
Gustave Fayet, Béziers, France. Paul Bacou (?), Paris. By 1958, acquired by Jacques Dubourg, Paris; January 1959, sold by Dubourg to Laurence K. Marshall, Boston; 1959–64, Laurence K. Marshall, Boston; 1964, gift of Laurence K. Marshall.

SELECTED EXHIBITIONS
1926 • Paris, Musée des Arts Décoratifs, March, *Odilon Redon: Exposition rétrospective de son oeuvre*, no. 110.

1938 • London, Wildenstein Galleries, January, *Exhibition of Paintings by Odilon Redon*, no. 33.

1948 • Paris, Galerie Jacques Dubourg, June 16–July 3, *Odilon Redon: Peintures, pastels, dessins*, no. 16.

1949–50 • Paris, Musée de l'Orangerie, *Eugène Carrière et le Symbolisme*, December 1949–January 1950 (Musée de l'Orangerie [1950]), no. 144.

1958 • Bern, Kunsthalle, August 9–October 12, *Odilon Redon, 1840–1916* (Redon [1958]), no. 158.

1964 • Waltham, Mass., Brandeis University, summer, *Boston Collects Modern Art*.

1970 • Boston, Museum of Fine Arts, opened February 4, *Centennial Acquisitions: Art Treasures for Tomorrow* (MFA 1970), no. 88.

SELECTED REFERENCES
Berger [1964], no. 344; Murphy 1985, 237; Wildenstein 1992–98, 2: no. 1245.

Pierre-Auguste Renoir
French, 1841–1919

93. *Woman with a Parasol and Small Child on a Sunlit Hillside*, 1874–76
Oil on canvas
47 x 56.2 cm (18 ½ x 22 ⅛ in.)
Bequest of John T. Spaulding 48.593

PROVENANCE
August 25, 1891, purchased from the artist by Durand-Ruel, Paris, no. 1541; 1891–1917, with Durand-Ruel, Paris and New York, no. 1845-4935 (New York stock number); January 14, 1917, sold by Durand-Ruel, New York, to W. Josef Stansky, New York; 1917–26, W. Josef Stansky, New York; 1926, acquired from Stansky by Duncan Phillips, Washington, D.C.; April 1926,

acquired from Phillips by Durand-Ruel, New York, no. 8239; April 27, 1926, sold by Durand-Ruel to John Taylor Spaulding (d. 1948), Boston; 1926–48, John Taylor Spaulding; 1948, bequest of John Taylor Spaulding.

SELECTED EXHIBITIONS
1921 • New York, The Metropolitan Museum of Art, May 3–September 15, *Impressionist and Post-Impressionist Paintings*, no. 104.

1929 • Cambridge, Mass., Fogg Art Museum, Harvard University, March 6–April 6, *Exhibition of French Painting of the Nineteenth and Twentieth Centuries* (Fogg Art Museum [1929]), no. 79.

1948 • Boston, Museum of Fine Arts, May 26–November 7, *The Collections of John Taylor Spaulding, 1870–1948* (MFA 1948), no. 7c.

1950 • Springfield, Mass., Springfield Museum of Fine Arts, January 15–February 19, *In Freedom's Search* (Springfield Museum 1950), no. 6.

1953–54 • Edinburgh, Royal Scottish Academy, September 25–October 25; London, The Tate Gallery, *Renoir* (Edinburgh Festival Society 1953), no. 9.

1973 • *Impressionism: French and American* (MFA 1973a), no. 70.

1979–80 • *Corot to Braque* (Poulet and Murphy 1979), no. 57.

1985–86 • London, Hayward Gallery, January 30–April 21, 1985; Paris, Grand Palais, May 14–September 2, 1985; Boston, Museum of Fine Arts, October 9, 1985–January 5, 1986, *Renoir* (Hayward Gallery 1985), no. 31.

1989 • *From Neoclassicism to Impressionism* (Kyoto Museum, Kyoto Shimbun, and MFA 1989), no. 72.

1992 • *Crosscurrents*.

1996 • Tokyo, Tobu Museum of Art, March 30–June 30, *Inshoha wa koshite umareta: Akademisumu kara Kurube, Mune, Mone, Runowaru* (The Birth of Impressionism) (Tobu Bijutsukan 1996), no. 147.

1999 • *Monet, Renoir, and the Impressionist Landscape* (Nagoya / Boston and MFA 1999), no. 50.

2000–2 • *Monet, Renoir, and the Impressionist Landscape* (Shackelford and Wissman 2000), no. 55.

SELECTED REFERENCES
Meier-Graefe 1929, 61, no. 52; Pope 1930, 97, 121; MFA 1948, 17, 25, no. 70; Edgell 1949, 63; Kerr 1954, 14–17; MFA 1955, 54; Daulte 1971, no. 260; MFA 1973b, no. 18; Schneider 1984, 25; Murphy 1985, 240; Rabinow 2000, 12.

102. *The Seine at Chatou*, 1881
Oil on canvas
73.5 x 92.5 cm (28 ⅞ x 36 ⅜ in.)
Gift of Arthur Brewster Emmons 19.771

PROVENANCE
August 25, 1891, purchased from the artist by Durand-Ruel, Paris (stock no. 1326) and New York; January 26, 1900, sold by Durand-Ruel, New York, no. 1324, to Mrs. Blair, New York. By 1901, Mr. J. M. Sehley, New York; March 4, 1901, purchased from Sehley by Durand-Ruel, New York; 1901–6, with Durand-Ruel, New York, no. 2511; March 5, 1906, purchased from Durand-Ruel by Arthur Brewster Emmons, Newport, R.I., and New York; 1919, gift of Arthur Brewster Emmons.

SELECTED EXHIBITIONS
1882 • Paris, 251, rue Saint-Honoré, March, *Septième Exposition des Artistes Indépendants*, no. 154.

1935 • Boston, Museum of Fine Arts, March 15–April 28, *French Exhibition*.

1937 • New York, The Metropolitan Museum of Art, May 18–September 12, *Renoir: A Special Exhibition of His Paintings* (Metropolitan 1937a), no. 28.

1958 • New York, Durand-Ruel, May 30–October 15, *Hommage à Renoir*, no. 5.

1973 • *Impressionism: French and American* (MFA 1973a), no. 71.

1978 • Boston, Museum of Fine Arts, May 2–August 27, *French Paintings from the Storerooms and Some Recent Acquisitions*.

1979–80 • *Corot to Braque* (Poulet and Murphy 1979), no. 54.

1985–86 • London, Hayward Gallery, January 30–April 21, 1985; Paris, Grand Palais, May 14–September 2, 1985; Boston, Museum of Fine Arts, October 9, 1985–January 5, 1986, *Renoir* (Hayward Gallery 1985), no. 57.

1989 • *From Neoclassicism to Impressionism* (Kyoto Museum, Kyoto Shimbun, and MFA 1989), no. 73.

1992 • *Crosscurrents*.

1992–93 • *Monet and His Contemporaries* (Bunkamura Museum and MFA 1992), no. 55.

1995–96 • London, Hayward Gallery, May 18–August 28, 1995; Boston, Museum of Fine Arts, October 4, 1995–January 14, 1996, *Impressions of France: Monet, Renoir, Pissarro, and Their Rivals* (House et al. 1995), no. 98.

1996–97 • Washington, D.C., The Phillips Collection, September 21, 1996–February 23, 1997, *Impressionists on the Seine: A Celebration of Renoir's "Luncheon of the Boating Party"* (Rathbone et al. 1996), no. 57.

2001 • Tokyo, Bridgestone Museum of Art, February 10–April 15; Nagoya, Nagoya City Art Museum, April 21–June 24, *Renoir: From Outsider to Old Master, 1870–1892* (Bridgestone 2001), no. 21.

2000–2 • *Monet, Renoir, and the Impressionist Landscape* (Shackelford and Wissman 2000), no. 56 (Richmond venue only).

SELECTED REFERENCES

Hawes 1919, 65; Allen 1937, 112–13; McBride 1937, 158; Florisoone 1938a, 120; Edgell 1949, 5; MFA 1955, 54; Fezzi 1972, no. 443; Feaver 1985, 48; Murphy 1985, 239; Bernard 1986, 179, 258; Langdon 1986, 28–29, no. 7; Moffett et al. 1986, 380, fig. 5; Wadley 1987, 226, pl. 78; Updike 1989, 83; Kapos 1991, 282, pl. 88; Berson 1996, 2:211, 231, VII–154.

106. *Rocky Crags at L'Estaque,* 1882
Oil on canvas
66.5 x 81 cm (26⅛ x 31⅞ in.)
Juliana Cheney Edwards Collection
39.678

PROVENANCE

By 1891, probably acquired from the artist by Durand-Ruel, Paris and New York; February 25, 1892, sold by Durand-Ruel, New York, no. 193-1191, to Caroline Lambert, Boston. By 1915, probably sold by Durand-Ruel to Robert J. Edwards (d. 1924), Boston (probably for his sister Hannah Marcy Edwards); 1915–31, Hannah Marcy Edwards (d. 1929), Boston; 1931–38, inherited by Grace M. Edwards (sister, d. 1938), Boston; 1939, bequest of Hannah Marcy Edwards [1].

NOTE

1. See note 1 to the provenance for Corot's *Morning near Beauvais,* cat. no. 14, p. 246.

SELECTED EXHIBITIONS

1887 • New York, National Academy of Design, May 25–June 30, *Celebrated Paintings by Great French Masters* (National Academy 1887), no. 181.

1915 • Boston, Museum of Fine Arts, opening February 3, *Robert Dawson Evans Memorial Galleries Opening Exhibition.*

1939–40 • *Juliana Cheney Edwards Collection* (Cunningham 1939b), no. 48.

1942 • Montreal, Montreal Museum of Fine Arts, February 5–March 8, *Masterpieces of Painting* (Montreal 1942), no. 73.

1950 • New York, Wildenstein Galleries, March 23–April 29, *A Loan Exhibition of Renoir, for the Benefit of the New York Infirmary* (Wildenstein 1950), no. 35.

1958 • New York, Wildenstein Galleries, April 8–May 10, *Renoir: Loan Exhibition for the Benefit of the Citizens' Committee for Children of New York City, Inc.* (Wildenstein 1958), no. 35.

1973 • *Impressionism: French and American* (MFA 1973a), no. 77.

1975 • Framingham, Mass., Danforth Museum, May 24–September 30, *Inaugural Exhibition.*

1979–80 • London, Royal Academy of Arts, November 17, 1979–March 16, 1980, *Post-Impressionism: Cross-Currents in European Painting* (Royal Academy 1979), no. 171.

1980 • Washington, D.C., National Gallery of Art, May 25–September 1, 1980, *Post-Impressionism: Cross-Currents in European and American Painting, 1880–1906* (National Gallery 1980), no. 34.

1985–86 • London, Hayward Gallery, January 30–April 21, 1985; Paris, Grand Palais, May 14–September 2, 1985; Boston, Museum of Fine Arts, October 9, 1985–January 5, 1986, *Renoir* (Hayward Gallery 1985), no. 64.

1988–89 • Nagoya, Nagoya City Art Museum, October 15–December 11, 1988; Hiroshima, Hiroshima Museum of Art, December 17, 1988–February 12, 1989; Nara, Nara Prefectural Museum of Art, February 18–April 9, 1989, *Renoir Retrospective* (Nagoya City 1988), no. 25.

1990 • Cologne, Wallraf-Richartz Museum, April 6–July 1; Zurich, Kunsthaus Zurich, August 3–October 21, *Landschaft im Licht: Impressionistische Malerei in Europa und Nordamerika, 1860–1910* (Czymmek 1990), no. 151.

1992 • *Crosscurrents.*

1992–93 • *Monet and His Contemporaries* (Bunkamura Museum and MFA 1992), no. 56.

1994 • Glasgow, National Gallery of Scotland, August 11–October 23, *Monet to Matisse: Landscape Painting in France, 1874–1917* (Thomson 1994), no. 98.

1999 • *Monet, Renoir, and the Impressionist Landscape* (Nagoya / Boston and MFA 1999), no. 51.

2000–1 • Paris, Grand Palais, September 19, 2000–January 15, 2001, *Méditerranée: De Courbet à Matisse, 1850–1925* (Cachin and Nonne 2000), no. 69.

2000–2 • *Monet, Renoir, and the Impressionist Landscape* (Shackelford and Wissman 2000), no. 57 (not in Richmond venue).

SELECTED REFERENCES

Cunningham 1939a, 8, 16; Venturi 1939, 1:61; Rewald 1946, 363; Edgell 1949, 64–65; Goldwater 1958, 60; Hoffmann 1958, 185; MFA 1973b, no. 20; Thomas 1980, 17; Callen 1982, 118–21; White 1984, 120, fig. 123; Murphy 1985, 239; Schneider 1985, 54, fig, 13; Keller 1987, 91, 165, no. 66.

107. *Landscape on the Coast, near Menton,* 1883
Oil on canvas
65.8 x 81.3 cm (25⅞ x 32 in.)
Bequest of John T. Spaulding 48.596

PROVENANCE

1884, acquired from the artist by Durand-Ruel, Paris and New York (in Durand-Ruel inventory of 1886, 1891, and 1897 when shipped to New York); by 1918, sold by Durand-Ruel to Prince Alexandre Berthier de Wagram (d. 1918), Paris. By 1924, possibly acquired from Wagram heirs by Durand-Ruel, Paris and New York; December 1, 1924, sold by Durand-Ruel, New York, no. 1848, to John Taylor Spaulding (d. 1948), Boston; 1924–48, John Taylor Spaulding, Boston; 1948, bequest of John Taylor Spaulding.

SELECTED EXHIBITIONS

1931–32 • Boston, Museum of Fine Arts, May 26, 1931–October 27, 1932, *Collection of Modern French Paintings, Lent by John T. Spaulding.*

1939 • Boston, Museum of Fine Arts, June 9–September 10, *Art in New England: Paintings, Drawings, and Prints, from Private Collections in New England* (MFA 1939), no. 105.

1948 • Boston, Museum of Fine Arts, May 26–November 7, *The Collections of John Taylor Spaulding, 1870–1948* (MFA 1948), no. 73.

1973 • *Impressionism: French and American* (MFA 1973a), no. 80.

1978 • Boston, Museum of Fine Arts, May 2–August 27, *French Paintings from the Storerooms and Some Recent Acquisitions.*

1985 • Boston, Museum of Fine Arts, February 13–June 2, *The Great Boston Collectors: Paintings from the Museum of Fine Arts, Boston* (Troyen and Tabbaa 1984), no. 51.

1985–86 • London, Hayward Gallery, January 30–April 21, 1985; Paris, Grand Palais, May 14–September 2, 1985; Boston, Museum of Fine Arts, October 9, 1985–January 5, 1986, *Renoir* (Hayward Gallery 1985), no. 71 (Boston venue only).

1992 • *Crosscurrents.*

1995–96 • London, Hayward Gallery, May 18–August 28, 1995; Boston, Museum of Fine Arts, October 4, 1995–January 14, 1996, *Impressions of France: Monet, Renoir, Pissarro, and Their Rivals* (House et al. 1995), no. 105.

1999 • *Monet, Renoir, and the Impressionist Landscape* (Nagoya / Boston and MFA 1999), no. 52.

2000–2 • *Monet, Renoir, and the Impressionist Landscape* (Shackelford and Wissman 2000), no. 58.

SELECTED REFERENCES

Watson 1925, 328, 338; Meier-Graefe 1929, 194, no. 162; Pope 1930, 98, 122; MFA 1931, 53; Barnes and de Mazia 1935, 82, 455, no. 140; McBride 1937, 60; MFA 1948, 18; MFA 1955, 54; Fezzi 1972, no. 591; MFA 1973b, no. 21; *Guida all pittura di Renoir* 1980, 83; White 1984, 135; Murphy 1985, 240; Wadley 1987, 228, pl. 80; Updike 1989, 83; Renoir 1990, 54–55; Fell 1991, 19.

140. *Girls Picking Flowers in a Meadow,*
about 1890
Oil on canvas
65 x 81 cm (25⅝ x 31⅞ in.)
Juliana Cheney Edwards Collection
39.675

PROVENANCE
By 1894, acquired from the artist by
Durand-Ruel, Paris and New York. By
1912, Palmer Potter, Chicago. 1912–31,
Hannah Marcy Edwards (d. 1929), Boston;
1931–39, inherited by Grace M. Edwards
(sister, d. 1938), Boston; 1939, bequest of
Hannah Marcy Edwards [1].

NOTE
1. See note 1 to the provenance for Corot's
Morning near Beauvais, cat. no. 14, p. 246.

SELECTED EXHIBITIONS
1900 • New York, Durand-Ruel, April,
*Exhibition of Paintings: Claude Monet and
Pierre Auguste Renoir* (Durand-Ruel [1900]),
no. 30.

1939–40 • *Juliana Cheney Edwards
Collection* (Cunningham 1939b), no. 49.

1941 • New York, Duveen Galleries, No-
vember 8–December 6, *Centennial Loan
Exhibition, 1841–1941: Renoir, for the Benefit
of the Free French Relief Committee*
(Fighting [1941]), no. 60.

1946 • Colorado Springs, Colo., Colorado
Springs Fine Arts Center, November 5–
December 9, *French Paintings of the
Nineteenth Century,* unnumbered entry in
exhibition pamphlet.

1948 • Springfield, Mass., Springfield
Museum of Fine Arts, October 7–
November 7, *Fifteen Fine Paintings*
(Springfield Museum 1948), unnumbered
entry.

1948 • New York, Paul Rosenberg & Co.,
November 15–December 18, *Twenty-One
Masterpieces by Seven Great Masters* (Paul
Rosenberg 1948), no. 5.

1955 • Los Angeles, Los Angeles County
Museum of Art, July 14–August 21; San
Francisco, M. H. de Young Museum of
Art, September 1–October 2, *Pierre Auguste
Renoir, 1841–1919: Paintings, Drawings,
Prints, and Sculpture* ([LACMA] 1955),
no. 38.

1964–65 • San Francisco, M. H. de Young
Museum of Art, November 10, 1964–
January 3, 1965, *Man: Glory, Jest, and Riddle;*

*a Survey of the Human Form through the
Ages* (M. H. de Young 1964), no. 214.

1973 • *Impressionism: French and American*
(MFA 1973a), no. 81.

1983–84 • *Masterpieces of European Painting*
(Nippon Television 1983), no. 59.

1985–86 • London, Hayward Gallery,
January 30–April 21, 1985; Paris, Grand
Palais, May 14–September 2, 1985; Boston,
Museum of Fine Arts, October 9, 1985–
January 5, 1986, *Renoir* (Hayward Gallery
1985), no. 86.

1988 • Springfield, Mass., Springfield
Museum of Fine Arts, September 25–
November 27, *Lasting Impressions: French
and American Impressionism from New
England Museums* (Harris, Kern, and Stern
1988), no. 20.

1989 • *From Neoclassicism to Impressionism*
(Kyoto Museum, Kyoto Shimbun, and
MFA 1989), no. 74.

1991 • Nagoya, Matsuzakaya Museum
of Art, March 21–April 28; Nara, Nara
Prefectural Museum, May 3–June 16;
Hiroshima, Hiroshima Museum of Art,
June 22–July 28, *The World of Impressionism
and Pleinairism* (Matsuzukaya 1991), no. 24.

1992–93 • *Monet and His Contemporaries*
(Bunkamura Museum and MFA 1992),
no. 58.

1994–95 • Brisbane, Queensland Art
Gallery, July 30–September 11, 1994;
Melbourne, National Gallery of Victoria,
September 18–October 30, 1994; Sydney,
Art Gallery of New South Wales, Novem-
ber 5, 1994–January 15, 1995, *Renoir: Master
Impressionist* (House 1994), no. 23.

1995 • *The Real World* (Sogo Museum and
MFA 1994), no. 44.

1999 • *Monet, Renoir, and the Impressionist
Landscape* (Nagoya/Boston and MFA
1999), no. 54.

2000–2 • *Monet, Renoir, and the Impression-
ist Landscape* (Shackelford and Wissman
2000), no. 60.

SELECTED REFERENCES
Meier-Graefe 1929, 199, no. 203;
Cunningham 1939b, 96–98, 101, 110;
Wilenski 1940, 338; Edgell 1949, 64–65;
MFA 1955, 54; Daulte 1971, no. 609; White
1984, 192, 195; Murphy 1985, 239; Stevens
1985, 317.

Henri Rivière
French, 1864–1951

128. *The Chéruette Beacon at Low Tide,
Saint-Briac, Brittany,* 1890
Color woodcut on beige Japanese paper
Block/image: 22.7 x 35.2 cm (8¹⁵⁄₁₆ x 13⅞ in.)
Stephen Bullard Memorial Fund by sale of
duplicate 1983.225

SELECTED REFERENCE
Fields 1983, 80–83.

Louis-Rémy Robert
French, 1810–1882

33. *The Baths of Apollo, Versailles,* 1853
Photograph, albumen print from paper
negative, mounted
Sheet: 31.8 x 25.8 cm (12½ x 10⅛ in.)
Lucy Dalbiac Luard Fund 1986.138

PROVENANCE
Robert Hershkowitz, London; 1986, sold
by Hershkowitz to MFA.

SELECTED EXHIBITIONS
1987 • Boston, Museum of Fine Arts,
February 22–May 3, *Photographic
Highlights.*

1998–99 • Boston, Museum of Fine Arts,
November 21, 1998–May 23, 1999, *French
Photography: Le Gray to Atget.*

SELECTED REFERENCES
Jammes 1981, illus., 283; Jammes and Janis
1983, 242–45; Lebon 1999.

Théodore Rousseau
French, 1812–1867

19. *Pool in the Forest,* early 1850s
Oil on canvas
39.5 x 57.4 cm (15½ x 22⅝ in.)
Robert Dawson Evans Collection 17.3241

PROVENANCE
M. Garnier, Paris. By 1909, Robert
Dawson Evans, Boston; 1909–17, inherited
by Mrs. Robert Dawson Evans (Maria
Antoinette Hunt, d. 1917), Boston; 1917,
bequest of Mrs. Robert Dawson Evans.

SELECTED EXHIBITIONS
1938–39 • Springfield, Mass., Springfield
Museum of Fine Arts, December 6, 1938–
January 2, 1939.

1953–54 • New Orleans, Isaac Delgado
Museum of Art, October 17, 1953–January
10, 1954, *Masterpieces of French Painting
through Five Centuries, 1400–1900* (Isaac
Delgado Museum of Art 1954), no. 66.

1967 • Wellesley, Mass., Wellesley College
Art Museum, for use in study, November
1–December 4.

1979–80 • *Corot to Braque* (Poulet and
Murphy 1979), no. 14.

1983–84 • *Masterpieces of European Painting*
(Nippon Television 1983), no. 39.

1989 • *From Neoclassicism to Impressionism*
(Kyoto Museum, Kyoto Shimbun, and
MFA 1989), no. 22.

1992–93 • *Monet and His Contemporaries*
(Bunkamura Museum and MFA 1992),
no. 7.

1999 • *Monet, Renoir, and the Impressionist
Landscape* (Nagoya/Boston and MFA
1999), no. 9.

2000–2 • *Monet, Renoir, and the Impression-
ist Landscape* (Shackelford and Wissman
2000), no. 9.

SELECTED REFERENCE
Murphy 1985, 251.

20. *Gathering Wood in the Forest of
Fontainebleau,* about 1850–60
Oil on canvas
54.7 x 65.3 cm (21½ x 25¾ in.)
Bequest of Mrs. David P. Kimball 23.399

PROVENANCE
Until 1921, Samuel Putnam Avery collec-
tion, New York; 1921, acquired by David P.
Kimball, Boston; by 1923, Mrs. David P.
Kimball, Boston; 1923, bequest of Mrs.
David P. Kimball.

SELECTED EXHIBITIONS
1940 • Colorado Springs, Colo., Colorado
Springs Fine Arts Center, January; Boston,
St. Botolph Club, March 16–April 16; New
London, Conn., Lyman Allen Museum,
Connecticut College, November 17–
December 15.

1942 • Norfolk, Va., Norfolk Museum of
Arts and Sciences.

1999 • *Monet, Renoir, and the Impressionist
Landscape* (Nagoya/Boston and MFA
1999), no. 10.

2000–2 • *Monet, Renoir, and the Impression-
ist Landscape* (Shackelford and Wissman
2000), no. 10.

SELECTED REFERENCES

Murphy 1985, 251; Thomas 2000, 163, fig. 71.

21. *Wooded Stream,* 1859
Oil on panel
53.2 x 74.5 cm (21 x 29⅜ in.)
Gift of Mrs. Henry S. Grew 17.1461

PROVENANCE
By 1907, Thomas Wigglesworth Collection (d. 1906), Boston. By 1917, with Mrs. Henry S. Grew, Boston; 1917, gift of Mrs. Henry S. Grew.

SELECTED EXHIBITIONS
1879? • Boston, Boston Art Club.

1915 • Boston, Museum of Fine Arts, opened February 3, *Robert Dawson Evans Memorial Galleries Opening Exhibition.*

1938 • Utica, N.Y., Munson Williams Proctor Institute, December 4–19.

1942 • Norfolk, Va., Norfolk Museum of Arts and Sciences.

1958–59 • Boston, First National Bank of Boston.

1961 • Dallas, Dallas Museum for Contemporary Arts, March 8–April 2, *Impressionists and Their Forebears from Barbizon* (Dallas [1961]), no. 32.

1968 • Boston, Copley Hall, May 24–June 14, *Barbizon School.*

1972 • Providence, R.I., Museum of Art, Rhode Island School of Design, February 3–March 5, *To Look on Nature: European and American Landscape, 1800–1874* (Brown University 1972), unnumbered entries, pl. 40.

SELECTED REFERENCE
Murphy 1985, 251.

22. *The Oak Tree of the Rock, Forest of Fontainebleau,* 1861
Etching in brown ink on cream laid paper.
Delteil 4
Image: 12.3 x 16.9 cm (4¹³⁄₁₆ x 6⅝ in.); platemark: 13.3 x 21 cm (5¼ x 8¼ in.)
Bequest of William P. Babcock, 1900
B3950

23. *Cherry Tree at La Plante-à-Biau,* 1862
Cliché-verre, salt print. Delteil 5
Borderline: 21.7 x 27.6 cm (8⁹⁄₁₆ x 10⅞ in.)
Bequest of William P. Babcock, 1900
B3956.5/7

SELECTED REFERENCE
Glassman and Symmes 1980.

Ker-Xavier Roussel
French, 1867–1944

147. *Woman in Red in a Landscape,* 1898
Color lithograph on cream Chinese paper.
Salomon 15
Image: 23.5 x 35.4 cm (9¼ x 13¹⁵⁄₁₆ in.)
Gift of Mrs. Frederick B. Deknatel
1985.858

Paul Sérusier
French, 1864–1927

126. *Breton Landscape,* 1893
Color lithograph on yellow wove paper
Image: 23.2 x 30.1 cm (9⅛ x 11⅞ in.)
Bequest of W. G. Russell Allen 60.742

SELECTED REFERENCE
Boyle-Turner 1986, 70–75.

Paul Signac
French, 1863–1935

133. *View of the Seine at Herblay, Opus 203,* 1889
Oil on canvas
33.2 x 46.4 cm (13⅛ x 18¼ in.)
Gift of Julia Appleton Bird 1980.367

PROVENANCE
By the late 1880s, given by the artist to Edmond and Lucie Cousturier, Paris [1]. Hugo Moser, New York. Until March 1960, Hammer Galleries, New York; March 1960, sold by Hammer Galleries to Mrs. Charles Sumner Bird (Julia Appleton Bird), East Walpole, Mass.; 1980, gift of Mrs. Charles Sumner Bird.

NOTE
1. According to a letter of August 20, 1997, from Marina Ferretti to George Shackelford in curatorial file.

SELECTED EXHIBITIONS
1893 • Brussels, February, *Dixième Exposition des XX,* mistakenly called *Op. 227, Vert et Violet (?).*

1989 • *From Neoclassicism to Impressionism* (Kyoto Museum, Kyoto Shimbun, and MFA 1989), no. 79.

1999 • *Monet, Renoir, and the Impressionist Landscape* (Nagoya/Boston and MFA 1999), no. 62.

2000–2 • *Monet, Renoir, and the Impressionist Landscape* (Shackelford and Wissman 2000), no. 69.

2002 • Portland, Maine, Portland Museum of Art, June 27–October 20, *Neo-Impressionism: Artists on the Edge.*

SELECTED REFERENCES
"Principales acquisitions" 1981, 69; Murphy 1985, 263; Cachin 2000, 193, no. 188.

134. *Port of Saint-Cast, Opus 209,* 1890
Oil on canvas
66 x 82.5 cm (26 x 32½ in.)
Gift of William A. Coolidge 1991.584

PROVENANCE
1890, sold by the artist to Victor Boch, Brussels. Léon Marseille, Paris. A. Zwemmer (dealer), London. A. Ehrman, London. By 1958, Marlborough Fine Arts, Ltd., London; June 16, 1958, sold by Marlborough to William A. Coolidge, Topsfield and Cambridge, Mass.; 1958–91, William A. Coolidge, Topsfield and Cambridge, Mass.; 1991, gift of William A. Coolidge.

SELECTED EXHIBITIONS
1891 • Brussels, February, *Huitième Exposition des XX,* unnumbered entry, as *Op. 209, Saint-Cast (Côtes-du-Nord), Mai, 1890* under the general title *La Mer.*

1891 • Paris, pavillon de la Ville de Paris, Champs-Elysées, March 20–April 27, *Septième Exposition de la Société des Artistes Indépendants,* no. 1112, as *Op. 209, Saint-Cast (Côtes-du-Nord), Mai, 1890* under the general title *La Mer.*

1930 • Paris, Bernheim-Jeune, May 19–30, *Paul Signac,* no. 11.

1932 • Paris, Galerie Braun et Cie., February 25–March 17, *Le Néo-impressionnisme,* no. 25.

1934 • Paris, Grand Palais, February 2–March 11, *Quarante-quatrième Exposition de la Société des Artistes Indépendants, Exposition du Cinquantenaire,* no. 4106.

1936 • Paris, Grand Palais, February 7–March 8, *Quarante-sixième Exposition de la Société des Artistes Indépendants, Exposition posthume de Paul Signac,* no. 3067.

1951 • Ostende, Belgium, Galeries Royales, August 5–September 4, *La peinture sous le signe de la mer,* no. 85.

1958 • London, Marlborough Fine Arts, Ltd., April–May, *La création de l'oeuvre chez Paul Signac* (Marlborough [1958a]), no. 217.

1958 • London, Marlborough Fine Arts, Ltd., June, *Nineteenth and Twentieth Century European Masters* (Marlborough [1958b]), no. 64.

1963–64 • Paris, Musée du Louvre, December 1963–February 1964, *Signac* (Musée du Louvre [1964]), no. 35.

1992 • *Crosscurrents.*

2001 • Paris, Galeries Nationales du Grand Palais, February 27–May 28; Amsterdam, Van Gogh Museum, June 15–September 9; New York, The Metropolitan Museum of Art, October 9–December 30, *Signac, 1863–1935* (Ferretti-Bocquillon et al. 2001), no. 49.

2000–2 • *Monet, Renoir, and the Impressionist Landscape* (Shackelford and Wissman 2000), no. 70 (Ottawa and Richmond venues only).

2002 • Portland, Maine, Portland Museum of Art, June 27–October 20, *Neo-Impressionism: Artists on the Edge.*

SELECTED REFERENCES
Antoine 1891, 157; Christophe 1891, 100; Ernst 1891, 2; Germain 1891, 535; Krexpel 1891, 381; Leclercq 1891, 298; [Lecomte] 1891, 324; [Maus] 1891, 216; Rette 1891, 295; Geffroy 1892, 308; Roger-Marx 1933, 36; Champigneulle 1934, 407; Guenne 1934, 126; Hermant 1934, 87; Turpin 1934, 2, no. 2; Sarradin 1936, 3; Roger-Marx [1947], 51; Besson 1954, pl. 44; Rewald 1956, 135; Russel 1958, 39; Rewald [1961], fig. 25; Roger-Marx 1963, 20; Charensol 1964, 134; Lerrant 1964, 13; Jalard 1966, 23; Chartrain-Hebbelinck 1969, 67–68, no. 1–2; Sutton 1995, 96–101, no. 21, Cachin 2000, 199, no. 205.

136. *Les Andelys,* 1897–98
Color lithograph on cream wove paper.
Kornfeld and Wick 10
Image: 30 x 45 cm (11¹³⁄₁₆ x 18 in.)
Anonymous gift 1971.709

137. *Boats,* 1897–98
Color lithograph on cream wove paper.
Kornfeld and Wick 13
Image: 23.5 x 39.8 cm (9¼ x 15¹¹⁄₁₆ in.)
Anonymous gift 54.721

138. *Boats,* 1897–98
Color lithograph on cream wove paper, trial proof, annotated by the artist.
Kornfeld and Wick 13
Image: 23.5 x 39.8 cm (9¼ x 15¹¹⁄₁₆ in.); sheet: 39 x 53.5 cm (15⅜ x 21¹⁄₁₆ in.)
Gift of Peter A. Wick 55.576

Alfred Sisley
British (worked in France), 1839–1899

80. *Early Snow at Louveciennes,* about 1870–71
Oil on canvas
54.9 x 73.7 cm (21 ⅝ x 29 in.)
Bequest of John T. Spaulding 48.600

PROVENANCE
By 1892, M. Picq-Véron of Ermont-Eaubonne, France; June 25, 1892, sold by Picq-Véron to Durand-Ruel, Paris; October 25, 1897, sold by Durand-Ruel to the National Gallery, Berlin; 1936, sold by the National Gallery, Berlin, to the Galerie Nathan, St. Gallen, Switzerland, in exchange for Caspar David Friedrich's *Man and Woman Looking at the Moon* [1]. By 1937, Raphael Gérard, Paris; 1939, sold by Gérard to Arthur Tooth & Sons, London; May 19, 1939, sold by Arthur Tooth & Sons to John Taylor Spaulding (d. 1948), Boston; 1948, bequest of John Taylor Spaulding.

NOTES
1. See Hohenzollern and Schuster 1996, 106, no. 32.

SELECTED EXHIBITIONS
1937 • London, Alex Reid & Lefevre Ltd., January, *Pissarro and Sisley,* no. 15.

1939 • Boston, Museum of Fine Arts, June 9–September 10, *Art in New England: Paintings, Drawings, and Prints, from Private Collections in New England* (MFA 1939), no. 126.

1948 • Boston, Museum of Fine Arts, May 26–November 7, *The Collections of John Taylor Spaulding, 1870–1948* (MFA 1948), no. 76.

1949 • Manchester, N.H., The Currier Gallery of Art, October 8–November 6, *Monet and the Beginnings of Impressionism: Twentieth Anniversary Exhibition* (Currier Gallery of Art [1949]), no. 29.

1950 • New York, Paul Rosenberg & Co., March 7–April 1, *The Nineteenth Century Heritage* (Paul Rosenberg 1950), no. 25.

1961 • New York, Paul Rosenberg & Co., October 30–November 25, *Alfred Sisley,* no. 2.

1973 • *Impressionism: French and American* (MFA 1973a), no. 85.

1984–85 • Los Angeles, Los Angeles County Museum of Art, June 28–

September 16, 1984; Chicago, The Art Institute of Chicago, October 18, 1984–January 6, 1985; Paris, Grand Palais, February 8–April 22, 1985, *A Day in the Country: Impressionism and the French Landscape* (Brettell et al. 1984), no. 19.

1992 • *Crosscurrents.*

1992–93 • London, Royal Academy of Arts, July 3–October 18, 1992; Paris, Musée d'Orsay, October 28, 1992–January 31, 1993; Baltimore, Walters Art Gallery, March 14–June 13, 1993, *Alfred Sisley* (Stevens and Cahn 1992), no. 10.

1996–97 • Berlin, Neue Nationalgalerie, September 20, 1996–January 6, 1997; Munich, Neue Pinakothek, January 24–May 11, 1997, *Manet bis van Gogh: Hugo von Tschudi und der Kampf um die Moderne* (Hohenzollern and Schuster 1996), no. 32.

SELECTED REFERENCES
Bibb 1899, 151; Ortwin-Rave 1945, pl. 196; Rewald 1946, 181; Edgell 1949, 3; Daulte 1959, no. 18; Constable 1964, fig. 11; MFA [1970], 38, no. 58; Brown University 1972, 139–40, pl. 48; MFA 1973b, no. 25; Rewald 1973a, 211, fig. 7; Rewald 1973–74, 52, fig. 10; Shone 1979, 84, pl. 7; Southgate 1979, 2375, repr. cover; Kelder 1980, 151; Murphy 1985 264; Bernard 1986, 210, 261; MFA 1986, 77.

91. *Waterworks at Marly,* 1876
Oil on canvas
46.5 x 61.8 cm (18 ¼ x 24 ⅜ in.)
Gift of Miss Olive Simes 45.662

PROVENANCE
By about 1910–15, with Durand-Ruel, New York and Paris; about 1910–15, bought from Durand-Ruel by William Simes [1]; by 1945, inherited by Miss Olive Simes (daughter), Boston; 1945, gift of Miss Olive Simes.

NOTE
1. According to Miss Simes, her father purchased the painting sometime about 1910–15. Letter in object file from Lucretia H. Giese in the Paintings Department at the MFA to Ronald Pickvance dated January 21, 1971.

SELECTED EXHIBITIONS
1973 • *Impressionism: French and American* (MFA 1973a), no. 86.

1983–84 • *Masterpieces of European Painting* (Nippon Television), no. 51.

1992 • *Crosscurrents.*

1992–93 • London, Royal Academy of Arts, July 3–October 18, 1992; Paris, Musée d'Orsay, October 28, 1992–January 31, 1993; Baltimore, Walters Art Gallery, March 14–June 13, 1993, *Alfred Sisley* (Stevens and Cahn 1992), no. 20.

1995–96 • London, Hayward Gallery, May 18–August 28, 1995; Boston, Museum of Fine Arts, October 4, 1995–January 14, 1996, *Impressions of France: Monet, Renoir, Pissarro, and Their Rivals* (House et al. 1995), no. 83.

1996–97 • Washington, D.C., The Phillips Collection, September 21, 1996–February 23, 1997, *Impressionists on the Seine: A Celebration of Renoir's "Luncheon of the Boating Party"* (Rathbone et al. 1996), no. 46.

1999 • *Monet, Renoir, and the Impressionist Landscape* (Nagoya / Boston and MFA 1999), no. 33.

2000–2 • *Monet, Renoir, and the Impressionist Landscape* (Shackelford and Wissman 2000), no. 36.

2002–3 • Ferrara, Palazzo dei Diamanti, February 17–May 19, 2002; Madrid, Museo Thyssen-Bornemisza, June 6–September 15, 2002; Lyon, Musée des Beaux-Arts, October 9, 2002–January 6, 2003, *Alfred Sisley: Poet of Impressionism* (Madrid venue only).

SELECTED REFERENCES
MFA 1946a, 30; MFA 1946b, 43; MFA 1955, 61; Daulte 1959, no. 216; Murphy 1985, 264.

Constant Troyon
French, 1810–1865

34. *Field outside Paris,* 1845–51
Oil on paperboard
27 x 45.5 cm (10 ⅝ x 17 ⅞ in.)
The Henry C. and Martha B. Angell Collection 19.117

PROVENANCE
Until 1886, Thomas Robinson, Providence, R.I.; November 16, 1886, sold at Robinson sale, Moore's Art Galleries, New York, no. 117, and bought by Vose Galleries, Providence, R.I.; 1886–1911, probably acquired through Vose Galleries by Dr. Henry Clay Angell (d. 1911), Boston; 1911–19, inherited by Martha Bartlett Angell (widow, d. 1919), Boston; 1919, gift of Martha B. Angell.

SELECTED EXHIBITIONS
1946–47 • Cambridge, Mass., Fogg Art Museum, Harvard University, September 1946–September 1947.

1959 • Deerfield, Mass., Hilson Gallery, *Landscape through Time.*

1962–63 • San Francisco, California Palace of the Legion of Honor, September 24–November 4, 1962; Toledo, Ohio, The Toledo Museum of Art, November 20–December 27, 1962; Cleveland, The Cleveland Museum of Art, January 15–February 24, 1963; Boston, Museum of Fine Arts, March 15–April 28, 1963, *Barbizon Revisited* (Herbert 1962), no. 104.

1978 • Chapel Hill, N.C., William Hayes Ackland Memorial Art Center, University of North Carolina, March 5–April 30, *French Nineteenth Century Oil Sketches, David to Degas: An Exhibition in Honor of the Retirement of Joseph Curtis Sloane* (Wisdom et al. 1978), no. 60.

1999 • *Monet, Renoir, and the Impressionist Landscape* (Nagoya / Boston and MFA 1999), no. 7.

2000–2 • *Monet, Renoir, and the Impressionist Landscape* (Shackelford and Wissman 2000), no. 7.

SELECTED REFERENCES
Durbé and Damigella 1969, 41; Bouret 1972, 111; Goldstein 1979, 223, fig. 6.26; Murphy 1985, 283; Cormack 1986, 164–65, fig. 160.

35. *Windswept Meadow with Shepherd and Flock,* about 1850
Black chalk on beige paper
Sheet: 25.4 x 35.4 cm (10 x 13 ¹⁵⁄₁₆ in.)
Gift of L. Aaron Lebowich and Harvey D. Parker Collection, by exchange 63.263

PROVENANCE
Nathan Chaikin, New York; 1963, sold by Chaikin to MFA.

SELECTED EXHIBITION
1967 • Wellesley, Mass., Wellesley College Art Museum, November 1–30, *Nineteenth-Century Art.*

38. *Hound Pointing,* 1860
Oil on canvas
163.8 x 130.5 cm (64 ½ x 51 ⅜ in.)
Gift of Mrs. Louis A. Frothingham 24.345

PROVENANCE

1861, Senator Prosper Crabbe, Brussels. By 1885, A. Dreyfus. By 1889, E. Secrétan; July 1, 1889, sold by E. Secrétan at Chevallier, Aulard, Paris. Frederick Lothrop Ames (d. 1893), Boston; by 1924, probably inherited by Mrs. Louis A. (Mary S. Ames) Frothingham; 1924, gift of Mary S. Ames Frothingham to the MFA.

SELECTED EXHIBITIONS

1883 • Paris, Galerie Georges Petit, *Cent chefs-d'oeuvres des collections parisiennes* (Wolf 1883), no. 91 (?).

1889 • New York, Union League Club, December, no. 28.

1898 • Boston, Copley Hall, *Modern Painters*, no. 84.

1904 • New York, American Fine Arts Society, *Comparative Exhibition of Native and Foreign Art*, no. 160.

1908 • Boston, Copley Hall, March, *French School of 1830* (Copley Society 1908), no. 68.

1962–63 • San Francisco, California Palace of the Legion of Honor, September 24–November 4, 1962; Toledo, Ohio, The Toledo Museum of Art, November 20–December 27, 1962; Cleveland, The Cleveland Museum of Art, January 15–February 24, 1963; Boston, Museum of Fine Arts, March 15–April 28, 1963, *Barbizon Revisited* (Herbert 1962), no. 106.

1968 • New York, Knoedler's Gallery, May 7–24, *The Artist and the Animal*.

1978–79 • Philadelphia, Philadelphia Museum of Art, October 1–November 26, 1978; Detroit, The Detroit Institute of Arts, January 15–March 18, 1979; Paris, Grand Palais, April 24–July 2, 1979, *The Second Empire, 1852–1870: Art in France under Napoleon III* (PMA 1978), no. VI–107.

1983–84 • *Masterpieces of European Painting* (Nippon Television 1983), no. 38.

1991–92 • Indianapolis, The National Art Museum of Sport, January 14–April (day unknown) 1991; Washington, D.C., The Corcoran Gallery of Art, September 1991–January 1992; Phoenix, Phoenix Art Museum, May–August 1991; New York, IBM Gallery of Science and Art, January 14–March 28, 1992, *Sport in Art from American Museums*.

SELECTED REFERENCES

Secrétan 1889, 79; Soullié 1900a, 158; MFA 1924, 36; Baudelaire 1966, 1200; Rodee 1974, 16–17; Didier Aaron 1990, fig. a (accompanying entry no. 26).

Lancelot-Théodore, comte du Turpin de Crissé
French, 1782–1859

8. *The Bay of Naples*, 1840
Oil on canvas
97 x 146 cm (38⅛ x 57½ in.)
Charles H. Bayley Picture and Painting Fund 1980.3

PROVENANCE

July 10, 1974, sold at Galerie des Chevau-Légers, Versailles, no. 235. By 1980, Hazlitt, Gooden & Fox, Ltd., London; 1980, sold by Hazlitt, Gooden & Fox to the MFA.

SELECTED EXHIBITIONS

1979 • London, Hazlitt, Gooden & Fox, October 31–November 27, *The Lure of Rome: Some Northern Artists in Italy in the Nineteenth Century, Paintings and Drawings* (Hazlitt, Gooden & Fox 1979), no. 18, pl. 40.

1983–84 • *Masterpieces of European Painting* (Nippon Television 1983), no. 33.

1989 • *From Neoclassicism to Impressionism* (Kyoto Museum, Kyoto Shimbun, and MFA 1989), no. 5.

1991–92 • Boston, Museum of Fine Arts, July 13, 1991–July 5, 1992, *Romantic and Fantastic Landscapes*.

SELECTED REFERENCES

MFA 1980, 28–29; Murphy 1985, 285; Zafran 1998, 198–99, no. 90.

Pierre-Henri de Valenciennes
French, 1750–1819

1. *Italian Landscape with Bathers*, 1790
Oil on canvas
54 x 81.6 cm (21¼ x 32⅛ in.)
Gift of John Goelet 1980.658

PROVENANCE

By 1975, Palais Galliéra, Paris. H. Shickman Gallery, New York. By 1978, John Goelet, New York; 1988, gift of John Goelet.

SELECTED EXHIBITIONS

1791 • Paris, *Salon*, no. 11? or 132?

1983–84 • *Masterpieces of European Painting* (Nippon Television 1983), no. 27.

1991–92 • Boston, Museum of Fine Arts, July 13, 1991–July 5, 1992, *Romantic and Fantastic Landscapes*.

1992–93 • Boston, Museum of Fine Arts, July 24, 1992–January 17, 1993, *The Grand Tour: European and American Views of Italy*.

SELECTED REFERENCES

Dézallier d'Argenville 1791, 4, no. 11 (?); *Explication des peintures* 1791, 26, no. 132 (?); *Béquille de Voltaire* 1791, 4, no. 11; Liepmannssohn 1870, 11, no. 11; Murphy 1985, 288; Zafran 1998, 156–57, no. 70.

Vincent van Gogh
Dutch (worked in France), 1853–1890

129. *Ravine*, 1889
Oil on canvas
73 x 91.7 cm (28¾ x 36⅛ in.)
Bequest of Keith McLeod 52.1524

PROVENANCE

1890, from the artist to Theo van Gogh (brother), Paris [1]. By 1908, Prince Alexandre Berthier de Wagram (d. 1918), Paris. Barbazanges Art Gallery, Paris [2]. By 1918, J. B. Stang, Oslo. By 1926, with Leicester Galleries, London. By 1928, with Galerie Thannhauser, Berlin, Lucerne, and New York; by 1929, sold by Galerie Thannhauser to Keith McLeod, Boston; 1952, bequest of McLeod.

NOTES

1. According to documentation from the 1960s in curatorial file, there is some evidence that the picture may have passed from Theo van Gogh to Paul Gauguin as part of an exchange and placed on deposit with Chaudet and later Amadée Schuffenecker, Paris, when Gauguin sailed for Tahiti.

2. Letter of January 25, 1930, from a representative of Galerie Thannhauser to Keith McLeod, in curatorial file.

SELECTED EXHIBITIONS

1890 • Paris, pavillon de la Ville de Paris, Champs-Elysées, March 20–April 27, *Sixième Exposition de la Société des Artistes Indépendants*, no. 833(?).

1901 • Paris, Bernheim-Jeune, March 15–31, *Vincent van Gogh*, no. 58.

1914 • Berlin, Paul Cassirer [Art Gallery], May–June, *Vincent van Gogh*, no. 117.

1926 • London, Leicester Galleries, November–December, *Vincent van Gogh*, no. 24.

1929 • New York, The Museum of Modern Art, November, *First Loan Exhibition: Cézanne, Gauguin, Seurat, Van Gogh* (MoMA [1929]), no. 84.

1935–36 • New York, The Museum of Modern Art, December 1935–January 1936; Chicago, The Art Institute of Chicago; Boston, Museum of Fine Arts, February 19–March 15, 1936; Cleveland, The Cleveland Museum of Art, March 25–April 19, 1936; Detroit, The Detroit Institute of Arts, October 6–28, 1936; Kansas City, Mo., William Rockhill Nelson Gallery of Art and Mary Atkins Museum of Fine Arts; Minneapolis, The Minneapolis Institute of Arts; Philadelphia, Philadelphia Museum of Art; San Francisco, California Palace of the Legion of Honor, *Vincent van Gogh* (MoMA 1935), addendum 55a, not in catalogue (Boston venue only).

1939 • Boston, Museum of Fine Arts, June 9–September 10, *Art in New England: Paintings, Drawings, and Prints, from Private Collections in New England* (MFA 1939), no. 56.

1992 • *Crosscurrents*.

Note: Although catalogued and reproduced in the exhibition catalogue for the following exhibition, the painting was withdrawn at the last moment and did not appear: New York, Wildenstein Galleries, October–November 1943, *The Art and Life of Vincent van Gogh: Loan Exhibition in Aid of the American and Dutch War Relief* (DeBatz 1943), no. 55.

SELECTED REFERENCES

Meier-Graefe 1912, 41; Van Gogh 1927, nos. 610, 619, 621, 622, 629, 630, B20; De la Faille 1928, 1: no. 662; Scherjon 1932, no. 60; Scherjon and De Gruyter 1937, 256–57, no. 60; De la Faille 1939, 462, no. 671; De Batz 1943, no. 55; Constable 1946, 8; Derkert, Eklund, and Reuterswärd 1946, 128–29; Meyerson 1946, 141–42; Buchmann 1948, 36–39, 51; Clark [1949], 121; Weisbach [1949–51], 2:177–78, no. 69; Leymarie 1951,

126; Rewald 1956, 362, 378; Van Gogh 1958, 3:223, 240, 243, 244, 260, 263, 521, 561 (T24), 565 (T29); Van Gogh 1966, nos. 610, 619, 621, 622, B20, T24; De la Faille 1970, 261, no. 662; MFA [1970], 97, no. 65; Roskill [1970], fig. 2; Cavallo et al. 1971, no. 143; Lecaldano 1977, no. 712; Murphy 1985, 120; Van Gogh 1985, 325, no. 287; Stein 1986, 277, pl. 101; Hulsker 1996, H1804.

130. *Houses at Auvers*, 1890
Oil on canvas
75.5 x 61.8 cm (29¾ x 24⅜ in.)
Bequest of John T. Spaulding 48.549

PROVENANCE

After 1890, Mrs. Johanna van Gogh-Bonger, Amsterdam. Tilla Durvieux-Cassirer, Berlin; Paul Cassirer Gallery, Berlin. Galerie Thannhauser, Lucerne. Voss Collection, Berlin. By 1926, with Wildenstein and Co., New York; October 18, 1926, sold by Wildenstein to John Taylor Spaulding (d. 1948), Boston; 1926–48, John Taylor Spaulding, Boston; 1948, bequest of John Taylor Spaulding.

SELECTED EXHIBITIONS

1905 • Amsterdam, Stedelijk Museum, July–August, *Vincent van Gogh*, no. 210.

1908 • Paris, Bernheim-Jeune, January, *Cent tableaux de Vincent van Gogh.*

1912 • Cologne, Kunsthalle, May–September, *International Exposition*, no. 105.

1929 • Cambridge, Mass., Fogg Art Museum, Harvard University, March 6–April 6, *Exhibition of French Painting of the Nineteenth and Twentieth Centuries* (Fogg Art Museum [1929]), no. 95.

1929 • New York, The Museum of Modern Art, November, *First Loan Exhibition: Cézanne, Gauguin, Seurat, Van Gogh* (MoMA [1929]), no. 90.

1931–32 • Boston, Museum of Fine Arts, May 26, 1931–October 27, 1932, *Collection of Modern French Paintings, Lent by John T. Spaulding.*

1935–36 • New York, The Museum of Modern Art, December 1935–January 1936; Chicago, The Art Institute of Chicago; Boston, Museum of Fine Arts, February 19–March 15, 1936; Cleveland, The Cleveland Museum of Art, March 25–April 19, 1936; Detroit, The Detroit

Institute of Arts, October 6–28, 1936; Kansas City, Mo., William Rockhill Nelson Gallery of Art and Mary Atkins Museum of Fine Arts; Minneapolis, The Minneapolis Institute of Arts; Philadelphia, Philadelphia Museum of Art; San Francisco, California Palace of the Legion of Honor, *Vincent van Gogh* (MoMA 1935), no. 64.

1939 • Boston, Museum of Fine Arts, June 9–September 10, *Art in New England: Paintings, Drawings, and Prints, from Private Collections in New England* (MFA 1939), no. 58.

1948 • Boston, Museum of Fine Arts, May 26–November 7, *The Collections of John Taylor Spaulding, 1870–1948* (MFA 1948), no. 33.

1949 • Cambridge, Mass., Fogg Art Museum, Harvard University.

1951 • Cambridge, Mass., Busch-Reisinger Museum, Harvard University, *Van Gogh.*

1956 • Raleigh, N.C., North Carolina Museum of Art, June 15–July 29, *French Painting of the Last Half of the Nineteenth Century* (NCMA 1956), unnumbered entry.

1975 • Auckland, Auckland City Art Gallery, August 18–October 5, *Van Gogh in Auckland* (Auckland City 1975), no. 8.

1979–80 • *Corot to Braque* (Poulet and Murphy 1979), no. 63.

1983–84 • *Masterpieces of European Painting* (Nippon Television 1983), no. 63.

1985 • Boston, Museum of Fine Arts, February 13–June 2, *The Great Boston Collectors: Paintings from the Museum of Fine Arts, Boston* (Troyen and Tabbaa 1984), no. 54.

1990–91 • Essen, Museum Folkwang, August 10–November 4, 1990 (Dorn et al. 1990), no. 54; Amsterdam, Van Gogh Museum, November 16, 1990–February 18, 1991, *Vincent van Gogh and Early Modern Art, 1890–1914* (Költzsch and de Leeuw 1990), no. 43.

1992 • *Crosscurrents.*

1999 • *Monet, Renoir, and the Impressionist Landscape* (Nagoya/Boston and MFA 1999), no. 59.

2000–2 • *Monet, Renoir, and the Impressionist Landscape* (Shackelford and Wissman 2000), no. 66.

SELECTED REFERENCES

Meier-Graefe 1921b, 2:98, no. 100; De la Faille 1928, 1:228, no. 805; Scherjon and De Gruyter 1937, 363, no. 198; De la Faille 1939, 539, no. 789; Edgell 1949, 84; Malraux 1952, 15; Estienne 1953b, 73; MFA 1955, 29; Reidemeister 1963, 164; De la Faille 1970, 306, no. 805; Lecaldano 1977, 853; Hulsker 1980, no. 1989; Nemeczek 1981, 33; Naeling 1984, 4; Murphy 1985, 120; MFA 1986, 81; Mothe 1987, 160; Hulsker 1996, H1989.

Antoine Vollon
French, 1833–1900

36. *Meadows and Low Hills*
Oil on panel
28 x 46.2 cm (11 x 18⅛ in.)
Bequest of Ernest Wadsworth Longfellow
37.602

PROVENANCE

With Goupil and Co., London. By 1937, Ernest Wadsworth Longfellow, Boston; 1937, bequest of Ernest Wadsworth Longfellow.

SELECTED EXHIBITIONS

1999 • *Monet, Renoir, and the Impressionist Landscape* (Nagoya/Boston and MFA 1999), no. 30.

2000–2 • *Monet, Renoir, and the Impressionist Landscape* (Shackelford and Wissman 2000), no. 31.

SELECTED REFERENCE
Murphy 1985, 297.

Edouard Vuillard
French, 1868–1940

148. *Crossing the Field*, 1899
Color lithograph on cream Chinese paper.
Roger-Marx 34
Image: 25.3 x 34.3 cm (9 15⁄16 x 13½ in.)
Bequest of W. G. Russell Allen 60.108

Glossary for Works on Paper

Photography Techniques

ALBUMEN PRINT—A print made with light-sensitive silver salts held in an albumen (egg white) coating on paper. Unlike SALT PRINTs, albumen prints have a glossy surface, and the image appears to sit on top of the paper, rather than in it. Albumen prints are usually, although not always, made with GLASS-PLATE NEGATIVEs. (Invented 1850; commonly used 1850s–90s.)

CALOTYPE—A term often used to refer to both the PAPER NEGATIVE and the resulting SALT PRINT. Calotype negatives are made by applying a series of solutions to create light-sensitive salts on paper. The sensitized paper is exposed in a camera to produce a latent image that is then developed. The negative is contact printed in daylight, producing a salt print. (Invented 1840; commonly used 1840s–early 50s.)

CLICHÉ-VERRE—A type of GLASS-PLATE NEGATIVE in which the glass is coated with a wet or dry opaque substance, through which an artist draws or scratches a design. The resulting negative is printed as with any glass-plate negative and can be turned over to print the reverse image. (In use as early as 1835.)

GLASS-PLATE NEGATIVE—A negative created by applying a light-sensitive emulsion to a plate of glass. Glass negatives typically produce a sharper and more detailed image than paper negatives. However, the fragility of large glass plates makes them more difficult to use in the field. These negatives are most often used in the creation of ALBUMEN PRINTS. (First in use in 1848 with WET-COLLODION PROCESS.)

PAPER NEGATIVE—A negative made by applying a series of solutions to create light-sensitive salts on paper. In order to make the paper more transparent, it is sometimes treated with a wax or gelatin coating. Individual paper fibers are often visible in prints made from paper negatives. See also SALT PRINT, CALOTYPE, and ALBUMEN PRINT. (First used in 1840.)

PHOTOGRAVURE—A photomechanical process in which a photographic image is transferred and etched into a copper plate. As with traditional printmaking, the resulting plate is inked and printed in a press. The appeal of printing photographic images in ink is that an artist can easily produce a large number of consistent prints that will not discolor over time. (In experimental form in the 1860s; modern photogravure invented in 1879.)

SALT PRINT (or SALTED PAPER PRINT)—The earliest photographic print process to use a negative. Paper is made light sensitive by application of a salt solution followed by silver nitrate. Salt prints are contact printed from the negative and appear as though the image is embedded in the paper. (Invented 1840; commonly used 1840s–50s.)

STEREOCARD (or STEREOGRAPH)—A small card displaying two nearly identical images side by side. Such a card, in combination with a special viewer called a stereoscope, imitates human binocular vision. The stereoscope blocks out peripheral vision and causes the eye to merge the two photographs into what appears to be a single, three-dimensional image.

WET-COLLODION PROCESS—A process whereby a sticky substance is poured onto a plate of glass and made light-sensitive immediately prior to exposure in the camera. The glass-plate negative is exposed while wet and then developed immediately after exposure. When executed outside the studio, the collodion process requires a portable darkroom for coating and developing the plates. By the mid-1850s, a less frequently used dry-collodion process was developed, which did not require exposing a wet negative. (Invented 1848; commonly used 1850s–70s.)

Print Techniques

AQUATINT—An etching technique used to create areas of graduated tone rather than lines. A printing plate is prepared by coating the area where tone is desired with tiny grains of an acid-resistant material such as rosin. When placed in an acid solution, the plate is bitten only around the grains, creating an irregular network of pits (or crevices). This pitted surface holds the ink and prints as an even tone. Variation in the tonality depends on the length of time the plate is exposed to the acid and the size and density of the granular particles: longer exposure creates deeper pits that hold more ink, resulting in a darker tone. In LIFT-GROUND ETCHING (also called sugar-lift) the portion of the plate to receive tone is brushed with a solution in which sugar has been dissolved. The entire plate is then covered with a stopping-out varnish and immersed in water. As the sugar in the solution swells, it lifts areas of varnish off the plate, leaving the brushed area exposed. These areas are then covered with an aquatint ground and bitten while the stopping-out varnish protects the rest of the plate. This technique is used to develop painterly, subtly toned imagery.

CHINE COLLÉ—A method whereby two pieces of paper (usually one much lighter-weight than the other, such as an Asian tissue) are adhered together during the printing process. This technique allows for printing effects that are unattainable on the thinner sheet without the support of the heavier paper.

CLICHÉ-VERRE—See under Photographic Techniques.

DRYPOINT—A technique often used in conjunction with etching, in which a steel or diamond point is used to scratch directly into the printing plate.

ETCHING—A printing process in which an artist covers a printing plate (traditionally made of copper) with a waxy ground, and then draws in the ground with a point or needle, exposing the plate. The plate is then submerged in acid, which bites away at the plate only where the ground has been removed, leaving grooves. Next, the plate is covered with ink, filling the grooves. The surface may be wiped clean, or some tone may be left on and manipulated. In either case, the plate is run through a press with dampened paper, causing the ink to be transferred to the paper. In SOFT-GROUND ETCHING an artist draws on a sheet of paper set on top of a plate covered with a sticky ground. Wherever the pressure of the drawing pushes the paper against the ground, the ground is removed along with the paper. The plate is then etched and printed, creating tonal areas and soft, granular lines reminiscent of chalk, crayon, or soft pencil.

LIFT-GROUND ETCHING—See AQUATINT.

LITHOGRAPH—A printing process in which the flat surface of a stone (traditionally limestone) or a metal plate (as in a ZINCO-GRAPH) is treated to make it receptive to printing ink wherever it is drawn on with a greasy medium, such as crayon or tusche (used as wash or with pen in the case of a pen lithograph). The remaining surface, where no drawing exists, is kept wet during the printing process to repel the greasy ink. Because there is no raised relief (as in woodcut) or depressed area (as in etching, drypoint, and aquatint) that wears out with repeated printing, lithographs are ideal for creating large numbers of prints.

MONOTYPE—A printing process in which an artist draws directly on some material (such as a metal plate or glass) with greasy ink or paint and then runs it through a press to create a print. Only one strong impression (or print) can be made, hence the name monotype.

PEN LITHOGRAPH—See LITHOGRAPH.

ROULETTE—A spiked wheel used to create a tone or dotted lines directly on the printing plate.

SOFT-GROUND ETCHING—See ETCHING.

STATE—A stage in the progress of a print at which impressions are printed. Only the addition or deletion of marks on the plate, stone, or block is considered a change of state.

TRIAL PROOF or WORKING PROOF—A preliminary impression of a print to check the progress of the work.

WOODCUT—A print made by carving a block or plank of wood to leave a raised surface, with the blank areas of the design cut away and the design itself standing out in relief. The raised surface is then inked, and the ink is transferred to paper, creating the print.

WOOD ENGRAVING—A relief printmaking process, similar to woodcut, in which areas of wood are cut away to leave the final image. The wood-engraving block—traditionally boxwood—is cut across the end-grain, in contrast to those used for woodcuts, which are cross-grained or plankside blocks. This allows for finer detail in the wood-engraved image. Wood engravings were often used as illustrations in nineteenth-century books and magazines.

ZINCOGRAPH—A printing technique similar to a lithograph except that it uses a zinc plate rather than limestone as the printing surface. *See* LITHOGRAPH.

For more information about photographic techniques, see Baldwin 1991, Crawford 1979, and Reilly 1986; for more information about printing techniques, see Brunner 1984 and Ivins 1987.

About, E. 1866. *Le Petit Journal*. Paris: D. Cassigneul.

Ackerman, Gerald A. 1986. *The Life and Work of Jean-Léon Gérôme with a Catalogue Raisonné*. London: Philip Wilson.

Acquavella Galleries. 1968. *Four Masters of Impressionism: Monet, Pissarro, Renoir, Sisley*. Exh. cat. New York: Acquavella Galleries.

———. 1976. *Claude Monet*. Exh. cat. New York: Acquavella Galleries.

———. 1978. *Edgar Degas*. Exh cat. New York: Acquavella Galleries.

Adams, Steven. 1994. *The Barbizon School and the Origins of Impressionism*. London: Phaidon.

Adhémar, Hélène, Anne Distel, and Sylvie Gache-Patin. 1980. *Hommage à Claude Monet (1840–1926)*. Exh. cat. Paris: Editions de la réunion des musées nationaux.

Adriani, Götz. 1993. *Cézanne: Gemälde*. Exh. cat. Cologne: DuMont.

Ady, Julia Mary Cartwright. 1896. *Jean-François Millet: His Life and Letters*. London: Swan Sonnenschein; New York: Macmillan.

Alain [pseud]. 1968. *Introduction à l'oeuvre gravé de K.X. Roussel par Alain accompagnée de vingt-huit dessins en fac-similé et suivie d'un essai de catalogue par Jacques Salomon*. Paris: Mercure de France.

Album artistique et biographique, deuxième année, Salon 1882. 1882. Paris: E. Francfort Edit.

Alexandre, Arsène. 1908. "Claude Monet: His Career and Work." *Studio* 34 (March): 87–106.

Allen, Josephine L. 1937. "Paintings by Renoir." *Metropolitan Museum of Art Bulletin* 32, no. 5 (May): 108–14.

Allston Club, Boston. 1866. *Annual Exhibition*. Exh. cat. Boston: [Allston Club?].

Alphant, Marianne. 1993. *Claude Monet: Une vie dans le paysage*. Paris: Hazan.

American Art Assoc. 1886. *Catalogue of the Private Collections of Modern Paintings Belonging to Mr. Beriah Wall and Mr. John A. Brown of Providence, R.I.* New York: n.p.

American Art Galleries. [1886]. *Works in Oil and Pastel by the Impressionists of Paris, 1886*. Exh. cat. [New York: J. J. Little].

———. 1889. *Catalogue of the Works of Antoine-Louis Barye . . . His Contemporaries and Friends for the Benefit of the Barye Monument Fund*. Exh. cat. [New York: J. J. Little].

Andersen, Wayne V. 1967. "Cézanne, Tanguy, Choquet." *Art Bulletin* 49, no. 2 (June): 137–39.

André, Albert. 1931. *L'atelier de Renoir*. Paris: Bernheim-Jeune.

Angrand, Charles. 1988. *Charles Angrand: Correspondances, 1883–1926*. Ed. François Lespinasse. [Rouen: François Lespinasse].

Antoine, Jules. 1891. "Exposition des artistes indépendants." *La Plume* (May 1): 156–57.

Art Association of Indianapolis/Herron Museum of Art. [1965]. *The Romantic Era: Birth and Flowering, 1750–1850*. Exh. cat. [Milan: A. Pizzi].

Art Institute of Chicago (AIC). 1933. *Catalogue of a Century of Progress Exhibition of Paintings and Sculpture, Lent from American Collections*. 2d ed. Exh. cat. [Chicago]: Art Inst. of Chicago.

———. 1934. *Catalogue of a Century of Progress Exhibition of Paintings and Sculpture, Lent from American Collections*. 1st ed. Exh. cat. Chicago: Art Inst. of Chicago.

———. 1952. *Cézanne: Paintings, Watercolors, and Drawings, a Loan Exhibition*. Exh. cat. Chicago: Art Inst. of Chicago.

———. 1959. *Gauguin: Paintings, Drawings, Prints, Sculpture*. Exh. cat. [Chicago]: Art Inst. of Chicago.

———. 1960. *Corot, 1796–1875: An Exhibition of His Paintings and Graphic Works*. Exh. cat. [Chicago: Art Inst. of Chicago].

———. 1977. *Niépce to Atget: The First Century of Photography; from the Collection of André Jammes*. Chicago: Art Inst. of Chicago.

"Art in Boston." 1891. *Art Amateur* 24, no. 6 (May): 141.

Arts Council of Great Britain. [1955]. *Gauguin: An Exhibition of Paintings, Engravings, and Sculpture*. Exh. cat. Essay by Douglas Cooper. [London: Arts Council of Great Britain].

Asahi Shimbun. 1970. *Mone meisakuten: furansu inshōshugi hyaku-nen kinen* (Claude Monet). Exh. cat. in Japanese. Tokyo: Asahi Shimbun.

Atlanta Art Association Galleries. [1955]. *Painting: School of France*. Exh. cat. [Atlanta: Atlanta Art Assoc.?]

Aubenas, Sylvie, et al. 2002. Gustave Le Gray 1820–1884. [Paris]: Bibliothèque nationale de France/Gallimard.

Auckland City Art Gallery. 1975. *Van Gogh in Auckland*. Exh. cat. [Auckland]: Auckland City Art Gallery.

———. 1985. *Claude Monet: Painter of Light*. Exh. cat. Auckland: Auckland City Art Gallery, NZI Corporation.

Auer, Michèle, and Michel Auer. 1985. *Encyclopédie internationale des photographes de 1839 à nos jours*. Geneva: Editions Camera Obscura.

Aurier, Albert. 1892. "Les Symbolistes." *La Revue Encyclopédique* (April): 474–86.

Baas, Jacquelynn, and Richard S. Field. 1983. *The Artistic Revival of the Woodcut in France, 1850–1900*. Exh. cat. Ann Arbor, Mich.: Univ. of Michigan Museum of Art.

Bailey, Colin B. 1997. *Renoir's Portraits: Impressions of an Age*. Exh. cat. New Haven, Conn., and London: Yale Univ. Press in assoc. with National Gallery of Canada, Ottawa.

Baldwin, Gordon. 1991. *Looking at Photographs: A Guide to Technical Terms*. Malibu, Calif.: J. Paul Getty Museum in assoc. with British Museum Press.

Ballu, R. 1877. "Les artistes contemporains: Diaz." *Gazette des Beaux-Arts*, 2d ser., 2, no. 15 (March): 294, 298.

Barazetti, Suzanne. 1936. "Degas et ses amis Valpinçon." *Beaux-Arts* 190 (August 21).

Bareau, Juliet Wilson. 1998. *Manet, Monet, and the Gare Saint-Lazare*. Exh. cat. Washington, D.C.: National Gallery of Art; New Haven, Conn.: Yale Univ. Press.

Barnes, Alfred C., and Violette de Mazia. 1935. *The Art of Renoir.* New York: Minton, Balch.

Barter, Judith, et al. 1998. *Mary Cassatt: Modern Woman.* Chicago and New York: Art Inst. of Chicago in assoc. with H. N. Abrams.

Bartsch, Adam. 1797. *Catalogue raisonné de toutes les estampes qui forment l'oeuvre de Rembrandt.* Vienna: A. Blumauer.

Baudelaire, Charles. 1965. *Art in Paris, 1845–1862: Salons and Other Exhibitions.* Trans. and ed. Johnathan Mayne. Ithaca, N.Y.: Cornell Univ. Press; Oxford: Phaidon.

———. 1966. "Catalogue de la collection de M. Crabbe." In *Oeuvres complètes,* ed. Y. G. Le Dantec and Claude Pichois. Paris: La Pléiade.

Becker, Christoph, et al. 1999. *Camille Pissarro.* Exh. cat. Ostfildern-Ruit: Hatje-Cantz.

Becker, David P. 1983. "Rodolphe Bresdin's *Le Bon Samaritain.*" *Nouvelles de l'Estampe,* nos. 70–71 (July–October): 6–14.

———. 1993. "On Camels in Art—Bresdin's Good Samaritan." *Print Quarterly* 10:43–46.

Bénédite, Léonce. 1901. "Jean-Charles Cazin." *Revue de l'Art Ancien et Moderne* 10 (August): 1–33.

Benfey, Christopher. 1997. *Degas in New Orleans: Encounters in the Creole World of Kate Chopin and George Washington Cable.* New York: Alfred A. Knopf.

La Béquille de Voltaire au Salon. 1791. Paris: n.p.

Béraldi, Henri. 1885–92. *Les graveurs du dix-neuvième siècle: Guide de l'amateur d'estampes modernes.* 12 vols. Paris: Librairie L. Conquet.

Berger, Klaus. [1964]. *Odilon Redon, Phantasie und Farbe.* Cologne: M. DuMont Schauberg.

Berhaut, Marie. 1978. *Caillebotte: Sa vie et son oeuvre. Catalogue raisonné des peintures et pastels.* Paris: La Bibliothèque des arts.

Bermingham, Peter. 1975. *American Art in the Barbizon Mood.* Exh. cat. Washington, D.C.: Smithsonian Inst.

Bernard, Bruce, ed. 1986. *The Impressionist Revolution.* London: Orbis.

Bernard, Emile. 1921. *Souvenirs sur Paul Cézanne, et lettres.* Paris: A la Renovation esthetique.

———. 1926. *Souvenirs sur Paul Cézanne: Une conversation avec Cézanne.* Paris: R. G. Michel.

Berson, Ruth, ed. 1996. *The New Painting: Impressionism, 1874–1886. Documentation.* 2 vols. San Francisco: Fine Arts Museums of San Francisco.

Bertram, Anthony. 1931. *Claude Monet.* London: Studio; New York: W. E. Rudge.

Besson, George. 1946. *Sisley.* Paris: Braun.

———. 1954. *Paul Signac, 1863–1935.* 1st ed. 1950. Paris: Braun.

Besson, Vorwort von Georges, and René Wehrli. [1952]. *Claude Monet, 1840–1926.* Exh. cat. [Zurich]: Kunsthaus Zurich.

Bibb, Burnley. 1899. "The Work of Alfred Sisley." *Studio* 18, no. 79 (October): 149–56.

Biermann, Georg. 1913. "Die Kunst auf dem internationalen Markt: Gemälde aus dem Besitz der modernen Galerie Thannhauser München." *Der Cicerone* (May): 309–26.

Bizardel, Yvon. 1974. "Théodore Duret: An Early Friend of the Impressionists." *Apollo* 100, no. 150 (August): 146–55.

Bodelsen, Merete. 1968. "Early Impressionist Sales, 1874–94, in the Light of Some Unpublished 'Procès-verbaux.'" *Burlington Magazine* 110, no. 783 (June): 331–49.

Boggs, Jean Sutherland. 1962. *Portraits by Degas.* Berkeley, Calif.: Univ. of California Press.

Boggs, Jean Sutherland, et al. 1988. *Degas.* Exh. cat. New York: Metropolitan Museum of Art; Ottawa: National Gallery of Canada.

———. 1998. *Degas at the Races.* Exh. cat. Washington, D.C.: National Gallery of Art; New Haven, Conn.: Yale Univ. Press.

Boime, Albert. 1971. *The Academy and French Painting in the Nineteenth Century.* London: Phaidon.

Boisdeffre, Pierre de. [1966]. *Cézanne.* Paris: Hachette.

Bonnici, Claude-Jeanne. 1989. *Paul Guigou, 1834–1871.* Aix-en-Provence: Edisud.

Borcoman, James. 1984. *Eugène Atget, 1857–1927.* Exh. cat. Ottawa: National Gallery of Canada.

Borgmeyer, Charles Louis. [1913]. *The Master Impressionists.* Chicago: Fine Arts.

Bortolatto, Luigina Rossi. 1972. *L'opera completa di Claude Monet, 1870–1889.* Milan: Rizzoli.

Bouret, Jean. 1972. *L'école de Barbizon et le paysage français au dix-neuvième siècle.* Paris: Neuchâtel, Ides & Calendes.

———. 1973. *The Barbizon School and Nineteenth-Century French Landscape Painting.* Greenwich, Conn.: New York Graphic Society.

Bouvet, Francis. 1981. *Bonnard: The Complete Graphic Work.* New York: Rizzoli.

Boyle-Turner, Caroline. 1986. *The Prints of the Pont-Aven School: Gauguin and His Circle in Brittany.* Exh. cat. Washington, D.C.: Smithsonian Inst. Traveling Exhib. Serv.

Breeskin, Adelyn D. 1948. *The Graphic Work of Mary Cassatt: A Catalogue Raisonné.* New York: H. Bittner.

Brennan, Anne G., and Donald Furst. 1992. *Cassatt, Degas, and Pissarro: A State of Revolution.* Exh. cat. Wilmington, N.C.: St. John's Museum of Art.

Brettell, Richard R. 1990. *Pissarro and Pontoise: The Painter in a Landscape.* New Haven, Conn., and London: Yale Univ. Press.

———. 1996. "The River Seine: Subject and Symbol in Nineteenth-Century French Art and Literature." In *Impressionists on the Seine: A Celebration of Renoir's "Luncheon of the Boating Party,"* by Eliza E. Rathbone et al., 81–130. Exh. cat. Washington, D.C.: Counterpoint in assoc. with The Phillips Collection.

Brettell, Richard R., and Suzanne Folds McCullagh. 1984. *Degas at The Art Institute of Chicago.* Exh. cat. [Chicago]: Art Inst. of Chicago; New York: H. N. Abrams.

Brettell, Richard R., et al. 1980. *Pissarro.* Exh. cat. London: Arts Council of Great Britain; Boston: Museum of Fine Arts.

———. 1984. *A Day in the Country: Impressionism and the French Landscape.* Exh. cat. Los Angeles: Los Angeles County Museum of Art.

———. 1988. *The Art of Paul Gauguin.* Exh. cat. Washington, D.C.: National Gallery of Art.

Bridgestone Museum of Art. 2001. *Runowāru: Itanji kara kyoshōe no michi, 1870–1892* (Renoir: From Outsider to Old Master, 1870–1892). Exh. cat. Nagoya: Chunichi Shinbunsha.

Brooks, John H. 1985. *Monet in Massachusetts.* Exh. cat. Williamstown, Mass.: Sterling and Francine Clark Art Inst.

Brown, Marilyn Ruth. 1978. "The Image of the 'Bohémien' from Diaz to Manet and Van Gogh." Ph.D. diss., Yale Univ.; Ann Arbor, Mich.: Univ. Microfilms.

Brown University Department of Art. 1972. *To Look on Nature: European and American Landscape, 1800–1874.* Exh. cat. Providence, R.I.: Brown Univ. Dept. of Art.

Brunner, Felix. 1984. *A Handbook of Graphic Reproduction Processes.* New York: Hastings House.

Buchmann, Mark. 1948. *Die Farbe bei Vincent van Gogh.* Zurich: Bibliander-Verlag.

Bühler, Hans-Peter. 1985. "Rückkehr zu den Mannen: Jean-François Millet." *Weltkunst* 55, no. 18 (September 15): 2551–55.

Bunkamura Museum of Art and the Museum of Fine Arts, Boston. 1992. *Mone to inshōha: Bosuton Bijutsukan ten* (Monet and His Contemporaries: From the Museum of Fine Arts, Boston). Exh. cat. Original text by Eric M. Zafran, Robert J. Boardingham, and Shunsuke Kijima. Bunkamura: Bunkamura Museum.

Burmester, Andreas, Christoph Heilmann, and Michael F. Zimmermann, eds. 1999. *Barbizon: Malerei der Natur—Natur der Malerei.* Munich: Klinkhardt & Biermann.

Burty, Philippe. 1877. *Maîtres et petits maîtres*. Paris: G. Charpentier.

Cabanne, Pierre. 1958. *Edgar Degas*. Paris: Editions Pierre Tisné; New York: Universe Books.

Cachin, Françoise. 1971. *Paul Signac*. Trans. Michael Bullock. Greenwich, Conn.: New York Graphic Society.

———. 2000. *Signac: Catalogue raisonné de l'oeuvre peint*. Paris: Gallimard.

Cachin, Françoise, and Monique Nonne. 2000. *Méditerranée: De Courbet à Matisse*. Exh. cat. Paris: Réunion des musées nationaux.

Cachin, Françoise, et al. 1995. *Cézanne*. Exh. cat. Paris: Réunion des musées nationaux.

Cahen, Gustave. 1900. *Eugène Boudin: Sa vie et son oeuvre*. Paris: H. Floury.

Cailler, Pierre, ed. 1946. *Corot, raconté par lui-même et par ses amis*. 2 vols. Geneva: P. Cailler.

Callen, Anthea. 1982. *Techniques of the Impressionists*. Secaucus, N.J.: Chartwell Books; London: Orbis.

Calvet, Arlette, et al. 1968. *Baudelaire*. Exh. cat. Paris: Réunion des musées nationaux.

Canaday, John. 1981. *Mainstreams in Modern Art*. 2d ed. New York: Holt, Rinehart & Winston.

Carjat, Etienne. 1874. "L'Exposition du boulevard des Capucines." *La patriote français* (April 27).

"Carnet d'un collectionneur. Les grandes ventes prochaines. Collection L. O. . . . [Léon Orosdi]." 1923. *Le Figaro*, supplément artistique, no. 3 (May 24): 3.

"'Carriages at the Races,' One of Degas's Early Impressions of the Race Track. . . ." 1929. *International Studio* 92 (April): 34.

Cartwright, Julia M. 1896. *Jean-François Millet: His Life and Letters*. London: Swann Sonnenschein.

Cary, Elisabeth Luther. 1918. "Millet's Pastels at the Museum of Fine Arts, Boston, in the Quincy Adams Shaw Gift." *American Magazine of Art* 9, no. 7 (May): 261–69.

Catalogue des dessins de Millet provenant de la collection de M. G. 1875. Paris: Renou, Maulde & Cock.

Catalogue des tableaux, aquarelles, dessins, gravures, eaux-fortes, lithographies, photographies, etc. . . . Composant la collection de Théophile Gautier. 1873. Exh. cat. Paris: n.p.

Cate, Phillip Dennis, "Japanese Influence on French Prints, 1882–1910." In *Japonisme: Japanese Influence on French Art, 1854–1910*, by Gabriel Weisberg et al., 53–67. Exh. cat. Cleveland: Cleveland Museum of Art.

Cavallo, Adolph S., et al. 1971. *Museum of Fine Arts, Boston: Western Art*. [Boston: Museum of Fine Arts].

Centre Culturel du Marais. [1933]. *Claude Monet au temps de Giverny*. Exh. cat. Paris: Centre culturel du Marais.

Champa, Kermit S. 1973. *Studies in Early Impressionism*. New Haven, Conn.: Yale Univ. Press.

Champa, Kermit Swiler, Fronia E. Wissman, and Deborah Johnson. 1991. *The Rise of Landscape Painting in France: Corot to Monet*. Introd. by Richard R. Brettell. Exh. cat. Manchester, N.H.: Currier Gallery of Art.

Champigneulle, Bernard. 1934. "Le Salon des Indépendants." *Mercure de France* (March 1): 405–12.

Charensol, Georges. 1964. "Paul Signac au Louvre." *La Revue des Deux Mondes* (January 1): 130–35.

Chartrain-Hebbelinck, M.-J. 1969. "Les lettres de Paul Signac à Octave Maus." *Bulletin des Musées Royaux des Beaux-Arts de Belgique*, nos. 1–2:52–95.

Chase's Gallery. [1891]. *Catalogue of Paintings by the Impressionists of Paris: Claude Monet, Camille Pissarro, Alfred Sisley, from the Galleries of Durand-Ruel*. Exh. cat. n.p.

Chesneau, Ernest. 1874. "A côté du Salon, II. Le plein air: Exposition du boulevard des Capucines." *Paris-Journal* (May 7): 2.

———. 1875. "Jean-François Millet." *Gazette des Beaux-Arts* 11, no. 2 (May): 428–41.

Child, Theodore. 1890. "Some Modern French Painters." *Harper's New Monthly Magazine* 80, no. 480 (May): 817–42.

———. 1892. *Art and Criticism; Monographs and Studies*. New York: Harper & Brothers.

Christophe, Jules. 1891 "Le néo-impressionnisme à l'exposition des artistes indépendants." *Journal des Artistes*, no. 13 (April 12): 100.

"La Chronique des arts." 1962. *Gazette des Beaux-Arts*, supplement, 6th ser., 59, no. 1117 (February): 1–68.

Chu, Petra ten Doesschate. 1974. *French Realism and the Dutch Masters: The Influence of Dutch Seventeenth-Century Painting on the Development of French Painting between 1830 and 1870*. Utrecht: Haentjens Dekker & Gumbert.

———. 1990. "At Home and Abroad: Landscape Representation." In *The Art of the July Monarchy: France, 1830 to 1848*, 116–30. Exh. cat. Columbia, Mo.: Univ. of Missouri Press.

City Art Museum of Saint Louis. 1957. *Claude Monet: A Loan Exhibition*. Exh. cat. St. Louis: City Art Museum.

Claretie, Jules. 1875. "Diaz." *L'Art* (October 4): 204–9.

———. 1876. *L'art et les artistes français contemporains*. Paris: Charpentier.

———. 1882–84. *Peintres et sculpteurs contemporains*. Vol. I. Paris: Librairie des Bibliophiles.

Clark, Kenneth. [1949]. *Landscape into Art*. London: J. Murray.

———. 1973. *The Romantic Rebellion: Romantic versus Classic Art*. London: J. Murray and Sotheby Parke Bernet.

Clarke, Michael. 1991a. *Corot and the Art of Landscape*. London: British Museum.

———. 1991b. "Degas and Corot: The Affinity between Two Artists' Artists." *Apollo* (July): 15–20.

"Claude Monet Exhibit Opens." 1905. *Boston Post* (March 15): 9.

Clement, Clara Erskine, and Laurence Hutton. 1879. *Artists of the Nineteenth Century and Their Works: A Handbook Containing Two Thousand and Fifty Biographical Sketches*. 2 vols. Boston: Houghton, Osgood.

———. 1883. *Artists of the Nineteenth Century and Their Works*. 2 vols. Boston: Houghton, Mifflin; Cambridge, Mass.: Riverside.

The Cleveland Museum of Art (CMA). 1916. *Catalogue of the Inaugural Exhibition, June 6–September 20, 1916*. Exh. cat. Cleveland: Cleveland Museum of Art.

———. 1947. *Works by Edgar Degas . . . Catalogue of a Loan Exhibition at the Cleveland Museum of Art*. Exh. cat. Cleveland: Cleveland Museum of Art.

Cogeval, Guy, Claire Frèches-Thory and Gilles Genty. 1998. *The Time of the Nabis*. Exh. cat. Montreal: Montreal Museum of Fine Arts.

Cogniat, Raymond. 1939. *Cézanne*. Paris: Bibliothèque française des arts, Editions Pierre Tisne.

Coke, Van Deren. 1964. *The Painter and the Photograph*. Exh. cat. Albuquerque, N.M.: Univ. of New Mexico Press.

"Collection de tableaux de M. Charles L." 1888. *La Chronique des Arts*, no. 9 (March 3): 65.

Comstock, Helen. 1956. "The Connoisseur in America." *Connoisseur* 138, no. 556 (November): 141–46.

Conisbee, Philip, et al. 1996. *In the Light of Italy: Corot and Early Open-Air Painting*. Exh. cat. Washington, D.C.: National Gallery of Art; New Haven, Conn.: Yale Univ. Press.

Constable, W. G. 1946. "Random Reflections from a Landscape Exhibition." *Bulletin of the Museum of Fine Arts* (Boston) 44 (February): 2–23.

———. 1964. *Art Collecting in the United States of America: An Outline of a History*. London and New York: Nelson.

Cooper, Douglas. 1954. "Two Cézanne Exhibitions—II." *Burlington Magazine* 96, no. 621 (December): 378–83.

———. 1960. "Courbet in Philadelphia and Boston." *Burlington Magazine* 102, no. 687 (June): 244–45.

Coplans, John. [1968]. *Serial Imagery*. Exh. cat. [Pasadena, Calif.]: Pasadena Art Museum.

The Copley Society of Boston. 1903. *Illustrated Catalogue: A Loan Collection of Pictures by Old Masters and Other Painters.* Exh. cat. Boston: Copley Society.

———. 1905. *Loan Collection of Paintings by Claude Monet and Eleven Sculptures by Auguste Rodin.* Exh. cat. Boston: Copley Society.

———. 1908. *The French School of 1830: Loan Collection.* Exh. cat. Boston: Copley Society.

———. 1914. *Portraits by Living Painters, Loan Collection.* Exh. cat. Boston: Copley Society.

Cormack, Malcolm. 1986. *Constable*. Oxford: Phaidon.

Crawford, William. 1979. *The Keepers of Light: A History and Working Guide to Early Photographic Processes.* Dobbs Ferry, N.Y.: Morgan & Morgan.

Cunningham, Charles C. 1936. "Some Corot Paintings in the Museum's Collection." *Bulletin of the Museum of Fine Arts* (Boston) 34, no. 206 (December): 99–102.

———. 1939a. "From Gainsborough to Renoir: Boston Exhibits Its New Bequest of the J. C. Edwards Collection." *Art News* 38, no. 10 (December 9): 8, 16–17.

———. 1939b. "The Juliana Cheney Edwards Collection: Catalogue of Paintings." Exh. cat. in *Bulletin of the Museum of Fine Arts* (Boston) 37, no. 224 (December): 96–112.

———. 1977. *Jongkind and the Pre-Impressionists: Painters of the Ecole Saint-Siméon.* Williamstown, Mass.: Sterling and Francine Clark Art Inst.

Currier Gallery of Art. [1949]. *Monet and the Beginnings of Impressionism: Twentieth Anniversary Exhibition.* Exh. cat. Manchester, N.H.: Currier Gallery of Art.

Curtis, Atherton. 1939. *Catalogue de l'oeuvre lithographié de Eugène Isabey.* Paris: Paul Prouté.

Czymmek, Götz. 1990. *Landschaft im Licht: Impressionistische Malerei in Europa und Nordamerika, 1860–1910.* Exh. cat. Cologne: Wallraf-Richartz Museum; Zurich: Kunsthaus Zürich.

Dallas Museum for Contemporary Arts. [1961]. *Impressionists and Their Forebears from Barbizon.* Exh. cat. [Dallas]: Dallas Museum for Contemporary Arts.

Dame, Lawrence. 1948. "Spaulding Collection of Modern Art Willed to Boston Museum." *Art Digest* 22, no. 17 (June 1): 12, 38.

Daniel, Malcolm R. 1992. "Edouard-Denis Baldus and the Chemin de fer du Nord Albums." *Image* 35, nos. 3–4 (fall–winter): 2–37.

———. 1994. *The Photographs of Edouard Baldus.* Exh. cat. New York: Metropolitan Museum of Art.

———. 1996. *Eugène Cuvelier*. New York: Metropolitan Museum of Art.

Daulte, François. 1959. *Alfred Sisley: Catalogue raisonné de l'oeuvre peint.* Lausanne: Durand-Ruel.

———. 1971. *Auguste Renoir: Catalogue raisonné de l'oeuvre peint.* Lausanne: Durand-Ruel.

Dayez-Distel, Anne, et al. 1974. *Impressionism: A Centenary Exhibition.* Exh. cat. [New York: Metropolitan Museum of Art].

De Batz, Georges. 1943. *The Art and Life of Vincent van Gogh: Loan Exhibition in Aid of American and Dutch War Relief.* Exh. cat. New York: Wildenstein & Co.

De Gail, Sylvie Lamort. 1989. *Paul Guigou: Catalogue raisonné.* Paris: Editions d'art & d'histoire.

Degas, Edgar. 1931. *Lettres de Degas.* Ed. Marcel Guérin. Paris: B. Grasset.

De la Faille, J. B. 1928. *L'oeuvre de Vincent van Gogh: Catalogue raisonné.* 4 vols. Paris: G. Van Oest.

———. 1939. *Vincent van Gogh.* Trans. Prudence Montagu-Pollock. New York: French and European Publications.

———. 1970. *The Works of Vincent van Gogh: His Paintings and Drawings.* [New York]: Reynal in assoc. with Morrow.

De la Fizelière, Albert, Jules Champfleury, and Frédéric Henriet. 1874. *La vie et l'oeuvre de Chintreuil.* Paris: Cadart.

De Leiris, Alain, and Carol Hynning Smith. 1977. *From Delacroix to Cézanne: French Watercolor Landscapes of the Nineteenth Century.* Exh. cat. College Park, Md.: Univ. of Maryland.

Delestre, Gatson. 1961. "Courbet et Corot à Saintes." *Les Amis de Gustave Courbet* (bulletin), no. 27:1–5.

Delteil, Loys. 1906–30. *Le peintre-graveur illustré (dix-neuvième et vingtième siècles).* 32 vols. Paris: Chez l'auteur.

Denoinville, Georges. 1901. *Sensations d'art.* 3d ed. Paris.

Derkert, C., H. Eklund, and Oscar Reuterswärd. 1946. "Van Gogh's Landscape with Corn Shocks." *Konsthistorik Tidskrift* 15 (December): 121–30.

"'The Descent of the Gypsies.' From the Picture by Diaz in the Secretan Collection." 1890. *Studio* 5, no. 18 (April 5): 176–77.

Detroit Institute of Arts. 1950. *French Painting from David to Courbet.* Exh. cat. Detroit: Inst. of Arts.

De Veer, Elizabeth, and Richard J. Boyle. 1987. *Sunlight and Shadow: The Life and Art of Willard L. Metcalf.* New York: Abbeville.

Dewhurst, Wynford. 1904. *Impressionist Painting: Its Genesis and Development.* London: G. Newnes.

Dézallier d'Argenville, Antoine-Joseph. 1791. *Explication et critique impartiale . . . quatrième édition revue et corrigée.* Paris: n.p.

D. F. [Desmond Fitzgerald]. 1892. *Claude Monet: An Exhibition of Paintings by Claude Monet.* St. Botolph Club, Boston: St. Botolph Club.

Didier Aaron. 1990. *French Paintings and Drawings, 1700–1865.* Exh. cat. Paris, London, and New York: Didier Aaron.

Dixon, Annette, Carole McNamara, and Charles Stuckey. 1998. *Monet at Vétheuil: The Turning Point.* Exh. cat. Ann Arbor, Mich.: Univ. of Michigan.

Dormoy, (Marie) Dominique. 1926. "La Collection Schmitz à Dresde." *L'Amour de l'Art*, annual edition, 7:339–43.

Dorn, Roland, et al. 1990. *Vincent van Gogh en de moderne Kunst, 1890–1914.* Exh. cat. Zwolle: Waanders.

Downes, William Howe. 1888a. "Boston Painters and Paintings: IV. French Works in the Museum of Fine Arts." *Atlantic Monthly* 62, no. 372 (October): 500–510.

———. 1888b. "Boston Painters and Paintings: VI. Private Collections." *Atlantic Monthly* 62, no. 374 (December): 776–86.

Druick, Douglas W., et al. 1994. *Odilon Redon, 1840–1916: Prince of Dreams.* Exh. cat. Chicago: Art Inst. of Chicago in assoc. with Harry N. Abrams.

———. 2001. *Van Gogh and Gauguin: The Studio of the South.* Exh. cat. Chicago: Art Inst. of Chicago; New York: Thames & Hudson.

Dufwa, Jacques. 1981. *Winds from the East: A Study in the Art of Manet, Degas, Monet, and Whistler, 1856–86.* Stockholm: Almqvist & Wiksell; Atlantic Highlands, N.J.: Humanities.

Dumas, Ann, and David A. Brenneman. [2001]. *Degas and America: The Early Collectors.* Exh. cat. Atlanta: High Museum of Art; [Minneapolis]: Minneapolis Inst. of Arts.

Dumas, Anne, et al. *The Private Collection of Edgar Degas.* 1997. Exh. cat. New York: Metropolitan Museum of Art.

Dumesnil, Henri. 1875. *Corot: Souvenirs intimes.* Paris: Rapilly.

Dunlop, Ian. 1979. *Degas.* London: Thames & Hudson.

Durand-Gréville, E. 1887. "La peinture aux Etats-Unis." *Gazette des Beaux-Arts*, 2d ser., 36, no. 1 (July 1): 65–75.

Durand-Ruel Galleries. 1895. *Exposition of Forty Paintings by Claude Monet.* Exh. cat. [New York: Durand-Ruel].

———. [1900]. *Exhibition of Paintings: Claude Monet and Pierre Auguste Renoir.* Exh. cat. [New York: Durand-Ruel].

———. 1902. *Exhibition of Paintings by Claude Monet.* Exh. cat. [New York: Durand-Ruel].

Durbé, Dario, and Anna Maria Damigella. 1969. *La scuola di Barbizon.* Milan: Fratelli Fabbri.

Duret, Théodore. 1916. *Vincent van Gogh.* 2d ed. Paris: Bernheim-Jeune.

———. 1937. "Vincent van Gogh, sa vie et son oeuvre." *L'Amour de l'Art* 18, no. 4 (April): 1–40.

Ecole nationale supérieure des beaux-arts (France). 1874. *Tableaux, études et dessins de Chintreuil, exposés a l'Ecole des Beaux-Arts du 25 avril au 15 mai 1874.* Exh. cat. Paris: J. Claye.

Edelson, Douglas E. 1990. "Patronage and Criticism of Gustave Courbet in Nineteenth-Century America." Ph.D. diss., City Univ. of New York Queens College.

Edgell, George Harold. 1949. *French Painters in the Museum of Fine Arts: Corot to Utrillo.* Boston: Museum of Fine Arts.

Edinburgh Festival Society. 1953. *Renoir.* Exh. cat. Edinburgh: Edinburgh Festival Society.

Eisenman, Stephen F. 1992. *The Temptation of Saint Redon: Biography, Ideology, and Style in the Noirs of Odilon Redon.* Chicago and London: Univ. of Chicago Press.

"Enriching U.S. Museums." 1948. *Art News* 157, no. 5 (September): 26–48.

Ernst, Alfred. 1891. "Exposition des artistes indépendants." *La Paix* (March 27): 2.

Erpel, Fritz, ed. 1958. *Paul Cézanne: Zwölf farbige Gemäldereproduktionen, vier einfarbige Tafeln.* Berlin: Henschelverlag.

Estienne, Charles. 1953a. *Gauguin.* Geneva: Skira.

———. 1953b. *Vincent van Gogh.* Geneva: Skira.

Explication des ouvrages de peinture, sculpture, architecture, gravure, et lithographie des artistes vivants, exposés au musée royal. 1843. Paris: Vinchon.

Explication des ouvrages de peinture, sculpture, architecture, gravure, et lithographie des artistes vivants. . . . 1844. Paris: Vinchon.

Explication des peintures, sculptures et gravures, de Messieurs de L'Académie Royale. . . . 1791. Paris: L'Imprimerie des bâtiments du roi et de l'Académie royale de peinture.

Exposition Universelle de 1889. [1889]. *Catalogue illustré des beaux-arts, 1789–1889.* Exh. cat. Lille: Danel; Paris: Baschet.

Fairbrother, Trevor J. 1986. *The Bostonians: Painters of an Elegant Age, 1870–1930.* Exh. cat. Boston: Museum of Fine Arts.

Fairley, John. 1984. *Great Horse Races in Art.* Oxford: Phaidon.

"Faits-Divers." 1888. *Le Temps* (February 29): 2.

Farinaux-Le Sidaner, Yann. 1989. *Le Sidaner: L'oeuvre peint et gravé.* Monaco: A. Sauret.

Faunce, Sarah, et al. 1988. *Courbet Reconsidered.* Exh. cat. Brooklyn: Brooklyn Museum.

Feaver, William. 1985. "The Elusive Renoir." *Art News* 84, no. 10 (December): 44–48.

Feigenbaum, Gail, et al. 1999. *Degas and New Orleans: A French Impressionist in America.* Exh. cat. New Orleans: New Orleans Museum of Art; [Copenhagen]: Ordrupgaard.

Fell, Derek. 1991. *Renoir's Garden.* London: Frances Lincoln.

Fels, Marthe de, comtesse. 1929. *La vie de Claude Monet.* Paris: Gallimard.

Fermigier, André. 1977. *Jean-François Millet.* Geneva: Skira.

———. 1991. *Millet.* Geneva: Skira.

Ferretti-Bocquillon, Marina, et al. 2001. *Signac, 1863–1935.* Exh. cat. New York: Metropolitan Museum of Art in assoc. with Yale Univ. Press.

Feuillet, Maurice. 1923. "Revue des ventes de la semaine. Vendredi 25 mai." *Le Figaro,* supplément artistique, n.s., no. 1 (May 31): 11.

Fezzi, Elda. 1972. *L'opera completa di Renoir nel periodo impressionista, 1869–1883.* Milan: Rizzoli.

Fidell-Beaufort, Madeleine, and Janine Bailly-Herzberg. 1975. *Daubigny.* Trans. Judith Schub. Paris: Geoffroy-Dechaume.

Fields, Armond. 1983. *Henri Rivière.* Salt Lake City: G. M. Smith.

Fighting French Relief Committee. [1941]. *Centennial Loan Exhibition, 1841–1941: Renoir, for the Benefit of the Free French Relief Committee.* Exh. cat. New York: [W. Bradford].

Fitzwilliam Museum. 1960. *Catalogue of Paintings.* Vol. 1, French School section written by J. W. Goodison and Denys Sutton. Cambridge, England: Printed for the Syndics of the Fitzwilliam Museum.

Fleming, Susan. 1984. "The Boston Patrons of Jean-François Millet." In *Jean-François Millet,* by Alexandra Murphy, viii–xviii. Exh. cat. Boston: Museum of Fine Arts.

Florisoone, Michel. 1938a. *Renoir.* Trans. George Frederic Lees. Paris: Hyperion.

———. 1938b. "Renoir et la famille Charpentier." *L'Amour de l'Art* 19, no. 2 (February): 31–40.

Fogg Art Museum. [1929]. *Exhibition of French Painting of the Nineteenth and Twentieth Centuries.* Exh. cat. [Cambridge, Mass.: Harvard Univ. Press].

———. 1936. *Paul Gauguin, 1848–1903: Arranged by the Boston Chapter of the Museum of Modern Art, New York, at the Fogg Art Museum of Harvard University. . . .* Exh. cat. New York: Harbor.

———. [1938]. *The Horse: Its Significance in Art.* Exh. cat. [Boston: G. H. Ellis].

———. [1955]. *From Sisley to Signac: A Museum Course Exhibition.* Exh. cat. [Cambridge, Mass.: Harvard Univ. Press].

———. [1967]. *Eugène Isabey: Paintings, Watercolors, Drawings, Lithographs.* Exh. cat. Cambridge, Mass.: Fogg Art Museum.

Forges, Marie-Thérèse de. 1962. "La Descente des Vaches de Théodore Rousseau au Musée d'Amiens." *La Revue du Louvre et des Musées de France* 12, no. 1:85–90.

Fort Worth Art Center. 1957. *Horse and Rider.* Exh. cat. [Fort Worth, Tex.: Fort Worth Art Assoc.?].

Forthuny, Pascal. 1920. "Des prix considérables." *Le Bulletin de la Vie Artistique* (February 15): 179.

Fosca, François [pseud.]. 1930. *Corot.* Paris: H. Floury.

———. 1954. *Degas.* Trans. James Emmons. Geneva: Skira.

———. 1961. *Renoir, l'homme et son oeuvre.* Paris: A. Somogy.

Foucart, Jacques. 1964. "Paysagistes et petits maîtres." In *Art de France,* ed. Pierre Berès and André Chastel, 347. Paris: Art de France.

Fourny-Dargère, Sophie. 1992. *Monet.* [Paris]: Chêne.

Francis, Henry S. 1960. "Claude Monet's Water Lilies." *Bulletin of the Cleveland Museum of Art* (October): 192–98.

Frankfurter, A. M. 1936. "Gauguin, Fifty Paintings in a First American One-Man Loan Exhibition." *Art News* (March 21): 5–6.

Frapp, A. 1903. "Chronique des ventes." *Les Arts* (American edition) 2, no. 14 (February): 34.

Galassi, Peter. 1991. *Corot in Italy: Open-Air Painting and the Classical-Landscape Tradition.* New Haven, Conn.: Yale Univ. Press.

Galerie Georges Petit. 1918–19. *Atelier Edgar Degas. Catalogue des tableaux, pastels, et dessins par Edgar Degas et provenant de son atelier.* 4 vols. [Paris: Galerie Georges Petit].

———. 1924. *Exposition Degas, au profit de la Ligue franco-anglo-américaine contre le cancer; peintures, pastels et dessins, sculptures, eaux-fortes, lithographies et monotypes.* Exh. cat. Paris: Galerie Georges Petit.

Galerie Thannhauser. 1928. *Claude Monet, 1840–1926.* Exh. cat. [Berlin: Galerie Thannhauser].

Gammell, R. H. Ives. [1946]. *Twilight of Painting: An Analysis of Recent Trends to Serve in a Period of Reconstruction.* New York: G. P. Putnam's Sons.

Gauguin, Paul. [1936]. *Paul Gauguin's Intimate Journals.* Trans. Van Wyck Brooks. New York: Crown.

Geelhaar, Christian, et al. 1986. *Claude Monet, nymphéas: Impression, vision.* Entries by Christian Geelhaar et al. Exh. cat. [Basel]: Kunstmuseum Basel.

Geffroy, Gustave. 1892. "Les Indépendants. 10 avril 1891." In *La Vie artistique,* 306–12. Paris: n.p.

———. 1920. "Claude Monet." *L'Art et les artistes,* no. 11 (November): 51–81.

———. 1922. *Claude Monet: Sa vie, son temps, son oeuvre.* Paris: G. Crès & Cie.

———. 1924. *Monet: Sa vie, son oeuvre.* Paris: G. Crès & Cie.

Geffroy, Gustave, and Arsène Alexandre. 1903. *Corot and Millet.* Ed. Charles Holne. New York: International Studio.

Geist, Sidney. 1975. "The Secret Life of Paul Cézanne." *Art International* 19, no. 9 (November 20): 7–16.

Gensel, Walther. 1902. *Millet und Rousseau.* Bielefeld and Leipzig: Velhagen & Klasing.

Georgel, Pierre. 1999. *Claude Monet: Waterlilies.* Paris: Hazan.

Gerdts, William H. 1983. *Down Garden Paths: The Floral Environment in American Art.* Exh. cat. Madison, N.J.: Fairleigh Dickinson University Press; London and Cranbury, N.J.: Associated Univ. Presses.

———. 1984. *American Impressionism.* 1st ed. New York: Abbeville.

———. 1993. *Monet's Giverny: An Impressionist Colony.* New York: Abbeville.

Germain, Alphonse. 1891. "A l'exposition des Indépendants. Les néo-luminaristes et les néo-traditionnistes." *Le Moniteur des Arts* (March 27): 543–44.

Gibson, Walter S. 2000. *Pleasant Places: The Rustic Landscape from Bruegel to Ruisdael.* Berkeley and Los Angeles: Univ. of California Press.

Gilmour, Pat. 1990. "New Light on Paul Signac's Colour Lithographs." *Burlington Magazine* 123, no. 1045 (April): 269–75.

———, ed. 1988. *Lasting Impressions: Lithography as Art.* Philadelphia: Univ. of Pennsylvania Press.

Glasgow Museums. 1997. *The Birth of Impressionism: From Constable to Monet.* Exh. cat. Glasgow: Glasgow Museums.

Glassman, Elizabeth, and Marilyn F. Symmes. 1980. *Cliché-verre: Hand-Drawn, Light-Printed; a Survey of the Medium from 1839 to the Present.* Exh. cat. Detroit: Detroit Inst. of Arts.

Golden Gate International Exposition. 1939. *Masterworks of Five Centuries.* Exh. cat. San Francisco: Golden Gate International Exposition.

———. 1940. *Art: Official Catalogue.* Exh. cat. [San Francisco: Recorder Printing and Publishing; H. S. Crocker].

Goldstein, Nathan. 1979. *Painting: Visual and Technical Fundamentals.* Englewood Cliffs, N.J.: Prentice-Hall.

Goldwater, Robert. 1938. "Cézanne in America." *Art News* 36, no. 26 (March 26): 135–60.

———. 1958. "Renoir at Wildenstein." *Art in America* 46, no. 1 (spring): 60–62.

Gordon, Robert, and Andrew Forge. 1983. *Monet.* New York: H. N. Abrams.

Göteborgs Konstmuseum. 1997. *Claude Monet: Tolv mästerverk.* Exh. cat. [Göteborg]: Göteborgs Konstmuseum.

Gowing, Lawrence. 1956. "Notes on the Development of Cézanne." *Burlington Magazine* 98, no. 639 (June): 185–92.

Gowing, Lawrence, et al. 1954. *An Exhibition of Paintings by Cézanne.* Exh. cat. London: Arts Council of Great Britain.

Grad, Bonnie L. 1980. "Le Voyage en Bateau: Daubigny's Visual Diary of River Life." *Print Collector's Newsletter* 11, no. 4 (September–October): 123–27.

Grad, Bonnie L., and Timothy A. Riggs. 1982. *Visions of City and Country: Prints and Photographs of Nineteenth-Century France.* Exh. cat. Worcester, Mass.: Worcester Art Museum; New York: American Federation of Arts.

Grafton Galleries. 1905. *Pictures by Boudin, Cézanne, Degas, Manet, Monet.* Exh. cat. London: n.p.

Grappe, Georges. 1911. *E. M. Degas.* London, Berlin, and Paris: n.p.

Grate, Pontus. [1959]. *Deux critiques d'art de l'époque Romantique: Gustave Planche et Théophile Thoré.* Stockholm: Almqvist & Wiksell.

Gray, Christopher. 1972. *Armand Guillaumin.* Chester, Conn.: Pequot.

Greenberg, Clement. 1957. "The Later Monet." *Art News,* annual edition, 26:132–48, 194–96.

———. 1961. "The Later Monet." In *Art and Culture: Critical Essays,* 37–45. Boston: Beacon Press.

Greta. "'Greta's' Boston Letter." 1881. *Art Amateur* 5, no. 4 (September): 72–73.

Grieve, Maud. 2001. *A Modern Herbal.* 2 vols. New York: Harcourt Brace, 1931; reprint, New York: Dover, 1971. Hypertext version on Botanical.com. First published on the World Wide Web in 1995 by Ed Greenwood, Arcata, Calif. Sponsored by Mountain Rose Herbs. Copyright 1995–2000, Electric Newt. Site accessed June 18 and October 2, 2001. http://www.botanical.com/botanical/mgmh/mgmh.html.

Guenne, Jacques. 1934. "Le Salon des Indépendants." *L'Art Vivant,* no. 182 (March): 126–27.

Guérin, Marcel. 1927. *L'oeuvre gravé de Gauguin.* 2 vols. Paris: H. Floury.

Guida alla pittura di Renoir. 1980. 1st ed. Milan: A. Mondadori.

Guiffrey, Jean. 1913. "Tableaux français conservés au Musée de Boston et dans quelques collections de cette ville." *Archives de l'art français,* n.s., 7:531–52.

Gutwirth, Suzanne. 1974. "Jean-Victor Bertin, un paysagiste neo-classique." *Gazette des Beaux-Arts,* 6th ser., 83, no. 1263 (May–June): 337–40.

———. 1977. "'The Sabine Mountains': An Early Italian Landscape by Jean-Joseph-Xavier Bidauld." *Bulletin of the Detroit Institute of Arts* 55, no. 3:147–52.

Haags Gemeentemuseum. [1952]. *Claude Monet.* Exh. cat. ['s- Gravenhage: Gemeentemuseum].

———. [1956]. *Paul Cézanne, 1839–1906.* Exh. cat. ['s- Gravenhage: Gemeentemuseum?].

Hamilton, Vivien. 1992. *Boudin at Trouville.* Exh. cat. London: John Murray in assoc. with Glasgow Museums.

Harris, Jean C., Steven Kern, and Bill Stern. 1988. *Lasting Impressions: French and American Impressionism from New England Museums.* Exh. cat. Springfield, Mass.: Springfield Museum of Fine Arts.

Harris, Nathaniel. 1979. *A Treasury of Impressionism.* [London]: Optimum and Hamlyn.

Harrison, Sharon R. 1986. *The Etchings of Odilon Redon: A Catalogue Raisonné.* New York: Da Capo.

Harvard University, Busch-Reisinger Museum of Germanic Culture. [1954]. *Impressionism and Expressionism: An Exhibition Prepared by Members of the Museum Course.* Exh. cat. [Cambridge, Mass.: Harvard Univ.].

Haus der Kunst. [1960]. *Paul Gauguin.* Exh. cat. [Munich]: Ausstellungsleitung München e.V. Haus der Kunst.

Hawes, Charles Henry. 1919. "A Miniature Panel Portrait by Corneille de Lyon; 'La Seine à Chatou' by Pierre-Auguste Renoir." *Bulletin of the Museum of Fine Arts* (Boston) 17, no. 104 (December): 64–66.

Hayward Gallery. 1985. *Renoir.* Ed. Michael Raeburn. Exh. cat. [London]: Arts Council of Great Britain.

Hazlitt, Gooden & Fox. 1979. *The Lure of Rome: Some Northern Artists in Italy in the Nineteenth Century. Paintings and Drawings.* Exh. cat. London: Hazlitt, Gooden & Fox.

Hefting, Victorine. 1975. *Jongkind: Sa vie, son oeuvre, son époque.* Paris: Arts et métiers graphiques.

Heilbrun, Françoise. 1986. *Les paysages impressionistes.* Paris: Editions Hazan, Réunion des musées nationaux.

Heim, Jean-François, Claire Béraud, and Philippe Heim. 1989. *Les Salons de peinture de la Révolution française, 1789–1799.* Paris: C.A.C. Sarl.

Heinrich, Christoph. 2001. *Monets Vermächtnis Serie. Ordnung und Obsession.* Ed. Uwe M. Schneede. Exh. cat. Hamburg: Hamburger Kunsthalle; Ostfildern: Hatje Cantz.

Hellebranth, Robert. 1976. *Charles-François Daubigny, 1817–1878.* Morges: Matute.

Herbert, Robert L. 1962. *Barbizon Revisited*. Exh. cat. [New York: Clarke & Waye].

———. 1975. *Jean-François Millet*. Trans. Marie-Geneviève de la Coste-Messelière. Exh. cat. Paris: Secrétariat d'Etat à la culture/Editions des musées nationaux.

———. 1976. *Jean-François Millet*. Exh. cat. London: Arts Council of Great Britain.

———. 1979. "Method and Meaning in Monet." *Art in America* 67, no. 5 (September): 90–108.

———. 1988. *Impressionism: Art, Leisure, and Parisian Society*. New Haven, Conn.: Yale Univ. Press.

———. 1994. *Monet on the Normandy Coast: Tourism and Painting, 1867–1886*. New Haven, Conn.: Yale Univ. Press.

Hering, Fanny Field. 1892. *Gérôme: Life and Works of Jean-Léon Gérôme*. Introd. by Augustus St. Gaudens. New York: Cassell.

Hermant, Paul. 1934. "Salons, galeries et ateliers." *Le Figaro Artistique et Illustré* (February): 87.

Hertz, Henri. 1920. *Degas*. Paris: Félix Alcan.

Hirshler, Erica E., and David Park Curry, et al. 1994. *Dennis Miller Bunker: American Impressionist*. Exh. cat. Boston: Museum of Fine Arts.

Hoffmann, Edith. 1958. "Review of Renoir Exhibition at Wildenstein, New York." *Burlington Magazine* 100, no. 662 (May): 185–86.

Hohenzollern, Johann Georg Prinz von, and Peter-Klaus Schuster. 1996. *Manet bis van Gogh: Hugo von Tschudi und der Kampf um die Moderne*. Exh. cat. Munich and New York: Prestel.

Holmes, C. J. 1909. "Two Modern Pictures." *Burlington Magazine* 15, no. 74 (May): 75–81.

Hours, Madeleine. [1972]. *Jean-Baptiste-Camille Corot*. New York: H. N. Abrams.

House, John. 1986. *Monet: Nature into Art*. New Haven, Conn.: Yale Univ. Press.

———. 1988. *Renoir, 1841–1919*. Exh. cat. Guernsey: Guernsey Museum & Art Gallery.

———. 1994. *Renoir: Master Impressionist*. Exh. cat. The Rocks, Sydney, N.S.W.: Art Exhibitions Australia.

House, John, et al. 1995. *Impressions of France: Monet, Renoir, Pissarro, and Their Rivals*. Exh. cat. Boston: Museum of Fine Arts.

Howard, Michael. 1989. *Monet*. London: Brompton.

Huet, René Paul. 1911. *Paul Huet (1830–1869), d'après ses notes, sa correspondance, ses contemporains: Documents recueillis et précédés d'une notice biographique par son fils, René Paul Huet*. Paris: H. Laurens.

Hulsker, Jan. 1980. *The Complete Van Gogh: Paintings, Drawings, Sketches*. New York: H. N. Abrams.

———. 1996. *The New Complete Van Gogh: Paintings, Drawings, Sketches*. Amsterdam: J. M. Meulenhoff; Amsterdam and Philadelphia: John Benjamins.

Hustin, Arthur. 1893. *Constant Troyon*. Paris: Librairie d'Art.

Huth, Hans. 1946. "Impressionism Comes to America." *Gazette des Beaux-Arts*, 6th ser., 29 (April): 225–52.

Hüttinger, Eduard. 1977 [1988]. *Degas*. New York: Crown.

[Huyghe, René, et al.]. [1960]. *Gauguin*. Paris: Hachette.

Iida, Yuzo. 1979. *J.-F. Millet*. Tokyo: Kodansha.

Ikegami, C. *Cézanne*. 1969. Tokyo: Shueisha.

Isaac Delgado Museum of Art. 1954. *A Loan Exhibition of Masterpieces of French Painting through Five Centuries, 1400–1900, in Honor of the 150th Anniversary of the Louisiana Purchase*. Exh. cat. New Orleans: Isaac Delgado Museum of Art.

Isaacson, Joel. 1978. *Observation and Reflection: Claude Monet*. Oxford: Phaidon; New York: Dutton.

———. 1980. *The Crisis of Impressionism, 1878–1882*. Exh. cat. Ann Arbor, Mich.: Univ. of Michigan Museum of Art.

———. 1984. "Observation and Experiment in the Early Work of Monet." In *Aspects of Monet: A Symposium on the Artist's Life and Times*, ed. John Rewald and Frances Weitzenhoffer, 16–35. New York: H. N. Abrams.

———. 1992. "Pissarro's Doubt: Plein-Air Painting and the Abiding Questions." *Apollo* 136, no. 369 (November): 320–24.

Isetan Museum of Art. 1984. *Retrospective Camille Pissarro*. Exh. cat. [Tokyo]: Art Life.

Ittman, John W., et al. 1972. *The Forest of Fontainebleau, Refuge of Reality: French Landscape from 1800 to 1870*. Introd. by John Minor Wisdom, Jr. Exh. cat. [New York: Shepherd Gallery].

Ives, Colta Feller. 1974. *The Great Wave: The Influence of Japanese Woodcuts on French Prints*. Exh. cat. New York: Metropolitan Museum of Art.

Ives, Colta Feller, Helen Giambruni, and Sasha M. Newman. 1989. *Pierre Bonnard: The Graphic Art*. Exh. cat. New York: Metropolitan Museum of Art.

Ives, Colta, Susan Alyson Stein, and Julie A. Steiner. 1997. *The Private Collection of Edgar Degas: A Summary Catalogue*. Exh. cat. New York: Metropolitan Museum of Art.

Ivins, William M. 1987. *How Prints Look*. Revised by Marjorie B. Cohn. Boston: Beacon Press.

Jacobson, Ken. 2001. *"The Lovely Sea-View . . . Which All London Is Now Wondering At": A Study of the Marine Photographs Published by Gustave Le Gray, 1856–1858*. Petches Bridge, Great Bardfield, England: Ken & Jenny Jacobson.

Jalard, Michel-Claude. 1966. *Le Post-impressionisme*. Histoire générale de la peinture, vol. 18. Lausanne: Rencontre.

Jammes, André, and Eugenia Parry Janis. 1983. *The Art of French Calotype, with a Critical Dictionary of Photographers, 1845–1870*. Princeton, N.J.: Princeton Univ. Press.

Jammes, André, and Robert Sobieszek. 1969. *French Primitive Photography*. Philadelphia: Philadelphia Museum of Art in collab. with *Aperture*.

Jammes, Isabelle. 1981. *Blanquart-Evrard et les origines de l'édition photographique française, catalogue raisonné des albums photographiques édités, 1851–1855*. Geneva: Librairie Droz SA.

Jamot, Paul. 1918. "Degas." *Gazette des Beaux-Arts*, 4th ser., 14, no. 695 (April–June): 123–66.

———. 1924. *Degas*. Paris: Editions de la Gazette des Beaux-Arts.

Janis, Eugenia Parry. [1968]. *Degas Monotypes: Essay, Catalogue, and Checklist*. Exh. cat. [Cambridge, Mass.]: Fogg Art Museum, Harvard Univ.

———. 1973. "An Autumnal Landscape by Edgar Degas." *Metropolitan Museum of Art Bulletin* 31, no. 4 (summer): [178–79].

———. 1987. *The Photography of Gustave Le Gray*. Chicago: Art Institute of Chicago and Univ. of Chicago Press.

Jay, Robert. 1995. "The Late Work of Charles Marville: The Street Furniture of Paris." *History of Photography* 19, no. 4 (winter): 328–37.

Jean-Aubry, Gérard. [1968]. *Eugène Boudin (La vie et l'oeuvre d'après les lettres et les documents inédits)*. Paris: Neuchâtel, Editions Ides & Calendes.

Jenks, A. C. 1927. "'Carriages at the Races' by Edgar Degas." *Bulletin of the Museum of Fine Arts* (Boston) 25, no. 147 (February): 2–3.

Jewell, Edward A. 1944. *Paul Cézanne*. New York: Hyperion.

Johnson, Una E. 1944. *Ambroise Vollard Editeur, 1867–1939*. New York: Wittenborn.

Joslyn Art Museum (JAM). [1969]. *Mary Cassatt among the Impressionists*. Exh. cat. [Omaha, Nebr.: Joslyn Art Museum].

Joyes, Claire, et al. 1975. *Monet at Giverny*. London: Mathews Miller Dunbar.

Junior League of Albuquerque. 1965. *Impressionism in America*. Exh. cat. [Albuquerque]: n.p.

Kapos, Martha, ed. 1991. *The Impressionists: A Retrospective*. London: Hugh Lauter Levin.

Kelder, Diane. 1980. *The Great Book of French Impressionism*. New York: Abbeville.

Keller, Horst. 1982. *Ein Garten wird Malerei: Monets Jahre in Giverny*. Cologne: DuMont.

———. 1987. *Auguste Renoir*. Munich: Bruckmann.

Kendall, Richard. 1993. *Degas Landscapes*. Exh. cat. New Haven, Conn., and London: Yale Univ. Press.

———, ed. 1987. *Degas by Himself: Drawings, Prints, Paintings, Writings*. London: Macdonald Orbis.

———, ed. 1988. *Cézanne by Himself: Drawings, Paintings, Writings*. London: Macdonald Orbis.

———, ed. 1989. *Monet by Himself: Paintings, Drawings, Pastels, Letters*. Trans. Bridget Strevens Romer. London: Macdonald Orbis.

Kerr, John O'Connell. 1954. "Renoir at the Tate." *Studio* 147, no. 730 (January): 14–17.

Kitson, Michael, et al. 1990. *Claude to Corot: The Development of Landscape Painting in France*. Ed. Alan Wintermute. Exh. cat. New York: Colnaghi.

[Knoedler & Co.]. [1939]. *Views of Paris: Loan Exhibition of Paintings*. Exh. cat. [New York?: n.p.]. Printed at Spiral Press, New York.

Kokuritsu Seiyo Bijutsukan. 1978. *Human Figures in Fine Arts: Boston Museum Exhibition*. Exh. cat. Tokyo: Nippon Television Network.

Költzsch, Georg-W., ed. 1998. *Paul Gauguin: Das verlorene Paradies*. Exh. cat. Cologne: DuMont; Essen: Museum Folkwang Essen; Berlin: Neue Nationalgalerie.

Költzsch, Georg-W., and Ronald de Leeuw. 1990. *Vincent van Gogh and the Modern Movement, 1890–1914*. Trans. from the original German by Eileen Martin. Ed. Inge Bodesohn-Vogel. Exh. cat. Freren: Luca.

Kornfeld, Eberhard W. 1988. *See* Mongan, Kornfeld, and Joachim 1988.

Kornfeld, Eberhard W., and Peter A. Wick. 1974. *Catalogue raisonné de l'oeuvre gravé et lithographié de Paul Signac*. Bern: Kornfeld & Klipstein.

Krexpel, J. 1891. "Les XX." *La Revue Blanche*, série belge, 2, no. 12 (March): 379–81.

Kunsthalle Basel. 1928. *Paul Gauguin, 1848–1903*. Exh. cat. [Basel: Kunsthalle Basel].

Kunsthalle Bern. [1958]. *Odilon Redon, 1840–1916*. Exh. cat. Bern: Kunsthalle Bern.

Kunsthalle Bremen. 1965. *Ker-Xavier Roussel: Gemälde, Handzeichnungen, Druckgraphik*. Exh. cat. Bremen: Kunsthalle Bremen.

Kunstverein in Hamburg. [1963]. *Wegbereiter der modernen Malerei: Cézanne, Gauguin, Van Gogh, Seurat*. Exh. cat. [Hamburg: Kunstverein?].

Küster, Bernd. 1992. *Monet: Seine Reisen in den Süden*. Hamburg: Ellert & Richter.

Kyoto Municipal Museum of Art, Kyoto Shimbun, and the Museum of Fine Arts, Boston. 1989. *Bosuton Bijutsukan ten: Jyūkyū seiki furansu kaiga no meisaku* (From Neoclassicism to Impressionism: French Paintings from the Museum of Fine Arts, Boston). Original text by Lucy MacClintock. Exh. cat. Kyoto: Kyoto Shimbun.

La Farge, John. 1903. "The Barbizon School." *McClure's Magazine* 21, no. 2 (June): 127–29.

———. 1908. *The Higher Life in Art: A Series of Lectures on the Barbizon School of France, Inaugurating the Scammon Course at the Art Institute of Chicago*. New York: McClure.

Lafond, Paul. 1918–19. *Degas*. 2 vols. Paris: H. Floury.

Lagrange, Léon. 1861. "Salon de 1861 (suite et fin.)" *Gazette des Beaux-Arts* 11 (August): 135–71.

Langdon, Helen. 1986. *Impressionist Seasons*. Oxford: Phaidon.

Lebon, Baudoin. 1999. *Louis Robert: L'Alchimie des images*. Paris: Baudoin Lebon and NBC éditions.

Lecaldano, Paolo, ed. 1977. *L'opera pittorica completa di Van Gogh e i suoi nessi grafici*. Introd. and ed. Paolo Lecaldano. Milan: Rizzoli.

Leclercq, J. 1891. "Aux Indépendants." *Mercure de France* (May): 298–300.

[Lecomte, Georges]. 1891. "Causerie." *L'Art dans les Deux Mondes* (April 4): 324.

Léger, Charles. 1929. *Courbet*. Paris: Les Editions G. Crès & Cie.

Leighton, John, et al. 1997. *Seurat and the Bathers*. Exh. cat. London: National Gallery.

Lemoisne, Paul-André. [1911?]. *Degas: Quarante-huit planches hors-texte. . . .* Series *L'Art de notre temps*. Paris: Librairie centrale des beaux-arts.

———. 1924. "Artistes contemporains: Edgar Degas, à propos d'une exposition récente." *Revue de l'Art* 46 (June–December): part 1, 17–28; part 2, 95–108.

———. 1946–49. *Degas et son oeuvre*. 4 vols. Paris: P. Brame et C. M. de Hauke, aux arts et métiers graphiques.

Le Pelley Fonteney, Monique. 1991. *Léon Augustin Lhermitte (1844–1925): Catalogue raisonné*. Paris: Editions Cercle d'Art.

Leroi, Paul. 1887. "Salon of 1887." *L'Art* 43, no. 2:3–42.

Leroy, Louis. 1874. "L'exposition des impressionnistes." *Le Charivari* (April 25).

Lerrant, Jean-Jacques. 1964. "Paul Signac à qui le Louvre consacre une rétrospective est un grand peintre français." *Le Progrès* (January 12): 13.

[Lespinasse, François]. 1982. *Charles Angrand, 1854–1926*. [Rouen: François Lespinasse].

Levine, Steven Z. 1994. *Monet, Narcissus, and Self-Reflection: The Modernist Myth of the Self*. Chicago: Univ. of Chicago Press.

Lewis, Mary Tompkins. 1989. *Cézanne's Early Imagery*. Berkeley, Calif.: Univ. of California Press.

Leymarie, Jean. 1951. *Van Gogh, par Jean Leymarie*. Paris: P. Tisne.

———. 1963. *Great Private Collections*. Ed. Douglas Cooper. New York: Macmillan.

———. 1966. *Corot: Biographical and Critical Study*. Trans. Stuart Gilbert. Geneva: Skira.

Lhôte, André. 1939. *Traité du paysage*. Paris: H. Floury.

———. 1958. *Traité du paysage et de la figure*. Paris: B. Grasset.

Liebermann, Max. 1918. *Degas*. Berlin: Bruno Cassirer.

Liepmannssohn, L., ed. 1870. *Exposition de 1791. Collection des livrets des anciennes expositions depuis 1673 jusqu'en 1800*, vol. 3, no. 36. Paris: Liepmannssohn & Dufour.

Lindsay, Jack. 1969. *Cézanne: His Life and Art*. [Greenwich, Conn.]: New York Graphic Society; London: Evelyn, Adams & MacKay.

Lipton, Eunice. 1986. *Looking into Degas: Uneasy Images of Women and Modern Life*. Berkeley, Calif., Los Angeles, and London: Univ. of California Press.

Los Angeles County Museum of Art (LACMA). 1955. *Pierre Auguste Renoir, 1841–1919: Paintings, Drawings, Prints, and Sculpture*. Exh. cat. Los Angeles: Los Angeles County Museum of Art.

———. [1958]. *An Exhibition of Works by Edgar Hilaire Germain Degas, 1834–1917*. Exh. cat. [Los Angeles: Los Angeles County Museum of Art].

Loyrette, Henri. 1988. "The Landscapes of 1869, Cat. Nos. 92–93." In *Degas*, by Jean Sutherland Boggs et al., 153–54. Exh. cat. New York: Metropolitan Museum of Art; Ottawa: National Gallery of Canada.

Loyrette, Henri, and Gary Tinterow. 1994. *Impressionnisme: Les origines, 1859–1869*. Exh. cat. Paris: Réunion des musées nationaux.

Lugt, Frits. 1921. *Les marques de collections de dessins et d'estampes*. Amsterdam: Vereenigde Drukkerijen. 1956. Supplement. The Hague: Martinus Nijhoff.

MacOrlan, Pierre. 1951. *Courbet*. Paris: Editions du dimanche.

Malingue, Maurice. 1943. *Claude Monet*. Monaco: Les documents d'art.

———. 1948. *Gauguin: Le peintre et son oeuvre*. Paris: Presses de la Cité.

Malraux, André. 1952. "Auvers vu par les peintres." *L'Amour de l'Art* 31, no. 64:13–16.

Mandel, Gabriele, ed. 1972. *L'opera completa di Gauguin*. Introd. by G. M. Sugana. Milan: Rizzoli.

Manoeuvre, Laurent. 1996. *Millet: Les saisons*. Paris: Herscher.

Manson, J. B. 1927. *The Life and Work of Edgar Degas*. London: Studio Limited.

Mantz, Paul. 1887. *Catalogue descriptif des peintures, aquarelles, pastels, dessins rehaussés, croquis et eaux-fortes de J.-F. Millet*. Exh. cat. Paris: Ecole des Beaux-Arts.

Marcel, Henry Camille. 1901. "Quelques lettres inédites de J.-F. Millet." *Gazette des Beaux-Arts*, 3d ser., 26, no. 529 (July): 69–78.

———. [1905]. *La peinture française au dix-neuvième siècle*. Paris: A. Picard & Kaan.

Marlborough Fine Arts. [1958a]. *La création de l'oeuvre chez Paul Signac*. Text by Paul Gay. Exh. cat. London: [Marlborough Fine Arts].

———. [1958b]. *Nineteenth- and Twentieth-Century European Masters: Paintings, Drawings, Sculpture*. Exh. cat. London: Marlborough Fine Arts.

Martindale, Meredith. 1990. *Lilla Cabot Perry: An American Impressionist*. Exh. cat. Washington, D.C.: National Museum of Women in the Arts.

Mason, Rainer Michael, et al. 1982. *Le cliché-verre: Corot et la gravure diaphane*. Exh. cat. Geneva: Cabinet des estampes, Musée d'art et d'histoire.

Masson, André, Grace Seiberling, and J. Patrice Marandel. 1975. *Paintings by Monet*. Ed. Susan Wise. Exh. cat. Chicago: Art Inst. of Chicago.

Mathews, Nancy Mowll, ed. 1996. *Cassatt: A Retrospective*. New York: Hugh Lauter Levin.

Mathews, Nancy Mowll, and Barbara Stern Shapiro. 1989. *Mary Cassatt: The Color Prints*. Exh. cat. New York: H. N. Abrams in assoc. with Williams College Museum of Art.

Matsuzakaya Art Museum. 1991. *World Impressionism and Pleinairism*. Exh. cat. in English and Japanese. [Tokyo?]: Chunichi Shimbun.

Mauclair, Camille. 1903. *The Great French Painters and the Evolution of French Painting from 1830 to the Present Day*. London: Duckworth.

———. 1928. *Henri Le Sidaner*. Paris: G. Petit.

———. 1937. *Degas*. Paris: Editions Hypérion.

Maurer, Naomi Margolis. 1998. *The Pursuit of Spiritual Wisdom: The Thought and Art of Vincent van Gogh and Paul Gauguin*. Madison, N.J.: Fairleigh Dickinson Univ. Press; London: Associated Univ. Presses in assoc. with Minneapolis Inst. of Arts.

[Maus, Octave]. 1891. "Courrier de Belgique." *L'Art dans les Deux Mondes* (March 21): 216.

McBride, Henry. 1937. "The Renoirs in America: In Appreciation of the Metropolitan Museum's Exhibition." *Art News* 35, no. 31 (May 1): 59–60, 158.

McMullen, Roy. 1984. *Degas: His Life, Times, and Work*. Boston: Houghton Mifflin.

Meier-Graefe, Julius. 1912. *Vincent van Gogh: Mit fünfzig Abbildungen und dem Faksimile eines Briefes*. Munich: R. Piper.

———. 1921a. *Courbet*. Munich: R. Piper.

———. 1921b. *Vincent van Gogh*. 2 vols. Munich: R. Piper.

———. 1923. *Degas*. Trans. J. Holroyd-Reece. London: E. Benn.

———. 1929. *Renoir*. Leipzig: Klinkhardt & Biermann.

Meixner, Laura L. 1982. *An International Episode: Millet, Monet, and Their American Counterparts*. Exh. cat. [Memphis]: Dixon Gallery & Gardens.

Mellerio, André. 1913. *Odilon Redon*. Paris: Société pour l'étude de la gravure française.

Melot, Michel. 1977. "La pratique d'un artiste: Pissarro graveur en 1880." *Histoire et Critique des Arts*, no. 2 (June): 16.

———. 1980. *Graphic Art of the Pre-Impressionists*. Trans. Robert Erich Wolf. New York: Harry N. Abrams.

Messer, Thomas M. 1960. *The Image Lost and Found . . . the Inaugural Exhibition Opening the New Gallery at the Metropolitan Boston Arts Center*. Exh. cat. Boston: Inst. of Contemporary Art.

The Metropolitan Museum of Art. 1937. *Renoir: A Special Exhibition of His Paintings*. Exh. cat. New York: Metropolitan Museum of Art and William Bradford.

———. 1978. *Monet's Years at Giverny: Beyond Impressionism*. Exh. cat. New York: Metropolitan Museum of Art.

———. 1980a. *After Daguerre: Masterworks of French Photography (1848–1900) from the Bibliothèque Nationale*. New York: Metropolitan Museum of Art in assoc. with Berger-Levrault, Paris.

———. 1980b. *The Painterly Print: Monotypes from the Seventeenth to Twentieth Century*. Exh. cat. New York: Metropolitan Museum of Art.

Meyerson, Ake. 1946. "Van Gogh and the School of Pont-Aven." *Konsthistorisk Tidskrift* 15 (December): 135–49.

Meynell, Everard. 1908. *Corot and His Friends*. London: Methuen.

M. H. de Young Memorial Museum. 1964. *Man: Glory, Jest, and Riddle; a Survey of the Human Form through the Ages*. Exh. cat. San Francisco: n.p.

Milner, Frank. 1991. *Monet*. London: Bison Books.

Milwaukee Art Institute. 1951. *Masters of Impressionism*. Exh. cat. Milwaukee: Milwaukee Art Inst.

Miquel, Pierre. 1980. *Eugène Isabey, 1803–1886: La marine au dix-neuvième siècle*. Maurs-la-Jolie: Martinelle.

Moderne Galerie Heinrich Thannhauser. 1916. *Katalog der modernen Galerie Heinrich Thannhauser in München*. Munich: Moderne Galerie Heinrich Thannhauser.

Moffett, Charles S. 1984. "Monet's Haystacks." In *Aspects of Monet: A Symposium on the Artist's Life and Times*, ed. John Rewald and Frances Weitzenhoffer, 140–60. New York: Harry Abrams.

Moffett, Charles S., et al. 1986. *The New Painting: Impressionism, 1874–1886*. San Francisco: Fine Arts Museums of San Francisco.

———. 1998. *Impressionists in Winter: Effets de Neige*. Exh. cat. Washington, D.C.: Phillips Collection in collab. with Philip Wilson Publ.

Mollett, John W. 1890. *The Painters of Barbizon: Millet, Rousseau, Diaz, Corot, Daubigny, Dupré*. London: S. Low, Marston, Searle & Rivington.

Mongan, Elizabeth, Eberhard W. Kornfeld, and Harold Joachim. 1988. *Paul Gauguin: Catalogue Raisonné of His Prints*. Bern: Galerie Kornfeld.

Montreal Museum of Fine Arts. 1942. *Loan Exhibition of Masterpieces of Painting . . . for the Benefit of the Men of the Merchant Navies. . . .* Exh. cat. Montreal: Montreal Museum of Fine Arts.

———. 1952. *Six Centuries of Landscape*. Exh. cat. Montreal: Montreal Museum of Fine Arts.

Moreau-Nélaton, Etienne. 1921. *Millet, raconté par lui-même. . . .* 3 vols. Paris: H. Laurens.

———. 1924. *Corot, raconté par lui-même*. Vol. 1. Paris: H. Laurens.

Morse, Anne Nishimura. 2001. "The Early Ukiyo-e Collection at the Museum of Fine Arts, Boston." In *The Dawn of the Floating World, 1650–1765: Early Ukiyo-e Treasures from the Museum of Fine Arts, Boston*, by Timothy Clark et al. Exh. cat. London: Royal Acad. of Arts.

Mothe, Alain. 1987. *Vincent van Gogh à Auvers-sur-Oise*. Paris: Valhermeil.

Murphy, Alexandra R. 1984. *Jean-François Millet*. Exh. cat. Boston: Museum of Fine Arts.

———. 1985. *European Paintings in the Museum of Fine Arts, Boston: An Illustrated Summary Catalogue*. Boston: Museum of Fine Arts.

Murphy, Alexandra R., and Lucretia H. Giese. 1977. *Monet Unveiled: A New Look at Boston's Paintings*. Exh. cat. Boston: Museum of Fine Arts.

———. 1985. *Monet in the Museum of Fine Arts, Boston*. Boston: Museum of Fine Arts.

Murphy, Alexandra R., et al. 1999. *Jean-François Millet: Drawn into the Light*. New Haven, Conn., and London: Yale Univ. Press.

Musée de l'Orangerie. [1937]. *Degas*. Exh. cat. Entries by Jaqueline Bouchot-Saupique and Marie Delaroche-Vernet. [Lille: L. Daniel].

———. 1949. *Gauguin: Exposition du centenaire*. Exh.cat. [Paris]: Editions des musées nationaux.

———. [1950]. *Eugène Carrière et le Symbolisme. Exposition en l'honneur du centenaire de la naissance d'Eugène Carrière*. Exh. cat. [Paris]: Editions des musées nationaux.

———. 1955. *De David à Toulouse-Lautrec: Chefs-d'oeuvre des collections américaines*. Exh. cat. Paris: [Presses artistiques].

———. 1999. *Monet: Le cycle des nymphéas*. Text by Pierre Georgel. Exh. cat. Paris: Réunion des musées nationaux.

Musée du Louvre. [1964]. *Signac*. Exh. cat. [Paris]: Ministère d'Etat, affaires culturelles.

Musée Rodin. [1989]. *Claude Monet–Auguste Rodin: Centenaire de l'exposition de 1889*. Exh. cat. Paris: Musée Rodin.

Museum of Art and Archaeology, University of Missouri, Columbia. 1990. *The Art of the July Monarchy: France, 1830 to 1848*. Exh. cat. Columbia, Mo.: Univ. of Missouri Press.

Museum of Fine Arts, Boston (MFA). 1902. *Museum of Fine Arts, Catalogue of Paintings and Drawings, with a Summary of Other Works of Art Exhibited on the Second Floor*. Boston: Museum of Fine Arts.

———. [1903]. *Museum of Fine Arts, Boston: Catalogue of Paintings on Exhibition*. Boston: Museum of Fine Arts.

———. 1906. "Picture Galleries Recent Loans." *Bulletin of the Museum of Fine Arts* (Boston) 4 (October–December): 34–35.

———. 1911. "Exhibition of Paintings by Claude Monet." Supplement in the *Bulletin of the Museum of Fine Arts* (Boston) 9 (August): 43.

———. 1916. "A Landscape by Corot: A Memorial Gift." *Bulletin of the Museum of Fine Arts* (Boston) 14, no. 81 (February): 4.

———. 1918a. *Quincy Adams Shaw Collection: Italian Renaissance Sculpture; Paintings and Pastels by Jean-François Millet*. Exh. cat. Boston: Museum of Fine Arts.

———. 1918b. "The Quincy Adams Shaw Collection." *Bulletin of the Museum of Fine Arts* (Boston) 16, no. 94 (April): 11–29.

———. 1919. "The Bequest of Alexander Cochrane." *Bulletin of the Museum of Fine Arts* (Boston) 17, no. 102 (August): 44–45.

———. 1920a. "The Gift of Miss Theodora Lyman." *Bulletin of the Museum of Fine Arts* (Boston) 18, no. 105 (February): 1–9.

———. 1920b. *Museum of Fine Arts, Boston, Forty-fourth Annual Report for the Year 1919*. Boston: Museum of Fine Arts.

———. 1921. *Catalogue of Paintings*. Boston: Museum of Fine Arts.

———. 1924. "Acquisitions, June 5 through July 17, 1924." *Bulletin of the Museum of Fine Arts* (Boston) 22, no. 132 (August): 35–36.

———. 1927. *Claude Monet: Memorial Exhibition*. Exh. cat. Boston: Museum of Fine Arts.

———. 1931. "Exhibition of French Paintings Lent by Mr. John T. Spaulding." *Bulletin of the Museum of Fine Arts* (Boston) 29, no. 173 (June): 53.

———. 1939. *Art in New England: Paintings, Drawings, and Prints, from Private Collections in New England*. Exh. cat. Boston: Museum of Fine Arts.

———. 1946a. "Acquisitions, September 13, 1945, through December 13, 1945." *Bulletin of the Museum of Fine Arts* (Boston) 44, no. 255 (February): 29–30.

———. 1946b. *Museum of Fine Arts, Boston: Seventieth Annual Report for the Year 1945*. Boston: Museum of Fine Arts.

———. 1948. *The Collections of John Taylor Spaulding, 1870–1948*. Exh. cat. Boston: Museum of Fine Arts.

———. 1955. *Summary Catalogue of European Paintings in Oil, Tempera, and Pastel*. Introd. by W. G. Constable. Boston: Museum of Fine Arts.

———. 1959. *A Memorial Exhibition of the Collection of the Honorable Alvan T. Fuller*. Exh. cat. Boston: Museum of Fine Arts.

———. 1970. *Centennial Acquisitions: Art Treasures for Tomorrow*. Boston: Museum of Fine Arts.

———. [1970]. *One Hundred Paintings from the Boston Museum*. Boston: Museum of Fine Arts.

———. 1973a. *Impressionism in the Collection of the Museum of Fine Arts, Boston: A Picture Book by the Department of Paintings*. Exh. cat. Boston: Museum of Fine Arts.

———. 1973b. *Impressionism in the Collection of the Museum of Fine Arts, Boston*. Boston: Museum of Fine Arts.

———. [1977]. *The Second Greatest Show on Earth: The Making of a Museum*. Exh. cat. Boston: Museum of Fine Arts.

———. 1980. *The Museum Year, 1979–1980*. Boston: Museum of Fine Arts.

———. 1986. *Masterpiece Paintings from the Museum of Fine Arts, Boston*. Boston: Museum of Fine Arts.

———. 1987. *Printmaking: The Evolving Image*. Boston: Museum of Fine Arts.

———. 1996. *Lithography's First Half Century: The Age of Goya and Delacroix; Artists' Lithographs in Europe, 1801–1851*. Exh. cat. Boston: Museum of Fine Arts.

Museum of Fine Arts of Houston. [1954]. *Paul Gauguin: His Place in the Meeting of East and West*. Exh. cat. Houston: Museum of Fine Arts of Houston.

Museum of Modern Art (MoMA). [1929]. *First Loan Exhibition: Cézanne, Gauguin, Seurat, Van Gogh*. [New York: Trustees of the Museum of Modern Art].

———. 1935. *Vincent van Gogh*. Ed. Alfred H. Barr, Jr. Exh. cat. New York: Museum of Modern Art.

———. 1961. *Odilon Redon, Gustave Moreau, Rodolphe Bresdin*. Exh. cat. New York: Museum of Modern Art.

———. 1968. *De Cézanne à Miró*. Exh. cat. New York: Museum of Modern Art.

Naeling, Bernard. 1984. "Vincent van Gogh: Der Herbst eines Lebens." *Pan* 9 (September).

Nagoya/Boston Museum of Fine Arts and the Museum of Fine Arts, Boston. 1999. *Mone, Runowāru to inshōha no fūkei* (Monet, Renoir, and the Impressionist Landscape). Exh. cat. Original texts written by George T. M. Shackelford, Fronia E. Wissman, and Makiko Yamada. Nagoya: Nagoya/Boston Museum of Fine Arts.

Nagoya City Art Museum. 1988. *Runowāru ten* (Renoir Retrospective). Exh. cat. in English and Japanese. Nagoya: Chunichi Shimbun.

Natanson, Thadée. 1951. *Le Bonnard que je propose, 1867–1947*. Geneva: P. Cailler.

National Academy of Design (U.S.). 1887. *Catalogue of Celebrated Paintings by Great French Masters, Brought to This Country from Paris for Exhibition Only. . . .* Exh. cat. New York: [National Academy of Design?].

National Gallery of Art. 1980. *Post-Impressionism: Cross-Currents in European and American Painting, 1880–1906*. Exh. cat. Washington, D.C.: National Gallery of Art.

National Gallery of Australia. 2001. *Monet and Japan*. Exh. cat. Canberra: National Gallery of Australia.

Néagu, Phillipe, and Françoise Heilbrun. 1983. "Baldus: Paysages, architectures." *Photographies*, no. 1 (October): 56–77.

Needham, Gerald. 1975. "Japanese Influence on French Painting, 1854–1910." In *Japonisme: Japanese Influence on French Art, 1854–1910*, by Gabriel P. Weisberg et al., 115–31. Exh. cat. Cleveland: Cleveland Museum of Art.

Nemeczek, Alfred. 1981. "Die letzten Wochen des Malers Van Gogh." *Art das Kunstmagazine*, no. 2 (February): 23–45.

Nippon Television Network Corporation. 1983. *Bosuton Bijutsukan ten: Runessansu kara inshōha made* (Masterpieces of European Painting from the Museum of Fine Arts, Boston). Original English text by Carol Troyen and Pamela S. Tabbaa. Exh. cat. [Tokyo]: Nippon Television.

Nippon Television Network Corporation and the Museum of Fine Arts, Boston. 1984. *Mire ten, Bosuton Bijutsukan zō* (Jean-François Millet Exhibition from the Museum of Fine Arts, Boston). Original texts written by Alexandra R. Murphy, Susan Fleming, and Heisaku Harada. Exh. cat. Tokyo: Nippon Television.

Nodier, Charles. 1844. *Journal de l'expédition des portes de fer.* Paris: Imprimerie Royale.

Noon, Patrick. 1991. *Richard Parkes Bonington—On the Pleasure of Painting.* Exh. cat. New Haven, Conn.: Yale Center for British Art.

Norelli, Martina Roudabush. 1988. "The Watercolors of Antoine-Louis Barye." In *Antoine-Louis Barye: The Corcoran Collection,* by Lilien F. Robinson and Edward J. Nygren et al., 61–65. Exh. cat. Washington, D.C.: Corcoran Gallery of Art.

Norfolk Museum of Arts and Sciences. 1941. *French Impressionists: Spring Exhibition.* Exh. cat. Raleigh, N.C.: Norfolk Museum of Arts and Sciences.

North Carolina Museum of Art (NCMA). 1956. *French Painting of the Last Half of the Nineteenth Century.* Exh. cat. Raleigh, N.C.: North Carolina Museum of Art.

Novotny, Fritz. [1937]. *Cézanne.* Vienna: Phaidon-Verlag.

———. 1960. *Painting and Sculpture in Europe, 1780–1880.* Baltimore: Penguin.

———. 1971. *Painting and Sculpture in Europe, 1780–1880.* 2d ed. New Haven, Conn.: Yale Univ. Press.

Ordrupgaardsamlingen. 1979. *Monet i Giverny, 1883–1926.* Exh. cat. Copenhagen: Ordrupgaardsamlingen.

Orr, Lynn Federle, Paul Hayes Tucker, and Elizabeth Murray. 1994. *Monet: Late Paintings of Giverny from the Musée Marmottan.* Exh. cat. New Orleans: New Orleans Museum of Art; San Francisco: Fine Arts Museums of San Francisco in assoc. with H. N. Abrams.

Ortwin-Rave, P. 1945. *Die Malerei des 19. Jahrhunderts.* Berlin: n.p.

Palace of Fine Arts. 1940. *Art; Official Catalogue.* Exh. cat. for the Golden Gate International Exposition. [San Francisco: Recorder Printing & Publishing/H. S. Crocker].

Palais National des Arts. 1937. *Chefs-d'oeuvre de l'art français.* Exh. cat. Paris: Palais National des Arts.

Paul Rosenberg & Co. 1948. *Loan Exhibition of Twenty-One Masterpieces by Seven Great Masters.* Exh. cat. New York: [Paul Rosenberg & Co.].

———. 1950. *The Nineteenth Century Heritage.* Exh. cat. New York: Paul Rosenberg & Co.

———. 1957. *A Loan Exhibition of Nineteenth- and Twentieth-Century French Paintings: "Masterpieces Recalled" for the Benefit of the League for Emotionally Disturbed Children, Inc.* Exh. cat. New York: Paul Rosenberg & Co.

Peacock, Netta. 1905. *Millet.* London: Methuen.

Perry, Lilla Cabot. 1927. "Reminiscences of Claude Monet from 1889 to 1909." *The American Magazine of Art* 18, no. 3 (March): 119–25.

Petrie, Brian. 1979. *Claude Monet: The First of the Impressionists.* Oxford: Phaidon; New York: Dutton.

Philadelphia Museum of Art (PMA). 1936. *Degas, 1834–1917.* Exh. cat. Philadelphia: Philadelphia Museum of Art.

———. 1946. *Corot, 1796–1875.* Exh. cat. with entries by Lionello Venturi. Philadelphia: Philadelphia Museum of Art.

———. 1959. *Gustave Courbet.* Exh. cat. Philadelphia: Philadelphia Museum of Art.

———. 1978. *The Second Empire, 1852–1870: Art in France under Napoleon III.* Philadelphia: Philadelphia Museum of Art.

Phoenix Art Museum. 1961. *One Hundred Years of French Painting, 1860–1960.* Exh. cat. Phoenix: Phoenix Art Museum.

Pickvance, Ronald. 1963. "Degas's Dancers, 1872–76." *Burlington Magazine* 105, no. 723 (June): 256–57.

———. 2001. *Corot: El parque de los leones en Port-Marly, 1872.* Exh. cat. Madrid: Museo Thyssen-Bornemisza.

Piedagnel, Alexandre. 1876. *J.-F. Millet: Souvenirs de Barbizon.* Paris: Vve A. Cadart.

Pindar. [1915] 1946. *The Odes of Pindar.* Trans. Sir John Sandys. Reprint, Cambridge, Mass.: Harvard Univ. Press.

Pissarro, Camille. 1980–91. *Correspondance de Camille Pissarro.* Ed. Janine Bailly-Herzberg. 5 vols. Paris: Presses Universitaire de France.

Pissarro, Joachim. 1997. *Monet and the Mediterranean.* Exh. cat. New York: Rizzoli in assoc. with Kimbell Art Museum, Fort Worth, Tex.

Pissarro, Joachim, and Stephanie Rachum. 1995. *Camille Pissarro: Impressionist Innovator.* Exh. cat. Jerusalem: Israel Museum.

Pissarro, Ludovico R., and Lionello Venturi. 1939. *Camille Pissarro, son art—son oeuvre.* Paris: P. Rosenberg.

Pollock, Griselda. 1977. *Millet.* London: Oresko Books.

Pope, Arthur. 1930. "French Paintings in the Collection of John T. Spaulding." *Art News* 28, no. 30 (April 26): 97–128.

Porat, Efrat Adler. 1994. "Dennis Miller Bunker: A Chronology of His Life and Work." In *Dennis Miller Bunker: American Impressionist,* by Erica E. Hirshler and David Park Curry et al., 167–79. Exh. cat. Boston: Museum of Fine Arts.

Potterton, Homer. 1991. "Corot to Monet." Exhibition review in *Apollo* (July): 47–48.

Poulet, Anne L., and Alexandra R. Murphy. 1979. *Corot to Braque: French Paintings from the Museum of Fine Arts, Boston.* Exh. cat. Boston: Museum of Fine Arts.

Prather, Marla, and Charles S. Stuckey, eds. 1987. *Gauguin: A Retrospective.* New York: Hugh Lauter Levin.

Préaud, Maxime. 2000. *Rodolphe Bresdin, 1822–1885: Robinson graveur.* Exh. cat. Paris: Bibliothèque nationale de France.

Preutu, Marina. 1974. *Pissarro: Monografie.* Bucharest: Meridiane.

"Principales acquisitions des musées en 1980." 1981. *La Chronique des Arts,* supplement to the *Gazette des Beaux-Arts,* no. 1346 (March): 1–76.

Pyle, Hilary. 1986. *Jack B. Yeats in the National Gallery of Ireland.* Dublin: National Gallery of Ireland.

Rabinow, Rebecca A. 2000. "Modern Art Comes to the Metropolitan: The 1921 Exhibition of 'Impressionist and Post-Impressionist Paintings.'" *Apollo* 152, no. 464 (October): 3–12.

Ramade, Patrick. 1986. "Theodore Caruelle d'Aligny: Dessins du première séjour italien (1822–1827)." *La Revue du Louvre et des Musées de France,* no. 2 (April): 121–30.

Rapetti, Rodolphe. 1990. *Monet.* New York: Arch Cape.

Ratcliff, Floyd. 1992. *Paul Signac and Color in Neo-Impressionism.* New York: Rockefeller Univ. Press.

Rathbone, Eliza E., and George T. M. Shackelford. 2001. *Impressionist Still Life.* Exh. cat. Essays by Jeannene M. Przybylski, John McCoubrey, and Richard Shiff. New York: Harry N. Abrams in assoc. with the Phillips Collection.

Rathbone, Eliza E., et al. 1996. *Impressionists on the Seine: A Celebration of Renoir's "Luncheon of the Boating Party."* Exh. cat. Washington, D.C.: Counterpoint in assoc. with the Phillips Collection.

Raynal, Maurice. 1922. "Renoir Nachlass." *Der Cicerone* (July): 603–4.

———. 1954. *Cézanne: Biographical and Critical Studies.* Trans. James Emmons. Geneva: Skira.

Redon, Odilon. 1869. "Rodolphe Bresdin, dessins sur pierre, eaux-fortes, dessins originaux." *La Gironde* (January 10): 2.

———. 1986. *To Myself: Notes on Life, Art, and Artists.* Trans. Mira Jacob and Jeanne L. Wasserman. New York: George Braziller.

Reed, Sue Welsh, and Barbara Stern Shapiro. 1984. *Edgar Degas: The Painter as Printmaker*. Exh. cat. Boston: Museum of Fine Arts, Boston.

Reff, Theodore. 1982. *Manet and Modern Paris: One Hundred Paintings, Drawings, Prints, and Photographs by Manet and His Contemporaries*. Exh. cat. Washington, D.C.: National Gallery of Art.

Reidemeister, Leopold. 1963. *Auf den Spuren der Maler der Ile de France*. Exh. cat. Berlin: Propyläen Verlag.

Reilly, James M. 1986. *Care and Identification of Nineteenth-Century Photographic Prints*. Rochester, N.Y.: Eastman Kodak Co.

Renoir, Auguste. 1990. *Renoir by Renoir*. Ed. Rachel Barnes. New York: Knopf.

Rette, Adolph. 1891. "Septième exposition des artistes indépendants." *L'Ermitage* 2 (May): 293–301.

Reuterswärd, Oscar. 1948. *Monet: En konstnärshistorik*. Stockholm: A. Bonnier.

"Revue des ventes. Collection Léon Orosdi." 1923. *Le Journal des Arts* (May 26): 2–3.

Rewald, John. 1946. *The History of Impressionism*. New York: Museum of Modern Art.

———. [1954]. *Camille Pissarro (1830–1903)*. New York: Abrams in assoc. with Pocket Books.

———. 1956. *Post-Impressionism: From Van Gogh to Gauguin*. New York: Museum of Modern Art.

———. [1961]. *The History of Impressionism*. Rev. ed. New York: Museum of Modern Art.

———. 1963. *Camille Pissarro*. New York: H. N. Abrams.

———. 1971. *Cézanne: An Exhibition in Honor of the Fiftieth Anniversary of the Phillips Collection*. Exh. cat. Boston: Museum of Fine Arts.

———. 1973a. *The History of Impressionism*. 4th rev. ed. New York: Museum of Modern Art.

———. 1973b. "Théo van Gogh, Goupil, and the Impressionists." *Gazette des Beaux-Arts* (January–February): 2–64, 65–108.

———. 1973–74. "The Impressionist Brush." *Metropolitan Museum of Art Bulletin* 32, no. 3 (January–February): 52.

———. 1978. *Post-Impressionism: From Van Gogh to Gauguin*. 3d ed. New York: Museum of Modern Art.

Rewald, John, with Walter Feilchenfeldt and Jayne Warman. 1996. *The Paintings of Paul Cézanne: A Catalogue Raisonné*. New York: H. N. Abrams.

Rewald, John, and Frances Weitzenhoffer, eds. 1984. *Aspects of Monet: A Symposium on the Artist's Life and Times*. New York: H. N. Abrams.

Rich, Daniel Catton. 1951. *Edgar-Hilaire-Germain Degas*. New York: H. N. Abrams.

Rilke, Rainer Maria. 1985. *Letters on Cézanne*. Ed. Clara Rilke. Trans. Joel Agee. New York: Fromm International.

Rivière, Georges. 1935. *Mr. Degas, bourgeois de Paris*. Paris: H. Floury.

Robaut, Alfred. 1881. "Corot." *Camées Artistiques* 188, nos. 2, 5 and note 3. [Paris]: n.p.

Robaut, Alfred, and Etienne Moreau-Nélaton. 1905. *L'oeuvre de Corot: Catalogue raisonné et illustré*. Vols. 1, 2, and 4. Paris: H. Floury.

Rodee, Howard. 1974. "Constant Troyon—Head of a Hound." In *Bulletin* (University Art Museum, Univ. of New Mexico), no. 8:16–17.

Roger-Marx, Claude. 1933. "Paul Signac. Ch. 2: Le néo-impressionisme." *L'Amour de l'Art*, no. 2 (February): 36–38.

———. [1947]. *Avant la destruction d'un monde: De Delacroix à Picasso*. Paris: Plon.

———. 1963. "Signac le marin magicien méthodique." *Le Figaro Littéraire* (December 12–18): 20.

———. 1990. *The Graphic Work of Edouard Vuillard*. Trans. Susan Fargo Gilchrist. Reprint, San Francisco: A. Wofsy Fine Arts.

Roger-Milès, Léon. 1896. *Album classique des chefs-d'oeuvre de Corot*. Paris: Braun Clement & Cie.

———. 1920. *La collection Ferdinand Blumenthal*. Paris: n.p.

Rolland, Romain. 1902. *Millet*. London: Duckworth; New York: E. P. Dutton.

Rosenblum, Robert. 1989. *Paintings in the Musée d'Orsay*. New York: Stewart, Tabori & Chang.

Rosenthal, Donald A. 1982. *Orientalism: The Near East in French Painting, 1800–1880*. Exh. cat. Rochester, N.Y.: Memorial Art Gallery of Univ. of Rochester.

Roskill, Mark. [1970]. *Van Gogh, Gauguin, and the Impressionist Circle*. Greenwich, Conn.: New York Graphic Society.

Rostrup, Haavard. 1956. "Gauguin et le Danemark." *Gazette des Beaux-Arts*, 6th ser., 47, no. 1044:63–82.

Roth, Michael S., ed. 1994. *Rediscovering History: Culture, Politics, and the Psyche*. Stanford, Calif.: Stanford Univ. Press.

Rouart, Denis. [1958]. *Claude Monet*. Introd. and conclusion by Léon Degand. Geneva: Skira.

———. [1990]. *Monet*. Renens-Lausanne: Nathan.

Rouart, Denis, et al. 1972. *Monet, nymphéas: Ou, les miroirs du temps*. Paris: F. Hazan.

Royal Academy of Arts. 1979. *Post-Impressionism: Cross-Currents in European Painting*. Ed. John House and MaryAnne Stevens. Exh. cat. New York: Harper & Row.

Russell, H. Diane. 1972. *Rare Etchings by Giovanni Battista and Giovanni Domenico Tiepolo*. Exh. cat. Washington, D.C.: National Gallery of Art.

Russell, John. 1958. "This Summer in London: Signac." *Art News* (summer): 39.

Russoli, Franco, and Fiorella Minervino. 1970. *L'opera completa di Degas*. Milan: Rizzoli.

Sagner-Düchting, Karen. 1990. *Claude Monet, 1840–1926: Ein Fest für die Augen*. Cologne: Benedikt Taschen.

Salomon, Jacques. 1968. *See* Alain 1968.

Roger-Milès, Léon. 1896. *Album classique des chefs-d'oeuvre de Corot*. Paris: Braun Clement & Cie.

"Salon de 1844. Les Coloristes MM Couture, Diaz, Muller, Baron, Lemud, Saint Jean." 1844. *Le Charivari*, no. 84 (March 24): 1–2.

Sarradin, Edouard. 1936. "Le Salon des Indépendants." *Le Journal de Débats* (February 7): 3.

Scharf, Aaron. 1962. "Painting, Photography, and the Image of Movement." *Burlington Magazine* 104, no. 710 (May): 186–95.

———. 1968. *Art and Photography*. London: Allen Lane, Penguin Press.

Scheffler, Karl. 1921. "Die Sammlung O. Schmitz in Dresden." *Kunst und Künstler* 19 (February): 178–86.

Scherjon, W. 1932. *Catalogue des tableaux par Vincent van Gogh décrits dans ses letters. Périodes: Saint-Rémy et Auvers-sur-Oise*. Utrecht: A. Oosthoek.

Scherjon, W., and Joseph De Gruyter. 1937. *Van Gogh's Great Period: Arles, St. Rémy, Auvers-sur-Oise*. 2 vols. Amsterdam: De Spieghel.

Schmit, Robert. 1973. *Eugène Boudin, 1824–1898*. Paris: Schmit.

Schmitz, Oscar. 1936. *La Collection Oscar Schmitz: Chefs-d'oeuvre de la peinture française du dix-neuvième siècle*. Exh. cat. Paris: Wildenstein & Co.

Schneider, Bruno F. 1984. *Renoir*. New York: Crown.

Schneider, Cynthia P. 1985. "Renoir: Le peintre de figures comme paysagiste." *Apollo* 122, no. 281 (July): 49–56.

Secrétan, E. 1889. *Catalogue de tableaux anciens et modernes, aquarelles et dessins et objets d'art formant la . . . collection de . . . E. Secrétan. . . .* Paris: [A. Lahure].

Seiberling, Grace. 1981. *Monet's Series*. New York: Garland.

Seitz, William C. 1956. "Monet and Abstract Painting." *College Art Journal* 16, no. 1 (1956): 34–46.

———. 1960. *Claude Monet: Seasons and Moments*. Exh. cat. Garden City, N.Y.: Museum of Modern Art in collab. with Los Angeles County Museum.

———. 1982. *Monet: Twenty-Five Master-works*. New York: Abrams.

Sensier, Alfred, and Paul Mantz. 1881. *La vie et l'oeuvre de J.-F. Millet*. Paris: A. Quantin.

Shackelford, George T. M. 1984. *Degas: The Dancers*. Exh. cat. Washington, D.C.: National Gallery of Art.

Shackelford, George T. M., and Fronia E. Wissman. 2000. *Monet, Renoir, and the Impressionist Landscape*. Exh. cat. Ottawa: National Gallery of Canada; Boston: Museum of Fine Arts.

Shapiro, Barbara Stern. 1973. *Camille Pissarro: The Impressionist Printmaker*. Exh. cat. Boston: Museum of Fine Arts.

———. [1974]. *Edgar Degas: The Reluctant Impressionist*. Exh. cat. Boston: Museum of Fine Arts.

———. 1980. "Pissarro as Print-Maker." In *Pissarro: Camille Pissarro, 1830–1903*, by Richard R. Brettell et al., 191–234. Exh. cat. London: Arts Council of Great Britain; Boston: Museum of Fine Arts.

———. 1997. "A Printmaking Encounter." In *The Private Collection of Edgar Degas*, by Ann Dumas et al., 244. Exh. cat. New York: Metropolitan Museum of Art.

Shapiro, Barbara Stern, et al. 1991. *Pleasures of Paris: Daumier to Picasso*. Exh. cat. Boston: Museum of Fine Arts.

Shiff, Richard. 1984. *Cézanne and the End of Impressionism: A Study of the Theory, Technique, and Critical Evaluation of Modern Art*. Chicago: Univ. of Chicago Press.

Shinoda, Yujiro. 1957. *Degas: Der Einzug des Japanischen in die französische Malerei*. [Tokyo: Toppan-Druckerei].

Shone, Richard. 1979. *Sisley*. Oxford: Phaidon.

Sickert, Bernhard. 1905. "The Pre-Raphaelite and Impressionist Heresies." *Burlington Magazine* 7, no. 26 (May): 97–111.

Silverman, Debora. 1994. "Weaving Paintings: Religious and Social Origins of Vincent van Gogh's Pictorial Labor." In *Rediscovering History: Culture, Politics, and the Psyche*, ed. Michael S. Roth, 137–68, 465–73. Stanford, Calif.: Stanford Univ. Press, 1994.

Silvestre, Armand. 1874. "Chronique des beaux-arts: Physiologie du refusé—l'exposition des révoltés." *L'Opinion Nationale* (April 22).

Silvestre, Théophile. 1856. *Histoire des artistes vivants français et étrangers: Etudes d'après nature*. Paris: E. Blanchard

———. 1875. Notes on *Catalogue des dessins de Millet provenant de la collection de M. G.* (Paris: Renou, Maulde & Cock), annotated catalogue in the Department of Art of Europe's curatorial object file 17.1525, Museum of Fine Arts, Boston.

———. 1878. *Les artistes français*. Paris: G. Charpentier.

Simpson, Lisa A. 1987. *From Arcadia to Barbizon: A Journey in French Landscape Painting*. Exh. cat. Memphis: Dixon Gallery & Garden.

Simpson, Marc. 1993. "Reconstructing the Golden Age: American Artists in Broadway, Worcestershire, 1885 to 1889." 3 vols. Ph.D. diss., Yale Univ.

Smith, Paul. [1994]. *Impressionism: Beneath the Surface*. New York: Harry N. Abrams.

Society of the Four Arts. [1961]. *Paintings in the Collection of Alvan T. Fuller: Lent by the Trustees of the Alvan T. Fuller Foundation, Twenty-Fifth Anniversary Exhibition*. Exh. cat. [Palm Beach, Fla.: Society of the Four Arts].

Sogo Museum of Art and the Museum of Fine Arts, Boston (MFA). 1992. *Bosuton Bijutsukan no shihō: Jyūkyū seiki yōroppa no kyoshō* (The Real World: Nineteenth-Century European Paintings from the Museum of Fine Arts, Boston). Original English text written by Anna Piussi, Eric M. Zafran, et al. Exh. cat. Yokohama: Sogo Museum of Art.

Soullié, Louis. 1900a. *Les grands peintres aux ventes publiques: Constant Troyon*. Paris: L. Soullié.

———. 1900b. *Peintures, aquarelles pastels, dessins de Jean-François Millet relevés dans les catalogues de ventes de 1849 à 1900*. Paris: L. Soullié.

Southgate, Therese M. 1979. Editorial on the cover frontispiece in the *Journal of the American Medical Association* (JAMA) 242, no. 22 (November 30): 2375.

Springfield Museum of Fine Arts. 1948. *The Springfield Museum of Fine Arts Presents a Special Loan Exhibition of Fifteen Fine Paintings in Honor of the Fifteenth Anniversary of the Opening of the Museum on October Seventh, 1933*. Exh. cat. [Springfield, Mass.: Springfield Museum of Fine Arts].

———. 1950. *In Freedom's Search: An Exhibition of Works by Courbet, Degas, Cézanne . . . [et al.]*. Exh. cat. Springfield, Mass.: Springfield Museum of Fine Arts.

Staatliche Museen Preussischer Kulturbesitz. [1963]. *Die Ile de France und ihre Maler*. Exh. cat. [Berlin]: Druckhaus Templehof.

Staatsgalerie, Stuttgart. 1996. *Eugène Cuvelier*. Exh. cat. Ostfildern-Ruit: Cantz.

St. Botolph Club. [1899]. *Loan Exhibition of Pictures by Claude Monet*. Exh. cat. [Boston: St. Botolph Club?].

Stechow, Wolfgang. 1981. *Dutch Landscape Painting of the Seventeenth Century*. London: Phaidon, 1966; reprint, Ithaca, N.Y.: Cornell Univ. Press.

Stedelijk Museum. [1938]. *Honderd jaar Fransche kunst*. Exh. cat. Amsterdam: [Druk de Bussy].

Stein, Susan Alyson, ed. 1986. *Van Gogh: A Retrospective*. New York: Hugh Lauter Levin.

Sterling, Charles, and Hélène Adhémar. 1958–61. *Peintures: Ecole française, dix-neuvième siècle* (Musée du Louvre). 4 vols. Paris: Editions des musées nationaux.

Stevens, MaryAnne. 1985. "London: Renoir at the Hayward." *Burlington Magazine* 127, no. 986 (May): 314–18.

———, ed. 1984. *The Orientalists: Delacroix to Matisse; the Allure of North Africa and the Near East*. Exh. cat. Washington, D.C.: National Gallery of Art.

Stevens, MaryAnne, and Isabelle Cahn. 1992. *Alfred Sisley*. Exh. cat. London: Royal Academy of Arts in assoc. with Yale Univ. Press, New Haven, Conn.

Strahan, Edward [Earl Shinn]. 1879. *Art Treasures of America*. Vol. 3. Philadelphia: George Barrie.

Stranahan, Clara Harrison. 1888. *History of French Painting: From Its Earliest to Its Latest Practice*. New York: C. Scribner's Sons.

Strick, Jeremy. 1996. "Nature Studied and Nature Remembered: The Oil Sketch in the Theory of Pierre-Henri de Valenciennes." In *In the Light of Italy: Corot and Early Open-Air Painting*, by Philip Conisbee et al., 79–87. Exh. cat. Washington, D.C.: National Gallery of Art.

Stuckey, Charles F. 1988. "The Impressionist Years." In *The Art of Paul Gauguin*, by Richard R. Brettell et al., 11–16. Exh. cat. Washington, D.C.: National Gallery of Art.

———. 1995. *Claude Monet, 1840–1926*. Exh. cat. New York: Thames and Hudson; Chicago: Art Inst. of Chicago.

———, ed. 1985. *Monet: A Retrospective*. New York: H. L. Levin.

Sutton, Denys. 1975. "The Centenary of Impressionism." *Apollo* (January): 2–8.

———. 1978. "Editorial: Monet at Giverny." *Apollo* 108, no. 198 (August): 85–89.

———. 1984. "Degas: Master of the Horse." *Apollo* 119, no. 266 (April): 282–93.

———. 1986. *Edgar Degas: Life and Work*. New York: Rizzoli.

Sutton, Peter C. 1987. *Masters of Seventeenth-Century Dutch Landscape Painting*. Exh. cat. Boston: Museum of Fine Arts.

———. 1991. *Eugène Boudin: Impressionist Marine Painting*. Exh. cat. Salem, Mass.: Peabody Museum of Salem.

———. 1995. *The William Appleton Coolidge Collection*. Boston: Museum of Fine Arts.

Szarkowski, John. 2000. *Atget*. New York: Museum of Modern Art.

Szarkowski, John, and Maria Morris Hambourg. 1983. *The Work of Atget: The Ancien Régime*. Vol. 3. Exh. cat. New York: Museum of Modern Art.

T. [Tabarant, Adolphe]. 1923. "La curiosité: Léon Orosdi." *Le Bulletin de la Vie Artistique* (February 15): 89.

Tabarant, Adolphe. 1942. *La vie artistique au temps de Baudelaire*. Paris: Mercure de France.

Taft Museum. 1995. *The Taft Museum: Its History and Collections*. 2 vols. New York: Hudson Hills Press.

Tapié, Alain. 1998. *Chemins de l'impressionnisme: Normandy-Paris, 1860–1910*. Exh. cat. Graz: Landesmuseum Joanneum.

The Tate Gallery. [1957]. *Claude Monet*. Entries by Douglas Cooper and John Richardson. Exh. cat. London: Tate Gallery.

Teilhet, Jehanne, ed. [1973]. *Dimensions of Polynesia*. Exh. cat. [San Diego: Univ. of California?].

Thiébault-Sisson, François. 1900. "Claude Monet par lui-même." *Le Temps* (November 6).

———, ed. 1918. "L'homme et l'oeuvre." *Le Temps* (May 18).

Thieme, Ulrich, and Felix Becker, eds. 1933. *Allgemeines Lexikon des bildenden Künstler von der Antike bis zur Gegenwart*. Leipzig: E. A. Seeman.

Thomas, David. 1980. *Renoir*. London: Medici Society.

Thomas, Greg M. 1999. "The Practice of 'Naturalism': The Working Methods of Théodore Rousseau." In *Barbizon: Malerei der Natur—Natur der Malerei*, ed. Andreas Burmester, Christoph Heilmann, and Michael F. Zimmermann, 139–52. Munich: Klinkhardt & Biermann.

———. 2000. *Art and Ecology in Nineteenth-Century France: The Landscapes of Théodore Rousseau*. Princeton, N.J.: Princeton Univ. Press.

Thomson, Belinda. 1988. *Vuillard*. New York: Abbeville.

Thomson, Richard. 1990. *Camille Pissarro: Impressionism, Landscape, and Rural Labour*. Exh. cat. London: South Bank Centre, Herbert.

———. 1994. *Monet to Matisse: Landscape Painting in France, 1874–1914*. Exh. cat. Edinburgh: National Galleries of Scotland.

Thoré, Théophile. 1844. "Salon of 1844." Trans. in *The Triumph of Art for the Public: The Emerging Role of Exhibitions and Critics*, ed. Elizabeth Gilmore Holt. Garden City, N.Y.: Anchor.

Thurwanger, Camille. 1892. "'Corot,' His Life and Character, by His Godson." *New England Magazine* 5, no. 6 (February): 691–716.

Tinterow, Gary, and Henri Loyrette. 1994. *Impressionisme: Les origines* (Origins of Impressionism). Exh. cat. New York: Metropolitan Museum of Art.

Tinterow, Gary, Michael Pantazzi, and Vincent Pomarède. 1996. *Corot*. Exh. cat. New York: Metropolitan Museum of Art.

Tobu Bijutsukan. 1996. *Inshōha wa kōshite umareta: Akademisumu kara Kurube, Mane, Mone, Runowāru* (The Birth of Impressionism). Exh. cat. [Tokyo]: Tobu Bijutsukan.

Tokyo Shimbun. 1987. *Gōgyan ten* (Paul Gauguin). Exh. cat. Tokyo: Tokyo Shimbun.

Toledo Museum of Art. [1946]. *The Spirit of Modern France: An Essay on Painting in Society, 1745–1946*. Exh. cat. [Toronto: Art Gallery of Toronto].

Tomson, Arthur. 1903. *Jean-François Millet and the Barbizon School*. London: George Bell and Sons, 1903.

Trillat, J. J., et al. 1979. *Les trésors de la Société française de photographie*. Exh. cat. Paris: Société française de photographie.

Troyen, Carol, and Pamela S. Tabbaa. 1984. *The Great Boston Collectors: Paintings from the Museum of Fine Arts*. Exh. cat. Boston: Museum of Fine Arts, Boston.

Trumble, Alfred, ed. 1890. "A Boon for Cazin." *Collector* 1, no. 16 (July 1): 131.

———. 1893. "Cazin in America." *Collector* 4, no. 19 (October): 299–300.

Tucker, Paul Hayes. 1982. *Monet at Argenteuil*. New Haven, Conn.: Yale Univ. Press.

———. 1989. *Monet in the '90s: The Series Paintings*. Exh. cat. Boston: Museum of Fine Arts in assoc. with Yale Univ. Press.

———. 1990. *Monet: Le triomphe de la lumière*. Paris: Flammarion.

———. 1995. *Claude Monet: Life and Art*. New Haven: Yale Univ. Press.

Tucker, Paul Hayes, Katsunori Fukaya, and Katsumi Miyazaki. 1994. *Monet: A Retrospective*. Exh. cat. Nagoya: Chunichi Shimbun.

Tucker, Paul Hayes, et al. 1998. *Monet in the Twentieth Century*. Exh. cat. Boston: Museum of Fine Arts; London: Royal Academy of Arts.

Turpin, Georges. 1934. "Le Salon des Indépendants. La peinture." *La Vie Contemporaine*, no. 2 (February): 3.

University of Iowa, Gallery of Art. [1964]. *Impressionism and Its Roots*. Exh. cat. Iowa City: University of Iowa, Gallery of Art.

Updike, John. 1989. *Just Looking: Essays on Art*. New York: Knopf.

Valenciennes, Pierre-Henri. 1800. *Eléments de perspective pratique à l'usage des artistes; suivis de la réflexions et conseils à un élève sur la peinture et particulièrement sur le genre du paysage*. Paris: Desenne.

Van der Marck, Jan. [1984]. *In Quest of Excellence: Civic Pride, Patronage, Connoisseurship*. Exh. cat. Miami: Center for the Fine Arts.

Van Dovski, Lee. 1950. *Gauguin*. Olten and Bern: Delphi-Verlag.

Van Gelder, Dirk. 1976. *Rodolphe Bresdin: Monographie et catalogue raisonné de l'oeuvre gravé*. 2 vols. The Hague: Martinus Nijhoff.

Van Gogh, Vincent. 1927. *The Letters of Vincent van Gogh to His Brother, 1872–1886*. 3 vols. London: Constable; Boston and New York: Houghton Mifflin.

———. 1929. *Further Letters of Vincent van Gogh to His Brother, 1886–1889*. London: Constable; Boston: Houghton Mifflin.

———. 1938. *Letters to Emile Bernard*. Ed., trans., and with a foreword by Douglas Lord. London: Cresset.

———. 1958. *The Complete Letters of Vincent van Gogh*. 3 vols. Greenwich, Conn.: New York Graphic Society.

———. 1966. *The Complete Letters of Vincent van Gogh*. Introd. by V. W. van Gogh. Preface and memoir by Mrs. Johanna van Gogh-Bonger. 3 vols. Greenwich, Conn.: New York Graphic Society.

———. 1985. *Vincent by Himself: A Selection of His Paintings and Drawings Together with Extracts from His Letters*. Ed. Bruce Bernard. London: Orbis.

———. 2000. *The Complete Letters of Vincent van Gogh*. 3d ed. 3 vols. Boston: Bullfinch.

Van Rensselaer, Mrs. Schuyler [Mariana Griswold]. 1889a. "Corot." *Century Magazine* 38, no. 2 (June): 255–71.

———. 1889b. *Six Portraits: Della Robbia, Correggio, Blake, Corot, George Fuller, Winslow Homer*. Boston: Houghton Mifflin; Cambridge, Mass.: Riverside.

Vauxcelles, Louis. 1922. "Claude Monet." *L'Amour de l'Art* (August): 230–36.

"Vente E. May." 1890. *La Chronique des Arts*, no. 23 (June 7): 179.

Venturi, Lionello. 1936. *Cézanne: Son art, son oeuvre*. Paris: P. Rosenberg.

———. 1939. *Les archives de l'Impressionnisme. Lettres de Renoir, Monet, Pissarro, Sisley et autres. Mémoires de Paul Durand-Ruel. Documents*. Ed. Durand-Ruel & Cie. Paris and New York: Durand-Ruel.

———. 1978. *Cézanne*. Geneva: Editions d'Art Albert Skira S.A.; New York: Rizzoli.

Virginia Museum of Fine Arts. [1960]. *Sport and the Horse*. Exh. cat. [Richmond: Virginia Museum of Fine Arts].

———. 1978. *Degas*. Exh. cat. Richmond: Virginia Museum of Fine Arts.

Vital, Christophe. 1988. *Auguste Lepère, 1849–1918*. Exh. cat. Saint-Sébastien: Société Crocus (Musées de la Vendée).

Vollard, Ambroise. 1928. *Degas: An Intimate Portrait*. Trans. Randolph Weaver. London: George Allen and Unwin.

———. 1937. *Paul Cézanne: His Life and Art*. Trans. Harold L. Van Doren. New York: Crown.

Wadley, Nicholas, ed. 1987. *Renoir: A Retrospective.* New York: H. L. Levin.

Wagner, Anne M. 1981. "Courbet's Landscapes and Their Market." *Art History* 4, no. 4 (December): 410–31.

Waldman, Emil. 1927. *Die Kunst des Realismus und Impressionismus.* Berlin: Propyläen-Verlag.

Wall, George. A. 1884. *An Illustrated Catalogue of the Art Collection of Beriah Wall, Providence, R.I.* Providence: J. A. & R. A. Reid.

Wallraf-Richartz Museum. 1956. *Cézanne: Austellung zum Gedenken an sein 50. Todesjahr.* Exh. cat. Cologne: Greven & Bechtold.

Walter Kimball Gallery. 1907. *Paintings by Claude Monet.* Exh. cat. [Boston: Walter Kimball?].

———. 1910. *Paintings by Claude Monet.* Exh. cat. [Boston: Walter Kimball?].

Washington County Museum of Fine Arts. [1971]. *Fortieth Anniversary Exhibition, 1931–1971.* Essay by Alfred Werner. Exh. cat. n.p.

Watson, Forbes. 1925. "American Collections: No. 2—the John T. Spaulding Collection." *Arts* 8, no. 6 (December): 321–44.

———. 1928. "Recent Exhibitions." *Arts* 13, no. 1 (January): 33–43.

Weisbach, Werner. [1949–51]. *Vincent van Gogh, Kunst und Schicksal.* 2 vols. Basel: Amerbach-Verlag.

Weisberg, Gabriel, et al. 1975. *Japonisme: Japanese Influence on French Art, 1854–1910.* Exh. cat. Cleveland: Cleveland Museum of Art.

Weitzenhoffer, Frances. 1984. "The Earliest American Collectors of Monet." In *Aspects of Monet: A Symposium on the Artist's Life and Times,* ed. John Rewald and Frances Weitzenhoffer, 74–121. New York: H. N. Abrams.

———. 1986. *The Havermeyers: Impressionism Comes to America.* New York: H. N. Abrams.

Werner, Alfred. 1960. "The Contradictions of Courbet." *Arts* 34, no. 6 (March): 42–47.

Wheelwright, Edward. 1876. "Personal Recollections of Jean François Millet." *Atlantic Monthly* 38, no. 227 (September): 257–76.

White, Barbara Ehrlich. 1984. *Renoir: His Life, Art, and Letters.* New York: H. N. Abrams.

Whitman, Walt. 1982. *Walt Whitman: Complete Poetry and Selected Prose.* New York: Viking.

Wick, Peter A. 1962. "Some Drawings Related to Signac Prints." In *Prints: Thirteen Illustrated Essays on the Art of the Print, Selected for the Print Council of America by Carl Zigrosser,* by the Print Council of America, 83–96. New York: Holt, Rinehart & Winston.

Wickenden, Robert J. 1913. "Charles-François Daubigny, Painter and Etcher." *Print Collector's Quarterly* 3 (April): 190–93.

———. 1914. *The Men of 1830.* Exh. cat. Boston: Houghton Mifflin.

Wildenstein, Alec. 1992–98. *Odilon Redon: Catalogue raisonné de l'oeuvre peint et dessiné.* 4 vols. Paris: Wildenstein Institute.

Wildenstein & Company. [1936]. *Paul Gauguin, 1848–1903: A Retrospective Loan Exhibition for the Benefit of Les Amis de Paul Gauguin in the Penn Normal Industrial and Agricultural School.* Exh. cat. New York: Wildenstein & Company.

———. 1942. *The Serene World of Corot: An Exhibition in Aid of the Salvation Army War Fund, November 11–December 12, 1942.* Exh. cat. New York: Wildenstein & Company.

———. [1945]. *A Loan Exhibition of Paintings by Claude Monet, for the Benefit of the Children of Giverny.* Exh. cat. [New York: Wildenstein & Company].

———. 1949. *A Loan Exhibition of Degas for the Benefit of the New York Infirmary.* Exh. cat. New York: Wildenstein & Company.

———. 1950. *A Loan Exhibition of Renoir for the Benefit of the New York Infirmary.* Exh. cat. New York: Wildenstein & Company.

———. [1956]. *Loan Exhibition, Gauguin: For the Benefit of the Citizens' Committee for Children of New York City, Inc.* Exh. cat. New York: Wildenstein & Company.

———. 1958. *Renoir: Loan Exhibition for the Benefit of the Citizens' Committee for Children of New York City, Inc.* New York: Wildenstein & Company.

———. 1965. *C. Pissarro.* Exh. cat. New York: Wildenstein & Company.

———. 1968. *Degas' Racing World: A Loan Exhibition of Painting, Drawings, and Bronzes.* Exh. cat. New York: Wildenstein & Company.

———. 1969. *Corot.* Exh. cat. New York: Wildenstein & Company.

———. 1978. *Romance and Reality: Aspects of French Landscape Painting.* Exh. cat. New York: Wildenstein & Company.

Wildenstein, Daniel. 1974–91. *Claude Monet: Biographie et catalogue raisonné.* 5 vols. Lausanne: La Bibliothèque des arts.

———. 1996. *Monet: Catalogue raisonné.* 4 vols. Cologne: Taschen.

Wildenstein, Georges. 1964. *Gauguin.* Paris: Les Beaux-Arts.

Wilenski, Reginald Howard. 1931. *French Painting.* Boston: Hale, Cushman & Flint.

———. 1940. *Modern French Painters.* 1st ed. New York: Reynal & Hitchcock.

———. 1947. *Modern French Painters.* 2d ed. London: Faber & Faber.

William Rockhill Nelson Gallery of Art and Mary Atkins Museum of Fine Arts. 1935. *One Hundred Years of French Painting, 1820–1920.* Kansas City, Mo.: William Rockhill Nelson Gallery of Art and Mary Atkins Museum of Fine Arts.

Wilmerding, John, ed. 1986. *Essays in Honor of Paul Mellon, Collector and Benefactor.* Washington, D.C.: National Gallery of Art.

Winnipeg Art Gallery. [1955]. *Modern European Art since Manet.* Exh. cat. [Winnipeg?]: n.p.

Wisdom, John Minor, et al. 1978. *French Nineteenth-Century Oil Sketches, David to Degas: An Exhibition in Honor of the Retirement of Joseph Curtis Sloane. . . .* Chapel Hill, N.C.: Univ. of North Carolina at Chapel Hill.

Wolf, N. H. 1938. "100 Jaar Fransche Kunst." *De Kunst* 30, no. 1440 (September 10): 116–17.

Wolff, Albert. 1883. *Cent chefs-d'oeuvres des collections parisiennes.* Ed. Georges Petit and Ludovic Baschet. Exh. cat. Paris: Impr. Pillet & Dumoulin.

———. 1886. *Notes upon Certain Masters of the Nineteenth Century.* New York: Gilliss Brothers & Turnure, the Art Age.

Yomiuri Shimbun. 1979. *Exposition Renoir Japon, 1979.* Exh. cat. [Tokyo: Yomiuri Shimbun].

Yomiuri Shimbun. 1994. *1874 nen—Pari, "Daiikkai Inshōhaten" to sono jidai (Paris en 1874: L'année de l'Impressionnisme).* Exh. cat. Tokyo: Yomiuri Shimbun.

Yriarte, Charles. 1885. *J.-F. Millet.* Paris: Jules Rouam.

Zafran, Eric M. 1982. *French Salon Paintings from Southern Collections.* Exh. cat. Atlanta: High Museum of Art.

———. 1992. "Monet in Boston." Manuscript, Department of Art of Europe's curatorial file "Monet General," Museum of Fine Arts, Boston. Japanese trans. publ. in exh. cat., Bunkamura Museum of Art and the Museum of Fine Arts, Boston, *Mone to inshōha: Bosuton Bijutsukan ten* (Bunkamura: Bunkamura Museum, 1992).

———. 1998. *French Paintings in the Museum of Fine Arts, Boston.* Vol. 1, *Artists Born before 1790.* Boston: Museum of Fine Arts, Boston.

Zola, Emile. 1959. *Salons.* Ed. F. W. J. Hemmings and Robert J. Niess. Paris: Minard; Geneva: E. Droz.

———. 1974. *Le bon combat: De Courbet aux impressionnistes.* Paris: Hermann.

Figure Illustrations

Fig. 1. Paul Huet
The Forest of Compiègne, about 1830
Oil on canvas
33.4 x 44.4 cm (13¼ x 17½ in.)
Museum of Fine Arts, Boston
Juliana Cheney Edwards Collection
2002.124

Fig. 2. Jean-Baptiste-Camille Corot
Old Man Seated on a Trunk, 1826
Oil on panel
32.1 x 22.9 cm (12⅝ x 9 in.)
Museum of Fine Arts, Boston
The Henry C. and Martha B. Angell
Collection 19.79

Fig. 3. Jean-François Millet
The Sower, 1850
Oil on canvas
101.6 x 82.6 cm (40 x 32½ in.)
Museum of Fine Arts, Boston
Gift of Quincy Adams Shaw through
Quincy Adams Shaw, Jr., and Mrs. Marian
Shaw Haughton 17.1485

Fig. 4. Jean-Baptiste-Camille Corot
A Morning, Dance of the Nymphs, 1850
Oil on canvas
97 x 131 cm (38¼ x 52 in.)
Musée d'Orsay, Paris/Art Resource, New
York R.F. 73
Photograph by Erich Lessing

Fig. 5. Gustave Le Gray
Seascape—Mediterranean with Mount Agde,
1856–59
Photograph, albumen print from wet col-
lodion glass negative
30.7 x 40 cm (12¹⁄₁₆ x 15¾ in.)
Museum of Fine Arts, Boston
Gift of Charles Millard in honor of Alan
and Nancy Shestack 1997.240

Fig. 6. Jean-François Millet
Twilight, 1859–63
Black conté crayon and pastel on buff
wove paper
50.5 x 38.9 cm (19⅞ x 15⁵⁄₁₆ in.)
Museum of Fine Arts, Boston
Gift of Quincy Adams Shaw through
Quincy Adams Shaw, Jr., and Mrs. Marian
Shaw Haughton 17.1518

Fig. 7. Claude Monet
Woodgatherers at the Edge of the Forest,
about 1864
Oil on panel
59.7 x 90.2 cm (23½ x 35½ in.)
Museum of Fine Arts, Boston
Henry H. and Zoë Oliver Sherman Fund
1974.325

Fig. 8. Claude Monet
La Grenouillère, 1869
Oil on canvas
74.6 x 99.7 cm (29⅜ x 39¼ in.)
The Metropolitan Museum of Art, New
York
H. O. Havemeyer Collection, Bequest of
Mrs. H. O. Havemeyer, 1929 29.100.112

Fig. 9. Paul Cézanne
*Quartier Four, Auvers-sur-Oise (Landscape,
Auvers)*, about 1873
Oil on canvas
46.3 x 55.2 cm (18¼ x 21¾ in.)
Philadelphia Museum of Art
The Samuel S. White 3rd, and Vera White
Collection 1967-30-16
Photograph by Eric Mitchell, 1983

Fig. 10. Claude Monet
Cliffs of the Petites Dalles, 1880
Oil on canvas
60.6 x 80.3 cm (23⅞ x 31⅝ in.)
Museum of Fine Arts, Boston
Denman Waldo Ross Collection 06.116

Fig. 11. Alfred Sisley
Overcast Day at Saint-Mammès, about 1880
Oil on canvas
54.9 x 74 cm (21⅝ x 29⅛ in.)
Museum of Fine Arts, Boston
Juliana Cheney Edwards Collection
39.679

Fig. 12. Pierre-Auguste Renoir
Grand Canal, Venice, 1881
Oil on canvas
54 x 65.1 cm (21¼ x 25⅝ in.)
Museum of Fine Arts, Boston
Bequest of Alexander Cochrane 19.173

Fig. 13. Claude Monet
Cap Martin, near Menton, 1884
Oil on canvas
67.3 x 81.6 cm (26½ x 31⅛ in.)
Museum of Fine Arts, Boston
Juliana Cheney Edwards Collection
25.128

Fig. 14. Claude Monet
Old Fort at Antibes, 1888
Oil on canvas
65.4 x 81 cm (25¾ x 31⅞ in.)
Museum of Fine Arts, Boston
Anonymous gift 1978.634

Fig. 15. Thomas E. Marr
American, 1849–1910
Picture gallery, Museum of Fine Arts,
view to the northeast, 1902
Museum of Fine Arts, Boston
Museum Archives, no. 7190

Fig. 16. Jean-François Millet
Harvesters Resting (Ruth and Boaz), 1850–53
Oil on canvas
67.3 x 119.7 cm (26½ x 47⅛ in.)
Museum of Fine Arts, Boston
Bequest of Mrs. Martin Brimmer 06.2421

Fig. 17. Jean-François Millet
Young Shepherdess, about 1870–73
Oil on canvas
162 x 113 cm (63¾ x 44½ in.)
Museum of Fine Arts, Boston
Gift of Samuel Dennis Warren 77.249

Fig. 18. Thomas E. Marr
American, 1849–1910
Picture gallery, Museum of Fine Arts,
view to the southeast, 1902
Museum of Fine Arts, Boston
Museum Archives, no. 7189

Fig. 19. Henri Regnault
French, 1843–1871
Automedon with the Horses of Achilles, 1868
Oil on canvas
315 x 329 cm (124 x 129½ in.)
Museum of Fine Arts, Boston
Gift by subscription 90.152

Fig. 20. William Morris Hunt
American, 1824–1879
Self-Portrait, 1849
Oil on canvas
27.3 x 21.3 cm (10¾ x 8⅜ in.)
Museum of Fine Arts, Boston
Gift of William Perkins Babcock 92.2742

Fig. 21. William Morris Hunt
American, 1824–1879
The Belated Kid, 1854–57
Oil on canvas
137.8 x 98.4 cm (54¼ x 38¾ in.)
Museum of Fine Arts, Boston
Bequest of Miss Elizabeth Howes 07.135

Fig. 22. Gustave Courbet
The Quarry, 1856
Oil on canvas
210.2 x 183.5 cm (82¾ x 72¼ in.)
Museum of Fine Arts, Boston
Henry Lillie Pierce Fund 18.620

Fig. 23. John Singer Sargent
American, 1856–1925
*Claude Monet Painting by the Edge of a
Wood*, 1887
Oil on canvas
54 x 64.8 cm (21¼ x 25½ in.)
Tate Gallery, London/Art Resource, New
York
Presented by Miss Emily Sargent and Mrs.
Ormond through the National Art
Collections Fund, 1925 N4103

Fig. 24. Dennis Miller Bunker
American, 1861–1890
Chrysanthemums, 1888
Oil on canvas
90.2 x 121.9 cm (35½ x 48 in.)
Isabella Stewart Gardner Museum, Boston
P3w5

Fig. 25. Léon Lhermitte
French, 1844–1925
Wheatfield (Noonday Rest), 1890
Oil on canvas
53.3 x 77.5 cm (21 x 30½ in.)
Museum of Fine Arts, Boston
Bequest of Julia C. Prendergast in mem-ory of
her brother James Maurice Prendergast 44.38

Fig. 26. Claude Monet
Boulevard Saint-Denis, Argenteuil, in Winter, 1875
Oil on canvas
60.9 x 81.6 cm (24 x 32⅛ in.)
Museum of Fine Arts, Boston
Gift of Richard Saltonstall 1978.633

Fig. 27. Claude Monet
The Seine at Lavacourt, 1880
Oil on canvas
61 x 81.2 cm (24 x 32 in.)
Fogg Art Museum, Harvard University Art
Museums/Bridgeman Art Library FOG126726

Fig 28. Claude Monet
Valley of the Creuse (Gray Day), 1889
Oil on canvas
64.5 x 81.3 cm (25⅜ x 32 in.)
Museum of Fine Arts, Boston
Denman Waldo Ross Collection 06.115

Fig. 29. Katsushika Hokusai
Japanese, 1760–1849
The Yoshitsune Horse-washing Waterfall at Yoshino,
about 1832
Woodblock print
35.8 x 25.6 cm (14⅛ x 10¹⁄₁₆ in.)
Museum of Fine Arts, Boston
William S. and John T. Spaulding Collection
21.6686

Fig. 30. Claude Monet
Valley of the Petite Creuse, 1889
Oil on canvas
65.4 x 81.3 cm (25¾ x 32 in.)
Museum of Fine Arts, Boston
Bequest of David P. Kimball in memory of
his wife Clara Bertram Kimball 23.541

Fig. 31. Edgar Degas
Orchestra Musicians, 1870–71
Oil on canvas
69 x 49 cm (27⅛ x 19¼ in)
Städelsches Kunstinstitut, Frankfurt/Artothek
SG237

Fig. 32. Pierre-Henri de Valenciennes
At the Villa Farnese: Houses among the Trees
Oil on paper on cardboard
26 x 39.5 cm (10¼ x 15½ in.)
Musée du Louvre, Paris
Réunion des Musées Nationaux / Art
Resource, New York ART160030

Fig. 33. Claude Lorrain
French, 1600–1682
Landscape with a Temple of Bacchus, 1644
Oil on canvas
96.5 x 123.1 cm (37 x 45½ in.)
National Gallery of Canada, Ottawa
Purchased, 1939 4422

Fig. 34. Théodore Rousseau
Cattle Descending the Jura, 1834–35
Oil on canvas
259 x 166 cm (102 x 65⅜ in.)
Musée de Picardie, Amiens / Art Resource,
New York 65 DN 5100
Photograph © Réunion des Musées
Nationaux

Fig. 35. Johannes van Doetechum,
the Elder
Dutch, died 1605
Lucas van Doetechum
Dutch, died after 1589
*Praediorum Villarum: pl. 14 (Village with
Pond and Church Tower),* 1561
Etching retouched with engraving
Platemark: 16.2 x 20.5 cm (6⅜ x 8¹/₁₆ in.)
Sheet: 17.2 x 24 cm (6¾ x 9⁷/₁₆ in.)
National Gallery of Art, Washington
Rosenwald Collection 1964.8.500
Photograph © Board of Trustees,
National Gallery of Art, Washington

Fig. 36. Meindert Hobbema
Dutch, 1638–1709
Farmland with a Pond and Trees, about
1663–64
Oil on canvas
96.5 x 128.3 cm (38 x 50½ in.)
Taft Museum of Art, Cincinnati, Ohio
Bequest of Charles Phelps and Anna
Simon Taft 1931.407

Fig. 37. Meindert Hobbema
Dutch, 1638–1709
A Pond in a Forest, 1668
Oil on panel
60 x 84.5 cm (23⅜ x 33¼ in.)
Allen Memorial Art Museum, Oberlin
College, Ohio
Mrs. F. F. Prentiss Bequest, 1944 44.52

Fig. 38. Simon de Vlieger
Dutch, about 1600–1653
*Sleeping Peasants near Fields (Parables of the
Weeds),* 1650–53
Oil on canvas
90.4 x 130.4 cm (35⅝ x 51⅜ in.)
The Cleveland Museum of Art
Mr. and Mrs. William H. Marlatt Fund
1975.76

Fig. 39. Richard Parkes Bonington
English, 1801–1828
Rouen, before 1822
Watercolor on paper
18.1 x 23.8 cm (7⅛ x 9⅜ in.)
The Wallace Collection, London
Reproduced by permission of the
Trustees P704

Fig. 40. Louis-Auguste Bisson
French, 1814–1876
Auguste-Rosalie Bisson
French, 1826–1900
Alpine View, Mer de Glâce, about 1860
Photograph, albumen print from glass-
plate negative
Image: 30.5 x 44.5 cm (12 x 17½ in.)
Sheet: 42.2 x 61 cm (16⅝ x 24 in.)
Museum of Fine Arts, Boston
Ernest Wadsworth Longfellow Fund
2000.776

Fig. 41. Jean-Baptiste-Camille Corot
Bacchante with a Panther, 1860, reworked
about 1865–70
Oil on canvas
54.6 x 95.3 cm (21½ x 37½ in.)
Shelburne Museum, Shelburne, Vermont
27.1.1-226

Fig. 42. Claude Monet
Rue de la Bavolle, Honfleur, about 1864
Oil on canvas
58 x 63 cm (22⅞ x 24¾ in.)
Städtische Kunsthalle, Mannheim 299
Photograph by Margitta Wickenhäuser

Fig. 43. Claude Monet
The Old "Le Pollet" Quarter of Dieppe,
1856–57
Graphite and watercolor on scratchboard
13.4 x 21.9 cm (5¼ x 8⅝ in.)
Museum of Fine Arts, Boston
Gift of Elizabeth K. Davis 1998.577

Fig. 44. Utagawa Hiroshige
Japanese, 1797–1858
The Five Pines at Onakigawa, 1856
Color woodcut
34 x 22.2 cm (13½ x 8¾ in.)
Philadelphia Museum of Art
Gift of Mrs. Anne Archbold, 1946
1946-66-92

Fig. 45. Edouard Manet
French, 1832–1883
The Railway, 1873
Oil on canvas
93.3 x 111.5 cm (36¾ x 45⅛ in.)
National Gallery of Art, Washington
Gift of Horace Havemeyer in Memory of
his mother, Louisine W. Havemeyer
1956.10.1
Photograph © Board of Trustees,
National Gallery of Art, Washington

Fig. 46. Pierre-Auguste Renoir
The Seine at Chatou, about 1871
Oil on canvas
46.7 x 56.1 cm (18⅜ x 22⅛ in.)
Art Gallery of Ontario, Toronto
Purchase, 1935 2304

Fig. 47. Claude Monet
The Sheltered Path, 1873
Oil on canvas
54.5 x 65.4 cm (21½ x 25¾ in.)
Philadelphia Museum of Art
Gift of Mr. and Mrs. Hughs Norment in
honor of William H. Donner 1972-227-1

Fig. 48. Théodore Rousseau
Oak Trees in the Gorge of Apremont, about
1850–52
Oil on canvas
63.5 x 99.5 cm (25 x 39⅛ in.)
Musée du Louvre, Paris / Art Resource,
New York
Bequest of Thomy Thiéry, 1902 1447

Fig. 49. Paul Cézanne
Bottom of the Ravine, about 1879
Oil on canvas
73 x 54 cm (28¾ x 21¼ in.)
The Museum of Fine Arts, Houston
Gift of Audrey Jones Beck 98.274

Fig. 50. Paul Cézanne
Picnic on a River, about 1872–75
Oil on canvas
26.4 x 34 cm (10⅜ x 13⅜ in.)
Yale University Art Gallery, New Haven,
Connecticut
Gift of Mr. and Mrs. Paul Mellon,
B.A. 1929 1983.7.6

Fig. 51. Camille Pissarro
Standing Peasant Girl, about 1884
Black chalk and watercolor
50.6 x 39 cm (19⅞ x 15⅜ in.)
Whitworth Art Gallery, Manchester,
England

Fig. 52. Ferdinand Hodler
Swiss, 1853–1918
*Lake of Geneva and the Range of Mont-
Blanc, at Dawn,* 1918

Oil on canvas
61.2 x 128 cm (24⅛ x 50⅜ in.)
Musée d'art et d'histoire, Ville de Genève
1918-25

Fig. 53. Paul Signac
The Seine at Herblay, 1889
Oil on canvas
33 x 55 cm (13 x 21⅝ in.)
Musée d'Orsay, Paris / Art Resource, New
York
Photograph © Réunion des Musées
Nationaux

Fig. 54. Georges Seurat
French, 1859–1891
Head of a Woman, study for the painting
*Sunday Afternoon on the Island of La Grande
Jatte,* about 1884–85
Black conté crayon on cream laid paper
29.8 x 21.6 cm (11¾ x 8½ in.)
Smith College Museum of Art,
Northampton, Massachusetts
Purchased, Tryon Fund, 1938 1938:10-1

Fig. 55. François Boucher
French, 1703–1770
Spring, 1745
Oil on canvas
100.3 x 135.6 cm (39½ x 53⅜ in.)
The Wallace Collection, London
Reproduced by permission of the
Trustees P445

Fig. 56. Camille Pissarro
The Côte des Boeufs at L'Hermitage, 1877
Oil on canvas
115 x 87.5 cm (45¼ x 34½ in.)
National Gallery, London NG4197

Fig. 57. Jean-Baptiste-Camille Corot
Souvenir of Mortefontaine, 1864
Oil on canvas
65 x 89 cm (25½ x 35 in.)
Musée du Louvre, Paris / Art Resource,
New York MI 692 bis

Fig. 58. Paul Gauguin
Fatata te Moua, 1892
Oil on canvas
68 x 92 cm (26¾ x 36¼ in.)
The State Hermitage Museum, Saint
Petersburg, Russia

Fig. 59. Paul Gauguin
*Where Do We Come From? What Are We?
Where Are We Going?* 1897–98
Oil on canvas
139.1 x 374.6 cm (54¾ x 147½ in.)
Museum of Fine Arts, Boston
Tompkins Collection 36.270